BENTON, POLLOCK, AND THE POLITICS OF MODERNISM

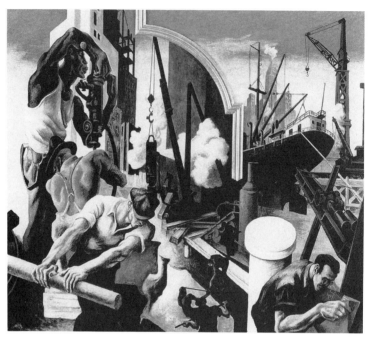

THE UNIVERSITY OF CHICAGO PRESS CHICAGO AND LONDON

ERIKA DOSS

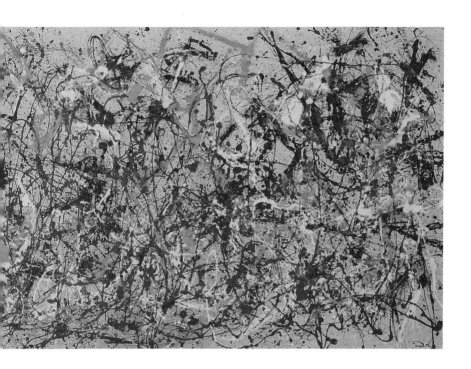

BENTON, POLLOCK, AND

THE POLITICS OF MODERNISM:

FROM REGIONALISM TO

ABSTRACT EXPRESSIONISM

The University of Chicago Press, Chicago 60637
The University of Chicago Press, Ltd., London

ISBN 0-226-15942-6 (cl.)
ISBN 0-226-15943-4 (pbk.)

Library of Congress Cataloging-in-Publication Data

Doss, Erika Lee.
 Benton, Pollock, and the politics of modernism : from regionalism
to abstract expressionism / Erika Doss.
 p. cm.
 Includes bibliographical references and index.
 1. Benton, Thomas Hart, 1889–1975—Criticism and interpretation.
2. Regionalism in art—United States. 3. Pollock, Jackson,
1912–1956—Criticism and interpretation. 4. Abstract expressionism—
United States. 5. Modernism (Art)—Political aspects—United
States—History—20th century. I. Title.
 ND237.B47D67 1991 91-18541
 759.13—dc20 CIP

Title page illustrations
Left: Thomas Hart Benton, *City Building,* from *America Today,* 1930; distemper, egg tempera, and oil glaze on linen, 92″ × 117″. Originally painted for the New School for Social Research, New York; now on display at Equitable Life Assurance Society, 787 Seventh Avenue, New York City. Copyright The Equitable Life Assurance Society of the United States.
Right: Jackson Pollock, *Autumn Rhythm,* 1950; oil on canvas, 105″ × 207″. Courtesy of The Metropolitan Museum of Art, George A. Hearn Fund, 1957. Copyright 1990 Pollock-Krasner Foundation/ARS N.Y.

For my mentors,
Miss K., Erv, KAM, Lary,
and, most of all,
Alice and Seale

CONTENTS

List of Illustrations ix

Acknowledgments xv

Introduction 1

O N E *Republicanism and Modernism: The Genesis of Regionalism in* The American Historical Epic 9

T W O *Liberal Reform and the American Scene: Benton's 1930s Murals* 67

T H R E E *Thomas Hart Benton in Hollywood: Regionalist Art and Corporate Patronage* 147

F O U R *Modernist Accommodation, Corporate Appropriation: The Collapse of Regionalism and the New Deal* 229

F I V E *From Regionalism to Abstract Expressionism: Modern Art and Consensus Politics in Postwar America* 311

S I X *The Misconstruction of Abstract Expressionism: Institutional Orthodoxy and Commodification* 363

Index 425

1.1 Thomas Hart Benton, *Discovery* 11
1.2 Thomas Hart Benton, *Over the Mountains* 12
1.3 Thomas Hart Benton, *Slaves* 13
1.4 Harriet Hosmer, *Thomas Hart Benton* 18
1.5 George Caleb Bingham, *Thomas Hart Benton* 19
1.6 George Caleb Bingham, *Stump Speaking* 20
1.7 Photo of M. E. Benton and Tom Steele 23
1.8 Thomas Hart Benton, *Politics, Farming, and Law in Missouri* (detail) 26
1.9 Thomas Hart Benton, *Landscape* 39
1.10 Thomas Hart Benton, *Figure Organization No. 3* 40
1.11 Michelangelo, *The Battle of the Lapiths and the Centaurs* 41
1.12 Everett Shinn, *Murals, Commission Chambers* 46
1.13 John Sloan, *Movies, 5 Cents* 47
1.14 Robert Minor, *Pittsburgh* 51
1.15 Thomas Hart Benton, *Mine Strike* 52
1.16 Thomas Hart Benton, *1927—New York Today* 55
2.1 Joseph Urban and Thomas Hart Benton, original third floor boardroom, New School for Social Research 69
2.2 Thomas Hart Benton, *Instruments of Power* 70
2.3 Thomas Hart Benton, *City Building* 71
2.4 Thomas Hart Benton, *Steel* 72
2.5 Thomas Hart Benton, *Coal* 73
2.6 Thomas Hart Benton, *Deep South* 74
2.7 Thomas Hart Benton, *Midwest* 75
2.8 Thomas Hart Benton, *Changing West* 76
2.9 Thomas Hart Benton, *City Actitivies with Dance Hall* 77
2.10 Thomas Hart Benton, *City Activities with Subway* 78
2.11 Thomas Hart Benton, *Outreaching Hands* 80
2.12 Joseph Urban, New School for Social Research 82
2.13 José Clemente Orozco, *The Struggle in the Occident* 84
2.14 Diego Rivera, *Detroit Industry* 84
2.15 Millard Sheets, *Tenement Flats* 86
2.16 Thomas Hart Benton, *Arts of the South* 89

2.17 Thomas Hart Benton, *Political Business and Intellectual Ballyhoo* 89

2.18 Cover of *Time* magazine 99

2.19 Indiana Pavilion at the Chicago World's Fair, featuring Thomas Hart Benton's *Social History of the State of Indiana* 101

2.20 Thomas Hart Benton, *Industrial Panel 6: Civil War, Expansion* 103

2.21 Thomas Hart Benton, *Cultural Panel 6: Old Time Doctor, the Grange, Woman's Place* 103

2.22 Thomas Hart Benton, *Industrial Panel 4: Home Industry, Internal Improvements* 104

2.23 Thomas Hart Benton, *Cultural Panel 4: Early Schools, Communities, Reformers, Squatters* 104

2.24 Thomas Hart Benton, *Industrial Panel 11: Indiana Puts Her Trust in Work* 106

2.25 Thomas Hart Benton, *Cultural Panel 11: Indiana Puts Her Trust in Thought* 107

2.26 Thomas Hart Benton, *Factory Workers* and *Strike*, in Leo Huberman's *We, the People* 114

2.27 Stuart Davis, *New York Mural* 117

2.28 "U.S. Scene," *Time* magazine 119

2.29 Thomas Hart Benton, *Pioneers Days and Early Settlement* 127

2.30 Thomas Hart Benton, *Politics, Farming and Law in Missouri* 128

2.31 Thomas Hart Benton, *St. Louis and Kansas City* 130

2.32 Joe Jones, *Harvest* 135

3.1 Thomas Hart Benton, *Set Designing* 148

3.2 Thomas Hart Benton, *Dubbing in Sound* 149

3.3 Thomas Hart Benton, *Hollywood* 150

3.4 Advertisement for the Associated American Artists, *Art Digest* 159

3.5 Advertisement for the Associated American Artists, *American Artist* 160

3.6 Grant Wood, *American Gothic* 163

3.7 John Steuart Curry, *Baptism in Kansas* 164

3.8 Thomas Hart Benton, *Plowing It Under* 165

3.9 "Curry of Kansas," *Life* magazine 168–69

3.10 Cover, *Time* magazine 173

3.11 "Thomas Benton Paints a History of His Own Missouri," *Life* magazine 176–77

3.12 Grant Wood, *Spring Turning* 178–79

3.13 "Artist Thomas Hart Benton Hunts Communists and Fascists in Michigan," *Life* magazine 182–83

3.14 "'Menaces' to Michigan Democracy As Sketched & Captioned by Tom Benton," *Life* magazine 184–85

3.15 Philip Evergood, *American Tragedy* 187

3.16 John Steuart Curry, *Hoover and the Flood* 190–91

3.17 Paul Cadmus, *The Herrin Massacre* 193

3.18 Reginald Marsh, *Twenty Cent Movie* 199

3.19 Stanton MacDonald-Wright, *Motion Picture Industry* (detail) 200

3.20 Composite photo of "Hollywood Beauties," *Vanity Fair* magazine 205

3.21 Thomas Hart Benton, *Burning of Chicago* 206

3.22 Film still of *In Old Chicago* 207

3.23 Film still of *Life Begins in College* 209

3.24 Film still of *Ali Baba Goes to Town* 210

3.25 Thomas Hart Benton, *Directors Conference* 216

3.26 Photograph of Darryl F. Zanuck 217

3.27 Photograph of Hedda Hopper interviewing Gene Tierney 218

3.28 Doris Lee, *Edward G. Robinson* 219

4.1 Advertisement for Lucky Strike cigarettes featuring Thomas Hart Benton's *Outside the Curing Barn* 230

4.2 Advertisement for Lucky Strike cigarettes featuring Thomas Hart Benton's *Tobacco* 231

4.3 Thomas Hart Benton, *Sorting Tobacco at Firing House* 234

4.4 Thomas Hart Benton, *Tobacco Sorters* 236

4.5 Advertisement for Lucky Strike cigarettes featuring John Steuart Curry's *Grading a Pile of Tobacco after Curing* 237

4.6 Advertisement for Lucky Strike cigarettes featuring an untitled painting by Cosmo de Salvo. 238

4.7 Thomas Hart Benton, *Shore Leave* 240

4.8 Photo of Walter Wanger (right) and unidentified man in front of Grant Wood's *Sentimental Ballad* 241

4.9 Photograph of Rivoli Theater, where *The Long Voyage Home* premiered 243

4.10 Film stills from *The Long Voyage Home* 244–45

4.11 Luis Quintanilla, *Bumboat Girls* 249

4.12 Ernest Fiene painting John Wayne's portrait 250

4.13 Thomas Hart Benton, *Persephone* 254

4.14 Thomas Hart Benton, *After Many Springs* 255

4.15 Thomas Hart Benton, *Prodigal Son* 256

4.16 Thomas Hart Benton, *Fantasy* 257

4.17 Peter Blume, *Landscape with Poppies* 259

4.18 Ivan Albright, *Wherefore Now Ariseth the Illusion of a Third Dimension* 259

4.19 Nathaniel Pousette-Dart, *Tree Chart of Contemporary American Art* 260

4.20 Advertisement for Pepsi-Cola, *Time* magazine 273

4.21 Advertisement for Coca-Cola, *Time* magazine 274

4.22 Stuart Davis, *History of Communications* 276–77

4.23 Cover, *The Year of Peril: A Series of War Paintings by Tom Benton* featuring Benton's *Starry Night* 284

4.24 Thomas Hart Benton, *Indifference* 285

4.25 Thomas Hart Benton, *The Sowers* 286

4.26 Thomas Hart Benton, *Invasion* 286

4.27 Thomas Hart Benton, *Exterminate!* 287

4.28 Thomas Hart Benton, *Again* 288

4.29 David Stone Martin, *OWI Poster No. 8* 290

4.30 Salvador Dali, *Soft Construction with Boiled Beans, Premonition of Civil War* 292

4.31 Salvador Dali, *The Spectre of Sex Appeal* 294

4.32 Salvador Dali, *Family of Marsupial Centaurs* 295

4.33 Advertisement for Pan American Airlines, featuring commentary from John Dewey, *Life* magazine 298–99

4.34 Advertisements for Johnson Wax Company and Koppers Company by Salvador Dali, illustrated in *Newsweek* magazine 302–3

5.1 Jackson Pollock, *Going West* 312

5.2 Thomas Hart Benton, *Cattle Loading, West Texas* 314–15

5.3 Jackson Pollock, *Alchemy* 316–17

5.4 José Clemente Orozco, *Prometheus* 320

5.5 Thomas Hart Benton, *The Ballad of the Jealous Lover of Lone Green Valley* 321

5.6 Jackson Pollock, *Cody, Wyoming* 324

5.7 Thomas Hart Benton, *Saturday Afternoon* 325

5.8 Jackson Pollock, *Departure* 326

5.9 Thomas Hart Benton, *Threshing Wheat* 327

5.10 Jackson Pollock, *Landscape with Steer* 329

5.11 Jackson Pollock, *Man, Bull, Bird* 330

5.12 George Tooker, *Subway* 340

5.13 Jackson Pollock, *Autumn Rhythm* 342–43

5.14 Hans Namuth, photograph of Jackson Pollock 344

5.15 Jackson Pollock, *Moon Woman Cuts the Circle* 352

5.16 Ad Reinhardt, *How to Look at Modern Art in America* 355

6.1 Thomas Hart Benton, *Achelous and Hercules* 366–67

6.2 Jackson Pollock, *Alchemy* 368–69

6.3 Adolf Wissel, *Worker's Family;* Paul Padua, *10th of May, 1940* 390

6.4 "Jackson Pollock: Is He the Greatest Living Painter in the United States?" *Life* magazine 394

6.5 "A *Life* Round Table on Modern Art," *Life* magazine 396–97

6.6 "The Art of Russia . . . That Nobody Sees," *Life* magazine 402–3

6.7 "Make Up Your Mind: One-Picture Wall or Many-Picture Wall," *Vogue* magazine featuring Mark Rothko's *Number Eight* 406–7

6.8 Advertisement for County Homes, *Partisan Review* magazine featuring a drawing by Jackson Pollock 408

6.9 "Spring Ball Gowns," *Vogue* magazine featuring models posed in front of paintings by Jackson Pollock 410

6.10 Drip-style fashion design in *Vogue* magazine 412–13

6.11 Jackson Pollock, *Number 27, 1951* 414

ACKNOWLEDGMENTS

As an art historian, it is only appropriate that I acknowledge my gratitude to "all those wonderful people out there in the dark." Those words, spoken by Norma Desmond (Gloria Swanson) in one of the final scenes of the film noir classic *Sunset Boulevard* (1950), more or less sum up the audience for those of us who rely on visual evidence as a means of historical inquiry. Presenting our ideas in "the dark" and mumbling the less than heroic phrase "next slide please" every few minutes, the art historian is truly dependent on the audience in the shadows.

In the writing of this book, that audience has included many friends, colleagues, and students, all of whom merit my thanks. In particular, I am indebted to the provocative insights and critiques provided by Karal Ann Marling and Lary May in the course of this study. Although their points of view differ considerably, their support of my work has been generous and invaluable.

Benton, Pollock, and the Politics of Modernism has its origin in my studies with Marling and May at the University of Minnesota in the early 1980s. Marling introduced me to Thomas Hart Benton and American art and encouraged my presentation of research on Benton and popular culture at professional meetings. May invited me to participate in the seminar Promise and Peril: Rethinking Post-War America, sponsored by the American Studies Program at the University of Minnesota in 1984. I am grateful to them both for their encouragement at early stages and throughout the shaping of this project.

Many early versions of chapters were presented as papers at meetings of the American Studies Association, the College Art Association, the Mid-America College Art Association, and the Organization of American Historians. In addition, many friends and colleagues listened to arguments and slide lectures, read drafts of chapters, and gave close critical readings to the entire manuscript. For their helpful suggestions and advice, I thank Wanda Corn, Lewis Erenberg, Claire Farago, Andrew Feffer, David Grimsted, Camille Guerin-Gonzales, Patricia Hill, Jackson Lears, Roland Marchand, Elaine Tyler May, Mark Crispin Miller, David W. Noble, George H. Roeder, Jr., Bruce Ronda, Frances Pohl, Dan Schiller, and the late Lawrence Alloway and Warren Susman. I am especially grateful to my graduate students at the University of Colorado, particularly Barbara Coleman, Leigh Ann Hallberg, and Leo Mazow, for their enthusiastic and critical support.

For generously sharing information with me, I would like to thank Henry Adams, Jessie Benton, Barbara Carr, James Dennis, M. Sue Kendall, and Sidney Larson. In this regard, I am indebted to the staffs of the Academy of Motion Pictures Art and Sciences; the Archives of American Art; the Billy Rose Theatre Collection of the New York Public Library; the Los Angeles County Museum of Art; the Rare Books and Manuscript Library, Columbia University; the Theater and Film Arts Library, University of California at Los Angeles; the University of Southern California Special Collections Library; and the Wisconsin Center for Theater and Film Research. Thanks also to Stephen Campbell and the Trustees of the Benton Testamentary Trust for allowing me to view and photograph many of Benton's drawings in the basement vault of the United Missouri Bank in summer 1980.

Grants from the Graduate School at the University of Colorado provided support for the research and writing of this book.

Most of all, I want to thank Geoffrey Thrumston. Throughout the hours of "art in the dark," his sustenance and sense of humor have kept me and this book on course.

Boulder, Colorado
July 1990

During the 1940s, a remarkable transformation occurred in American art patronage and taste. Throughout the Depression, the anecdotal style of regionalism held popular, critical, and institutional attention, but in the postwar era the nonobjective art of abstract expressionism achieved success, albeit mostly critical and institutional success. This shift has been largely ignored in recent histories of American art, which have isolated regionalism and abstract expressionism as two quite distinct and seemingly disconnected aesthetic entities. Both revisionist and mainstream historians have viewed the emergence of postwar abstraction in a vacuum, failing to show either its stylistic and intellectual debt or the complete nature of its discontinuity with regionalist art. The fact is that regionalism, a narrative style of upbeat content and dramatic form, was the dominant style of American art during the 1930s. In the 1940s, its cultural dominance eroded and the style of abstract expressionism came into ascendancy. This book is concerned with how and why the shift from regionalism to abstract expressionism actually occurred. By seeing American art from the Depression to the Cold War in terms of the sociopolitical and cultural conditions of its age, I hope to explain the reasons for this change and cast light on its significance for contemporary culture.

My inquiry focuses on two artists, Thomas Hart Benton and Jackson Pollock, each a principal painter in his own era. Benton, the Depression regionalist, offered his American scene audience public pictures of promise and regeneration, as the 1930 mural panel *City Building* (fig. 2.3) reveals. Pollock, the postwar abstractionist, painted equally large pictures, such as *Autumn Rhythm* (1950; fig. 5.13), but offered a darker, weblike vision of social and political entrapment. In the early thirties Pollock had been Benton's foremost student and close friend, imitating the regionalist style and even the personal mannerisms of his teacher. But in the 1940s Pollock reneged on Benton's art and moved to a painting style of apparently different content and form altogether. Investigating the political ideologies in which regionalism and abstract expressionism were intertwined aids in our understanding of Pollock's radical departure from regionalism. I also propose that Pollock attempted to sustain certain aspects of Benton's aesthetic and political strategies in his own nonobjective art. Despite claims to the contrary, *both* Benton and Pollock were bound to an art of social contract.

This study especially centers on Thomas Hart Benton (1889–1975), who may be recognized as the foremost painter of his generation; he was certainly one of the most popular American artists. During the late 1920s and throughout the Depression, Benton was regarded as a major artist, a regionalist who painted dynamic, narrative murals that represented American life and legend. The members of the so-called regionalist triumvirate—Benton, John Steuart Curry, and Grant Wood—gave Depression era audiences images of what seemed to be ordinary, everyday Americana: the stoic farmers of Wood's painting *American Gothic* (1930), the country christening depicted in Curry's picture *Baptism in Kansas* (1928), the men at work in Benton's *City Building*. Benton and his fellows were adamant about creating a uniquely American art aimed at widespread popularity, an art intelligible and meaningful to all citizens, an art grounded especially in the values of the American republic.

Benton, in particular, linked his brand of regionalism with the tenets of liberal politics and modern art. The son of a Missouri congressman with ties to the populist and progressive movements, and the great-nephew of Senator Thomas Hart Benton, exemplar of the producer tradition and republican values in mid-nineteenth-century America, Benton eventually came to accept and advance his inheritance of liberal democratic ideology. He did so in the realm of public art, however, not electoral politics. Benton studied art in Paris for several years prior to World War I. He also worked for the burgeoning motion picture industry in New York and New Jersey during the teens. Modern art and the movies were enormously appealing to him, for both proposed the merger of art and life, the integration of spheres that had been separated in the Gilded Age. Adopting various strains of European and American modern art, from Cézannesque structuralism to synchromism, and also assimilating the style and subjects of the early motion pictures, Benton linked avant-garde art and popular culture with the politics of his upbringing. The result was regionalism.

In the years of the Depression, Benton's modern art corresponded and often directly reflected the liberal ideology of the New Deal. Within the narrative and anecdotal framework of his 1930s murals, Benton promoted an energetic America of autonomous workers, collective citizenship, and cultural unity. These were the same values projected by the Roosevelt administration, especially during FDR's first term. Benton, like historian Charles Beard, saw in the early years of the New Deal the revival of the reform spirit of progressive era republicanism. For both the artist and the historian, Roosevelt's paeans to the rebirth of liberal

politics suggested the potential for significant social change at a time when reform was desperately needed. In this light, Benton's regionalist murals can be seen as his modern updating and revision of the republican tradition he inherited from his father and great- uncle.

While Jackson Pollock (1912–56) did not aspire to the particular republican politics of his teacher, he too projected a vision of social reform on his canvases. His was also a style of modern art that challenged traditional modes of cultural behavior and proposed the integration of art and life, albeit with radically different aesthetic criteria. Dropping obvious narrative references to the American folk and to cultural nationalism, Pollock pioneered an improvisational painting style characterized by its thick, gestural application of paint, its ambivalent spatial relations, and its emphasis on aesthetic experimentation. While markedly dissimilar from his earlier regionalist art, Pollock's abstractions still sustained the faith that personal and social reform were possible. While the dense forms of his large poured pictures suggest the social alienation of postwar America, they also embody Pollock's attempt to liberate himself, and his art audience, from the entrapment of consensus culture. Combining the healing strategies of Jungian therapy and Indian sand painting, Pollock attempted to cure himself of personal problems and suggest the possibilities for broad social reform. He obviously shifted from the regionalist to abstract expressionist style, but remained committed to an art of social contract.

Much of the analysis of Pollock's shift has focused on the style's formalist development. In 1944, Pollock made a remark about his former teacher that has often been quoted. When asked how his studies with Benton in New York in the early 1930s had affected him, Pollock replied: "My work with Benton was very important as something against which to react very strongly, later on; in this, it was better to have worked with him than with a less resistant personality." Armed with this quote, art critics and historians after World War II suggested that the stylistic shift from Depression regionalism to postwar abstract expressionism was simply one of generational progress. Pollock "progressed" from figurative and narrative art to a gestural art of abstraction. He expanded on the rhythmic contours and vivid palette of his teacher's anecdotal Americana but rejected the content of regionalist art. His formal innovations, like those of other postwar abstract artists, were termed "breakthroughs" and their art was heralded as the "triumph of American painting."[1]

More recently, historians have turned away from this reading of ab-

stract art and have begun to examine the historical circumstances that led to its postwar triumph. Serge Guilbaut, for example, ties the postwar dominance of abstract expressionism to its use as a "weapon against totalitarianism" by various cultural and political entities, remarking, "Avant-garde art succeeded because the work and the ideology that supported it, articulated in the painters' writings as well as conveyed in images, coincided fairly closely with the ideology that came to dominate American political life after the 1948 presidential election." This ideology was inherent, Guilbaut explains, in the concept of "freedom," which became "the symbol most actively and vigorously promoted by the new liberalism in the Cold War period." For many, abstract expressionism became the perfect "expression of freedom: the freedom to create controversial works of art, the freedom symbolized by action painting, by the unbridled expressionism of artists completely without fetters."[2]

That the aesthetics of regionalism were formally expanded and revised within the abstract expressionist camp is an accurate analysis, as is Guilbaut's assessment of Cold War ideology and its impact on postwar culture. What is of equal importance, however, and certainly merits further attention, is the simple fact that regionalism was a dominant style of American art throughout the Depression and yet failed to sustain its popularity with the public, with critics, and with younger artists after the Second World War. Neither interpretations that chart the internal, formal development of abstract expressionism nor those that focus on the external circumstances of the Cold War adequately explain this change from one leading style to the next. What is needed is an exploration of this radical shift in art within the context of a major cultural and political transition at work in the 1940s.

Perhaps the most important influence affecting the art of both Benton and Pollock was politics, not as party tactics or organization, but as a set of cultural beliefs. That Benton was definitively linked with the New Deal had an enormous impact on the positive reception of his work in the 1930s and was in large part responsible for the dismissal of regionalism in the 1940s. That Pollock attempted to maintain certain aspects of a social reform aesthetic was largely ignored, for very particular political and sociocultural reasons, by liberal critics and others who sided with the ideology of consensus and anticommunism after World War II.

In this book I aim to illuminate this political culture in the shift from regionalism to abstract expressionism. It begins with an assess-

ment of early twentieth-century American modernism and an investigation into the political context of Benton's upbringing, as integrated in his first regionalist work of note, his mural *The American Historical Epic* (1919–28).

Next I focus on Benton's four major regionalist murals of the 1930s and assess their significance in terms of the liberal politics seemingly espoused by the New Deal. Differing from his father, Benton is more accurately described as a liberal than as a populist in terms of his political persuasion during the 1930s. His liberal mentality deviated from that of many early twentieth-century American populists on two issues: race and industrialization. Benton took pains to integrate ethnic minorities within his painted schemes of a better future. Moreover, he did not condemn the machine age and burgeoning large-scale urban industry. Rather, he attempted to address this significant change in the nature of American labor in his 1930s murals (with varying degrees of success). Benton was a liberal accommodator, hoping to see a loosely defined and often ambiguous form of democracy revived in the 1930s under Roosevelt's leadership. Yet, as this chapter demonstrates, Benton was no great champion of the masses like Eugene V. Debs or Mexican muralist Diego Rivera. Indeed, the potential mob mentality of the masses terrified Benton and became a considerable source of conflict for him in the later years of the Depression and in the forties.

In chapter 3, I focus on Benton's patronage by *Life* magazine in the late 1930s. Aiming to merge his painterly visions of social reform with mass media, Benton embarked on a series of corporate-sponsored ventures in the Depression. Through the brokerage of art world entrepreneur Reeves Lewenthal, Benton's dealer and head of the Associated American Artists agency, Benton's art was purchased and directly commissioned by major American corporations intent on bettering their ravaged public image. Benton accepted these assignments for the money, of course, but also because he believed that creating art for mass media enabled him to perform in the role of a truly *public* artist, and thereby reach a far greater number of people with his regionalist message. As Benton discovered during his assignment with *Life*, however, corporate America was not particularly interested in promoting his liberal politics but in appropriating his regionalist style of modern art for their own particular agenda.

In chapter 4, I continue to assess Benton's involvement with various business patrons of regionalist art, most notably the American Tobacco Company and United Artists, explaining how and why these corporate patrons of regionalism reduced the reform sentiment of Benton's mod-

ern art to substantiate their authority. Here, too, I deal with the reasons for the decline of both Benton's art and the New Deal during the war years and discuss the bloodiest and most despondent paintings of Benton's career: the eight wartime propaganda pictures, *The Year of Peril*.

Expanding on regionalism's demise in the 1940s in chapter 5, I focus on the emergence of abstract expressionism and consensus politics after World War II. Jackson Pollock is singled out as the prototypical postwar abstract painter, largely because this is how he was viewed at the time but also because of his links with regionalism. In this chapter I examine Pollock's upbringing in the West, his antiauthoritarian nature, his interest in the radical political art of the Mexican muralists, his study with Benton at the Art Students League in New York, and his close personal relationship with the Benton family. As his pictures from the early to mid-thirties reveal, Pollock developed a considerable affinity for regionalist art. Indeed, Benton considered him the logical heir of regionalism.

Yet, in the 1940s Pollock rejected his mentor's aesthetic. His declension from regionalism and shift to abstract expressionism are seen in the often conflicted context of consensus politics and anticommunism, and the postwar atmosphere of both abundance and anxiety. Pollock's drip paintings embodied the instability of life in postwar America and the entrapment of consensus culture. But they were also therapeutic. Pollock was a chronic alcoholic and treated artmaking as a ritualistic process by which he hoped to cure himself. Uniting southwestern shamanism with Jungian theory, Pollock placed his canvas on the floor, worked with impermanent materials, and searched for self-healing. By extension, Pollock provided a model for social reform via individual autonomy: rather than retreating from the sociopolitical concerns of his age, his abstract art demonstrated a way in which his postwar audience could achieve self-determination. Pollock, and other abstract artists of his generation, thus developed a particular form of modern art with profoundly revolutionary intentions.

I examine the critical, political, and corporate appropriation of Pollock's art in chapter 6. Although he painted to express social alienation and propose modes of personal transformation, Pollock's abstract pictures were lauded by many consensus era critics as emblems of postwar America's unique freedom and strength. Both Clement Greenberg and Harold Rosenberg championed the individualist thrust of Pollock's abstract art, but by claiming that it was remote from mass culture and

politics, they redefined it as art for art's sake. Their praise for abstract expressionism is seen in the context of growing postwar distaste for the masses and for representational art, both of which were linked with dangerous political ideologies, including the New Deal and Stalinism. The chapter ends with a focus on the corporate patronage of postwar abstract painting, examining in detail *Life* magazine's neutralizing institutionalization of modern art.

The problem that faced both Benton and Pollock, as Walter Benjamin elucidated in his 1937 essay "The Author as Producer," was that "the bourgeois apparatus of production and publication is capable of assimilating, indeed of propagating, an astonishing amount of revolutionary themes without ever seriously putting into question its own continued existence or that of the class which owns it." Benjamin advised artists that they "should not supply the production apparatus without . . . changing that apparatus in the direction of Socialism." Both Benton and Pollock offered their particular versions of modern art in the hope that it would generate social reform. Nevertheless, each saw their art assimilated and hence manipulated by political and corporate powers which neither believed they could control. For a contemporary generation of artists likewise committed to social change, the experiences of Benton and Pollock in the shift from regionalism to abstract expressionism may provide some insight into, as Warren Susman put it, "how to function *in* the world and yet not become *of* that world."[3]

NOTES

1. Jackson Pollock, "Jackson Pollock," *Arts and Architecture* 61, no. 2 (February 1944): 103. Irving Sandler, author of *The Triumph of American Painting: A History of Abstract Expressionism* (New York: Harper & Row, 1970), uses the term "breakthrough" in *The New York School: The Painters and Sculptors of the Fifties* (New York: Harper & Row, 1978), ix.

2. Serge Guilbaut, *How New York Stole the Idea of Modern Art: Abstract Expressionism, Freedom, and the Cold War* (Chicago: University of Chicago Press, 1983), 3, 201.

3. Walter Benjamin, "The Author as Producer," in *Understanding Brecht*, trans. Anna Bostock (London: NLB, 1973), 93–94; Warren Susman, "Socialism and Americanism," in *Culture as History: The Transformation of American Society in the Twentieth Century* (New York: Pantheon Books, 1984), 76. Sus-

man's essay was originally published in 1974 as "Comment 1," in John H. M. Laslett and Seymour Martin Lipset, ed., *Failure of a Dream?* (New York: Doubleday).

Republicanism and Modernism:

The Genesis of Regionalism in

The American Historical Epic

I n 1919, thirty-year-old artist Thomas Hart Benton embarked on a project that would consume nine years of his life: a multipaneled mural called *The American Historical Epic*. "My original purpose," he observed some years later, "was to present a peoples' history in contrast to the conventional histories which generally spotlighted great men, political and military events, and successions of ideas. I wanted to show that the peoples' behaviors, their *action* on the opening land, was the primary reality of American life." Benton projected that his history of the United States could be illustrated in 60 to 75 different panels, all larger than life-size and meant for display in a public setting. Although he completed only eighteen of the panels, the mural was a major rite of passage for him, marking his rejection of "the art-for-art's sake world" he had lived in for more than a decade while painting abstract canvases in Paris and New York.[1] *The American Historical Epic* was the genesis of an aesthetic vision that obsessed Benton until his death in 1975: to depict the American scene in a modern style which in the 1930s came to be called, ironically, regionalism.

Since the 1920s, when Benton tore himself away from what he termed "aesthetic drivelings and morbid self-concerns" and began painting representational pictures of the American scene, critics have labeled him an "antimodernist." In 1938, Meyer Schapiro stated that Benton had a "purely philistine attitude" toward modern art: "He ig-

nores its distinctive character as an art and describes it as a product of neurotic minds." In 1982 Hilton Kramer reaffirmed Benton's long-standing parochial status: "We shall probably have to await a full-scale biography of Benton before his vehement rejection of modernism can be fully understood. How deeply had Benton been committed to modernist art before his conversion to a more politically oriented vision?" And, even Benton sometimes substantiated his stature as the heretic among the modernists: "I set out painting American histories in defiance of all the conventions of our art world. I talked too much, and trod on all sorts of sensibilities and made enemies." But, Schapiro and Kramer (and here, Benton) defined modernism in the narrowest terms as that brand of avant-garde abstraction with which bohemians shocked the bourgeoisie. For these critics modern art was separate and distinct from politics and history. However, as Eugene Lunn notes, "Modernism in the arts represents neither a unified vision nor a uniform aesthetic practice." [2]

As the dominant culture of the twentieth century, modernism encompassed a variety of often paradoxical efforts to reveal the world of experiences and fuse art and life. As a twentieth-century artist determined to link American experience and culture in the guise of such public manifestos as his *American Historical Epic,* Benton was very much a modernist. This mural merged the modern styles Benton learned in the teens with his search for a socially engaged culture in the twenties. As such it foreshadowed his later regionalist work of the 1930s.

Focusing, as he said, on "the peoples' behaviors, their *action,*" Benton's social history of the United States ranged from European settlement and confrontation (*Discovery,* fig. 1.1) to frontier exploration (*The Pathfinder* and *Over the Mountains,* fig. 1.2), and the Civil War (*The Slaves,* fig. 1.3). The dynamic forms of his mural, which Lewis Mumford described in one 1928 review as "moving rhythmically through space and time," reveal Benton's own certainty that social "*action*" conveys "the primary reality" of American experience, past and present.[3]

Benton's understanding of modernism centered on its capacity to reconcile, through energetic and open-ended forms, that which a previous culture kept separate. If late nineteenth-century culture emphasized the disjunction between civilization and savagery, between art and passion, twentieth-century modernists were determined to connect them. Pronouncing the Gilded Age repressive and bankrupt, Benton and others of his generation seceded from it, challenging the overall dichotomy

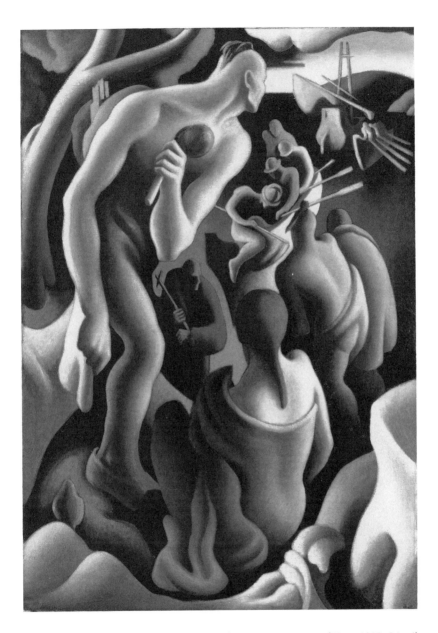

1.1. Thomas Hart Benton, *Discovery,* from *The American Historical Epic,* 1919–24; oil on cotton duck on aluminum honeycomb panel, 60 ³⁄₁₆″ × 42 ⅛″. Courtesy of The Nelson-Atkins Museum of Art, Kansas City, Missouri (Bequest of the artist) F75-21/1.

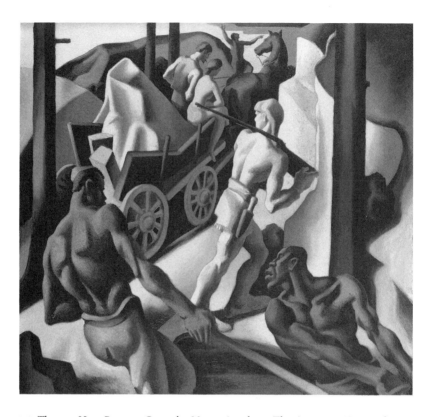

1.2 Thomas Hart Benton, *Over the Mountains,* from *The American Historical Epic,* 1924–26; oil on linen on aluminum honeycomb panel, 65 ⅞″ × 71 ⅞″. Courtesy of The Nelson-Atkins Museum of Art, Kansas City, Missouri (Bequest of the artist) F75-21/7.

of nineteenth-century culture with the "integrative mode" of modernism.[4] Benton painted *public* murals to fuse the previously separated worlds of "high culture" and "the people." And he painted them in a *modern* style which completely abandoned the scientific perspective and overall stasis of Renaissance art, the preferred aesthetic model for the Gilded Age. Modern art was powerful, its overlapping forms, rhythmic compositions, and brilliant colors a definitive break from the art of the past. Benton's public version of modern art emphasized cultural synthesis, not separation. Like the Dutch De Stijl and Russian constructivist artists who were his contemporaries, Benton used his modern art to serve, to enlighten, "the people."

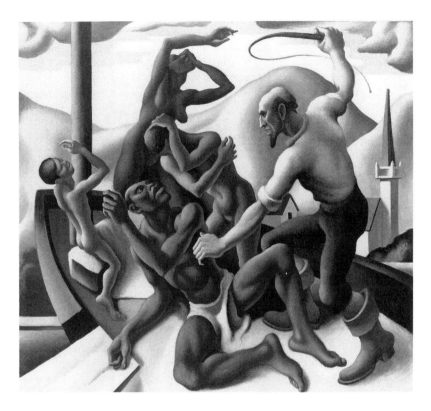

1.3. Thomas Hart Benton, *Slaves,* from *The American Historical Epic,* 1924–27; oil on cotton duck mounted on panel, 66 ¼″ × 72 ⅜″. Courtesy of Lyman Field & United Missouri Bank of Kansas City, n.a.; Trustees of Thomas Hart and Rita P. Benton Testamentary Trusts.

In 1928, when several of the *American Historical Epic* panels were exhibited and criticized as "superficial" decorations in a "particularly convolvulus" style, Benton defended himself. The dynamic style of his pictures, he said, embodied his desire to combine the "extensive experience one has of the real world" with the abstract patterns and designs that were his "modern inheritance." Such a technique, Benton explained, allowed him to "handle the modern world" in a style of representational dynamism. Earlier, in a series of five articles he published in *The Arts* from 1926 to 1927, Benton noted the "fundamental mechanical factors which underlie what we generally respond to as aesthetic values."[5] Dynamic pictures, the sort that grab our attention, Benton

said, make special use of the artistic strategies of overlapping and rhythm. Repeating and alternating forms dissolve into one another, foreground elements and deep space blend together, and the constant activity of these intertwined, unified forms attracts us visually.

That Benton's *American Historical Epic* mural was itself structured this way is revealed in this description of the panel *Discovery* (fig. 1.1): "The space that exists between the Indian woman in the foreground and the European boatmen appears to be arbitrary. . . . curving forms echo and parallel one another, and light and dark areas alternate. Edges of one form glide into those of others." The style of Benton's historical mural not only challenged the temporal limitations of Renaissance art but, like cubist paintings and edited films, heralded the integrative mode of modern art. He retained recognizable subject matter in his historical mural, but "the intellectualized abstract rhythmic interaction of curving shapes, the all-over fluctuating light and dark pattern, and the spatial arrangement which pulls all forms in depth back to the surface," are clearly the elements of modern art. Only this modern style was strong enough to buttress Benton's painterly construction of a world, as he described it in 1928, "that is fairly equivalent in its spatial structure to the real world." [6]

Benton's yearning to reconstruct the world in modern murals was the direct result of personal experience. Born in 1889 to a United States congressman from Missouri, and named after his great-uncle, Senator Thomas Hart Benton, the champion of manifest destiny, Benton inherited the values of a politically engaged family. In particular, Benton was the twentieth-century heir presumptive of American republicanism: the ideology of uniqueness out of which the new world of the United States was originally conceived. This ideology was especially demarcated by the widespread notion that the American people were more virtuous than the corrupt aristocracy of old world Europe. Such virtue, writes J. G. A. Pocock, could only be found "in a *republic* of equal, active, and independent citizens, and it was a term applied both to the relations between these citizens and to the healthful conditions of the personality of each one of them." The overriding concern of the republican citizen, then, was to sustain such virtue against the constant threat of corruption that had defeated republics in the past. In the United States this became translated in terms of production: American workers, or producers, became, as Steven Ross has detailed, "the linchpins of republican ideology." The virtuous American producer, working both independently and collectively, became associated with the virtue of the

American republic. As Lary May explains, "An expanding frontier of small yeoman farmers, independent businessmen, and artisans guaranteed that production rather than monopoly and greed would dominate in the 'new world.'" Producerism, coupled with the active participation of republican citizens in the shaping of American communities and the direction of American politics, became the single most dominant factor distinguishing the new world of the United States from the old world of European immorality.[7]

As increasing numbers of historians have suggested in recent years, the republican tradition defined the American sense of self, state, and progress in the nineteenth century. As such, it was a tradition that consistently underwent revision and redefinition, especially as industrialization and nationalism burgeoned. Benton's forefathers, for instance, consistently readdressed the meaning of republicanism and redefined it to mesh with their nineteenth-century political concerns, which were mostly oriented to the American economy. Benton's great-uncle influenced mid-nineteenth-century national land policy and banking reforms, redefining republicanism in terms that meshed with the geographic and capitalist expansion of the United States. Benton's father did much the same by tackling the unbridled greed of corporate capitalism in the Gilded Age.

The eldest male, Benton was expected to carry his family's mode of political engagement into the twentieth century: "Politics," he wrote in the opening pages of his 1937 autobiography, "was the core of our family life."[8] Benton's father took it for granted that his son would sustain the political sensibility of republicanism in the modern world, perhaps redefining that tradition but nevertheless continuing to promote producerism and public virtue. But for the first thirty years of his life, Benton rejected paternal anticipations and his political inheritance, disillusioned by what he felt was the complete irrelevance of the republican tradition in the modern world. His generational rebellion led him, as it did others, to search for a new vision to correspond with the changed world of the twentieth century, a vision which he eventually found in modern art. Only after ten years of experimentation with those modernist styles which embodied the dynamic world view of his age did he return to the socially engaged values of his family and to the ideology of producerism.

The incipient regionalist mural *American Historical Epic* was Benton's first reconciliation with his inheritance. As he noted in his 1928 defense of the mural:

I was raised in an atmosphere of violent political opinions. The stuff I soaked in lights up the epic I have started. What happened in Oklahoma in my lifetime, happened in Missouri in my father's and in Kentucky and Tennessee in my grandfather's; and living words from people, not books, have linked them up in feeling and established their essential sameness. The job for me is how, using the precise and involved technique of deep space composition . . . I can order my recessions of form so that they really carry my content and are not mere suites of objects with a name appended.[9]

These sentences, coupled with the visual evidence of his first historical mural, reveal Benton's aesthetic goal of linking his modern style—the energetic overlapping of deeply recessed forms—with the context of American history. Deep space composition itself was not a modern invention, but Benton's manner of using it was. In each of his mural panels historical episodes were layered, one on top of the other, so that each historical moment became connected with the next, ad infinitum. Thus, as Benton painted it, American history was dynamic and continuous, its past inextricably linked with its present. His modern style broke down the barriers separating contemporary America from her historical traditions, thus creating the necessary preconditions for the social and political reconstruction of twentieth-century America. Like the cubist painters, Benton did not paint the world outside his window; his mural was the painterly vision of a new world. It offered his intended audience a model of what a reborn and remade America could look like. As Benton observed, there was an "essential sameness" between his modern world and the world of his ancestors. That "sameness" was a shared political vision of democratic liberalism. *The American Historical Epic,* then, was Benton's first effort to restore his political inheritance of republican ideology in modern America, to revise the republican tradition of his forefathers by meshing it, especially its producerist strains, with the modern forms of a new twentieth-century world.

Reinterpreting the meaning of American democracy and reconciling those interpretations in modern public art, Benton elaborated on a family political tradition begun in 1820, when his great-uncle was elected Missouri's first Democratic senator. Born in 1782, Thomas Hart Benton was a tall (6½ feet), pugnacious man who rose to the rank of colonel in the War of 1812, engaged in a street brawl with Andrew Jackson (Benton nearly killed him), and shortly thereafter began his political career. During his six successive terms in the Senate (1820–50), Benton played

a major role in redefining republicanism to accommodate the country's expanding geography and booming economy. Expounding on the virtues of manifest destiny and its Lockean roots in private property ownership, Benton directed Americans toward entrepreneurship and the republic itself toward "free-soil, free-labor" politics. Harriet Hosmer's gigantic bronze sculpture of him (1861, fig. 1.4) cast the senator in a Roman toga and bearing a legal scroll: the American politician in the guise of the classical republican law-giver. George Caleb Bingham, Missouri's most acclaimed nineteenth-century artist, painted the senator as a florid, chunky man (fig. 1.5) and mythologized his career choice in *Stump Speaking* (1853–54, fig. 1.6), picturing Western politicking as a rhetorical exchange between campaign hopefuls and their would-be electorate. Like his counterpart in *Stump Speaking*, Benton addressed his constituents in dynamic public speeches thundered "in a roaring voice" and a "jabbing, repetitive" style. His "impassioned" orations overflowed with "facts, figures, logical deduction, and historical illustration"—the proofs of truth. He often used invectives—Thomas Biddle was "an overbearing aristocrat" and a "miserable poltroon," his brother's bank a "hydra-headed monster"—realizing their public appeal and hence, campaign effectiveness. Like others of the time, his speeches were often three or more hours long. Simple words just did not match the power of poetic tirades: "The bank is in the field; enlisted for the war; a battering ram—the *catapulta,* not of the Romans, but of the National Republicans; not to beat down the walls of hostile cities, but to beat down the citadel of American liberty; to batter down the rights of the people." The style of these speeches—dramatic and gestural, bombastic and vitriolic, grandiloquent in length and metaphor—was that of incantation; their purpose was to create community and frontier commonality. With his rallying cry of "Demos Krateo" (rule by the people) Benton's voice—like his great-nephew's paintings a century later—affirmed and extended the domain of American republicanism.[10]

Like most Americans of the nineteenth century, Senator Benton was preoccupied with the economy. By the 1820s, incredible industrial and agrarian productivity had turned the United States into an economic power second only to Great Britain. Under the sway of this recently acquired financial superiority, which was quickly integrated with the ideology of manifest destiny, politicians treated domestic issues—territorial expansion, slavery, Indian removal, tariff and bank controversies—on economic terms. Some, notably Andrew Jackson and Benton,

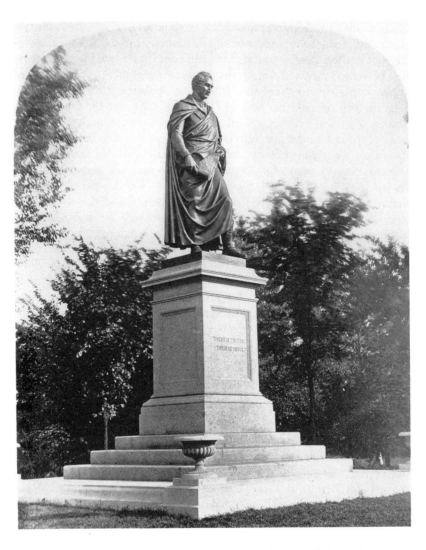

1.4. Harriet Hosmer, *Thomas Hart Benton,* c. 1861, Lafayette Park, St. Louis. Courtesy of the Missouri Historical Society, St. Louis. GPN Por B-6. Photo Emil Boehl.

dealt also with the inadequacies of this capitalist eruption and tried to redirect it to the country's original goals. Economic expansion was fine, as long as it was widely democratic. For Benton, the best of American democracy was represented by the small farmers and merchants of the

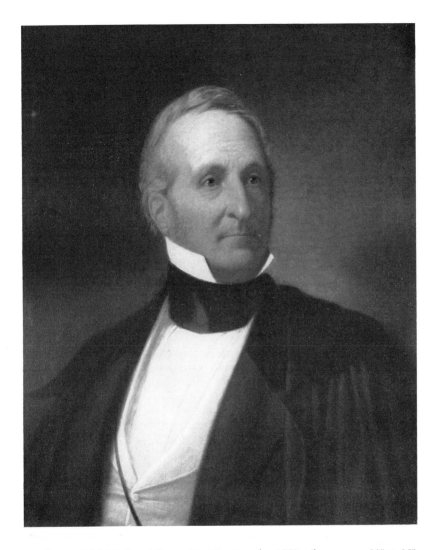

1.5. George Caleb Bingham *Thomas Hart Benton,* after 1850; oil on canvas, 30″ × 25″. Courtesy of the Missouri Historical Society, St. Louis. Portraits B-136.

West, his kin and constituency, the ruddy folk in Bingham's pictures. The worst was represented by the decadent monied elite of the East. In his Senate speeches Benton denounced American divisionism, the "people" on one side, corrupt Northeastern aristocracy on the other, and talked of "retrieving the country from the deplorable condition in

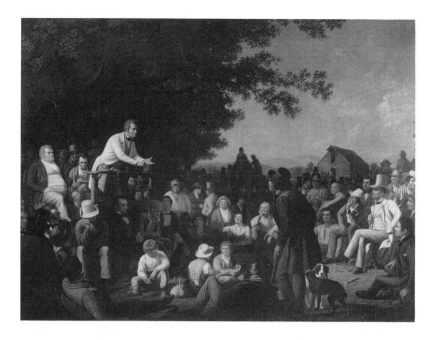

1.6. George Caleb Bingham. *Stump Speaking*, 1853–54; oil on canvas, 42 ½″ × 58″. Courtesy of the Art Collection of The Boatmen's National Bank of St. Louis.

which the enlightened classes had sunk it." True to the dynamic pragmatism of his time, Benton's talk of retrieval translated into political action. His earliest legislation proposed abolishing the electoral college system (which he called the "favorite institution of aristocratic republics") and replacing it with direct popular voting (the "favorite institution of democratic republics").[11] Although this reform bill was defeated, it suggests the public advocacy Benton maintained during his thirty years in the Senate. He was not necessarily one of "the people" (Bingham's portrait reveals a patrician, not a proletariat, as more obviously does Hosmer's statue), but he was their defender.

Benton's politics were roughly focused in three main areas: land sales, tariffs, and banking. During most of the 1820s he lobbied for national land policy reform, for the sale of cheap public lands and homesteading. His version of a virtuous republican citizen was a landowner: as he explained in an 1826 speech "tenantry is unfavorable to freedom. It lays the foundation for separate orders in society." Obviously, Benton's promotion of inexpensive or free Western soil was a political ploy

to build his Missouri electorate. But, as Rowland Berthoff has argued, Benton's push for national land reform was also shaped by the new meaning republicanism took on in the 1830s, whereby private property ownership became the linchpin in economic development.[12] Although earlier generations looked upon entrepreneurial activities as evidence of an aberrant republic, during the Jacksonian years Benton and others openly commended the profit-seeking motives of American producers and keyed their success to economic independence. This new reading of virtuous American citizenry retained the classical republican qualities of self-reliance and individualism, but added the acceptability of material prosperity gained especially through landownership. Such a redefinition of the republican tradition was necessary to account for and further the tremendous success of American capitalism.

Linked to Senator Benton's crusade for capitalism was his denunciation of government control in areas where independent citizens stood to make a profit. His campaigns against oppressive taxation on government-leased salt and mineral properties in Missouri, for example, led to tariff repeals and open land sales. The government must sell such lands, Benton insisted, "to the pursuit of individual industry, to the activity of individual enterprise. . . . Without a freehold in the soil . . . the riches of the mineral kingdom can never be discovered or brought into action."[13] By "action" Benton meant economic opportunity, convinced that the American entrepreneur stood a fair chance only if government strangleholds were released. He worked hardest to break those holds in his war on the National Bank.

Benton's advocacy for banking reform had a lot to do with the losses he and most of his constituency suffered during the Panic of 1819. The blame for this first great American Depression and subsequent economic hardship, Benton decided, lay with the bank's policies of land and paper-money speculation, which hit Westerners who had taken advantage of such policies especially hard. Even if Benton's losses were tied more directly to his own faulty speculation in Missouri real estate and his personal misdirection of the St. Louis Bank of Missouri (he was a primary stockholder), which went under during the panic, Benton assailed Biddle's Philadelphia Bank and its Eastern stockholders for having "too much power over the people and the government, over business and politics," for being "unfavorable to small capitalists," and "injurious to the working classes." "Gold and silver," said Benton, "are the best currency for a republic; it suits the men of middle property and the working people best; and if I was going to establish a workingman's party it should be on the basis of hard money—a hard money party

against a paper party." His vehement antibank speeches of the early 1830s helped encourage Jackson to veto the rechartering of the "monster" bank and induced fiscal changes which included shifting the ratio between gold and silver (from 15:1 to 16:1) and reissuing gold coins, soon dubbed "Benton's mint drops." [14] The bank took the fall for all the evils Benton saw threatening the republic; his reform measures were aimed at creating an economic system which worked on behalf of all citizens, at least those who were white males.

Conflicts and contradictions aside—he attacked the bank but owned bank stock and fought government control except when it benefitted Westerners—Benton's political stance was that of the reformer, the public advocate. His thunderous speeches addressed the major problem facing America before the Civil War: how to maintain the tenets of American republicanism in a rapidly expanding capitalist economy. Benton's war with the bank was to a large degree a war over corporate capitalism, the direction he saw the American economy taking if it was not restrained. Thus, reformist economic policies that favored small-scale producers were a large part of his political commitment.

Benton was also committed to the sanctity of the Union, and spent his last two decades in the Senate resisting Southern demands to expand slavery. Although he himself owned slaves, he was absolutely opposed to slavery's extension into the territories: slavery would hinder independent capitalism's expansion in the West. If economic independence was the key to personal freedom and material success in the growing republic, most particularly for free white males, then it was his duty to make sure the West stayed slave-free. (Southern slavery, said Benton, should be allowed to die of its own accord, as he believed capitalism would eventually replace it.) In 1847, opposing specific instructions from his home state, he refused to support John C. Calhoun's resolutions to introduce slavery in the far West; in 1850, he successfully lobbied for California's entrance into the Union as a free state. His "free soil, free labor" principles cost him his Senate seat in 1850, but his fight against national dissolution was simply the manifestation of long-held beliefs in the republican tradition, albeit redefined. When Senator Benton died in 1858, he left a legacy of reform politics and producerism continued by subsequent generations of Bentons.

Thomas Hart Benton, the artist, first learned about republicanism, both classical and revisionist, from his father, "Colonel" Maecenas Eason Benton, a stout man of some 200 pounds who delighted in eating, arguing, and campaigning (fig. 1.7). His father was not really a colonel,

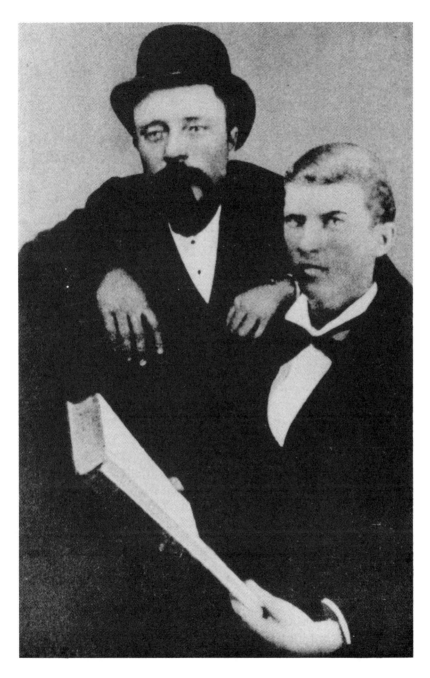

1.7. Photo of M. E. Benton and Tom Steele, c. 1896. Reprinted from Lucile Morris, *Bald Knobbers* (Caldwell, Idaho: Caxton Printers, 1939).

his eldest son revealed in his autobiography, but "as he grew portly and substantial, was called so after the Southern fashion of the day." A former Confederate soldier who became a successful lawyer in Neosho, a small mining and farming community on the fringe of the Ozarks, Colonel Benton married Elizabeth Wise, a Texas beauty almost twenty years his junior, in 1888. Their union was not a happy one—Elizabeth Benton preferred parties to politics and, unlike her husband, harbored considerable social ambitions. Marital tensions especially erupted over the rearing of their eldest son, born in Neosho in 1889.

Colonel Benton was a prominent figure in Missouri Democratic politics, many times a delegate to state political conventions, a U.S. district attorney during Grover Cleveland's first term (1885–89), and Missouri's Fifteenth District congressional representative from 1897 to 1905. Aiming to shape his young son's political future, Colonel Benton took his first-born everywhere: "Almost as soon as I could walk, my father in some pride of spirit about his first child began taking me on his political tours. By the time I was eight or nine years old I had become familiar with camp meetings, political rallies, and backwoods hotels." The colonel's oratorical skills were in heavy demand during the 1890s, when farm debt, industrial unrest, tariff conflicts, and gold-silver controversies inflamed the nation and racked the Democratic party. Although Grover Cleveland was swept back into the White House (after his 1888 defeat) and Democrats gained congressional control in 1892, the party could not control the five-year Depression that followed. Colonel Benton was called on to soothe chronic party factionalism and give strength to waning Democratic power in his home state.[15]

"Dad was always campaigning over southwest Missouri," his son recalled, "either for himself or for some other Democrat. Political meetings of the eighteen-nineties were regular carnivals. I remember these affairs well, with their flags and big glare-eyed, staring posters." Benton's childhood memories of provincial politics were articulated in a corner of his 1937 mural for the Missouri State Capitol: *Politics, Farming, and Law in Missouri* (fig. 1.8) shows a robust orator—his father—working the crowd under a "big glare-eyed" campaign poster of Champ Clark, famed turn-of-the-century Missouri congressman. But, Benton recognized his father was more than just a party speech-maker, he was the exemplar of republican politics in the Gilded Age:

> The public image he presented was that of a man of the people, a plain, straight forward small town lawyer, and therefore the best

fitted to represent the peoples interests. In accordance with the Populist line he was against big bankers, big railroad magnates, big corporations (TRUSTS) and above all against the corruptions and nefarious influences of the rich Eastern society.[16]

This image of Gilded Age republican politics was one which Colonel Benton's son would eventually embrace in his modern murals of the 1920s and 1930s.

Colonel Benton first represented the "peoples interests" in 1887, when as U.S. attorney he successfully prosecuted several members of southwest Missouri's notorious "Bald Knobber" gang, a "secret society of avengers" who obstructed the Homestead Act by driving "undesirable" settlers off their lands. In his closing jury arguments Benton bitterly denounced the vigilante group and questioned "how any good citizen could belong to it."[17] Like his uncle, Colonel Benton believed economic opportunity in America was broadly democratic and should not be restricted to powerful minorities—outlaws or elites. Thomas Hart Benton, the artist, emulated both his father and his great-uncle in this regard: all four of his major murals, and many of his smaller pictures as well, feature an integrated American scene where blacks and whites toil together.

Benton's father sympathized with Populist causes (although staying loyal to the Democrat party) and took up their battles during his four terms in the House. His overall political ambition was to correct the main problem he saw facing the nation: unrestrained corporate capitalism. A half-century earlier his uncle and others had unwittingly laid the groundwork for the economic situation in which 1890s America found itself. In their revision of republicanism, which equated civic virtue with entrepreneurship, the Senator and his generation had legitimized the rampant greed of the robber baron. Now, their heirs were faced with the task of somehow disciplining the corporate monster that ungoverned economic liberty had become. In the agitated 1890s, Congressman Benton took up the same political mission of Senator Benton: the economic terms of republican ideology.

At the turn-of-the-century Benton's constituency demanded resolution of their economic quandaries: deflated currency, lowered farm prices, and increasing corporate monopolization in an expanding economy. The small-scale farmers and merchants of his seven-county district were tired of abuse suffered under the Eastern trusts that controlled their credit, transportation of goods, and tariffs. Benton's response was

1.8. Thomas Hart Benton, *Politics, Farming, and Law in Missouri,* east wall, detail, from *A Social History of the State of Missouri,* 1936; oil and egg tempera on linen mounted on panel, 14′ × 23′. State Capitol Building, House of Representatives' Lounge, Jefferson City, Missouri. Photo courtesy of the Missouri Division of Tourism.

to lobby for economic reforms which would benefit his constituency. In particular, they saw currency constriction, brought on to curb post–Civil War deflation, as the root of all their economic problems. Some of their blame was certainly justified, especially since congressional pref-

erence for gold in the 1870s forced those who had borrowed on a bimetallic basis (or with greenbacks, which were gradually retired after the war) to pay back their debts at much higher rates. Benton reinforced their censure in his House speeches, attacking gold as "un-American, un-businesslike, unconstitutional, and hurtful to the wealth producers of our country." Gold symbolized the greed of Wall Street, the corrupt "money power" of Eastern monopolists and their preference for a restrictive economy. The fact that by 1890 all of western Europe was on the gold standard only emphasized, for Benton and his constituents, its rottenness.[18]

Silver, on the other hand, represented grassroots democracy, "the peoples" interest in an expansive economy. In 1877, Missouri silver prophet Richard ("Silver Dick") Bland promoted unlimited silver coinage as the basis for economic reform; in 1896, William Jennings Bryan denounced the "cross of gold" on which American producers were being nailed. Congressman Benton concurred that free silver would create economic reform and put an end to the Wall Street "leeches that suck the blood of honest yeomanry of the west." A Republican-sponsored bill to establish the gold standard evoked this tirade from Benton in 1899:

> It means the contraction or expansion of the paper currency at the will and pleasure of the national banking corporations.
>
> It means the weeding out of the middle classes, the bone and sinew of free government, and leaving us two classes, the very poor and the very rich. It means, as I read it, the enslavement of the farmer, miner, country merchant, small banker, mechanic, and day laborer to the money power.

His attacks on gold, the "money power," and the national bank are similar to those made by his uncle a half-century earlier. Indeed, like Dorothy in Frank Baum's parable on populism and the silver issue, *The Wonderful Wizard of Oz* (originally published in 1900), Benton went on a crusade not dissimilar from Senator Benton's campaign against Biddle's bank. Benton's politics and Baum's parable were both Gilded Age millennial dreams aimed at the reformation of the republican tradition.[19]

Other economic issues preoccupied Colonel Benton as well, including tariff reform and anti-imperialism. Aimed at protecting American business interests from foreign competition, tariffs were a boon to the trusts and a severe hardship to the producers who sold their goods in an unprotected market and bought in one restricted by tariffs. The long-standing tariff controversy, in which Democrats usually sided with pro-

ducers and favored free trade while Republicans sided with business interests, reached a fever pitch in the mid-1890s. High tariffs had created a tremendous Treasury surplus, which Democrats like Benton saw as an economic injustice against the American worker:

> The professional man, the merchant, the farmer, the miner, and the day laborer are entitled to have the burdens of Federal taxation fairly distributed. This can not be done under a system that enables the manufacturer to sell his finished product to foreign consumers cheaper than he does to the home market.

Joining Missouri senator George Vest in condemning the 1897 Dingley Tariff, Benton tried to make tariff reform a paramount political issue: "The Democratic party does not believe in artificial inflation of prices at home. . . . Give every man a fair chance and that will naturally develop every industry." [20] But, party disunity—some Democrats were free traders, some were decidedly not—weakened the cause. Even more, the American public had become bored with economic reform and cynical about its chances, especially since McKinley's "Republican Prosperity" seemed to be a fact: harvests were good and prices were high. The public was, instead, completely captivated by the "splendid little wars" being waged all over the world, much to the dismay of anti-imperialist Congressman Benton.

His protestations against colonialism in Cuba and the Philippines stemmed from personal anxiety that American warmongering overseas would be the complete undoing of domestic republicanism. "The money power," Benton said, had already made great strides in trampling nascent republicanism abroad, forcing "this republican Government . . . to go into world politics, spit on our great past, and deny liberty to a struggling people." He feared much the same would happen at home. Colonial expansion required recruits and financing. Bills to increase the size of the regular army from 26,000 to 100,000 men were condemned by Benton in 1898 and 1899 as "the beginning of militarism," which he viewed as a Wall Street scheme to "keep labor in subjection": "Make the Army four times as large . . . put the soldiers under control of the Federal courts, and government by injunction . . . will bully labor till in all the centers of population capitalized trusts can absolutely and completely control labor with an iron hand." Moreover, military costs would "pile up additional burdens in the way of taxation upon the producer." [21]

Seeing domestic issues slighted in preference to world affairs, Benton grew increasingly apprehensive. Focusing on what he thought were the concerns of the producers he represented, Benton denounced financial and political alliances with old world countries. He was convinced that these alliances would benefit only England, which already, he observed, "owns our securities and much of our property." [22] Other anti-imperialists decried American expansionism on racial grounds, some opposing U.S. involvement with nonwhites, some equating U.S. imperialism with slavery. But Benton viewed American involvement overseas, which demanded exorbitant financing and could result in the importation of a less expensive labor force, as a significant menace to the economic independence of his Missouri electorate. Imperialism, symbolized by military power and foreign influence, posed a real threat to the reconciliation of American republicanism and late nineteenth-century capitalism. His son would take a similar stance years later, when U.S. involvement in World War II posed what he saw as a threat to newly emergent strains of twentieth-century republicanism.

Colonel Benton's reconciliatory efforts were soon dismissed by his electorate, who considered his battles against the gold standard, Wall Street, tariffs, and foreign wars completely irrelevant in light of the new century America was entering. By 1900, the economic situation in Missouri had changed considerably. Urban population growth and industrialization had increased tremendously and corporate concerns outweighed those of producers in the political realm. In Congressman Benton's own district, for example, lead and zinc manufacturers began to favor high tariffs. His beloved constituency, the independent "farmer, miner, country merchant, small banker, mechanic, and day laborer," was fast disappearing as Missouri, like the rest of the nation, grouped into the economic factions of organized industry and organized labor. Although his version of reformist politicking coincided with the beginnings of the Progressive movement, Colonel Benton was viewed as an old-fashioned conservative whose version of economic independence was out of step with the bureaucratic collectivism of progressive politics and the increasingly organized sphere of the modern corporation. His "energetic participation" in congressional politics ended in 1904, when a young Republican candidate who favored high tariffs took his place in Missouri's Fifteenth District. [23]

Likewise, Thomas Hart Benton rejected his father's politics, although with considerable ambivalence, until he redefined it in the panels of *The American Historical Epic*. Much later, in 1951, he wrote:

My father was always quoting our old Missouri Senator George Vest's famous description of the cow "which had its head in the west where it ate, and its teats in Wall Street where it was milked." I had been raised on the idea that the big capitalist monopolies, centered in New York, were against the "people's" interests. . . . I was convinced that the American dream had been continually discounted by capitalist organizations which had grown beyond the people's control.[24]

But, it was not until he was in his thirties that Benton was "convinced" enough to reconcile himself artistically to the political sensibility he inherited from his father and his great-uncle. Prior to the genesis of his first public mural in 1919, Benton considered the republican tradition completely bankrupt. His rejection of it related first to his personal repudiation of family expectations and second to his opinion that his father's generation had completely failed in their efforts to sustain either a virtuous republic or democratic politics.

As the eldest son Thomas Hart Benton was expected to carry the tradition of family politicking into the twentieth century. "From the moment of my birth," he wrote, "my future was laid out in my father's mind. A Benton male could be nothing but a lawyer—first because the law was the only field worthy of the attention of responsible and intelligent men, and second because it led naturally to political power." But this Benton male had other ideas. When his father handed him weighty tomes like *Plutarch's Lives* or Senator Benton's *Thirty Years View,* he concentrated chiefly on their illustrations. A childhood "propensity for drawing"—congressmen and battleships, Missouri trains and Ozark Indians—did not subside in young adulthood. He took art classes at Washington's Corcoran Gallery, and was more aroused by murals in the Capitol and the Library of Congress than the "harness" of the legal future planned by his father. His mother encouraged his aesthetic pursuits and by so doing escalated tensions between herself and her husband, and between the colonel and his eldest son. Although named after Maecenas (70?–8 B.C.), Roman general and patron of the arts, Colonel Benton patronized only the political arts. He regarded most artists as "mincing, bootlicking portrait painters" who "hung around the skirts of women" and "lisped a silly jargon about grace and beauty." His son's visual orientation ("I had the artist's interest. . . . I could sit for long periods simply staring") disturbed him: it clearly conflicted with his own rhetorical pragmatism, and worse, what kind of career was "boot-

licking" for a Benton male? He did not prohibit his son's aesthetic ambitions—that would be a denial of self-determination—but, as the younger Benton reached adolescence, they "drifted apart," the colonel unhappy with his eldest child's seeming rejection of law and politics, his son questioning the very meaning of that politics.[25]

In addition to thwarting paternal ambitions by retreating from law and politics, Benton viewed his father's political career as an utter failure and looked upon his father's world as one of unbearable repression and corruption. Colonel Benton represented producers from several small southwest Missouri communities; Neosho had a population of about two thousand in 1890. Benton later wrote that most of his boyhood memories centered around his upbringing in this prototypical Midwestern town, characterized by its neighborliness and civic participation. Communal sensibilities were strengthened by frequent picnics and parades; "the town was addicted to celebrations," Benton recalled. This "great community," as John Dewey described the town where he grew up (Burlington, Vermont), certainly fostered Benton's later efforts to recreate a communitarian culture in regionalist art. But, as Benton himself noted, Neosho "changed rapidly during my childhood," readily accepting industrial growth and civic scientific management in the early twentieth century. During the years he grew up, Neosho changed from a small town to a prosperous center for flour milling, manufacturing, lead mining, and dairy farming. Its massive berry industry employed some three thousand pickers during the 1902 season. "Neosho needs you" became the town slogan, and civic groups like the Merchant's Association and the Commercial Club developed the Neosho Plan to promote civic betterment.[26] In the twentieth century Neosho's citizens aimed for a version of community solidarity patterned on factory and municipal management. Benton grew up, then, in a place where he saw the classical republican values of egalitarianism and fraternity undercut by corporate capitalism, where the independent producer was threatened by a loss of economic autonomy. In large part, he rejected his father's politics because it not only failed to keep the republican tradition alive in the nineteenth century but it failed even to recognize the threats being made against that tradition in the changed world of the twentieth century. Eventually, Benton himself would aim to resolve the threat of corporate capitalism by integrating the modernism of this new century with democratic politics. But, he did so in the realm of modern art, not electoral politics.

In the years after his father's death in 1924, Benton reflected on

their falling out and contrasted his "aesthetic sensibility" with what he termed "the parvenu spirit" of his father's generation. Obviously, Benton's oedipal revolt was a youthful search for self-definition, but that rebellious search stemmed from a crisis he perceived within the political and social culture that was his inheritance:

> Every artist in a world of "practical" men shares somewhat the uneasiness I describe, but those who came out of the Middle West at the beginning of the century, I imagine, have had a larger dose than all others. There was the most complete denial of aesthetic sensibility . . . crushed almost utterly in favor of a short-range philosophy of action. What really crushed it was the rise of the parvenu spirit during the great exploitative period following the Civil War, and the enthronement then of the ideals and practices of the go-getter. . . . Things—all things—are, for his kind, merely instruments extending areas of control and promoting his wealth and power. Aesthetic values cannot survive when the particular pragmatism of the parvenu is socially dominant.

Condemning the pragmatism of his father's world, with its "short-range philosophy of action" and "enthronement" of materialism, Benton was especially bitter that his own father had accepted and worked within this world, rather than challenged its inadequacies. In particular, he criticized the failure of his father's generation to sustain democratic politics in the Gilded Age or to reshape it for the modern age. His father's attempts to redefine republicanism with outmoded and unpopular economic reforms failed: his actions were ignored or defeated and he lost his job when he insisted on tariff reform. His party dropped him in 1904—much as they had abandoned Senator Benton in 1850—because partisan politics triumphed over legislative reform. After his political defeat, colonel Benton became depressed and his relationship with his first-born became strained. Politics had been, his son recalled, "the breath of his life," the "*go* that electrifies existence"; now he had "frequent moody spells," and "began to be dissatisfied" with his eldest son, who "lost all intimate connection" with him.[27] Given this, it is no surprise that Benton rejected the political culture of his inheritance during his young adulthood: he saw political liberalism as a failed ideology, especially as party loyalty took precedence over reform.

Benton saw the failure of democratic action in his father's politics, and corruption in his father's world. He rejected the go-getting materialism of the Gilded Age because he felt it was morally and spiritually

hollow. His father's generation had reduced the world to the profit of "things—all things." They were obsessed with control, rather than quality, with a shrewd and narrow practicality instead of aesthetic values. Their parvenu spirit, Benton wrote, had even corrupted the realm of folk art, as quilts and handmade chairs were "thrown out of home after home" and replaced by cheap, jerry-built factory products. His indictment of this inauthentic materialism, as revealed in his 1937 autobiography, paralleled Lewis Mumford's in *Sticks and Stones* (1924), a study of American architecture which argued that "the country had sacrificed its aesthetic and spiritual heritage to the pressures of manufacturing and money-making—with the result that the artist could never find his proper audience, [and] 'culture' became synonymous with a middle-class hunger for status." [28]

Benton demonstrated his lack of confidence in his father's world by seceding from it for the world of modern art. Only art, not electoral politics, seemed to provide the spiritual regeneration he longed for. His quest for intense experience was shared by others at the turn of the century who were equally alienated from their upbringing: Frank Lloyd Wright searched for an architecture of "*space* instead of matter," Gustav Stickley searched for the revitalization of an Arts and Craft sensibility, Gustav Klimt searched for an emotive, organic style of modern painting. [29] Like them, Benton embarked on an aesthetic crusade, hoping to transcend the corrupt parvenuism of his father's world and participate with other dissenters in a personal, and eventually public, regeneration.

Joining the "radical protestants, the philosophers, artists, writers, musicians . . . [who] ran in a body to the cities," Benton fled Neosho in 1907 and enrolled in the School of the Art Institute of Chicago. He eventually journeyed to the art worlds of both Paris and New York. Still, his break with his father was a difficult one, and his letters home are marked by a plea for understanding. A 1909 letter to his father ended:

> You have admired Byron, who put his stormy passionate soul, at times, into such powerful form. But the painter poet you have missed. I hope soon to see all America putting aside the idea that a painter's aim is to please the eye alone, and give him his place as a man who makes his fellowman better by helping to find his own soul. [30]

The tone of this letter, paralleled by Benton's behavior in the decade after it was written, reveals a profound ambivalence. He rejected his father's world, but sought his approval; he ran away to Chicago, Paris,

and New York seeking personal liberation in modern art but sustained a family tradition of public welfare by hoping to better the life of his "fellowman." During the teens Benton found the art world congested with rules and immorality; he dabbled in a variety of styles but never quite developed a personal vision. Still, after ten years of searching, all of these experiences and attitudes coalesced, and in 1919 Benton reconciled himself with his political inheritance by developing the accommodating aesthetic of regionalism in *The American Historical Epic*.

In Chicago, Benton had his first experiences with the art world. But, this world proved to be no escape—he discovered the same parvenu spirit among students who wanted to be successful illustrators and "exploit the rising trade in pretty girl pictures" made popular by Charles Dana Gibson. Benton had shared their material ambitions when he spent the summer of 1906 as a newspaper cartoonist in Joplin. Now, however, he wanted to be an aesthete. He took up dress "fitting and appropriate for a genius"—black shirt, red tie, derby hat—and distinguished his quest from that of his peers:

> My thoughts for a good many years have been toward fame and greatness . . . I don't necessarily mean the fame and greatness that appeals to the usual commercialized American mind, I mean *that* fame and greatness which comes to oneself when he knows that what he has done is good, when he knows that he is nearing the goal of his quest in my case the one of beauty, of form and color and mystery.

Benton searched for "beauty" and "mystery" in his Art Institute classes, where he studied watercolor and oil painting, sketched plaster casts of Greek and Roman sculpture, drew from live models, and imitated the fluid line and exotic subject matter of Whistler paintings and Hokusai prints. Chicago itself, he ironically observed, represented "the rebirth of our aesthetic sensibilities" in the "dramatic effect and form" of its skyscrapers. Standing above the "crude commercialism that generated it," the skyscraper offered a symbol of solace. Born into similar circumstances, he also hoped to rise above his pragmatic upbringing. He worked constantly at his regenerative goal and when his Art Institute roommates questioned his genius, he moved to a solitary room on the city's South Side.[31] Determined to avoid the art world's commercialism, Benton focused only on his own aesthetic enterprise. His search for more autonomy and an even more intense artistic experience took him to Paris in 1908, where he began studies at the Académie Julian.

In this school, as in Chicago, Benton rejected a strict aesthetic methodology. He rebelled against "narrow and rigid" art training which focused on drawing casts and perspective studies and was, he observed, a "strictly visualistic" methodology. The Académie, for instance, demanded that students copy plaster casts or live models. They were expected to formulate imagery "easily grasped by a large audience," and abstract art, because it seemed to represent "art for art's sake," was rejected as morally suspect self-indulgence. Not surprisingly, Benton bolted from these rigid formal studies after only one year. Although he eventually embraced a public art and may indeed have been influenced by the "republican" aims of the French schools and their emphasis on the dissemination of fine art to the masses, Benton's personal dynamic modernism maintained both an autonomy and a focus on American producerism which distinguished it from French academic art.[32]

Benton's art world ambivalence paralleled that of other dissenters engaged in the shift to the modern era. As Jackson Lears has explained, "the dilemmas of authority in a liberal, democratic society" obsessed many during this period. Benton later noted that he challenged the strict authority of certain aesthetic methods because his Populist background taught him to resent "institutionalized forms of art, whether they are radical or conservative."[33] But even more, Benton understood from familial experience that group loyalty could lead to victory or defeat: partisan politics and its often blind allegiances had first carried his forebears to public success, but then it had led them to political ostracism. As the son of a politician with ties to the republican tradition, Benton was encouraged toward both independent self-expression and the external authority of law and electoral politics. These dual expectations created the aesthetic (and political) ambivalence that marked Benton throughout his life: he championed personal liberation but also celebrated public regeneration under the authority of his regionalist art. Like his forebears, he also first met with success and then with failure.

Other experiences at this particularly impressionable age (he was seventeen when he started at the Art Institute, and twenty-two when he left Europe for New York) affected Benton as much as his disappointment about art world materialism and organization. Several sexual episodes led Benton to assume both misogynistic and homophobic attitudes. Benton was a short, slight figure only 5 feet 2¾ inches tall; living up to his namesake must have been a chore. Self-consciously, Benton developed a macho image—drinking, brawling, whoring—while still a Missouri teenager. In a Joplin brothel, Benton lost his virginity to a

"blackhaired harlot in a red kimono." Apparently, as he recounted in an unpublished autobiography called "The Intimate Story," it was not an entirely pleasurable experience: afterward, the woman "laughingly announced" to a group of his friends sitting in the brothel parlor: "The kid has been fucked." The encounter soured Benton to sex for quite some time and certainly shaped his uneasy relations with women. In Paris, for instance, Benton's lengthy affair with a model named Jeanette ended when she gave birth to a stillborn child. Benton was so horrified by "the awful night" of this incident, he was rendered sexually impotent. Shortly thereafter his mistress left and as Benton later wrote, he "welcomed the new quiet and Jeanette's absence along with it. When she was away I forgot what a grim problem she had been for me." Benton's apprehensions about the opposite sex were especially manifested in his marriage to Rita Piacenza (in 1922), which was marked by his long absences. As he recalled: "the bonds of marriage did not lay very heavily on my back." [34]

Such attitudes were also disclosed in his artwork. Women, said Benton, were "touchy" subjects, thus explaining their infrequent appearance in his drawings. Perhaps reflecting on his father's disdain for the mincing artist who "hung around the skirts of women," Benton justified his career choice with big, bold paintings that showed a mostly masculine American scene. While that scene was integrated both in terms of race and gender, Benton's America was hardly balanced in terms of male and female roles and responsibilities. As Elizabeth Schultz explains, "the egalitarianism which Benton would embrace in his concern for 'people in general' appears restricted by the heterosexual and masculine bias of his assertions." [35] His representations of women showed them relegated to the domestic sphere or as sex objects; Benton's version of a working woman was most often a chorus girl or burlesque queen. To his credit, Benton did include activist Fanny Wright in the 1933 Indiana mural, but positioning her between naked boys at a swimming hole and a young couple making out in a horse-drawn buggy suggests his less than enthusiastic championship of her causes. Joining other mythic males, most notably Huck Finn, Benton avoided (or ridiculed) the world of women and domesticity. The contributions women made in shaping America's past history and to producerism's rebirth in the twentieth century were simply not given much credence.

Benton's ambivalence in linking women with the producer tradition was paralleled by his homophobic posturing. In 1941, Benton publicly denounced the typical museum director as a "pretty boy with delicate

wrists and a swing in his gait." It was a none-too-subtle reference to staff members at Kansas City's Nelson-Atkins Museum of Art, with whom Benton had personal grievances. His remarks led to his being fired from his teaching job at the Kansas City Art Institute. Benton's homophobia certainly stemmed from anxiety that his father viewed artists as "boot-licking" fops, but it was heightened by personal experience: as an art student in Chicago, Benton was sexually molested by one of his older male buddies.[36] The tense tug-of-war that Benton's parents played regarding his aesthetic pursuits, coupled with the uneasy sexual encounters he experienced, affected Benton's personal relations, his artwork, and his attitudes about the art world. Benton's adult friends were mostly of the heavy-drinking, boot-stomping, he-man variety, like Jackson Pollock. When, after World War I, Benton began to accommodate his aesthetic studies with his political inheritance, his art focused on the labors of muscular, macho, and presumably heterosexual men who were shown free of corporate *and* female restraint. And throughout his life, Benton would be ambivalent about the art world: struggling to make a viable living in that world and yet constantly challenging its rules. The art world of the teens, then, was a place where Benton found a thriving "spirit of commerce," restrictive rules, and aberrant sexual behavior. He was confused by its materialism and mores, an ambivalence revealed especially in his aesthetic wandering. In Paris and in New York (where he settled in 1912) he copied all sorts of modern styles—impressionism, pointillism, symbolism, fauvism, synchromism, constructivism—but "was unable to make decisions" about any of them. Still, he remained dogmatic about his quest: "I am *absolutely* sure of myself as an artist. . . . Art is not lucrative at first but at least its devotees have a purpose in life, which is more than most men have." [37] Benton was unsure what his "purpose in life" really was in terms of a personally regenerative aesthetic style, but he never stopped searching. In New York his search took him in wild directions, from synchromist painting to the movies, from settlement-house work to marxism. But it was fruitful: by 1919 Benton began to link various aesthetic agents with republicanism in his regionalist mural *The American Historical Epic.*

One of the most important formal factors to influence Benton's genesis of regionalism in the late teens was modern art. Indeed, the innovations of Cézannesque structuralism and synchromism became essential elements in his regionalist style. Comparing *The American Historical Epic* with Bingham's depiction of somewhat similar subjects (fig. 1.6) we recognize Benton's rejection of the symmetrical order and naturalis-

tic palette of the premodern canvas for the collaged compositions and bright hues of the modern styles he assimilated in Paris and New York. He pursued modern art not only because it was an explicit escape from the bankrupt culture of his father's world, but because it reaffirmed, he wrote, "what had been largely lost in a society devoted to the curious *abstractions* of a money profit way of life." [38]

Modernism was a regenerative aesthetic for Benton and had tremendous appeal for him throughout his artistic life. Small watercolors such as *Landscape* (ca. 1915–20, fig. 1.9), like the panels in *The American Historical Epic,* reveal Benton's serious study, especially, of Cézanne's organization of the picture plane. Benton was especially attracted to the French artist's emphasis on the problems of composition:

> At a time when artists were dealing with *effects,* he tackled the fundamentals of the creative processes in painting. He pointed up . . . the central problem in painting, the old perhaps insoluble problem of the relation of form, which is a matter of knowledge, to color, which is a matter of sensational impact.

Cézanne, Benton observed, rejected "the fragmented pictorial world" of impressionism and sought a "unified" world of internal pictorial consistency, where the "dynamics of lines, shapes, and colors" were defined by the conditions of canvas shape, thematic content, and painterly activity. He abandoned the art world of his immediate past because it was "formless" and "lacked substance [and] power." Cézanne had "set out to reconstruct his world" with what some consider the first truly modern art.[39]

Benton was especially intrigued with the manner in which Cézanne's modern style recombined form and color "in the interest of a better representation of nature." Because of his background Benton divided modernists with purely private motives from those like Cézanne (and ultimately himself) who used modern art to create an authentic and integrated world. Cézanne, wrote Benton, was no "aesthetic hedonist" but an artist concerned with the "*public* nature" of art: "Cézanne's 'nature' . . . existed in a public stream beyond himself. Nowhere does he assume nature to be a *property* of his perceptions. She is out there." It is no surprise, then, that Cézanne's reconstructive, socially oriented, and formally harmonious version of modernism had a great impact on Benton's burgeoning development of regionalism in the late teens. In 1921 one critic, declaring him among the "most ultramodern in tendency among modern American painters," praised Benton's experimen-

1.9. Thomas Hart Benton, *Landscape,* c. 1915–20; oil on paper, 7 ½″ × 8 ¼″. Courtesy of the Salander-O'Reilly Galleries, New York.

tation with Cézanne's structuralism, which included adding "orange, green, and violet to the triad of yellow, red, and blue upon which the Provençal master based his harmonies." [40]

Benton's restructuring of Cézanne was paralleled by his study of synchromism, an innovative mode of nonobjective color-field painting developed by two Americans, Stanton MacDonald-Wright and Morgan Russell, during the early teens. Both oriented their abstract paintings to expressive "waves of color" whose pictorial intensity rivaled the "chaotic sounds and lights in our daily experience." This is Benton's description of their first exhibit at New York's Carroll Gallery in 1914:

> The first impression I received, all the pictures being large and crowded together, was like an explosion of rainbows. The Syn-

1.10. Thomas Hart Benton, *Figure Organization No. 3*, 1915–16; oil on canvas. Now lost; reprinted from *The Forum Exhibition of Modern American Painters* (New York: Arno Press, 1968).

chromists had extended and intensified Cézanne's color-form theories, in which form was seen as a derivative of the organization of color planes. They had intensified these planes by abandoning completely the usual colors of nature, replacing them with highly saturated colors, and had extended them into an area of purely "abstract" form.

In addition to the style's visual power, Benton was intrigued by its rhythmic quality, which he defined as a kind of baroque dynamism similar to Michelangelo's sculpture. But, he "could not accept" the synchromists' "repudiation of all representational art."[41] Accordingly, Benton's interpretation of synchromism, as seen in *Figure Organization No. 3* (1915–16, fig. 1.10) was a modern painted version of Michelangelo's bas relief, *The Battle of the Lapiths and the Centaurs* (ca. 1492, fig. 1.11).

1.11. Michelangelo, *The Battle of the Lapiths and the Centaurs,* c. 1492; marble, 33 ¼″ × 35 ⅛″. Photo courtesy of Casa Buonarroti, Florence.

Benton relied on contour and line in his synchromist pictures as much as he relied on color, and thus rejected a strict color-form method of abstraction. It was aesthetic strength that he searched for, not theory, as he clarified in his statement for the Forum Exhibition, a 1916 New York show of modern paintings which included *Figure Organization No. 3*: "My experience has proved the impracticability of depending upon intellectualist formulas . . . and for this reason [I] employ any means that may accentuate or lessen the emotive power of the integral parts of my work." While his comment may be perceived as anti-intellectual, it also demonstrates his independence from stylistic constraints. This, along with the reinvigorating "power" of his work and

its capacity for distilling "the irascible dynamism of our epoch," was cited in John Weischel's review of the Forum Exhibition:

> The fundamental difference between traditional and New Art ideals lies in the fact that the New Art Movement is more than a search for this or that aesthetic incarnation. It is an all-inclusive renascence . . . an embodiment of the modern spirit . . . an initiation of a search for a living truth that is above factional strife and partisan cannon [sic] above either academic or secessionist doctrine; as a token of a liberating affirmation.[42]

Weischel saw the commonality of Benton's assault on the past and his quest for modernist reconstruction. With the other Forum artists he was developing a "New Art" of modernism which would encourage the development of an integrative, emotional, and "liberating" world. For Benton, synchromist and Cézannesque styles were pictorial devices which conveyed power and unity, and he adapted them in the ways he saw fit. His version of a regenerative modern aesthetic was stylistically *open*—embodying the flux of modern life, its ongoing potential, and its often paradoxical denial of a fixed system of values.

The other major influence on Benton's regionalist style was the early motion picture. When he landed in New York in the teens, Benton took up quarters at the Lincoln Square Arcade at 65th and Broadway and shared a room with Rex Ingram, destined for fame as the director of such Rudolph Valentino films as *The Four Horsemen of the Apocalypse* (1921). Ingram had quit Yale to work in the movies and found early employment in the New York studios of Edison and Vitagraph. For five years he passed on movie work—set designing, carpentry, scene painting, historical research, advertising—to Benton, and once he even got him a bit part in an early film. But, the movies were more than just a healthy seven-dollar-a-day salary for Benton. They were a powerful new form of mass communication grounded in montage and typology which had a major impact on audience mores and values in the early twentieth century.[43]

Ingram, who had studied sculpture at Yale, treated his movies as art: "the same laws apply to the production of a film play which has artistic merit, and to the making of a fine piece of sculpture or a masterly painting." At the same time, he recognized the wider cultural orientation of the new mass media: "sculpture [and] painting belong to the art-loving minority of the nation, the motion picture belongs to the whole people." And he also recognized the unifying potential of the new

media: "Somewhere between the extreme realists and the ultra-modernists we will find the happy medium of expression, a screen Esperanto." His aspirations to a regenerative mass aesthetic were similar to Benton's and each proceeded along analogous formal lines. In 1917, during the time he was working for the movies, Benton started making clay models to "study anatomical detail and the play of light and shade" before he painted. Similarly Ingram, the former sculpture student, "worked out his production with models and voluminous sketches for the decors" before he began shooting. Benton also began to assimilate the formal qualities of the movie sets he designed into his personal artwork:

> As the movies of these days did not employ color, I made my set designs and backdrops in black and white. My conceptions were enlarged and sometimes modified by professional scene painters. . . . Observing the scene painters, I became interested in "distemper," or glue painting, and began experiments with that medium. . . . Later it would lead to the egg-tempera techniques which I used for my murals of the thirties.[44]

Indeed, the huge size and monochromatic palette of these movie flats was copied in *The American Historical Epic,* whose larger-than-life panels reveal strong light-dark contrasts. And, like these set designs, Benton's mural panels particularly emphasize foreground activity. Originally planned as a series of some 60 to 75 panels, each the size of a movie screen, the completed mural would have been the canvas equivalent of a feature-length film.

Benton described these panels as dynamic "formal experiments" inlaid with a "social meaning, a cultural meaning, one attached to the United States." [45] The genesis of his regionalist style, *The American Historical Epic* was the visual arena where Benton began to work out his oedipal struggles and develop a sense of artistic self. The stark contrasts between hues, the spatial depth (whereby the canvas recedes but also rises), and the overall energy of these pictures can be seen as Benton's representation and resolution of the ambivalence that enveloped him in the teens: the conflicts between parental authority and personal independence, and between the use of modern art for private or public purposes. Their modern form, the result of Cézannesque structuralism, synchromism, and the motion picture, gives visual evidence of Benton's release from the world of his father; the panels clearly reveal Benton's new sense of self and personal identity as a *modern artist.* Further, their

subject matter, a modern artists' survey of the history of the United States, indicates Benton's initial reconciliation with the republican ideology of his upbringing.

It was while he worked for the movies during the teens that Benton began to shift from personal to public art. He had always been uneasy about a solely private aesthetic, the result of an upbringing by a political servant of "the people." But, having rejected his father's world, he was unsure how to create a modern version of public service. He learned how from Rex Ingram and the movies. Movies, then and now, tend to rely on a language of typology: the blonde, the cowboy, the Kansas farm, and the Manhattan penthouse are visual clues that guide audience expectations. The movies Benton worked on from 1913 to 1918, Westerns and two-reel melodramas, consisted of easily recognizable images presented in a narrational format. And their montage form and fast pace furthered audience accessibility: their dynamism was that of the modern age.[46] As a participant in the creation of this new form of mass communication, Benton learned the parlance of popular culture and applied it when he began to create regionalist art. The way the movies looked—flickering black and white scenes full of pantomimed theatrics embroidered in the dramatic camera action and editing of such art-conscious directors as Ingram and D. W. Griffith—emerged in Benton's public murals. The panels for *The American Historical Epic* consist of the same snappy sequences and conventional imagery as movies of the teens and twenties. And because motion pictures were aimed at the audience he also wanted to reach, it was natural for Benton to adopt a cinematic style of painting.

These comparisons between Benton's art and the early motion picture suggest more than just the influence of film form on his nascent regionalist sensibilities. Tracing his aesthetic development during the late teens from Cézanne to synchromism and from Rex Ingram to the movies, we see that Benton was, somewhat paradoxically, striving to develop an aesthetic *system* by which a new world could be constructed. Benton, who had rebelled all his life against systems, was now moving toward one—as *The American Historical Epic* mural shows—and the irony did not escape him. In a letter of the period he wondered if artists could "catch the swing of the modern world with a method which is in direct contrast with our individualistic freedom." And in a 1924 article he admitted: "form construction is—whether we wish it or not—an affair of long accumulated habits. . . . art will gain by more reflection on the value of the meaning it creates."[47] As he struggled to release the

shackles of his father's world and reveal the modern world's dynamism in a rhythmic, open-ended style, he came to realize he was also constructing an aesthetic methodology. It was, he realized, the product of his entire life—from Missouri's producer tradition to New York's art world—and it would gain its strongest impact through the meaning it created for its audience. By the twenties, as these writings and *The American Historical Epic* suggest, Benton's oedipal struggles had seized the public authority that was previously his father's and linked it with his version of modern art. His regenerative efforts were redirected from the personal to the social realm. If he was going to develop an aesthetic system, it would be one that fit with the "long accumulated habits" of his upbringing in democratic politics.

Aimed at integrating the modern world with American political engagement, Benton's aesthetic system of regionalism became manifest in the years following World War I. Benton suggested it was his wartime experience as an architectural draftsman in the Navy that tore him away from "the art-for-art's-sake world" and shot him "in a flash" to the narrative public art of regionalism. But well before the war Benton had been contemplating the development of public art. In the earlier cited 1909 letter to his father, Benton revealed he wanted to make "his fellowman better" through art. His desire to do so, although not the form that desire ultimately took, was similar to that of the Ash Can school artists. These early twentieth-century American painters revolted against their inheritance of high-brow styles and searched for authenticity in the life and culture of urban New York. Benton knew Ash Can leader Robert Henri (they were both on the faculty of the New York Art Students League during the late twenties) and was familiar, as most artists were in the teens, with Henri's philosophy of the "art spirit":

> I mean by this, the development of individual judgement and taste, the love of work for the sake of doing things well. . . . If anything can be done to bring the public to a greater consciousness of the relation between art and life, of the part each person plays by exercising and developing his own personal taste and judgement and not depending on outside "authority," it would be well.[48]

Espousing an aesthetic of humane individualism, Henri and his followers aimed to create a broadly democratic art which would raise public consciousness, much like the progressive politics of the era. Their art focused on the realities of modern America and described its urban ethnicity and vigor: Everett Shinn's 1911 mural for the Trenton City Hall

1.12. Everett Shinn, *Murals, Commission Chambers,* 1911; oil on canvas, 45' × 22'. Trenton City Hall, Trenton, New Jersey. Courtesy of the Department of Parks and Public Property, Trenton, N.J.

in New Jersey (fig. 1.12) portrays workers at the Roebling Steel Mills and the Mattock Kilns; John Sloan's *Movies, 5 Cents* (1907, fig. 1.13) shows those workers at play. The arenas of labor and amusement were both redefined in the twentieth century, as the development of paternalistic corporate attitudes and the birth of the movies suggest, and the regenerative milieu of each was repeatedly portrayed by various Ash Can school artists.[49] Likewise, these realist painters aimed for an American cultural revolution which would erase the Gilded Age division between art and life, between art and the human spirit: Shinn's mural depicts a communal, organized corporate factory and Sloan shows—like D. W. Griffith and Rex Ingram—popular culture as a liberating form of mass communication. These painterly aspirations to regenerate American culture certainly affected Benton's development of *The American Historical Epic* and later regionalist pictures which debunked the highbrow culture of the parvenu era and located American energies in "the people." But Benton's paintings linked cultural regeneration with a decidedly modern style, whereas Shinn's mural and Sloan's picture had more in common with the premodern style of Bingham's paintings. The 1913 Armory Show made these old world/new world distinctions clear: Ash Can school art conveyed the subjects of the modern world, but Du-

1.13. John Sloan, *Movies, 5 Cents,* 1907; oil on canvas, 59.6 × 80 cm. Reprinted from *John Sloan, 1871–1951* (Washington, D.C.: National Gallery of Art, 1971).

champ's *Nude Descending a Staircase II* (1912) captured its dynamism.[50] Benton's regionalist art did both.

Despite his claims to the contrary, Benton did not generate regionalism overnight "in a flash." Rather, he spent most of the teens struggling to resolve his ambivalent attitudes about modern art and public responsibility. In the early teens, for example, he was struck by Hippolyte Taine's *Philosophie de l'art* (1875), an environmentalist treatise which revealed the "close ties of the older arts to specific social backgrounds and cultures." Taine convinced him that "the art of Paris" embodied "degeneration" because of its seeming denial of sociocultural factors.[51] But Benton did not retreat to "the older arts" in his search for an authentic culture: he merged "the art of Paris" with the political milieu of the modern age.

If Rex Ingram schooled Benton in the primacy of popular culture, the major figure to help him reconcile his political inheritance with

modern art was Polish émigré John Weischel. An art critic, mathematician, and civil engineer who taught at the Hebrew Technical Institute during the first half of the twentieth century, Weischel introduced Benton to the "theoretical literature of the day"—James, Dewey, Freud, Marx—and showed him how to apply theory to aesthetic action. He was one of the American art world's prewar seers, rivaling Photo-Secession prophet Alfred Stieglitz. Benton later wrote that in Stieglitz's art temple, the modest New York gallery called 291, "aesthetic pose and lunatic conviction" were typical, whereas among Weischel's group he found that "social as well as artistic questions were discussed."[52] Again, his upbringing led him to favor the latter.

Weischel's parallel to Steiglitz's 291 was the People's Art Guild, an organization he founded in 1915 to "bring about a direct approach of artists and the people, so that in the midst of a beautifully active people, a hospitable home for great artists may arise." Weischel followed Henri's emphasis on the social function of art: "The true artist regards his work as a means of talking with men. . . . The artist is teaching the world the idea of life." But, unlike Henri, Weischel believed that the best art for this task was modern art. Modernism, as expressed in art, movies, and technology, could create a public culture that would foster urban solidarity. His optimism was that of the modern engineer: the People's Art Guild, like Jane Addams's Hull-House, was a prototypical progressive era institutional solution to the urban problems of social estrangement and class division. The guild sponsored classes in drawing, sculpture, art history, and crafts, arranged lectures by activist artists like John Sloan, George Bellows, and Abraham Walkowitz, and mounted exhibits featuring amateur and professional artists in many New York settlement houses and neighborhood centers to foster the development of community culture. Prints and paintings were sold for two or three dollars each to challenge the concept of art as a luxury product meant only for elites. But Weischel considered the guild even more than a vehicle for developing urban cultural identity. He thought of it as a community service which could link "artistic interests with the social interests of the workers' organizations, the unions." Together, art and labor would create a kind of community solidarity to encourage activist politics. Benton met several labor leaders at guild meetings and got jobs in several settlements, including the Henry Street house, through them. Throughout the teens he taught art in settlement houses and planned many of the guild's art shows.[53]

It is not surprising that Benton was attracted to Weischel's progressive humanitarianism and his development of a new aesthetic ideology

for the failed worldview of a previous generation. It was from Weischel, a sort of modern version of the father from whom Benton had long ago "drifted apart," that he learned to have a certain faith in the power of visual ideas to create social change. Weischel reintroduced him to the possibilities of American democratic reform, which Benton had considered vanquished by the corrupt political culture of his father. These possibilities, Weischel made clear, lay not in politics but in art. He showed Benton that social reform and aesthetics could be joined in the public milieu of the art gallery; like most progressives, Weischel saw art showplaces not as treasure-houses or temples, but as places for social improvement. And he helped convince Benton that modern artists should contribute to this cultural regeneration. Otherwise, as progressive sociologist Charles Horton Cooley warned, American culture would be left "backward, inferior to countries far less fortunate, in the richness, beauty, and moral authority of its public life." Benton was probably also attracted to the guild's urbanization of the small-town values he had grown up with, such as civic participation and face-to-face communication. Under Weischel's guidance, then, Benton actively participated in a process where, as he noted, "ideas about the social meaning and values of art were germinated." And, he added, "they were to bear fruit later." These "ideas" were by no means as radical as those that informed the merger of culture and politics in the Paterson Strike Pageant, a 1913 event organized by John Reed, Mabel Dodge, and various IWW representatives to raise funds for striking New Jersey silk workers.[54] Rather, Weischel encouraged a far more accommodating social art, one whose liberal tone Benton would first advance in *The American Historical Epic* and then sustain in his 1930s murals.

Well before his experiences in the navy, then, Benton began to formulate the ideas that led to regionalism. His experiences after the war, in an America where progressives felt increasingly alienated, further solidified his reconciliation with his producer inheritance. Returning to New York after his stint in the navy, Benton searched for ways to make money. He was unable to find freelance work in the movie industry "due to the tighter organization of the companies and the unions." Instead, he worked as a longshoreman and then a cooper on the Hudson River piers. After a few weeks on the job, he discovered he was a scab: "I should have known this from the hundreds of idle men hanging out in the streets adjacent to the piers." Indeed, in 1919 alone one seventh of American workers were striking, as producers from steelworkers and millhands to telephone operators and Port of New York harbor workers demanded wage hikes.[55] Although Benton was broke he was also pro-

labor; he quit the job. Benton's postwar labor experiences are further evidence of his ambivalence about authority and personal freedom: unionization prevented his further work in the movie industry, yet he recognized the necessity for labor reform and quit his job as a long-shoreman when it conflicted with producer struggles.

Nor could he find work through the Peoples Art Guild—it had disbanded. Like many progressives, Weischel was unable to sustain his faith in reform after the war and succumbed to the widespread disillusionment brought on by the collapse of Wilsonian idealism, the 1919 Red scare, and a dramatic increase in industrial productivity unaccompanied by truly significant labor reform. The closing of the guild is but one indication of the progressives' sense of defeat in the 1920s, evidenced further by intellectual cynicism about collective action and rising suspicions about mass culture. But Benton was not so disillusioned, perhaps because he had only just begun, in 1919, to construct the integrative and reconciliatory art of regionalism. In the 1920s, he did not renounce reform and American culture and escape to Europe, nor did he renounce ideology and escape into a private art world. The progressive spirit he had learned from Weischel had disintegrated but Benton did not abandon it. Instead, in the years after World War I, Benton cultivated all the aesthetic styles and progressive ideas he had experimented with and brought them to fruition in *The American Historical Epic.* This mural, which he began in 1919 and worked on until about 1928, reconciled him with his political inheritance and defined his identity as a modern artist. Despite the disillusionment of the era, Richard Pells writes, a "reform spirit managed to remain alive after 1920." Certain intellectuals, among them John Dewey, Charles Beard, and Lewis Mumford, refused to abandon reform politics entirely and searched throughout the 1920s for "a suitable role" they could play in its revitalization.[56] Benton, too, searched for a way to keep the progressive dream alive in the twenties. Weischel had convinced him that art had a "social" purpose, but what did that really mean in this decade?

Looking for answers, Benton turned for a while to the politics of the radical left. Like other Americans who drifted from progressive to leftist politics in the 1920s, Benton saw the Bolshevik Revolution as the premiere model for American social change. "In the upheavals of the early twenties," he said, "during the Palmer raids and the crushings of the I.W.W., all of my sympathies were on the labor and radical side." He made his apartment available for "secret meeting places for the persecuted members of the commie party," was on "reasonably good terms

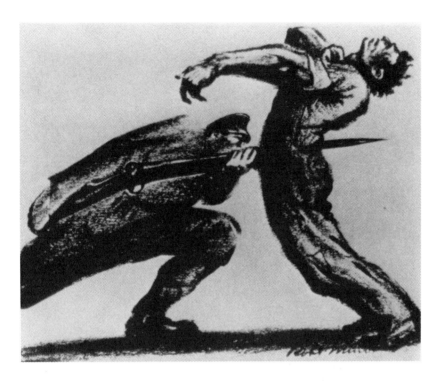

1.14. Robert Minor, *Pittsburgh*, 1916, in *The Masses*. Reprinted from *The Critical Vision: A History of Social and Political Art in the U.S.*, by Paul von Blum with permission of South End Press, Boston.

with the boys of the John Reed Club and the Russo-American front," including *The Masses* cartoonist Robert Minor, and "applauded the success of Lenin and Trotsky in establishing what appeared to be a true socialist state." However, if Benton sided with radical politics during the twenties, he did not adopt its aesthetics. Minor's *Pittsburgh* (1916, fig. 1.14) is archetypal social realism, quickly provoking an emotional response which leads the viewer to side with its leftist indictment of government strike-breaking. Benton's depiction of a similar subject, *Mine Strike* (1934, fig. 1.15) is more anecdotal, if no less emotionally compelling. But it is a more complex analysis of labor conflict, revealing both the opposition of workers and militia and the damage done by their conflict: the police have murdered a striker and in the background the mine has caught fire. While Benton certainly sided with producers over

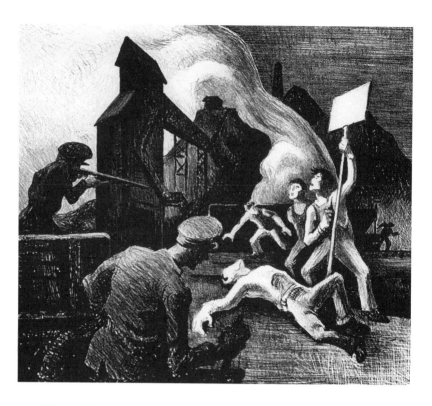

1.15. Thomas Hart Benton, *Mine Strike,* 1934; lithograph, 9 ¾″ × 10 ¾″. Courtesy of the State Historical Society of Missouri.

management—his upbringing and his own aesthetic and labor experiences convinced him—his depiction of their conflict reveals dissatisfaction with violent labor struggle. Mob rule of any sort did not jibe with republicanism: "I was enough of a politician by memories of family experience to know that governing power could not be exercised by the mass." [57]

Indeed, Benton's interest in marxist politics must be placed in the context of his own family life, as he did:

> The idea of a ruthless and greedy crowd of economic buccaneers sucking the life blood of the country for their profits was familiar to me before I had ever heard of Karl Marx, Communism, or even Socialism. It was acceptable on plain American grounds. It had

long been a part of Midwestern Democratic campaign talk, and I could remember it from my earliest childhood.

Benton saw marxism as a familiar form of political reform, and it further reawakened his nascent republicanism. In 1932 he even provided the illustrations for Leo Huberman's marxist history of the United States, *We, the People*. And the tenor of the liberal New Deal politics Benton sided with in the 1930s was often indistinguishable from that of Popular Front radicalism.[58]

But Benton came to reject orthodox marxism (in the late 1920s) for the same reasons he rejected his father's politics: neither old-style democratic reform nor new-style marxism spoke to the contemporary issues that he wanted to address: the dynamic and not entirely rational spirit of his modern times, and the individualism of the American folk. His faith in the republican tradition and in the independence of American producers was out of step with both corporate capitalism and its marxist critics. His faith was confirmed when in the mid-twenties he began to take lengthy sketching trips across America gathering material for his *American Historical Epic* project. He discovered that the problems facing the American people were not entirely related to issues of class but to the more pragmatic issues of individual survival. By the end of the decade Benton had "completely lost faith in the efficacy of Marxism in the United States." Later reflecting on the left-liberals he met in the twenties, including Boardman Robinson, Eugene Debs, and Norman Thomas, he explained:

> None of them had my kind of background. They were innocents. I had known enough about politics to know that while Marxist theory was itself logical and quite convincing, there was always the political business, the question of power. And I was proved right later, with the rise of Stalin.[59]

Differences in cultural backgrounds, Benton felt, called for different political and aesthetic responses, and marxist thought and social realism did not, he believed, correspond to the American experience. Republicanism, not marxism, as revealed in the guise of modern art, would be Benton's response to past American experiences and present American needs.

His first cohesive analysis of those experiences and needs was *The American Historical Epic*. The immense scope of such a subject reveals Benton's bold confidence in himself and his political aesthetic. Working on the panels throughout the twenties, he exhibited it in "chapters" at

New York's Architectural League, hoping to attract a patron. In this history mural Benton focused on "the 'people' of America—the simple, hard working, hard fighting people who had poured out over the frontiers and built up the country." His ideas for such a history may have come from Jesse Ames Spencer's illustrated *History of the United States* (1858), which he read in the navy, but comparison of the John Vanderlyn and Emanuel Leutze etchings in Spencer's book with Benton's pictures reveals a marked difference between an interpretation of "history from above" and "history from below." "I wanted to show," said Benton, "that the people's behaviors, their *action* on the opening land, was the primary reality of American life." His comment suggests that rather than Spencer the major historical source for his mural was Charles Beard, with whom he "often discussed" his art projects. Indeed, Beard and nineteenth-century historian George Bancroft were cited as seminal influences in a 1928 article Benton wrote in which he detailed his sources for the mural.[60]

Beard's jeremiad history, by which he blamed the problems confronting American republicanism on the retention of old world traditions and institutions and not on modern industrialization, paralleled Benton's worldview, as well as that of his ancestors. Beard insisted on the beneficence of industrial progress in such texts as *The Economic Origins of Jeffersonian Democracy* (1915). In postwar tracts such as *The Rise of American Civilization* (1927), he cautioned that "industrialism would restore the American heritage of democracy only if the nation followed a course of isolation" and its people turned back to "the republican virtues of the founding fathers—simplicity, native democracy, isolation, and eternal harmony."[61]

Benton first envisioned Beard's merger of industrialism, republicanism, and isolationism in *The American Historical Epic*. While class and race conflict are portrayed in *The Slaves* (fig. 1.3), they are resolved in *Over the Mountains* (fig. 1.2) and in the modern-day panel *1927—New York Today* (fig. 1.16), where black and white Americans unite to settle the frontier and build the urban scene. European influence as class hierarchy or aristocratic values is completely avoided: all figures are recognizable, but not as specific historical personalities. Instead, Benton used stereotyping to suggest the broad commonality of American history. Beard's overall emphasis on the guiding ideology of U.S. economic determinism is certainly reflected in Benton's division of the mural into chapters—from discovery to settlement to industrialization—which show the development of American civilization "as an evolution from primitivism to technology through a succession of peoples' frontiers."[62]

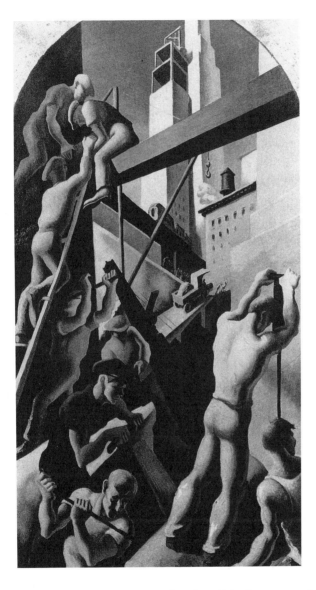

1.16. Thomas Hart Benton, *1927—New York Today,* 1927; oil on canvas. Courtesy of the Trustees of the Benton Testamentary Trusts, Kansas City.

Also like Beard, Benton aimed to show how the American people had become "increasingly separated" from the benefits of "civilization and technology." Pinpointing the inequities of laissez-faire expansionism, Benton returned to the rhetoric and ideology of his father and his great-uncle: "I was convinced that the American Dream had been continually discounted by capitalist organizations which had grown beyond the people's control. . . . I would go in my history from the frontiers, where the people controlled operations, to the labor lines of the machine age, where they decidedly did not." Like his forefathers Benton sought a reconciliation of political democracy and economic opportunity, the restoration of the "people's control," in his *American Historical Epic*. But his aesthetic vehicle was different from theirs, stemming from the visual age of movies, photo magazines, and pictorial advertising into which he was born.[63]

As initiated in the historical mural he began in 1919, regionalist art was Benton's twentieth-century version of republicanism: an integration of contemporary art and popular culture which addressed physical and spiritual regeneration in the modern world. Like the Dutch De Stijl and Russian constructivist artists of the teens and twenties, whose broad ambition was to "lead art and culture at large into a new direction," Benton aimed to create a modern art which could generate social and political reform in post–World War I America. His version of modernism followed less the marxist slant of these European artists than the pragmatic philosophy of John Dewey, whose works Benton began reading in the 1920s. Dewey's version of American modernism combined communitarian republicanism with a commitment to social and industrial progress. His modernism, writes Daniel Singal, "tends to focus on society as a whole, emphasizes the elimination of social barriers (geographic, economic, ethnic, racial, and gender), and tries to weld together reason and emotion in the service of programmatic social aims."[64] It is an apt description of what Benton hoped to do with the American modernism he brought forth in regionalist art.

The American Historical Epic paralleled similar efforts by writers (Cather, Crane, Fitzgerald, Hemingway, Lewis), historians (Beard and Parrington), critics (Dewey, Thomas Craven, Van Wyck Brooks, Edmund Wilson), movie directors (Griffith, King Vidor) and other painters. Joseph Stella repeatedly portrayed the Brooklyn Bridge, calling it "the shrine containing all the efforts of the new civilization of America." Edward Hopper, Charles Demuth, and Charles Sheeler painted other American places: row-houses on empty urban streets, enigmatic grain

elevators, Shaker barns. Benton, however, like Henri and Sloan, painted the American *people*. His father's death in 1924 further codified his regionalist aesthetic, already well in place in the early panels of the historical mural which focused on the "action" of the "people" his father and his great-uncle had championed. Watching his father die of cancer in a Missouri hospital, Benton recalled later:

> I got a renewed sense of the variety and picturesqueness of his life and of the life of the people of my home country. . . . I discovered a deep run of common human sentiment which I shared. Missouri['s] rural conservatism has preserved, in prejudice and action, a large residue of that old-time American individualistic psychology with which we are going to need a large measure of acquaintance if we are to avert disaster in our further social travels.[65]

His father's death was the final catalyst in Benton's reconciliation with the producer tradition of his inheritance, a reconciliation first demonstrated in *The American Historical Epic* mural.

The visual evidence of his first historical mural suggests that Benton came full circle to the liberalism of his upbringing by the end of World War I. His obviously modern survey of America's economic evolution was described in a 1927 review by Lewis Mumford in the *New Republic* as "a brave challenge":

> For Mr. Benton, 1400, 1653, 1865, 1927, are successive planes that lead the eye from the background of primordial Nature to the foreground of the Machine. In hard contrasts of light and shade, in a somewhat metallic palette, and in rigorous line, Mr. Benton brings into all his pictures the quality of our own day. If this art does not belong to the age of the Skyscraper, then Spengler is right: such an age has no place for art!

Expected by his family to become a lawyer and eventually a reform politician, Benton became instead a modern artist and promoted social change with a regenerative art bent on restoring producerism in contemporary America. During the 1930s, when the exigencies of social reform became obvious, Benton further reconciled himself to the progressive politics of his forebears by promoting the reform politics of the New Deal through his public art. For Benton and for others, the Depression was truly "an unprecedented opportunity to realize long-cherished projects and goals."[66]

1. Benton discussed the mural in "American Regionalism: A Personal History of the Movement," in *An American in Art: A Professional and Technical Autobiography* (Lawrence: University Press of Kansas, 1969), 149. He described his abstract art in *An Artist in America,* 4th rev. ed. (Columbia: University of Missouri Press, 1983), 44.

2. Benton, *An Artist,* 44, 45–46; Schapiro, "Populist Realism," *Partisan Review* 4, no. 2 (January 1938): 54; Kramer, "Benton, the Radical Modernist," *New York Times,* January 10, 1982, sec. D, p. 25; Eugene Lunn, *Marxism and Modernism: An Historical Study of Lukács, Brecht, Benjamin, and Adorno* (Berkeley: University of California Press, 1982), 33.

3. Benton, *An American,* 149; Lewis Mumford, "Thomas H. Benton," *Creative Art* 3, no. 6 (December 1928): 37.

4. For a good analysis of modernism, see Daniel Joseph Singal, "Towards a Definition of American Modernism," *American Quarterly* 39, no. 1 (Spring 1987): 7–26. See also Malcolm Bradbury and James McFarlane, eds., *Modernism, 1890–1930* (New York: Humanities Press, 1976).

5. Lee Simonson criticized the mural in "The Palette Knife," *Creative Art* 3, no. 4 (October 1928): 28–32. Benton responded with "My American Epic in Paint," *Creative Art* 3, no. 6 (December 1928): 31–36. For Benton's essays in *The Arts,* see "Mechanics of Form Organization in Painting," vol. 10, no. 5 (November 1926): 285–89, no. 6 (December 1926): 340–42; vol. 11, no. 1 (January 1927): 43–44, no. 2 (February 1927): 95–96, and no. 3 (March 1927): 145–58.

6. Matthew Baigell discusses *Discovery* in *Thomas Hart Benton* (New York: Abrams, 1974), 70, and Stephen Polcari analyzes Benton's modernist style in "Jackson Pollock and Thomas Hart Benton," *Arts Magazine* 53, no. 7 (March 1979): 120. Benton is quoted in "My American Epic," 36.

7. J. G. A. Pocock, "Between Machiavelli and Hume: Gibbon as Civic Humanist and Philosophical Historian," *Daedalus* (Summer 1976): 153–54; Steven J. Ross, *Workers on the Edge: Work, Leisure, and Politics in Industrializing Cincinnati, 1788–1890* (New York: Columbia University Press, 1985), 3; Lary May, "Making the American Way: Moderne Theaters, Audiences, and the Film Industry, 1929–1945," *Prospects* 12 (1987): 90.

The dominant work on the republican synthesis is Pocock's *Machiavellian Moment: Florentine Political Thought and the Atlantic Republican Tradition* (Princeton: Princeton University Press, 1975). On the republican synthesis and producerism, see Eric Foner, *Free Soil, Free Labor, Free Men: The Ideology of the Republican Party before the Civil War* (New York: Oxford University Press, 1970); on republicanism and the arts from the eighteenth to the nineteenth century, see John Barrell, *The Political Theory of Painting from Reynolds to Hazlitt* (New Haven: Yale University Press, 1986). For an overview of the republican

synthesis and its use by contemporary historians, see Gordon S. Wood, "Hellfire Politics," *New York Review of Books*, February 28, 1985, pp. 29–32.

8. Benton, *An Artist*, 5.

9. Benton, "My American Epic," 33, 35–36.

10. See Rowland Berthoff's discussion of Senator Benton in "Independence and Attachment, Virtue and Interest: From Republican Citizen to Free Enterpriser, 1787–1837," in Richard L. Bushman, ed., *Uprooted Americans: Essays to Honor Oscar Handlin* (Boston: Little, Brown & Co., 1979), 97–124. On Hosmer, see Charlotte Streifer Rubenstein, *American Women Artists from Early Indian Times to the Present* (Boston: G. K. Hall & Co., 1982), 76, 78. On Bingham, see E. Maurice Bloch, *The Paintings of George Caleb Bingham: A Catalogue Raisonné* (Columbia: University of Missouri Press, 1986). Benton's oratorical style is described in William Nisbet Chambers, *Old Bullion Benton: Senator from the New West* (Boston: Little, Brown & Co., 1956), xiii, 113–14, 177, 184, 194, and in his entry in *Appleton's Cyclopaedia of American Biography*, 1 (New York: Appleton & Co., 1894): 242. Benton's bank speech is quoted from his *Thirty Years' View: A History of the Working of the American Government for Thirty Years, from 1820 to 1850*, 1 (New York: Appleton & Co., 1856): 257. See also Frances Lea McCurdy, *Stump, Bar, and Pulpit: Speechmaking on the Missouri Frontier* (Columbia: University of Missouri Press, 1969), 85, 91, 110, and Hugh D. Duncan, *Culture and Democracy* (New York: Bedminster Press, 1965), chap. 4, "Oral Art and American Vernacular in the Middle West," 35–47.

11. Edward Pessen, in *Jacksonian America: Society, Personality, and Politics* (Homewood, Ill.: Dorsey Press, 1969), 93–94, discusses American economic concerns during the 1820s. See also John William Ward, *Andrew Jackson: Symbol for an Age* (New York: Oxford University Press, 1955), passim. On Benton, see Theodore Roosevelt, *Thomas Hart Benton* (New York: Houghton Mifflin Co., 1886 and 1914), 2, and Chambers, *Old Bullion Benton*, 113.

12. Benton quoted in *Register of Debates in Congress*, 19 Cong., 1 sess., 727, May 16, 1826; Berthoff, "Independence and Attachment, Virtue and Interest," 106–10.

13. *Annals of Congress*, 17 Cong., 2 sess., 241, February 14, 1823, quoted in Berthoff, "Independence and Attachment, Virtue and Interest," 110.

14. Benton, *Annals of Congress*, 17 Cong., 2 sess., 241, February 14, 1823, quoted in Berthoff, "Independence and Attachment, Virtue and Interest," 110, and quoted in Roosevelt, *Thomas Hart Benton*, 106–8. See also Chambers, *Old Bullion Benton*, 106. Ironically, many of these financial measures hastened the Panic of 1837 and the second great American depression, which Benton again blamed on the machinations of the bank.

15. On Benton's family, see Benton, *An Artist*, 4, 6; Henry Adams, *Thomas Hart Benton: An American Original* (New York: Alfred A. Knopf, 1989), 2–5; and Mildred Small, "'Sane People, Sane Life': The Death of Elizabeth Wise Ben-

ton," *Massachusetts Review* 22, no. 3 (Autumn 1981): 519–22. On Democratic party factionalism in Missouri, see John F. Fenton, *Politics in the Border States* (New Orleans: Hauser Press, 1957), 12, 126–48.

16. Benton, *An Artist,* 5–7, and "Boyhood," an unpublished, unpaginated manuscript in the Thomas Hart Benton Papers, Archives of American Art (AAA), Smithsonian Institution, Washington, D.C.

17. Lucile Morris, *Bald Knobbers* (Caldwell, Idaho: Caxton Printers, 1939), 169. Facing this page is a photo (see fig. 1.7) labeled "M. E. Benton (left) and Tom Steele, his secretary, while in Congress, 1889." This is an error: Benton's term in Congress did not begin until 1896.

18. Benton, *Congressional Record,* 56th Cong., 1st sess: 309. On Democratic party currency concerns in the 1890s, see J. Rogers Hollingsworth, *The Whirligig of Politics: The Democracy of Cleveland and Bryan* (Chicago: University of Chicago Press, 1963), 52–73; Walter Karp, *The Politics of War: The Story of Two Wars Which Altered Forever the Political Life of the American Republic (1890–1920)* (New York: Harper & Row, 1979), 59–62; and Russel B. Nye, *Midwestern Progressive Politics: A Historical Study of Its Origins and Development, 1870–1958* (East Lansing: Michigan State University Press, 1959), 43–44, 103–6.

19. Benton, speech of October 11, 1885, noted in Robert McElroy, *Grover Cleveland: The Man and the Statesman* (New York: Harper & Row, 1923), 162–63; speech of 1899 in *Cong. Record,* 56th Cong., 1st sess., 309–10. On Bland, see Edwin C. McReynolds, *Missouri: A History of the Crossroads State* (Norman: University of Oklahoma Press, 1962), 305. On millennial attitudes about free silver, see Richard Jensen, *The Winning of the Midwest: Social and Political Conflict, 1888–1896* (Chicago: University of Chicago Press, 1971), 276–86. Baum's silverite fairy tale, *The Wonderful Wizard of Oz,* is discussed on pp. 282–83; see also Henry Littlefield, "The Wizard of Oz: Parable on Populism," *American Quarterly* 16 (1964): 47–58.

20. Nye, *Midwestern Progressive Politics,* 11. Benton, *Cong. Record,* 58th Cong., 2d sess., 5357–59.

21. Benton, *Cong. Record,* 56th Cong., 1st sess., 309–10.

22. Benton, *Cong. Record,* 55th Cong., 3d sess., 1138.

23. On Missouri's economy around 1900, see McReynolds, *Missouri,* 308, and the WPA-sponsored handbook originally published in 1941, *Missouri: A Guide to the "Show Me" State* (New York: Hastings House, 1959), 69, 82–84.

24. Benton, "American Regionalism," 163, 167.

25. Benton discussed his father's plans for him, and his visual orientation in *An Artist,* 10–12, 15–16, 23–24, and his early art experiences in *An American,* 10–11. See also Adams, *Thomas Hart Benton,* 2, 5.

26. See Jean B. Quandt, *From the Small Town to the Great Community: The Social Thought of Progressive Intellectuals* (New Brunswick: Rutgers University Press, 1970), 154–55. Benton discussed Neosho in *An Artist,* 3–4, 15–16, 28;

see also Mary Cozad, *Neosho, Missouri: The Story of an American Town* (Neosho, 1968), 11–14.

27. Benton, *An Artist,* 16, 26–27.

28. Benton, *An Artist,* 28. Richard Pells discusses Mumford in *Radical Visions and American Dreams: Culture and Social Thought in the Depression Years* (New York: Harper & Row, 1973), 106.

29. For a discussion of other dissenters who searched for "more intense forms of physical or spiritual experience" see Jackson Lears, *No Place of Grace: Antimodernism and the Transformation of American Culture, 1880–1920* (New York: Pantheon Books, 1981). Stickley is discussed on pp. 68–71. See also John Higham, "The Re-Orientation of American Culture in the 1890's," in *Writing American History: Essays on Modern Scholarship* (Bloomington: Indiana University Press, 1970), 73–102; Wright is discussed on pp. 95–99. Carl Schorske discusses Gustav Klimt in *Fin-de-Siècle Vienna: Politics and Culture* (New York: Vintage Books, 1981), chap. 5. See also Schorske's "Generational Tension and Cultural Change: Reflections on the Case of Vienna," *Daedalus* 107, no. 4 (Fall 1978): 111–22.

30. Benton, *An Artist,* 27, and letter to Colonel Benton, written in Paris in 1909, Benton Papers, AAA.

31. Benton, letter to his family, February 1907, Benton Papers, AAA. On his teenage cartooning for the *Joplin American,* see *An Artist,* 17–22. His comments about his fellow Art Institute students are found in "Chicago," an unpublished manuscript in the Benton Papers. Benton describes his Art Institute experiences in *An American,* 11–13, and *An Artist,* 30–33. Chicago skyscrapers are discussed in the latter on p. 29.

32. Benton, *An American,* 13–16. On the Académie Julian, see Miriam R. Levin, *Republican Art and Ideology in Late Nineteenth-Century France* (Ann Arbor: UMI Research Press, 1986), 81, 112, 212.

33. Lears, *No Place of Grace,* 220. Benton quoted in Robert S. Gallagher, "An Artist in America," *American Heritage* 24 (June 1973): 43.

34. Benton's account of these incidents can be found in "The Intimate Story," which is among the Benton Papers, AAA. Portions of these writings have been published in Adams, *Thomas Hart Benton,* 19, 44–45. Benton commented on his marriage in *An Artist,* 74–75.

35. Benton quoted in *An Artist,* 79. Elizabeth Schultz, "*An Artist in America*: Thomas Hart Benton's 'Song of Himself,'" in *Thomas Hart Benton, Artist, Writer, Intellectual,* eds. R. Douglas Hurt and Mary K. Dains (Columbia, Missouri: State Historical Society of Missouri, 1989), 171.

36. Benton's comments about museum directors to Floyd Taylor of the New York *World Telegram* are excerpted in "Blast by Benton," *Art Digest* 15, no. 14 (April 15, 1941): 6. On the Chicago incident, see Adams, *Thomas Hart Benton,* 29–30.

37. Benton describes the various styles he studied in *An American,* 19–27,

and made clear his convictions in an unidentified letter, c. 1912, Benton Papers.

38. Benton, "American Regionalism," 187.

39. Benton, "American Regionalism," 181–82, and *An American*, 76.

40. Benton, *An American*, 76, and "American Regionalism," 184. See also John Adkins Richardson's discussion of Cézanne in *Modern Art and Scientific Thought* (Urbana: University of Illinois Press, 1971), 33–56. In a 1914 essay, "The Debt to Cézanne," Clive Bell declared that the French artist "founded" the movement of modern art. The essay is reprinted in *Modern Art and Modernism: A Critical Anthology*, ed. Francis Franscina (New York: Harper & Row, 1982), 75–78.

Elizabeth Broun discusses Benton's experimentation with modernism in "Benton and European Modernism," *Benton's Bentons* (Lawrence: Spencer Museum of Art, University of Kansas, 1980), 11–21. Most of Benton's early modernist works were apparently destroyed in a 1917 fire at the family home in Neosho, although a large group of small paintings and sketches were discovered in 1981. See the catalog, *Thomas Hart Benton: Synchromist Paintings 1915–1920, from a Private Collection* (New York: Salander-O'Reilly Galleries, 1982). Critic Paul Rosenfeld linked Benton and Cézanne in "American Painting," *The Dial* 71 (December 1921): 660–61.

41. Morgan Russell quoted in Gail Levin, *Synchromism and American Color Abstraction, 1910–1925* (New York: Braziller, 1978), 17, and *The Forum Exhibition of Modern American Painters* (New York: Anderson Galleries, 1916; reprint ed., New York: Arno Press, 1968), unpaginated. Benton quoted from *An American*, 33, 36–38.

42. Benton, *The Forum Exhibition*, n.p. Weischel, "Another New Art Venture: The Forum Exhibition," *International Studio* 58, no. 232 (June 1916): 116–17.

43. Benton recalled his early movie studio work in *An American*, 37–38. On Ingram, see Liam O'Leary, *Rex Ingram: Master of the Silent Cinema* (New York: Harper & Row, 1980). See also Karal Ann Marling, "Thomas Hart Benton's *Boomtown*: Regionalism Redefined," *Prospects* 6 (1981): 106–13. On movies and mass communication, see, for example, Lary May, *Screening Out the Past: The Birth of Mass Culture and the Motion Picture Industry* (New York: Oxford University Press, 1980).

44. Rex Ingram, "The Motion Picture as Art," *Art Review*, February 1922, p. 12. His use of sketches is noted in O'Leary, *Rex Ingram*, 187. Benton commented on his art techniques in a reply to a telegram dated August 15, 1940, from Betty Chamberlain of Time-Life, Inc., published as Appendix 2, "Benton the Model Maker," in Bob Priddy, *Only the Rivers Are Peaceful: Thomas Hart Benton's Missouri Mural* (Independence, Mo.: Independence Press, 1989), 272–75, and in *An American*, 34–35. He also gave credit to Renaissance and mannerist art, from Michelangelo to Tintoretto, in the formal development of regionalism on pp. 41, 46.

45. Benton, quoted from an interview with Paul Cummings, *Artists in Their Own Words* (New York: St. Martin's Press, 1979), 39. Baigell notes that Benton projected an American history series of some 60 panels, with another four panels describing the history of New York City; see *Thomas Hart Benton,* 55–56. Emily Braun, in "Thomas Hart Benton & Progressive Liberalism: An Interpretation of the New School Murals," *Thomas Hart Benton: The America Today Murals* (New York: Equitable Life Assurance Society, 1985), says Benton planned as many as 75 canvases; see p. 31. Benton himself noted in the Gallagher interview that he worked on the mural series from 1920 to 1926 and planned to make 50 pictures but only completed ten; see "An Artist," 44. The panels illustrated here give a representative sample of the mural; *1927—New York Today* (fig. 1.15) was also part of a proposed mural for the New York Public Library.

46. On the visual aesthetics of early movies, see May, *Screening Out the Past,* 72, 123.

47. Benton, letter to *The Arts* magazine, c. 1924, in the Forbes Watson Papers, Microfilm Roll D–54, AAA, and "Form and Subject," *The Arts* 5, no. 6 (June 1924): 306.

48. Benton, *An Artist,* 44–45. Robert Henri, "Letter, 1916," *The Art Spirit,* notes compiled by Margery Ryerson (Philadelphia: J. B. Lippincott Co., 1923), 129. Karal Ann Marling notes the connections between Henri and Benton in *Tom Benton's Drawings* (Columbia: University of Missouri Press, 1985), 17.

49. See, for example, David Montgomery, *Workers' Control in America* (Cambridge: Cambridge University Press, 1979), 32–33, Lewis Erenberg, *Steppin' Out: New York Nightlife and the Transformation of American Culture, 1890–1930* (Westport, Conn.: Greenwood Press, 1981), and May, *Screening Out the Past,* passim. On the Ash Can school, see Milton Brown, *American Painting from the Armory Show to the Depression* (Princeton: Princeton University Press, 1955), 9–38.

50. Benton was in Neosho during the Armory Show, called home because of an illness of his mother's. See *An American,* 30. Both Shinn and Sloan were invited to participate in the show but only Sloan accepted. See Edith Deshazo, *Everett Shinn, 1876–1953* (New York: Clarkson N. Potter, 1974), 204, and *John Sloan's New York Scene,* ed. Bruce St. John (New York: Harper & Row, 1965), 644.

51. Benton, *An American,* 25–26.

52. Benton discussed Weischel in *An Artist,* 41–42, and in *An American,* 35–36. See also Jonathan Green's short biography on Weischel in *Camera Work: A Critical Anthology* (New York: Aperture, 1973), 342–43. Weischel helped organize the 1916 Forum Exhibit and wrote several articles for Stieglitz's *Camera Work.* He died in 1946.

53. Robert A. Woods and Albert J. Kennedy discuss the People's Art Guild in *The Settlement Horizon: A National Estimate* (New York: Russell Sage Foun-

dation, 1922), 152; Henri is quoted on p. 114. Benton commented about his work through the guild in the unpublished portions of Paul Cummings's interview with Benton, July 1973, Archives of American Art Transcript, p. 24. For more on Weischel and the guild, see Rebecca Zurier, *Art for "The Masses": A Radical Magazine and Its Graphics, 1911–1917* (Philadelphia: Temple University Press, 1988), 106–7. Weischel probably also helped Benton get a teaching job at the Young Women's Hebrew Association, where he worked sporadically from 1915 to 1920. See Benton's entry in *The National Cyclopaedia of American Biography*, Vol. G, 1943–1946 (New York: James T. Whale & Co., 1946), 502.

54. See Daniel M. Fox, *Engines of Culture, Philanthropy and Art Museums* (Madison: State Historical Society of Wisconsin, 1963), 14–18. Cooley quoted in Quandt, *From the Small Town*, p. 81. Benton quoted in "A Chronology of My Life," *Thomas Hart Benton* (Lawrence: University of Kansas Museum of Art, 1958), unpaginated entry for years 1913–16. On the Paterson Strike Pageant, see Zurier, *Art for "The Masses,"* 107; Linda Nochlin, "The Paterson Strike Pageant of 1913," *Art in America* 62 (May-June 1974): 64–78; and Martin Green, *New York 1913: The Armory Show and the Paterson Strike Pageant* (New York: Charles Scribner's Sons, 1988).

55. See Sidney Lens, *Radicalism in America* (New York: Thomas Crowell Co., 1969), 258. Benton describes his labor experience in *An American*, 44, and "American Regionalism," 165.

56. Pells, *Radical Visions,* 12–13.

57. Benton, "American Regionalism," 165–66, 168, 169. He commented on Communist party meetings in his home in "The Thirties," a handwritten manuscript among the Benton Papers, AAA, p. 14. This has been published as Appendix 1, "The Thirties," in Priddy, *Only the Rivers Are Peaceful,* 219–62. On Minor, see Paul von Blum, *The Critical Vision: A History of Social and Political Art in the U.S.* (Boston: South End Press, 1982), 32–33. See also David Shapiro, *Social Realism: Art as a Weapon* (New York: Ungar Publishing, 1973).

58. Benton, "American Regionalism," 166–67. On his drawings for Huberman's book, see chap. 2.

59. Benton, "American Regionalism," 169, and in Gallagher, "An Artist in America," 86. He discussed his leftist acquaintances and sketching trips in *An American*, 51–52. Benton's sketches are scattered throughout Huberman's *We, the People* (New York: Harper & Row, 1932).

60. Benton described the mural in "American Regionalism," 149, 167, and *An Artist,* 62, 247. See also Braun, "Thomas Hart Benton," 12. He never did find a patron for the mural and abandoned the project when he received the New School contract in 1930. Baigell suggests the possible influence of Spencer on Benton's mural in *Thomas Hart Benton,* 55. Benton noted his conversations with Beard in a letter to Baigell dated November 22, 1967, cited in Braun, p. 31, n. 12. See note 5 above for reference to Benton's 1928 article.

61. On Beard, see David W. Noble, *Historians against History: The Frontier*

Thesis and the National Covenant in American Historical Writing Since 1830 (Minneapolis: University of Minnesota Press, 1965), 56–75, 118–38, and *The End of American History: Democracy, Capitalism, and the Metaphor of Two Worlds in Anglo-American Historical Writing, 1880–1980* (Minneapolis: University of Minnesota Press, 1985), 41–64.

62. Braun, "Thomas Hart Benton," 12, notes that Benton was familiar with Beard's *Economic Interpretation of the Constitution of the United States* (1913) and *The Rise of American Civilization*. Benton quoted in "American Regionalism," 149.

63. Benton, "American Regionalism," 149, 167.

On the visual culture of the modern age, see Neil Harris, Introduction, in *The Land of Contrasts, 1880–1901* (New York: George Braziller, 1970), 6–9.

64. On De Stijl artists, see Nancy Troy and Kenneth Frampton, *De Stijl, 1917–1931: Visions of Utopia* (New York: Abbeville Press, 1982); on Russian revolutionary art, see John Bowlt, *Russian Art of the Avant-Garde* (New York: Viking Press, 1976). Quote from Norbert Lynton, *The Story of Modern Art* (Ithaca: Cornell University Press, 1980), 112. Singal, "Towards a Definition," 18.

65. Stella quoted in Matthew Baigell, "American Art and National Identity: The 1920s," *Arts Magazine* 61, no. 6 (February 1987): 50. Benton, *An Artist*, 75–76.

66. Lewis Mumford, "An American Epic in Paint," *New Republic* 50, no. 644 (April 6, 1927): 197. Pells, *Radical Visions*, 46.

Liberal Reform and the

American Scene:

Benton's 1930s Murals

I t is no surprise that during the 1930s Benton produced his strong-
est regionalist statements—the obvious crisis of the Depression
begged for visions of reform. Having spent the twenties synthesizing
modern art, movies, and republicanism into the regionalist pictures of
The American Historical Epic, Benton spent the thirties refining his aes-
thetic vision in terms of the urgencies of the Depression. Much of his art
in the thirties attacked the dehumanized organization of American life.
More specifically, Benton presented a revival of a worker-determined
economy in the wake of what he perceived—and the Depression made
clear—was the failure of corporate leadership. Despite claims to the
contrary, Benton did not pine for a return to a premodern, preindustrial-
ized America. Rather, like his political forebears, Benton hailed the so-
cial progress promised by the machine age, as long as it was tempered
by the American democratic tradition. Like Charles Beard, whose his-
torical theories helped shape his art during the twenties, Benton blamed
the "corrupting self-interest" of laissez-faire capitalism for the 1929
economic collapse. The solution Beard proposed in *The American Le-
viathan* (1930) was to "unite politics, government, and technology"
under the auspices of "the federal system of the United States." Capital-
ism, Beard argued, had always been "the enemy of production"; its self-
destruction in the late twenties thus paved the way for a "New World"
of industrial democracy constructed by producers and government.[1] As

painted by Benton and promoted by Franklin Delano Roosevelt's administration, this new world hinged on linking federal planning and economic growth with the virtuous democratic values of the American republic: cooperation, citizenship, hard work, and productivity.

In the 1920s Benton embraced both avant-garde art and popular culture to create on canvas a world markedly different from the repressive and fragmented one of the Gilded Age. In the 1930s he continued to rely on an integrative modern style to construct this new world. His overwhelming ambition, stemming from the progressive politics he inherited from his father and his great-uncle, was to link his regionalist version of modern art with the reform-oriented politics of his time, the New Deal. As he later noted:

> Regionalism was . . . very largely affirmative of the social exploration of American society and resultant democratic impulses on which President Roosevelt's New Deal was based. Roosevelt's early social moves were overwhelmingly Americanist and were concentrated on the solution of specifically American problems. This Americanism found its aesthetic expression in Regionalism.[2]

An artist with a profound political and social conscience, Benton sincerely believed in both the efficacy of New Deal politics and regionalist art to facilitate the sweeping social changes he felt were necessary in Depression America. Often, his politics (like those of the New Deal) were fraught with ambiguities; Karal Ann Marling notes that Benton was "neither a systematic thinker nor a dogmatist."[3] Still, in his four major murals of the thirties—*America Today* (1930–31), *The Arts of Life in America* (1932), *A Social History of the State of Indiana* (1933), and *A Social History of the State of Missouri* (1936)—Benton transferred his personal politics into public art and thus, he hoped, into the realm of national reform.

While teaching at the Art Students League in New York, Benton received his first public commission. In 1930, Alvin Johnson, the director of the New School for Social Research, agreed to "finance the eggs" for a ten-panel tempera mural. Formerly located in Chelsea, the New School was moving to a modern building at the northern edge of Greenwich Village, and Johnson was intent on filling it with the finest examples of contemporary art. The Mexican social realist José Clemente Orozco agreed to paint a series of frescoes in the school's dining room, and Benton was given the walls of the third-floor boardroom. Finally, after more than a decade of searching for patronage Benton had a public

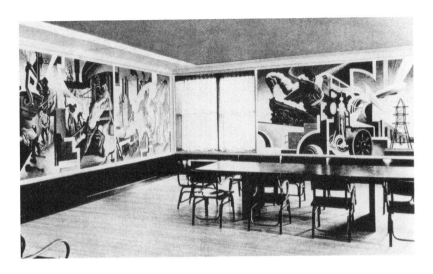

2.1. Joseph Urban and Thomas Hart Benton, original third-floor boardroom for the New School for Social Research, showing Benton's mural *America Today,* 1931. The mural filled the room, which measured approximately 30′ long × 25′ wide; the mural panels had a height of 7′8″. Reprinted from *Thomas Hart Benton: The America Today Murals* (New York: Equitable Life Assurance Society, 1985).

space in which to articulate his synthesis of republican ideology and twentieth-century American life. He filled the New School boardroom (about 30 feet long and 25 feet wide) with the *America Today* mural (fig. 2.1).[4] Oriented to producers and popular culture, this mural was Benton's earliest depiction of liberal reform in the 1930s. It was followed by similar murals for the Whitney Museum, the 1933 Chicago World's Fair, and the Missouri State Capitol, all of which presented the revitalization of American democratic values in the Depression.

Benton arranged *America Today* for maximum pictorial impact to convince his boardroom audience that in modern America the producer tradition was not just healthy, it was dominant. Facing the south wall as one stood in the boardroom doorway, the viewer was confronted with a huge scene of modern technology, *Instruments of Power* (fig. 2.2). In this central and largest panel Benton presented the primary tools of American industry—the dynamo, electric generator, water-powered dam, turbine, piston, train, airplane, and blimp. Of the ten panels, only this one contained no human figures. But this should not dissuade us from Benton's primary motives because the left and right walls focused

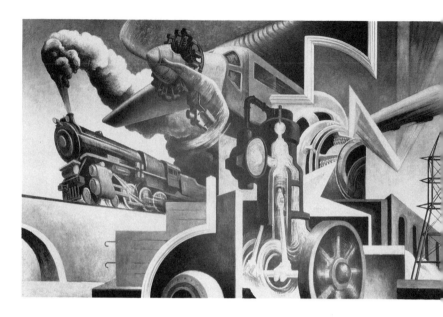

2.2. Thomas Hart Benton, *Instruments of Power,* from *America Today,* 1930; distemper, egg tempera, and oil glaze on linen, 92″ × 160″. Copyright The Equitable Life Assurance Society of the United States.

specifically on men at work. Here, on the east (left) wall Benton painted three panels—*City Building, Steel,* and *Coal* (figs. 2.3, 2.4, 2.5)—and filled them with scenes of producers in their workplace context. Similarly, the west wall, with *Deep South, Midwest,* and *Changing West* (figs. 2.6, 2.7, 2.8), showed American farmers, loggers, cowboys, and oilmen. One of his Art League students, Jackson Pollock, served as a sort of generic model for these figures, although the scenes were derived from hundreds of sketches Benton made during road trips across the country in the twenties. *Steel,* for instance, stemmed from drawings at Bethlehem Steel's Sparrows Point (Maryland) plant.[5] But, contrary to the real-life milieu of mass-production industry or that of the large-scale corporate farm, both of which increasingly characterized work in modern America, Benton painted the organic producerism of the past with its emphasis on skilled labor and worker autonomy. That is not to say he painted the past, but that he transferred an older republican ideal of the American worker to a contemporary setting. In the panels of *America Today,* Benton envisioned the restoration of republicanism in an

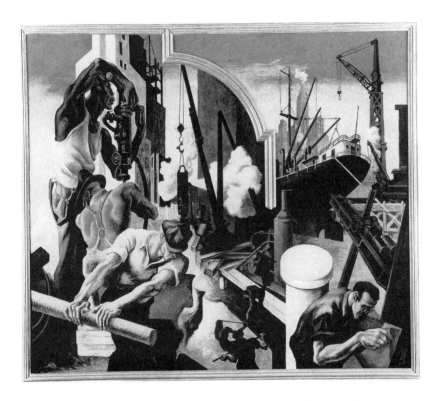

2.3. Thomas Hart Benton, *City Building*, from *America Today*, 1930; distemper, egg tempera, and oil glaze on linen, 92″ × 117″. Copyright The Equitable Life Assurance Society of the United States.

idealistic worker environment where all sorts of men, of all races, energetically labored together with the tools of their trades. Emphasizing worker control of these "instruments of power," Benton implied the larger possibility: the merger of producerism and industrialism in twentieth-century America.

The north wall of this democratic workplace featured producers at play in the movie theaters, soda shops, and public parks of modern America. Benton did not ignore the needs workers had for recreation: *City Activities with Dance Hall* (fig. 2.9) and *City Activities with Subway* (fig. 2.10) teem with their popular culture playgrounds. If the overall theme of the mural stressed producer control of the workplace, its

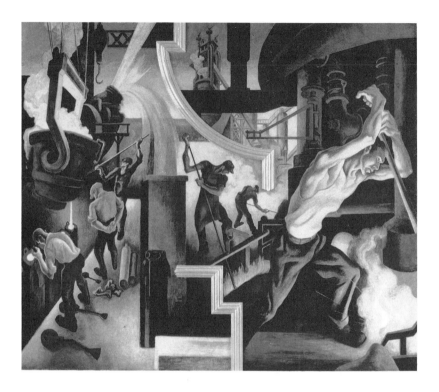

2.4. Thomas Hart Benton, *Steel,* from *America Today,* 1930; distemper, egg tempera, and oil glaze on linen, 92″ × 117″. Copyright The Equitable Life Assurance Society of the United States.

subtheme embraced the essential democracy of modern American leisure. Blacks and whites toil together in factories and farms, and people of all backgrounds play together in Benton's America. Burlesque queen Peggy Reynolds grabs a subway strap-handle in one picture, while sitting beneath her is Max Eastman, radical intellectual and former editor of the old *Masses.* On the far right of *Dance Hall,* between a vignette of Benton and New School director Johnson sharing a drink, a small sign reading "S. S. VanD . . . Myste" refers to former art critic turned mystery writer Willard Huntington Wright, also known as S. S. Van Dine. Wright's shift from avant-garde analysis to Philo Vance whodunits like *The Canary Murder Case* (a scene from the 1929 Paramount movie version may well be in the middle of *Dance Hall*) paralleled Benton's own

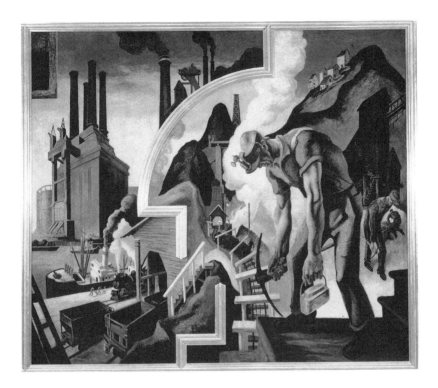

2.5. Thomas Hart Benton, *Coal*, from *America Today*, 1930; distemper, egg tempera, and oil glaze on linen, 92″ × 117″. Copyright The Equitable Life Assurance Society of the United States.

shift from an elite art to public murals in the twenties. The development of these forms of popular culture, Lewis Erenberg explains in his study of early twentieth-century New York City nightlife, mitigated Victorian era distinctions between high and low culture. Cabarets, like movies, mystery novels, and regionalist murals, "relaxed boundaries between the sexes, between audiences and performers, between ethnic groups and Protestants, between black culture and whites." [6]

Picturing the promise of modernist integration, Benton also showed, in the narrow panel *Outreaching Hands* above the boardroom door (fig. 2.11), the hardships facing twentieth-century producers. Contrasting the desperate hands of breadline beggars with those of greedy businessmen, Benton's political message is clear. As blacks and whites

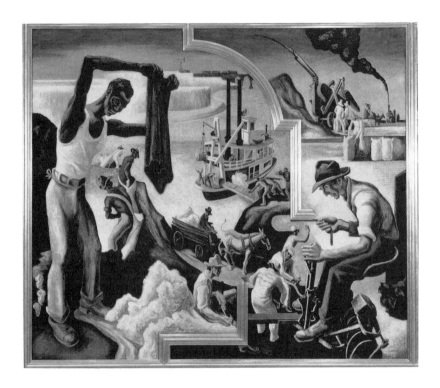

2.6. Thomas Hart Benton, *Deep South*, from *America Today*, 1930; distemper, egg tempera, and oil glaze on linen, 92″ × 117″. Copyright The Equitable Life Assurance Society of the United States.

grasp for bread and coffee, financiers in dark suits and top hats stand in front of what is either a bank or a prison clutching wads of greenbacks. A purpled dawn breaks in the distance. In this closing panel, the last of the ten he painted, Benton projected the final moments of unprincipled capitalism. In *Steel* and *Midwest* and other *America Today* panels, he promised the new age: the restoration of the producer tradition in modern times.

The New School was the perfect location for Benton's revitalization of producerism. Founded by a group of academic dissidents associated with Herbert Croly's *New Republic,* including Columbia University historians Beard and James Harvey Robinson, the school opened its doors to college-level students in the spring of 1919. Beard and Robinson resigned from Columbia in 1917 to protest the firing of several professors

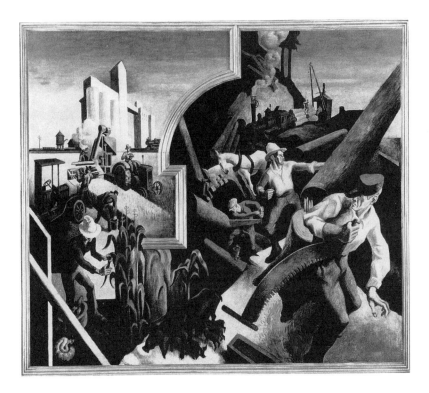

2.7. Thomas Hart Benton, *Midwest*, from *America Today*, 1930; distemper, egg tempera, and oil glaze on linen, 92″ × 117″. Copyright The Equitable Life Assurance Society of the United States.

opposed to America's entry into World War I. The New School was to provide a refuge, then, for intellectuals with political viewpoints antithetical to various American institutions of power, such as the government and the modern university. Its liberal philosophy, like that of the *New Republic* (founded only a few years earlier, in 1915), stressed the need for social reconstruction along more egalitarian and scientific lines.

At the New School that meant rejecting the "structural flaws" inherent in traditional American educational institutions such as the emphasis on vocational training rather than intellectual growth, the disturbing bureaucratic similarities between universities and corporations, the moral indifference of administrators, the careerism of faculty. The

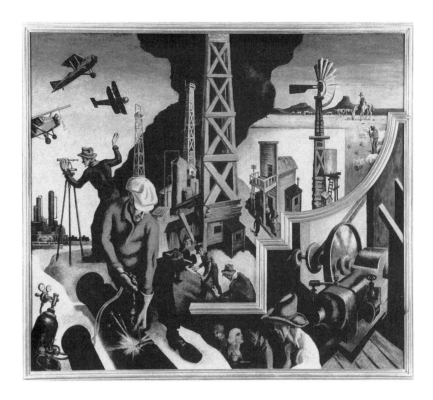

2.8. Thomas Hart Benton, *Changing West,* from *America Today,* 1930; distemper, egg tempera, and oil glaze on linen, 92″ × 117″. Copyright The Equitable Life Assurance Society of the United States.

New School, as the name itself implied, was to be an alternative: a "social science laboratory" which could "lead in emancipating learning from the narrow trammels of lay boards of trustees." Following the theoretical guidance of John Dewey and Thorstein Veblen, the school's community of scholars would redirect "the inherently progressive character of scientific knowledge" to the solution of social problems in America. Classes (60 percent were in the social sciences) were informal, without prerequisites, grades, or degrees. A diverse student body enrolled; having no quota system the school drew a high percentage of women and Jews. Realization of the New School dream, however, was limited by the postwar fallout of the 1920s, when many became disillusioned about the efficacy of progressive era institutions to create true

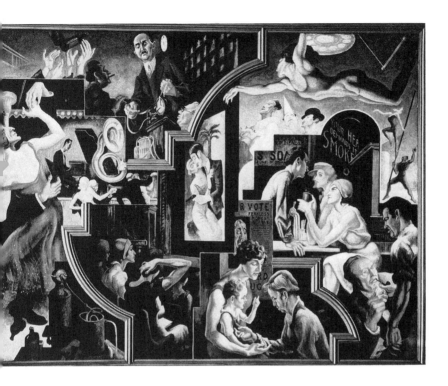

2.9. Thomas Hart Benton, *City Activities with Dance Hall*, from *America Today*, 1930; distemper, egg tempera, and oil glaze on linen, 92″ × 134 ½″. Copyright The Equitable Life Assurance Society of the United States.

social reconstruction. Their alienation was similar to John Weischel's postwar loss of faith in the People's Art Guild.[7]

Rather than being abandoned, however, the New School was reorganized in the mid-1920s along cultural lines by Alvin Johnson, then associate editor at the *New Republic*. Catalog offerings show the dramatic increase in art, literature, and film courses and the shift away from social science classes. The school's original philosophy of social reconstruction was maintained, but Johnson and the lecturers he hired—including Lewis Mumford, Leo Stein, Aaron Copeland, Waldo Frank, Doris Humphrey, and Meyer Schapiro—now saw art, especially modern art, as the essential agent in that reconstruction. In the late twenties the school especially "came to represent 'modernism,' broadly

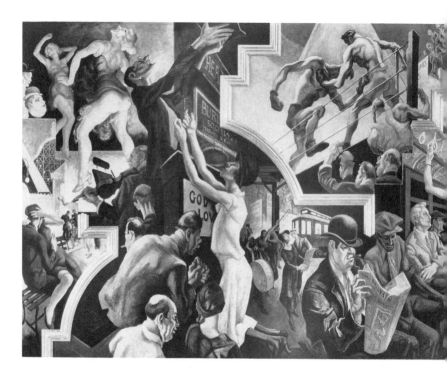

2.10. Thomas Hart Benton, *City Actitivities with Subway,* from *America Today,* 1930; distemper, egg tempera, and oil glaze on linen, 92″ × 134 ½″. Copyright The Equitable Life Assurance Society of the United States.

defined as artistic creativity, social research, and democratic reform."[8] Modernism, the symbol of social integration and reconstruction, became the natural aesthetic choice at the school. Ultramodern architect Joseph Urban was commissioned to design its new building in 1929 and Benton and Orozco were hired to paint modern art murals for its walls.

At the New School, modernism signified the "battle cry of the young against the old." As New School biographers Peter Rutkoff and William Scott explain:

> the New School artists considered themselves the cultural vanguard of a new, more rational, and egalitarian society. They were committed to a universal, or cosmopolitan, art which transcended particular cultures and classes. Moreover, they presumed that anyone could be creative and that modern art served the public func-

tion of interpreting and articulating the complexities of contemporary reality. They understood themselves as egalitarians and humanists as well as modernists.

Urban designed the new building on West Twelfth as an "architectural affirmation" of the school's philosophy of democratic liberalism (fig. 2.12). The auditorium had a lowered stage and open seating, which eliminated traditional barriers between performers and audience and thus, in the spirit of modernism, between art and life.[9] The building also included lots of windows, which linked the outer world of nature with the inner world of education. The open interior was left uncluttered, creating the kind of uninhibited space considered most conducive for broadly democratic learning. Walls everywhere, from the dining room and lounges to the boardroom and exhibition gallery, were used to display modern art. When the school opened its new doors in early 1931, visitors saw its new philosophy of cultural modernism blatantly expressed.

Both Orozco and Benton were asked, Johnson recalled, to paint a contemporary subject "of such importance that no history written a hundred years from now could fail to devote a chapter to it." Benton chose "the tremendous burst of human energy and mechanical power that characterizes the present phase of economic life in America"; Orozco the "revolutionary unrest that smolders in the non-industrial periphery, India, Mexico, Russia." Johnson added that both murals were "essentially complementary" and that each artist realized "his picture was only one aspect of the common theme, the forward plunging spirit, industrial and social, abroad in the modern world."[10] Indeed, although each did so in a strikingly different way, both muralists addressed the life of the modern producer. Orozco's five frescoes, including *The Struggle in the Occident* (fig. 2.13) and *The Struggle in the Orient*, are somber views of worker oppression relievable only through class revolution. In a harsh style intensified by a vivid red palette, Orozco contrasted the good life of revolutionary activism in Russia and Mexico with grim scenes of imperialist brutality in India. His modernist exposé of class struggle, the "forward plunging spirit" of his time, was that of struggle to come.

Benton, by contrast, painted the aftermath of struggle, whereby the producer tradition was revitalized in modern America. He was not oblivious to the reasons for its resuscitation: references to the speculators and financiers whose greed necessitated producerism's rebirth were included throughout *America Today*, most notably in *Outreaching Hands*

2.11. Thomas Hart Benton, *Outreaching Hands,* from *America Today,* 1931; distemper, egg tempera, and oil glaze on linen, 17 ⅛″ × 97″. Copyright The Equitable Life Assur-

but also in *City Activities with Dance Hall,* where an imperturbable ticker-tape operator casually glances at the day's final tallies in front of an anxious, cigar-chomping investor. Nor did Benton ignore the impact that modern producerism would have on certain groups. Recognizing that twentieth-century industrialization necessarily triumphed over its premodern counterpart, Benton relegated the producers of the past, cowboys and sheepherders, to the deepest background of *Changing West.* Likewise, he recognized that for many the struggle for autonomy was by no means over: in *Deep South,* in a small central scene depicting the black victims of chain-gang labor, he articulated the problems facing producerism in a region of the country where racism clouded the issue. Still, almost all of the *America Today* panels are dominated by sturdy, muscular men of varying racial and ethnic backgrounds, themselves dominating their particular industrial workplaces. As Johnson observed:

> Benton does not look upon modern industry as a horrible martyrdom of the worker amid the clangor and heat of colossal machines. He has seen men at work. He has observed the sense of triumph on the face of the man who handles a great machine, taps a blast furnace, sees a building rising out of the blueprint in his hands. For the strong and fit, the life of big industry is one of victory.[11]

ance Society of the United States.

That is, Benton did not recognize, as Orozco certainly did, the barbarous circumstances of laborers in the mass-production workplace of the modern factory, with its scientific and centralized system of management, its stress on efficiency through production speed-ups and increased automation, and its enormous scale. By 1923, "half of all industrial wage earners worked in factories employing more than 250 people and over 800 factories employed more than 1,000." [12] Benton painted this large-scale industrial factory, with its up-to-the-minute technology and its huge numbers of employees, but he rendered it in terms of a "human-scale" worker environment of the past, with its craft identity and autonomous producerism. His ideological countenance of the genuine "hopelessness and degradation" that workers faced in the modern factory was not to abolish or ignore the industrial workplace, but to reintroduce the ideal of worker strength and status that he thought typified labor in the nineteenth century. If Orozco advocated worker revolution, Benton hoped to see the resolution of labor conflict and the restoration of labor autonomy through the revitalization of accommodating producerism in modern industry.

Like Urban's building, Benton's mural affirmed the New School's advocacy of social reconstruction through modern culture. More specifically, it announced human liberation through producerism. With their large scale and dynamic form, Benton's panels demanded that viewers pay attention to regionalism's optimistic message of social reform. Re-

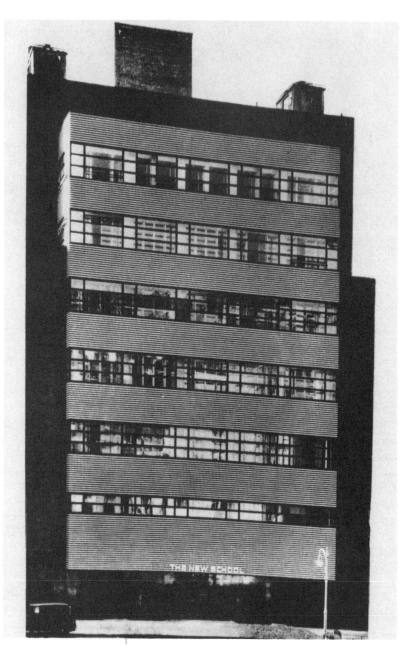

2.12. Joseph Urban, New School for Social Research, 66 West 12th Street, New York, 1930. Reprinted from *Thomas Hart Benton: The America Today Murals* (New York: Equitable Life Assurance Society, 1985).

lying on the skills he learned during his time in the movie business, Benton painted what his Depression-era audience would find typical: *City Activities with Subway* reveals burlesque dancers and boxers, evangelists and park-bench lovers; *City Building* shows construction workers and shipbuilders. To make a cohesive visual statement about life in America circa 1930, Benton arranged these vignettes into one big mural and united them through decorative strips of wooden moldings. Such moldings were, he noted, common to the "illustrated pages of nineteenth century magazines and books" and could easily be seen in the rotogravure section of modern tabloids.[13]

Benton expanded on the popular culture orientation of his mural by organizing particular scenes and shots in a cinematic manner. In *City Building* he edited certain motifs (tall skyscrapers, muscular workers) and sequences (men hoisting drills or hauling steel poles) and coordinated them in a seemingly haphazard way, with figures from one scene touching those in another. His style is diametrically opposed to the long-standing pictorial conventions of scientific perspective, symmetrical order, realistic anatomy, modelling according to the incidence of light, and a fixed point of view. Instead, this regionalist mural, like the earlier *American Historical Epic,* is formally predicated on the modern spatial concepts Benton learned from his study of modern art and the movies. The action and energy of *America Today* parallels that of 1930s films: the fast pace of his spontaneous scenes is similar to their dynamic energy and their "split screens, zip pans, moving cameras—all combine[d] to force the narrative pace relentlessly."[14]

Benton arranged his New School anecdotes about the American scene in this cinematic, semitabloid, modernist manner to attract his 1930s audience. He recognized their attentiveness to other media, in particular movies and magazines, and relied on a similar look. But if Benton appropriated a popular culture style to lure his public viewers, he used it in quite a different way: to convey a modernist message of social reform. Often assessed as simply the painterly version of Benton's innumerable sketches from real life, *America Today* is actually Benton's vision of machine-age producerism. In *City Building* and *Steel* he emphasized the vital role of autonomous, skilled workers in the development of modern industry: heroic laborers, their straining muscles conveying their capable strengths, are seen purposefully rebuilding America. Unlike other murals of similar subjects, such as Everett Shinn's 1911 depiction of Roebling Steel Mill workers (fig. 1.12), or Diego Rivera's 1932 *Detroit Industry* fresco (fig. 2.14), Benton showed men tow-

2.13. José Clemente Orozco, *The Struggle in the Occident* (west wall), 1930; fresco,

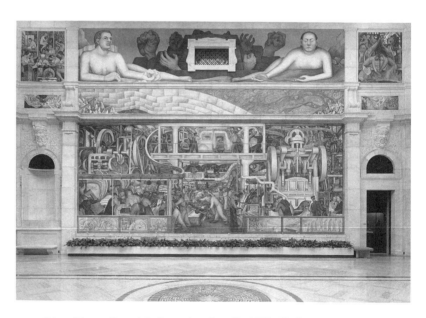

2.14. Diego Rivera, *Detroit Industry* (south wall), 1932–33; fresco, 13.11 × 20.42 m. Copyright The Detroit Institute of Arts 1990, Founders Society Purchase, Edsel B. Ford Fund and Gift of Edsel B. Ford.

6′ × 40′. Courtesy of the New School for Social Research, New York.

ering over their machines.[15] In his visionary workplace, producerism has been revitalized in the modern-day, mass-production workplace. That is not to imply that *America Today* was only geared toward factory workers. Benton's producer ideology accommodated the productive capacity of all Americans: shopkeepers, secretaries, farmers, professors, students. The intrinsic autonomous value of their productivity is what he idealized in *America Today*.

To assume that this mural is a species of either social realism or American scene documentation is to ignore both Benton's intentions and the facts of the Depression. Benton chose neither the leftist anger of social realism, personified by Rivera's mural, nor the noncommittal approach of thirties artist Millard Sheets (fig. 2.15). Rather, he opted for an optimistic *modus operandi* which posited change via liberal accommodation and the regeneration of the producer tradition. Obviously, as the left would soon argue, Benton's limited view of modern industrial conditions was far from realistic. One contemporary critic observed that "far from being an impersonal realist" Benton was, in fact, "more interested in expressing his conception of American life and labor than in recording objective reality."[16]

2.15. Millard Sheets, *Tenement Flats (Family Flats)*, 1934; oil on canvas, 40 ¼″ × 50 ¼″. Courtesy of the National Museum of American Art, Smithsonian Institution, transfer from the U.S. Department of the Interior, National Park Service.

Indeed, to his 1930s Depression audience the simple fact that men were *working* in *Steel* and *City Building* was hardly "objective reality" since by the early 1930s the jobless rate in America was high and rising. By 1932, steel plants would operate at only 12 percent of capacity, industrial construction would drop from $949 to $74 million, and the unemployed would number some 13 million (out of a population of 120 million). And, it would only get worse: "U.S. Steel's payroll of full-time workers fell from 225,000 in 1929 to zero on April 1, 1933." But *Steel* showed men at work in the foundries, pouring molten metal and feeding the furnaces of industry. Moreover, *City Building* depicted black and white workers together, an unlikely scenario in the segregated construction industry of the thirties. Admittedly, *America Today* was painted before the Depression made its heaviest impact on either Benton or his audience, even though by 1930 one out of four factory workers in towns

like Muncie, Indiana, had lost their jobs and the streets of urban America were filled with unemployed men selling apples for a nickel. Still, whether viewed in January 1931, when the Depression had not "sunk very deeply into the general public consciousness," or in the mid-thirties when it had become a fact of life, Benton's mural was an idealistic depiction of the possibilities of modern-day American producerism.[17] Certainly, the scenes looked plausible: having culled them from his real-life sketches and from the stereotypical material of popular culture, Benton wanted them to look plausible. But, for his intended thirties viewers, Benton's *America Today* mural also assumed mythical dimensions when measured against the reality of the Depression.

Realizing the country was in a state of upheaval, Benton responded as his father and great-uncle might have, with a vision of social reconstruction. However, befitting his personal preferences and the faith his generation held in the efficacy of modern culture to create a new world, Benton's reform vehicle was art, not electoral politics. With a visually dynamic style derived from popular culture and modern art, Benton was assured of the public appeal of his reformist aesthetic. Its social function hinged on the possibility of change, not the objective scrutiny (or complete avoidance) of Depression conditions. *America Today* was meant to inspire its New School audience, who would surely recognize its mythical character, to create a new world by restoring the producer tradition. With such art Benton hoped he could encourage the birth of a new America where speculative capitalist elements had been expunged, where corporate hegemony was halted, and where the popular arts maintained a credibility previously reserved only for high-brow culture. And, in the following years, when his positive views of the American producer seemingly coincided with the ideology of the New Deal, Benton believed his hopes would come to fruition.

The mural was greeted with kudos when it was unveiled in January 1931. One critic observed "no one will dare to be dull" in the New School boardroom: "Everything about the murals is alive. Vitality is the dominating note: rich country, busy men turning it to their purpose; cities bustling even in their leisure-time pursuits." Likewise, Lloyd Goodrich, an editor at *The Arts,* the unofficial organ of the Whitney Studio Club and the Whitney Museum of American Art, championed *America Today*'s "furious vitality" and "sense of the restless, teeming, tumultuous life of this country." Goodrich had posed for one of Orozco's New School panels, but seemed to prefer Benton's upbeat depiction of producerism:

In this busy scene pessimism has no part. Man dominates the machine; there is no suggestion of the inhuman mechanized world pictured by so many artists. But also man and the machine are inseparable; the individual is of interest less as a person than as a workman. A common life animates man and his machinery, which is endowed by the artist with a life and character of its own.

Positive response from critics who understood and agreed with Benton's conceptualization of social and labor reform helped him garner other mural commissions throughout the Depression. Goodrich's celebration of Benton's New School depiction of "productive labor," for instance, helped convince Juliana Force that Benton should paint something similar for the Whitney Museum's newly renovated townhouse headquarters on 8th Street. His eight-panel mural *The Arts of Life in America* (figs. 2.16, 2.17) was unveiled there in December 1932.[18]

When the Metropolitan Museum rejected Gertrude Vanderbilt Whitney's personal collection of some five hundred American paintings and sculpture ("we have a cellar full of those American things already," Met director Edward Robinson purportedly said), the railroad heiress cum sculptress decided to open her own place and appointed Juliana Force as director. Inaugurated in 1931, it was called the Whitney Museum of American Art, a title carefully chosen to distinguish it from another recently opened (in 1929) art temple, the Museum of Modern Art. The collections of each were distinct, too. The Whitney catered primarily to narrative art by living U.S. artists, Gertrude Vanderbilt Whitney's personal preference. She had patronized such art since the early part of the century, purchasing Ash Can school paintings in 1908, donating funds for the 1913 Armory Show, sponsoring arts groups (the Friends of Young Artists, the Whitney Studio Club) throughout the teens and twenties. Her museum essentially institutionalized the lifelong support she had given to American modernists whose work fell outside the arena of academic support. Almost until the 1940s, the National Academy of Design and other similar organizations controlled the domestic art market through exhibitions, juries, and prizes. The Whitney challenged this by offering a "sympathetic environment" for the independent American artist. Perhaps from her own efforts to obtain public sculpture commissions, Whitney recognized the need for public patronage. Her museum especially encouraged artists through its biennial exhibitions, first held in 1932. With its policy of "purchases not prizes" the Whitney spent $20,000 that year in show acquisitions; for many of the 157 invitees (ranging from regionalists John Steuart Curry and

2.16. Thomas Hart Benton, *Arts of the South*, from *The Arts of Life in America*, 1932; tempera with oil glaze on canvas, 8' × 13'. Originally painted for the Whitney Museum of American Art, the mural was purchased by the New Britain Museum of American Art in 1954. Courtesy of the New Britain Museum of American Art, Connecticut, Harriet Russell Stanley Fund. Photo E. Irving Blomstrann.

2.17. Thomas Hart Benton, *Political Business and Intellectual Ballyhoo*, from *The Arts of Life in America*, 1932; tempera with oil glaze on canvas, 4'8 ½" × 9'5". Courtesy of the New Britain Museum of American Art, Connecticut, Alix W. Stanley Foundation. Photo E. Irving Blomstrann.

Grant Wood to abstract painters Georgia O'Keeffe, Stuart Davis, and Max Weber) this was a much needed financial boon. Although artists as diverse as these showed their work at the biennials, a perusal of the museum's purchases during the Depression, including still life, landscape, and portrait paintings, reveals a preference for the contemporary narrative art of Edward Hopper, Reginald Marsh, Peter Blume, and Benton.[19]

The Museum of Modern Art, on the other hand, aimed to "show and advertise the advanced artists of Paris to America." If the central figures at the Whitney were the modernist followers of Robert Henri, uptown at 57th and 5th MOMA centered on Picasso and his disciples. Less interested in supporting living artists (American or European) MOMA took on the task of convincing the public that the modern style of the European avant-garde was the most tasteful of the day. As defined by museum director Alfred Barr, "modern" was "a relative, elastic term that serves continually to designate painting, sculpture, moving pictures, architecture and the lesser visual arts, original and progressive in character."[20] MOMA's definition of modern art, one of many competing for legitimacy throughout the twentieth century, was almost entirely formalist in nature: "modern" was a succession of new styles, rather than the merger of art and life. Modernism's original sensibility as an aesthetic which aimed to integrate disparate cultures and classes was abandoned, replaced by an institutional obsession with the objective qualities of pioneering styles. Moreover, MOMA declared, "modern" was almost exclusively the property of stylistically advanced Europeans. Although the museum's second show, Nineteen Living Americans, featured the work of native modernists, critics found nothing original or progressive in the art of John Sloan and Hopper. Indeed, following MOMA's opening exhibit of Cézanne, Seurat, Gauguin, and Van Gogh paintings, American modernism—always compared with that of Europe—looked like lame imitation.

Thus, by the early years of the Depression, the meaning of modernism was urged toward redefinition by powerful art world institutions. Originally a strategy of avant-garde resistance and a volatile vehicle for cultural reconstruction, modernism became appropriated by the status quo. Institutions such as MOMA, financed by Rockefeller dollars and positioned in elite, uptown locales, rendered modernism mere formal exercise and denied its role as cultural critic or transformer. Further, MOMA's adherence to aesthetic experimentation and originality allowed it to ignore American art for the most part (until after World War

II), especially the narrative art of the twenties and thirties. Such art was declared provincial, especially when it was lifted out of its original context and compared with the mighty modernism of Europe. Benton's New School mural just did not look modern when posed against Picasso's *Les Demoiselles d'Avignon*. Lines were drawn: those artists associated with MOMA were labeled "modernist"; those patronized by the Whitney were merely "contemporary." Prominent among the latter was Benton, whose Whitney mural was first shown to the public during the museum's 1932 biennial.

At first glance, *The Arts of Life in America* seems, quite unlike Benton's New School mural, to have little to do with twentieth-century republicanism. Filling the walls and ceiling of the museum's reading room, a small cubicle beneath the eaves of the brick townhouse, the mural concentrated not on America's industry but on its popular culture. Overall, it extended Benton's New School catalog of urban recreation (as seen in the *City Activities* panels) by detailing leisure time pursuits across the country, past and present. *Indian Arts* depicts native American culture before white settlement; *Arts of the West* reveals a milieu of bronco-busting and shoot-em-ups long gone by 1932. Contemporary popular culture was represented by the gospel singing, crap shooting, and evangelism of *Arts of the South* (fig. 2.16) and the jazz dancing, radio broadcasting, and bootlegging of *Arts of the City*. Explaining that the mural's title was "only a tag" for all the "American doings" he found interesting, Benton explored the political arts in two of the ceiling panels, *Political Business and Intellectual Ballyhoo* (fig. 2.17) and *Unemployment, Radical Protest, Speed*. His attention to American culture, both material and political, was not, however, a retreat from producerism. As historian Richard Pells observes, thirties reformers did not dwell exclusively on "questions of political strategy." [21] They also directed their attention to the cultural accommodation of reform. In the Whitney mural Benton focused on the restoration of republicanism through the rejuvenation of American folk traditions and values.

Working on the mural during the summer of 1932, while FDR was on the campaign trail promising a "new deal for the American people," Benton proposed his own vision of reform. Like others in the thirties, he viewed the Depression as a symptom of American spiritual and cultural malaise. Correspondingly, he believed, as did the Southern Agrarians and Lewis Mumford, that the crisis required a reassessment of American values. Social problems might be solved when Americans recog-

nized the shallow inadequacy of their beliefs and embraced a new value system. In the New School mural Benton suggested that the inequities of corporate capitalism could be rectified through the rebirth of the republican values of an earlier generation, such as producerism. In the Whitney panels Benton submitted that folk culture could unite the American people and thus strengthen their fight against corporate hegemony and the alienation of modern life. Contrasting his pictures with the "specialized arts which the museum harbors and which are the outcome of special conditioning and professional direction," Benton said the "arts of life" were the "popular arts":

> They run into pure, unreflective play. People indulge in personal display; they drink, sing, dance, pitch horseshoes, get religion, and even set up opinions as the spirit moves them.
>
> These popular outpourings have a sort of pulse, a go and come, a rhythm; and all are expressions—indirectly, assertions of value.

The popular arts were not only as valid as the "specialized arts" of high culture, but they could transform America. That is, when Americans embraced the culture of their indigenous regions, they would discover the spiritual and communal values missing under the competitive, individualist orientation of corporate capitalism. "There is a precedent for taking the Arts of Life seriously," Benton observed. Comparing his paintings with Renaissance religious art, he argued that "the serious person may discover in the local pursuits here represented the peculiar nature of the American brand of spirituality." [22]

Celebrating the communal and spiritual values of Dixieland, for example, the *Arts of the South* might be seen as a kind of visual substantiation for the essays in the 1930 manifesto, *I'll Take My Stand*. Denouncing the "false promise of industrialism," Donald Davidson and other poets and novelists in the Southern Agrarian group promoted the regional culture of the rural South, with its "balanced life" and "harmony between the artist and society." [23] Likewise, Benton balanced black gospel singers and white evangelists in his picture, emphasizing the unifying values of their activities. He and Davidson both focused on folk art's value as a socially regenerative force.

But, a distinction should be made. Benton was less interested in the preservation of southern agrarianism than in the communal and regenerative values seemingly offered by this, and many other, regional cultures. Moreover, as the Whitney and New School murals both attest,

Benton did not condemn machines or urbanism: he strove to revitalize the producerism that would unite them in a humanist, liberalist framework. Later, conceding that "regionalism," the term used to pinhole his work in the art world, was derived from the Southern Agrarians, Benton noted their significant differences:

> I was after a picture of America in its entirety. The regionalism of the southern agrarians was anti-industrial and anti-metropolitan. A large part of my own work has been concerned with industrial and metropolitan factors. I ranged north and south and from New York to Hollywood and back and forth in legend and history.[24]

Although he depicted the popular arts of several different regions in the Whitney mural, Benton was not a provincial antimodernist. Rather, his organization of the vernacular arts into one broadly painted program reveals a concern with the communal fellowship and common values that could unite the American people and thus create a popular alliance which could help transform America.

One critic found the mural to be "limited " because "the gunman, and the Indian and the Negro and the city gals all have the same expression."[25] Certainly, Benton was most interested in reaching a broad audience and thus made full use of stereotypical subject matter. His experiences with Rex Ingram and the early motion picture industry had taught him the success of stereotypes in the pursuit of mass communication. However, Benton's stylized renderings do not show a world of identical masses, but one of distinct, albeit limited, figures and personalities. Relying on a kind of type-cast subject matter easily recognized by most Americans and working in an accessible narrative style derived in part from the movies and in part from modern art, Benton, in his pictures of regional and local cultures, appealed on a broadly nationalist level.

Almost antithetical to the reactionary conservatism of *I'll Take My Stand*, Benton's cultural critique is more in line with Lewis Mumford's *Technics and Civilization* (1934), where American social reform was predicated on the fusion of pre–machine-age communal values with industrial era efficiency. Mumford, too, believed regionalism could solve the dilemma of the Depression, but his use of the term differed greatly from that of the Southern Agrarians. Regionalism, Mumford wrote, combined the modern, industrial age values of scientific planning and organization with an emphasis on local cultures, organic producerism, and the humanist orientation of liberalism. As he defined it, regionalism was Depression era progressivism:

In its recognition of the region as a basic configuration in human life; in its acceptance of natural diversities as well as natural associations and uniformities; in its recognition of the region as a permanent sphere of cultural influences and as a center of economic activities, as well as an implicit geographic fact—here lies the vital common element in the regionalist movement. So far from being archaic and reactionary, regionalism belongs to the future.[26]

Rather than seeking escape in a utopian American past, both Mumford and Benton urged, in writings and pictures that came to be identified as "regionalist," the essential importance of *linking* localized contemporary social, geographic, and economic cultures. Both prophesied that such a program of hopeful cooperation could generate the spiritual and physical values with which Americans could create a new society, a new "future." Their views were widespread. Movie director King Vidor, for example, showed in *Our Daily Bread* (1934) the success of a cooperative communal farm (six miles from "Arcadia," somewhere in the United States) and the positive rewards of creating a "community of interests and shared experiences."[27] Filmmakers, like artists and writers, shared a belief in the regenerative power of a collective American culture and hoped for a new modern America which would retain the values of its republican past.

Benton, Mumford, and Vidor, joining Ruth Benedict and Van Wyck Brooks, pinned their hopes for reform in the 1930s on American culture more than on politics. Indeed, like most in the early years of the Depression, Benton was fairly cynical about the efficacy of politics and politicians to create genuine social change. Broadway musicals from George S. Kaufman's *Of Thee I Sing* (which won the 1932 Pulitzer Prize for drama) to Moss Hart's *Face the Music* spoofed political campaigns and corruption; Hollywood followed with *The Dark Horse* and *The Phantom President* (both 1932). A new magazine called *Ballyhoo* generated a huge circulation by satirizing America's businessmen and politicians. And in his daily coverage of the summer 1932 political conventions, Will Rogers satirized the "combat" of politics:

That's the old Democratic spirit. A whole day wasted and nothing done.
 A whole day fighting over what? A President? No. A platform? No. Well, then, what did take up eleven hundred delegates' and twelve thousand spectators' time for? Why, to see whether Huey Long, the Louisiana porcupine, was to sit on the floor or in

the gallery. Well, the porcupine sticks right on the floor. And, the other four hours was fighting over who would be chairman of a convention that's already a week old.[28]

Benton took the same satirical approach in the Whitney ceiling panel *Unemployment, Radical Protest, Speed,* a jumbled compilation of planes, trains, automobiles, chorus girls, strikers, and militia. While he depicted strikers being shot and killed by uniformed guards, his point in doing so is unclear; there is a tone of ambivalence here that betrays the political cynicism of many intellectuals prior to Roosevelt's election in late 1932. Within a few years Benton's political sarcasm, which he defended as the objective reporting of a roving regionalist, would come under severe attack by art world critics.

Benton's early thirties cynicism was especially evident in the lunette he painted for the Whitney called *Political Business and Intellectual Ballyhoo.* At the top of the panel a grim bald eagle perches on a bullhorn, out of which spill the mottoes of various "representatives of the people." On the right, a straw mannequin decked out in dress shirt and top hat mouths "We nominate for" His broom-handle body is firmly stuck into advertising placards intoning: "O.K. / Don't Be a Trillium / They Call it Halitosis / 5 Out of 6 Have It."

On the other side, figures shielded in huge copies of the journals of the political left vie for attention. A scantily clad representative from *The New Republic* mutters up to the eagle, "Really merely quantitative," while the spectacled figure next to him, draped in a copy of *The Nation* adds, "You don't know the half of it, dearie." On the far left a figure standing up for *The New Masses* trumpets, "The hour is at hand," while pushing the figure from *The Nation* away. Nearby are the announcements "Greenwich Village Proletarian Costume Dance" and "Expressing American Class Solidarity." Directly under the eagle can be seen the cartoon figures of Mickey Mouse, the Katzenjammer Kids, and Mutt and Jeff, the latter holding up a placard which reads: "Literary Playboys League for Social Consciousness." And finally, the whole tableau rests on top of the musical notation for the opener of the folk song "The Eagles They Fly High":

> Oh, the eagles, they fly high over Mobile,
> Oh, the eagles, they fly high over Mobile,
> Oh, the eagles, they fly high
> And they shit right in your eye,
> Oh, I'm glad that cows don't fly over Mobile.[29]

Between the eagle—the symbol of democratic strength and certitude—and the musical bars and opening line of this ribald folk song, Benton made a mockery of contemporary American politics. The radical left was portrayed as a pack of back-stabbing braggarts more concerned with rhetoric than reform. The political right, dressed in the requisite outfit of Republican party success (like the speculators in the New School panel *Outreaching Hands*), was not depicted any more favorably: its spokesman a straw dummy linked to the money-making concerns of corporate America—like Listerine, heavily promoted by the Lambert Pharmaceutical Company as a cure-all for everything from halitosis to dandruff.[30]

Benton's implications were obvious: neither the dueling doctrinaires of the political left, nor the business world mouthpieces of the right were capable of addressing—let alone solving—the crisis of the Depression. Moreover, neither side was particularly interested in the American folk, somewhat sardonically represented by the comic-book figures under the eagle. Pinpointing his generation's lack of faith in politics, Benton used this lunette in the same way he had used *Outreaching Hands* in his New School mural: to justify the spirit of democratic participation he celebrated in the other panels of each mural. Skeptical about social reform through the politics of parties and platforms in the early 1930s, Benton directed his audience instead to the communal, cooperative milieu of their popular arts. Benton clearly trusted in the historical promise of collectivism; America's history, at least as he painted it at the New School and the Whitney, was that of assembly and fellowship.

His plea for national unity through regional culture was condemned, not surprisingly, as "caricatural illustration" in *The New Republic*. Paul Rosenfeld, a Stieglitz circle supporter who had earlier hailed Benton's "ultramodern" synchromist work, now attacked his "super life-sized" depiction of low-brow culture. Benton's focus on the popular arts generated "a power and importance which they actually have not got"; his version of "the arts of life in America" was "thoroughly crude, gross and ungracious." Rosenfeld, who thoroughly detested popular culture, hated the powerful challenge Benton's mural made to the once "peaceful" space of the Whitney's third-floor reading room. Interestingly, both he and Benton advocated the cultivation of an explicitly American modernism: Rosenfeld had observed in 1924, "We have been sponging on Europe for direction instead of developing our own."[31]

In the thirties, however, each assumed very different ideas about the form this "Great American Thing" should take. Rosenfeld believed it should consist of aesthetic experimentation and private expression, supporting the personalized spiritualism of abstract painters Georgia O'Keeffe and Arthur Dove. But Benton's idea of American culture, as the Whitney mural clearly showed, mixed popular and modern art with republican ideology. Again, Benton's view of modernism as a unifying vehicle for mass cultural transformation conflicted with that of others. Moreover, his spoof of radical politics did not go over, understandably, with left-wing writers and artists. Within a few years leftist sympathizer Stuart Davis would condemn Benton as a racist, saying that "Hitler would love" Benton's depiction of "a Jew in vicious caricature holding the New Masses," and that Huey Long would applaud his "caricatures of crap shooting and barefoot shuffling negroes." [32] When the left saw its political ideology belittled, it reduced the argument to charges of racism. The fact that in his Whitney lunette Benton belittled *all* politics and caricatured *all* people was conveniently dismissed, as was the fact that in other panels of this and other 1930s murals Benton envisioned an integrated and harmonious American scene.

Benton found his strongest, but ultimately most dangerous, defender in Thomas Craven. Benton had known the Kansas-born critic since 1912, when they shared quarters at the Lincoln Square Arcade, an episode of aesthetic experimentation and debauchery which Craven described in his 1923 novel *Paint*. Failing at both picture making (he, like Benton, tested a variety of modern styles) and story writing, Craven turned to criticism, churning out essays and reviews for *The Arts, The Dial, The American Mercury,* and *Scribner's* in the 1920s and 1930s, and publishing *Men of Art* in 1931 and *Modern Art: The Men, the Movements, the Meaning* in 1934. His increasingly reactionary agenda was that of cultural nationalism, which he specifically defined as an anecdotal public art based on whatever was unique to the American experience. Such an agenda was nothing new: Henri and Weischel had encouraged the development of national culture in the progressive era and Paul Rosenfeld's goals might be construed as somewhat similar. But Craven was an especially narrow-minded and malevolent critic. He nastily attacked European modernism as an "emasculated tradition" of "babyish patterns," and condemned those "victims of a Bohemian corruption" who did not create socially useful art. Modern art, said Craven, was immoral, irresponsible, and abstract; the best art for thirties America was preachy, purposeful, and public. [33] Craven's diatribes coin-

cided with American cultural insecurity heightened by the psychological effects of the early Depression; nevertheless, many recoiled from his caustic aesthetic jingoism. In the changed political climate of the late thirties and especially after World War II, the kind of cultural nationalism Craven advocated—American scene art—was stridently dismissed by critics (Clement Greenberg, for example) often as narrow-minded as Craven in their aesthetic preference for a new national style—abstract expressionism.

During the Depression Craven touted American-scene painters Charles Burchfield, Edward Hopper, Reginald Marsh, and Benton, claiming they were "active participants in life . . . free from the esoteric absurdities of modernists who are unable to cope with realities." In a particularly rabid essay of 1932 which began, "From time to time, it has been my unpleasant duty to review the general degradation of American painting," Craven incriminated modern mural painting (this was before any New Deal mural projects had been developed) and denounced the Museum of Modern Art as "the high-toned asylum of French art and culture in America." He had praise only for Benton:

> He knows his politics, his America, and his technical history of art. By the time this article is in print, he will have finished his job for the Whitney Museum. . . . it will stand out as a brutally realistic organization of American life, the most powerful, the most engaging summary of the freakish pranks and manias of our civilization that has yet appeared in mural dress.

Craven's accolades helped launch Benton's public popularity: within two years of the unveiling of the Whitney mural, Benton was on the cover of *Time* magazine, the first artist to be so featured (fig. 2.18).[34] But his backing also helped create Benton's ostracism in the art world. Naturally, the orchestration of public attention by the critic who despised most other forms of American art did not sit well with most other American artists. And for those artists only one or two generations removed from European heritage, Craven's xenophobia was viewed as an acute form of racism, as was, by extension, his championship of Benton. Perhaps more important, however, was Craven's formalist definition of modern art, which completely differed from Benton's integrative and recuperative interpretation. In subsequent decades, when modern art was increasingly defined on formal terms alone, Benton's art, championed by Craven for its sociocultural context, would be misconstrued as antimodernist pap.

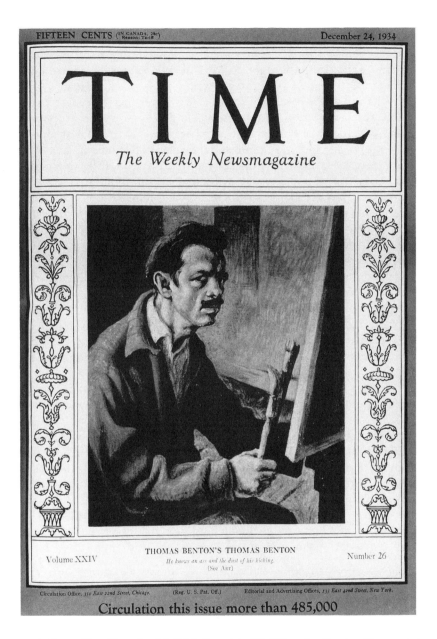

TIME

The Weekly Newsmagazine

Volume XXIV

THOMAS BENTON'S THOMAS BENTON
He knows an ass and the dust of his kicking.
(See ART)

Number 26

Circulation this issue more than 485,000

2.18. Cover, *Time,* December 24, 1934. Copyright 1934 Time, Inc. Reprinted by permission.

Shortly after he finished the Whitney mural, Benton signed a contract to paint *A Social History of the State of Indiana* for the state's pavilion at the 1933 Chicago World's Fair, a three-mile expanse of lakefront exhibits, art deco architecture, and midway extravaganza (like Sally Rand's notorious Fan Dance) called A Century of Progress (fig. 2.19). For Benton, this was an especially grueling assignment: he was expected to deliver a truly gigantic tempera mural (250 feet long and 12 feet high) to the Indiana Commission, headed by Colonel Richard Lieber, before the fair officially opened on May 27, 1933. Despite the difficulty of completing such a huge work in just a few months, this project proved enormously satisfying for Benton and may have been his most effective work of the early thirties. Although only a temporary installation (the Indiana pavilion closed October 31, 1933), the commission gave him the opportunity to create truly *public* art: even though the Depression was into its fourth harrowing year, millions were expected to attend the fair, and indeed, some thirty-eight million did. Further, *A Social History of the State of Indiana* was Indiana's major World's Fair offering; unlike his earlier projects it was not merely a decorative afterthought. It dominated the pavilion's largest room (a rotating exhibition of contemporary Indiana art was featured in a smaller gallery), and it generated a tremendous amount of publicity, both for Benton and for Indiana.[35]

Benton began work on the project in January 1933 and traveled three thousand miles all over the state, "searching out Indiana characters, historical buildings, implements and machinery." From February through May he constructed the mural in an Indianapolis warehouse. The months he spent in Indiana, away from his family and from the New York art world, had a profound effect on him. For the first time while working on a mural he discovered that his republican cultural critique completely meshed with the politics of its context, in this case, the progressive politics of Indiana New Dealers. Not surprisingly, Benton began to feel an overwhelming kinship to the society and culture of this midwestern region. As he later recalled,

> It is possible that the political climate of the time where our whole system was everywhere under question made my reintegration with the midwestern mind much easier than it might have been earlier. Ideas questioning the nature of our culture though they might put a scare into wealthy people, had massive support in the dissatisfactions of farmers, workers and small businessmen and

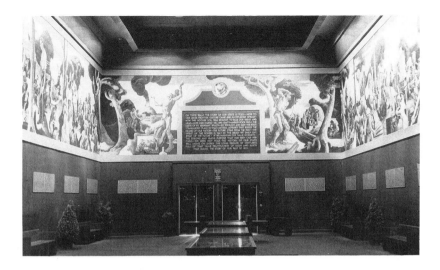

2.19. Indiana Pavilion at the Chicago World's Fair, featuring Thomas Hart Benton's *A Social History of the State of Indiana*, 1933; egg tempera and oil glaze on canvas. The interior of the pavilion measured 38' wide and 78' long; the complete mural measured 12' × 200'. It is now located at three sites on the Indiana University campus, at Bloomington. Photo courtesy of The Wallace Richards Papers, Archives of American Art, Smithsonian Institution.

their political representatives all over the Midwest. This created an atmosphere where a new willingness to experiment politically put such novelty as my own ideas might have in the natural order of things. I had no difficulty whatever in justifying them with the politicians who had control of Indiana.[36]

He may have spoofed leftist and Republican politics in his Whitney mural, but in his project for the Chicago World's Fair Benton celebrated the producerism he heard expounded by newly elected President Roosevelt and his Indiana backers.

Unifying the themes of his two previous projects, Benton focused the twenty-two panels of the World's Fair mural on Indiana's industry and culture. At the entrance to the pavilion the two categories were linked in pictures which showed the "simple craft" of the Algonquians and the "noble" rituals of the Moundbuilders. Between them a large introductory text declared the mural's overall agenda:

On these walls the story of our state is told—How to our crude frontier culture came and knowledge spread—How the Hoosier soil was brought to bear our bread and meat—How men learned skill and craftsmanship—Took from the earth of its abundant wealth—So wrought and gave the state commanding place in that material advance that builds the record of our nation—The future stems from the past—The sweat of the pioneer is salt in the bread we daily eat—What of the future? If we maintain the same integrity—The strong and simple purpose that has been our heritage—We need not fear. The history of our state will move on down the long parade of centuries full of that same fruitfulness of man and earth that makes the story of our past so rich.[37]

Inside, visitors walked a visual gauntlet between "the story" of Indiana, assaulted by an iconic barrage of the state's industrial progress on one wall and her cultural advancement on the other. The panels were hung fairly high on the walls and underneath each were lengthy captions full of state facts and figures. The text for the first two panels stressed the "informal, democratic" and "republican" nature of native American society. In picture and in text, the continuity between Indiana's broadly democratic beginnings (native American though they might be) and her present-day republicanism was emphasized. The historically consistent "story" of Indiana was that of an industrious and cooperative commonwealth.

Such a story must have become self-evident when Indiana Hall visitors walked between Benton's pictures, especially as the two sides were carefully matched in form and in content. Huge plumes of smoke, for example, were painted in each of the middle panels, symbolizing the devastation of the Civil War. In the industrial panel (fig. 2.20) Governor Oliver Morton directed a regiment of snappily dressed soldiers into the smoke; in the cultural panel (fig. 2.21) a smaller band of crippled survivors emerged out of it carrying a tattered U.S. flag.

As viewers themselves marched down the pavilion, they marched against the wind. They marched past fur traders and early settlers, past Fort Harrison and Indiana's first state house in Corydon. They marched past pioneers cutting virgin land, churning butter, and shingling log cabins (fig. 2.22), and past the stone fort of New Harmony's Rappite Colony, where Christian communist Father Rapp preached celibacy and community equality and Robert Owen later established his own utopia (fig. 2.23). They marched past New Harmony scientist William Ma-

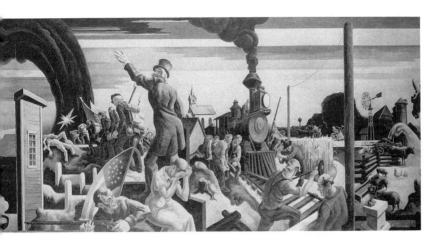

2.20. Thomas Hart Benton, *Industrial Panel 6: Civil War, Expansion,* from *A Social History of the State of Indiana,* 1933; egg tempera and oil glaze on canvas, 12′ × 10′. Courtesy of the Indiana University Auditorium, Bloomington.

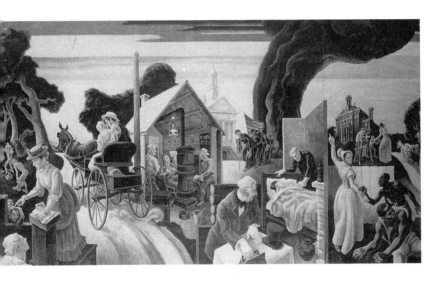

2.21. Thomas Hart Benton, *Cultural Panel 6: Old Time Doctor, the Grange, Woman's Place,* from *A Social History of the State of Indiana,* 1933; egg tempera and oil glaze on canvas, 12′ × 10′. Courtesy of the Indiana University Auditorium, Bloomington.

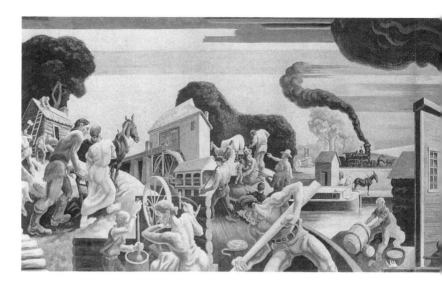

2.22. Thomas Hart Benton, *Industrial Panel 4: Home Industry, Internal Improvements,* from *A Social History of the State of Indiana,* 1933; egg tempera and oil glaze on canvas, 12′ × 10′. Courtesy of the Indiana University Auditorium, Bloomington.

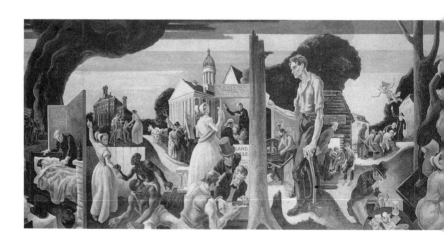

2.23. Thomas Hart Benton, *Cultural Panel 4: Early Schools, Communities, Reformers, Squatters,* from *A Social History of the State of Indiana,* 1933; egg tempera and oil glaze on canvas, 12′ × 10′. Courtesy of the Indiana University Auditorium, Bloomington.

clure, the "Father of American Geology," and past a progressive Owen-
ite school, where boys and girls received equal educational opportuni-
ties. They marched past a huge, skinny Abe Lincoln, past canal boatmen
and railroad engineers, past land speculators and snake-oil salesmen.
The Civil War, with its huge plumes of dense smoke, threatened them in
the middle of their march, but they were urged to march right past the
chains of slaves and the graves of soldiers.

The cadence of their march quickened (even more!) as they hiked
past pictures of post–Civil War Indiana. Endless scenes of farmers, coal
miners, engineers, factory workers, stonecutters, steelmakers, auto me-
chanics, and construction builders glutted one side of the pavilion,
while members of the Minerva Club (the first organized women's club
in the U.S.), drinkers at the Claypool Hotel (like "children's poet" James
Whitcomb Riley), frolicking kids at "The Old Swimmin' Hole" (Riley's
most famous verse), painters, students, political campaigners, circus
bareback riders, journalists, architects, Indianapolis 500 racers, and
highschool basketball players filled the other side. Nor did Benton hesi-
tate to include less stellar moments from Indiana's history, such as its
Ku Klux Klan rallies and bloody labor riots.

Finally, at the end of Indiana Hall, viewers came to a halt in front
of two linked panels. On the left side, above the caption "Indiana Puts
Her Trust in Work" (fig. 2.24), angry investors could be seen shaking
their fists at the closed doors of an Indiana bank. Next to them a black
construction worker aimed his drill into a block of reinforced concrete.
On the right side, above "Indiana Puts Her Trust in Thought" (fig.
2.25), handsome Governor Paul McNutt, newly elected in the Demo-
cratic landslide of 1932, pointed to the political agenda of the New
Deal, the words "State Reorganization," "Banking," "Unemployment,"
"School Salaries," and "Repeal" written above him. A lab-coated tech-
nician near him checked the vials and tubes of modern medicine.

The text under the industrial panel read:

> Anxious are the days still. But if the farmer worries about the price
> of corn, he does not starve. Nobody starves in Indiana. If industry
> limps, it goes on. Spirits rise to the slogan: "Modernize now and
> give some fellow a job!" Where shall the state put her trust if not
> in work, faithful, intelligent, kindly, determined? The struggle will
> avail.

The caption under the cultural panel was similar:

2.24. Thomas Hart Benton, *Industrial Panel 11: Indiana Puts Her Trust in Work*, from *A Social History of the State of Indiana*, 1933; egg tempera and oil glaze on canvas, 12' × 10'. The extended portion of this panel is now lost. Courtesy of the Indiana University Auditorium and Indiana University Art Museum, Bloomington.

The bread-line forms. Poor relief is organized everywhere. New taxes are voted. Sweeping powers are given the governor. Indiana chemists, cooperating with physicians, have shared in the development of important medical discoveries. . . . Where shall the state put her trust if not in thought, scientific, political, spiritual? There lies her hope to overbalance every counsel of despair.[38]

Repeating the hopeful, but anticipatory rhetoric of these captions, Benton painted a big question mark at the top of the mural's concluding

2.25. Thomas Hart Benton, *Cultural Panel 11: Indiana Puts Her Trust in Thought,* from *A Social History of the State of Indiana,* 1933; egg tempera and oil glaze on canvas, 12′ × 10′. The extended portion of this panel is now lost. Courtesy of the Indiana University Auditorium and Indiana University Art Museum, Bloomington.

panel. Indiana Hall visitors were left, then, with the sense that the future *could* be one of reform, but it was no matter-of-fact guarantee.

The "story" Benton told in these last panels was that a combination of racial equality, progressive politics, and scientific engineering (in part, the "story" of the New Deal) *could* help end the crisis of the Depression, but only if Indiana renewed its faith in republicanism. This tradition, so blatantly described in endless scenes of worker determination on the one wall of the pavilion and in countless views of collectivist culture—camp meetings, stump politicking, public schools, women's

clubs, bars, car races—on the other, was for Benton the overwhelming feature of Indiana's "social history." It opens the mural in scenes of Algonquian and Moundbuilder "republicanism" and it closes it in views of New Deal workers, politicians, and scientists working together. It is threatened by the disruptive force of the Civil War, but it survives. It is the most resounding element of the new world that Benton, like FDR, Governor McNutt, Beard, and Mumford, hoped would emerge in the 1930s.

Painted on a much grander scale than his earlier projects, *The Social History of the State of Indiana* easily demanded viewer attention. Figures were larger (Abe Lincoln was 9 feet tall!) and they pulsated with more energy, more determination. Colors were vibrant—like the 24 neon shades on the outside of the fair's Travel and Transportation Building, a gigantic Art Deco building whose exterior color scheme (designed by New School architect Joseph Urban) was meant to give "a spirit of gayety and carnival . . . different from the homes and towns from which the millions of visitors will come." [39] Similarly, Benton chose screechier colors and larger-than-life figures to show his Indiana Hall audience a different world, a new world of possibilities. After grabbing their attention, he showed them that Indiana's republican past was exemplary and that republican restoration, particularly in the changed political and cultural ambience of the New Deal, could effectively put an end to the crisis of the Depression.

While Benton was at work on *The Social History of the State of Indiana,* FDR was at work on the New Deal. In his inaugural address (4 March 1933) he, too, spoke of a new world: "The money changers have fled from their high seats in the temple of our civilization. We may now restore that temple to the ancient truths. The measure of the restoration lies in the extent to which we apply social values more noble than mere monetary profit." From his first day in office, Roosevelt seemingly worked to create that world through government economic intervention and federal programs. Emergency bank measures were immediately proposed, followed by economic reform bills, the repeal of prohibition, and the creation of the New Deal's alphabet agencies: AAA (Agricultural Adjustment Administration), CCC (Civilian Conservation Corps), NRA (National Recovery Administration), SEC (Securities and Exchange Commission), PWA (Public Works Administration), FERA (the Federal Emergency Relief Administration), and eventually WPA (Works Progress Administration).[40] While the creation of all of these agencies and institutions hardly conformed to Benton's republican ideal of an

autonomous producer constituency, it did seem to suggest that the government was doing something about the Depression, and doing something for the American people.

All over the country, people saw Dr. New Deal's "take action" attitude as the signal of something new. A sign in a New Jersey factory declared: "President Roosevelt has done his part: now you do something. . . . It does not matter what you do—but get going and keep going. This old world is starting to move." The NRA's Blue Eagle, a very different eagle from the one Benton painted in the Whitney Museum panel *Political Business and Intellectual Ballyhoo,* became an omnipresent reminder of the promise of this new world. Compare the lyrics of NRA theme song "The Blue Eagle's Flying High" to those of "The Eagles They Fly High:"

> There is a New Eagle, up in the sky,
> The Blue Eagle, he's flying high.
> This mammoth bird is soaring near and far,
> He brings a cheerful word from FDR.
> In his mighty claws, he holds a mighty cause;
> A brand new understanding,
> We know he'll make a happy landing;
> Blue Eagle, he'll do or die,
> the Blue Eagle's flying high![41]

Benton's Indiana mural, the notices in U.S. factories, New Deal songs, and the writings of contemporary historians all reflected the anticipation with which Depression Americans greeted the New Deal, believing it truly signaled the creation of a new world.

In 1933, Charles Beard published *The Future Comes,* a celebratory account of Roosevelt's first eight months in office. The New Deal, Beard declared, was "a break with the historic past and the coming of a future collectivist in character." It marked the overthrow of laissez-faire capitalism's selfish individualism (the "historic past") and summoned the restoration of America's democratic ("collectivist") and essentially nationalist economic tradition. Roosevelt was viewed as the figure who could help integrate industrial America with her republican past, "the Moses who would lead Americans into a New World of industrial democracy." Beard praised, especially, two aspects of the New Deal. The first was its restoration of democratic participation: "The Recovery Program calls upon millions of individuals in industry and agriculture, who have hitherto been pursuing their own interests at pleasure, to cooperate

in adjusting production, setting prices, and maintaining standards." The second was its revitalization of economic nationalism: "The Recovery Program surrenders the official thesis that foreign trade is the only outlet for 'surpluses,' [and] substitutes the proposition that domestic economy must be made to function in a manner to keep industry at a high tempo." [42] The New Deal, for Beard, seemed to embody the merger of modern industrialization and participatory democracy by which he, and Benton, defined republican regeneration.

Beard's reading of the new world seemingly predicated by the New Deal was echoed in Benton's Indiana Hall mural. To be sure, the president himself was not seen, but his Indiana backers—Governor McNutt and his producer constituency—showed the dissemination of his New Deal ideology. Still, the creation of this new world was no *fait accompli.* Benton showed that republican revitalization required public cooperation. In this he concurred with FDR, who intoned in his first presidential radio speech (March 12, 1933): "Confidence and courage are the essentials in our plan. You must have faith. We have provided the machinery to restore our financial system; it is up to you to support and make it work. Together we cannot fail." Both he and Benton appealed to "the great body of the lower middle class, laborers, and farmers"; indeed, Roosevelt's sweeping 1932 victory was largely the result of their votes. [43] Beginning his "Fireside Chats" with the warm, neighborly greeting "My friends," Roosevelt brilliantly used radio to manipulate public opinion, encouraging the American public with a steady barrage of upbeat moralizing.

Benton did much the same. Marching against the winds of hardship like the Civil War, his Indiana Hall audience was accosted by positive, serious scenes of Indiana's producers. They were reminded again and again that Indiana, having survived the adversity of the past, *could* survive the Depression. But they were also reminded that survival, under the direction of New Deal leadership, depended on *their* commitment. Like FDR's speeches, Benton's mural was directed at the American folk. In gripping, dramatic scenes of their history, he hoped to convince them of the possibility of republican revival. In one panel, for example, Socialist party labor organizer Eugene Debs (from Terre Haute) is pictured galvanizing Indiana workers in front of a sign reading "Workers, Why Vote a Rich Man's Ticket? You've Got a Choice."

Benton, like Debs, showed his audience that such a world depended on the "choices" they made. His mural was tough and gritty, but it carried a sense of energy and promise:

Mr. Benton attempted to portray the toil and suffering and disillusion encountered by the pioneering men and women who created Indiana. Few happy or laughing faces will be found. However, there is in it tremendous vigor, not one placid figure, and a freshness and force of color. It is a history of the *people* of Indiana, not the historical characters.[44]

In this sense, the Indiana Hall mural was different from the pictures Benton painted for the New School and the Whitney Museum, which depicted the revitalization of producerism in America during the 1930s. The Indiana mural was tied more directly to the spirit of the early New Deal and its cultural emphasis on "making" a new world, rather than dreaming of a utopia already extant.

On the whole, Indiana Hall visitors liked the visual bombardment and encouragement they received: William Brown of East Cleveland, Ohio, found the mural "energetic" and "compelling"; Mrs. Sydney Temple of Los Angeles said, "the strength of the figures, the harmony of color and atmosphere of space are magnificent"; George Sconce of Pinder, Nebraska, wrote, "the Hoosier blood of my pioneer ancestors tingled when I stepped into the Indiana Exhibit"; Edwin Earle of New York City declared that the mural alone was "worth many miles of travel to the Fair." Wallace Richards, chief publicist for the Indiana Commission, kept a close watch on how visitors responded to Benton's mural and collected their written comments. A few months before the pavilion closed he summarized its effectiveness in a letter to commission chief Richard Lieber:

> I think that we have been extremely successful in having won over half the visitors to an understanding of an exhibit modern in atmosphere and often brutally truthful in content. The significant feature is the interest shown by the working man. The carpenter, the electrician, the plumber, the janitor, all grasp what the working man and woman underwent in creating a state—and that is what Benton wanted to show.[45]

Benton also considered the Indiana mural a huge success. He had some problems with Lieber, who objected to the inclusion of the KKK, but on the whole the mural was well received in Indiana. While working on it, he spent a lot of time with state legislators curious about his family ties to midwestern politics and to Senator Thomas Hart Benton. He found that their characterization as "prejudiced and venal promoters of

narrow interests" by "intellectualist magazines" was erroneous, and discovered, in fact, that there was "much more narrowness of vision among [his] intellectualist acquaintances in New York." Talking freely with these Indiana representatives about his "communist" leanings in the 1920s and how he had come to reject the "intellectual artifice" of radical politics, he recalled: "This was the first time I had ever discussed political theory with men in whose hands actual political power rested." These hotel drinking sessions reacquainted Benton with the midwestern political milieu of his family and his youth. Moreover, they convinced him (although he had discovered this considerably earlier) that public art demanded "a language that was plain, direct and devoid of any of the fancy specialisms of Art." The Indiana experience, Benton wrote later, taught him "how to advance artistic reasons so that they appeared commonly American." It also "provided a political training ground for the future." [46]

He returned to New York in the summer of 1933 and resumed teaching at the Art Students League. Missing the "stimulation" of "dealing with actual political power," he tried to get involved with local politics, but was completely turned off by the "small time poker playing [and] dice throwing" of Tammany Club politics. Instead, he wrote articles and provided illustrations for the liberal journals *Modern Monthly* and *Common Sense*. With author Samuel Putnam and composer George Antheil, he joined the editorial board of *New Hope*, a 1930s magazine compiled by "America's foremost creative workers to interpret contemporary Art, Literature and Music to the cultured layman." Its title alone embodied the great expectations of thirties liberals. He also lectured on the renaissance of modern American art at schools all over the country, meeting Grant Wood at the University of Iowa in 1934. Benton's essays and lectures followed the themes of the three murals he had completed by this time: the collective importance of American workers and the development of national culture. His optimism about both, stemming from confidence that the New Deal could engender labor reform and help form a unified culture, was paralleled by a fear that radical intellectuals were impeding such reform efforts. His ornery essays, blatantly pro–New Deal art, and patronage by critic Craven made Benton an easy target among what he nastily termed the "left wing cabal" of the mid-thirties Eastern art world, many of whom were anti-Roosevelt.[47] Benton seemed to cherish the role of art world dissident and he played it well, but in the long run it marked him an antimodernist and a fascist and led him to seek a new art world milieu in the Midwest.

Benton-baiting began in earnest in 1935, when he and members of two leftist art groups in New York—the John Reed Club (an arm of the Communist party's International Union of Writers and Artists from 1929 to 1935, which held exhibitions and published the *Partisan Review*) and the Artist's Union (a fine arts trade organization which published the journal *Art Front*)—got into a vicious tangle. Benton had been on "reasonably good terms with the boys of the John Reed Club" in the early thirties and had been invited to exhibit in their February 1933 show The Social Viewpoint in Art. He had illustrated *We, the People*, Leo Huberman's marxist history of America in 1932, although the gloomy tone of his pen and ink vignettes echoed more Benton's pre–New Deal political cynicism than the idealized and heroic tenor of much marxist social realist illustration of the day (fig. 2.26). When he returned to New York from Indiana in 1933, Benton believed he and leftist artists could link forces: "As I also advocated a sort of social realism for my own art . . . I thought I could make it clear that what separated us was not our basic attitudes toward the depression ridden people of America or even the morality of the Capitalist system, but only a theory about what should be done to improve the situations of these."[48]

But within the year, as it became increasingly clear that the left distrusted him and his politics, Benton changed his mind. Despite the creation of the Popular Front in the mid-thirties, whereby U.S. communists hoped to "Americanize" marxism by "emphasizing not proletarian dictatorship but the greater democracy and freedom people could enjoy under socialism" (a goal not dissimilar from that of the New Deal and Benton's own republicanist agenda), he and the left formed no alliance. Reviewing the Social Viewpoint in Art exhibition for the *New Masses*, marxist critic John Kwait attacked the John Reed Club for including Benton: his presence demonstrated a "confused effort to designate a united artistic front." Favoring art which clearly addressed "revolutionary ideas" and "class issues" Kwait found that presentation of all sides of "the social viewpoint" only reinforced the status quo: "It flatters the patron ruling class to hear that its factories, industries, and cities are noble subjects of art, in fact the materials of a renaissance, and that the American artist, to produce great art, must confront 'life,' like a hard-boiled businessman." Benton's "vague liberalism" was especially singled out for criticism. Although Kwait wrote his review during the "ultra-revolutionary Third Period" of Communist party politicking (1928–33) and thus before the accommodating platform of the Popular Front had been developed, it was nevertheless typical of the kind of criticism that Benton would receive from the leftist press throughout the

2.26. Thomas Hart Benton, *Factory Workers* and *Strike;* pen and ink drawings, 6″ × 4″ and 1 ⅝″ × 4″, respectively. Reprinted from Leo Huberman's *We, the People* (New York: Harper & Bros., 1932).

rest of the 1930s.[49] Following the admittedly "vague" tenets of New Deal reform, Benton's liberal political aesthetic was viewed suspiciously by leftists advocating radical change.

Benton's response to leftist criticism was no less narrow-minded and shows the increasing factionalization of thirties artists. In a May

1934 article for the *Modern Monthly*, V. F. Calverton's eclectic compilation of liberal and radical writing, Benton blasted social realist artists:

> You members of the John Reed Club . . . unless you are able to subordinate your doctrines . . . you will not make artists.
>
> The ability to submerge yourself in the actual culture, to emotionally share the play of American life, with or without your baggage of verbal convictions, is your only hope of producing anything but stock figures or bare symbols, like those of Hugo Gellert and Louis Lozowick.[50]

Benton's essay, published a month after John Dewey's "Why I Am Not a Communist" appeared in the same magazine, typifies the heated, bitter debates that raged between art world liberals and leftists in the mid-thirties. By now, Benton had lost sympathy for leftist intellectuals like Sidney Hook, who rebutted Dewey's article with his own "Why I Am a Communist" and expressed support for the American Workers party, a U.S. Trotskyist affiliate which Calverton and Hook's New York University colleague James Burnham joined.[51]

Benton, with Dewey, viewed such leftist alignment with radical politics with alarm. He was deeply troubled that leftists were not supporting New Deal efforts to reform capitalism (which is understandable since the left did not so much want to reform capitalism as to see it replaced) and were proposing a political system which, Benton felt, revealed little understanding of the particular context of the American experience. His argument closely followed Dewey's: "It is nothing short of fantastic to transfer the ideology of Russian Communism to a country which is so profoundly different in its economic, political, and cultural history." Benton continued his condemnation of radical politics in a 1935 essay, stating: "Marxists in a country like the United States are not directors of men in actual economic struggles. They are evangelists of a faith, of a doctrine. They are more like Holy Rollers than politicians." Moreover, Benton wrote, "the outcome of the Marxist theory of class struggle" was fascism, because it "left no choice in the political arena except as between two class dictatorships."[52] This, coupled with his prejudice that strict adherence to Communist "doctrine" did not create real "art," led Benton to denounce social realist artists, such as Gellert and Lozowick. Their subordination to the leftist "doctrine" of class struggle was, Benton believed, inherently faulty for the development of an authentic American culture. Benton, of course, offered his own paradigm as an alternative: the "doctrine" of liberalism, based not on class issues but on the producer tradition and republican revision.

By the mid-1930s, Benton and certain left-wing artists, in particular abstract painter Stuart Davis (1894–1964), were engaging in out-and-out combat over what, indeed, was the most valid culture for Depression era America. Their debate has most often been viewed as one of aesthetic differences—Davis the modernist versus Benton the provincial antimodernist—but it actually centered on political ideology: Davis the leftist versus Benton the liberal. It was grounded on a personal level, too: in 1916 an arrogant young Benton snottily told an untraveled young Davis he should "go to Paris and try to learn something." Benton regretted saying it the moment he "caught it's effect on Stuart's face," he recalled years later, but the damage had been done.[53]

It is worth noting that despite their apparent aesthetic and political differences, Benton and Davis actually shared a number of similar attitudes and approaches, particularly in the 1930s. In terms of personality, both were tenacious, aggressive men, hotheaded and outspoken. In terms of aesthetics, both followed Robert Henri's "art spirit" advice (Davis studied with Henri from 1909 to 1913) that artmaking reveal the realities of modern life, and both worked to legitimize further the use of the vernacular in their pictures. Davis's *New York Mural* (1932, fig. 2.27) shows the skyscraper towers, warehouses, shop fronts, and urban debris of its Manhattan location and reveals, as Benton's murals do, a particular attention to the details of the American scene.

Davis felt so strongly about this he declared: "I am an American, born in Philadelphia of American stock. I studied art in America. I paint what I see in America, in other words, I paint the American scene." Moreover, both he and Benton were aesthetic accommodators: Davis "colonized" cubism in his mechanistic abstractions of contemporary America, and Benton assimilated the modernist strains of synchromism and Cézannesque structuralism in his more curvilinear and anecdotal regionalist pictures. Both chose bright palettes and energetic forms, similarly composing their works to embody the sense of dynamism inherent in the industrialized world of the twentieth century.[54] Both strove to create modern American art by linking avant-garde and popular culture forms with the content of the American scene. But they had completely different views about the nature of this American modernism, views which stemmed from their diverse political beliefs. Their argument revolved around issues of concern to both leftists and New Dealers in the 1930s: race, class, nationalism, and economic reform. And, in the heated atmosphere of the mid-thirties, political differences set the tone for art world warfare.

2.27. Stuart Davis, *New York Mural,* 1932; oil on canvas, 84″ × 48″. Collection of the Norton Gallery of Art, West Palm Beach, Florida.

Drawing cartoons for *The Masses* from 1913 to 1916, participating in the John Reed Club in the early 1930s, and helping to organize the Artists Union in 1934, Davis consistently maintained politically left-wing views. From 1934 to 1936 he was editor-in-chief for *Art Front.* Nominally a nonpartisan journal, *Art Front* actually served as an "aesthetic dialogue on the left" in which condemnations of regionalist art, which Davis considered fascist and racist, were especially frequent.[55] In 1935, he and other *Art Front* staffers took umbrage when *Time* magazine announced, in a cover story that featured a Benton self-portrait, that American scene artists Benton, Curry, Wood, Burchfield, and Marsh "were destined to turn the tide of artistic taste in the United States" (figs. 2.18, 2.28).

Davis read *Time*'s prediction as evidence of growing public acceptance of American cultural fascism and the death knell of any possible mass cultural representation by leftist artists such as Gellert, Lozowick, or himself. He counterattacked in an *Art Front* essay that denounced Benton's "gross caricatures" of blacks, and their similarity to "the body of propaganda which is constantly being utilized to disfranchise the Negro politically, socially, and economically." (Attacking Benton personally, Davis observed that his *Time* self-portrait was similar in its "general underestimation of the human race" and said his "big gun" salute to America was "loaded with a commodity not listed in the *Consumers' Weekly*.") He likened regionalist views of the American scene to those promoted in William Randolph Hearst's *New York American,* the conservative newspaper that conducted its own "red-baiting" campaign against Professors Hook and Burnham in 1934. Davis closed his *Art Front* essay damning the regionalists seeming lack of class consciousness, and hinting of their tendency to fascism:

> The slight burp which this school of the U.S. scene in art has made, may not indicate the stomach ulcer of Fascism. I am not a political doctor, but I have heard the burp and as a fellow artist I would advise those concerned to submit themselves to a qualified diagnostician, other than witch doctor Craven, just to be on the safe side.[56]

Davis's criticism, although stemming from personal dislike, was obviously political. It should be noted that as an abstract artist Davis had no great love for either social realism or regionalism. Rather, like an earlier generation of nonobjective artists (the De Stijl, for example), Davis saw abstract art as an alternative to the easily manipulable imagery

2.28. "U.S. Scene," *Time*, December 24, 1934. Copyright 1934 Time, Inc. Reprinted by permission.

of narrative art, an argument that would be espoused by postwar abstract painters as well: "In the materialism of abstract art in general, is implicit a negation of many ideals dear to the bourgeois heart . . . the result of a revolutionary struggle relative to bourgeois academic associations." Still, as a proponent of radical politics, Davis certainly concurred that those artists who chose to create narrative art should follow a politically correct model. To engender political revolution a marxist aesthetic was necessary, for as leftist artist Diego Rivera wrote in 1932, art was a vital "weapon in the class struggle." American blacks, for example, should be pictured as the downtrodden underclass. Hoping to encourage a class-based revolution like the one recently enacted in Russia, American leftists aimed to convince American blacks of their inferior position under U.S. capitalism. Class revolution of this sort, it

was believed, would cut across *national* boundaries, and thus lead to *international* revolution on a large scale.[57]

But, by linking black construction workers with New Deal politicians and scientists in his Indiana Hall mural, for example, Benton seemed to hint that race equality was already underway in New Deal America and thus to deny the need for leftist intervention and class revolution. Benton did not think so much in terms of class or of the masses as he did in terms of producers and nonproducers; one of his 1937 *Common Sense* articles was titled "Class Rule vs. Democracy." For him, producerism—not class revolution—would join industrial age Americans, black and white, to their democratic traditions. His understanding of the American experience was the struggle of individual producers to gain a sense of autonomy, not of mass efforts to obtain political power. He did not show class conflict in his murals (although he did show conflict between producers and nonproducers) because like Beard and other heirs of progressive era liberalism Benton continued to believe that the promise of the American republic could be fulfilled in the harmonious unity of organic communities.

Benton focused on the American scene, not the international scene, because his personal agenda was to see republicanism restored to regional American venues. As he made clear in his 1934 *Modern Monthly* article, Benton thought of art and nationalism in "localist" terms as the "folk patterns" of America's diverse ethnic and regional communities. "The nature of art as a universal," he wrote, "has never been successfully defined—naturally, because it has no existence." Like Mumford and Beard, Benton hoped to see the emergence of a collective national culture but believed it must come from the authentic "conditions of its locality," rather than from the manufactured conditions of an imposed "foreign" political doctrine. "Otherwise," Benton intoned, American art would be "ineffective comment, or effective only among the verbally enwrapped intelligentsia." These kinds of comments, coupled with his refusal to focus on class and his repeated censure of communism as "nothing but a new oriental religion . . . put over on people who, like the Russians, had been raised in an authoritarian society and had never had a chance to think democratically," did not go over with Stuart Davis and other *Art Front* staffers.[58]

Their political volleying continued throughout 1935 in a series of *Art Front* and *Art Digest* articles and letters. Benton belittled Davis's initial *Art Front* attack as the "squawks of the defeated and the impotent"; Davis reviled Benton as a "petty opportunist" of "complete phil-

osophical irresponsibility." Benton tried to correct the growing art world assumption that he was a conservative antimodernist and wrote that he, too, wanted to see social change and a "better consumption-production economy" in America. But, he said, he chose to "work pragmatically with actual American forces to that end," through "democratic procedures" and "without the need of armed forces installing and protecting a dictatorship." [59]

Davis responded by attacking Benton's "social cynicism" and condemned the Whitney mural as the perfect art for "any Fascist or semi-Fascist type of government":

> His opinion of radical and liberal thought is clearly symbolized. It shows a Jew in vicious caricature holding the *New Masses* and saying "the hour is at hand." Hitler would love that. For Huey Long he can point to his *Puck* and *Judge* caricatures of crap shooting and barefoot shuffling negroes. No danger of these negroes demanding a right to vote even if the poll tax has been taken off. If art forms have meaning and purpose and are inseparable from human ways of perceiving and doing, it is quite clear what Benton has perceived and what the purposes of his forms are.

The 1932 Whitney mural proved to be Benton's nemesis; most of the charges of racism and fascism leveled against him in the 1930s were based solely on this mural. Davis's criticism found many supporters and lost Benton many former followers. Mervin Jules, one of Benton's students at the Art Students League, recalled that he and Benton "broke up over his portrayal of Negroes in the mural he did for the Whitney. There was a basic antihumanist approach that was reflected in all his people." [60]

Davis was right on the mark in pinpointing Benton's cynicism about political and social reform in his 1932, pre–New Deal mural at the Whitney Museum. What Davis failed to note, of course, was Benton's mockery of *both* leftist and conservative politics in the lunette *Political Business and Intellectual Ballyhoo,* where symbols of radical and rightwing politics were equally buffooned. Nor did Davis consider the liberal political aesthetic that Benton had advanced first in the *America Today* mural and then made especially clear in the 1933 mural for the Indiana pavilion at the Chicago World's Fair.

Davis's charge of racism was also unstudied; he disregarded the fact that while Benton showed blacks throwing dice in *Arts of the South* he showed whites gambling and brawling in *Arts of the West.* Davis also

ignored the scenes of integrated urban industry in *America Today* and the inclusion of skilled black laborers, muscular and almost heroic in representation, in the panel *Indiana Puts Her Trust in Work* of the 1933 mural. Jules's allegation of antihumanism is similarly remiss (although Benton's depiction of women is ambivalent, to say the least). It is true that Benton did not flatter the American folk, except in stoic scenes of muscular laborers, because he chose to picture the entire spectrum of life. Including scenes of chain-gang labor in *America Today* and KKK riders in the Indiana mural shows that Benton did not gloss over or idealize American reality. But this hardly made his an antihumanist art.

Davis's accusation of anti-Semitism, based on the figure Benton represented reading the *New Masses* in the Whitney lunette, bespeaks especially art world disgust with Thomas Craven. In the curious 1934 book *Modern Art: The Men, the Movements, the Meaning,* part art text and part autobiography (and like his 1931 book *Men of Art,* a Depression era best-seller), Craven was obsessed about the Jewish background of many modern artists. To his credit, Craven was attempting to provide a sociocultural context for his readers, and he did give an account of anti-Semitism in the French art world. But artists and critics were infuriated by Craven's offensive description of Alfred Stieglitz as "a Hoboken Jew without knowledge of, or interest in, the historical American background" who was "hardly equipped for the leadership of a genuine American expression." [61] And, because Craven claimed Benton as the leader of the American scene school of art for which he reserved his praise, Benton became identified with him as a bigot. While the only potentially anti-Semitic figure in Benton's oeuvre is that of the *New Masses* reader, Davis's charge of racism stuck.

Quite probably, the accusation of anti-Semitism stemmed from leftist fears that regionalist "Americanism" was tantamount to race prejudice and religious intolerance. Davis and other left-wing artists felt Benton's aesthetic platform was exclusionary and to a large degree they were right; the new world Benton envisioned was mostly filled with heroic and presumably heterosexual white males. Benton's art stressed the revival and revision of nineteenth-century American republican values. But these were values both foreign and unbelievable to a new generation of European immigrants. As Benton himself later noted, for many "idealistic young Jews coming mostly from families recently immigrated to America. . . . Life in the ghettos of New York had not provided . . . what the myths of 'Golden America' promised." [62] While Benton attempted to recreate this myth in his pictures of republican revival, he did so on terms conditioned by his upbringing.

What Davis and other critics completely failed to understand was Benton's use of stereotypical imagery. Developed during his stint in the teens with the early motion picture industry, Benton's reliance on type-cast figures—male and female, black and white, rural and urban—assured greater audience accessibility for his pictures. The vignettes in *Arts of the South,* for instance, stemmed from actual experience—his sketch of black crapshooters was based on a scene he saw in Louisiana in 1928. But Benton distilled these facts into archetypal anecdotes, much as Hollywood filmmakers did, to mesh with contemporary perceptions of real life. Exaggerating physical traits and other identifying elements, Benton made character recognition an easy task for his viewer. Regionalism, as Karal Ann Marling argues, "was an art of national stereotypes." [63] If Benton's images offended, it was because the stereotypes he presented were offensive, particularly to special-interest groups. Just as we are struck by his inadequate treatment of women, leftists of the era were offended by the manner in which Benton stereotyped them. While Davis found Benton's figures racist and Jules found them antihumanist, they were Benton's efforts to make the factual convincing to a broad national audience. The American scene he pictured was not altruistic, but then neither was life during the Depression.

The real nature of the left's objection to Benton's art lay with his preference for liberal politics. It was an irresolvable debate: Benton siding with middle-of-the-road New Deal efforts to reform American capitalism and leftists like Davis increasingly disenchanted with liberal panaceas which only seemed to sustain the inequities of corporate capitalism. After the first year of Roosevelt's administration, when his heavily publicized alphabet agencies seemed to have only a minimal effect in ending the Depression, much less creating "democratic socialism," the left became increasingly anti–New Deal. As regards labor policy, for example, the New Deal acted to "resolve the economic system's greatest crisis ever while destabilizing the institutional structures of capital as little as possible," an ambivalence which furthered leftist frustration. In particular, leftists saw liberal neutrality on the issue of class as an ominous signal of growing American interest in the kind of totalitarianism burgeoning in contemporary Germany and Italy. As leftist writer James Burnham observed in 1933, "The illusory belief that the state is autonomous, independent of classes, and therefore able to balance their claims, which is Roosevelt's belief, is fundamental to fascism." [64] For the left, the only possible solution to the crisis of the Depression was revolution.

For Benton, however, and for most Americans in the mid-1930s, the

psychological panaceas offered by the New Deal were effective. Roosevelt's uplifting intonation "we have nothing to fear but fear itself" convinced the general public that reform was in the offing and radical revolution simply unwarranted. Reasons for American indifference to leftist politics may lie in the absence of class ideology in the U.S. (a debatable issue) and certainly in Roosevelt's brilliant mass-media emphasis on "survival," but in any case, Benton remained convinced in the mid-1930s of the promise of liberal reform through New Deal politics. He became more and more disheartened, however, with the obvious factionalism of New York's art world and his status there as a political pariah. He was especially disheartened when the left labeled him a racist. He was also disturbed when they equated his liberalism with the disturbing mass politics of Huey Long and Father Coughlin. Certainly he, like they, envisioned a better future "in which the individual retained control of his own life and livelihood; in which power resided in visible, accessible institutions; in which wealth was equitably shared." [65] But did such views make him a regionalist demagogue? He was simply trying to sustain an earlier vision of republicanism in the modern world.

What Benton did not recognize, of course, was that American republicanism was not an ideal the left supported. In fact, they viewed it with genuine suspicion. Benton's inheritance of the values of the Founding Fathers was of little or no significance to recent immigrants grounded in completely different cultures and traditions. Further, the values themselves, especially producerism, conflicted with leftist ideals in the thirties. Benton's vision of a better future formulated out of a collective folk culture based on America's regional traditions conflicted with the universal world culture envisioned by the left. Benton's restoration of an autonomous and organic producer tradition conflicted with the left's ideological conception of urban mass labor. In short, Benton's accommodating art and its emphasis on regeneration conflicted with leftist commitment to revolution. Moreover, the fact that most of his pictures were filled with muscular, hardworking white males and his black figures were felt to be, as Stuart Davis described them, "gross caricatures," cast Benton as a racist, as did his championship by the xenophobic Craven.

But, it was his supposed emphasis on pictures of rural America that particularly separated him from the left. (His views of industry and urban life were mostly ignored.) Benton's regional scenes and his paeans to American localism were viewed as backward, parochial, and especially, antimodern. Those leftists situated in New York believed that

"confidence and intelligence glowed from the metropolis." [66] Out of their urban-cosmopolitan milieu would come the intellectual and political culture most appropriate for the modern world. With his emphasis on regional values and nativism Benton was, therefore, a prototypical anticosmopolitian antimodernist: the left refused to see Benton in the context of his personal political background or to admit the modern character of his art.

Benton, of course, was hardly faultless in widening the rift between himself and his critics. He made matters worse when he declared New York "feeble and querulous and touchy" in an April 1935 essay. Reiterating the old world/new world dichotomy, Benton argued that the "monkish and medieval" attitudes of many New Yorkers stemmed from European sources:

> New York has always had a little touch of the colonial spirit because of its large unassimilated, immigrant population, and partly because of the snobbishness of the rich and cultivated who gather here, and who have no way of manifesting their assumed superiorities except by adopting European manners.

In other words, New York was "on the downswing" because its denizens were no longer adopting (and perhaps never had) the "Americanist" values promoted in his regionalist pictures; failure to assimilate was, for Benton, tantamount to treason. Such irrational ramblings (which included the assertion that New York had "lost all masculinity") further convinced the left that Benton was an ignorant antimodernist. [67]

Partisan Review critic Meyer Schapiro made similar links between regionalism and antimodernism in his review of Benton's autobiography, *An Artist in America:*

> Benton has been criticized as fascist, but such a judgement is premature. To accept his ideas and art on their face value, to welcome them as an expression of "democratic individualism," would be no less absurd. Benton repudiates European fascism, but fascism draws on many streams including the traditional democratic. The appeal to the national sentiment should set us on guard, whatever its source. And when it comes as does Benton's with his conceited anti-intellectualism, his hatred of the foreign, his emphasis on the strong and the masculine, his uncritical and unhistorical elevation of the folk, his antagonism to the cities, his ignorant and violent remarks on radicalism, we have good reason to doubt his professed liberalism. [68]

Interpreting Benton's integrative mode of modernism as anti-intellectual, Shapiro censured it as dangerous "populist realism." His comments were written at a time when burgeoning national culture in fascist Europe began to alarm many former supporters of aesthetic populism. Benton's association with such art, even though his brand of regionalism had overwhelmingly modernist implications, made him a fascist in the eyes of the left.

Recalling his positive experience in Indiana, Benton began to view the Midwest as a more receptive environment for his art. In several articles, he spoke of the Midwest as the specific scene where the "actual American forces" of New Deal experimentation and reform were having their greatest effect. Asked by *Art Front* if he believed the "future" of American art was in the Midwest, Benton replied with an emphatic yes:

> The Middle West is the least provincial area of America. It is the least affected, that is, by ideas which are dependent on intellectual dogmas. . . . It has provided the substance of every democratic drive in our history and has harbored also the three important collective experiments in the United States. (Rapp, Owen, Amana.)

Such an obvious antiurban statement, although indicative more of Benton's discontent with the Eastern art world and with proponents of radical politics than with urban America itself, only further convinced the left of Benton's antimodernism. Benton was anxious to leave. When he was asked in the spring of 1935 to join the faculty of the Kansas City Art Institute and to paint a mural for the Missouri State Capitol in Jefferson City, he eagerly accepted. Leaving behind him a thoroughly stalemated political conflict, Benton journeyed to the Midwest, "to see what can be done for art in a fairly clean field less ridden with verbal stupidities." [69] After twenty-four years in the East, he returned to his roots, to propitiate the "democratic drive" of New Deal producerism in Missouri.

The Social History of the State of Missouri, which Benton worked on from 1935 to 1936, was his fourth, and last, mural of the thirties. As such, it summarized his faith in the New Deal's promise of economic reform and the development of a collective national culture. It also evinced his inherited ideology of liberal republicanism which he revised to fit the particular needs of the twentieth century. Rather than suggesting, as Matthew Baigell does, that Benton wished to return to the "idealized past" of an "agrarian, Jeffersonian society," this mural pos-

2.29. Thomas Hart Benton, *Pioneer Days and Early Settlement*, north wall, from *A Social History of the State of Missouri*, 1936; oil and egg tempera on linen mounted on panel, 25′ × 14′ 2″. House of Representatives' Lounge, State Capitol Building, Jefferson City, Missouri. Photo courtesy of the Missouri Division of Tourism.

ited Benton's consistent hopes for a kind of contemporary industrial progress tempered by the values of a reinvigorated producerism. As a close examination of the Jefferson City mural reveals, Benton was no populist antimodernist, but the self-appointed vanguard of New Deal reform.[70]

The mural fills all four walls of the house lounge, a third-floor meeting room (approximately 25 feet by 55 feet) in the west wing of the capitol. Missouri's early years are seen in *Pioneer Days and Early Settlement* (fig. 2.29); her nineteenth-century social history is portrayed in *Politics, Farming, and Law in Missouri* (fig. 2.30); and the contemporary scene is represented in *St. Louis and Kansas City* (fig. 2.31). The west wall is titled *Cornstalks and Power Lines*.

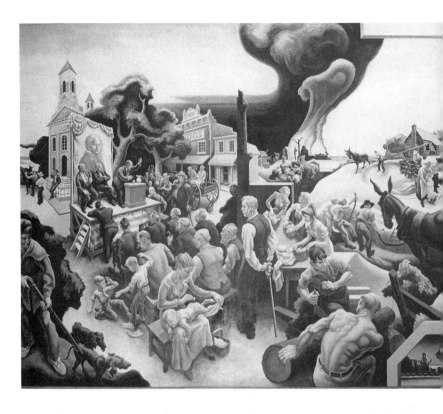

2.30. Thomas Hart Benton, *Politics, Farming, and Law in Missouri,* east wall, from *A Social History of the State of Missouri,* 1936; oil and egg tempera on linen mounted on panel, 55′ × 14′ 2″. House of Representatives' Lounge, State Capitol Building, Jefferson City, Missouri. Photo courtesy of the Missouri Division of Tourism.

Missouri history, from frontier to factory, from stump politics to modern courtroom, is fused into a swirling, vividly colored panorama that wraps itself around the lounge, itself the locus of contemporary political culture. Benton, like Charles Beard, viewed history as a progressive, rather than fixed, process, and the meandering sequences of his mural especially convey his search for the "characteristic aspects of the human struggle that was and is Missouri."[71] From one scene to the next indefatigable Missourians dominate: trappers, farmers, politicians, lumberjacks, engineers, lawyers, miners, brewers, butchers, jazz singers, secretaries, even bank robbers (Jesse James holds up a train in one panel)—all work hard in Benton's Missouri. From common folk to ce-

lebrities (Tom Prendergast holds court in the right panel of *St. Louis and Kansas City*), Missouri's people are producers. They work individually—tilling the soil, pitching hay, rolling biscuit, and drilling minerals, and they work together—cradling wheat, cutting timber, manning juries, playing in the band. Each is autonomous and yet all fit within the overall community of Missouri.

Throughout the rolling, cinematic flow of these cumulative vignettes there is no sharp break from one century to the next. Missouri's environment is somewhat altered as open prairie gives way to urban industry, but the productivity of its citizens remains the same. Missouri's agrarian past is not determined to be any better than its modern industrialization; industry is not a radical transformer but simply the contemporary setting for hard work. The panels on the west wall of the meeting room recapitulate this overall balance of farm and factory. Corn stalks in the one panel, perhaps parched but still bearing a few ears, and freight cars, highways, factories, and power lines in the other symbolize the successful merger of agriculture and industry in modern Missouri.

Linked with this representation of producerism past and present were depictions of Missouri's claims to culture, her legends, folk tales, and larger-than-life heroes. Centered between the scenes of *Pioneer Days and Early Settlements* are Huck Finn and Nigger Jim, fishing for catfish while floating down the Mississippi. In the background is a giant riverboat, the "Sam Clemens." The panel above the door of the east wall, in the middle of *Politics, Farming, and Law in Missouri,* shows the James gang holding up the Chicago and Alton Railroad and, in another scene, robbing a small-town bank. In the middle of the south wall, in the scenes of Missouri's largest cities, Benton painted the ballad of Frankie and Johnnie, the tale of a real-life murder in turn-of-the-century St. Louis. Frankie, the woman "done wrong" by her gallivanting man, is seen pulling her six-shooter on Johnnie in the middle of a St. Louis saloon. And in a small panel to the left of the south door Benton painted black jazz musicians entertaining a well-dressed white audience.

Not surprisingly, these scenes, and Benton's inclusion of Tom Prendergast in the *Kansas City* panel, resulted in critical condemnation from some conservative state legislators and outraged citizens. "Benton's shown Missouri as nothing but honky-tonk, hillbillies, and robbers. We're more than a 'coon dog state'!" said one, while another complained: "Not a brush mark indicates cultural, moral, or spiritual institutions in the state!" Although Benton did include the neoclassical facade of the Nelson Gallery of Art in the upper right-hand corner of

2.31. Thomas Hart Benton, *St. Louis and Kansas City,* south wall, from *A Social History of the State of Missouri,* 1936; oil and egg tempera on linen mounted on panel, 25′ × 14′ 2″. House of Representatives' Lounge, State Capitol Building, Jefferson City, Missouri. Photo courtesy of the Missouri Division of Tourism.

Kansas City, his view of Missouri culture focused on her folk heroes and popular arts. "To me these things are beautiful," Benton said, "They are part of the life and legend of Missouri as I know it. I am an ordinary American painting the world in front of me and I have no time for hokus-pocus." [72]

As he had in his three previous murals, Benton validated the popular arts as authentic and important cultural expressions. The small nightclub scene he painted demonstrated his continued faith in the folk collectivity and integration he had posited in his earlier murals. The panel that placed Huck and Jim's search for personal freedom between scenes of Missouri's early pioneers, and which centered Jesse James—who as legend had it, robbed from the rich and gave to the poor—be-

tween scenes of state farming and politics, suggested Benton's abiding belief in the socially regenerative power of popular culture. Positioning Frankie and Johnnie between Depression era workers, Benton may have been suggesting that contemporary producers likewise "take action" and seek revenge on the fat politicos and smug patronage seekers drinking whiskey in the lower right-hand corner of *Kansas City*. In any case, from the mid-nineteenth-century culture of Mark Twain to that of Depression jazz, Benton painted Missouri's folk heroes and indigenous music because such tales and songs were, he explained, "the chronicle of a people's mind." [73] If his images stirred up controversy, it was because some in the "Show-Me" state felt threatened by the political resonance of Benton's popular culture "chronicle."

The scenic creeping from one century to the next in *The Social History of the State of Missouri* substantiates Benton's regionalist political agenda: to show that the basic features of American republicanism— self-reliance, enterprise, civic responsibility—had not lost their importance for modern-day Missourians. By including scenes of slavery and lynching, of the expulsion of the Mormons, of poor folks stealing coal in railroad yards, and of corrupt politicians like Prendergast, Benton did not fail to remind his audience of the inadequacies of democracy in the past, and in the present. Still, the consistent productivity, the dynamic and purposeful energy dominating Benton's history of Missouri reveals his faith in the ability of the democratic system to regenerate, improve, progress. Showing his congressman-father making a stump speech in front of a huge poster of Champ Clark in the left panel of *Politics, Farming, and Law in Missouri* and his brother Nat Benton, a prosecutor for Greene County, pleading a case in a contemporary courtroom on the right side of the same panel, Benton made clear his family legacy of political commitment. Keyed to the urgencies of the Depression and assuming personal responsibility for the restoration of harmony between the republican ideal and the facts of real life in the 1930s, Benton reshaped the politics he inherited into the visual strategy of public art.

He elaborated on his liberal beliefs in a three-part series called "Confessions of an American," which he wrote for *Common Sense* in 1937. Begun in 1932 under the editorship of Selden Rodman and Alfred Bingham, *Common Sense* had been the organ for the League for Independent Political Action, a progressive third-party movement organized in the late twenties "to benefit farmers and wage earners." By the mid-thirties, when independent parties had gained no real political strength, the journal adopted a pro–New Deal stance on a variety of issues and

hosted a variety of articles by such diverse thinkers as John Dewey, Lewis Mumford, Max Eastman, James Rorty, and A. J. Muste. Largely through Bingham's leadership the journal offered a liberal or left-liberal focus on capitalist reform through the consolidation of the middle class and the labor force and through federal regulation of the economy. Transcending the traditional reform boundaries of the progressive movement, in which many of its writers (including Benton) had their intellectual roots, *Common Sense* advocated a kind of democratic socialism, a "fundamental reallocation of wealth and power," whereby a planned economy under the firm control of central government could transform America.[74] And, joining now conciliatory communists in the Popular Front, the editors at *Common Sense* were careful to add that this government control must be guided by an American public allied against fascism.

Benton's *Common Sense* essays, like his two latter murals of the 1930s, followed this line. Indeed, editor Rodman said Benton's articles, which he found "completely honest and profound," were "very close to the pioneer work that Bingham has been doing."[75] In the first essay, "Why I Don't Like Marxism," Benton contrasted the experimental and flexible makeup of his own pragmatism, or "what is called John Dewey's instrumentalist offshoot," with the "intellectual retrogression" of "absolutist" marxism.[76] Marxism, Benton explained, as he had three years earlier in his *Modern Monthly* article, simply did not correspond to the "Truth" of the American experience.

He explained why in his second *Common Sense* essay, "Marx and the Jeffersonian Ideal." He gave his full support to marxism's producerist ideology:

> The Socialism to which Communists aspire gives the ownership, the control, and the benefits of the productive mechanisms of society to those who work and produce rather than those who scheme. It gives power and freedom to those who labor and create, and puts the mark of the criminal on the cunning manipulator and exploiter. This is the ideal. Who can object to it?

But, he explained, actual communist practice "as it affects the common liberties of man seems to be identical with that of Fascism." Both communism and fascism adhered to "the leader principle" and were "contemptuous" of individual freedoms. Moreover, he observed, marxism in the U.S. simply could not contend with the "potent" strength of the middle class, to which he announced his proud fealty:

It is not really a class at all but a great shifting mass [with] a common psychological attitude toward what they take to be their personal rights in a world of free men. They are the children of more than a hundred years of democratic political practice and what is called "the American dream." They believe in the power of their vote and the fundamental rightness of their democratic political institutions. In its hands rests finally the power to determine the political nature of our future.[77]

Politically, this middle class adhered to a system of two parties, Democrat and Republican, which Benton admitted were hard to distinguish. But, he added, "I am a common Missouri Democrat. I vote the Democrat ticket." And, he explained, he was definitely not a "backward Democrat" who stuck to the "letter of Jefferson's individualistic agrarianism." Rather, he asserted his complete alliance with the merger of Jefferson's "liberal and humane spirit" and the necessities of modern-day capitalist reform. Foremost among the latter was the instilling of a social consciousness among America's corporate leaders. "Business men," he wrote, "have seen that business must justify itself as a form of social service in return for the liberty which democracy gave it to develop. They have seen that business must have a social function in harmony with our political ideals." To insure this, Benton said, corporations must be regulated "under social controls . . . which are politically administered" and which support the controlling influence of the federal government "in all the fields which involve necessary goods."[78]

This control, he explained in his final essay, "Class Rule vs. Democracy," must be constantly overseen by a well-educated public. "Capitalism," he summed up, "is doomed":

Can we attain a collectively controlled democratic economy by democratic means? I do not believe we can attain such an economy by any other means. Economic instrumentalities are going to be centralized. The important political trick, as I see it, lies in keeping political powers over these instrumentalities on a wide and continuously educated democratic base.[79]

This was hardly the voice of a conservative antimodernist speaking. He admitted that "the idea of free and independent states, groups and individuals freely cooperating" was personally more appealing, but he recognized that the changed world of corporate economics demanded that industrial capitalism be restrained by the federal government, "to control the business machine before it suppresses even the voice of de-

mocracy." He gave his support to organized labor—"somebody must question the powers of autocratic industrial management"—and urged the rest of the middle class to do the same. He advocated the power of the laboring electorate "over all fields of ownership which affect the lives of the mass of plain people who work," a kind of ownership which he admitted bordered on "collectivism." But he limited his support for labor by saying it "must remain severely practical" and avoid the "idealist" theories promoted in intellectual journals, such as *Art Front.* As he remarked:

> These groups have no relation to the practical aspects of the social struggle. Their ineffectual extravagances, their attitudinising, their patterned phrases, their idiotic emphasis on the importance of "ideology" smacks too much of the comic opera. Comic operas are all right but they are out of place on the battlefield where attention to the needs of the moment must not be turned by imaginative play acting.[80]

In his *Common Sense* essays, and in the visual episodes of his Indiana and Missouri murals, Benton did not advocate a hasty retreat to a preindustrialized American past but proposed the rapid reform of contemporary capitalism on terms similar to those articulated by the Roosevelt administration in 1937. Indeed, his articles were written at the time when New Deal economic regulations had made an impact: by the spring of 1937 "the country had finally pulled above 1929 levels of output." By the time they were published (July, August, and September 1937) the economy had taken a nosedive but they reflected a moment when it seemed as if government control of industrial capitalism had, in fact, made an impact. It is interesting to note that in the same issue as Benton's last essay the editors of *Common Sense* came to similar conclusions, abandoning their search for politically radical ways of creating capitalist reform (through, for example, the Popular Front) and declaring "it was never more important than today for the independent progressive and labor forces . . . to cement their ties to the New Deal."[81]

By 1937 then, as the tone of his *Common Sense* articles and the visual makeup of his Missouri mural both reveal, Benton was firmly aligned with the New Deal. He believed that "the new liberalist directions taken by actual political powers after Franklin Roosevelt's election" indicated a return to republicanism, both in the New Deal's emphasis on producerism and its burgeoning development of cultural collectivism. As he looked around after he finished the Missouri mural,

2.32. Joe Jones, *Harvest,* U.S. Post Office mural, Charleston, Missouri, 1939; oil on canvas mounted on masonite; dimensions unknown.

Benton could see that Roosevelt's concentration "on the solution of specifically American problems" was being carried out to the letter in hundreds of New Deal art projects all over the United States. In another corner of the state Joe Jones painted *Harvest* for the Charleston, Missouri, post office, offering a scene of agricultural productivity much like those in Benton's own murals (fig. 2.32). By 1943 Missouri would be dotted with thirty-two similar post office murals.[82]

Nationwide, through such agencies as the Federal Arts Project, New Deal patronage of the arts from 1935 to 1943 resulted in some 2,566 murals, 17,744 sculptures, 108,099 easel paintings, 250,000 prints, two million posters, and 500,000 photographs. Smaller agencies, such as the shortlived Public Works of Art Project (November 1933 to June 1934), the Treasury Section on Painting and Sculpture (October 1934 to June 1934), and the Treasury Relief Art Project (June 1935 to June 1939) also produced thousands of paintings and sculpture. Over a hundred community art centers were established, their art classes and exhibits attracting many Americans. Some twelve thousand artists were hired through government relief projects and hundreds of thousands more saw their creative output at the 450 exhibitions which traveled to city halls and public schools. A PWAP exhibit in 1934 at the Los Angeles County Museum of Art attracted 33,000 viewers, smashing attendance records for any previous California art show; almost as many turned out for a similar exhibit at the Corcoran Gallery of Art in Washington—and the media made much of the fact that the Roosevelts' selected 32 artworks from this show for display in the White House.

Spending $35 million during its ten-year foray into art patronage, the New Deal treated culture, from art centers to post office murals, from "Living Newspaper" theater productions to the complicated amassing of an *Index of American Design,* with a kind of seriousness never before experienced in America.[83]

The New Deal's arts patronage was, of course, not altruistic. Indeed, government support for art from the mid-thirties to 1943, when Congress axed what remained of the WPA, lay with its broad political desire to engender national unity. Accusations of "boondoggling" aside, New Deal recognition of the value of a national culture helped the Roosevelt government maintain broad public support during the 1930s. For all practical purposes, these government art projects were emergency labor relief programs for America's artists, but they also served to enhance the legitimacy of federal political maneuvers. Acting as the major patron of the arts during the Depression, the New Deal spurred a seeming renaissance in American art. As Benton noticed, murals like his own, many in a similar American scene style, were soon covering post offices, public schools, libraries, hospitals, and housing projects all across the country. In fact, he later took the credit for their impetus, saying these New Deal art projects were "largely sparked" by himself and other regionalist painters, including Grant Wood and John Steuart Curry.[84]

Ironically, Benton himself never completed a mural for a New Deal agency. He was given a postal commission in 1935 and made a few pencil studies. While he was initially enthusiastic about being "in on something which I believe has genuinely significant cultural prospects for the country," he soon turned the project down, claiming the "subject matter of the Post Office was just a bore." Perhaps, but it is equally probable that Benton—and many other artists of the period—did not like the aesthetic limitations imposed by the Treasury Section. The following subjects, said the section, were the only subjects suitable for public art: "the Post; Local History, Past or Present; Local Industries; Local Flora and Fauna; Local Pursuits, Hunting, Fishing, Recreational Activities; Themes of Agriculture or pure landscape." It was quite a list, but it was a list nonetheless and Benton preferred aesthetic autonomy. He later wrote of his "difficulties" in accommodating the "views of the Treasury's supervising committee." As soon as he was offered the Missouri mural opportunity, he "dropped the post office project flat."[85] While Benton was glad of New Deal "cultural prospects" for other artists, he was unsure about his own participation. He claimed commitment to

public art but claimed himself as the sole arbiter of that art, demonstrating an ambivalence about the depth of his commitment to the creation of national culture. Such ambivalence especially surfaced when Benton turned to corporate patronage in the late thirties, an act which convinced critics of his aesthetic self-interest.

Federal patronage of the arts during the Depression did more than give American artists employment and foster public appreciation for their efforts. Significantly, these New Deal art projects challenged traditional modes of support for American artists such as galleries and museums or the rigid control of the domestic market by the National Academy of Design. During the Depression, when private buyers largely vanished and art sales plummeted, when museums cut back on their exhibition schedules and the market price index for art shriveled (from 165 in 1929 to 50 in 1933), the federal government stepped in and took over the art market. Offering "social and economic integration" for American artists, emphasizing public accessibility by catering especially to art in the American scene style, the federal government actively pursued the development of a national culture. By so doing, the New Deal "sought to change the relationship between the artist and society by democratizing art and culture." Generating national unity through cultural sponsorship, the federal government used art to engender public support and legitimize the New Deal during a period of political disaffection. Roosevelt himself clarified the New Deal's creation of collectivism through culture in an address he gave at the 1941 opening of the National Gallery of Art:

> A few generations ago, the people of this country were taught to believe that art was something foreign to America and to themselves. But recently, within the last few years, they have seen in their own towns, in schoolhouses, in post offices, in the back rooms of shops and stores, pictures painted by their sons, their neighbors. They have seen rooms full of paintings by Americans— some of it good, some of it not good, but all of it native, human, eager and alive—all of it painted by their own kind in their own country, and painted about things they know and look at often and have touched and loved.[86]

For Benton, the New Deal's art projects confirmed his government's genuine interest in American collectivism. The federal government was assuming responsibility for the creation of national culture, and was doing so in ways that were broadly democratic. As Karal Ann Marling

explains in her book on New Deal post office murals, a compromising policy of "humane pluralism" characterizes government control of the arts during the Depression, in stark contrast to state patronage in Germany, Italy, and Russia at the same time. From one mural to the next, art style and art content varied (although the American scene style was the out-and-out favorite) and the public played a major role in the ultimate success or failure of each New Deal project. Moreover, "art workers" were taking an active role in creating public art. American artists, it seemed, were responding to the crisis of the Depression by shifting from self-oriented art to "art for the millions." Charles and Mary Beard observed in 1939:

> Artists and the wide public were now united as they had never been before in America. Through the patronage of the arts by the government of the United States, art was again to be a public affair, but emphasizing in form, color, and line the aesthetic affirmations of a democratic society wrestling with profound social disturbances, yet dreaming dreams of a greater dignity for man.[87]

For Benton, and for the Beards, these government-sponsored public art projects were one further indication of the successful revitalization of America's republican traditions under the guidance of the New Deal.

Meant as an inspiring, socially significant art which would link the American public with the reform ideology of the New Deal, Benton's murals were, controversy notwithstanding, well-known by the mid-1930s. Thomas Craven continued his jubilant support, declaring Benton's art "the outstanding style in American painting, perhaps the only style" in 1935. His praise, and *Time*'s 1934 cover story, snowballed into public and business world support for Benton and other regionalist artists in the rest of the decade. His art was steadily acquired by major museums during the 1930s, and corporate interest in utilizing the popular style of regionalism for public goodwill and product promotion was spurred in the mid-thirties. For Benton, big business interest in his art was especially appealing; perhaps through his art he could aid in the reform of the corporate workplace. It seemed the perfect opportunity to put into practice his aesthetic aspirations, and he looked with optimism to "the possibilities of a fruitful relation between big business and art."[88]

1. Barbara Rose maintains that Benton and other regionalists "wished to turn their backs on contemporary reality in order to preserve the atmosphere and life styles of times gone by." See *American Art Since 1900,* rev. ed. (New York: Holt, Rinehart, & Winston, 1975), 98. This reading of Beard is taken from David W. Noble's *End of American History: Democracy, Capitalism, and the Metaphor of Two Worlds in Anglo-American Historical Writing, 1880– 1980* (Minneapolis: University of Minnesota Press, 1985), 54–55. Emily Braun, in "Thomas Hart Benton and Progressive Liberalism: An Interpretation of the New School Murals," *Thomas Hart Benton: The America Today Murals* (New York: Equitable Life Assurance Society, 1985) also notes connections between Beard and Benton; see p. 24.

2. Thomas Hart Benton, "American Regionalism: A Personal History of the Movement," *An American in Art: A Professional and Technical Autobiography* (Lawrence: University Press of Kansas, 1969), 192.

3. Karal Ann Marling, "Thomas Hart Benton's Epic of the Usable Past," in *Thomas Hart Benton, Artist, Writer, Intellectual,* R. Douglas Hurt and Mary K. Dains, eds. (Columbia: State Historical Society of Missouri, 1989), 124.

4. Alvin Johnson, *Pioneer's Progress: An Autobiography* (Lincoln: University of Nebraska Press, 1952; reprint ed., New York: Viking Press, 1960), 328. The mural was removed in 1982 and sold to the Equitable Life Assurance Society, where it has been reinstalled on the first floor of their New York headquarters at 787 Seventh Avenue.

5. Noted in Braun, "Thomas Hart Benton," 18. On Pollock's involvement with the mural, see Deborah Solomon, *Jackson Pollock: A Biography* (New York: Simon & Schuster, 1987), 51.

6. Braun, "Thomas Hart Benton," discusses Wright on p. 21. Lewis Erenberg, *Steppin' Out: New York Nightlife and the Transformation of American Culture, 1890–1930* (Westport, Conn.: Greenwood Press, 1981), xiii. See also Lary May, *Screening Out the Past: The Birth of Mass Culture and the Motion Picture Industry* (New York: Oxford University Press, 1980), passim. Willard Huntington Wright was the brother of painter Stanton MacDonald-Wright.

7. On the New School, see Peter M. Rutkoff and William B. Scott, *New School: A History of the New School for Social Research* (New York: Free Press, 1986), 1–3, 12–16, 20–27. It should be noted that the proponents of the New School and *The New Republic* diverged on the issue of U.S. intervention in World War I.

8. Rutkoff and Scott, *New School,* 38.

9. Ibid., 49. See also Erenberg, *Steppin' Out,* 125–26.

10. Alvin Johnson, *Notes on the New School Murals* (New York: New School for Social Research, n.d.), 3.

11. Johnson, *Notes,* 7.

12. For information on modern American labor and the growth of mass industry, see David Brody, *Workers in Industrial America: Essays on the Twentieth Century Struggle* (New York: Oxford University Press, 1980), pp. 8, 38.

13. Benton, *An American*, 64.

14. John Baxter, *Hollywood in the Thirties* (New York: Paperback Library, 1970), 74.

15. Benton rejected preparatory sketches for the *America Today* mural which showed machines more prominent than men; see Karal Ann Marling, *Tom Benton and His Drawings* (Columbia: University of Missouri Press, 1985), 105.

16. On Sheets, see Joshua Taylor, *America as Art* (New York: Harper & Row, 1976), 244. Lloyd Goodrich reviewed the mural in "The Murals of the New School," *Arts* 17, no. 2 (March 1931): 401.

17. For facts on 1930s workers, see William E. Leuchtenburg, *Franklin D. Roosevelt and the New Deal, 1932–1940* (New York: Harper & Row, 1963), 1, 19; Irving Bernstein, *A Caring Society: The New Deal, the Workers, and the Great Depression* (Boston: Houghton Mifflin Co., 1985), 293–99; and Frederick Lewis Allen, *Since Yesterday: The 1930s in America* (New York: Harper & Row, 1972; originally published in 1939), 24.

18. "The American Scenes—Plural," *Survey*, December 1, 1930, p. 20. Goodrich, "The Murals of the New School," 401. See also "Lloyd Goodrich Reminisces," Part I, *Archives of American Art Journal* 20, no. 3 (1980): 16. The Whitney Museum of Art mural was sold in 1954 to the New Britain Museum of American Art, Connecticut.

19. Avis Berman, "A Pictorial History of the Whitney Museum," *Art News* 79, no. 5 (May 1980): 56; *Whitney Museum of American Art: History, Purpose, and Activities* (New York: Whitney Museum of American Art, 1937), 5.

20. Barr, quoted in Russell Lynes, *The Lively Audience: A Social History of the Visual and Performing Arts in America, 1890–1950* (New York: Harper & Row, 1985), 355. See also Nathaniel Burt, *Palaces for the People: A Social History of the American Art Museum* (Boston: Little, Brown & Co., 1977), 335.

21. Richard Pells, *Radical Visions and American Dreams: Culture and Social Thought in the Depression Years* (New York: Harper & Row, 1973), 96. Benton, quoted in "The Arts of Life in America," a statement prepared for the Whitney in 1932, reproduced in Matthew Baigell, ed., *A Thomas Hart Benton Miscellany* (Lawrence: University Press of Kansas, 1971), 22.

22. Benton, "The Arts of Life," 22–23.

23. Donald Davidson, "A Mirror for Artists," *I'll Take My Stand* (New York: Harper & Row, 1962), 40, 50–51.

24. Benton, "American Regionalism," 148.

25. "The Arts in New York," *Art and Decoration* 38 (February 1933): 58.

26. Mumford, quoted in R. Alan Lawson, *The Failure of Independent Liberalism, 1930–1941* (New York: G. P. Putnam's Sons, 1971), 208.

27. Andrew Bergman discusses Vidor and his expression of community val-

ues in *Our Daily Bread* in *We're in the Money: Depression America and Its Films* (New York: New York University Press, 1971); see esp. pp. 77, 79.

28. Rogers, "Article No. 3, Democratic Convention," *New York Times,* June 29, 1932, reprinted in Joseph A. Stout, Jr., ed., *The Convention Articles of Will Rogers* (Stillwater: Oklahoma State University Press, 1976), 139.

29. From Jerry Silverman, *Folk Song Encyclopedia,* 2 (New York: Chappell & Co., 1975): 227.

30. On Listerine, see Roland Marchand, *Advertising the American Dream: Making Way for Modernity, 1920–1940* (Berkeley: University of California Press, 1985), 18–19.

31. Paul Rosenfeld, "Ex-Reading Room," *New Republic* 74, no. 958 (April 12, 1933): 246; Wanda Corn, "Apostles of the New American Art: Waldo Frank and Paul Rosenfeld," *Arts Magazine* 54, no. 6 (February 1980): 162.

32. Davis's comments can be found in his "Rejoinder to Thomas Benton," *Art Digest* 9, no. 13 (April 1, 1935): 13.

33. Thomas Craven, "Politics and the Painting Business," *American Mercury* 27 (December 1932): 463, 466.

34. Thomas Craven, "American Men of Art," *Scribner's* 92, no. 5 (November 1932): 266 and "Politics," p. 466. Anon, "U.S. Scene," *Time* 24, no. 26 (December 24, 1934): 23–28.

35. A Century of Progress closed in November 1933, but was reopened (to increase city revenues) in June 1934. It finally closed on Halloween night, 1934. See "Chicago Fair," *Newsweek* 4, no. 19 (November 10, 1934): 32, and "Indiana at the World's Fair," *American Magazine of Art* 24, no. 8 (August 1933): 390. Benton's mural is now located at Indiana University, Bloomington.

36. Wallace Richards, "Information Concerning the Murals of Thomas Hart Benton in the Indiana Building at A Century of Progress," Archives of American Art (AAA), Microfilm Roll 1732, frame 47; Benton, "The Thirties," a handwritten manuscript among the Benton Papers, AAA, pp. 16–17. This has been published as Appendix 1, "The Thirties," in Bob Priddy, *Only the Rivers are Peaceful: Thomas Hart Benton's Missouri Mural* (Independence, Missouri.: Independence Press, 1989), pp. 219–62.

37. Thomas Hibben, an Indiana architect and friend of Benton's who helped him get the Indiana commision, wrote the introductory caption. See "The Thirties," Benton Papers, AAA, p. 8. Other captions were written by David Laurence Chambers, whose *Indiana: A Hoosier History with Illustrations from the Mural by Thomas Hart Benton* (Indianapolis: Bobbs-Merrill Co., 1933) was contracted by the Indiana Commission and sold at the pavilion. For further information on the mural, see the catalog *Thomas Hart Benton and the Indiana Murals: The Making of a Masterpiece* (Bloomington: Indiana University Art Museum, 1989).

38. Chambers, *Indiana,* pp. 44–45.

39. Otto Teegen, "Painting the Exposition Buildings," *Architectural Record* 73, no. 5 (May 1933): 366.

40. See "Inaugural Address of President Roosevelt," in John A. Lapp, *The First Chapter of the New Deal* (Chicago: John A. Prescott & Son, Publisher, 1933), 433, and Leuchtenburg, *Franklin D. Roosevelt and the New Deal,* pp. 41–55.

41. Sign noted in Leuchtenburg, *Franklin D. Roosevelt and the New Deal,* 47. Song by Baskette and Alban, 1933, from Susan Winslow, *Brother Can You Spare a Dime? America from the Wall Street Crash to Pearl Harbor: An Illustrated Documentary* (New York: Paddington Press, 1979), 62.

42. Noble, *The End,* 55, and Beard, *The Future Comes* (New York: Macmillan Co., 1933), 161, 163–64.

43. Winslow, *Brother Can You Spare a Dime?* p. 55. Frank Freidel, "Election of 1932," *History of American Presidential Elections, 1789–1968,* ed. Arthur M. Schlesinger, Jr. (New York: McGraw-Hill Book Co., 1971), 3:2738, notes that "those of higher social and economic status consistently tended to vote more heavily Republican" in the 1932 election. See also Beard, *The Future Comes,* 168.

44. Richards, AAA Roll 1732, frame 51.

45. Richards, letter to Lieber, 18 August 1933, AAA Roll 1732, frame 24. Written comments from pavilion visitors can be found in AAA Roll 1732, frames 61–65.

46. Benton, "The Thirties," Benton Papers, AAA, pp. 12–18.

47. Ibid., pp. 19, 35. *The New Hope* was published monthly by Peter Keenan in New Hope, Pennsylvania. See Benton's "American Mural," *New Hope* 2, no. 4 (August 1934): 12–13, 22–23.

48. For information on the John Reed clubs and the Artists Union, see David Shapiro, ed., *Social Realism: Art as a Weapon* (New York: Frederick Ungar Publishing Co., 1973), and Matthew Baigell and Julia Williams, eds., *Artists against War and Fascism: Papers of the First American Artists' Congress* (New Brunswick: Rutgers University Press, 1986). Benton, quoted in "American Regionalism," 168 and "The Thirties," Benton Papers, AAA, pp. 29–30. For a review of "The Social Viewpoint in Art," see Gertrude Benson, "Art and Social Theories," *Creative Art* 12, no. 3 (March 1933): 216–18.

49. Pells, *Radical Visions,* discusses the formation of the Popular Front on pp. 94, 294–95; see also Paul Buhle, *Marxism in the USA from 1870 to the Present Day* (London: Verso, 1987), 176–83, and Alan Wald, *The New York Intellectuals: The Rise and Decline of the Anti-Stalinist Left from the 1930s to the 1980s* (Chapel Hill: University of North Carolina Press, 1987), 80–81. Kwait, "John Reed Club Art Exhibition," *New Masses* (February 1933): 23–24.

50. Benton, "Art and Nationalism," *Modern Monthly* 8, no. 4 (May 1934): 236. Formerly titled *The Modern Quarterly,* the magazine became known as *The Modern Monthly* from 1933 to 1938. Wald suggests that it was a predecessor of the post-1937 marxist journal, *Partisan Review.* See his *New York Intellectuals,* 111–12.

51. Dewey, "Why I Am Not a Communist," and Hook, "Why I Am a Communist," *Modern Monthly* 8:135 and 165, respectively. On the American Workers party and its affiliates, see Wald, *New York Intellectuals*, 4, 102, 123, 178, and Terry Cooney, *The Rise of the New York Intellectuals, Partisan Review and Its Circle* (Madison: University of Wisconsin Press, 1986), 108–9.

52. Dewey, "Why I Am Not," 135. Benton, "Art and Social Struggle: Reply to Rivera," *University Review* 2 (Winter 1935): 74. Benton's essay was a response to Diego Rivera's essay, "Active Revolutionary Struggle Essential to Great Art," included in the same issue.

53. Benton, "The Thirties," Benton Papers, AAA, p. 29. For an overview of the aesthetic terms of the Benton-Davis debate, see Rose, *American Art*, 97; for the documents of their debate, see Shapiro, *Social Realism*, pp. 95–107.

54. Davis, quoted in Brian O'Doherty, "Stuart Davis: Colonial Cubism," *American Masters: The Voice and the Myth in Modern Art* (New York: E. P. Dutton, 1974, 1982), 72. See also Thomas Somma, "Thomas Hart Benton and Stuart Davis: Abstraction versus Realism in American Scene Painting," *Rutgers Art Review* 5 (Spring 1984): 46–55, for an overview of their compositional similarities.

55. Gerald Monroe, "Art Front," *Studio International* 188, no. 969 (September 1974): 69.

56. "U.S. Scene," *Time* 24:24; Stuart Davis, "The New York American Scene in Art," *Art Front* 1, no. 3 (February 1935): 6. On Hearst's *New York American*, see Wald, *New York Intellectuals*, 4.

57. Davis, "A Medium of Two Dimensions," *Art Front* 1, no. 5 (May 1935): 6; Diego Rivera, "The Revolutionary Spirit in Modern Art," *Modern Quarterly* 6, no. 3 (Autumn 1932): 54. For an overview of Communist party goals in America, see Buhle, *Marxism in the USA*. See also Rivera's article for the aesthetic components of marxism.

58. Benton, "Art and Nationalism," 235–36; "American Regionalism," 171.

59. Benton, "Why Mr. Benton," *Art Front* 1, no. 4 (April 1935): 4 and from a letter he wrote to *Art Front* in May 1935, as noted in Monroe, "Art Front," 66, 70; Davis, "Rejoinder," 13.

60. Benton, "Why Mr. Benton," 4; Davis, "Rejoinder," 13. Jules, quoted in Jeffrey Potter, *To a Violent Grave: An Oral Biography of Jackson Pollock* (New York: G. P. Putnam's Sons, 1985), 37.

61. Craven, *Modern Art: The Men, the Movements, the Meaning* (New York: Simon & Schuster, 1934), 312.

62. Benton quoted in "The Thirties," Benton Papers, AAA, p. 30. Matthew Baigell ("Thomas Hart Benton and the Left," *Thomas Hart Benton, Artist, Writer, Intellectual*, 19) argues that "unpublished passages among his papers suggest an anti-Semitic inclination." However, a close reading of these passages, such as the one quoted here, reveals more Benton's reflection on the difference in background between himself and the "young Jewish radicals" he worked with at the Peoples' Art Guild.

63. Karal Ann Marling, *Wall-to-Wall America: A Cultural History of Post-Office Murals in the Great Depression* (Minneapolis: University of Minnesota Press, 1982), 89.

64. Stanley Vittoz, *New Deal Labor Policy and the American Industrial Economy* (Chapel Hill: University of North Carolina Press, 1987), 12; James Burnham, "Comment," *Symposium* 4 (July 1933): 277, as noted in Pells, *Radical Visions*, 81–84, 374.

65. See, for example, Pells's analysis of American indifference to radical politics, *Radical Visions*, 86–88. On 1930s mass politics, see Alan Brinkley, *Voices of Protest: Huey Long, Father Coughlin, and the Great Depression* (New York: Vintage Books, 1983), xi.

66. Cooney, *The Rise of the New York Intellectuals*, 90.

67. Benton, quoted in "Mr. Benton Will Leave Us Flat," New York *Sun* (April 12, 1935), reprinted in Henry Adams, *Thomas Hart Benton: An American Original* (New York: Alfred A. Knopf, 1989), 242.

68. Meyer Schapiro, "Populist Realism," *Partisan Review* 4, no. 2 (January 1938): 57.

69. Benton, "Answers to Ten Questions," *Art Front* 1, no. 4 (April 1935): 2, and "Interview," New York *Sun*, April 12, 1935, noted in Baigell, *Benton Miscellany*, 78.

70. Matthew Baigell and Allen Kaufman cast Benton as a Jeffersonian populist in "The Missouri Murals: Another Look at Benton," *Art Journal* 36, no. 4 (Summer 1977): 314–21. Baigell reiterates this position, implementing psychoanalytic theory, in "Thomas Hart Benton and the Left," pp. 23–30.

71. Benton, "The Missouri Mural and Its Critics," manuscript among the Benton Papers, AAA, n.p., and published as Appendix 1, "The Missouri Mural and Its Critics," in Priddy, *Only the Rivers are Peaceful*, pp. 263–71.

72. Benton, quoted in "Thomas H. Benton Paints the History of Missouri, Starts Civil War," *Art Digest* 11, no. 9 (February 1, 1937): 10. For criticism of the mural, see Nancy Edelman, *The Thomas Hart Benton Murals in the Missouri State Capitol* (Jefferson City: Missouri State Council on the Arts, 1975), 1–4.

73. Benton, quoted in Edelman, *The Thomas Hart Benton Murals*, 2. On the controversy surrounding the mural, see Elizabeth Ourusoff de Fernandez-Giminez, "Thomas Hart Benton," in *Controversial Public Art from Rodin to di Suvero* (Milwaukee: Milwaukee Art Museum, 1983), 23–27. See also Priddy, *Only the Rivers are Peaceful*, pp. 83–127.

74. Lawson, *The Failure of Independent Liberalism*, 39, 43; Pells, *Radical Visions*, 74, 95. Benton also illustrated several articles for *Common Sense*, including Lester B. Granger's "What Future for the Negro?" 4, no. 4 (April 1935): 17; Thomas R. Amlie's "In Darkest Cleveland," 5, no. 7 (July 1936): 9; and Amlie's "How Radical Is the New Deal," 5, no. 8 (August 1936): 23–24.

75. Letter from Selden Rodman to Thomas Hart Benton, July 9, 1937, in the Benton Papers, AAA. For more on Bingham, see Donald L. Miller, *The New*

American Radicalism: Alfred M. Bingham and Non-Marxian Insurgency in the New Deal Era (Port Washington, N.Y.: Kennikat Press, 1979).

76. Benton, "Confessions of an American," Part 1: "Why I Don't Like Marxism," *Common Sense* 6, no. 7 (July 1937): 8, 9.

77. Benton, "Confessions of an American," Part 2, "Marx and the Jeffersonian Ideal," *Common Sense* 6, no. 8 (August 1937): 10–12.

78. Ibid., 12, 14.

79. Benton, "Confessions of an American," Part 3, "Class Rule vs. Democracy," *Common Sense* 6, no. 9 (September 1937): 20, 22.

80. Benton, "Class Rule vs. Democracy," 19–21.

81. Leuchtenburg, *Franklin D. Roosevelt and the New Deal*, 243; "New Deal or New Party," *Common Sense* 6, no. 9 (September 1937): 3, noted in Pells, *Radical Visions*, 311.

82. Benton, "The Thirties," Benton Papers, AAA, p. 35; Karal Ann Marling, "Joe Jones: Regionalist, Communist, Capitalist," *Journal of Decorative and Propaganda Arts* 4 (Spring 1987): 54; Marlene Park and Gerald E. Markowitz, *Democratic Vistas: Post Offices and Public Art in the New Deal* (Philadelphia: Temple University Press, 1984), 158, 216–17.

83. Francis V. O'Connor, *Art for the Millions* (Greenwich, Conn.: New York Graphic Society, 1973), 305; O'Connor, ed., *The New Deal Arts Projects: An Anthology of Memoirs* (Washington, D.C.: Smithsonian Institution, 1972), 12, 43–44; Richard D. McKinzie, *The New Deal for Artists* (Princeton: Princeton University Press, 1973), 29–32.

84. Benton, "American Regionalism," 192.

85. On Benton's Treasury Section studies and subjects, see Marling, *Wall-to-Wall America*, 140–41, 184, 81–82, and Benton, *An American*, 71. See Marling also for discussion of artist protests about bureaucratic review of public art commissions.

86. Park and Markowitz, *Democratic Vistas*, 5. See also Jane De Hart Mathews, "Arts and the People: The New Deal Quest for a Cultural Democracy," *Journal of American History* 62 (1975): 325. For statistics on the art market in the 1920s and 1930s, see McKinzie, *The New Deal for Artists*, 4. Roosevelt is quoted in Park and Markowitz, p. 6.

87. Marling, *Wall-to-Wall America*, 11, 13–15; Charles and Mary Beard, *America in Midpassage* (New York: Macmillan Co., 1939), 767.

88. Thomas Craven, *Modern Art*, 339; Benton, "After," a 1951 essay appended to his 1937 autobiography, *An Artist in America*, 4th rev. ed. (Columbia: University of Missouri Press, 1983), 292.

Thomas Hart Benton in

Hollywood: Regionalist Art and

Corporate Patronage

I n August 1937, Thomas Hart Benton went to Hollywood, sent on commission by *Life* magazine to paint a composite picture of the motion picture industry. Benton made a few quick portraits of such stars as Eddie Cantor and W. C. Fields and hobnobbed occasionally at chic gathering spots like the Cock and Bull but spent most of his time making carefully detailed sketches showing the movie business in action, from casting calls and director's meetings to set designing and soundtrack dubbing (figs. 3.1 and 3.2). The painted outcome of his movie industry observations was *Hollywood* (fig. 3.3), a large work (4½ ft. by 7 ft.) now in the collection of the Nelson-Atkins Museum in Kansas City. Placed in the context of Benton's movieland experiences, *Hollywood* reveals that Benton saw the motion picture industry as a place of work, an active place of dynamic production not unlike the steel mills and coal mines he had painted in his four earlier public murals. For Benton, Hollywood's workers were no different from those in New York, Indiana, and Missouri: common Americans collectively enjoined in the producer tradition. In *Hollywood* Benton envisioned worker control of the movie industry and, thus, the transformation of the American scene through the restoration of the producer tradition. Benton's vision of movieland producerism was not, however, shared by the editors of *Life* magazine, who rejected his picture.[1]

This episode in Benton's career reveals important links between the supposedly autonomous camps of modern art, corporate capitalism,

3.1. Thomas Hart Benton, *Set Designing*, 1937; ink wash on paper, 18″ × 14 ½″. Courtesy of the Trustees of the Benton Testamentary Trusts, Kansas City.

and political ideology in the 1930s. Indeed, the machinations of Benton's involvement with *Life* and other business patrons during the Depression points to the final stages of a dramatic shift in American

3.2. Thomas Hart Benton, *Dubbing in Sound,* 1937; ink wash on paper, 14 ½″ × 18″.
Courtesy of the Trustees of the Benton Testamentary Trusts, Kansas City.

identity begun some years earlier: from the organic framework of a pro-
ducer culture to the less autonomous world of consumerism.

 That the crash of 1929 resulted in a loss of faith in American busi-
ness during the Depression is, of course, an understatement. As the
Depression persisted throughout the 1930s, Americans were easily per-
suaded that businessmen, those self-styled proponents of plenty in the
1920s, were responsible for the economic failure and stagnation that
marked the 1930s. By 1932, when some twelve million were unem-
ployed and wages for those who still had jobs were slashed by 40 per-
cent, when more than nine million savings accounts had been wiped out
and tens of thousands of homes foreclosed, it was hard not to blame

3.3. Thomas Hart Benton, *Hollywood,* 1937; tempera over casein underpainting on canvas mounted on panel, *56″* × *84″.* Courtesy of the Nelson-Atkins Museum of Art, Kansas City, Missouri (Bequest of the artist) F75–21/12.

America's businessmen and their laissez-faire leader Herbert Hoover for the Depression. Benton, traveling around the country in the thirties gathering material for his murals, observed that the corporate magnates "who ran the country in the days of mounting prosperity and boom had lost their reputations for infallibility . . . from backwoods stores to the halls of legislatures, derisive jokes about 'their majesties' were becoming more and more frequent." The popularity of *Ballyhoo,* with its caricatures of Wall Street tycoons, and of movies such as Frank Capra's *An American Madness* (1932), in which the directors of a small-town bank are depicted as "greedy capitalists who place their own personal ambitions above the needs of the mass," highlighted American disillusion with corporate capitalism in the early years of the Depression.[2]

American distrust of government, on the other hand, which had also run rampant in the early thirties (as *Ballyhoo* and Benton's Whitney lunette *Political Business and Intellectual Ballyhoo* demonstrated) was

successfully undercut by a variety of New Deal public relations campaigns. Alphabet agency projects from post office murals to reforestation not only put Americans back to work but convinced them that government was working in their behalf. Such federal intervention in American cultural, social, and economic directions centered, of course, on converting the public to New Deal ideology and stressing the links between this version of reform politics and the country's original republicanism. Putting people to work on hospital, bridge, power plant, school, and local government projects through the CCC and the WPA, challenging private business economic control through the TVA, creating a collective national culture through the art centers, post office murals, and theater productions of the FAP and Section art projects, and hailing themselves as democratic leaders clearly distinct from the "privileged princes" and "economic royalists" of corporate capitalism, New Deal politicians worked hard to restore public confidence. With an official battalion in the mid-thirties of some two hundred and fifty public relations employees and an unofficial army made up of the thousands actually employed on New Deal projects, the federal government ably convinced the American public of its political success and stability.[3]

Although certainly stunned by the 1929 crash, big business was strangely acquiescent about resolving its own misfortune and restoring public confidence in industry until the middle years of the Depression. In the early thirties corporate leaders actually placed the blame for economic collapse on the American public's lack of "thrift and conservation"; William Leuchtenburg observes that "one of the most popular themes of business literature of the period was that the wealthy businessmen had suffered more than the worker." By the mid-1930s, business leaders complained mightily about New Deal infringement on free enterprise capitalism. The industrial recovery measures of the National Recovery Administration, which provided for minimum wages and maximum hours, were seen as a threat to corporate control; the constraints of the Securities and Exchange Commission were felt to discourage new investment. Roosevelt was rebuffed as "a traitor to his class," his New Deal damned as the onset of state socialism. The American press, itself a mouthpiece for big business, was overwhelmingly anti–New Deal, especially in daily editorials; Roosevelt-hating newspapers "had a combined circulation of more than twice the readership of newspapers that favored him in the election of 1936."[4]

Still, as advertising mogul Bruce Barton noted in a 1935 speech to the National Association of Manufacturers, the American public remained firmly aligned with the New Deal:

Industry and politics, at the moment, are competitors for the confidence and favor of the same patron, the public. Politics knows it; industry, for three years, has acted as if it did not.

Industry has stuck out its tongue at its political competitor. It has pouted and scolded and sulked. It has held luncheons and called on itself to unite and brow-beat the politicians. But the one person who can brow-beat the politicians is not Anybody; it is Everybody. Politics concentrates on that great truth; industry neglects it.

The way to restore public confidence in big business, as Barton explained in his address and in the advertising campaigns he led for General Electric, U.S. Steel, and Du Pont throughout the thirties, was for American corporations to convince the public that they had "great benefits to confer." Industry leaders had to persuade consumers that they were "more reliable than the politicians; that [they would] work for them more cheaply and with more satisfaction." While bountiful advertising of these "great benefits" could help restore public confidence in industrial goods, Barton also encouraged corporations to promote their public goodwill. Corporate America needed to stress the ways in which it, through "research, mass production, and low prices," created the "new products that give employment." Barton made it clear that business needed to promote *itself* as the authentic representative of the people: "Industry, in the long run, can and will do more for the people and their children than politics can ever do. But it must beat politics with its own weapon; it must speak not to the mind only, but to the heart." To do so, business needed to adopt a "new vocabulary" of unique visual elements to emphasize the new products, and hence new jobs, of modern corporate capitalism. With such a vocabulary "business might regain its rightful position of social and political leadership lost to the New Deal." [5]

In his speech Barton openly condemned the corporate magnate who said he did "not care what the common mass of people think about my business." Such a man was a "liability to *all* industry." Business must change and reform, he exhorted, shedding its old public image and its privileged stance of pouty elitism. Business must be reborn, and announce its new agenda: "to make ourselves popular with the Boss of the politicians, the public." While this could be done by adopting a new advertising strategy, success would depend on businessmen convincing the public—as New Deal politicians had—of their essential role in national life. In the thirties, corporate interest in public goodwill was in-

formed by the redefinition of republicanism in the modern consumer age. If an organic producer culture with its synthesis of self and society was the locus of nineteenth-century republicanism, in the changed industrial world of the modern machine age republican organicism became linked to leisure and consumption. The republican creed of American uniqueness, nationalism, and civic virtue was associated with mass consumerism. Barton urged business to compete "with the politicians for the owners of America" with the weapon of an already dominant consumer ethic.[6] And Thomas Hart Benton's regionalist art played a significant role in the manner in which American corporate capitalism became linked with this new republicanism.

Well before the Depression businessmen understood that attention to product design and promotion paid off, that corporate success depended on consumer approval of a particular corporate aesthetic. As a host of historians have begun to document, the transformation of American identity from a producer to consumer culture was well established by the 1920s. Encouraged in the nineteenth century to trust in the Protestant work ethic and its traditions of abstinence and thrift, Americans became convinced in the twentieth century of the "pleasure ethic" and consumption. As Warren Susman observed, the modern American "was encouraged increasingly (ways were found to help him) not to hoard his savings (a part of the evil of Puritanism) but to spend and spend. He was told that he no longer lived in a world of scarcity but in one of abundance and that he must develop new values in keeping with that new status." Lary May notes, further, that Americans absorbed "altered visions of success" which hinged on their new roles as consumers. As the world of work became increasingly hierarchical and alienating, Americans turned to consumer spending as a new way of achieving the American Dream. They continued to view themselves as key figures in the workings of modern economy (big business encouraged this), but their place in that economy had shifted dramatically.[7]

Advertising played an essential role in this shift by emphasizing the therapeutic benefits of consumption. In "The People as Consumers," a chapter in the 1933 findings of the President's Research Committee on Social Trends, sociologist Robert Lynd observed:

> During the past two decades the business of selling commercial products as substitutive reactions for more subtle forms of adjustment to job insecurity, social insecurity, monotony, loneliness, failure to marry, and other situations of tension has advanced to an effective fine art. The tendency of contemporary merchandising is

to elevate more and more commodities to the class of personality buffers. At each exposed point the alert merchandiser is ready with a panacea.

Such advertisements, Jackson Lears and Roland Marchand argue, maintained that work-related tensions could be released, and personal autonomy (and hence status) gained through product purchasing. But, as the president's report also found, consumption lagged far behind production in the early years of the Depression. How, businessmen asked, could consumer resistance be combated? How could public confidence in the economy be restored?[8]

The answer Barton and other advertising experts offered was with a new style of advertising and the invention of a corporate aesthetic. Thus, in the thirties advertising aggressively solicited consumer desire through visual, not rhetorical, tactics which personalized product consumption. Broadly speaking, in both the twenties and the thirties advertising promised self-fulfillment through consumption, but in the changed climate of the Depression, advertising took on the additional role of corporate promotion. Advertising strategies in the thirties including using more "down-to-earth and democratic" styles to working with modern styles, from creating new product designs to hiring well-known artists—such as Benton—to promote goods and companies. By the mid-thirties businessmen stopped sulking and began developing advertising tactics which not only sold products but proved that they were not, as B. C. Forbes of *Forbes Magazine* observed, "the ruthless and cold-blooded creatures they have been painted." Seeking public approval as the New Deal had, big business armed itself as Barton advised, hoping to "beat politics with its own weapon."[9]

Big business stopped haranguing New Deal public relations campaigns and began imitating them. During the middle years of the Depression the National Association of Manufacturers spent hundreds of thousands of dollars on newspaper ads and radio programs to promote big business, selling "free enterprise the way Proctor & Gamble sold soap." But corporate advocacy did not stop here. Businessmen saw that the New Deal had engendered public confidence by creating a collective national culture, a modern version of republicanism. They aspired to do the same. If post office murals stimulated public confidence in democratic politics, certainly arty advertising could do the same for capitalism.[10]

A case example is that of the Container Corporation of America, the industry leader in paperboard packaging. In 1935 CCA "initiated

an ambitious advertising campaign geared to win recognition for the company as an eminent exponent of art in commerce." First, the company developed a "uniform design image" whereby everything from trucks to office stationery sported the CCA logo: a plain box with a tilted top. Next, working with art director Charles Coiner of the N. W. Ayer and Son advertising agency and with European artists A. M. Cassandre, Toni Zepf, Herbert Bayer, Fernand Leger, and Gyorgy Kepes, the CCA created ads in a modern art style. As CCA founder Walter Paepcke told Coiner, "I want to give people the idea that our company is a new and progressive, modern operation. And I don't need a lot of text to do that if you can do it with art." General Motors did much the same at the 1939 New York World's Fair with its Futurama exhibit, a brilliant bit of institutional advertising which idealized the American future and directed its audience away from the labor disputes that wracked GM in the late thirties.[11]

Corporate use of fine art in advertising was not new: the Erie Railroad promoted itself through Currier and Ives prints in the nineteenth century, and Ayer chose pictures by Rockwell Kent and N. C. Wyeth to sell Steinway pianos in the 1920s. What was new in the thirties was how CCA, GM, and a host of other corporations actually used modern art—European and American, nonobjective and narrative, cubist and regionalist—to sell themselves. At the height of the Depression the merger of art and industry exploded as big business competed with the New Deal to become a modern day Medici. Some corporations did this directly, hiring artists to promote their products and hence the ideology of big business itself. The Dole Pineapple Company hired Georgia O'Keeffe, Isamu Noguchi, and Yasuo Kuniyoshi to "create pictorial links between pineapple juice and tropical romance"; DeBeers Diamonds commissioned Picasso, Dufy, Derain, Maillol, and Marie Laurencin to hawk fine jewels; the American Tobacco Company hired Benton and other American scene artists to sell Lucky Strike cigarettes.[12] Other corporate campaigns took a different tack. Abbott Laboratories, Encyclopaedia Britannica, and Time-Life Incorporated commissioned American art and reproduced it in their publications. Still other businesses took a subtler approach to self-promotion by amassing collections of modern art and exhibiting them publicly. IBM took the lead, establishing its collection in 1937, and Standard Oil of New Jersey and Pepsi-Cola soon followed. With all of these strategies big business aimed to do far more than simply establish itself as a new source of support for the contemporary American artist. Rather, corporate cultural philanthropy hinged on engendering public confidence. As Russell Lynes noted in 1949, "Al-

truism has not been the motive that has prompted diamond merchants, steamship lines, brewers, phonograph and pharmaceutical manufacturers, cigarette makers, and soft-drink bottlers to become large-scale art collectors and benefactors of artists. The motive, no matter how indirectly expressed, has been profit." [13] In their new role as "culture brokers," corporations in the 1930s and 1940s came to exert a tremendous influence on the meaning of modernism. If Benton and others adopted modern art as an oppositional stance, to challenge the status quo and emphasize new modes of cultural integration, big business adopted it to engender public support for corporate capitalism. Modernism became linked with consumerism.

The broker between the "culture brokers" and the artists for many of these corporate campaigns was a former newspaper reporter, artists' agent, and public relations expert named Reeves Lewenthal (1910–87). Born in Rockford, Illinois, Lewenthal knew both sides of the clientele that he managed from 1934 through the 1940s, having worked in the twenties as a small businessman, a reporter for the *Chicago Tribune,* and a personal publicist for London portrait painter Douglas Chandor. In the early thirties Lewenthal became the press agent for some 35 arts groups, including the National Academy of Design, the Beaux Arts Institute, and the Society of American Etchers.

From his experience as arts publicist for these conservative organizations Lewenthal came to recognize the inbred inertia of the American art market. Selling pricey art objects through high-class dealers to upscale clientele allowed art to maintain a certain ivory-tower character, but cut the art market off from significant profit. Focusing on high-priced goods and small-scale operations the art world shut itself off from the vast majority, the public body of consumers, and it shut itself off from their money. What the art market really needed to do, Lewenthal believed, was to adopt modern business procedures and cater to consumerism. The market needed to link consumer culture with the culture industry through an efficient, profit-oriented system of production and distribution. "The gallery system," Lewenthal observed, "is doomed. The rich collector class is dying out. There is no use in the galleries sitting around and complaining and waiting for the few old collectors who are left to come in and buy an occasional picture. American art ought to be handled like any other American business." [14]

Accordingly, in 1934 Lewenthal quit his public relations jobs and challenged the constraints of the art market by organizing his own business, the Associated American Artists. In July of 1934 he met with 23

artists in Benton's New York studio and ventured his proposal: he would hire each of them to produce etchings and lithographs and he would market their work for $5.00 a piece (plus $2.00 per frame) in department stores across the country. Lewenthal's publicity experience with the Society of American Etchers taught him that prints were relatively inexpensive to make and easily portable. They were the perfect medium to produce and distribute, and if the public could be persuaded to buy them Lewenthal knew prints would be easy money-makers.

Prior to Lewenthal's organization of the AAA, etchings and lithographs were published in limited editions of ten to a hundred prints and sold in galleries at prices ranging from $10.00 to $30.00 each. Under the FAP, New Deal artists churned out prints (nearly 250,000 prints were made from 11,285 original designs) but since they were usually distributed free of charge to schools and other public institutions artists made no money from outright sales. The AAA, by contrast, would publish prints in editions of 100–250 impressions and market them at low prices in places especially frequented by U.S. consumers. Artists would receive a flat $200.00 fee for each edition. Benton and the other artists, including John Steuart Curry, Adolph Dehn, Luigi Lucioni, Jerome Myers, and Margery Ryerson did not think they would make much money from Lewenthal's scheme, but they were game to try. What, in the middle of the Depression when they were not selling anything anyway, did they have to lose? As Lewenthal later observed, the AAA "couldn't have got them if their old galleries had been doing their jobs." The "old" galleries reacted to Lewenthal's art marketing by bouncing artists who signed AAA contracts; they were furious at Lewenthal's challenge to art world hegemony and worried that "a public sold on black and white prints would not be a market for paintings in color." They needn't have worried. Lewenthal's plans were no threat, and in fact anticipated the enormous expansion the art market would undergo from the 1940s to the present day. Eventually, Lewenthal's art market "marriage of producer and consumer" was celebrated in the *Magazine of Art* (in 1937), which said the AAA had won "an established place in the American art world" because it had "discarded outworn methods." [15]

By October 1934 Lewenthal had contracted over 50 department stores, from Wanamaker's and B. Altman's in New York to Bullock's in Los Angeles. Scarcely a city in the U.S. with a population over 150,000 failed to carry the AAA prints. Advertised as "signed originals by America's great artists, one price $5.00," they went on sale October 15. Lew-

enthal announced their availability in a flurry of mailers sent to newspapers, art magazines, and advertising journals. Cannily, his publicity focused on the patriotic and educational importance of buying the prints rather than making a direct appeal to consumer desire or art market profit. As *Prints* magazine reported, "Here is the first real movement against the flood of cheap foreign prints." The *New York Times* noted that "while the corporate structure of the AAA is necessarily commercial, the project represents an educational and promotional effort directed to bring about a wider understanding and appreciation of fine prints." [16]

To rouse the appeal of democratic culture, which the New Deal had begun to do in 1933, Lewenthal emphasized the populist nature of his AAA artists:

> The American artist realizes that in order to bring about a greater interest and appreciation of artistic accomplishment that a forceful contact with the public is needed. He realizes that yesterdays beliefs which stamped art as reserved for the wealthy have left their impressions of snobbery upon the majority today with the result that the uninitiated are timid where art ownership is concerned.
>
> Believing that the possession of a good work of art will more effectively stimulate an art interest the American artist further realizes that he must get genuine works into homes. [17]

Lewenthal's arts advocacy worked; Wanamaker's sold 1,300 prints the first day. But after six months sales fell off. The prints gathered dust and some stores marked them down for clearance. Undaunted, Lewenthal moved to a new marketing strategy: mail-order art.

Appealing directly to American consumers Lewenthal took out ads in *Time* and *Art Digest* and began selling the Associated American Artists collection of prints (fig. 3.4) by direct mail, "the way Montgomery Ward sells bathtubs and catsup." For ten cents in stamps consumers sent off for an AAA brochure listing "40 original etchings by 36 distinguished American artists." After receiving the catalog they could make their selections and a few weeks later hang the framed prints on their walls. Rather than depending on department stores to coordinate the flow of prints from manufacturer to consumer, the AAA became a mail order house and did it all itself: mass production, mass marketing, mass distribution. However, the AAA was hardly the collective suggested by its name. Instead, it was the perfect example of an efficiently run modern corporate enterprise, with Lewenthal firmly at its head. Benton later

3.4. Advertisement for the Associated American Artists, 1935. Reprinted from *Art Di-
gest*, January 4, 1935, back cover.

3.5. Advertisement for the Associated American Artists, 1940. Reprinted from *American Artist*, November, 1940.

recalled that the AAA "was not strictly speaking an association, at least not in the usual sense of the word. The artists involved had no hand in policy or management." [18]

Merging business world procedure with art world products, Lewenthal catered to consumerism by making art a commodity available to anyone, for a modest $5.00 fee. Fine art, the kind in museums, could be displayed in middle-class living rooms. As one AAA ad (fig. 3.5) boasted: "This is the moment you have waited for! Through this vital new Art Project you now can get museum-perfect Originals, personally signed by the artists, from the selfsame collection from which the Metropolitan Museum of Art, Chicago Art Institute, United States Library of Congress, Yale University and 74 other famous museums and galleries have acquired them."

Such ads personalized art consumption and appealed to the social ambitions of potential buyers by stressing that "the artist achieves his finest expression, attains a wider market only when every cultured person (not just wealthy collectors) can afford a genuine original." In other words, social status was limited and American art was doomed unless consumers purchased these five dollar prints. The genius of Lewenthal's scheme was that he challenged the idea of art as a luxury item and offered it as a popular product. Now "nobody," one article on the AAA pointed out, was "too poor to buy a masterpiece. Original works of art which once only museums and the rich could afford are now yours to live with at home." [19] Art consumption was one way to regain the social and self-esteem undercut by the Depression.

Sales, not surprisingly, boomed. Lewenthal jumped from a $30,000 loss in 1934 to a $50,000 profit in 1935. In the late thirties, responding to consumer demand that they actually "see" the art before they purchased it, the AAA moved from its spare 42d Street loft to a cushy Fifth Avenue gallery. By 1941 Lewenthal's operation was the "largest commercial art gallery in the world," a $500,000-a-year business occupying 30,000 square feet of prime New York real estate with art showrooms, offices, and shipping spaces. The mail-order $5.00 print business remained the spine of the organization, but the AAA soon expanded by selling much higher priced drawings and paintings, and by offering gelatone color reproductions of fine art. In the 1943–44 season the AAA handled 107 American artists and sold 62,374 prints and 1,736 paintings, netting an income of over a million dollars per month. The business branched out also, opening galleries in Chicago in 1945 and Beverly Hills in 1947. By the mid-forties the AAA staff included 53 clerical

workers, who sent out more than three million catalogs and gallery announcements each year. Business especially boomed during the Christmas season, when hundreds of pictures were shipped each day and Lewenthal sent monthly checks of $25,000 to $75,000 to his roster of artists.[20]

But it wasn't just good PR that made the AAA such a success. Lewenthal's triumph as the quintessential Horatio Alger of the arts came about because he catered to consumer desire for a particular kind of art: regionalism. From the first meeting in Benton's loft in 1934 until after World War II, the AAA focused almost exclusively on American scene art, already well known in the U.S. through critical, New Deal, and mass media attention. When Lewenthal saw Benton's picture on the cover of *Time* in late 1934 (fig. 2.18), he knew he was working with a winning product. He selected regionalism over other styles for several reasons, among them a personal feeling of "alienation" from European culture brought on by several unpleasant years of foreign schooling and the unsatisfying press work he had done in London for painter Douglas Chandor. Lewenthal recognized the incredible public appeal of regionalist style art:

I knew the regionalists were popular because their names were in the art magazines all the time. But they weren't popular enough, and they weren't making any money. Why, when I first went to Tom Benton's New York apartment he was living in utter squalor. I more or less rescued him.[21]

The members of the so-called regionalist triumvirate—Benton, Curry, and Wood—gave Depression era audiences pictures of what seemed to be ordinary, everyday Americana. From the stoic farmers of Wood's *American Gothic* (1930, fig. 3.6), to the country christening depicted in Curry's *Baptism in Kansas* (1928, fig. 3.7), and the industrial scene in Benton's *City Building* (1930, fig. 2.3), the regionalists seemingly captured the American scene. Much of the immense popular appeal of regionalism during the thirties hinged on its energetic and dynamic form and its appeal to American values through familiar and type-cast imagery. Audiences at the Indiana Pavilion, for instance, liked Benton's mural because after it grabbed them with its pulsating forms and gaudy colors, it told them a story of American progress and potential. Aspiring to cultural democracy and forecasting an American utopia based on the revitalization of the country's republican values, regionalism—like the New Deal—maintained public popularity throughout the

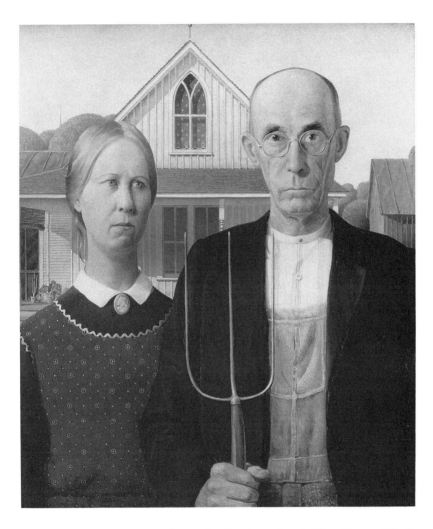

3.6. Grant Wood, *American Gothic*, 1930; oil on beaver board, 76 × 63.3 cm. Friends of American Art Collection, 1930.934. Copyright 1990 The Art Institute of Chicago. All rights reserved.

Depression. Helped along by the ballyhoo of its creators (all three waged well-publicized verbal campaigns publicly decrying the impact of European modernism on domestic culture and advocating the formation of a vital national art based on American values and experiences),

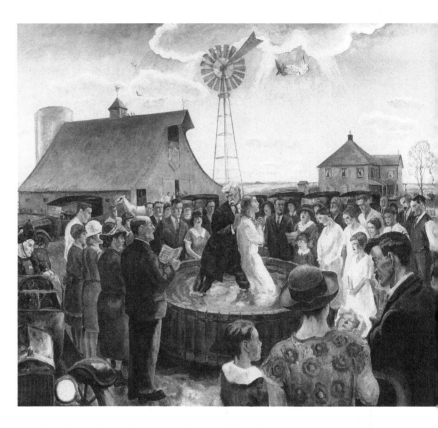

3.7. John Steuart Curry, *Baptism in Kansas,* 1928; oil on canvas, 40″ × 50″. Collection of the Whitney Museum of American Art, New York. Gift of Gertrude Vanderbilt Whitney. 31.159.

regionalism provided a panacea to Depression anxiety through a style which, ironically, appeared real, factual, and tangible.[22]

While the good fortune of the AAA certainly came about through Lewenthal's brilliant merchandising efforts, it was the appeal of regionalism that guaranteed his success. Benton's prints were the best-sellers of the business; his 1934 lithograph *Plowing It Under* (fig. 3.8) sold out almost immediately. A year earlier the Agricultural Adjustment Administration, under Secretary of Agriculture Henry Wallace and Under-Secretary Rexford Guy Tugwell, had arranged for millions of acres of Southern cotton to be "plowed under" in an effort to increase farm revenue by reducing output. Featuring a mule and his black driver, Benton's

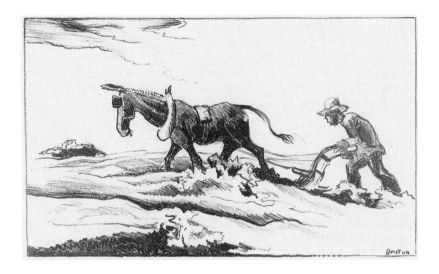

3.8. Thomas Hart Benton, *Plowing It Under*, 1934; lithograph, 13 ⅜″ × 8″. Courtesy of the State Historical Society of Missouri.

print, as he later recalled, showed "Tugwell's program in operation" and hinted of the $100 million in benefit payments that farmers collected that summer by teaching their mules to trample on rows of cotton.[23] In this simple print Benton showed the changes being implemented by the New Deal, federal action aimed at social improvement. Like his four murals, this print shows his support for the New Deal, even for crop destruction. This kind of picture, typical of the many others offered by the AAA's printmakers, who ranged from regionalists Curry and Wood to American scene artists Peggy Bacon, Arnold Blanch, Aaron Bohrod, Peter Hurd, Joe Jones, Doris Lee, Paul Sample, and Raphael Soyer, especially appealed to Americans in the Depression because it seemed to verify what they wanted to believe, namely, that the government was making real efforts to improve their lives. Aimed at a middle-class audience of American consumers, this kind of art sold like hot-cakes and helped create the AAA's incredible financial triumph.

So successful was Lewenthal's "marriage of producer and consumer" he soon arranged another marriage between producer, consumer, and corporation. In the late thirties, when businessmen strove to regain the public confidence they had lost to the New Deal, Lewenthal began to convince them of the rewards of using a popular style of Amer-

ican art in advertising. Like Bruce Barton, Lewenthal urged corporate leaders to adopt a new vocabulary to engender public support for their products and themselves. In particular, Lewenthal urged them to adopt a visual vocabulary already a proven favorite with the American public: regionalist art. Opening an "Art for Advertising Department" in its New York gallery the AAA declared:

> For a select group of industrial clients we have made our experience and the vast resources of our creative staff available in bringing the stimulation and beauty of great art into the practical everyday world of advertising. On every hand we have cooperated with the publishers of books and magazines, not only by providing the resources of our artistic talents for original commissioned illustrations, but also by furnishing outstanding creations for reproduction in every medium.

In the late thirties and until the mid-forties, the AAA served as a regionalist clearinghouse for a multitude of interested business clientele, ranging from Abbott Laboratories and the American Tobacco Company to Standard Oil and United Artists. Magazines, including *Time, Life, Fortune, Esquire, McCall's, Holiday, Look, Saturday Evening Post, Country Gentleman, The Farmer,* and *Coronet* also became regionalist patrons through the AAA.[24] Through these corporate commissions the regionalist style and its idealized iconography of reform became an even more popular style. But, in its new association with big business regionalism also came to be treated very differently by art world critics and eventually, by the American public.

Lewenthal's artists initially accepted his art-for-business commissions very willingly: AAA sponsorship was a substantial income boost. Benton reported that Lewenthal's deals brought his income up to "between twenty and thirty thousand dollars a year" from the mid-thirties to the late forties, an incredible sum for anyone, let alone an artist, in the Depression. Curry wrote that after accepting Lewenthal as his sole dealer in early 1941 he got "$4,000 worth of commissions" in just three weeks. And Grant Wood was rescued from financial trauma (he failed to pay income tax for three years in the 1930s, and a divorce in 1939 aggravated his financial difficulties) through Lewenthal's help.[25]

For Benton, particularly, the AAA's merger of art and industry seemed the perfect opportunity to further put into practice his aesthetic aspirations. He was optimistic about the "possibilities of a fruitful relation between big money and art." Working in the advertising industry

allowed him to act as a truly public artist and reach a far greater number of people with his regionalist message. Like the progressive era social reformers whose ideals were so much his own, Benton believed in the power of mass communication to create *community*. He harbored no hostility toward American industry; he simply wanted to see it as the contemporary locus of virtuous republicanism. Thus, he painted regionalist pictures for corporate America under two assumptions: first, that his art would aid in the reform of the corporate workplace, and second, that through this socially significant action, American art would be "returned to some functional place in the full stream of life."[26] Of course, the money he received from his mass media ventures was not unattractive.

Regionalism's first and foremost business patron was Time-Life, Incorporated. From its 1934 *Time* cover featuring Benton and the lengthy spread it gave Curry in *Life*'s first issue (November 23, 1936, fig. 3.9), to hiring regionalist artists like Benton as reporters, Time-Life supported regionalism for reasons related to profit and politics.

In February 1941 Henry Robinson Luce, chief editor, publisher, and spokesman for the Time-Life mass media empire, announced "America's Vision of Our World" in the most successful photojournal of the day, *Life* magazine. His "American Century" essay argued that America's providential mission was to assume "the leadership of the world." "We have," Luce wrote, "some things in this country which are infinitely precious and especially American—a love of freedom, a feeling for the equality of opportunity, a tradition of self-reliance and independence. . . . It now becomes our time to be the powerhouse from which the[se] ideals spread throughout the world." Taking his lead from nineteenth-century proponents of manifest destiny, Luce preached American republicanism cum imperialism in the twentieth century, which he called "the first great American century."[27] The cultural vehicle Luce selected to promote his vision of international republicanism was modern American art, an unusual choice, one might think, for the publisher of magazines directed at the masses. During the Depression and through the war years the kind of modern art most acclaimed by Time-Life was the American scene style of regionalism.

Time, Fortune, and *Life* embodied Henry Luce's vision of America. Born in China in 1898 to American Presbyterian missionaries, Luce transferred his inheritance of certain religious and political beliefs from the pulpit to the press. The call of capitalism replaced Christianity, and the goal of national consensus became an obsession. Early in the thirties

JOHN STEUART CURRY

Curry of Kansas

THE shirt-sleeved man with the pip
John Steuart Curry, just turning 3
of this Kansan's pictures of excitemen
eral and of Kansas in particular are s
the three following pages. The mural
lynchers and groveling fugitive (belc
now finishing for the U. S. Suprem
building. On December 1 he will acce
the strangest jobs ever offered a U.
His title will be "artist in residence
University of Wisconsin. At $4,000 a
duties will be to mingle with underg
ramble over Wisconsin farmland for
and occasionally drop remarks about
preciation of Art to students.

Wisconsin's apparent object is to st
from his native Kansas, which has
failed to buy his pictures. Curry's fathe
man in the hamlet of Dunavant, sh
neighbors by taking his honeymoon i
(see FATHER & MOTHER on oppos
His mother early told Son John a
wonderful Rubens paintings she had
London's National Gallery. But when
gan drawing on his slate in arithmetic
put down what he knew—crowing c
cackling chickens. Says he today: "
are foolishness when you can have

The Greatest Painter Kansas has produced,
John Steuart Curry, has long resented his
State's failure to appreciate him, its criticisms
of his Kansas pictures. His canvases were once
available to Kansans at $15 apiece. Now his
agents, Manhattan's Walker Galleries, ask over
$1,000 a picture. Currys hang in New York's
Metropolitan and Whitney Museums, Michi-
gan's Hackley Art Gallery.

When Curry attended the Kansas City Art
Institute in 1916, his fellow-students laughed
at his pictures and his 75c paint box. He went
on to the Chicago Art Institute, took two years
off to play halfback for Geneva College. He
failed at magazine illustrating, was supported
for two years by Art Patrons Seward Prosser
and Gertrude Vanderbilt Whitney. By the time
he was on his own (1929), he was painting real
pictures. That year he moved to Westport,
Connecticut, continued to paint Kansas. In
1931 he went traveling with Ringling Bros.
circus, painted elephants, trapezists, clowns.
Westport, learning to appreciate him, commis-
sioned him to do a double mural for its high
school. By this year his reputation had grown
sufficiently substantial for the United States
Government to take him up as one of its crack
decorators of New Deal buildings in Washington.
Big, round-faced and cheerful-looking, Curry
is actually gloomy and uncertain of himself,
has repeatedly decided he is no painter at all.

CURRY AT WORK ON A MURAL FOR THE U. S. SUPREME

28

3.9. "Curry of Kansas," *Life*, November 23, 1936. Reprinted with permission of Life

ADO OVER KANSAS

HER & MOTHER

Tornadoes Still Roar through the childhood memories of John Steuart Curry. In 1931 one skirted his father's farm. Two years before, Artist Curry painted the violent scene above in which a Kansas tornado is seen marching on a Kansas home as a terrible horn of destruction. As in many a Curry work, a great deal of life is organized into a compact composition, dominated in this case by the tornado funnel and the big, red-headed, Yankee father, barking at his distracted sons, while his green-faced wife enters the cyclone cellar.

The quiet scene at the left is Curry's aging father, alumnus of Kansas State University who fattens Herefords "so that the rain sets in the middle of their backs," and his art-loving mother. Through the window is the wide, flat Kansas noon. Like more Kansans, the Currys are of Scots-Irish stock. When they posed for their picture, in 1929, they were far from convinced that their son would establish himself as one of the half-dozen top-flight U. S. painters.

Luce encountered José Ortega y Gasset's *Revolt of the Masses* (1930), an analysis of contemporary Continental politics linking the rise of European fascism to the "hyperdemocracy" of an illiterate and irreligious mob. With his ideal of "democratic, capitalistic centrism" Luce was terrified by Ortega's gloomy assessment of world political and social conditions and their possible relationship to the American scene. He became convinced of Ortega's argument that national leadership demands men of morality who have a "consciousness of service and obligation." At the same time Luce became attracted to Benito Mussolini, especially admiring the way in which he and economist Vilfredo Pareto had transformed Italy from chaos to "corporate state." In a glowing 1934 account of Italy under Il Duce, *Fortune* observed that "Mussolini *did* make the trains run on time." Luce added: "a good journalist must recognize in Fascism certain ancient virtues of the race. . . . Discipline, Duty, Courage, Glory, Sacrifice." [28]

Assimilating the ideas of Ortega and Il Duce, Luce used his magazines to cultivate an American consensus centered on national unity, elite leadership, and capitalism. For Luce, those best qualified in America to lead and direct were her businessmen; Ortega's prophesied threat of "the triumph of mass man" could be subverted through the confident leadership of her corporate elite. In 1930 he urged America's "best young men" to join an aristocracy of big business, to which the masses and government were essentially subservient. "Business," he sermonized, "is what we believe in more than any other agency of society." He added that it would "never be run on a democratic basis." But, Luce warned his audience, this business aristocracy would only emerge when corporate America shed its secretive "self-consciousness" about making money and realize, in a paraphrase on Calvin Coolidge's adage, that "the business of business is America." Corporate America, Luce intoned, must assume an ever increasing public character and with it "public responsibility for the public weal." [29]

Luce's magazines were the missionary vehicles that helped to engender the success of this business elite. *Time,* born on 3 March 1923, was the "weekly news-magazine," an all-purpose compendium of brief, gossipy essays backed by candid photos and frequently, art reproductions (fig. 2.27). *Fortune*, a luxurious monthly inaugurated in January 1930, just months after the stock market crash, was completely dedicated to the workings of American business, which Luce declared in the magazine's prospectus was "obviously the greatest single common denominator of interest among the leading citizens of the U.S.A. . . . Our best

men are in business." In the late thirties *Fortune* sponsored a series of Round Tables in which corporate leaders discussed methods of restoring public confidence in big business and future plans for capitalist expansion.[30]

Life was devoted to a weekly parade of pictures, which Luce understood as "a new language, difficult, as yet unmastered, but incredibly powerful." In his prospectus for *Life* he revealed the primary visual focus of the magazine:

> To see life; to see the world, to eyewitness great events . . . to see strange things—machines, armies, multitudes, shadows in the jungle and on the moon; to see man's work—his paintings, towers, and discoveries . . . to see and to take pleasure in seeing; to see and be amazed; to see and be instructed.
>
> Thus to see, and to be shown, is now the will and new expectancy of half mankind.
>
> To see, and to show, is the mission now undertaken by *Life.*

His emphasis on the potential "mastery" of powerful images which could "instruct" their viewers suggests Luce's agenda as captain of American mass media. Pictures, he once wrote, were a "common denominator with low-brows." Thus, if properly "mastered," pictures could solicit and direct mass opinion. Indeed, former *Life* editor Wilson Hicks observed that pictures in *Life* were always presented to convey "the body of beliefs and convictions upon which the magazine was founded":

> *Life* looked at what people thought and did in particular ways. It stood for certain things, it entered at once the world-wide battle for men's minds. As a result, both word and picture took on extra meaning and vitality. If a picture was alive when it left a photographer's hands because of something he had put into it, it became still more alive for what it was to say as social, political or cultural report and commentary.[31]

In 1961 Luce remarked, "most of what I know and much of what I think, has been expressed in *Time, Life,* and *Fortune.*" Convinced that a "socially responsible mass media" could undermine the threat of mass man, Luce's magazines were structured to educate Americans "not only of their history but of the heritage of Western civilization."[32] *Life,* in particular, was the visual showcase for Luce's view of a free-market America led to a position of international superiority by her business-

men. Luce believed that corporate leadership would create a "Great Society," a better world, and he avidly promoted it.

Linked with this was his passionate anticommunism. As the heir of a system of religious and political beliefs overthrown in China, Luce turned his personal contempt for communism into a public calling. Determined that communism would gain no foothold in America, the Lucepress featured covers denigrating communist world leaders (fig. 3.10) and frequent articles condemning leftist political moves in the U.S. and elsewhere. One *Life* article gave advice on "How to Beat the Communists," and showed how "anti-Red" members of Pittsburgh Local 601 won a fierce 1949 battle over convention delegates and thus a "triumph for the democratic majority of U.S. labor." [33] As the pictorial bible of the Lucepress, *Life*'s special mission was to "see" and "show" the superiority of America's corporate industrial management as a political and economic model for the world.

From its inception in 1936, *Life* was a publishing industry hit. Initially, circulation outran revenue; a first run of 466,000 copies nearly killed it since ad rates had been set at 250,000. But, by 1939, with a circulation of more than two million (and ad rates substantially raised) *Life* had become one of the mostly widely consumed magazines in the country. In the late forties it reached "21 percent of the entire population over ten years old" and took in 19 percent of every magazine advertising dollar in America. Preceded by the Parisian *Vu*, the German *Munchner Illustrierte Presse*, and the London *Weekly Illustrated*, and followed by *Look, Photo-History, Picture Post, See, Photo, Picture, Focus, Pic*, and *Click, Life* was not the first or only picture magazine in the world, but it was the most successful. High quality picture reproduction and canny use of the photo-essay contributed to its popularity, but *Life* was a success because it correctly catered to what the American public especially wanted in a contemporary magazine: lots of pictures. If, as historian Neil Harris asserts, the past century is especially characterized as a "visual age," *Life* played a major role in disseminating information and ideas, and shaping their meaning, to an ever increasing body of consumers fluent in the language of pictorial communication. [34]

Life's editors focused the magazine's pictures in two major areas: photography and art. Both were strategically used in conjunction with headlines, captions, text, and story layout "to communicate editorial messages and politics, the respective roles of men and women in society, and the burgeoning progress of American culture." Although much attention has been paid to *Life*'s photographs, comparatively little study

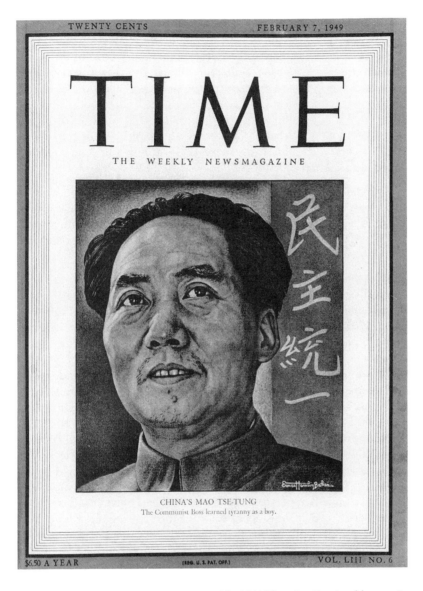

has been made of the art *Life* presented and often directly commissioned. And yet, a focus on art ("to see man's work—his paintings") was one of Luce's original objectives. Almost every issue of the magazine featured a page or more of color pictures printed on heavy coated enameled paper, a mass-reproduction process perfected in 1936 by R. R. Donnelley and Sons, the Chicago firm that printed both *Time* and *Life*. Luce was determined, according to *Life* biographer and former editor Loudon Wainwright, "to have stories somehow connected with Art (his capital) in almost every issue." In a memo to *Life* staffers in March 1937, Luce wrote:

> Especially this year we want to concentrate on American artists, and especially on those who delight in painting the American scene with some degree of sympathy. Except when genuine news interest exists, we want to avoid artists who are too bizarre or who exhibit a tortured satire.[35]

During the years of the Depression the Lucepress, *Life* in particular, especially patronized American art, covering everything from New Deal murals and contemporary California painters to art at the 1939 New York World's Fair. The American art that garnered the most attention from Time-Life during the late thirties and early forties was regionalism.

It seems a bit odd that this style, especially Benton's brand, gained leverage in the pages of the Lucepress during the Depression since it, like most of the American press at this time, was strongly anti–New Deal and its publisher supported the national leadership of a corporate elite. Emphasizing America's producerism and reform history, Benton's Missouri State Capitol mural, published in *Life* in March 1937 (fig. 3.11), disclosed a revival of a worker-determined economy. Producers—not corporate management—were the key figures in Benton's vision of a reconstructed American scene; workers controlling their workplace were those he considered best qualified to lead. Like New Deal politics, the social function of Benton's art involved the potential for change and improvement in America, not easy support for the status quo. Seemingly, Benton's aesthetic agenda was the antithesis of what Henry Luce was looking for.

But, the regionalists were also known for their chauvinism and it was on this level that Henry Luce responded to their art: it corresponded to his own nativist vision of American cultural superiority. Indeed, when Curry's pictures (fig. 3.9) were displayed in *Life*'s first issue,

the editors boasted that they were "particularly pleased that Art is represented here not by some artfully promoted Frenchman but by an American." A few months later Wood's *Spring Turning* (fig. 3.12) was featured in a full-color two-page spread, accompanied by this copy:

> In regional art Grant Wood is doing for Iowa what John Curry is doing for Kansas, Thomas Benton for Missouri. On his last visit to Germany, impressed by artists who drew their own environment, he suddenly decided his career was in Iowa. Wood's *American Gothic* brought him fame in 1930. *Daughters of Revolution* and other works later added to a reputation that today puts him in the front rank of U.S. painters.

In this manner regionalist and American scene art was featured in more than 29 separate stories in *Life* alone from 1936 to 1942, a number which far exceeded the magazine's attention to other styles.[36]

Life's full-color coverage of art was a great success with its consumers. Although one art magazine said critics and museum curators might find the quality of *Life*'s color pictures to be "cheap and shoddy," it observed that the millions who subscribed to the magazine found them highly "palatable." Indeed, within a few months of its start-up, *Life* was flooded with letters begging for more art reproductions. Pauline Colahan of Avenal, California, wrote, "Please, please, please give us colored pictures! Your black and white pictures are swell but *Life* without color is a stagnant thing." Fay Le Compte, Jr., of Williamsburg, Virginia, echoed with "long life to *Life*'s art presentations!" Some art lovers told how they were using the pictures: "The Grant Wood picture was big and fine and good. We framed it and it was wonderful." Even artists responded favorably: New York painter Yacob Pell wrote, "I said to myself and my friends, 'here is at last a magazine that will bring to the eyes of the public American works of art.' The reproductions you have had of American artists' works were very fine. How about more?" In the Letters to the Editors column of 12 April 1937 *Life* readers demanded more of two topics—art and movies—and *Life*'s editors set about providing exactly what their audience asked for. Coverage of the arts was soon expanded to a separate weekly section and the use of color reproductions was stepped up. Reader response proved that art generated consumer confidence, and *Life*'s editors made sure to feature large suitable-for-framing color pictures of American art frequently.[37]

Up to this point *Life* simply reproduced artwork already extant in galleries or museums or post offices, but through the auspices of Reeves

THOMAS BENTON PAINTS A HISTORY OF HIS OWN MISSOURI

IN 1935 the Missouri legislature commissioned Thomas Hart Benton to paint a mural history of the State on the walls of the lounge in the State House in Jefferson City. It chose Tom Benton because he is Missouri's ablest painter and comes from one of Missouri's most distinguished families. The legislature, however, never expected to get anything like the Benton History of Missouri which was completed just before this year's session began in January. No pretty glorification, the murals turned out to be a raw and animated review of Missouri's past and present (see pages 35-37 for color reproductions). They gave full space to Missouri's first settlers, its first railroad, its agriculture and industry, its great Champ Clark. But they also gave space to a slave auction, a lynching, Jesse James of Clay County, Frankie and Johnny of St. Louis. Loud were complaints that Benton was vulgar, that he had distorted Missouri into a "houn' dog State." But Benton supporters pointed out that Missouri was, after all, a "houn' dog State" whose natives did call each other "pukes." As the fuss subsided, Missourians began to look at the murals more calmly. Though they admitted that the pictures were interesting, they still felt that it wasn't a fitting way for a son of Missouri to tell the story of his native State.

The Missouri State House is in Jefferson City, right on the edge of this hay field. Since it was finished in 1917 many a mural has been painted on its walls, all of them much more staid than the gaunt and lively c with which Thomas Hart Benton covered 45,000 sq. of wall space in the House of Representatives' loun

The Missouri House of Representatives, shown in session above, convened last January to find that the subject of most violent discussion was Art, i.e. the Benton murals. There was an outburst of acrid comment but, Mr. Benton having finished his job and been paid $16,000, most legislators felt it was too late to do anything. Some die-hards, led by Chairman of Appropriations Commit Taylor insisted they would move to have the mur obliterated. It seemed unlikely that they would succe

3.11. "Thomas Benton Paints a History of His Own Missouri," *Life,* March 1, 1937.

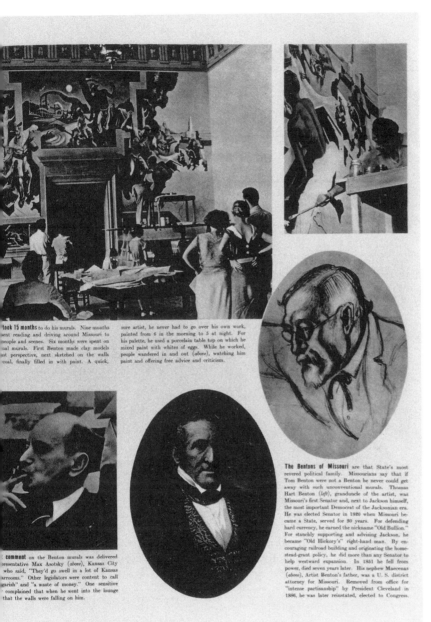

took 15 months to do his murals. Nine months spent reading and driving around Missouri to people and scenes. Six months were spent on tual murals. First Benton made clay models ast perspective, next sketched on the walls coal, finally filled in with paint. A quick,

sure artist, he never had to go over his own work, painted from 6 in the morning to 3 at night. For his palette, he used a porcelain table top on which he mixed paint with whites of eggs. While he worked, people wandered in and out (*above*), watching him paint and offering free advice and criticism.

comment on the Benton murals was delivered resentative Max Asotsky (*above*), Kansas City who said, "They'd go swell in a lot of Kansas arrooms." Other legislators were content to call garish" and "a waste of money." One sensitive complained that when he went into the lounge that the walls were falling on him.

The Bentons of Missouri are that State's most revered political family. Missourians say that if Tom Benton were not a Benton he never could get away with such unconventional murals. Thomas Hart Benton (*left*), granduncle of the artist, was Missouri's first Senator and, next to Jackson himself, the most important Democrat of the Jacksonian era. He was elected Senator in 1820 when Missouri became a State, served for 30 years. For defending hard currency, he earned the nickname "Old Bullion." For staunchly supporting and advising Jackson, he became "Old Hickory's" right-hand man. By encouraging railroad building and originating the homestead-grant policy, he did more than any Senator to help westward expansion. In 1851 he fell from power, died seven years later. His nephew Maecenas (*above*), Artist Benton's father, was a U. S. district attorney for Missouri. Removed from office for "intense partisanship" by President Cleveland in 1886, he was later reinstated, elected to Congress.

3.12. Grant Wood, *Spring Turning*, 1936; oil on masonite panel, 18 ⅛″ × 40″. Private

Lewenthal and the AAA's "Art for Advertising Department" *Life*'s editors began commissioning American artists to produce works specifically for the magazine. Like the texts and photographs carefully selected by the Lucepress, these commissioned artworks were largely connected with Henry Luce's expectations of America's political and economic future.

In mid-1937, *Life* hired Benton, probably through Lewenthal and the AAA, to provide sketches of an apparent "labor war" brewing in Michigan. Benton was picked as the magazine's visual reporter because

Collection. Courtesy of James Maroney, New York.

he was "the ablest living painter of the American scene" and as the "great-great-nephew of Missouri's first Senator" was "a serious student of that scene." *Life* knew Benton was a man to have on their side: earlier coverage of his hard-won battle with Missouri congressmen over his Jefferson City mural proved he was a skilled fighter. Benton was sent to Michigan during the July 4th weekend to gather the facts on leftist union organizing in Flint and to find out if anti-red vigilantes were really preparing for warfare in Detroit. The weekend promised to be a bloody one if events in South Chicago during the previous Memorial Day holi-

day, when a demonstration by striking Republic Steel workers resulted in ten dead and more than a hundred wounded, were any indication. Seventy-thousand steel workers in seven states were still out on strike and July 4th rallies were scheduled in major cities across the country.

Positioned in Michigan, Benton was to attend both labor and anti-labor gatherings to see if the state was really "verging on civil war." Seventeen of his reportorial sketches were published in *Life*'s July 26 issue, nudged in the middle of a lengthy nine-page spread on reports of burgeoning U.S. political extremism (figs. 3.13 and 3.14). Mid-1937 newspaper headlines "shrilled and boomed with alarms of the growth and imminent armed clash of fascist and communist forces," despite the fact, said *Life,* that "none of these has yet appeared convincingly in the U.S." To prove it the magazine offered its own "pictorial account of the struggle to date."[38] The visual truth inherent in their photographs and in Benton's on-the-spot sketches would show *Life*'s view of the situation, namely, that neither organized labor, even with its red infiltrators, nor vigilante alarmists, were a serious threat in America.

The situation in Flint was very serious from December 30, 1936, through February 11, 1937, when sit-down strikers occupied General Motors Fisher Body No. 2 plant to protest the company's discipline of laborers with United Automobile Workers membership. Production and corporate profits plummeted as strikes spread to other GM plants. Finally, despite several violent attempts to dislodge the strikers, the shutdown was settled in the UAW's favor. This was a major victory for mass-production unionism in the auto industry, "the inclusion of all workers in an industry within one union." In the case of the auto industry, the UAW was an arm of the Congress of Industrial Organizations (CIO), the "unionizing agency for the basic industries." As David Brody and other labor historians have documented, the emergence of CIO-affiliated unions at Flint and elsewhere in the mid-1930s was of the utmost significance because labor, for the first time, gained power in hitherto unorganized mass-production industries such as steel and rubber. Although craft unions had certainly existed in these industries, the CIO recognized that true power lay not with these limited groups of skilled laborers but with the larger organization of all workers. The CIO recognized the strength of mass man. Encouraged by the legal framework of the New Deal's Wagner Act, which protected labor's right to organize, and by the collapse of welfare capitalism's "company paternalism" under the strain of the Depression, CIO mass-production unionism emerged. With success at Flint came other strikes at other auto plants

(Chrysler, for example) and a tremendous jump in UAW membership, from 30,000 to 400,000 in a single year.[39] The latter in particular, with its suggestion of a transfer of power from corporate leadership to workers, must have worried Luce and *Life*'s editors, especially when reports of communist links to the UAW began circulating. As the threat of worker communism aroused right-wing alarmists throughout the state, *Life* editors knew "it was time to take notice" and set the record straight. Benton's art would help.

His contact in Michigan may have been Charles Pollock, a student (like his brother Jackson) during Benton's New York teaching days at the Art Student's League in the early thirties. Charles Pollock was now a layout editor and political cartoonist in Detroit for *United Automobile Work*, the UAW weekly newspaper, and through him Benton may have gained access to the union's Flint headquarters.[40] In the short snappy text that accompanied his sketches, *Life*'s readers were informed:

> Shunning the ease of an out-of-town newshawk whom they found reporting Michigan's "revolution" from the rear (Sketch No. 1), Thomas Benton and his guide set out for Pengelly Hall, United Automobile Workers headquarters in Flint. Often compared to Leningrad's Smolny Institute, nursery of the Russian Revolution, Pengelly showed nothing more sinister than workmen and women musing and talking over their beer (Sketch Nos. 2, ll, 14).

The satirical tone of the text (written by *Life* editors) was matched by the captions Benton provided for his drawings, from *Reds and Red-Hots* to *Workers! You've Got Nothing to Lose But Your Change*.

His sketches were much more ambivalent, however, more like "pleasant genre scenes" than the rabid antiunion, anti-red editorials *Life*'s editors made them out to be. Sketch No. 11, for example, called *Tactical Discussion in Flint's Smolny Institute* (fig. 3.14) was, as Benton himself later recalled, simply an eyewitness account of a "discussion between a union recruiter and a negro worker." Two men sharing a couple of cold ones was Benton's view of "tactical discussion." Not particularly flattering and not exactly a derogatory swipe, Benton's benign picture was hardly the disparaging satire suggested by its title. Certainly, if he had wanted to take a satirical stand he could have; *Political Business and Intellectual Ballyhoo* shows us that. But, although a champion of worker empowerment, Benton's rendering of the labor scene in the summer of 1937 is remarkably neutral. It is quite unlike, for instance, Philip

(continued)

ARTIST THOMAS HART BENTON HUNTS COMMUNISTS AND FASCISTS IN MICHIG

By mid-1937, rumors of the clashing rise of communism and fascism in America's industrial midland had grown so urgent that the imperturbable New York *Times* assigned one of its ablest reporters, F. Raymond Daniell, to investigate. He sped to Michigan, turned in an alarming report of a State verging on civil war. Solemnly he pointed out that "both armies are highly mobile" and "it is a rare household that has not at least one deer rifle or shotgun."

LIFE then decided to see for itself. For eyes it picked famed T Benton, not only because he is perhaps the ablest living painter of can scene (LIFE, March 1) but also because he, great-great-ne souri's first Senator, is a serious student of that scene. Guided by Detroit reporter, Painter Benton pursued his search over the July The resulting sketches, with captions by Benton, you see on these

SURROUNDED BY CURIOUS YOUNGSTERS, MR. BENTON MAKES SKETCHES FOR LIFE IN DETROIT'S SCHWABEN PARK

1—"BATTLE FRONT OF REVOLUTIONARY MICHIGAN"

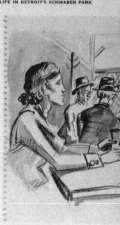

2—"PROLETARIAN DREAM OF THE FUTURE—W

3.13. "Artist Thomas Hart Benton Hunts Communists and Fascists in Michigan," *Life,*

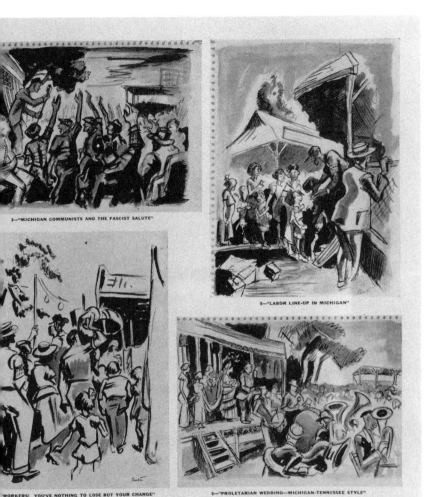

3—"MICHIGAN COMMUNISTS AND THE FASCIST SALUTE"

5—"LABOR LINE-UP IN MICHIGAN"

WORKERS! YOU'VE NOTHING TO LOSE BUT YOUR CHANGE"

6—"PROLETARIAN WEDDING—MICHIGAN-TENNESSEE STYLE"

g the case of an out-of-town newshawk whom they found reporting gan's "revolution" from the rear (Sketch No. 1). Thomas Benton guide set out for Pengelly Hall, United Automobile Workers head- in Flint. Often compared to Leningrad's Smolny Institute, nursery ussian Revolution, Pengelly showed nothing more sinister than work- women musing and talking over their beer (Sketch Nos. 2, 11, 14). ly conservatives that they would see a real "communist outing," nd guide proceeded next day to a big U.A.W. picnic in Flint Park. flags were in evidence, but the investigators did see "communists" scist salute in response to a speaker's query (3). They also saw picnick- ling around the game concessions (4); children lining up at the gate of

the baseball diamond (5); a unionist being publicly married by a Tennessee hill- billy preacher (6); assorted merrymakers just eating and loafing (9, 10, 13, 15, 16).

Painter and guide now turned their search toward Fascism. Just outside Detroit they discovered Schwaben Park, one of the many woodsy hideaways where they had heard that German-Americans, "undoubtedly Nazis," were reg- ularly engaging in uniformed parades, firearm practice, mounted drill. Schwa- ben's gatekeeper (7) invited them to beer and pretzels. Inside they were treated to the sight of fair-haired children riding ponies and popping air rifles while their elders listened to the music of a brass band (8, 12). Trudging on, LIFE's investi- gators tracked down American Legionnaires, reputed backbone of Michigan's vigi- lante movement, parading lustily at a Rose Festival in suburban Roseville (17).

CONTINUED ON NEXT PAGE

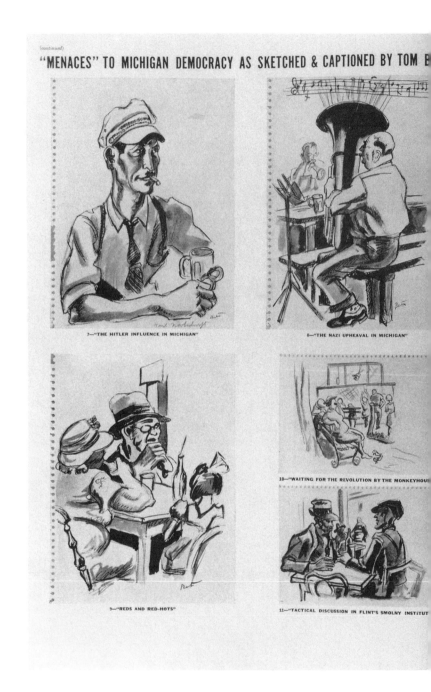

3.14. "'Menaces' to Michigan Democracy As Sketched & Captioned by Tom Benton," *Life,*

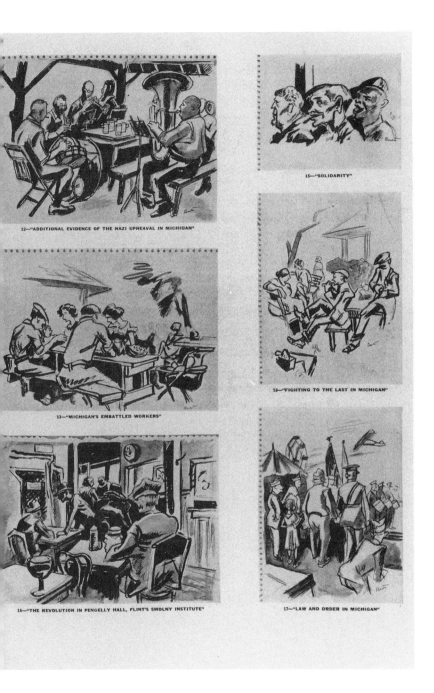

12—"ADDITIONAL EVIDENCE OF THE NAZI UPHEAVAL IN MICHIGAN"

15—"SOLIDARITY"

13—"MICHIGAN'S EMBATTLED WORKERS"

16—"FIGHTING TO THE LAST IN MICHIGAN"

14—"THE REVOLUTION IN PENGELLY HALL, FLINT'S SMOLNY INSTITUTE"

17—"LAW AND ORDER IN MICHIGAN"

July 26, 1937. Reprinted with permission of Life Magazine. Copyright Time Warner, Inc.

Evergood's contemporary illustration of labor warfare, *American Tragedy* (fig. 3.15). A depiction of the bloody Memorial Day Massacre at Republic Steel, Evergood's picture demonstrates his obvious support for the striking workers.[41] By comparison, Benton's sketches are—their ordinary subjects notwithstanding—extraordinarily uncertain, an unusual state of affairs given his obvious interest in the producer tradition.

Perhaps it was Benton's disdain for leftist politics, a carry-over from his battle two years earlier with Davis and other *Art Front* activists, that led to the overall ambivalence that characterizes these *Life* sketches. Benton's conflict with the left stemmed in large part from his lack of comprehension regarding issues of class and the obvious changes facing American workers. The emergence of mass-production unions in Flint suggested that the organic producerism that he, Lewis Mumford, Charles Beard, and many other liberals hoped to see revived in modern America was a pipe dream. The producer of the past simply did not exist in the giant factories of modern industry.

Perhaps the benign flavor of these sketches resulted from Benton's uneasiness about the direction worker empowerment *was* taking in the late thirties. It was obvious that organized labor was creating social and economic transformation, but it was not exactly the kind of change Benton had envisioned in his murals. Unions rather than individual producers, demanding wage increases rather than producer autonomy, were making a significant impact on the lives of American workers, but this was not Benton's vision of reinvigorated republicanism. Years later he recalled that in Michigan he "found neither talk about [nor] desire for revolution—only an itch for more money."[42] Even if Benton believed this in 1937, his sketches do not betray money-hungry proletarians any more than they show communist or fascist mobs. Perhaps Benton assumed that *Life*'s editors expected him to act as a reporter, an objective recorder of the facts, and he offered pictorial neutrality as part of the job—and as a way of dealing with his own confusion about the direction of the labor movement in the late thirties. If he made this assumption, however, he was mistaken. His ambivalence and the neutrality of his pictures simply wound up serving *Life* by reinforcing Henry Luce's denunciation of mass man.

This is evidenced further in the sketches he made of the picnics he attended over the weekend, a UAW picnic in Flint and several holiday get-togethers in various Detroit parks. At the UAW gathering Benton illustrated typical picnic scenes of hot-dog eaters and baseball enthusiasts. *Life*'s account of the Flint affair, however, was notably sardonic:

3.15. Philip Evergood, *American Tragedy*, 1937; oil on canvas, 29 ½″ × 39 ½″. Private Collection. Courtesy of the Terry Dintenfass Gallery, New York.

Assured by conservatives they would see a real "communist outing," Benton and guide proceeded next day to a big UAW picnic in Flint Park. No red flags were in evidence, but the investigators did see "communists" give a Fascist salute in response to a speakers's query (3). They also saw picnickers crowding around the game concessions (4); children lining up at the gate of the baseball diamond (5); a unionist being publicly married by a Tennessee hillbilly preacher (6); assorted merrymakers just eating and loafing (9, 10, 13, 15, 16).

In Detroit, sent to find proof of Midwestern fascism and Nazi-sympathizing subversives, Benton found mostly beer drinkers, pretzel

eaters, and big band fans (picture nos. 7, 8, and 12). In his sketch of a group of American legionnaires, whom *Life* termed the "reputed backbone of Michigan's vigilante movement," Benton provided only a mundane scene of a few elderly men in uniforms (picture no. 17). His pictures were utterly banal, the neutral offerings of an artist trying to act as an objective reporter. But, *Life* was not interested in simple reportage. Ambivalent alone, Benton's sketches were beefed up with textual parody and farcical titles. As it had in its satire of the UAW picnic, *Life* ridiculed the vigilante overtones of the "reputed" right-wing gatherings in Detroit. Both left- and right-wing politics with overtones of mass membership were treated with equal disdain. Their inherently ambivalent and intended documentary meaning altered by context, Benton's sketches were rendered both effective political satire and corporate capitalist propaganda.

One letter to *Life*, written by a group of left-wing New York artists, cannily recognized Benton's "thorough confusion on the issues of Communism and Fascism:"

> Although these drawings purport to deal with these political issues, as evidenced by the captions, they seem deliberately perpetrated for the purpose of ridiculing American Labor and deriding the dignity of the American Labor movement. In such troubled times as these, when poverty and depression are making themselves everywhere felt, and American Labor is nevertheless struggling loyally and desperately to make the best of the situation, such "gags" can be evaluated only as an insult to the American public.[43]

As these artists noted, at Time-Life, Benton's regionalist art, a modern style developed to challenge established notions regarding culture and society, was placed in an institutional context which did not threaten but actually helped to solidify the political and social tenets of Henry Luce's "American Century."

In addition to hiring America's fine artists to report on contemporary culture, in the late thirties *Life* began to commission them to depict "scenes from American history in the last 25 years." The idea was the brainchild of *Life* editor Daniel Longwell, formerly an adman at Doubleday and then an editor at *Time*. Longwell discovered, like Luce and Lewenthal, the power of pictures. As he explained, "Man's gift, his ability to depict things, has tended to be the exclusive property of a few. If *Life* has tended to a greater democratization of the artist, tended to

make their work shared by as many as possible, then it has accomplished its fundamental philosophy." But, lest the "democratization" of American art be seen as *Life*'s only objective, a perusal of the paintings commissioned by the magazine from 1939 to 1941, from artists almost exclusively on Lewenthal's AAA roster, reveals much more. Although magazine editors explained that "*Life* assigns only the subject, giving the painter free rein to recreate the scene in his own idiom and with his own ideas" their choice of subject was obviously planned with care. The pictures, from Edward Laning's *T.R. in Panama* and John McCrady's *The Shooting of Huey Long* (both 1939), to Reginald Marsh's *The Death of Dillinger* (1940) and Alexandre Hogue's *Spindletop* (1941) showed, respectively, how the country beat technological odds, fought demagogues, prevailed over evil, and conquered nature. Each thus reinforced the special promise of American history. The pictures took an overwhelmingly optimistic view of the trials and tribulations of the recent American past and by so doing prescribed "a confident expectation of a stable national future."[44] Each portrayed the American scene with the "degree of sympathy" Luce had asked for in his 1937 memo.

John Steuart Curry's *Hoover and the Flood* (fig. 3.16), for example, was commissioned in 1940 to illustrate Herbert Hoover's relief efforts during the disastrous 1927 Mississippi flood. The painting is divided into two sections: human pathos, rain-drenched animals, and general confusion on the left side, and the symbol of their salvation—then Secretary of Commerce Herbert Hoover—on the right, joined by his aides-de-camp, Red Cross nurses, newsreel cameras, and smiling children. The accompanying text (written by *Life*'s editors) emphasized that Hoover's "humanitarian spirit and organizing genius" primed him to "march straight to the White House" in 1929; his inability to tame the Depression once he got there was mostly ignored.[45] After lying low throughout most of the thirties, Hoover suddenly reappeared in the public eye in 1940, soliciting American dollars for European war refugees and campaigning on behalf of the Republican party's 1940 platform. Concurrent with his comeback was Curry's celebratory painting. While Curry's parents were "staunch Republicans," he favored progressive politics. When he moved to Wisconsin in 1936 Curry befriended governor Philip La Follette, the left-leaning radical progressive who declared that the "American principle of popular government, and the constitutions conceived to secure it, were not designed to sustain any particular economic system." Henry Luce, of course, held a completely different opinion on that topic. *Life*'s publication of Curry's regionalist

3.16. John Steuart Curry, *Hoover and the Flood*, 1940, *Life*, May 6, 1940. Reprinted

painting is a good example of how Luce, a Republican who thoroughly detested New Deal restrictions on private enterprise, promoted American art that lent support to the political aspirations of big businessmen such as Hoover (there was some talk in 1939 that he might run again) and public utilities executive Wendell Willkie, Republican candidate for president in the 1940 election. Although *Life* received numerous letters criticizing their obvious editorial page preference for Republican party candidates (to which editors replied: "It is true that Mr. Willkie's campaign has received more space. . . . The reason is that Willkie is campaigning in the usual way and Roosevelt is not"), no letters were received from angry readers wise to their use of Curry's picture for the same purpose.[46] *Life*'s political favoritism via paintings like this one may have been subtle (unlike their use of Benton's Michigan sketches), but the fact remains that Curry's picture, probably unintentionally on his part, reinforced Luce's mission to restore free-market capitalism under the direction of Republican and pro–big business leadership.

Paul Cadmus's picture, *The Herrin Massacre* (fig. 3.17) did not. An agonizing dramatization of the Lester Strip Mine disaster, a bloody 1925 riot in which 26 scabs were slain by armed unionists during a strike in the small mining town of Herrin, Illinois, Cadmus's 1940 picture revealed an ugly scene of class conflict and labor divisionism. A mob of miners with guns, steel pipes, and pitchforks are seen ruthlessly torturing and murdering the unarmed strikebreakers. Moving the site of the original massacre from the mine shaft to the town cemetery and making full use of Christian and national symbolism—the Lamb of God on a child's grave is streaked with blood, the victims are laid out near a tattered American flag—Cadmus's picture is a far cry from the jubilant survivalism painted by Curry and the other artists selected for *Life*'s history series. Although magazine editors had promised that each painter would be given "free rein" and color plates of *The Herrin Massacre* were proofed, the picture was never published by *Life*.[47] "We want to avoid artists who are too bizarre or who exhibit a tortured satire," Luce had admonished in his 1937 memo, and Cadmus's version of American history had none of the American scene "sympathy" he expected. Magazine staffers probably feared the loss of advertising revenue from U.S. industry if such a picture were published, especially at a time when industry was gearing up for military production and engaged in creating the semblance of patriotic unity, not labor strife. Avoiding the real issue of industry and union conflict altogether, Luce and *Life*'s editors rejected American art that did not celebrate corporate control.

3.17. Paul Cadmus, *The Herrin Massacre*, 1940; oil and tempera on pressed panel, 88.9 × 67.95 cm. Collection Thomas J. Lord and Robert E. White, Jr. Reprinted from Lincoln Kirstein, *Paul Cadmus* (New York: Imago Imprint, 1984).

Their reaction to Benton's picture *Hollywood* (fig. 3.3) was similar. The history of this commission and of the work itself clarifies the ways in which regionalist art, conservative politics, and corporate ideology became intertwined in the later years of the Depression. The impetus for the commission varies. It is possible that *Hollywood* was the precursor for the magazine's U.S. history series, since the motion picture industry had been an important part of American cultural history for some three decades and *Life* editor Longwell was responsible for Benton's hiring in August 1937. It is more likely that Longwell and other editors, responding to reader demand for more art and film coverage, aimed to satisfy both by dispatching artist Benton to movieland. In any case, Longwell commissioned Benton (through Reeves Lewenthal and the AAA) to paint a mural-sized picture for the magazine and to provide, as he had for *Life*'s pictorial coverage of "labor warfare" in Michigan, sketches of industry activities. His "base of operations" was the "luxuriously appointed" office of Raymond Griffith, a producer at Twentieth Century–Fox, the same studio for which he had painted movie backdrops twenty years earlier. In Hollywood, Benton was assigned to foray into the "vast departmentalized domain that is a major moving picture studio" and cover the on-set production of various Fox films, including the Eddie Cantor farce *Ali Baba Goes to Town,* the screwball comedy *Life Begins in College,* and the historical epic *In Old Chicago.*[48]

If *Life* acted as cultural tastemaker for the masses in its frequent features on regionalist art and its pictures of recent American history, it also served as America's middle-class movie magazine by heavily promoting Hollywood's movies, stars, and studio system. Starting with the first issue's five-page spread on Robert Taylor, then the "Great Lover of the Screen," *Life*'s coverage of movie-related stories was paralleled only by the headline articles in its Newsfront section. Movie of the Week was *Life*'s first regular feature and continued for sixteen years after its birth in the magazine's second issue. *Life*'s covers attest to the primary role it gave to the movies: of 1,864 covers from 1936 to 1972, more than 250 were of Hollywood stars and personalities. In 1940 the Gallup Poll reported that the best press a new release could get, better even than "a page-one break in all U.S. newspapers" was a "two-page layout of stills in *Life*." Giving free publicity to the movie industry was one thing but on at least twelve occasions *Life* became directly involved in production when it presented its own ideas for a proposed film. Key sequences in *Kitty Foyle* (1940) , for example, were staged, photographed, and then published in *Life* as "research notes for the yet-to-be-made film." Fur-

ther, the magazine took great pleasure in noting the similarities between "their" photos of Okies, published in *Life* in 1938, and Twentieth Century–Fox's version of migrant life in *The Grapes of Wrath* (1940). In both of these films, and with a few others, *Life*'s "treatment" exerted an obvious influence on Hollywood's product.[49]

Life was clearly wedded to "the pictures." From 1936 through the late forties, the peak years of studio control in the motion picture industry, *Life* was "inundated with such a flood of publicity pictures that its Los Angeles bureau became second only to Washington as a source for the editors in New York." Often the editors, wanting some movieland spice to "offset all the pictures of bad news" would cable the West Coast: "Need good girl act by Wednesday for issue balance." *Life*'s first major story on movieland (May 3, 1937), with blonde bombshell Jean Harlow on the cover, featured just such an "act." The article, "Hollywood Is a Wonderful Place," set the tone for most of *Life*'s movieland coverage: slightly irreverent (as *Life* was with almost everything) but mostly celebratory. Although Hollywood was called a "strange new culture" which lacked "all the elements of a stable community," criticism gave way to adulation in pictures of "Hollywood's Royalty," candids of Gary Cooper and Carole Lombard presented as "the living embodiments of all that the rest of the struggling Hollywood heap aspires to be." A photo montage of movieland's swimming pools and Rolls Royces highlighted *Life*'s view of Hollywood as "an unparalleled Land of Opportunity." When *Life*'s editors sent Benton to California in the summer of 1937, they probably expected him to provide a similar appraisal of movieland's legendary status as a sanctuary (albeit a "strange" one) of glamorous stars and good living, a pictorial version of what novelist Ruth Suckow called "the national fairy tale: the overnight rise to fame and material wealth, to social opulence, with Sex and Beauty in headline type."[50]

Hollywood, that summer of 1937, was indeed a "national fairy tale" in terms of booming production and profit. This was the height of movieland's "golden era" when eight major studios offered hundreds of films each year (MGM annually averaged 42 feature films, Warner director Michael Curtiz made 44 films from 1930 to 1939). The Big Eight monopolized all elements of film production, distribution, and exhibition. Movies were mass-produced in the assembly-line fashion of the Hollywood formula, with its reliance on typecast characters and conventional subjects, and they were mass-consumed. Despite the Depression moviegoing grew in the thirties from a weekly attendance of 37.6

million fans in 1929 to 45 million in 1937 and 54.6 million in 1941. Movie culture became in the thirties "a dominant culture for many Americans, providing new values and social ideals to replace shattered old traditions." [51]

If the economic dislocation of the Depression "shattered" the country, thirties movies showed how America could be rebuilt. This was not done by creating new traditions but by giving new meaning to old ones, especially by redefining republicanism. As Andrew Bergman argues, Depression era films "showed that individual initiative still bred success, that the federal government was a benevolent watchman, that we were a classless, melting pot nation." In other words, thirties movies, like New Deal art and much of corporate advertising, evoked the tradition of American republicanism in a contemporary context, by linking that tradition with the new consumerism. By the mid-thirties Hollywood moviemakers, like businessmen nationwide, recognized not only that new modes of product design and presentation could engender public confidence but that their future livelihood depended, as corporate spokesmen from Bruce Barton to Henry Luce intoned, on their assumption of an ever increasing public character. Adopting the PR strategies of the New Deal, the movie industry began to offer products that catered to public goodwill by stressing the virtues of American specialness and national unity in an optimistic, upbeat manner.

This can especially be seen in Hollywood's portrayal of the American worker during the thirties. Charles Beard noted in 1939 that Depression era motion pictures dealing with labor conflict "were conspicuous by their absence:"

> Why was this so? Those given to an economic interpretation of events had one answer: the bankers, financiers, corporation trustees, stockholders, and managers for the huge and complicated motion-picture industry, with hundreds of millions at stake, for their own reasons, did not want the conflicts of labor and the misery of a third of the nation to be advertised to their millions of customers. [52]

Hollywood's vested interest depended on the maintenance of the status quo. During the Depression the motion picture industry avoided serious analysis of American labor, especially that which might support mass-production industry. Instead, workers were portrayed as the prototypical producers of the nineteenth-century past, skilled individuals who mostly took care of themselves or, when they could not, accepted the paternalism of corporate capitalism.

In *Black Fury* (1935), for example, a drama about Pennsylvania coal miners, labor issues were reduced to personality conflicts rather than socioeconomic grievances. Union agitators were revealed as shysters, their followers the gullible masses. In this and other films about American workers, Hollywood showed how Depression problems were solved through good old American individual know-how and virtue. Hero-redeemers lived happily ever after in a comfortable, nonunion future. Twentieth Century–Fox's 1934 movie *Stand Up and Cheer* took a similar approach, while also lauding FDR and reform politics and turning "the New Deal into a veritable leading man."[53] The final scene of this musical ends with sailors, nurses, engineers, secretaries, firemen, milkmen, police, miners, cooks, moms, street cleaners, bellhops, mailmen, and farmers being led in a joyous parade by the NRA eagle; the final song hails: "Stand up and cheer / Banish all fear." Like one of Benton's murals, the movie celebrated America's producers and posited that the national unity of these autonomous folk would create a better future.

When Benton went to Hollywood in the summer of 1937, he was certainly aware that the movies were the "dominant" culture of the day. He probably also recognized the movie industry's seeming celebration of the New Deal, and its paeans to a new republicanism. Benton may have accepted *Life*'s commission to see if he had made the right decision in the late teens when he, in contrast to his director-friend Rex Ingram, opted for a career of public painting. It is just as likely Benton wanted to discover for himself if Hollywood's gesturing at reform was truly authentic. Given his own reform inclinations, it is probable that Benton hoped to link himself and his art with both dimensions of Hollywood's image, its power and its politics. Linking himself with Hollywood's fame and fortune must have appealed as well.

John Sloan's 1907 depiction of going to the flicks, *Movies, Five Cents* (fig. 1.13), reveals that the "national fairy tale" of movie culture has been the subject of artistic investigation since the movies began at the turn of the century. Especially during the 1930s "golden age," when hundreds of films were annually released and millions watched them, American artists paid particular attention to movie culture. Nathanael West explored the all-devouring decadence of movieland in *The Day of the Locust* (1939) and F. Scott Fitzgerald described Hollywood's destruction of the American Dream in *The Last Tycoon* (1941).

Visual artists offered their own views of movie culture. Positioning a tired-looking office worker in front of an alluring movie poster image of Claudette Colbert in his 1934 painting *Paramount Picture*, Reginald

Marsh showed the ironic contrast between what Hollywood presented and the reality of life in the Depression. In *Twenty Cent Movie* (1936, fig. 3.18) Marsh turned to the social nature of movie culture, picturing an urban crowd of pimps and punks, office girls and prostitutes in front of a 42d Street theater. Edward Hopper also analyzed movie audiences in paintings and engravings. *New York Movie* (1939) pictured a bored usherette inside a largely empty rococo style theater. Hopper was indebted to movie culture not only for the topical subject matter it provided but also for its formal qualities, and mirrored the dark, alienated sensibility of forties style film noir in paintings such as *Office at Night* (1940) and *Nighthawks* (1942).[54]

Benton's *Hollywood,* however, is different. Rather than focusing on movie culture consumption—moviegoing and movie watching, Benton investigated movie culture production. In this respect, *Hollywood* parallels West's and Fitzgerald's analyses of life, work, and ethics in the movie industry itself. It is also similar to a painting done in the mid–1930s by Benton's friend and former synchromist Stanton MacDonald-Wright for the Santa Monica Public Library (fig. 3.19). Like Benton, MacDonald-Wright dropped pure synchromism in the twenties for a style linking modern form and narrative content. From 1935 to 1943 he was supervisor of the Southern California WPA/FAP and became acquainted with public art. He was, like Benton, a modernist interested in social change. His Santa Monica painting, a gigantic 38-panel mural, showed the "twin streams of man's imaginative and inventive development," which MacDonald-Wright, a devotee of Oriental philosophy and art, credited to the East and West, respectively. In the first panel he portrayed "primitive" Western man trying to rope a Chinese dragon, symbol of "spiritual essence." (This was, apparently, a tongue-in-cheek portrait of Benton!) The merger of technique and creativity was demonstrated in the last panel, *A Motion Picture Studio,* where movie star Gloria Stuart and director Frank Tuttle were seen surrounded by movie cameras, lights, microphones and the blue- and white-collar laborers of the industry.[55] It is this view of movie culture as an industry, more than its representation as a place of leisure or its links to consumerism, that Benton painted in *Hollywood.* It is more than likely that Benton visited with MacDonald-Wright during his 1937 trip and relied on his mural as a model for his own picture.

With a cast of fifty actors, actresses, directors, and technicians, Benton's movie mural shows how movies were made and who, especially, made them. In this mural, as in earlier ones, we see a multiplicity of

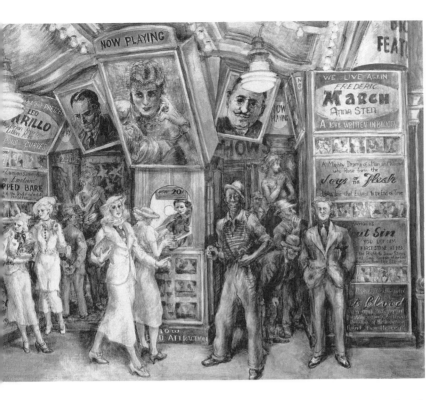

3.18. Reginald Marsh, *Twenty Cent Movie*, 1936; egg tempera on composition board, 30″ × 40″. Collection of the Whitney Museum of American Art, New York. Purchase. 37.43.

colorful, dynamic scenes: the audition of a scantily clad chorine, the filming of *In Old Chicago*'s fire scene, the direction of a dance number, extras applying makeup and reading newspapers, and especially, the blue-collar workers responsible for movieland's machines. Benton explained to *Life* editor Longwell that he "wanted to give the idea that the machinery of the industry, cameras, carpenters, big generators, high voltage wires, etc., is directed mainly toward what young ladies have under their clothes." [56]

Indeed, the "machinery of the industry" surrounds *Hollywood*'s chief blonde, the axle around which movie culture itself revolves. Although she is centered in Benton's picture, it is the machines of the movie industry—spotlights, movie cameras, microphones, wind-

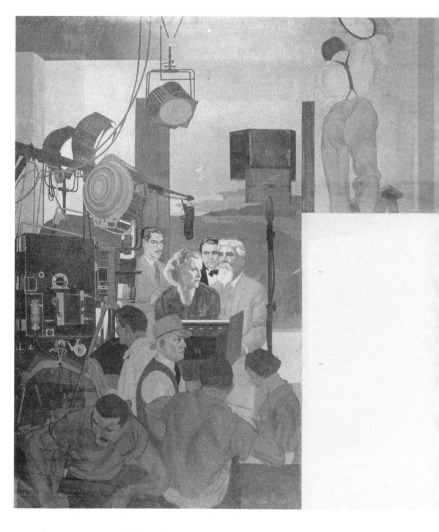

3.19. Stanton MacDonald-Wright, *A Motion Picture Studio*, detail from mural *Moving Picture Industry*, 1934–35; oil on plywood, 9′ 11″ × 9′ 6″. Originally painted as a Federal Arts Project mural for the Santa Monica Public Library; now in the National Museum of American Art. Courtesy of the National Museum of American Art, Smithsonian Institution, transfer from the City of Santa Monica, California.

machines, electric generators, soundboards—and those who control them—technicians, directors, actors, and actresses—that he actually focuses on. This seminude blonde, movieland's prototypical sex god-

dess, represents Hollywood's 1930s product. But unlike Marsh, Hopper, and the storywriters at *Life,* Benton was less interested in how she was consumed by movie audiences than in how she came into existence through the efforts of producers "behind the screens." Clearly, Benton saw the movie industry as a place of earnest work, not as the glamour capital of individual stars. Moreover, he saw in the movie industry evidence of the organic producerism he still hoped to see revived nationwide.

Like a movie itself, *Hollywood* features a dominant central figure, a cast of characters, and a variety of scenes, all of which make up its plot. Indeed, Benton's assimilation of an energetic style similar to that of 1930s films and his similar reliance on typical subject matter suggests the strong links between regionalist art and popular culture. Various thematic devices, from architectural elements to the cloud of smoke, connect scenes and characters and make the plot of *Hollywood,* like any mainstream movie, unfold easily. Benton's movie mural further resembles a film in its manipulation of spatial dimensions and its distortion of chronological time. The banks of the river surrounding the raging fire look as if they might flood the studio dressing room at any moment; the middle ground occupied by the blonde sex goddess falls into the dressing room and spills into the picture's immediate foreground through Benton's offsetting depiction of studio floorboards. Time and space are as ambiguous in *Hollywood* as they are in any movie that uses editing to link scenes from different moments and places.

Moreover, like thirties filmmakers, Benton relied on certain stylistic strategies to assure audience accessibility. During this "golden age" moviemakers relied on key and fill lights to produce a very high light level with only the faintest hint of shadow. The overall effect was a bright, vivid quality of illumination, which gave a uniform and often polished, glossy look to every scene. Film historian James Monaco suggests that this lighting style, a balance between expressionism and cinéma vérité, "provided thorough but not overt illumination and therefore presented a minimal barrier between observer and subject." The same can be said of Benton's picture, where characters and scenes are lit to have a maximum visual impact on their viewers. The blonde chorine in the middle of *Hollywood,* for example, fairly glows under the spots shining on her, and most other scenes in the picture display this same level of intense lighting. Describing his aesthetic techniques to a *Time* magazine staffer, Benton said he tried to "eliminate the form destroying accidents of light and shade which occur in nature" in his paintings.

Hollywood, the painterly equivalent of the bright-light uniformity of thirties films, has an even and glossy tone which looks, as do thirties movies, "inherently unrealistic." [57] But, as his comment makes clear, Benton was not especially interested in verisimilitude. Rather, he worked to present visually appealing stories to his audience. Once he had their attention, he could convince them of his message.

Similarly, Benton's riotous color use in *Hollywood* echoes the palette of certain 1930s films. Although most black-and-white movies were printed on tinted stock, the invention of Technicolor in the mid-thirties opened up the full range of color photography to moviemakers. Soon mainstream films, from *Kid Millions* (1935) to *Victoria the Great* (1937), featured color footage in their final scenes; by the end of the decade movies like *The Wizard of Oz* (1939) would make full use of color symbolism—the Yellow Brick Road and Dorothy's ruby slippers. Relying on a process similar to industrial ink printing, where colors are separated into the spectrums of magenta, cyan, and yellow, Technicolor films were especially gaudy and unrefined. Likewise, *Hollywood*'s colors are mostly primary reds, blues, and yellows and are particularly garish. Perhaps such color use stems from Benton's attention to the new look of Hollywood films while on various Twentieth Century–Fox sets. Indeed, portions of *In Old Chicago* may have been slated for color shooting, as the chemicals used to create its $500,000 fire sequence ("the largest sum ever plunked into a single picture for spectacle") emitted huge clouds of yellow and green smoke. "You saw jets of flame issuing from windows, black and yellow smoke pouring in stifling billows, and fire darting fully 40 feet into the air," a *Variety* reporter gushed, adding "and the camera lens eats it up." [58] Watching such a "spectacle," Benton may have been tempted to capture movieland's Technicolor pyrotechnics in his own picture.

Hollywood is most mimetic of film in its overall "pattern of action." Film form involves "the complex possibilities of a composition which moves, which develops from one stage to another." Thus the filmmaker creates a "pattern of action" through particular use of a mobile style. Thirties films, like Benton's regionalist paintings, are obsessively energetic, seething with fast-paced action, hurried scenes, quick talking, swift resolutions. The techniques for creating this pattern of dynamic motion in both Depression era films and in Benton's pictures are similar. Thirties filmmakers used "double-movement" camera shots and jumpy editing to create a kind of action-reaction design:

The double-movement shot gave each tiny segment in the progression a self-sufficiency and completeness in itself. A first small action would occur in the shot, a second one would complement or complete it: first the action and then the reaction and then the editor would cut to another shot. Gary Cooper would first pace, too nervous to make a pass at Marlene Dietrich, next he would take a drink to calm his nerves, and the editor would then cut (*Desire*, 1936).[59]

Hollywood is similarly divided into "action" and "reaction" scenes. The frenzied movements of the dancing couple on the left, the pose of the central blonde, and the raging fire are the results, the "reactions," of directorial and technical "actions." They are autonomous in and of themselves but when accompanied by counter-elements, they create a sense of action and a more complex and visually appealing form. Put literally, various vertical elements such as columns, arches, and towers are positioned in response to certain diagonal elements, such as the smoke cloud and the wooden planks and floorboards scattered throughout the picture. This action-reaction pattern makes *Hollywood* move before our eyes, stimulating our visceral participation in the plot, the message, of Benton's movie mural.

Obviously, Benton and thirties filmmakers adopted this particular fast-paced style for a reason. Karal Ann Marling suggests that the multitude of "zipping airplanes and thundering stagecoaches" in New Deal murals offered aesthetic alternatives "to Depression stagnation." Action-packed pictures in energetic styles and loud colors "invited escape from troubled times. Projected upon the American past, motion constituted a model for renewed activity in the present, but more especially, a magic carpet to tomorrow." [60]

In direct contrast to the economic and psychological lassitude of the Depression, filmmakers and artists created spunky pictures smacking with vitality. Since by definition motion implied progress from one place to another, their audiences were catapulted to another place and time far away from the Depression. The heir of a political ideology of social progress, Benton was obviously interested in a better future. *Hollywood*'s bright, colorful, and boldly energetic milieu was Benton's vision of a better world where America's producer tradition was restored. He used a formal strategy similar to 1930s films because it guaranteed audience interest: it turned his fine art into an accessible, popular culture product. By extension, such a form made the contemporary possibilities

of producerism convincing; social reform was not pictured as some misty utopia eons away but a plausible condition which might start as early as today.

The suggestion of progress through producerism was reinforced by Benton's choice of subject matter. He secured audience accessibility for his picture through dynamic structure and stereotypical imagery. The central blonde resembles any number of ingenues in *Photoplay* or *Picture Show*. She is the "sum total of Hollywood sex appeal," much like the composite female formed from superimposed photos of nine movie stars in a contemporary issue of *Vanity Fair* (fig. 3.20). Similarly, *Hollywood*'s fire scene is typical of *Saturday Evening Post* or *Life* pictorials on urban or industrial catastrophe. And Benton's audience would have especially recognized *Hollywood*'s workers. Their blue work shirts and appendant relationship with the machines of the industry linked them with producers nationwide, such as those profiled in *Life*'s March 1937 spread on "the common steel worker" or in Warner's 1937 movie *Slim*, a portrait of an electric lineman.[61] Benton derived his imagery from on site viewing at Twentieth Century–Fox studios. He rendered it familiar by turning specific subjects into the typical stuff common to the movies and magazines of the day.

Benton spent some of his time sketching Fox's production of *In Old Chicago*, an epic ostensibly about the Great Chicago Fire of 1871 but more accurately described as a "disaster musical whose roisterous tale of political chicanery was interspersed with seven songs and a jig." *Dubbing in Sound* (fig. 3.2) depicts two of the film's stars, Tyrone Power and Alice Faye; *Burning of Chicago* (fig. 3.21) shows the filming of the climactic fire scene. Produced by studio mogul Darryl F. Zanuck and directed by Henry King (best known for the 1933 *State Fair*), *In Old Chicago* details the trials and tribulations of the O'Leary family: matriarch Molly (Alice Brady), whose cow Daisy sets off the fire; her eldest son Jack (Don Ameche), who with support from "citizens who want a new deal in the city of Chicago," becomes mayor; her youngest son Dion (Power), who owns a gambling casino and nightclub in a shady part of town called The Patch; and music-hall singer Belle Fawcett (Faye).

Much of the film deals with sibling rivalry: both boys pine for Belle and both have different ideas about Chicago's future (fig. 3.22). Jack is a "high-minded" reform politician who objects to Chicago's "mushroom growth" and "vice and crime" in The Patch. He proposes to deal with both by "wiping them out" and "starting all over, on a sound basis, with steel and stone." Dion, on the other hand, is a "ruthless go-

e sum total of Hollywood sex appeal—Mlle. X, the golden-mean average in cinema beau

Here you have the composite feminine motio
picture star, who is made of sugar and spice ar
everything nice, not to mention Marlene Di
trich and eight other high-priced honeys of tl
screen. The resultant beauty is gained by supe
imposing on one another the photographs of t
nine women stars shown on this page. Togeth
they form the ideal.

3.20. Composite photo of "Hollywood Beauties," *Vanity Fair,* c. 1937. Reprinted from *Vanity Fair: Selections from American's Most Memorable Magazine—A Cavalcade of the 1920s and 30s,* edited by Cleveland Amory and Frederick Bradlee (New York: Viking Press, 1960). Copyright *Vanity Fair* 1937 (renewed 1965) by The Condé Nast Publications, Inc.

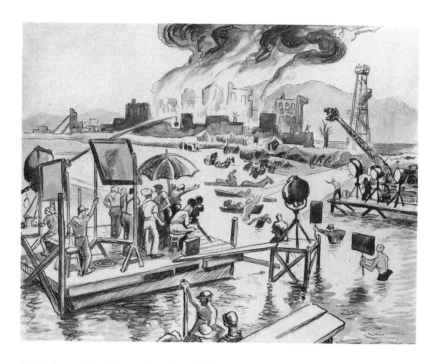

3.21. Thomas Hart Benton, *Burning of Chicago,* 1937; ink wash, 13 ½″ × 10 ½″. Courtesy of the Trustees of the Benton Testamentary Trusts, Kansas City.

getter" who while not exactly committed to corruption, certainly profits from it. At one point Jack tells Belle he wants to show Dion that "money and power aren't everything in life, that there are a lot of things more important, like being a good citizen." But, Jack is murdered by his political rival and the fire guts the city. Despite all of this, *In Old Chicago* ends on an upbeat note with Molly and Dion engaged in this spiel:

> Molly: It's gone! It was a city of wood, and now it's ashes. But out of fire'll be comin' steel.
> Dion: Nothing can lick Chicago.
> Molly: Aye—that's the truth. We O'Leary's are a strange tribe but there's strength in us and what we set out to do we'll finish.[62]

There is the implication at the end of the movie that although Jack has died, his crusade for a better Chicago will be carried out by his brother.

3.22. Film still from *In Old Chicago*, 1938. Copyright 1938 Twentieth Century–Fox Film Corporation. All rights reserved.

The fire in the movie, and in Benton's picture, is more than just a fire. It becomes a sweeping metaphor representative of fated and uncontrollable conditions out of which come change and betterment. Its destruction cleans up Chicago and leaves the city ripe for the steel architecture regeneration prophesied by Molly O'Leary. Although Jack's "new deal" fails during his lifetime, the conflagration of the fire guaranteed its success in the future. But, *In Old Chicago* was not simply a story about the past. Its success (it was a top 1938 moneymaker) sug-

gests that thirties audiences equated the Chicago Fire with the Depression, seemingly also an unpreventable disaster. And, since most of the O'Leary family survived their nineteenth-century catastrophe and even laid plans for a better future, perhaps thirties Americans would triumph over the Depression and someday live in a better world. Alfred Haworth Jones convincingly argues that the crises of the American past were frequently evoked in thirties literature and film to remind audiences that their ancestors had pulled through hardships and so would they. Indeed, Fox publicists dedicated *In Old Chicago* to "those dauntless Americans" who "had the courage to build anew on the ashes of old, for theirs was the spirit that made this nation great!" [63]

In his own picture, Benton treated the Chicago Fire less as an overt symbol of the Depression than as a symbol of production. Fox had never before attempted a film of *In Old Chicago*'s magnitude and spent millions on its making. The staging of the fire involved the construction of a huge two million gallon pond on the Fox lot. Although Chicago has only one lakefront, two were built "so that no matter which way the wind might be blowing the correct effect" could be filmed. The film's six-month production schedule was especially lengthy (film production averaged about a month in the thirties) and required the hiring of over 3,000 extras.[64] The fire in *Hollywood*, then, represents employment and accomplishment. It is the end result of productivity. An homage to collectivity, *Hollywood* is also an homage to the ideas of national unity and democratic control espoused by the New Deal. Despite the Depression the movie industry, as Benton painted it, was the locus of a united front of serious workers. And, in direct contrast to the mass-production auto industry workers he had sketched just a month earlier, Hollywood's workers are skilled. Their jobs are complex and autonomous, and their unique roles are essential in the creation of movieland's product. Moreover, if the fire does suggest the catastrophe of the Depression, Benton shows that Hollywood's revitalization of organic producerism has undercut its numbing destruction.

Other portions of *Hollywood* lend support to Benton's view of movieland as a place of producerism and New Deal success. Also in production at Fox during his visit were two musical comedies, *Life Begins at College* (fig. 3.23) and *Ali Baba Goes to Town* (fig. 3.24) . The former, described in *Variety* as a "riot of comedy and color," was a Ritz Brothers farce involving the screwball adventures of Nat Pendleton (the figure with raised tomahawk on the far left of *Hollywood*), and Gloria Stuart and Dick Baldwin (the dancing duo near Pendleton) at Lombardy

3.23. Film still from *Life Begins in College*, 1937. Copyright 1937 Twentieth Century–Fox Film Corporation. All rights reserved.

College. The plot concerns Pendleton's efforts to become part of the "college gang," which he does after joining the football team and leading Lombardy to its first victory "ever."

3.24. Film still from *Ali Baba Goes to Town*, 1937. Copyright 1937 Twentieth Century–Fox Film Corporation. All rights reserved.

Ali Baba Goes to Town starred Eddie Cantor as autograph hound Aloysius Babson, bound for booty in Hollywood. Kicked off his train in the middle of Monument Valley, Cantor dreams he is in Baghdad circa 937 (represented by the temple backdrop left of center in *Hollywood*). People are hungry and the sultan (Roland Young) doesn't know what to do. Cantor suggests that a "new deal" might cure the country's ailments and in no time at all he has converted the sultan to democratic politics (he runs for president), scientific management (filling stations for camels are instituted at every oasis), and the importance of national unity. The evil sultana (played by stripper-turned-movie-star Gypsy Rose Lee) makes tenth-century reformism difficult, however, and Cantor eventually "wakes up" to continue his journey to Hollywood circa 1937

where, the movie points out in its closing sequences, the New Deal really *was* working.[65] *Set Designing* (fig. 3.2) shows Fox craftsmen working on the stage sets for *Ali Baba.*

Like other screwball films of the era, *Life Begins in College* and *Ali Baba Goes to Town* aimed, as Bergman posits, to reconcile the irreconcilable:

> The comic technique of these comedies became a means of unifying what had been splintered and divided. Their "whackiness" cemented social classes and broken marriages; personal relations were smoothed out and social discontent quieted. Screwball comedy was implosive; it worked to pull things together.[66]

Both of these Fox films soothed an audience apprehensive about their own problems by showing characters taking control and reordering their lives. Like *Hollywood,* these comic films were styled in an energetic mode and pictured the fruitful activity of their characters. Nat Pendleton helps Lombardy College win the big game, Eddie Cantor creates a new deal in Baghdad, and *Hollywood*'s workers are engrossed in making more movies. All of these individuals successfully merge themselves with their social situations; each personifies Benton's ideal of the organic producer. Each heralded productivity and collectivity, positing that both could "pull things together" during hard times.

With its products, spokesmen, and even its theaters the movie industry solicited public confidence by changing its image in the 1930s. Spurred on by the public success of the New Deal, Hollywood adopted its tenets of optimism and national unity and its evocation of American values. Will Hays, hired by Hollywood as a glorified PR man some years earlier, instituted the Production Code in 1934, a censure of "sex perversion" and antisocial behavior to which all movies were subjected. The code shaped a "coherent ideological vision of the world" for mainstream movies by "equating entertainment with Americanism." Traditional values—community, home, individualism, and the work ethic— were glorified; America was presented as the land of opportunity for any individual with enough pluck and gumption to climb its ladder of fortune. Uplifting movies with down-home stars like Will Rogers, Jimmy Stewart, Alice Faye, Mickey Rooney, and Shirley Temple were the industry's typical thirties product. One film historian noted that "tales of American life" dominated 481 out of 574 feature films in 1938, a "domestic trend" related to "the great wave of regional art and literature, the discovery of America by Americans."[67]

With a monopoly in exhibition as much as production, the industry began to build smaller 600-seat streamlined or "moderne" movie houses whose architecture and interior decorations were often evocative of local styles and interests. The large, ornate theaters of the twenties were abandoned and with them the foreign exotica of their jazz age stars. The new moderne theaters catered to local public values, had egalitarian seating and showed Andy Hardy movies. Intimating unity, efficiency, and especially security, these new theaters often became the locus of community loyalty, which further consolidated public support for the movie industry. With their new products and their moderne places of presentation the movie industry helped to engender a new kind of American nationalism: "the merger of republican traditions with modern consumerism." [68] Like the New Deal, the movie industry of the thirties regenerated America's past values, especially those of collectivity and productivity, and stressed their new significance in the consumer culture of the twentieth century.

In *Hollywood* Benton painted the producerism of an industry that pictured its own version of republicanism. Focusing on movieland's workers he showed the links between the producer tradition and contemporary culture in Hollywood, and heralded the movie industry's workplace consolidation of productivity and collectivity. Center stage in *Hollywood* Benton showed what moviemakers produced and moviegoers consumed. Clad in not much more than a pair of hot-pink high heels, bikini-style panties and a shimmery uplift brassiere, *Hollywood*'s central blonde figure may be a referent to Gypsy Rose Lee, stripper-turned-star in *Ali Baba Goes to Town*. Burlesque signified controversy in the movie industry in 1937, as theater owners across the country, hoping to entice audiences, were hiring strippers to perform before movie showtimes. Industry officials were quick to condemn this defamation of "decent family movie houses" and it soon stopped. Faced with mounting costs and movie competition, burlesque was dying out as a form of popular culture in the late thirties. For Benton, it had long been a favorite subject; several seminude chorus girls can be seen in *City Activities with Dance Hall* (fig. 2.9). *Hollywood* may allude to its demise and to the fact that consumers could see almost the same thing in the movies. As he noted to *Life* editor Daniel Longwell, *Hollywood* was all about "sex, melodrama and machinery." The picture may also allude to Henry Luce's avid interest in burlesque. Like Reginald Marsh, who painted Luce and his friend Senator William Benton agog over a robust

chorine in the 1945 picture *Strip Tease in New Jersey*, Benton may have been offering *Life*'s owner a permanent record of his passion.[69]

Hollywood's centerpiece may be a tribute to Jean Harlow, who was scheduled to play Belle Fawcett in *In Old Chicago* but died on 9 June 1937. Or she may be a racy representation of Alice Faye, who did play the dancehall songstress in the movie. Whenever Faye is on stage, leading her buxom soubrettes through a cancan number or singing the lyrics to the title song in a flimsy ruffled outfit, the movie camera centers her, much as the blonde is centered in Benton's picture. But *Hollywood*'s central figure is not just Gypsy Rose Lee, Jean Harlow, or Alice Faye; she is, as Benton explained to Longwell, "more symbolical than an actual movie figure." Ironically, in view of Benton's overall ambivalence regarding the depiction of women, *Hollywood*'s centerpiece is female. That is because she represents what Benton thought movie culture was in 1937: the locus of reborn producerism. This is substantiated by the orb-tipped scepter she clutches. Her scepter, emblem of authority and nobility, suggests that this imperious female is indeed the "Hollywood Royalty" *Life* paid tribute to in its first movie culture coverage. Surmounted by an orb, a stylized reference to the globe, this scepter signifies movie culture's worldwide influence. Such an attribute was common to Athena, goddess of wisdom, patroness of the arts, "protectrix of the polis," and symbol of republic and reason.[70] *Hollywood*'s glossy goddess represents movieland's republicanism. She is central to Benton's view of Hollywood as a working community.

It was not a community without its share of labor struggles, however. Although industry executives fought hard against organized attack on their control of the studios, Hollywood was racked by union battles, particularly in the thirties. In 1933, an industry-wide strike by members of the International Alliance of Theatrical Stage Employees and Motion Picture Machine Operators (IATSE) closed some studios and threatened to paralyze production. The validation of the National Labor Relations Act on April 12, 1937, revived union activity nationally, and during the spring and summer of 1937 various Hollywood craft unions, including painters, plasterers, scenic artists, and utility employees, walked out on the studios. During these same months screenwriters, directors, and stars (including the head of the Screen Actor's Guild, Eddie Cantor) tangled in factional labor politics and the trades bulged with antiunion commentary from studio chiefs.[71]

Being in this hotbed of activism and personally committed to the

reform of the American workplace, Benton filled *Hollywood* with potential union members. This qualified as everyone, as Murray Ross noted:

> Hollywood is a union town. From the highest-paid directors to the lowly electrician, every group is organized. At labor rallies, its glamorous stars and suave writers hobnob with carpenters and painters. The popular conception of Hollywood as a land of make-believe is a figment of the imagination. The true Hollywood is just as firmly rooted in reality as Middletown. For every shining star there are thousands of little lights struggling to gain or keep a place. These men and women are interested in wages and hours, in working conditions, in union agreements, and in economic security.[72]

Benton had seen similar workers in Flint and Detroit. But, for reasons which stem from the differences in labor structuring and organizing in the movie and auto industries, Benton was not ambivalent about the American producer in *Hollywood*. In contrast to the mass-production unionizing in the auto and steel industries, Hollywood labor organizing stemmed from attempts by craft guilds to gain further autonomy. Although IATSE sought to organize all movie workers, it competed with union locals and with the Academy of Motion Picture Arts and Sciences (AMPAS), a "company" union organized by studio chiefs in 1927. (The evidence of AMPAS shows that corporate paternalism in the movie industry did not disappear during the Depression.) *Hollywood*'s workers are the skilled, autonomous producers that IATSE organizers and Benton hoped to see enjoined under revitalized republicanism. The movie industry, unlike the auto industry he had observed just a month earlier, was not presented as the locus of the mass mob that Henry Luce feared.

Hollywood shows that Benton sided with movie industry producers and supported their struggle to achieve autonomy in movieland. Like Leo Rosten, author of the 1941 book *Hollywood: The Movie Colony, the Movie Makers,* Benton recognized the vital role played by Hollywood's workers in industry production. Rosten observed:

> The dazzling spotlight which Hollywood turns upon its Personalities throws into shadow the thousands who work in the movie studios—technicians and craftsmen, musicians and sound engineers, painters, carpenters, laboratory workers. These, plus the thousands of extras whose faces are used in an agglomerate mass,

are the anonymous people who swarm over the sound stages, the lots, and the offices whereever pictures are fabricated. They are the movie workers.

Rosten divided Hollywood into three groups: movie workers, movie makers (producers, directors, writers, actors), and an elite group of 250 or so stars, the "personalities" of movieland. Throughout his text he gave credit to Hollywood's producers, the 30,000 movie workers behind the scenes.[73] Correspondingly, *Hollywood*'s central "star" is surrounded by movie workers and moviemakers, Benton's view of the industry's most important people. She may be their symbol, but her existence depends on their efforts. Obviously, Benton saw Hollywood as a working place, similar to the places of labor he painted earlier in his four public murals. In *Hollywood* he painted the industry's producers united in their control of their movieland workplace.

That Benton saw Hollywood as a working community, rather than the place of popular legend where stars lounged by swimming pools and rode in Rolls Royces, is further supported by his essay "Hollywood Journey." The prospectus for a book on his movieland experiences, illustrated with the studio sketches *Life* rejected, Benton's essay characterizes Hollywood as a place of business, not fantasy. Describing his artistic eavesdropping at a studio business meeting in Fox chief Darryl F. Zanuck's office (fig. 3.25), Benton observed:

> The moving picture Art is predominantly an economically conditioned Art. Although the fact may not be openly admitted because of certain illusions which have to be maintained, there is behind every movie story the immediate and pressing question of profit. It is because of this fact that the movie Art of Hollywood, the environment it creates and the behaviors it induces, may be regarded as genuinely a part of American business institutionalism. The movie Art is not only a business but a business expression. It speaks in by and through the patterns of the American business mind. It is go-getter, optimistic, sentimental, politically conservative.

Benton went on to explain that during his Hollywood visit he "was not interested in particular Stars but in what went on all the time." As *Hollywood* shows, Benton spent his month on the Fox lots investigating how their movies were made, and who made them. He recognized "the movie Art as a sort of communal Art."[74]

3.25. Thomas Hart Benton, *Directors Conference*, 1937; ink wash on paper, dimensions unknown. Courtesy of the Trustees of the Benton Testamentary Trusts, Kansas City.

But he also recognized that producerism in Hollywood was tightly controlled by the chiefs of the Big Eight: "I suspected as in the case of all communal activities someone was bossing the work. I figured that someone was supplying the 'idealogy' [sic]." The "boss idea man" at Fox was Darryl F. Zanuck (fig. 3.26). Holding court behind his huge desk, a duplicate of George Washington's left over from some Revolutionary War epic, and chomping on an ever-present cigar, Zanuck "announced assignments, assigned credits, rewrote dialogue, canceled projects, distributed praise as well as scorn, changed titles, and changed his mind." His gigantic visage (fig. 3.27), loomed over all eaters in the Twentieth Century–Fox commissary and confirmed his omnipresent status at this studio. He ran Fox, Benton said, like a "politician or a banker."[75] Labeling him thus, Benton recognized that Zanuck's authority conflicted with the organic producerism he envisioned in movieland.

3.26. Photograph of Darryl F. Zanuck, 1939. Reprinted from Mel Gussow, *Darryl F. Zanuck: Don't Say Yes Until I Finish Talking* (New York: Da Capo Press, 1971).

In *Hollywood*, his tribute to movieland's workers, he omitted him.

Although *Life* pictured Hollywood as a mecca of stars and their mansions, Benton saw it as an industry, a place of profit-based production. As he put it, "Hollywood is different. But it is not qualitatively different from a great deal that is very much American." [76] But *Life*'s editors had expected him to gather the facts on movieland's charming gods and goddesses, its mythical and legendary status. *Hollywood*, and its accompanying touristic sketches, did not mesh with their expectations. Benton's view of Hollywood as an industry, complete with producers and machines, collectivity and hard work, contrasted with *Life*'s view. Benton ignored movieland's role in consumer culture and described it in terms of an older producer identity. And his suggestion that an energetic, autonomous producerism was widespread in the movie

3.27. Photograph of Hedda Hopper interviewing Gene Tierney in the Twentieth Century–Fox commissary, beneath mural featuring Darryl F. Zanuck, *Life*, November 18, 1946. Reprinted with permission of Life Magazine. Copyright Time Warner, Inc.

industry must have needled Henry Luce and other *Life* editors. *Hollywood* pictured what Luce and movie industry chiefs wanted to avoid: the labor issue in modern America. That Benton himself avoided the

3.28. Doris Lee, *Edward G. Robinson*, 1945, reproduced in "Hollywood Gallery: A Painter's Portfolio of Impressions of Movie City," *Life*, October 15, 1945. Reprinted with permission of Life Magazine. Copyright Time Warner, Inc.

issue of mass labor was irrelevant; he broke taboo by portraying workers in a plausible and serious manner. His optimistic vision of worker control challenged Luce's ideal of corporate leadership and questioned Zanuck's paternalistic authority. The latter alone may have been important enough to figure in *Life*'s rejection of Benton's picture, since the magazine depended heavily on motion picture advertising and carefully avoided conflict with industry moguls. Of course, Luce may not have appreciated Benton's burlesque reference either.

For whatever reason, and none was ever given, *Life* rejected Benton's picture and never published the many sketches he made. Although *Hollywood* appeared in *Life* in late 1938, it was presented as a prize winner at the Carnegie Institute Art Exhibit, not as an in-depth analysis of the movie industry. The nature of the picture's commission was not described. *Life* did publish an article on movie production in late 1937, illustrated with photographs by Margaret Bourke-White. But no men-

tion was made of movieland's labor conflicts, and "producing geniuses" such as Zanuck were lauded for making the industry such a success. A few years after Benton's venture in movieland, *Life* hired another American artist, Doris Lee, to paint her "impressions of movie city." Lee's perky vignettes of movie culture included celebrity portraits of Edward G. Robinson (fig. 3.28) and Lena Horne and views of Graumann's Chinese Theater and starlet hangout Schwab's Pharmacy.[77] Avoiding industry production almost entirely, Lee's paintings showed movieland exactly as *Life* had first described it in May 1937: a "wonderful place" of smiling stars, exotic architecture, and fame and fortune. Unlike Benton's *Hollywood*, Lee's cheery pictures did not challenge broader cultural expectations about movie culture or movie workers.

In spite of *Life*'s rejection of his painting, Benton continued to accept the corporate art commissions that Reeves Lewenthal arranged for him. Well into the forties Benton remained convinced of "the possibilities of a fruitful relation" between big business and American art and still believed that he could restore the producer tradition by directing regionalism toward a mass audience.[78] But, he discovered that whereas *Life*'s editors simply rejected art they did not like, other corporate patrons were not so easily satisfied and demanded artistic alterations. Increasingly, working on assignment for the American Tobacco Company, United Artists, and Abbott Laboratories, Benton found that he, like the producers he painted in Flint and Hollywood, would have to reckon with the challenges made to worker autonomy in the changed climate of the late 1930s and during World War II. He would also have to face the fact that in the 1940s his brand of modern art became co-opted by the very elements of American society that he had hoped to see transformed.

NOTES

1. Rejected in conjunction with its original commission, *Hollywood* was published in *Life* on December 12, 1938 (pp. 74–75) to illustrate an article on the Carnegie Institute Exhibit, where the picture won first prize.

2. Thomas Hart Benton, *An Artist in America*, 4th rev. ed. (Columbia: University of Missouri Press, 1983; originally published in 1937), 259; Peter Roffman and Jim Purdy, *The Hollywood Social Problem Film: Madness, Despair, and Politics from the Depression to the Fifties* (Bloomington: Indiana University Press, 1981), 48.

3. Richard Tedlow, *Keeping the Corporate Image: Public Relations and Business, 1900–1950* (Greenwich, Conn.: JAI Press, 1979), 84, 88.

4. William E. Leuchtenburg, *Franklin D. Roosevelt and the New Deal, 1932–1940* (New York: Harper & Row, 1963), 21. On American press attitudes toward Roosevelt and the New Deal, see Frederick Lewis Allen, *Since Yesterday: The 1930s in America* (New York: Harper & Row, 1939, 1968), 218, and Caroline Bird, *The Invisible Scar* (New York: Pocket Books, 1967), 181–82.

5. Bruce Barton, "Business Can Win Public from Politician," *Printer's Ink* 173, no. 11 (December 12, 1935): 17. William Bird, "Enterprise and Meaning: Sponsored Film, 1939–1949," *History Today* 39 (December 1989): 24–30. See also Roland Marchand, "The Fitful Career of Advocacy Advertising: Political Protection, Client Cultivation, and Corporate Morale," *California Management Review* 24, no. 2 (Winter 1987): 142–43.

6. Barton, "Business Can Win," 20, 24. On the links between modern consumerism and republicanism, see Lary May, "Making the American Way: Moderne Theatres, Audiences, and the Film Industry, 1929–1945," *Prospects* 12 (1987): 89–124.

7. Warren Susman, "Culture and Civilization: The Nineteen-Twenties," in *Culture as History: The Transformation of American Society in the Twentieth Century* (New York: Pantheon Books, 1984), 111; Lary May, *Screening Out the Past: The Birth of Mass Culture and the Motion Picture Industry* (New York: Oxford University Press, 1980), xiii, 116–17, 240–41.

8. Robert Lynd, "The People as Consumers," *Recent Social Trends in the United States, Report of the President's Research Committee on Social Trends* (New York: McGraw-Hill Book Co., 1933), 2:867–68; Jackson Lears, "From Salvation to Self-Realization: Advertising and the Therapeutic Roots of the Consumer Culture, 1880–1930," *The Culture of Consumption*, Richard Wightman Fox and Jackson Lears, eds. (New York: Pantheon Books, 1983), 3–38; Roland Marchand, *Advertising the American Dream: Making Way for Modernity, 1920–1940* (Berkeley: University of California Press, 1985).

9. Marchand, *Advertising the American Dream*, 306; Forbes, quoted in Marchand's "The Fitful Career," 143; Barton, "Business Can Win," 24.

10. Tedlow, *Keeping the Corporate Image*, 63; Marchand, "The Fitful Career," 143.

11. On the CCA, see James Sloan Allen, *The Romance of Commerce and Culture: Capitalism, Modernism, and the Chicago-Aspen Crusade for Cultural Reform* (Chicago: University of Chicago Press, 1983), 27–29; Neil Harris, "Designs on Demand: Art and the Modern Corporation," in Martina Roudabush Norelli, *Art, Design, and the Modern Corporation* (Washington, D.C.: Smithsonian Institution Press, 1985), 15–19. Paepcke quoted in Norelli, "Catalogue of the Exhibit," 32. On the Futurama, see Alice G. Marquis, *Hopes and Ashes: The Birth of Modern Times, 1929–1939* (New York: Free Press, 1986), 202–5.

12. Walter Abell, "Industry and Painting," *Magazine of Art* 39 (March 1946): 84.

13. Virginia Mecklenburg, "Advancing American Art: A Controversy of Style," *Advancing American Art: Politics and Aesthetics in the State Department Exhibition, 1946–1948* (Montgomery, Ala.: Montgomery Museum of Fine Arts, 1984), 37, 60–61; Russell Lynes, *The Tastemakers* (New York: Harper & Row, 1949), 293.

14. "Money in Pictures," *Time* 37, no. 16 (April 21, 1941): 71; Walter Adams, "Nobody Too Poor to Buy a Masterpiece," *Better Homes and Gardens* 24 (December 1945): 30–33, 62–63.

15. W. Adams, "Nobody Too Poor," 33, 63; "Field Notes: Merchandising Fine Art," *Magazine of Art* 30 (January 1937): 62.

On New Deal graphic art, see Richard McKinzie, *The New Deal for Artists* (Princeton: Princeton University Press, 1973), 118. WPA/FAP chiefs did not seriously consider "letting WPA workers sell what they produced on government time" until 1940, when they changed policy and organized an "Art Week" to encourage public consumption of New Deal art. Held also in 1941, these national art weeks completely "flopped," netting less than $250,000 in sales. See also Francis V. O'Connor, "Introduction," *WPA/FAP Graphics* (Washington, D.C.: Smithsonian Institution Press, 1976), 5.

On the growth of the art market from the 1940s to the present, see Diana Crane, *The Transformation of the Avant-Garde: The New York Art World, 1940–1985* (Chicago: University of Chicago Press, 1987), chap. 1 and passim.

See Clinton Adams, *American Lithographers, 1900–1960: The Artists and Their Printers* (Albuquerque: University of New Mexico Press, 1983), 139–41 for an overview of the AAA.

16. "Making Fine Prints Popular," *Prints* (November 1934): 17, quoted in Adams, *American Lithographers,* 140; "The Associated American Artists," *New York Times* (October 15, 1934), from the Archives of American Art (AAA), the Associated American Artists File, Microfilm Roll D–255, frames 7–14.

17. "The Associated American Artists," *New York Times,* October 15, 1934.

18. W. Adams, "Nobody Too Poor," 30; Benton, *An Artist,* 279.

19. W. Adams, "Nobody Too Poor," 30. See also Creekmore Fath, *The Lithographs of Thomas Hart Benton,* new ed. (Austin: University of Texas Press, 1969, 1979), 18.

20. "Art by Big Business," *Newsweek* 24 (September 18, 1944): 102; Fred Ferretti, "The AAA and How It Grew," *Art News* 73 (February 1974): 57; W. Adams, "Nobody Too Poor," 30, 33; "Money in Pictures," *Time* 37:71.

21. Author interview with Reeves Lewenthal, New York, November 24, 1981.

22. See, for example, Benton's articles (see notes 50 and 52 in chap. 2) and his 1937 autobiography, as well as Curry's "What Should the American Artist

Paint?" *Art Digest* 9, no. 20 (1935): 29, and Wood's "Revolt against the City," published in James Dennis, *Grant Wood: A Study in American Art and Culture* (New York: Viking Press, 1975), 229–35.

23. On government crop destruction, see Leuchtenburg, *Franklin D. Roosevelt*, 72–73. Benton refers to this 1934 print in Fath, *The Lithographs*, 36.

24. "Art by Big Business," *Newsweek* 24:102. Further information on the AAA's business clientele can be found in their files in the AAA, Microfilm Rolls N–122 and D–255.

25. Benton, quoted in an interview with Paul Cummings, July 1973. See the transcript of their conversation in the Archives of American Art Oral History Collection, pp. 35, 59. Curry, whose previous dealer was Maynard Walker, is quoted from the Curry Papers, AAA, Microfilm Roll 166. Wood quoted in Wanda Corn, *Grant Wood: The Regionalist Vision* (New Haven: Yale University Press, 1983), 52.

26. Benton, "After" (1951), an essay appended to *An Artist in America*, 292. On Progressive efforts to engender community, see Jean B. Quandt, *From the Small Town to the Great Community: The Social Thought of Progressive Intellectuals* (New Brunswick: Rutgers University Press, 1970).

27. Henry Luce, "The American Century," *Life* 10 (February 17, 1941): 65.

28. Noted in W. A. Swanberg, *Luce and His Empire* (New York: Charles Scribner's Sons, 1972), 105, and in James L. Baughman, *Henry R. Luce and the Rise of the American News Media* (Boston: Twayne Publishers, 1987), 111–13. For biographical information on Luce, see John Kobler, *Luce, His Time, Life, and Fortune* (New York: Doubleday & Co., 1968). Baughman notes Luce's fascination with Mussolini on pp. 104–5. Luce died in 1967.

29. Luce, quoted in John K. Jessup, *The Ideas of Henry Luce* (New York: Atheneum, 1969), 99. His rehash of Coolidge is noted on p. 24.

30. Kobler, *Luce*, 80. On *Fortune*'s Round Tables, see Baughman, *Henry R. Luce*, 114.

31. Luce quoted in David Cort, *The Sin of Henry R. Luce* (Secaucus, N.J.: Lyle Stuart, 1974), 48, 133; see also Kobler, *Luce*, 105. Wilson Hicks, *Words and Pictures* (New York: Harper & Bros., 1952), 85.

32. Luce, quoted in Jessup, *The Ideas*, 3; see also Baughman, *Henry R. Luce*, 112.

33. "How to Beat the Communists," *Life* 27 (August 29, 1949): 28–29.

34. On *Life*'s success and photojournalism, see Swanberg, *Luce and His Empire*, 144, Cort, *The Sin of Henry R. Luce*, 108, and *Photojournalism* (New York: Time-Life Books, 1983), 92–105. Harris, "Introduction," *The Land of Contrasts, 1880–1901* (New York: George Braziller, 1970), 7.

35. Carol Squiers, "Looking at *Life*," *Artforum* 20, no. 4 (December 1981): 59. See also Maitland Edey, *Great Photographic Essays from Life* (New York: Little, Brown, & Co., 1978). Cort discusses the Donnelley firm in *The Sins of Henry R. Luce*, 46–47; see also Loudon Wainwright, *The Great American*

Magazine: An Inside History of Life (New York: Alfred Knopf, 1986), 22–23. Wainwright discusses Luce and art on pp. 22–23, 164, 90.

36. "Grant Wood's Latest Landscape, *Spring Turning*," *Life* 2 (February 1, 1937): 34–35. For a list of other articles, see entry headings in Jane Clapp, *Art in Life* (New York: Scarecrow Press, 1959). See also Patricia Havlice, *Art in Time* (New York: Scarecrow Press, 1970). A comparison between the number of articles on regionalist and American scene art published by the Lucepress and other major magazines of the day, such as *Newsweek, Look,* and the *Saturday Evening Post,* reveals that Time-Life not only covered art much more frequently but concentrated on these particular styles of art.

37. Letters to the Editor, *Life* 2 (April 12, 1937): 18, and *Life* 2 (April 26, 1937): 12, 14. For art world response to *Life*'s use of color pictures, see Thomas M. Folds, "A Consumer's Guide to Color Prints," *Magazine of Art* 36, no. 4 (May 1943): 185.

38. "Headlines Proclaim the Rise of Fascism and Communism in America," *Life* 3, no. 4 (26 July 1937): 19–27. Benton's sketches were featured in the article "Artist Thomas Hart Benton Hunts Communists and Fascists in Michigan," 22–25.

39. David Brody, "The Emergence of Mass-Production Unionism," *Workers in Industrial America: Essays on the Twentieth Century Struggle* (New York: Oxford University Press, 1980), 82–119. This essay was originally published in 1964.

On the GM strike in Flint, see John Barnard, *Walter Reuther and the Rise of the Auto Workers* (Boston: Little, Brown & Co., 1983), 45–49, and Irving Howe and B. J. Widick, *The UAW and Walter Reuther* (New York: Random House, 1949), 55–65. Leuchtenburg cites the rise in UAW membership, *Franklin D. Roosevelt and the New Deal,* 240.

40. Francis V. O'Connor, *Jackson Pollock* (New York: Museum of Modern Art, 1967), 21; Steven Naifeh and Gregory White Smith, *Jackson Pollock: An American Saga* (New York: Clarkson N. Potter, Inc., 1989), 305.

41. Karal Ann Marling notes the genre scene style of Benton's *Life* sketches in *Tom Benton and His Drawings* (Columbia: University of Missouri Press, 1985), 95. Benton quoted in Fath, *The Lithographs,* 184. On Evergood, see Patricia Hills, "Philip Evergood's *American Tragedy:* The Poetics of Ugliness, the Politics of Anger," *Arts* 54, no. 6 (February 1980): 138–39.

42. Benton, quoted in Fath, *The Lithographs,* 184.

43. Letters to the Editors, *Life* 3, no. 7 (August 16, 1937): 12, from Irving Marantz, Norman Lewis, Yankel Kufeld, William Gough, and Jan Bols.

44. Karal Ann Marling, "A Note on New Deal Iconography: Futurology and the Historical Myth," *Prospects* 4 (1979): 437.

Longwell's comments on *Life*'s art projects are found in a speech he gave at an "art luncheon," May 8, 1942. From the Daniel Longwell Papers, Box 32, Rare Book and Manuscript Library, Columbia University, New York.

The first history picture, Laning's *T.R. in Panama*, was published in *Life* on May 15, 1939 (pp. 44–45), and included editorial comments on the purpose of the art series. It was followed by *The Shooting of Huey Long* (6 [June 26, 1939]: 49–50); *The Death of Dillinger* (8 [March 11, 1940]: 71–72); and *Spindletop* (10 [February 10, 1941]: 41–42). There were eight paintings published in the series.

45. "*Hoover and the Flood,*" *Life* 8 (May 6, 1940): 58–61.

46. On Curry's politics, see M. Sue Kendall, *Rethinking Regionalism: John Steuart Curry and the Kansas Mural Controversy* (Washington, D.C.: Smithsonian Institution Press, 1986), 84. La Follette, quoted in Robert S. McElvaine, *The Great Depression: America, 1929–1941* (New York: Times Books, 1984), 231. For information on Hoover and the 1940 campaign, see Eugene Lyons, *Herbert Hoover: A Biography* (New York: Doubleday, 1964), 338. Regarding Luce and *Life*'s promotion of Republican candidates in the 1940 election, see Letters to the Editors, *Life* 8 (October 21, 1940): 2.

47. See Dorothy Miller and Alfred Barr, *American Realists and Magic Realists* (New York: Museum of Modern Art, 1943), 31, and Lincoln Kirstein, *Paul Cadmus* (New York: Imago Books, 1984), 45.

48. A few of Benton's rejected *Life* drawings were published in Harry Salpeter's "A Tour of Hollywood: Drawings by Thomas Benton," *Coronet* 7, no. 4 (February 1, 1940): 34–38, which also provides information on Benton's commission. Further data on *Life*'s hiring of Benton can be found in correspondence between him and Longwell in the Longwell Papers, Benton File, Box 32. Their correspondence suggests that Benton was in Hollywood on assignment for *Life* during August 1937, hired to paint a movie mural and to provide sketches for a "production series" *Life* planned on the movie industry. See Benton's letter to Longwell, September 15, 1937. Apparently, *Life*'s commissions were "pretty much by word of mouth agreements" as stated in the correspondence between Longwell and another artist, Alexander Brooks, hired by *Life* to paint portraits of Hollywood stars in 1948. Information on this commission can be found also among Longwell's papers.

Twentieth Century–Fox's production schedule for August 1937 included *In Old Chicago, Life Begins in College, Ali Baba Goes to Town, 45 Feathers,* and *Dangerously Yours.* See "Advance Production Chart," *Variety,* August 25, 1937, pp. 27.

49. See *Life Goes to the Movies* (New York: Time-Life, 1975), 4–6, 86, 92, 247, and Robert T. Elson, *Time, Inc.: The Intimate History of a Publishing Enterprise, 1923–1940* (New York: Atheneum, 1968), 281. For reference to the 1940 Gallup Poll, see Baughman, *Henry R. Luce,* 2, 206. On *Life* and *The Grapes of Wrath*, see my "Borrowing Regionalism: Advertising's Use of American Art in the 1930s and 40s," *Journal of American Culture* 5, no. 4 (Winter 1982): 13.

50. *Life Goes to the Movies,* 4; "Hollywood Is a Wonderful Place," *Life* 2

(May 3, 1937): 28–37. Suckow, quoted from "Hollywood Gods and Goddesses," *Harper's Magazine* 173 (July 1936): 189–200, reprinted in *Culture and Commitment, 1929–1945,* ed. Warren Susman (New York: George Braziller, 1973): 170–77.

51. John Baxter, *Hollywood in the Thirties* (New York: Paperback Library, 1970): 10, 19; Roffman and Purdy, *The Hollywood Social Problem Film,* 1–4. Film attendance figures for the thirties are analyzed in May, "Making the American Way," *Prospects,* 107–11. Quote from Robert Sklar, *Movie-Made America: A Cultural History of American Movies* (New York: Vintage Books, 1975), 161.

52. Charles Beard, *America in Midpassage* (New York: Macmillan Co., 1939), 2:593.

53. Andrew Bergman, *We're in the Money: Depression America and Its Films* (New York: New York University Press, 1971), xvi.

54. See my "Images of American Women in the 1930s: Reginald Marsh and *Paramount Picture,*" *Woman's Art Journal* 4, no. 2 (Fall-Winter 1983/1984): 1–4, and "Edward Hopper, *Nighthawks,* and *Film Noir,*" *Postscript: Essays in Film and the Humanities* 2, no. 2 (Winter 1983): 14–36.

55. "Wright's Huge Mural, 200 Figures, Is in Place," *Art Digest* 10, no. 1 (October 1, 1935): 7. For information on MacDonald-Wright, who worked in the movie industry in 1919 and "produced the first full-length, stop-motion film ever made in full color," see *The Art of Stanton MacDonald-Wright* (Washington, D.C.: National Collection of Fine Arts, Smithsonian Institution, 1967). The artist notes on p. 22 that he veered from the "personal academism" of synchromism in favor of "new areas of world art" in 1920. His Santa Monica mural is now in the collection of the Smithsonian Institution.

He and Benton maintained a friendship until MacDonald-Wright's death in 1973. Benton traveled to Los Angeles in 1961 to paint his portrait, illustrated in *Benton's Bentons* (Lawrence: Spencer Museum of Art, University of Kansas, 1980), 50.

56. Benton to Longwell, February 8, 1938, in the Longwell Papers, Benton File, Box 32.

57. James Monaco, *How to Read a Film* (New York: Oxford University Press, 1977), 162. Benton quoted from a reply made to a telegram dated August 15, 1940 from Betty Chamberlain at Time-Life, Inc., published as Appendix 2, "Benton the Model Maker," in Bob Priddy, *Only the Rivers Are Peaceful: Thomas Hart Benton's Missouri Mural* (Independence, Mo.: Independence Press, 1989), 272–75.

58. Denis Morrison, "Inside Stuff on Fire," *Variety,* August 4, 1937, pp. 3, 27. On the Technicolor process, see Monaco, *How to Read a Film,* 92.

59. Robert Manvell in his Introduction to Edward Carrick's (pseud. Edward Anthony Craig) *Art and Design in the British Film* (London: Dennis Dobson, 1948) describes the "pattern of action" inherent in any movie; see pp. 8–9. On action-reaction editing, see Jeffery Morton Paine, *The Simplification of Ameri-*

can Life: Hollywood Films of the 1930s, Dissertations on Film Series, Arno Press Cinema Program (Windsor: University of Windsor, 1977), 188.

60. Karal Ann Marling, *Wall-to-Wall America: A Cultural History of Post–Office Murals in the Great Depression* (Minneapolis: University of Minnesota), 17–18.

61. From *Vanity Fair: Selections from America's Most Memorable Magazine, A Cavalcade of the 1920s and 30s* (New York: Vanity Fair, 1972), 266. "The Common Steel Worker Gets His Pay Raised to $5.00 a Day," *Life* 2, no. 11 (March 15, 1937): 13–15. For information on *Slim,* see Roffman and Purdy, *The Hollywood Social Problem Film,* 113–14.

62. Clive Hirschhorn, *The Hollywood Musical* (New York: Crown Publishers, 1981), 144. Quotes from the *In Old Chicago* script, Theatre Arts Library, University of California, Los Angeles. This is almost exact to the final speech in the film.

63. Alfred Haworth Jones, "The Search for a Usable American Past in the New Deal Era," *American Quarterly* 23 (December 1971): 711–24. Information on the film's dedication can be found in the *In Old Chicago* file in the Theater Arts Library at UCLA.

64. Morrison, "Inside Stuff on Fire," 3, 27.

65. For information on both films, see Hirschhorn, *The Hollywood Musical,* 138. See also *Variety's* descriptions of *Life Begins in College* on August 4, 1937, p. 27, and of *Ali Baba Goes to Town* on October 20, 1937, p. 12.

66. Bergman, *We're in the Money,* 133–34.

67. For information on the Production Code, see Roffman and Purdy, *The Hollywood Social Problem Film,* 6–7, and Sklar, *Movie-Made America,* 174. Margaret Farrand Thorp described the trend of "domestic" movies in *America at the Movies* (New Haven: Yale University Press, 1939), 188–89.

68. See May, "Making the American Way," 91, on movie industry republicanism.

69. William F. Crouch, "'Strip-Tease' Dancers Invade Film Theaters," *Motion Picture Herald,* March 27, 1937, p. 5; Benton to Longwell, January 20, 1938, in the Longwell Papers. On Marsh's paintings, see Lloyd Goodrich, *Reginald Marsh* (New York: Whitney Museum, 1955).

70. Benton to Longwell, February 8, 1938. A statue of Athena placed in front of the Austrian Reichsrat in 1902 shows the goddess holding a scepter in one hand and an orb in the other. See Carl Schorske, *Fin-de-Siècle Vienna: Politics and Culture* (New York: Random House, 1981), 43–44.

71. On Hollywood labor organization in the thirties, see Sklar, *Movie-Made America,* 172. Cantor is mentioned on p. 171. See also Murray Ross, *Stars and Strikes: Unionization of Hollywood* (New York: Columbia University Press, 1941), 193; and Louis B. Perry and Richard S. Perry, *A History of the Los Angeles Labor Movement, 1911–1941* (Berkeley: University of California Press, 1963), 318–61.

72. Ross, *Stars and Strikes*, 3.

73. Leo Rosten, *Hollywood: The Movie Colony, the Movie Makers* (New York: Harcourt Brace & Co., 1941), 32–33. A reproduction of Benton's *Hollywood* accompanied the *New York Times*'s book review (December 7, 1941) of Rosten's book; see sec. 6, p. l.

74. Benton, "Hollywood Journey," from the Benton Papers, AAA, Microfilm Roll 2327.

75. Benton, "Hollywood Journey." On Zanuck, see Mel Gussow, *Don't Say Yes Until I Finish Talking: A Biography of Darryl F. Zanuck* (New York: Da Capo Press, 1971), 82.

76. Benton, "Hollywood Journey," 2.

77. "Sound Stages of Hollywood Hum with Work on Movies for 1938," *Life* 3, no. 26 (December 27, 1937): 39–46. See note 1 of this chapter on *Life*'s publication of *Hollywood*. On Lee, see "Hollywood Gallery: A Painter's Portfolio of Impressions of Movie City," *Life* 19, no. 16 (October 15, 1945): 84–89.

78. Benton, "After," 292.

Modernist Accommodation,

Corporate Appropriation:

The Collapse of Regionalism

and the New Deal

I n the early forties tobacco mogul George Washington Hill decided that regionalist art might be just the thing to position Lucky Strike as the top-selling cigarette in America. Hill, president of the American Tobacco Company since 1925, had jostled for years with competitors R. J. Reynolds (makers of Camels) and Liggett & Myers (makers of Chesterfields) for consumer favor. In 1940, when Lucky Strike sales were just slightly behind those of Camels, he became convinced that an advertising campaign featuring "America's foremost artists" could pull Luckies into the lead. Through Reeves Lewenthal's Associated American Artists agency, Hill hired Thomas Hart Benton, John Steuart Curry, and fifteen others to paint pictures of tobacco country for use in full-page magazine ads for Lucky Strike (figs. 4.1, 4.2).[1]

For Benton, this art-for-business assignment, like others he accepted before World War II from United Artists and Abbott Laboratories, was a great disappointment. He increasingly found that far from generating reform in the American workplace, his art was appropriated by big business and used to substantiate corporate authority. The intended meaning of his modern art was changed considerably. Benton also began to recognize that the American scene itself had changed, that the country's mood in the late thirties and early forties was very different from what it had been a few years earlier. For these reasons and others, by the time the United States became officially involved in World War II, Benton began seriously questioning the efficacy of regionalist art and

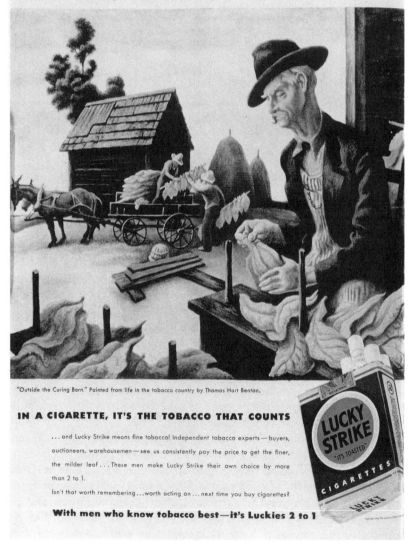

4.1. Advertisement for Lucky Strike cigarettes, *Time,* July 20, 1942, featuring Thomas Hart Benton's *Outside the Curing Barn,* 1942. Copyright The American Tobacco Company. Reprinted by permission.

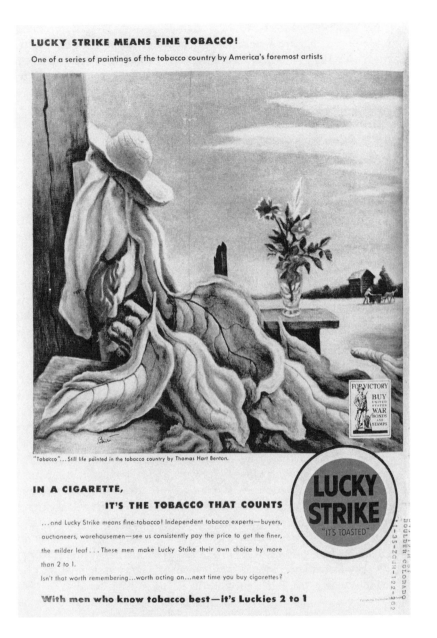

4.2. Advertisement for Lucky Strike cigarettes, *Time*, October 26, 1942, featuring Thomas Hart Benton's *Tobacco*, 1942. Copyright The American Tobacco Company. Reprinted by permission.

New Deal politics to create social change. Perhaps he recognized that he had allowed his art, originated to challenge the status quo and transform America, to become complicitous propaganda for big business. Certainly he saw that a new kind of modern art, one radically different in style and function, was garnering critical, corporate, and public attention.

In 1941, the American Tobacco Company encountered serious public confidence problems when it, along with R. J. Reynolds and Liggett & Myers, was found guilty of violating the Sherman Antitrust Act. After a five-month trial the Big Three were convicted of price fixing and monopolization. The Department of Justice, which had tried for years to curtail oligopolistic practices in the tobacco industry, considered this an enormous victory, although Ellis Hawley has shown such action "did little to alter market structures." The legal community saw the decision as a model for future litigation, especially in consumer industries. And the country's 1,602,000 tobacco farmers, depicted by trustbuster Thurman Arnold as being "at the mercy of the big tobacco firms that fix dates and places of auctions, use secret buying grades, avoid competition by not unanimously acquiring the same kind of leaf, and bid at auction in a gibberish which the farmer completely fails to understand," saw the trial as vindication for decades of economic exploitation.[2]

George Washington Hill worried that public reaction to his company's complicity might affect sales, and at a time when considerable profits were to be made. Hill was well aware that by the end of the First World War, cigarette smoking had risen more than 200 percent. He also knew that already, in 1941, prewar tensions had increased cigarette consumption by 13 percent. In the tradition of the corporate tycoon Hill oversaw every detail of his company's business, and that included its advertising. Like Evan Llewellyn Evans, the tyrannical manufacturer of Beautee Soap in Frederic Wakeman's 1946 advertising industry exposé *The Hucksters* (a thinly disguised portrait of Hill himself, written by a former copywriter on the Lucky Strike account), Hill believed his company's products should be tied to distinctive slogans and symbols. Lucky Strike cigarettes were promoted as candy substitutes ("Reach for a Lucky Instead of a Sweet") and were associated with what may be the most effective five-letter promotion in advertising history: L.S.M.F.T. ("Lucky Strike Means Fine Tobacco"). In an extended campaign begun in 1942 Luckies were tied to the down-home folksy look of regionalist art. Other cigarette manufacturers capitalized on the war and used military themes in advertising, but not the American Tobacco Company.

Even when wartime rationing forced the company to eliminate the green dye used in Lucky Strike packaging, it reserved the patriotic slogan "Lucky Strike Green Has Gone to War" for radio ads and carton inserts. From 1942 through 1944, the major promotional vehicle for Lucky Strike cigarettes was regionalism.[3]

To snare the continued confidence of consumers, to insure wartime sales, and to propel Luckies into the number one spot, Hill commissioned Benton and other American scene artists and used their pictures of tobacco country atmosphere in a protracted and ultimately very successful corporate campaign. Hill considered the nativist art of regionalism—at the height of its popularity in the late thirties as a result of the promotional efforts of Reeves Lewenthal, *Time* and *Life* magazines, and the artists themselves—the perfect vehicle to woo public goodwill and guarantee profits. Like Henry Luce, Hill believed that the representational style of regionalism could act as a mediating agent, in this case between his company's bad press and cigarette sales. Regionalist art had the power to persuade.

At the start of this assignment Benton was probably not aware of how his art really figured in corporate image-making, but even so this commission was an interesting twist for him. In his four murals of the thirties, his *Common Sense* articles, and his painting *Hollywood*, Benton had challenged corporate hegemony by positing capitalist restructuring. Now he allowed regionalist art to accommodate public support for corporate culture. His new and obvious links to this culture did not go unnoticed: in one scene in *The Hucksters*, Wakeman cattily observed that a "picture painted by Thomas Hart Benton" was purchased "with soap samples." Alluding to Benton's work for Lucky Strike, Wakeman intimated that any artist—or anybody for that matter—who worked for an American corporation would ultimately wind up subservient to institutional control. Although Wakeman wrote from personal experience, the history of Benton's work for the American Tobacco Company substantiates his argument. The pictures used for the Lucky Strike ad campaign portray tobacco country as an agricultural paradise full of bountiful fields and enthusiastic farmers. *Outside the Curing Barn* (fig. 4.1) endorses tobacco land as a rural utopia, and *Tobacco* (fig. 4.2) is the American scene equivalent of a Flemish still-life, or as Benton called it, "a bunch of big leaves sitting on a chair."[4]

But this was not exactly what he had seen while on location for the assignment in southern Georgia. There, tobacco farming was done by black sharecroppers, the subjects of Benton's original sketches (fig. 4.3).

4.3. Thomas Hart Benton, *Sorting Tobacco at Firing House,* 1942; ink wash on paper, 14″ × 10 ½″. Courtesy of the Trustees of the Benton Testamentary Trusts, Kansas City.

However, when he showed his work to admen at Lord & Thomas, the New York agency which handled the Lucky Strike account, he was told advertising did not allow images of "Negroes doing what looks like old-time slave work." Benton pointed out that he had been hired to paint "realistic pictures." In a 1951 essay he paraphrased the response of agency executives:

> Yes, yes, of course we want realism. That's why we quit the conventional model stuff and hired you artists, but we don't want realism that will foul up our sales. The Negro institutions would boycott our products and cost us hundreds of thousands of dollars if we showed pictures of this sort. They want Negroes presented as well-dressed and respectable members of society. If we did this, of course, the whole of the white south would boycott us. So the only thing to do is to avoid the representation of Negroes entirely in tobacco advertising.[5]

Benton tried again, going to fields in North Carolina this time, where tobacco was handled mostly by whites. Based on his sketches there he produced *Tobacco Sorters* (fig. 4.4), which features an older farmer and a young girl examining broad yellow tobacco leaves. It too was rejected. Benton was told it "was not suitable for public display because the thinness of the little girl might suggest that proximity to tobacco caused consumption." Agency spokesmen stressed "everything about tobacco must look healthy."[6]

The pictures that were accepted, *Outside the Curing Barn* and *Tobacco*, were completely inoffensive, the one focusing on white farmers handling huge golden leaves of tobacco, and the other a benign still-life. While they *looked* like regionalist art, they lacked any of that style's original political and social provocation. Featured as ads in *Time* and the *Saturday Evening Post*, Benton's pictures were accompanied by just a few sentences of copy: "Independent tobacco experts—buyers, auctioneers, warehousemen—see us consistently pay the price to get the finer, the milder leaf. . . . These men make Lucky Strike their own choice by more than 2 to 1." In an appeal to public goodwill the company heralded the impartiality of the "independent" experts that they had been convicted of bribing just a few months earlier. They backed their objectivity (and hence, innocence) with the equally impartial "realism" of Benton's art.

Earlier in this campaign some ads, such as one with a picture by John Steuart Curry (fig. 4.5), had lengthier texts with statistics on what the company paid ("34% more in Pamplico, S.C.") for its "milder, better-tasting" tobacco. But Fairfax Cone, the Lord & Thomas adman who handled the Lucky Strike account, felt too much text spoiled the "strong graphics" of the art and persuaded Hill to drop words for visuals.[7] In the age of advertising ushered in by Bruce Barton, pictures alone could be counted on to generate consumerism. Both Cone and Hill believed the powerful visual appeal of regionalist art could convince consumers of the American Tobacco Company's inculpability in tobacco-trust wrongdoing. Even after the company dropped this campaign and its "paintings of the tobacco country by America's foremost artists," it continued to promote Luckies with pictures in a pseudo-regionalist style by such commercial artists as Cosmo de Salvo (fig. 4.6). Of course, as Benton later noted with not a little chagrin, this was not "real" regionalism at all, but its "superficial representation."[8]

From their point of view, American Tobacco Company's aesthetic mandates paid off. By the end of 1942, Luckies had pulled into the lead as the country's number one cigarette, a position it would hold through-

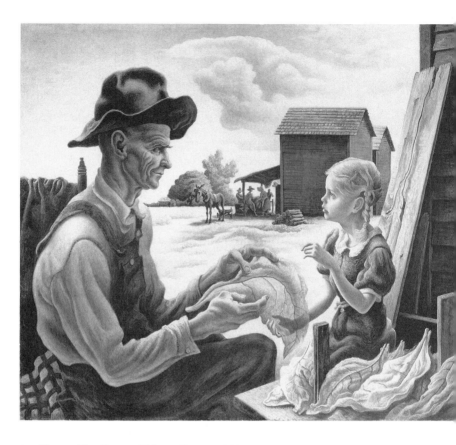

4.4. Thomas Hart Benton, *Tobacco Sorters,* 1942; tempera on canvas mounted on panel, 30″ × 35 ⅞″. Collection Oscar S. Brewer, Kansas City, on loan to The Nelson-Atkins Museum of Art. Reprinted by permission of Oscar S. Brewer.

out the war—and throughout the tenure of the company's regionalist art advertising campaign. However, most of the artists associated with the campaign felt "stifled by restrictions." Corporate demands, which resulted "in the preponderance of a conspicuous tobacco yellow in all the paintings, in a standardized grin on the farmers' faces, in the absence of Negroes working with whites, in a prim cleanliness of farmyards, and a complete absence of all Tobacco Road vulgarities," did not set well with Benton or the other artists. Raised on the notion of producer au-

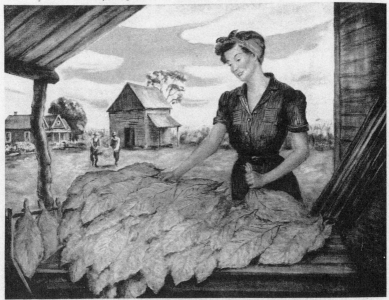

LUCKY STRIKE MEANS FINE TOBACCO!

One of a series of paintings of the tobacco country by America's foremost artists

Grading a pile of tobacco after curing. Painted from life by John Steuart Curry

To bring you fine, mild tobacco like this we paid 34%* more in Pamplico, S. C.

EVERYBODY KNOWS that some tobacco is better than other tobacco—and all through the South, year after year, the makers of Luckies pay the price to get the milder, better-tasting leaf.

For example: In Pamplico, S. C., at auctions of the 1939 crop, we paid 34% more—yes, 34% *above the average market price.*

This was in no way unusual. We paid well above the average market price in 108 tobacco markets that season. And that 1939 crop, properly aged, mellowed, and blended with other fine crops, is in the Luckies you buy across your retail counter today.

To independent tobacco experts—auctioneers, buyers and warehousemen—Lucky Strike *means* fine tobacco. With these men who know tobacco best, it's Luckies 2 to 1.

In a cigarette it's the tobacco that counts . . . and the milder, better-tasting leaf is in Luckies. Isn't that worth remembering . . . worth *acting* on, next time you buy cigarettes?

34% more than the average market price reported by U. S. Department of Agriculture.

With men who know tobacco best—it's Luckies 2 to 1

4.5. Advertisement for Lucky Strike cigarettes, *Time,* February 9, 1942, featuring John Steuart Curry's *Grading a Pile of Tobacco after Curing,* 1942. Copyright The American Tobacco Company. Reprinted by permission.

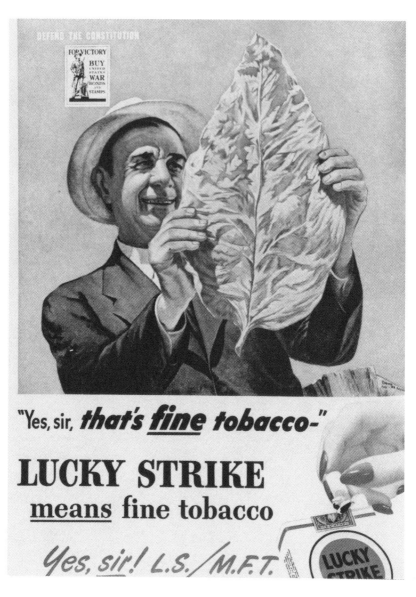

4.6. Advertisement for Lucky Strike cigarettes, *Time,* October 23, 1944, featuring an untitled painting by Cosmo de Salvo. Copyright The American Tobacco Company. Reprinted by permission.

tonomy, Benton was angered by corporate challenges to artistic control. As he bitterly complained a few years after this commission:

> Every time a patron dictates to an artist what is to be done, he doesn't get any art—he just gets a poor commercial job. For that reason I thought the series of paintings the American Tobacco Company used in its advertising was a failure. . . . The challenge we're making to business is, "Are you willing to proceed on the basis of complete freedom for the artist?" [9]

Obviously, the American Tobacco Company was not so willing. Indeed, Benton's question betrays considerable naiveté and even arrogance.

After years of his own success in the art world, Benton certainly understood that artists who desired visibility and recognition depended on some form of patronage, be it private, public, or corporate. And such patronage usually entailed some degree of compromise; "complete" aesthetic freedom was more often ideological fiction than social fact. Given his advocacy of a social art grounded in the conditions of its production and consumption, it is odd that in 1945 Benton seemingly endorsed a romantic ideal of the artist as a free individual, an outsider. If, earlier in his career he had avoided situations where he might have to compromise his aesthetic intentions—rejecting a government post office mural commission, for example—it is surprising that he did not recognize the restrictions that would be involved when he sought out commercial work.

As with his *Life* magazine commissions, mass media exposure and the healthy income it generated were both immensely appealing. But Benton also took the American Tobacco Company commission and other advertising jobs because he believed his art could transform the institutions of labor and mass media. His art, as Walter Benjamin described Bertold Brecht's epic theater, could "induce other producers to produce" and "put an improved apparatus at their disposal." [10] However, as the history of this commission reveals, Benton failed on both counts because he did not adequately consider the context in which his art was placed. He assumed his art would be used to sell cigarettes; he did not consider that regionalism would be used to solicit public confidence in corporate control. He hoped his art would elicit liberal reform, but the American Tobacco Company relied on it to do exactly the reverse: to fortify their image. Moreover, Benton acquiesced to corporate demands: he relinquished personal artistic control and by doing so vested the very institution he was hoping to reform. Recognizing the

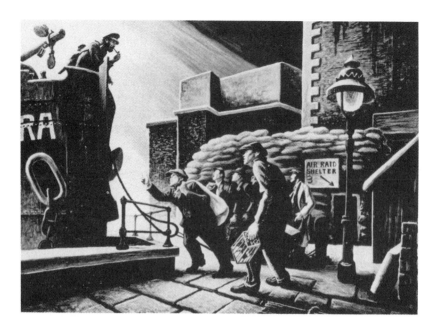

4.7. Thomas Hart Benton, *Shore Leave*, 1940. Reprinted from *American Artist*, September 1940.

power of representation, in this case the regionalist style, businesses like the American Tobacco Company were not about to give artists "complete freedom" to challenge their authority. Thus, Benton's artistic efforts to convince spokesmen for corporate hegemony like George Washington Hill, or Henry Luce, of worker autonomy and liberal ideology were defeated from the start. Other art-for-business commissions that he accepted during the early forties demonstrate that the mode of regionalist art itself was increasingly out of sync with American social and political culture.

In 1940 Hollywood's Big Eight, confronted with a rapidly vanishing foreign market (where they often made 40 percent of their annual gross) and slow domestic returns, decided to increase their publicity efforts dramatically. In addition to boosting advertising in the trades and local newspapers, many studios staged elaborate premieres in midtown America: at the Tacoma opening of *Tugboat Annie Sails Again* (1940) "thirty-five government planes, a sixty-piece Army band, a U.S. naval guard of honor, and blasts from the guns of offshore Coast Guard ships

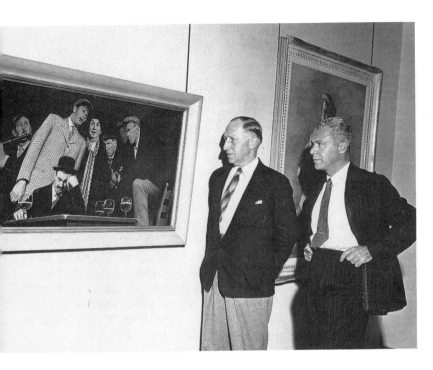

4.8. Photograph of Walter Wanger (right) and unidentified man in front of Grant Wood's *Sentimental Ballad* (1940; oil on masonite panel, 24″ × 50″, now in the collection of the New Britain Museum of American Art) at the opening of *The Long Voyage Home* art exhibit at the Associated American Artists Gallery, New York, 1940. Photograph courtesy of the Wisconsin Center for Film and Theater Research, State Historical Society of Wisconsin, Madison.

greeted the arrival of the stars." Movieland's search for increased profits and public goodwill, pursued in the mid-1930s with products and theaters evoking American unity and virtue, now expanded to include civic celebrations with increasingly nationalist and militarist attitudes.[11]

United Artists went a step further, hiring Benton, Wood, and seven other American scene artists to promote *The Long Voyage Home*, a war-at-sea picture based on several plays by Eugene O'Neill. As in the case of the Lucky Strike campaign, the mediator between art and industry was Reeves Lewenthal. In May 1940 producer Walter Wanger hired painters from Lewenthal's Associated American Artists stable to sketch scenes during the production of United's movie (figs. 4.7, 4.8). They

were given their own studios on the UA lot, free access to the stages during production, rushes of each day's shooting, and their choice of what to paint. In conjunction with the film's release in October, their eleven canvases were displayed at the movie's premiere in New York and then toured museums across the country (fig. 4.9).[12]

The stunt attracted an enormous amount of publicity for the movie, which was exactly what Wanger wanted. This elaborate campaign was staged to offset studio worries that *The Long Voyage Home* was going to be a real box office dud. Although directed by John Ford, recently successful with *The Grapes of Wrath*, and featuring *Stagecoach* star John Wayne, this movie had several problems to contend with: its "arty" connotations and its interventionist intimations. A compilation of four one-act plays O'Neill wrote in the teens, *The Long Voyage Home* centered on the crew of the S.S. *Glencairn*, a freighter bound for England with a load of munitions (fig. 4.10). Updated to 1940, the movie's episodic plot meandered from scenes of the sailors battling the sea to sneaking through U-boat blockades to reach blitzed London. The irony of using Irish-American plays to substantiate English war efforts (and from the Irish-born Ford!) was ignored by both Wanger and contemporary critics, who reduced war itself to the simple formula of fascism versus the free world. Equally ironic was the movie's dark and moody tone. Despite its anti-isolationist overtones it was overwhelmingly fatalistic, opening with the titles "Men who live on the sea never change. They live apart in a lonely world, moving from one rusty tramp steamer to another," and ending with the few surviving members of the *Glencairn*'s crew shipping out on yet another *Odyssey*-like voyage.[13] More an existential study of uncontrollable fate than a gung-ho win-the-war actioner, *Voyage* was an unusual and nonconformist movie for 1940, although its film noir style would eventually come to dominate Hollywood in the forties and fifties.

Wanger had produced such atypical movies before, and he knew this one would be a hard to sell. Its highbrow character was a serious handicap. Earlier film adaptations of O'Neill, including *Anna Christie* (1930) and *The Emperor Jones* (1933) had been only moderately successful, and Wanger recognized that the pessimistic ambience of O'Neill's gloomy stories did not carry the same appeal to 47 million weekly moviegoers as did *In Old Chicago* or *Andy Hardy Gets Spring Fever* (1939). Moreover, the success of a prowar movie was questionable until Pearl Harbor. Before December 1941 most Americans opposed direct intervention. Although many supported Roosevelt's advo-

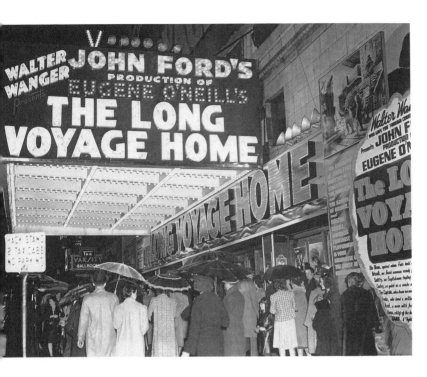

4.9. Photograph of premiere of *The Long Voyage Home* at the Rivoli Theater, New York, October 8, 1940. Photograph courtesy of the Wisconsin Center for Film and Theater Research, State Historical Society of Wisconsin, Madison.

cacy of "all aid short of war" others concurred with Montana senator Burton Wheeler's denunciation of New Deal internationalism as a foreign policy version of the Agricultural Adjustment Administration: "It will plough under every fourth American boy." [14] Reeves Lewenthal, visiting Hollywood to arrange an exhibit of his agency's American scene pictures, convinced Wanger that a publicity campaign featuring the popular and generally upbeat art of regionalism could undercut any highbrow or warmongering tensions *The Long Voyage Home* might evoke.

Prior experience as a military propagandist had convinced Wanger of the importance of advertising. Born in San Francisco in 1894, Wanger studied drama at Dartmouth, worked for a theatrical promoter in New York, and in the mid-teens absorbed himself in Allied propaganda efforts by distributing James Montgomery Flagg's famous poster of Uncle

Death at sea? Yank is mortally injured in the storm.

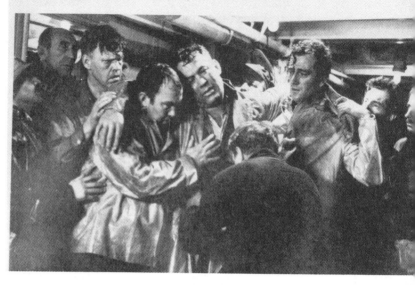

4.10. Two film stills from *The Long Voyage Home,* 1940. Reprinted from J. A. Place, *The Non-Western Films of John Ford,* Copyright 1979 by J. A. Place. A Citadel Press book. Published by arrangement with Carol Publishing Group.

Sam beckoning "I Want You." As Wanger later observed, his "concept of and experience at influencing the masses came very early." [15] Stationed in Italy during World War I, he produced propaganda films; after the war he served as an attaché to the 1919 Paris Peace Conference. Inspired by his involvement with Wilson's League of Nations, Wanger returned to New York intent on pursuing a diplomatic career. But after meeting Jesse Lasky, of Paramount Pictures, he shifted to the film industry. Working independently, Wanger quickly earned a reputation as a daring and provocative entrepreneur with his production of *Gabriel over the White House* (1933) and *Blockade* (1938). Ostensibly a pro–New Deal Democrat, the movies he produced reveal Wanger to be a very different kind of liberal from Charles Beard or Benton. In fact, Wanger had much more in common with corporate liberal Henry Luce.

 Gabriel over the White House, for instance, gave a ringing endorsement of authoritarianism, albeit that of the executive office not the corporate boardroom. The story of American president Jud Hammond, a

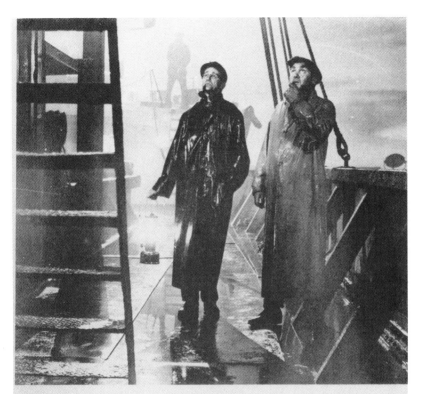

The dark lure of death is expressed in the mise en scene.

Hoover clone transformed by the archangel Gabriel into a "dictatorial presence made in differing parts of Theodore Roosevelt, Abraham Lincoln, and Huey Long," *Gabriel* is the story of the triumph of elite leadership.[16] To solve the problems of the Depression, Hammond fires his cabinet, disbands Congress, declares martial law, and executes gangsters. He alone, as sanctioned by the almighty, controls the country and leads the masses to a better future. Nor is he simply a national savior: Hammond singlehandedly dictates world peace by drawing up a world disarmament treaty which all leaders are forced to sign. Reference is made to the foreign powers who "plucked" the American eagle by failing to pay their war debts; with Hammond's treaty America will be forever free of pernicious foreign exploitation. Shortly thereafter he dies, a martyr to the ideal of national unity via elite rule. In the early thirties

both Wanger and Luce, who condoned Mussolini's fascist control of the new Italian "corporate state," were attracted to the kind of strong leadership which might bring together a badly divided America.

Five years later, for United Artists, Wanger produced *Blockade*, a pro-Loyalist view of the Spanish Civil War (begun in 1936) scripted by Hollywood radical John Howard Lawson. Like those who joined the Abraham Lincoln Brigade to fight for Republican Spain, Lawson, Wanger, and *Blockade* director Lewis Milestone sympathized with the Loyalists. Others in Hollywood, however, including Catholic layman Martin Quigley, editor of the influential trade journal *The Motion Picture Herald*, took the side of the American right (and the Catholic church) and supported Franco and the fascists. Official U.S. policy was that of neutrality and most in movieland, dependent on foreign markets until the late thirties, adhered to it. But United Artists had already closed its Spanish office by 1938 and Wanger was determined to make a serious film about the true conditions of European fascism.[17] If *Gabriel* advocated a kind of domestic isolationism, *Blockade* argued that American intervention in world affairs was now a necessity. It did so, however, very gingerly.

Set in "Spain 1936" (the film's only direct reference to the war) *Blockade* told the story of peasant rebel Marco (Henry Fonda) and his efforts to defend Spain from "enemies" (the movie's term for fascists) who have blockaded a Loyalist-controlled harbor and are trying to starve the country into submission. "This is our land, it's ours, it's part of us, it's worth fighting for," Marco passionately pleads, all the while pursuing fascist spy and reluctant Nazi Norma (Madeleine Carroll). Suddenly struck guilty by bombed schoolyards and the "faces of hungry Spaniards," Norma repents and the film ends, blockade lifted and lovers united. As a supply ship makes its way into the harbor Fonda declares "we're part of something, something greater than we are," and then, facing the camera directly, makes a plea for international involvement:

> The whole country's a battle ground. There is no peace. There is no safety for women and children. Schools and hospitals are targets. And this isn't war, not war between soldiers. It's not war, it's murder. It makes no sense. The world *can* stop it. Where is the conscience of the world? Where is the conscience of the world?[18]

Hollywood's version of a morality play, *Blockade* reduced fascist politics to the conflicted love affair of a freedom fighter and a Nazi spy. Still, it did take a stand against international fascism, and even in its

compromised state generated considerable controversy. Lawson's involvement (he was head of Hollywood's branch of the Communist party in the thirties) was viewed by the right with suspicion. Catholic church officials denounced the film as "war propaganda." IATSE union projectionists concurred and many theater chains refused to show it, although box-office returns were higher than average.[19] Two years later, Wanger knew that the similarly interventionist movie *The Long Voyage Home* would have to be promoted very carefully in order to avoid industry and church censorship.

For Wanger, production of both *Blockade* and *Voyage* marked an obvious shift from a preoccupation with American unity to a concern with the international scene. In the early forties he lectured and wrote about the need for "entertaining but enlightening" movies:

> Hollywood should make more pictures about North and South America, about America's history and its great enduring traditions, its life and its people. We want more people to be rededicated to the meaning and the purpose of democracy. We want the movies to do more of what they alone can do so admirably, in making America's past live again for Americans who have forgotten it; to awaken America to the majesty and achievements of our immense democratic society. The American public has been asleep and I maintain Hollywood must play an important part in America's awakening.

At first glance, Wanger's prose seems remarkably like Benton's art in its appeal to the cultural restoration of American "traditions" to revitalize "our democratic society." But, while the two men may have held similar ideals each had diametrically opposed views on how to implement them. Benton consistently avoided referents to leadership, mobs, or America's place in the world. His idea of reform was individual, organic, and, in its emphasis on the unique qualities of the American experience, essentially isolationist. Wanger, however, like Henry Luce, viewed reform from the stance of the corporate liberal, in terms of elite control and world leadership. And as America headed into another world war, Wanger, like Luce, used mass media to "see this global war to its finish" and to create the conditions by which "men and nations should live together in goodwill."[20] *The Long Voyage Home*, released only a few months before Luce's "American Century" essay was published, was one of Hollywood's earliest efforts to convince Americans of their international obligations. Wanger used a publicity campaign cen-

tered on regionalist art to solicit public approval for his highbrow movie and an end to American isolationism.

The catalog that accompanied the exhibition of the pictures observed that the art would "serve the film well" by emphasizing its "dramatic values" and encouraging "the public to search the film from an entirely new angle, from the artists' angle." [21] The problem was that the "artists' angle" on the movie was completely different from the movie itself. The artists focused on the movie's few scenes of dramatic action and human interest. Benton painted the crew on shore leave and Wood showed them drinking in the Ship Ahoy Saloon (figs. 4.7, 4.8). Luis Quintanilla pictured them dancing with "bumboat" girls and Ernest Fiene opted to paint a conventional portrait of John Wayne (figs. 4.11, 4.12). All of the artists focused on the crew of the S.S. *Glencairn*, on their endeavors, entertainments, and lust for life. Typical of regionalism, the art focuses on people.

Director John Ford, however, focused most of his attention on the *Glencairn* itself, on its dank decks, narrow hallways, bellowing smokestacks. In scene after scene the freighter takes center stage as it cuts through storms and torpedoes. As one reviewer noted, "here is a director who is not afraid to leave the screen blank as the *Glencairn* moves into an intense fog, or to say with lights and shadows things of a dock at night that could not be said with words." Indeed, during one battle scene the film's vantage point is that of the ship, not the crew; afterward the camera lingers on the damage done to the freighter, not to its men. There is also the foreboding presence of death throughout the movie, the "voyage" itself a sort of watery hell. The crew of the *Glencairn* embrace their fate by consistently shipping out on dangerous wartime missions. Death, obvious when crew members are killed and symbolically suggested by the movie's shadowy ambience, is "ultimately more attractive than the life of the land, contaminated by women, war, and families." The overall gloomy fatalism of *The Long Voyage Home* was enhanced and made "sensually compelling" by cinematographer Gregg Toland, who followed the film with work on *Citizen Kane*.[22] Toland brooded on foggy expressionistic shots, experimented with deep focus photography, and created a moody atmosphere completely different from the pictures Benton, Wood, and the other American scene artists offered.

The contrast between the art used to promote *The Long Voyage Home* and the style of the film itself is a contrast between two disparate styles: regionalism and film noir. It is, moreover, a study in the cultural

4.11. Luis Quintanilla, *Bumboat Girls*, 1940. Reprinted from *American Artist*, September 1940.

4.12. Ernest Fiene painting John Wayne's portrait during *The Long Voyage Home* commission, 1940. Reprinted from *American Artist*, September 1940.

transition from a style popular and most meaningful in the thirties to one symptomatic of the forties. Film noir, of which *The Long Voyage Home* is an early example, was a dominant visual style in Hollywood movies throughout the forties and fifties, a style characterized by shadowy, low-key lighting, sharp tonal contrasts, and disorienting, unbalanced camera work ranging from claustrophobic close-ups to ensnaring deep focus shots. The term itself refers to the murky and sardonic movies of the period, from *The Maltese Falcon* (1941) to *Touch of Evil* (1958); their "disorientation and unease" completely different from the look and content of mainstream movies from Hollywood's golden years.[23] Such a shift is reinforced by comparing King Vidor's *Our Daily Bread* (1934) and Frank Capra's *Meet John Doe* (1941): the one characterized by a bright neutral look and the other by a tense murkiness,

the one a paean to populism and the other riddled with the dangers of mass man, the one a film about cooperation and the other about corruption. Their stylistic and narrative differences indicate a significant shift in American cultural and political attitudes from the years of the New Deal to those just before World War II.

The pressing question is why such popular culture texts, these early forties movies, were so different in style from movies of the thirties. The easy answer is to link the style of noir to the mood of uncertainty that enveloped America on the eve of its involvement in another world war. The more complex answer, however, is one that accounts for this attitudinal malaise by focusing on the decline of the New Deal, and of reform politics in general, and the burgeoning of corporate hegemony in the later years of the 1930s. Americans were not simply and suddenly unhappy with their lives around 1940, nor does unhappiness completely characterize the American psyche throughout the forties and fifties. There is, however, a recurring tenor of insecurity and uneasiness in a considerable body of American material culture during these decades to justify the argument that the United States, especially after World War II, was engrossed in malaise because the hope and promise offered by reform politics and culture in the 1930s had come to naught. Obviously America around 1945 was not the same country it had been in the thirties. But, the reasons for this are not simply that the war changed America, but that the New Deal (and other varieties of political liberalism) failed to change America. Film noir movies showed that the promises of the thirties, made by politicians, revolutionaries, and artists alike, had not been kept.

The film *The Long Voyage Home* reveals this, whereas the American scene art used to promote it maintained an earlier culture's faith in humanism, optimism, and the historical possibility of a better future. Their coupling in Wanger's publicity stunt indicates a moment of transition from the one dominant cultural mode to the other, just before the Second World War. A comparison of their style and sentiment reveals their differences. The pictures are upbeat and cheerful, the movie gloomy and anxious. The pictures show the crew drinking and playing, the movie mostly shows them aboard the *Glencairn* and confined by its architecture, boxed in doorways or trapped in their low-ceilinged quarters. The artists painted the men as individuals, the movie often reduced them to faceless shadows. The artists maintained an optimistic tone while the movie is overwhelmingly fatalistic. Moviegoers who saw these American scene pictures and then watched *The Long Voyage Home*

were apt to be confused. But they probably ascertained that the noir style of the movie was more indicative of life in 1940, while the regionalist style of Benton and Wood seemed that of another era.

It should come as no surprise that *The Long Voyage Home*, despite Wanger's best efforts, was a box-office bomb. Although some critics said the art stunt heightened the movie's highbrow handicap, it did arouse public curiosity. The movie itself did not. It garnered acclaim from *Commonweal* and the *New Republic*, received raves from filmmaker Pare Lorentz ("unquestionably one of the greatest motion pictures of all times"), was voted one of the top ten pictures of 1940 by national critics, and was nominated for eight Academy awards, but it did not go over with the American public.[24] It had neither "big" stars nor romance, both considered essentials in securing favor from the female majority of the typical movie audience of the day. When the public did go to see war pictures in 1940, they chose *Women in War* ("love-starved women in uniform . . . the love and laughter that is war") or *Arise My Love*, a sort of April in Paris romance which only becomes clearly antifascist in its final scene.[25] Wanger's film was too ambiguous, too realistic. Ostensibly anti-isolationist, its fatalism undercut any wartime propaganda effectiveness. Released the same month FDR was on the campaign trail declaring that Americans were "not going to be sent into any foreign wars," *The Long Voyage Home* was as incongruous as the "peacetime" draft Congress approved that September. Its bonding with American scene art only enhanced its ambiguity: it did not make sense to promote wartime mobilization with peacetime producerism. Although the movie's noir style and aura of despair would figure in Hollywood's postwar movies it was sorely out of place—especially as a war picture!—in 1940.

This movie-art venture did attract considerable press coverage, most of it derogatory. One *Esquire* writer ended his account of "how art came to Hollywood" with the toast "Lorenzo the Magnificent is dead; long live Walter Wanger," but others demurred. *Parnassus* critic Milton Brown said the stunt revealed no American art renaissance and in fact, did "more harm than good." He ended his scathing review of the "Wanger Circus" by panning the magazine illustration sentimentality of *The Long Voyage Home* pictures, saying they were so awful that even the artists were "probably trying to forget, so why shouldn't we." Brown's denunciation of this art-for-business stunt, and by extension, of regionalist art, indicates the burgeoning of a new kind of American art criticism at this time, one accompanied by the advent of an art style which did fit the needs of an American "renaissance."[26]

In the twenties and thirties popular culture and any art—like regionalism—attached to it was debunked by critics like Paul Rosenfeld as provincial antimodernism. But in the postwar era, Brown denounced the popular arts on different terms altogether. The old criticism of regionalism as antimodernism was rekindled, but now it was increasingly linked to dangerous political and social trends. In his review Brown did not simply attack American scene art but what he believed it represented: mass taste. In the decade of the forties other critics, especially Clement Greenberg, assaulted American scene art and mass culture with the bombast of art world evangelists. Mass culture, coined "kitsch" by Greenberg, was denounced because, as events of the late thirties and forties easily proved, the masses were irrational and dangerous. By implication, any art linked to mass culture, such as regionalism, was also dangerous. The only art safe from the taint of kitsch was that which avoided infection from the public and politics. In the years following World War II, Greenberg and others would promote abstract expressionism as that kind of art. Only a few writers, notably Nathaniel Pousette-Dart (father of the abstract expressionist painter Richard Pousette-Dart), in his essay "Freedom of Expression" (1938), would hail the broad democracy of American culture, recognizing that the "healthy condition" of contemporary American art was largely due to the fact that "no one individual or group [was] dominating it." [27]

In the late thirties Benton himself became increasingly disillusioned with regionalist art and with the chances for social reform in America. His disenchantment was not founded on some new fear of the American mob but stemmed from increasing feelings of powerlessness. After he finished the Missouri State Capitol mural in 1936, Benton turned exclusively to art-for-business commissions and private paintings; he did not paint another mural until 1947. He may have tried to maintain the pretense of reform in his commercial work for the American Tobacco Company and for United Artists, but in his private paintings of the period Benton revealed a profound lack of faith in the tradition he had celebrated throughout the thirties.

Persephone (1938–39, fig. 4.13), a depiction of a Rita Hayworth pin-up type plunked down nude in a Missouri hay field, is not exactly a picture about labor reform. *After Many Springs* (1940, fig. 4.14), the juxtaposition of a skull and a revolver with a farmer and his mule, does not exactly celebrate producerism. *Prodigal Son* (1943, fig. 4.15), a twist on the parable showing the penitent wanderer returning not to feast and fatted calf but the wreck of the family farm, does not exactly speak to the promise of a better future. And *Fantasy* (1945, fig. 4.16),

4.13. Thomas Hart Benton, *Persephone*, 1938–39; egg tempera and resin oil over casein on linen over panel, 72″ × 56″. Collection of the Nelson-Atkins Museum of Art, Kansas City, Missouri.

4.14. Thomas Hart Benton, *After Many Springs*, 1940; oil and tempera on masonite, 30″ × 22 ¼″. Collection of the Museum of Western Art, Denver.

4.15. Thomas Hart Benton, *Prodigal Son*, 1943; oil and tempera on panel, 26 ⅛″ × 30 ½″. Collection of the Dallas Museum of Art, Dallas Art Association Purchase. Copyright 1983. All rights reserved.

an utterly abstract play of textures and colors, does not exactly keep with the narrative tradition Benton considered essential in regionalist art. Benton had always painted small nonobjective studies similar to *Fantasy* for aesthetic exercise. Still, his retreat from regionalist concerns did not occur because he was suddenly interested in stylistic experimentation or because he had developed a fascination with classical myths and Bible stories.

Artists do not simply renege on styles, especially if they have been as committed to them and as successful with them as Benton had been in the 1930s with regionalism. His stylistic shift can only be explained,

4.16. Thomas Hart Benton, *Fantasy*, 1945; oil and tempera on board, 21 ¾″ × 15″.
Courtesy of the Trustees of the Benton Testamentary Trusts, Kansas City.

then, in terms of the increasing despair he felt about fulfilling his aesthetic ambitions with regionalism. These mythical landscapes, allegorical still lifes, and obvious revelations of personal experience suggest Benton was no longer convinced of the republican tradition. He no longer painted an America transformed through producerism and he abandoned his attention to workers. Instead, he focused on fiction and universal myths which bore little relationship to the American scene themes he had painted for over two decades.

His work began to resemble somewhat the magic realist style, a term coined in 1942 by Museum of Modern Art director Alfred Barr to describe the contemporary art of "painters who by means of an exact realistic technique try to make plausible and convincing their improbable, dreamlike or fantastic visions." Benton's fanciful pictures of the late thirties, such as *Persephone* and *After Many Springs*, resembled the contemporary work of American surrealist Peter Blume (fig. 4.17); his new obsession with texture, color, and pattern led to art similar to the bizarre visions of Ivan Albright (fig. 4.18). It is interesting to note that in his "Gestaltian Chart of Contemporary American Art," a tree diagram of various art styles which accompanied his defense of cultural diversity, Nathaniel Pousette-Dart placed Benton between the categories of surrealism and realism (fig. 4.19). As Matthew Baigell observes, "the general drift of realistic American painting" during the late 1930s "turned toward a greater reliance on imagination and fantasy and toward concern for the manipulation of color, as well as of texture, and pattern." [28] The question is why Benton no longer held faith with reform and shifted to an art of fantasy. Why did he, and some other American artists, choose to paint an imaginary, private world in a new proto-surrealist style, rather than continue to envision a better future? Why did increasing numbers of American artists, from groups as diverse as the regionalists to those associated with the Popular Front renege on their commitment to an art of social contract?

The answers are found by placing Benton's art, and that of other American scene painters, in the context of American political culture in the late 1930s. Despite the contentions of consensus historians after the Second World War, the United States never completely retreated from world politics after the defeat of Wilsonian idealism. Indeed, in the years between the two world wars American foreign policy makers established and tried to maintain "a world order which would be conducive to the prosperity and power of the United States." [29] "Open Door" economics and "Dollar Diplomacy" allowed the United States to enjoy

4.17. Peter Blume, *Landscape with Poppies*, 1939; oil on canvas, 18″ × 25 ⅛″. Collection of the Museum of Modern Art, New York. Gift of Abby Aldrich Rockefeller.

4.18. Ivan Albright, *Wherefore Now Arisesth the Illusion of a Third Dimension*, 1931; oil on canvas, 50.8 × 91.4 cm. Collection of the Art Institute of Chicago. Gift of Ivan Albright, 1977.23. Copyright 1990 The Art Institute of Chicago. All rights reserved.

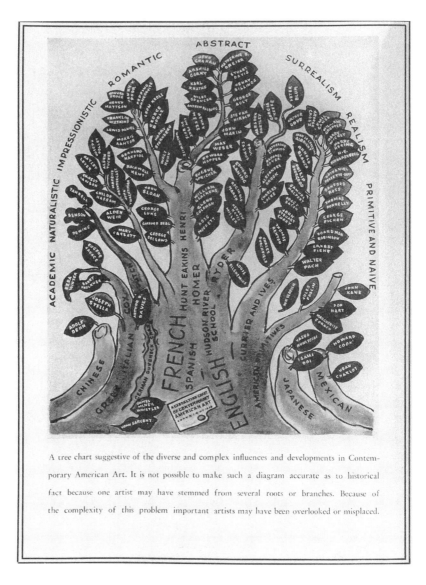

A tree chart suggestive of the diverse and complex influences and developments in Contemporary American Art. It is not possible to make such a diagram accurate as to historical fact because one artist may have stemmed from several roots or branches. Because of the complexity of this problem important artists may have been overlooked or misplaced.

4.19. Nathaniel Pousette-Dart, *Tree Chart of Contemporary American Art*, 1938. Reprinted from *Art and Artists of Today*, June–July 1938.

imperialist economic power without the military backup such a position normally entails. Even during the thirties, with the country apparently consumed by domestic concerns, American economic interests dictated an active foreign policy (especially in Latin America) far from isolationism. As long as other nations played by the rules of order the United States imposed, peace and prosperity would reign.

The Depression, however, put a strain on U.S. imperialism. As the worldwide struggle for economic survival intensified America's stance of nonmilitarist leadership was contested. By the mid-thirties Germany and Japan were denounced as "aggressors" for challenging American economic power; by the late thirties their economic aggression was called fascism. Put simply, free market capitalism, headed by American leadership, became linked with freedom and democracy; any other economic system was totalitarianism. As international tensions mounted— the Spanish Civil War, the Sino-Japanese war, the Rome-Berlin axis— national attention focused on how the United States could maintain world order, and its position of economic superiority, without going to war. While the Roosevelt administration paid heed to public desire for neutrality, the world situation in the late 1930s and America's economic position in that world made U.S. involvement in the war seem inevitable.

While the spectre of fascism loomed across Europe and Asia, liberals took sides on exactly how the United States should deal with it. Some, including Lewis Mumford, demanded immediate intervention. In an extraordinary *New Republic* article titled "Call to Arms" Mumford condemned American neutrality and clamored for a policy of nonintercourse with Germany, Japan, and Italy, backed by U.S. military mobilization. "Fascism has already declared war," Mumford stated, raging at the end of his essay:

> To arms! We must rally to our free republican institutions and be prepared to fight for them. The time for action is now. The place is the United States. The people to do it are the great mass of free, self-governing, liberty-loving Americans. To arms! Gather together your strength and prepare for action. Strike first against fascism; and strike hard. But strike.

In this and subsequent writings Mumford urged the suspension of civil liberties for "fascist allies" in America (i.e., the pro-Franco Catholic church) and aligned himself with the absolute authority of the executive office in such times of crisis. Making a case for U.S. militarism, censor-

ship, and authoritarianism, Mumford showed he obviously no longer held faith in the rational and organic restructuring of America that had preoccupied him throughout the thirties. Still, he did not completely abandon his hopes for a better future. Although the old ways of revivifying America were found futile, perhaps a war of redemption would return the country to its original traditions and virtues. Mumford was not alone in his transference of loyalties from domestic house-cleaning to foreign intervention. His "call to arms" was echoed by liberals from poet Archibald MacLeish ("there is only one line on which fascism can successfully be fought . . . attack") to novelist Waldo Frank, from moviemaker Walter Wanger to Southern Agrarian writer Herbert Agar.[30] For all of them, Ortega's mass man was no longer just a prophecy. The threat his irrational mob politics posed to U.S. and world freedom had to be squashed, now, and with force.

Other liberals, such as Benton, Alfred Bingham, and Charles Beard were adamantly opposed to American involvement in a foreign war. They did not want to see the recent directions of regenerated republicanism undermined by "foreign entanglement." The terms of their argument were laid out in Bingham's journal *Common Sense* in 1938. In August of that year Bingham linked world peace with rational and equitable economic planning; "appeasement" and cooperation would rectify both capitalist and fascist greed. "All nations controlling their own external trade, must agree together on a planned control of the flow of the world's wealth," Bingham wrote. Such was the "essence of a peaceful world" and it was the New Deal's responsibility, with its "high ideals and power" to create it. A few months later he editorialized on liberals and antifascism. Those who advocated intervention had been "duped," Bingham said, "as many of them were in the last war—duped into betraying their liberalism for a demonic cult of ignorance and crusading intolerance." He described fascism as "one further great experiment" in the "search for economic order and rationality" but condemned "its illiberalism, its intolerance, its fanaticism, its romantic and hysterical hatreds." Antifascism, however, with its "fanatical hatred" and "cult of fear" was equally "demonic" said Bingham, reiterating that the only way to defeat fascism was through "building a peaceful and abundant world order." Convinced that the "maladjusted world" could be reordered through scientific planning and rational thought, Bingham reduced political ideologies purely to issues of economic competition. America must show "the rest of the world how sanity and good will can solve the basic economic problems of our time without revolution and

without destruction"; "if war comes it is the liberals' task to keep America out, to keep America sane." [31]

Soliciting replies to Bingham's editorial, *Common Sense* published letters from Charles Beard and Benton in the next month's issue. Both expressed their hearty approval of what Bingham had said. Beard warned that the "madness" of the antifascist movement would lead Americans to "underwrite Great Britain, France, and Russia on the naive assumption that they are controlled by interest in democracy." His plea for nonintervention stemmed from personal fears that a foreign war, conducted on the tainted soil of the corrupt Europe that America had seceded from centuries before, might completely sever Americans from their organic democratic traditions. The promise of the new world, as embodied in American republican virtue, must be maintained; the "frenzied meddlers in world affairs east of the Hudson River" must be curtailed. "America can do more good to Europe," said Beard, "by setting her own house in order than by working up a Walpurgis night of international wrath." [32]

In his letter Benton expressed similar concerns, although he concentrated on the links between liberals and the antifascist movement, or as he put it, "the nature of the dope in the anti-fascist pipe." He stated outright that antifascism was "far more dangerous to the maintenance of democratic attitudes and through that to the maintenance of democratic procedures in the inevitable increase in the powers of the American government than Fascism itself." Fascism, said Benton, "openly" expressed its "enmity of democratic procedure and form," while antifascism was the "disguised instrument" of those intent on involving America in a foreign war. The "thoroughly undemocratic" and "viciously brutal" suspension of "free expression of political views" by the antifascists was as much a danger as "the Fascist powers themselves." In other words, Mumford's call for authoritarianism and censorship was denounced as the real threat to the retention of the "democratic attitudes" only recently revitalized under New Deal and regionalist directions. "Our American fight," said Benton, "is against *all* forms of power beyond the reach of popular democratic recall." [33]

He ended his letter stating he found Bingham's editorial "an important call to all genuine radicals." It would seem then that at least on paper Benton, like Beard, was keeping faith in a vision of domestic reform and the regeneration of producerism. The high-pitched tone of his letter suggests, however, deep fears that he may have already lost his aesthetic independence, the "free expression" of his political views. His

paintings of the time also betray a profound ambivalence, a lack of faith. He may have stated his opposition to American intervention in this letter to *Common Sense*, but Benton knew he was fighting a lost cause. Benton did not create any antiwar pictures in the thirties but fellow regionalist John Steuart Curry painted *Parade to War* (1938–39), a ghostly promenade of soldiers with death skulls for faces.[34] The American scene that the regionalists and Beard had concentrated on for almost two decades was disappearing, its new world promise obliterated by new concerns.

It was not simply that Americans were shifting their focus from domestic problems to international tensions, but that the political culture in which both Benton and Beard had invested themselves for most of the decade was dissipating, without having created the changes they had expected. "The liberal reforms of the New Deal," as historian Barton Bernstein observes, "did not transform" America:

> they conserved and protected American corporate capitalism, occasionally by absorbing parts of threatening programs. There was no significant redistribution of power in American society; only limited recognition of other organized groups, seldom of unorganized peoples. Neither the bolder programs advanced by New Dealers nor the final legislation greatly extended the beneficence of government beyond the middle classes or drew upon the wealth of the few for the needs of the many. Designed to maintain the American system, liberal activity was directed toward essentially conservative goals.[35]

The reasons the New Deal failed to create the radical social, economic, and political restructuring that liberals like Beard and Benton anticipated are, of course, extremely complex, but they stem largely from the inability of New Dealers to adopt a coherent strategy of reform. Stopgap measures proliferated and the set-up of welfare capitalism prevented revolution, but New Deal "liberalism" was often more accommodating than regenerative. Reformist ideology was announced with a good deal of radical rhetoric but little of it resulted in authentic change.

Benton's lack of faith, his inability to remain convinced that the New Deal truly offered a new world, was demonstrated in the changed style and subject matter of his late thirties art. Similarly, Beard reversed his earlier praise for the New Deal in his 1940 book *The Old Deal and the New*, in which he damned FDR for creating a dictatorship which made the economy dependent on the federal government. He also

damned the American public for allowing this expansion of executive authority, declaring that their "acceptance of all that was handed out to them by the Administration" revealed "a profound change in national temper—a deeper subservience to government policy and instruction." The title alone revealed his despair that the New Deal was no new world at all but simply a "continuation and consolidation of the old." [36] Nor were Benton and Beard alone; by the late thirties many Americans were beginning to realize that the New Deal had not created significant and lasting improvement in areas ranging from labor and agriculture to politics and the arts.

True, in terms of conditions for American workers there was the appearance of genuine reform: millions of the unemployed benefited from federal relief; legislation was established regarding minimum wages and maximum hours for industrial workers; child labor was outlawed; collective bargaining was validated. But these gestures fell short of true labor reform. Even after six years of the New Deal over eleven million Americans remained unemployed, some 26 percent of the workforce. The jobs that the CCC and the WPA provided were makeshift, short-term solutions which did not return the United States to pre-Depression standards of production, prosperity, or full employment. Further, the Fair Labor Standards Act (1938) was weakened by those it exempted, including "agricultural workers, employees in intrastate retail and servicing establishments, seamen, fishermen, and employees in a number of other industries." And only about 50,000 of the approximately 850,000 children employed in 1938 were subject to the Act; those in agriculture, service industries, and intrastate commerce were not protected.[37]

While New Deal legislation helped mass-production labor make substantial gains, particularly with GM and US Steel in 1937, by the late thirties unionization was stalemated. The reasons, as David Brody has observed, lay with the "small utility" of the 1935 Wagner Act in collective bargaining: "no legal force sustained the objectives of unions either in improving wages, hours, and conditions or in strengthening their position through the union shop, master contracts, and arbitration of grievances." Despite the pro-worker rhetoric of the New Deal, labor-management relations remained dependent on the good faith of employers; the vestiges of corporate paternalism remained. Admittedly, the war changed this situation: the dramatic increase in defense production in the late thirties and early forties created jobs with fat paychecks and in such a healthy economic situation union membership jumped. Fur-

ther, to prevent strikes and inflationary moves harmful to a wartime economy the government became directly involved in labor-management relations. Theoretically then, the last traces of antiunionism were abolished. But this state-backed corporate liberalism was not exactly the industrial democracy that Benton and Beard had envisioned. Labor became doubly dependent: "First, there was the worker's traditional and obviously unchanged reliance upon the capitalist for the material means of sustenance through employment. And now, suddenly, labor also had become dependent upon the state's capacity to assure that the worker's effective subordination to capital would be rewarded equitably." [38] With the shift to a wartime economy came the reinvigoration of corporate control, now coupled with government support, and the collapse of the kinds of domestic reforms geared toward worker control.

Although the New Deal suggested the federal government's commitment to the American people, it mostly created a dependency relationship for producers which further strengthened corporate hegemony. The Agricultural Adjustment Act, for instance, was enacted to create a balance between farm production and consumption, the Farm Credit Administration made loans available to farmers, and the Rural Electrification Administration lit up their homesteads. But, while these New Deal responses to the Depression farm crisis salvaged the interests of middle-class commercial farmers (and not those of the agricultural underclass) they did so by completely restructuring traditional American farming. As Richard Kirkendall notes, New Dealers "discarded the view that farming is a highly individualistic enterprise and insisted that it must be dealt with on a collective basis." The "romantic" view of the farmer as a "self-sufficient yeoman" was also rejected, as were reformist agricultural proposals "designed to destroy the power and change the practices of big business." Instead, farmers were urged to adopt "the production control methods of the most successful businessmen," and government relief programs were developed to help them "behave like the urban businessman who benefited from the corporate form of organization." [39] By subsidizing restricted production and labor cutbacks the AAA especially benefited the large farm owner, who took his government check, fired his help, and bought a few tractors to run his farm more efficiently with seasonal migrant laborers. By encouraging the development of large commercial farms New Deal aid only further empowered big business interests.

While Benton had heralded the collectivization of New Deal programs, he had believed they would be accompanied by the retention of

the democratic individualism of the republican tradition. His pictures of autonomous producers hard at work on family farms, as seen in his Indiana and Missouri murals, showed what he believed the New Deal had promised to do for the "self-sufficient yeoman." But, agriculture under these New Deal programs became a "collectivist type of capitalism" and the American farmer was moved "several giant steps away from an individualistic economic system" of an earlier era. "By 1940," notes Kirkendall, "the American farmer worked in a system that was dominated by the interplay among large public and private organizations." Statistics released that year showed that while New Deal collectivism had increased agricultural productivity, the number of farms and farm workers in America had substantially declined.[40]

By the late thirties it was increasingly obvious that the Roosevelt administration had "sacrificed the interests of the marginal and the unrecognized to the welfare of those with greater political and economic power." Further evidence of the limits of New Deal reform can be found in the analysis of civil rights legislation in the 1930s. Benton's pictures of blacks and whites laboring together, as in the New School panel *City Building* (fig. 2.3) and the Century of Progress scene "Indiana Puts Her Trust in Work" (fig. 2.24) showed the promise of liberalist reform, but New Deal impact on civil rights was mostly symbolic and led to little genuine economic or political change for American minorities.[41] The contrast between what Benton envisioned and what the New Deal actually yielded is a contrast between the ideology of producerism and the corporate liberalism endorsed by the New Deal. Benton, like Beard, initially hailed the New Deal as the rebirth of progressive politics. Corporate capitalism would be replaced by industrial democracy and a modern version of republicanism would be generated. But by the late thirties they realized that the actual New Deal was, in fact, very different. It had not generated a new world of reinvigorated producerism. Worse, the government in which they had placed their faith was leading them into a foreign war.

Toward the end of the decade the reform impulses that had originally sparked the New Deal burned out, but not because change had actually been accomplished. A conservative Congress stalemated most major extensions of the New Deal from 1936 onward, and by the early forties much reform legislation had been axed. Cognizant of the ways in which dictators in Italy and Germany had gained power, congressional tendencies to conservatism in the late thirties were understandable as a means of trying to reduce the authority of the executive office. Still, this conservatism effectively halted further domestic reform. The

1937–38 recession, during which unemployment skyrocketed, Depression conditions worsened, and Roosevelt vacillated on how to deal with the situation, further deflated public confidence in the efficacy of the New Deal. The American people still wanted to see change: a Gallup poll conducted in the early forties showed that a majority found "too much power in the hands of a few rich men and large corporations in the United States." [42] But, if the public greeted the early New Deal with great enthusiasm, they were now hesitant about how exactly reform could be accomplished, especially as so few authentic results had actually been produced. Moreover, as the issue of economic and political liberty came to an international crescendo, many simply did not want to risk losing their individualism for state control, or for an American form of fascism.

Such sentiments were especially expressed in the 1941 movie *Meet John Doe*, in which director Frank Capra linked the demise of democratic liberalism with the assault of a mass mentality. Doe (Gary Cooper) is the prototypical Depression Everyman whose populist philosophy (loosely, that of "neighborliness") is co-opted by malevolent rich man D. B. Norton (Edward Arnold) to gain political power. While an obvious play of populism vs. fascism, Capra's film is remarkably ambivalent, expressing both sympathy and out-and-out hatred for "all the John Does of this world." It is also formally inconsistent, skewing madly from the neutral look of Hollywood's golden age to the dark shadowy ambience of film noir. Ambiguity completely dominates at the film's finish when Doe, made out as a fraud by Norton, tries to kill himself but is persuaded not to by the few remaining devotees of the John Doe Clubs (formerly 20 million strong).

Meet John Doe ends with the former leader of the "little people" persuaded once again of the promise of social reform. But it is doubtful that many moviegoers in 1941 were equally convinced. Capra himself was so unconvinced he actually filmed Cooper jumping off of City Hall but decided not to use this ending because "you just don't kill Gary Cooper." What he was really afraid of killing, as Lawrence Levine has observed, was the reform dream evident in earlier Depression movies such as *Our Daily Bread*. But while he may have wanted to retain that dream, *Meet John Doe* shows that Capra simultaneously wondered if reform, specifically collectivity, created a democracy of thinking Americans or a mob ruled by mass appetite. Indeed, he later wrote that *Meet John Doe* embodied the "rebellious cry of the individual" against "mass production, mass thought, mass education, mass politics, mass wealth, mass conformity." [43] So much for the unity of the "little people." The

tone of Capra's film, much like Benton's paintings of the same period, reveals a growing sense of ambivalence in late Depression America. Audiences at the 1939–40 New York World's Fair, for example, were confronted with the urgency of nationalism in the Democracity exhibit but were also tantalized by the private consumption paradise embodied in the techno-landscape of GM's Futurama. Neither the fair nor Capra's movie sustained the merger of individualism and collectivity championed by Roosevelt and seemingly envisioned in the New Deal.

Ellis Hawley explains that New Dealers, like the American public as a whole, were caught on the horns of a dilemma that has long plagued reform efforts in modern America: how to reconcile the material benefits of an industrial economy with the "democratic, individualistic, and libertarian ideals" of the American republic. New Deal reformers wanted an organized, efficient, centralized, and well-planned economic system, but they also wanted the entrepreneurial opportunities that existed under a mostly unregulated form of free-enterprise capitalism. It should be no surprise, that, wanting the best of both worlds and "unwilling to renounce the hope of achieving both," New Dealers were ambivalent. As Hawley observes, the result was "an economy characterized by private controls, partial planning, compensatory governmental spending, and occasional gestures toward the competitive ideal." In other words, New Deal inconsistency elicited little genuine reform and helped status quo interest groups, economic and political, maintain stability and control. Corporate power was not curtailed but grew: "the practical effect of the NRA, then, was to allow the erection, extension, and fortification of private monopolistic arrangements, particularly for groups that already possessed a fairly high degree of integration and monopoly power." Thus, to a large degree, New Deal reform, much of it actually supported (if not sponsored) by leading corporate liberals, strengthened corporate culture. The 1935 Social Security Act, for instance (backed by industrialists Gerard Swope, president of General Electric, and Walter Teagle of Standard Oil), did benefit the poor and the elderly. But it did not redistribute wealth and power, and, like the Agricultural Adjustment Act, created a dependency situation for marginal groups. Such forms of New Deal legislation were reformist but not revolutionary; they "eased tensions" and "created stability" but "prevented or broke any movements for radical structural change." [44] Reform was redirected to help maintain the status quo; substantial social change—the kind that Benton and Beard envisioned—was arrested.

The collective culture spawned by the New Deal was equally con-

servative. While government patronage certainly rescued thousands of artists from poverty, offering them social and economic integration and challenging their dependency on galleries and agents, it also worked to sustain the status quo and ultimately to sever connections between American artists and the public. In addition to working as emergency labor relief measures New Deal art programs were geared toward legitimizing the government. Linked with the conservative politics of the New Deal an art originally meant to represent reform came to signify preservation. Reform itself was institutionalized, largely because the aesthetic by which it was most often expressed in the thirties, the "documentary" style, was institutionalized. The "documentary imagination" of New Deal culture, from the Farm Security Administration photographs of Dorothea Lange to the quasi-realism of Benton's regionalist art was, as William Stott suggests, practiced to engender cultural nationalism. While WPA artists were more or less free to make what they wanted, they consistently offered "documents" of Americana: the *Index of American Design* catalogued the country's decorative arts; the Federal Writer's Project painstakingly surveyed each state and major city; New Deal post office murals told the story of local and regional America. The "consummate need" of this documentary approach was aimed at getting "the texture of reality" in Depression America, "to feel it and make it felt." [45]

But the underlying criterion for this documentary approach was an ideological one aimed at linking the American people with the unique aspects of their culture and thereby engendering national collectivity. Like the admen at the American Tobacco Company, New Dealers recognized the power of the documentary style (cum pseudo-realism) to persuade. While New Deal art was never as strident as propaganda in Germany or Russia, American realism was linked with a political agenda. National unity burgeoned (providing the captive audience and ready participants for World War II), and realist art, ranging from WPA murals to New Deal posters, became inextricably linked with particular political motivations. In the 1940s, when a new generation of seemingly apolitical artists began searching for their own means of personal and cultural expression, they avoided realist art like the plague. New Deal culture, originally lauded by Benton and Beard as the return of republicanism, was dismissed by this generation (and the general public). So, too, was an art of social contract bounded in a representational style. In the 1940s facts were as suspicious as fiction; authentic art was abstract.

While claiming to be a protectorate of the people, the New Deal

actually vested the interests of corporate culture. New Dealers actively worked to absorb dissidents from the left and the right; *Common Sense*'s shift from the League for Independent Political Action to a pro–New Deal stance by 1936 is one example of their success. A consensus was shaped, which not only helped prevent radical affronts to American political structure but also gave the semblance of national unity under the New Deal. At first, liberals like Benton and Beard were delighted at this seeming merger of public, business, and government interests. What they came to realize by the end of the thirties, however, was that this kind of political structuring had not empowered industrial democracy but had created a corporate state. Economic power had not been redistributed, workers had not achieved true autonomy, corporate control had not been curtailed. Instead, the emergence of a corporate state which offered public appeasement through welfare capitalism only furthered producer dependency. The tenets of this corporate liberalism, particularly with its preference for consensus and its stress on compromise rather than conflict, set up the terms for reform (or the lack thereof) in postwar America.

Beard protested in *The Old Deal and the New* that the American people were to blame for the New Deal's failure to create a new world. Oddly, Beard now seemed to have the same disgust with the American folk-mob as critic Clement Greenberg. Americans had allowed the executive office to gain complete authority and now they were allowing FDR to lead them into a foreign war. They were a fickle lot, not unlike the New Deal itself. In the early years of the Depression they distrusted both government and big business, as Benton's Whitney lunette *Political Business and Intellectual Ballyhoo* reveals. By the mid-1930s they had been pacified by New Deal rhetoric and by the goodwill campaigns conducted by corporations. Following the recession of 1937–38, one would expect to see an outbreak of anticorporate sentiment and the demand for authentic domestic reform. But, much to Beard's chagrin, Americans became increasingly ambivalent about domestic reform. Despite their earlier denunciation of big business, by 1940 they were as tolerant of corporate culture as they had been in the 1920s.[46]

At a time when it seemed as if the country might return to the humanist democracy that Beard and Benton believed was America's dominant historical characteristic, the public and the president had become derelict. Initially committed to this public, to this president, and to the promise of the New Deal, both men were profoundly disillusioned by the end of the thirties. The New Deal, which they had celebrated as the

integration of federal economic planning, industrial growth, and the individualism, citizenship, productivity, and collectivity of America's democratic traditions, had become a political hegemony backed by big business with an internationalist agenda.

If we look at visual culture, such as advertising, in the late 1930s and early 1940s it is not surprising that the American public became so ambivalent about politics, big business, and the possibilities for reform in America. As countless ads for hundreds of different products demonstrate, the style and content of much of regionalist and New Deal art was appropriated by corporate culture to promote mass consumption. An artform that had suggested reform and the radical transformation of American society was now used to sell goods, to uphold the status quo, and to promote U.S. involvement in World War II. Comparing the producerist sentiment of Benton's Indiana and Missouri murals with several 1942 ads for Pepsi and Coca-Cola readily reveals this (figs. 4.20 and 4.21). "You work better refreshed," Coca-Cola's ad proclaimed; "American energy will win!" boasted Pepsi. The workers that Benton had glorified as autonomous producers were now depicted as consumers, for whom the very act of drinking Pepsi or Coke contributed to the war effort. Work was no longer a goal in and of itself, but a way in which Americans could consume. The work ethic was retained, but transformed from producerism to consumerism. And Benton's art—here, the style of his art—aided in this transformation. His modern art now gave legitimacy to the corporate culture he had tried to reform. Moreover, it was being used to uphold a war that he (until Pearl Harbor) did not support. Placed in this context, his rejection of the regionalist style in the late thirties and his disenchantment with the political culture regionalism had once embraced begins to make sense.

Of course, it was not just liberal proponents of the New Deal who were deeply disillusioned by the end of the thirties. Those on the left also saw their hopes for a better future thwarted. FDR's rhetorical crusade against "economic royalists" and "princes of property" made the New Deal sound like the socialist democracy that the Popular Front championed; it was hard to fight an enemy that sounded like an ally. But if the left was partially disarmed through its absorption by the New Deal's liberal consensus, it was completely throttled by its defense of the Soviet Union in the late thirties. As the Nazi threat to the U.S.S.R. increased, the Popular Front understandably advocated U.S. intervention and antifascism. Russia, after all, had been the only country to offer the Spanish Loyalists direct aid. But, as news of the Moscow Show trials

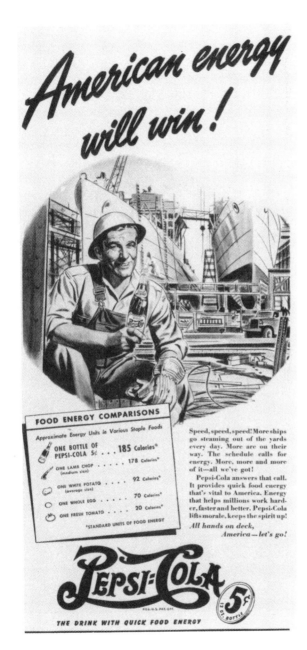

4.20. Advertisement for Pepsi-Cola, *Time,* April 20, 1942. Reproduced with permission of Pepsico, Inc. Copyright 1942.

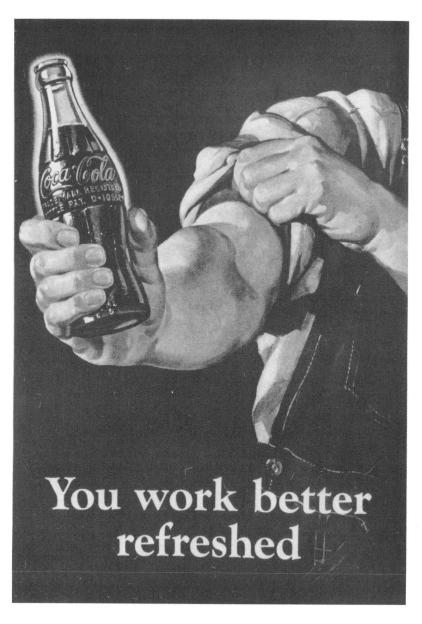

4.21. Advertisement for Coca-Cola, *Time,* July 13, 1942. Reprinted with permission of The Coca-Cola Company. Copyright 1942. Coca-Cola is a registered trademark of The Coca-Cola Company and is used with permission.

(August 1936 to March 1938) leaked out, it became increasingly difficult for leftists to remain loyal to communist ideology. When Hitler and Stalin agreed to a nonaggression pact in August 1939, leftist disillusion intensified. The attack on Pearl Harbor gave both liberals and Communists the political permission to shift their disillusion to prowar patriotism, "as though America's entrance into combat would cleanse the atmosphere of all the ideological disputes and social disappointments that had characterized the waning years of the Depression."[47]

If Benton is the prime example of a liberal artist whose affiliation with New Deal ideology generated profound personal disappointment in the late thirties, Stuart Davis is his parallel on the left. Executive secretary and then national chairman of the American Artists' Congress, a leftist artists' union and political group that lasted from 1935 to 1942, Davis generally condoned Popular Front politics (although he was not a member of the Communist party). He particularly championed the fight against fascism at home and abroad. "There is a real danger of Fascism in America," Davis declared at the first AAC meeting in 1936:

> The examples of the so-called national resurgence that were accompanied by the most brutal destruction of the economic and cultural standards of the masses of people in Italy and Germany through the introduction of Fascism should warn us of the real threats that lie behind the rabidly nationalistic movements in this country.

Davis adopted the Popular Front strategy of battling fascism by defending democratic rights, especially those of individualism and free expression, and did so with his particular brand of modern art. His earlier allegiance to an abstract style of modernism ("in the materialism of abstract art . . . is implicit a negation of many ideals dear to the bourgeois heart") now became linked with antifascism. He wrote in 1937, "Why does Hitler outlaw abstract art? Because fascism denies democracy in culture just as it denies democracy in science and government. Those who would theoretically liquidate abstract art as a reactionary art should give thought to the social implications of their argument."[48] Put simply, if Hitler hated modern abstract art, then it was perfect for the United States. American abstract art, Davis believed, exhibited a freedom of expression not allowable under fascism; thus, American patrons should support it as a show of faith in the country's democratic tradition. The gist of his argument would be repeated endlessly in discussions of postwar American culture.

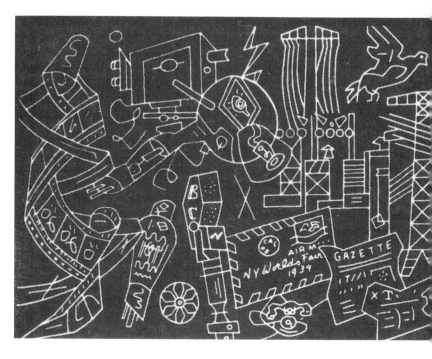

4.22. Stuart Davis, *History of Communications*, mural for Hall of Communications,

While abstract art provided Davis with the stylistic means to express himself, what was he to express? In the early years of the decade, in pictures like the 1932 *New York Mural* (fig. 2.27), he painted the American scene. But now that that scene was menaced by fascism, he turned to pictures whose themes celebrated American freedom, democracy, and technological progress. For accommodating Popular Front leftists like Davis, the issues that took precedence in the mid to late thirties were not so much capitalism versus communism as fascism versus democracy. A good example of his work at this time is his *History of Communications* mural, painted for the 1939 New York World's Fair (fig. 4.22). Benton showed a small nondescript landscape picture in the fair's Contemporary Arts Building. Davis, by contrast, displayed a large, visually arresting mural that "constituted a liberal defense of American democracy." Like the fair itself, a huge celebration of "The World of Tomorrow" where the Futurama and Democracity exhibits stressed the links between freedom and technological progress (and be-

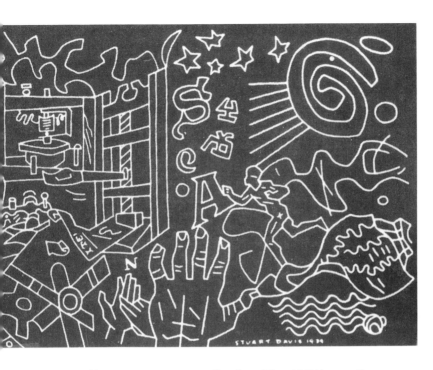

New York World's Fair, 1939; paint on wall surface, 44′ × 136′ (destroyed).

tween consumerism in the Futurama), Davis's mural championed the steady progress from oral to written to visual communication. His message was clear: the freedom of expression inherent in his modern art and the technological progress intimated in the advance of communication were the unique manifestations of American democracy. As he had noted in 1937, fascism not only restricted modern art, it restricted "science and government." By simplistic reasoning, then, democracy must necessarily be the champion of modern art and modern science. Of course, Davis's argument was not unique to the Popular Front. Many other thirties liberals, including Bingham and Benton, believed fascism could be countered with scientific planning and rational thought; that at least had been Bingham's assessment in his 1938 *Common Sense* editorial.[49] Only after the war, when they realized the true nature of the scientific "progress" of the atomic bomb, would liberal faith in technology be questioned.

But even as he celebrated American democracy and technology with

modern art, Davis became involved in a number of conflicts with the American Artists' Congress. In August 1939 he refused to join many of his AAC comrades in signing an "Open Letter" to the *Daily Worker* which disavowed connections between the Soviet Union and "totalitarian states." Following the Hitler-Stalin pact and the Russian invasion of Finland in late 1939, Davis's declension from the pro-Stalinist left was all but complete; he resigned from the AAC in April 1940. For him, the issue was above all an aesthetic one. In 1938 the Soviet Union banned modern art and declared social realism the official art of communism. Now, neither the left nor the right seemed to support the abstract art Davis associated with individual freedom, aesthetic progress, and radical political change. In fact, in a curious sort of way, the left and the right adopted surprisingly similar aesthetic attitudes, favoring narrative art, either "documentary style" pseudo-realism or "propaganda style" social realism, to promote their politics. Neither was the genuine protectorate of the "free" expression Davis rather naively believed modern abstract art embodied. When the constraints of leftist political patronage conflicted with his own desire for the fiction of aesthetic freedom and autonomy, Davis rebelled. Even communist faithful and *Blockade* scriptwriter John Howard Lawson deviated from the party line on social realism. "The whole problem of the artist," said Lawson, "is to deepen and extend and strengthen the character of his work. . . . I have always made my own judgements on my work and not been affected by judgements coming from any political source." [50]

Even as he was blacklisted as one of the Hollywood 10 in 1947, Lawson was able, more or less, to sustain his confidence in communism. Davis, however, like Benton, no longer held faith in the possibility of a reformist political culture. Condemning the aesthetic restraints under leftist sponsorship, Davis also chose to renounce radical politics. In 1940 he made a complete about-face from the position he had taken five years earlier in *Art Front* and declared: "I oppose the totalitarianism of Nazism. I oppose the totalitarianism of Communism. I support the social need for individual freedom of expression as manifested in so-called bourgeois democracies." He switched his allegiance from the Popular Front to American style democratic politics, "bourgeois" though they might be. He also cautioned that the real role for "genuine" art, meaning modern abstract art, was now apolitical: in August 1941 Davis declared "fascism on the political and economic level can only be stopped by political and military action, genuine art is ineffective." Such a comment indicates that by this date Davis had reneged on an art of social

contract.[51] During the war, when American artists were encouraged to contribute to the war effort with propaganda pictures, Davis steadfastly refused. While maintaining that his art would be "ineffective" in the fight against fascism, Davis may have feared a loss of aesthetic autonomy under government patronage. Reacting as Benton did to the conditions of the American Tobacco Company commission, Davis denounced the curbs of aesthetic sponsorship and assumed the romantic ideal of the artist as an outsider and of an art somehow free of ideology. He and other artists failed to recognize that despite the declaration that their art was apolitical, their art could, in fact, be seized for political purposes by various patrons, which is exactly what occurred in postwar America.

Many other socially committed Americans came to rebuff reform in the late thirties. The Popular Front had persuaded leftists that American-style communism could be achieved by adopting and then redefining the basic principles of democracy. But, the antifascist movement took precedence over domestic experimentation and soon the taint of Stalin and the Moscow trials led many leftists to question the validity of radical change in America. Similarly, FDR had persuaded liberals that the New Deal could overcome the crisis of the Depression and create a better future. But, when it was shown that the military buildup of 1940–41 "did more to revive American industry and reduce unemployment than any New Deal program," many who had trusted in reform politics became profoundly disillusioned.[52] The irony that only international economic maneuvers and a world war would return the U.S. to the standards of production, consumption, and employment it had enjoyed prior to the Depression must have been especially painful for Benton and Beard.

For artists in the late thirties, from Davis the leftist to Benton the liberal, came the disappointment that the merger of art and politics—at least by the methods they tried—did not evoke reform. Benton reacted by retreating from an art of social contract. As America crept steadily into World War II, he may have looked askance at the hundreds of New Deal murals dotting the American scene. The better future they promised—was it a world war? The American public that this art professed to represent—did they really want to go to war? It was not simply that the New Deal had failed and that his intimate connection with this political culture implied his own failure. But, during the years the New Deal had been supposedly generating reform and he had painted murals describing that reform, a more complete corporate hegemony had

emerged. To be sure, laissez-faire capitalism was modified under the New Deal, but the mixed economy that emerged was what John Kenneth Galbraith would call a "countervailance" or balance of forces between big business, big labor, and big government.[53] Withdrawing from reform, the federal government abandoned trust-busting, subsidized the conversion of consumer industries to defense production, and forged a planned economy largely run by leaders from America's largest corporations. By the end of the war prosperity had indeed returned, and with it the prestige and power of corporate capitalism. Obviously, Benton's ideal of a populist industrial democracy was not achieved.

Moreover, he had been the aesthetic servant of this corporate empowerment. His art-for-business endeavors, the "arty" end of the public relations campaigns cannily conducted by growing numbers of U.S. businesses, directly aided in garnering public acceptance for Time-Life, Incorporated, the American Tobacco Company, and United Artists. Indirectly, the style of his regionalist art did much the same, as ads in this style were increasingly used to sell the products of mass consumption industries, such as Pepsi and Coca-Cola. Although Benton initiated this integration of American art and big business as a reform gesture, he had only succeeded in becoming defined as a member of corporate culture, and that dismayed him. In 1945 he told a reporter:

> Advertising is a lying art—it depends upon suggestions that are not wholly true. And you can't expect art to deal in half-truths. Business can't expect the artist to tell its lies for it. If we do, we're pure prostitutes and should be paid high. I'm not a prostitute and I'm sick of advertising.[54]

Still, the fact remained that he had accepted these art-for-business assignments; no one had forced him to become an advertising "prostitute." His outburst only revealed his despair over the loss of artistic autonomy, the result of failed efforts to create a "fruitful relation between big money and art."

Benton betrayed his feelings of personal powerlessness in a number of different ways, most notably in the changed style of his art but also in his well-publicized attacks on museum directors in the early forties. At a notorious press conference in April 1941, a drunken Benton made the following comments:

> Do you want to know what's the matter with the art business in America? It's the third sex and the museums. Even in Missouri

we're full of 'em. The typical museum is a graveyard run by a pretty boy with delicate wrists and a swing in his gait. If it were left to me, I wouldn't have any museums. I'd have people buy the paintings and hang 'em in privies. . . . I'd like to sell mine to saloons, bawdy houses.[55]

Benton's remarks were carried by newspapers and magazines across the country, with predictable results: nightclub owner and theater entrepreneur Billy Rose delightedly displayed *Persephone* for a month in his New York saloon the Diamond Horseshoe, and art world critics and museum directors blasted Benton and his American scene style. Within the month he was fired from his teaching job at the Kansas City Art Institute.

Rankling the art world at a time when regionalism's dominance was eroding was not exactly a prescient move on Benton's part and probably hastened his art's swift decline in terms of popular and institutional support during the 1940s. His homophobic assaults were engendered by his father's intimation that an art career would turn him into a mincing portrait painter and by his sexual molestation as an art student in Chicago. When Benton felt the ideological structure of his art threatened by the storms of world war and the growing strength of corporate hegemony, he reacted on a personal level: challenges to regionalism became threats to his own masculinity. His attacks on "critics and museum boys" who saw art "as a collection of objects rather than as a living necessity of the spirit of man," were bitter revelations of his own sense of impotence in the changed world of the 1940s.[56]

Linked both with a failed vision of social reform and with corporate hegemony, it is no surprise that Benton wrote that "gnawing suspicions of failure" gripped him at this time. Accounting for the changes in style and subject matter that are evident in pictures like *Persephone* in the later thirties, he explained:

How difficult it was for me to paint significantly about the social situation that developed. . . . I began giving much of my attention to the details of the natural world, flowers, trees, and foliage. I had had a lifelong interest in such growing things, but my major painting themes, when I turned my attention to our native scene, were nearly always about the activities of people. . . . Now, however, people began to be accessory. . . . Although I did not realize it at the time, I was thus myself moving away from Regionalism, at least from Regionalism as I had heretofore conceived it.

The "social situation" to which Benton specifically referred was World War II, which destroyed, he noted, "that national concentration on our American meanings out of which the images of Regionalism grew and in which the movement found its justification and its successes." [57] More specifically, as the country shifted from a reform-oriented culture to a consensus society in favor of corporate (and state) control, Benton knew his producerism, and its visualization in regionalist art, was no longer viable. He shifted his attention from "people" and reformist politics to "flowers, trees, and foliage." Not until Pearl Harbor did Benton try to re-engage his art in a social capacity, and this time his vision was not one of optimism but of apocalypse.

In the fall of 1941, unable to "concentrate on painting" because of "the international situation" Benton went on a nationwide lecture tour. It was while he was speaking to a crowd of art enthusiasts in Cincinnati that he received the news of Japan's attack in Hawaii. Promptly leaving the stage, Benton returned to his Kansas City home with one thought in mind: "I would try to wake up the middle west to the grimness of our national situation." For six weeks he sequestered himself in his studio and painted the bloodiest pictures of his career: *The Year of Peril* series.[58]

The eight works—*Starry Night, Again, Indifference, Casualty, The Sowers, The Harvest, Invasion,* and *Exterminate!*—were "deliberate propaganda pictures, cartoons in paint, dedicated solely to arousing the public mind." His original intention was to have the poster-sized pictures hung in Kansas City's Union Station "where the milling travelers would see them, and be shocked, maybe by the violence of their subject matter, into a realization of what the United States was up against." But Reeves Lewenthal, who served throughout the war as an art consultant to various service branches of the U.S. military, convinced him that *The Year of Peril* pictures were important enough to merit widespread attention. Benton later wrote that Lewenthal told him, "Tom, this is no local affair you have here. It's a national one. Forget the Union Station business. Leave these pictures to me and I'll put them over the whole country." Of course, Lewenthal's interest was as much motivated by profit as patriotism; he took a hefty commission when he arranged for Abbott Laboratories, the major wartime pharmaceutical firm, to purchase Benton's pictures for $20,000. Abbott then published the series in a glossy pamphlet with a foreword by poet Archibald MacLeish, chief of the Office of Facts and Figures (predecessor of the Office of War Information) and head of the Library of Congress; the catalog also included

captions and an essay by Benton. Eventually, copies of the booklet and reproductions of the pictures were distributed worldwide by the OFF and OWI; Benton claimed "over fifty-five million" stamps, stickers, and posters went "all over the embattled world." *The Year of Peril* exhibit at the Associated American Artists gallery, which opened on 6 April 1942 ("Total War Day") and eventually attracted some 75,000 viewers, was filmed by Paramount Pictures and featured in newsreels shown in movie theaters across the country.[59]

Ostensibly painted as an inspirational call to arms, the horrific style and equally grotesque subject matter of Benton's series seem to thwart such intentions. Content for the pictures came from various fine art and popular culture sources. Newspaper photographs of the exploded U.S.S. *Shaw* and the sinking of the *West Virginia* furnished Benton with the imagery for the drowning midshipman of *Starry Night*, whose title is an obvious play on Van Gogh's symbolic landscape (fig. 4.23). The downed planes and decapitated airmen of *Indifference* (fig. 4.24) and burning battleship, barbed wire, and bodies in *Casualty* also stemmed from mass media sources.

Wartime editorial cartoons depicting the Axis powers as inhuman aggressors in a racial war and portraying the Japanese as slant-eyed "murderous little ape men," the Germans as "shark-faced" beasts, and the Italians as black-shirted bullies also supplied Benton with the subject matter for the series. Like most Americans during the war years Benton easily subscribed to national media stereotypes of "the enemy": racial prejudice fueled the national "mandate for revenge." He emphasized the differences between "alien others" and Americans and Allies in his war pictures.[60] *The Sowers* (fig. 4.25), a gruesome update of Millet's peasant proletariat, shows the "yellow peril" seeding human skulls across a ravaged land; *Invasion* (fig. 4.26) shows ape-men aggressors raping and plundering their way across America, literally from shining sea to amber waves of grain; *Exterminate!* (fig. 4.27) shows enthusiastic G.I. Joes disemboweling a jaundiced ogre clutching the tattered remnants of the Rising Sun; and *Again* (fig. 4.28) shows the Axis menace, typed by racial characteristics, uniforms, and national flags, sharing in Christ's crucifixion. In each picture the basic tenets of the democratic republic have been upset: the American family is destroyed in *Invasion*, fascists replace farmers in *The Sowers*, self-determination is violated in *Indifference*, Christianity and, by implication, religious freedom are crushed in *Again*. Obviously, Benton's war pictures bear as little relation to his earlier regionalist art as 1940s film noir movies such as *The*

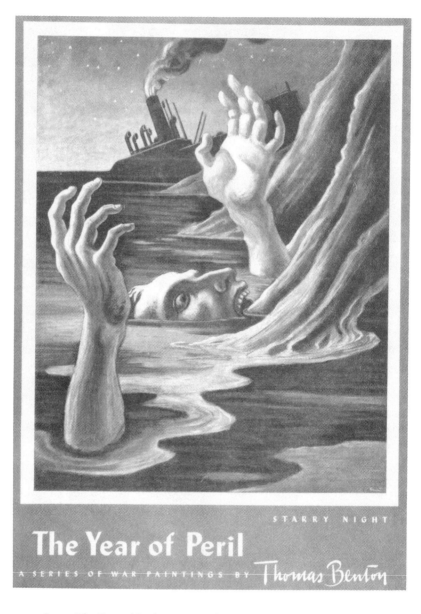

4.23. Cover, *The Year of Peril: A Series of War Paintings by Tom Benton* (Chicago: Abbott Laboratories, 1942), featuring Benton's *Starry Night*, 1942. Courtesy of the State Historical Society of Missouri.

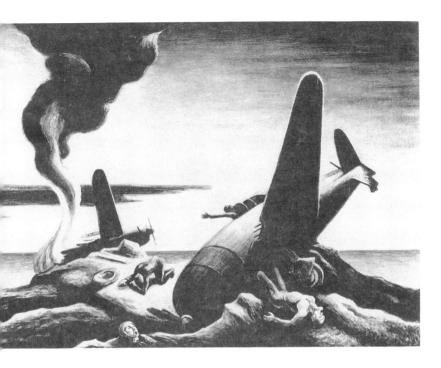

4.24 Thomas Hart Benton, *Indifference*, from *The Year of Peril*, 1942; oil on canvas, 21 ¼″ × 31 ¼″. Courtesy of the State Historical Society of Missouri.

Maltese Falcon or *Spellbound* (1945) relate to 1930s movies like *Our Daily Bread* or *In Old Chicago*.

Oddly, Benton's war pictures do not show—or even imply—the success of democratic efforts in winning the fight against fascism. *Starry Night* suggests the futility of war; *Again* shows fascism putting the kibosh on Christianity; *Invasion* illustrates the extinction of the American way of life. MacLeish, whose policy at the OFF was a "strategy of truth," praised Benton's depiction of the "horror of war":

> This work of Benton's is as true as it is moving—and true not only as art. . . . The war waged against us and against all free peoples by the conspirators of Fascism and Nazism and Jingoism is precisely such a war as Benton says it is. . . . the conspirators have counted upon the decent reluctance, the common humanity, of the people of the United States. . . . That confidence has been mis-

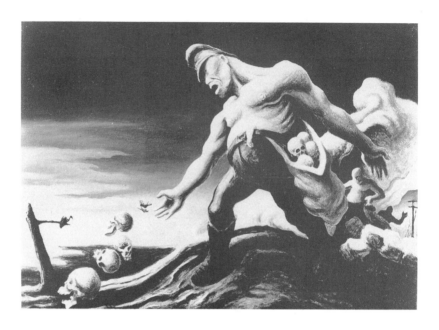

4.25 Thomas Hart Benton, *The Sowers,* from *The Year of Peril,* 1942; oil on canvas, 28″ × 39″. Courtesy of the State Historical Society of Missouri.

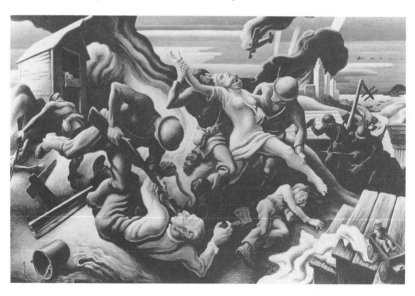

4.26. Thomas Hart Benton, *Invasion,* from *The Year of Peril,* 1942; oil on canvas, 48″ × 78″. Courtesy of the State Historical Society of Missouri.

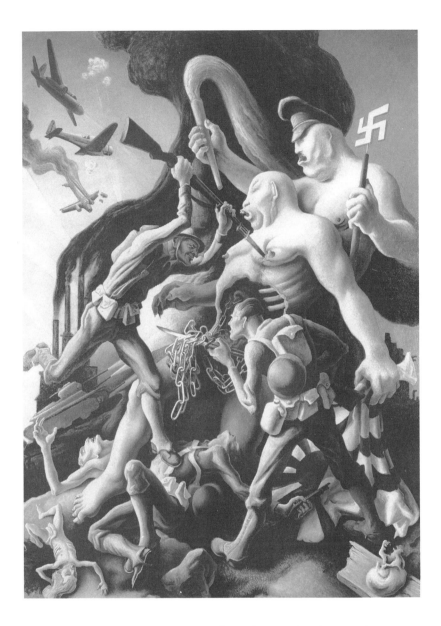

4.27. Thomas Hart Benton, *Exterminate!* from *The Year of Peril*, 1942; oil on canvas, 97 ½″ × 72″. Courtesy of the State Historical Society of Missouri.

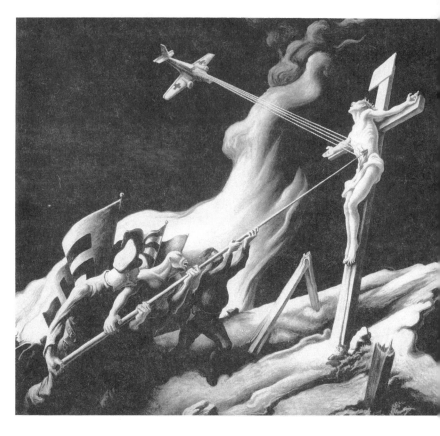

4.28. Thomas Hart Benton, *Again*, from *The Year of Peril*, 1942; oil and tempera on canvas mounted on panel, 47" × 56". Courtesy of the State Historical Society of Missouri.

placed. . . . This war will be won by the very men and women whose incapacity for action our enemies have counted on.

MacLeish believed Benton's propaganda pictures would ignite "the just indignation of a great people" and lead them to victory; the truth inherent in Benton's art would set them free. Other OFF staffers, including former Columbia Broadcasting System vice-president William B. Lewis were less convinced, fearful "lest the paintings horrify rather than inspire." And a few months later, when propaganda outposts in Iceland and the Congo declared the pictures "too brutal," government agencies

decided to drop them. As State Department personnel noted, "the grotesque nature of the religious theme might offend Christians, and the posters are unsuitable for territories populated by non-Christians."[61]

Done so soon after Pearl Harbor, Benton's war pictures obviously reveal his hysterical reaction to American unpreparedness; his caption for *Indifference* noted that "young men died and machines were needlessly destroyed" because of "the inertia of a national habit of ignoring the unprecedented." Benton and MacLeish believed the horror of *The Year of Peril* pictures was necessary to stimulate wartime consciousness. But it is questionable how successful the pictures really were in this capacity; despite MacLeish's claims to the contrary, "truth" was not always the best method of persuading the public. The advertising executives who staffed the OWI (which replaced the OFF in June 1942) understood this only too well; when they came in, they replaced MacLeish's "strategy of truth" with their own strategy of optimistic hype, one that paralleled the "documentary" style pseudo-realism of corporate and New Deal culture.[62] The "realism" of Benton's art clashed with what the propaganda brokers at the OWI preferred, just as it had with the admen at the American Tobacco Company.

David Stone Martin's morale-boosting poster of American solidarity showed how the OWI felt the war ought to be promoted (fig. 4.29). Certainly Benton, well-schooled in public persuasion after two decades of regionalist art, understood that the ways of propaganda were nearly always geared—as Martin's poster was—toward public uplift, not to reminders of defeat or hardship. The question remains, then, why he chose these subjects and this look for *The Year of Peril* pictures. Their formal style, for instance, is an obvious continuation of the magic realism or pseudo-surrealism that Benton had begun practicing in his private paintings in the late thirties. And surrealism, with its emphasis on aesthetic individualism, formalist experimentation, and the creepy underbelly of the human unconscious, was not exactly the kind of art most conducive to engineering prowar sentiment. Benton knew this. Choosing a proto-surrealist look for his war pictures demonstrates a certain ambivalence on his part as to what they were really all about. While he said they were "dedicated solely to arousing the public mind," what exactly was it that he was trying to arouse?

Benton's shift from regionalist to magic realist themes reflects the collapse of the political culture in which he had placed his faith, a context in which the pseudo-surrealist style he adopted for *The Year of Peril* series needs to be placed. In 1924 André Breton defined surrealism as

4.29. David Stone Martin, *OWI Poster No. 8*, 1942. Reprinted from Denis Judd, *Posters of World War Two* (New York: St. Martin's Press, 1973).

"pure psychic automatism," a broad description which covered the genre from the calligraphic formalism of Paul Klee and the frottage mannerism of Max Ernst to the hallucinatory enigmas of René Magritte. But to the average art aficionada in Depression America the image of the prototypical surrealist was inevitably Spanish artist Salvador Dali. Other European surrealists, such as Ernst and Giorgio de Chirico, had exhibited first in the United States but the theatrics surrounding Dali's one-man show at New York's Julien Levy Gallery in 1934 led many Americans to believe surrealism was strictly madcap antics and delirious dream states. Dali, like the regionalists, was a press hound. Cherishing the limelight, he reveled in "imposing himself on the public," as Breton scornfully observed. In 1936, just two years after Benton was featured on the cover of *Time*, Dali made his appearance. In 1939 his outrageous Dream of Venus pavilion attracted far more attention than Benton's art did at the New York World's Fair. Even Stuart Davis's Hall of Communications mural could not compete with the "liquid ladies" in Dali's show, "girls provided with mermaid tails afloat against a background of ruined Pompeii, performing such Surrealist functions as milking an underwater cow." [63]

Dali's popularity in Depression America could be attributed to the press his weird exploits received. More important, however, his pictures corresponded to the cultural climate of a tense prewar America in ways that Benton's regionalism and Davis's abstract paintings simply did not. Although pictures like *Soft Construction with Boiled Beans, Premonition of Civil War* (1936, fig. 4.30) were criticized by leftists such as Breton for their fuzzy relevancy to the real facts of the Spanish Civil War (which this picture actually preceded by a few months), they did embody the devastation visited upon the European scene in the late thirties. Set in a mysterious landscape (a more or less literal depiction of the craggy geology of Dali's home in southeastern Spain), *Soft Construction* is a hellish vision of a gigantic humanoid form ripping itself to shreds. The monstrous body, rotting flesh, and maggoty beans all symbolically suggest the terrible conflict in his native land. Like Picasso's *Guernica* (1937) and Benton's *Year of Peril* pictures, Dali's painting attests to a world gone mad. While Dali said the Civil War was inevitable ("a phenomenon of natural history") and ignored its political realities, he did recognize its implications; in 1942 he observed that Spain was "the first country in which all the ideological and insoluble dramas of post-war Europe, all the moral and aesthetic anxiety of the 'isms' polarized in those two words 'revolution' and 'tradition'" were first solved in "the

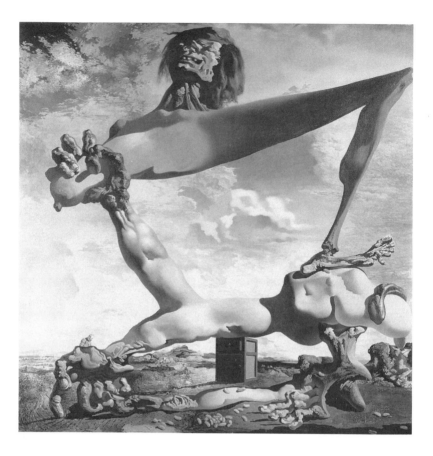

4.30. Salvador Dali, *Soft Construction with Boiled Beans: Premonition of Civil War,*
1936; oil on canvas, 39 ⅜″ × 39″. Philadelphia Museum of Art. Louise and Walter
Arensberg Collection. Copyright 1990 Demart Pro Arte/ARS N.Y.

crude reality of violence and blood." [64] Benton said much the same in his
essay on *The Year of Peril* series.

During the late 1930s and throughout the 1940s, Benton and Dali
frequently crossed paths: both exhibited in New York in April 1939 and
in November 1941; both frequented Hollywood in the 1940s (Dali
worked on Alfred Hitchcock's *Spellbound*); both worked at the Walt
Disney studios in 1946.[65] It is highly probable that just a month before
he began *The Year of Peril* series Benton saw Dali's retrospective at the
Museum of Modern Art. Indeed, in their formal attention to abstract

space, theatrical settings, horrific detail, frozen action, and deliberately exaggerated elements, Benton's war pictures bear uncanny similarities to several of Dali's works on view at MOMA that fall. *The Sowers* and Dali's *The Spectre of Sex Appeal* (1934, fig. 4.31), where the child Dali (dressed in a sailor suit, complete with ossified penis) stares at a monstrous female apparition, rely equally on grotesque ogre forms cast in vague histrionic landscapes. The flat sky, mystic shoreline, concentration on huge foreground figures, and overall paucity of detail are also comparable. Likewise, the spatial arrangement of Dali's *Persistence of Memory* (1931), the show-stopper at the MOMA exhibit, is reiterated in Benton's *Indifference*. Both Dali's infamous illustration of decaying timepieces (his "soft watches") and Benton's picture depict a fantasy environment; both convey an endless dimensionality. Although their content is dissimilar their grim tone and strident coloration are analogous: both artists used sour greens and ghastly yellows and daubed their pictures with eerie crimsons and cobalts. This was not the palette Benton had relied on for his four regionalist murals of the 1930s.

Nor did he retain the compositional style of those murals in *The Year of Peril* pictures. *Exterminate!* is an incredible melange of bodies, bayonets, tanks, chains, skulls, flags, factories, and airplanes punctuating a ravaged smoky landscape. Completely clogged and close to incoherent, this is a far cry from either the crowded panels of the New School or the scenic hodgepodge of *Hollywood*. Rather, *Exterminate!* finds its counterpart in Dali's *Family of Marsupial Centaurs* (1941, fig. 4.32), a similar potpourri of writhing and intertwined forms. Thus, in their surreal overtones, their pageant of carnage, their improbable and ruined landscapes, and their vast horizons, *The Year of Peril* pictures parallel contemporary works by Dali. It is not surprising that when Benton began to assess his personal reaction to America's involvement in world war he turned to Dali's own tormented insights on fascism for inspiration and advice. Each viewed the war on personal terms, as an invasion into the habits and modes of behavior they had practiced for decades. For Benton, in particular, the war represented the complete breakdown of all that he had championed in the thirties.

Benton's assimilation of Daliesque surrealism, and the overwhelming horror of what he chose to paint, disclose his personal despondency over the bankruptcy of liberal reform in New Deal America. In some ways *The Year of Peril* pictures, and his explanations of them, represent Benton's last plea with the American public to turn their attention to the country's republican tradition. In other ways they show his complete

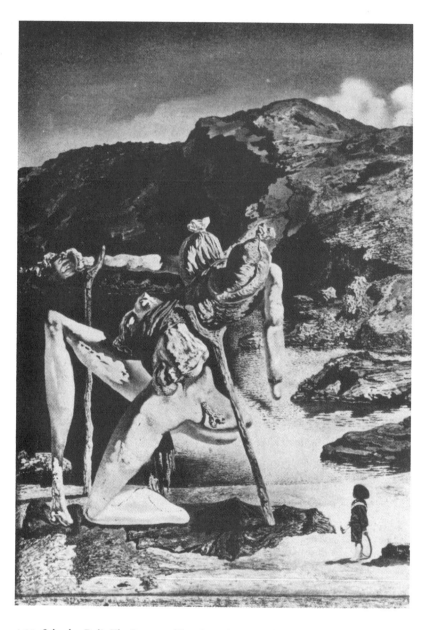

4.31. Salvador Dali, *The Spectre of Sex Appeal,* 1934; oil on wood, 7″ × 5 ½″. Private Collection. Copyright 1990 Demart Pro Arte/ARS N.Y.

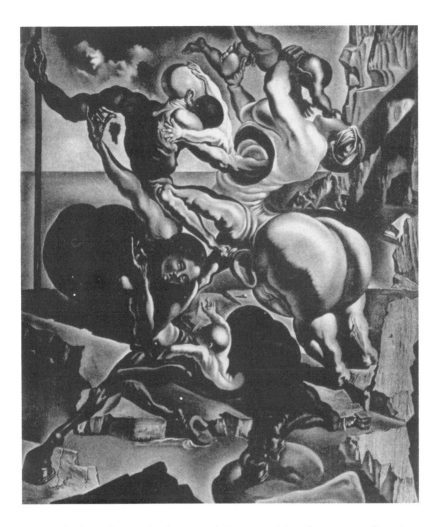

4.32. Salvador Dali, *Family of Marsupial Centaurs,* 1941; oil on canvas, dimensions unknown. Private Collection. Copyright 1990 Demart Pro Arte/ARS N.Y.

lack of conviction about the regeneration of that tradition. Benton looked on the war as both retribution for American declension from the true path of reform and as an event which, ironically, could engender that reform.

In a revealing essay written to accompany the publication of *The Year of Peril* series, Benton denounced American reluctance to "tackle

the problems of actuality" which had been brewing for years:

> It showed itself blatantly in and after the economic upheaval of twenty nine. It has just lately showed itself in the naive isolationism of the middle west where a doctrine was advocated by men who would have fought tooth and nail against the socialization necessary to make it even partially successful. It has showed itself in the lunatic jurisdictional fight which halted organization progress in the ranks of labor and put the blot of social irresponsibility on the Unions. It permeates the whole of our social fabric and reaches even into the field of our cultural effort which have in many places become infested with the growing sores of moral and intellectual decadence.[66]

In other words, by refusing to adopt the liberal strategies of reform, the "socialization" of industry, labor, and the arts that the early New Deal seemed to offer, America was plunged into the horror of world war.

Benton expanded his argument to explain that the same narrow state of mind which led America to abandon domestic reform had also led it to forsake "responsible participation in world affairs" by refusing to see that "in a mechanically knit economic world . . . her political voice was as essential as her trade." [67] America had reneged on the strategy of social planning and shared economic responsibility outlined by Bingham in *Common Sense* and the result was international carnage.

But, said Benton, the war also offered an opportunity for the organic democracy of American republicanism to be achieved at last. If Americans accepted wartime "socialization" and then maintained it postwar as well, they could transform corrupt laissez-faire capitalism into an industrial democracy. Mumford's war of redemption had become an actuality and Benton was apparently trying to make the best of it. Benton ended his essay (only parts of which were eventually published) by dedicating his war paintings to "those new Americans who born again through appreciation of their country's great need" might actually be able to spawn the social progress he had failed to create.[68] On paper, Benton tried to redirect his personal despair into optimism about a better tomorrow.

This future forecasting was echoed a few months later by John Dewey, acting as corporate spokesman for Pan American Airlines in their "forum on the future" ad campaign of late 1942 (fig. 4.33). Dewey had adamantly opposed U.S. intervention during the late thirties, writing one article titled "No Matter What Happens—Stay Out." But with

the German invasion of Poland and the bombing of Pearl Harbor, he softened his stand. Asked by Pan Am what he saw "coming in the post-war world," Dewey maintained the progressive party line: "the future is up to the people. . . . the opportunities for us, the people of the United States, will be tremendous. A means for widely distributing the world's goods among the nations of the earth must be provided. . . . A way of carrying health and education and a higher standard of life to the utmost corners of the earth must be assured." [69] Corporate America, of course, was only too eager to participate in this postwar abundance: Pan Am's ad, pictured with a pseudo-regionalist icon of a brawny farmer and his straw-hatted son, made it clear that "when peace comes" the company looked forward "to playing its part" in the "widespread distribution of the world's goods."

But was Benton really as convinced as Dewey and Pan Am were about this abundant future? His essay on *The Year of Peril* series tells us that he was, but the pictures themselves tell us that he was so completely devastated by the war's eruption he was not at all convinced there would ever be a peaceful, let alone abundant, future. Like Dali, Benton viewed the war as a bloody and violent departure from the past; he also seemingly shared Dali's opinion that this apocalypse was inevitable. He may have dedicated *The Year of Peril* series to "those new Americans" reunited with the country's democratic tenets, but the horror and over-riding fatalism of his war pictures suggests that he was not at all sure these "born again" citizens would be any more successful than he had been in generating reform through republicanism. *The Year of Peril* series, especially, betrays Benton's loss of intellectual innocence.

Benton's half-hearted final appeal to the restoration of republicanism was, not unexpectedly, slammed by critics. Manny Farber at the *New Republic* called them "Benton's bad paintings." Compositions were chaotic and colors clashed, the overall design was "spotty and falls apart." And, said Farber, the pictures failed as effective propaganda too, having "so little emotional truth" that he expected curtains to go down "and the figures to get up and walk off the stage." Farber's criticism was echoed by many in the art press as well. *Art News* editor Alfred Frankfurter found that Benton's mixture of "vague Baroque mannerism" with a "boys'-book imagination" led to a series of work "which so overplays its theme of blood, thunder, and destruction that it ends in looking like the silliest scene in Donald Duck's mix-ups with jam and fly-paper." Compared with similar works by Goya and Forain, Benton's pictures were declared "ridiculous in relation to their propagandistic as well as

"The f

4.33. Advertisement for Pan American Airlines, featuring commentary from John Dewey,

...e people will be *up to the people*"

What kind of a world are we fighting to create?
Because this question is one of the vital questions of our time, Pan American has asked
John Dewey, America's most eminent philosopher—and other leaders of thought—
to tell you what he sees coming in the post-war world. *Here is Mr. Dewey's statement:*

"THERE IS NOTHING PERMANENT EXCEPT CHANGE," wrote that great Greek philosopher, Heraclitus, ...er two thousand years ago.

Today it seems to me, looking back over my four-...re years of work and study, that too many men ...we recently paid too little attention to this great truth.

Every day I hear people talking about the future in ...ms of "after the last war." But this is *another* war. ...hat comes after this war will not be what came after ... last one. Men have changed, living conditions have ...anged, ideas have changed.

Just as this is a new-style war, so the peace will be—...st be—new-style, also. Military triumph, followed ... truce, is not enough. Peace alone will not settle ...ngs permanently. Peace offers only an *opportunity* for ...ilding a better world.

⋇ ⋇

...E HAVE BEEN PROMISED a *people's* world of security ...d opportunity after the war. But unless the peace is *...eople's* peace, the promises may fail.

More than at any previous time in the world's his-...ry, *the future is up to the people.* They must see that

the victory is a *true* victory for the democratic nations.

Of course, there will be no short cuts to our goal. The growing bounty, the widespread plenty, the higher standards of life for all—these will come slowly and painfully, as they always have. But they will come surely, inevitably, if we keep our vision clear, and direct our energies into productive channels.

⋇ ⋇

THE OPPORTUNITIES FOR US, the people of the United States, will be tremendous. A means for widely distributing the world's goods among the nations of the earth must be provided . . . A way of carrying health and education and a higher standard of life to the utmost corners of the earth must be assured.

The mechanical means have already been produced by science and invention. *Physically,* the world is now one and interdependent. Only human beings—interested that men everywhere have a society of peace, of security, of opportunity, of growth in co-operation—can assure its being made *morally* one.

A genuine democratic victory will be achieved only when it is made *by* democratic governments *for* the well-being of the common people of the earth.

John Dewey

...E PART WHICH AIR TRANSPORT WILL PLAY in the vast post-war adjust-...nts and developments is, of course, obvious to everyone.

...Inexpensive, fast passenger and freight carrying—with air travel ... a global scale available to all—will be one of the most important ...gle factors of the future.

...Pan American has an experience record based on over 110 million ...les of overseas flight. Nothing like the fund of scientific fact built ... by this pioneering exists anywhere else in the world today. All

of it—and also our carrying services and trained personnel—have been placed at the disposal of the state and military services of the United States government, for the duration.

When peace comes, Pan American looks forward to playing its part, through technological research as well as with trained personnel and flight equipment, in providing the "widespread distribution of the world's goods" which Mr. Dewey recognizes as an essential for a lasting peace. Pan American World Airways System.

Life, September 7, 1942.

their artistic end." Even his defenders at *Art Digest* found *The Year of Peril* pictures a bit much, observing that "in most of them Benton shouts at the top of his voice—and thus deprives his work of the power and impact of shrewd understatement." [70]

Such criticism recognized the major failing of this series: it lacked a persuasive and enduring vision of the national unity and emotional commitment necessary to fight a world war. While Benton expressed the horror he felt about this war, he was so disillusioned by what he believed it represented for the producer tradition he was incapable of depicting or even implying its successful outcome. After being castigated by critics and then dropped by the OWI, *The Year of Peril* series quickly disappeared from view. Benton made a few more propaganda pictures during the war, but he never again made a direct appeal to republicanism. [71]

Ironically, however, the surrealist style he assimilated gained further dominance in the war years in both critical estimation and as the style of choice for American advertisers. Jumping from the cover of *Time* in 1936 to the Museum of Modern Art in 1941, Dali's art became a big hit in the advertising world by 1944. Early that year *Printer's Ink* noted that "one of the most conspicuous trends in advertising today is the adoption of surrealist techniques." Corporations from Sylvania and Pittsburgh Steel to Schiaparelli Cosmetics and Koppers Paints discovered that the "very weirdness" of surrealist-style ad campaigns had a higher "potentiality for attracting attention" and hired Dali to sell products ranging from lipstick to paint (fig. 4.34). While many 1930s critics had dismissed surrealism as "sham humbuggery," in the 1940s, they grudgingly admitted that its "rejuvenation of art's imaginative faculties remains a major and pervasive contribution, and has affected many younger American artists." [72]

Fleeing European fascism, many of the refugee artists who settled in New York in the late thirties and early forties were surrealists, from style spokesman André Breton to painters Roberto Matta, André Masson, Ernst, and Dali. Their art had a tremendous impact on a "younger" generation of American artists, the abstract expressionists. Indeed, comparing Jackson Pollock's 1930s regionalist paintings with his 1940s art, the impact of a surrealist aesthetic is obvious. While surrealism would never dominate 1940s American culture in quite the same way that American scene painting and regionalist art had during the Depression, it did serve as a mediating style during the moment of a major transformation in American culture: from regionalism to abstract expressionism.

If the 1930s are characterized by an auspicious regionalist folk aesthetic that focused on the reform of American society, the postwar years were marked by abstract expressionism, a completely different style, which embodied growing international and personal tensions. Regionalism dominated American culture during the Depression through its public popular culture appeal and its promotion of liberal sentiments similar to those expressed by the New Deal. But, it failed to maintain its dominance after the Depression.

While it is customary to see the change from regionalism to abstract expressionism as a tremendous alteration in terms of art form, the shift in style from the art of Benton to that of Pollock demonstrates a larger cultural and political transition at work. For Benton, regionalism was a vehicle that promoted the rebirth of the producer tradition in modern America. But for students trained in that tradition, such as Pollock, regionalism was seen as a failed style by the late thirties. Its subject matter and form lost popular and artistic credibility because its vision of social reform never materialized. In the 1940s, Pollock's generation shifted to an art style that allowed them to respond to both regionalism's and the New Deal's failure to restructure American society. As Benton noted, in the 1940s:

> Regionalism was as much out of place as New Dealism itself. It declined in popular interest and lost its grip on the minds of young artists. Shortly after our entrance into the War, what was left of it turned to a swift and superficial representation of combat and production scenes, to a business of sensational reporting for the popular magazines. There it had its grass-roots substance knocked out.[73]

The major proponent of a passé art style in a changed American scene, Benton obviously felt a sense of defeat. His "gnawing suspicions of failure" were shared by his partners in regionalism. Wood, on his deathbed early in 1942, said he wanted to "start all over again with a new style of painting." Curry, shortly before he died in 1946 said, "Maybe I'd have done better to stay on the farm. No one seems interested in my pictures. Nobody thinks I can paint. If I *am* any good, I lived at the wrong time." The sense of failure that all three shared was reinforced by 1940s critics who increasingly attacked regionalism as commercialized "escapist material." Their criticism, and the lack of rebuttal, codified the loss of support for regionalism in the forties from institutions and artists alike. Later, Benton wrote that by the time the United States entered World War II, regionalism had lost its influence "among

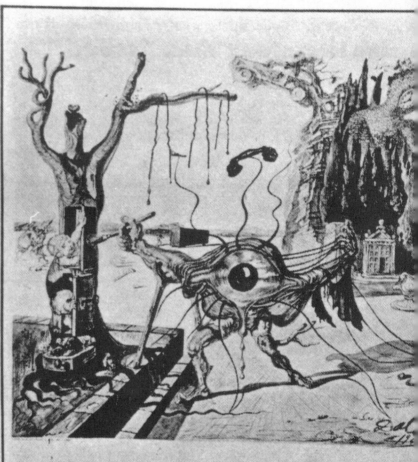

A PAINT-MAKER'S PLIGHT... interpreted by Salvador Dali

Bizarre and baffling it might be, but it c

4.34. Advertisement for Johnson Wax Company and Koppers Company featuring paintings and drawings by Salvador Dali, illustrated in *Newsweek*, January 3, 1944. Copyright

Airplanes

make "duds" of cardboard heroes

Every prophecy about the end of Hitler begins with a prediction on the fall of Mussolini. Italy's hollow shell may be the doorway to Europe. American planes, poised on the lip of Africa, look like the key to that doorway. One Koppers division has been getting ready for that fateful day for years — building up the nation's greatest output of aircraft piston rings, — teaching other companies the delicate art of making aircraft rings, — helping a great sewing machine builder become a ring maker.

Koppers American Hammered Piston Rings flew over Tokyo with Jimmy Doolittle. They powered the plane that rescued Eddie Rickenbacker, strapped to the wings, they took the pounding in PT boats that carried MacArthur out of Bataan. Other Koppers divisions make ingredients for plywood planes and plastics, tars for airport runways, electrode pitch for aluminum, paints for planes and other products. — Koppers Company, Pittsburgh, Pa.

For Victory — Buy War Bonds and Stamps

KOPPERS
THE INDUSTRY THAT SERVES ALL INDUSTRY

ttention, so advertising art goes surrealistic

the newly budding artists and the young students. The band wagon practitioners left our regionalist banner like rats from a sinking ship."[74] Foremost among those "newly budding artists" was Benton's most promising student, Jackson Pollock.

N O T E S

1. Russell Lynes, *The Tastemakers* (New York: Harper & Bros., 1954), 287. On estimates of 1940 cigarette sales, see "Wartime Smoking," *Business Week,* no. 624 (August 16, 1941), p. 20.

Other artists included in this campaign were Georges Schreiber, Aaron Bohrod, Peter Hurd, Paul Sample, Lawrence Beall Smith, James Chapin, Arnold Blanch, Doris Lee, Ernest Fiene, Robert Phillipp, Joe Jones, David Stone Martin, Fletcher Martin, Irwin Hoffman, and Frederic Taubes. See the Associated American Artists file, Microfilm Roll D–256, Archives of American Art (AAA), Smithsonian Institution, Washington, D.C.

2. "Behind the Cigarette Verdict," *Business Week,* no. 636 (November 8, 1941), p. 17. See also Nannie M. Tilley's account of the conviction in *The R. J. Reynolds Tobacco Company* (Chapel Hill: University of North Carolina Press, 1985), 414–26. For Hawley's assessment of New Deal trust-busting, see *The New Deal and the Problem of Monopoly: A Study in Economic Ambivalence* (Princeton: Princeton University Press, 1966), 451.

3. "Wartime Smoking," 19–20. Wartime rationing prevented the American Tobacco Company from obtaining chromium, used to color the green background of the Lucky Strike package. For more on American advertising campaigns, see *Sold American! The First Fifty Years: The American Tobacco Company* (New York: American Tobacco Co., 1954), 94 and passim.

4. Frederick Wakeman, *The Hucksters* (New York: Rinehart & Co., 1946), 242; Benton, "After," a 1951 essay appended to his 1937 autobiography, *An Artist in America,* 4th ed. (Columbia: University of Missouri Press, 1984), 296.

5. Benton, "After," 294–95.

6. Ibid., 295.

7. Fairfax Cone, *With All Its Faults: A Candid Account of Forty Years in Advertising* (Boston: Little, Brown, & Co., 1969), 116–18. As the campaign progressed text was eliminated to a single sentence of copy.

Benton's picture *Outside the Curing Barn* can be seen in *Time* 40, no. 3 (July 20, 1942), next to p. 29, and in the *Saturday Evening Post* 215, no. 3 (July 18, 1942): 31. *Tobacco* can be seen in *Time* 40, no. 17 (October 26, 1942), back cover, and *Saturday Evening Post* 215, no. 17 (October 24, 1942): 31.

8. Thomas Hart Benton, "American Regionalism," a 1951 essay appended to *An American in Art* (Lawrence: University Press of Kansas, 1969), 192. The Cosmo de Salvo painting is found on the back cover of *Time* 42, no. 17 (October 23, 1944).

9. "Fine Arts in Ads," *Business Week*, no. 768 (May 20, 1944), pp. 76, 79. On cigarette consumption, see chart "How the Cigarette Brands Stand," *Business Week*, no. 778 (July 29, 1944), p. 21. See also Harry M. Wootten, "1947 Cigarette Consumption Up 4.6%," *Printer's Ink* 222, no. 4 (January 23, 1948): 27–30, 64, which analyzes competition among the Big Three from the early forties to after the war. Benton quoted in "Business and Art as Tom Benton Sees It," *P.M.*, December 24, 1945, from the Associated American Artists File, Microfilm Roll D–255, AAA.

10. Walter Benjamin, "The Author as Producer," a 1934 essay reprinted in *Art after Modernism: Rethinking Representation*, ed. Brian Wallis (New York: New Museum of Contemporary Art, 1984), 306.

11. "Movie Promotion Up," *Business Week*, no. 562 (June 8, 1940), p. 47; David Karnes, "The Glamorous Crowd: Hollywood Movie Premieres between the Wars," *American Quarterly* 38, no. 4 (Fall 1986): 566.

12. The seven other artists involved in *The Long Voyage Home* commission were Raphael Soyer, Robert Phillipp, Ernest Fiene, Georges Schreiber, Luis Quintanilla, James Chapin, and George Biddle. Information on the commission can be found in the Associated American Artists file, Microfilm Roll D–255, AAA.

13. Janey Place, *The Non-Western Films of John Ford* (Secaucus, N.J.: Citadel Press, 1979), 258–61. The movie was adapted from O'Neill's *The Moon of the Caribees, Bound East for Cardiff, In the Zone,* and *The Long Voyage Home.*

14. On movie attendance figures, see Lary May, "Making the American Way: Moderne Theatres, Audiences, and the Film Industry, 1929–1945," *Prospects* 12 (1987): 110. Wheeler, quoted in Clayton R. Koppes and Gregory D. Black, *Hollywood Goes to War: How Politics, Profits, and Propaganda Shaped World War II Movies* (New York: Free Press, 1987), 19.

15. Wanger, quoted in Bernard Rosenberg and Harry Silverstein, *The Real Tinsel* (New York: Macmillan Co., 1970), 82.

16. Andrew Bergman, *We're in the Money: Depression America and Its Films* (New York: New York University Press, 1971), 116.

17. Koppes and Black, *Hollywood Goes to War,* 24–26.

18. For Fonda's speech, see Peter Roffman and Jim Purdy, *The Hollywood Social Problem Film: Madness, Despair, and Politics from the Depression to the Fifties* (Bloomington: Indiana University Press, 1981), 207.

19. For information on Lawson, see Victor S. Navasky, *Naming Names* (New York: Viking Press, 1980), 81–83. On industry and church censorship of *Blockade,* see Winchell Taylor, "Secret Movie Censors," *Nation* 147, no. 2 (8 July 1938): 38–40.

20. Walter Wanger, speech to the Variety Club Seventh Annual Convention, Atlantic City, N.J., May 1941, from the Walter Wanger Collection, Speeches, Box 1, Wisconsin Center for Film and Theater Research, University of Wisconsin, Madison; Wanger, "Hollywood and the Intellectuals," *Saturday Review of Literature* 25, no. 49 (December 5, 1942) 6, 40.

21. "The Long Voyage Home," Associated American Artists exhibition catalog, 1940; Associated American Artists file, Microfilm Roll D–255, AAA.

22. Hermine Rich Isaacs, "Film in Review," *Theatre Arts* 24, no. 12 (December 1940): 868; Place, *The Non-Western Films of John Ford*, 261.

23. Sylvia Harvey, "Woman's Place: The Absent Family of Film Noir," in E. Ann Kaplan, ed., *Women in Film Noir* (London: British Film Institute, 1980), 22. For more on noir, see Alain Silver and Elizabeth Ward, *Film Noir* (Woodstock, N.Y.: Overlook Press, 1979).

24. For reviews, see Lynn Farnol, "Hollywood Build-Up," *Theatre Arts* 25 (April 1941): 305–26; "They All Know What They Want," *Commonweal* 33, no. 1 (October 25, 1940): 24; "Film Ups and Downs," *New Republic* 103, no. 17 (October 21, 1940): 558; and publicity materials on the film in the Wisconsin Center for Film and Theater Research.

25. In their study of Muncie, Indiana, Robert and Helen Lynd found that "adult females predominate" among movie audiences and "set the type of picture that will 'go.'" See their *Middletown in Transition: A Study in Cultural Conflicts* (New York: Harcourt Brace Jovanovich, 1937, 1965), 261. See also Margaret Farrand Thorp, *America at the Movies* (New Haven, Conn.: Yale University Press, 1939), 5–8. On the pictures preferred by 1940 audiences, see Colin Shindler, *Hollywood Goes to War: Films and American Society, 1939–1952* (London: Routledge & Kegan Paul, 1979), 11, 18, 24.

26. Harry Salpeter, "Art Comes to Hollywood," *Esquire* 14, no. 3 (September 1940): 64, 174; Milton Brown, "Wanger Circus," *Parnassus* 12 (October 1940): 38.

27. Clement Greenberg, "Avant-Garde and Kitsch," *Partisan Review* 6, no. 5 (Fall 1939): 34–49, reprinted in Francis Frascina, ed., *Pollock and After: The Critical Debate* (New York: Harper & Row, 1985), 21–33; Nathaniel Pousette-Dart, "Freedom of Expression," *Art and Artists of Today* 1, no. 6 (June-July 1938): 2.

28. Barr, quoted in Dorothy Miller's foreword to *American Realists and Magic Realists,* ed. Miller and Barr (New York: Museum of Modern Art, 1943), 5. Pousette-Dart's "tree" is remarkably similar to Ad Reinhardt's diagram, discussed in chap. 5; see fig. 5.9; Baigell, *Thomas Hart Benton* (New York: Abrams, 1974), 152.

29. Robert Freeman Smith, "American Foreign Relations, 1920–1942," in *Towards a New Past,* ed. Barton J. Bernstein (New York: Pantheon Books, 1968), 236–38, 247–48.

30. Lewis Mumford, "Call to Arms," *New Republic* 95, no. 1224 (May 18,

1938): 39–42; Mumford, *Men Must Act* (New York: Harcourt, Brace, 1939), 171, 141–42; and *Faith for Living* (New York: Harcourt, Brace, 1940), 95, 100, 105–6. On Mumford and other prointervention liberals, see R. Alan Lawson, *The Failure of Independent Liberalism, 1930–1941* (New York: G. P. Putnam's Sons, 1971), 169–79, 212–16; and Richard Pells, *Radical Visions and American Dreams* (New York: Harper & Row, 1973), 359–62. MacLeish, quoted in his essay "The Young Can Choose," *Common Sense* 8, no. 5 (May 1939): 14.

31. Alfred Bingham, "A Positive Program for Peace," *Common Sense* 7, no. 8 (August 1938): 3–5; "The Liberal and Anti-Fascism," *Common Sense* 7, no. 10 (October 1938): 3–5.

32. Charles Beard, "Letter to the Editor," *Common Sense* 7, no. 11 (November 1938): 2, 30.

33. Thomas Hart Benton, "Letter to the Editor," *Common Sense* 7, no. 11 (November 1938): 30.

34. On Curry, see M. Sue Kendall, *Rethinking Regionalism: John Steuart Curry and the Kansas Mural Controversy* (Washington, D.C.: Smithsonian Institution Press, 1986), 83–85.

35. Barton J. Bernstein, "The New Deal: The Conservative Achievements of Liberal Reform," in Bernstein, ed., *Towards a New Past*, 264.

36. David W. Noble, *Historians against History* (Minneapolis: University of Minnesota Press, 1965), 133–34.

37. "For Work Relief," *New York Times*, April 30, 1939, sec. 4, p. 1, noted in Alice G. Marquis, *Hopes and Ashes: The Birth of Modern Times, 1929–1939* (New York: Free Press, 1986), 192; Robert H. Bremner, "The New Deal and Social Welfare," in Harvey Sitkoff, ed., *Fifty Years Later: The New Deal Evaluated* (Philadelphia: Temple University Press, 1985), 81–82.

38. David Brody, "The New Deal and the Emergence of Mass Production Unionism," *Workers in Industrial America: Essays on the Twentieth Century Struggle* (New York: Oxford University Press, 1980), 110; Stanley Vittoz, *New Deal Labor Policy and the American Industrial Economy* (Chapel Hill: University of North Carolina Press, 1987), 172.

39. Richard S. Kirkendall, "The New Deal and Agriculture," in Alonzo L. Hamby, ed., *The New Deal: Analysis and Interpretation* (New York: Longman, 1981), 65, 82. From 1930 to 1940 the number of American farms declined from 6.3 million to 6.1 million, the number of farm workers decreased from 12.5 million to 11.0 million, the number of persons supplied per farm worker increased in the United States from 8.8 to 10.3.

40. Kirkendall, "The New Deal and Agriculture," 82, and Thomas K. McCraw, "The New Deal and the Mixed Economy," in Harvey Sitkoff, ed., *Fifty Years Later*, 55.

41. Bernstein, "The New Deal," 270. For contrasting views on the New Deal and civil rights, see Leslie H. Fishel, Jr., "A Case Study: The Negro and the New

Deal," in Hamby, ed., *The New Deal,* 177–87; Harvey Sitkoff, "The New Deal and Race Relations," in Sitkoff, *Fifty Years Later,* 93–112; and Raymond Wolters, "The New Deal and the Negro," in John Braeman, Robert H. Bremner, and David Brody, eds., *The New Deal,* vol. 1: *The National Level* (Columbus: Ohio State University Press, 1975), 170–217.

42. Robert S. McElvaine, *The Great Depression: America, 1929–1941* (New York: Times Books, 1984), 321. The poll was conducted in May 1941.

43. Lawrence Levine, "Hollywood's Washington: Film Images of National Politics during the Great Depression," *Prospects* 10 (1985): 189–90; Frank Capra, *The Name above the Title: An Autobiography* (New York: Macmillan, 1971), 186.

44. Ellis W. Hawley, *The New Deal and the Problem of Monopoly: A Study in Economic Ambivalence* (Princeton: Princeton University Press, 1966), 4, 472–73, 479, 490. See also Christopher Lasch's discussion of Hawley, "Liberalism in Retreat," in Douglas MacLean and Claudia Mills, eds., *Liberalism Reconsidered* (Totowa, N.J.: Rowman & Allanheld, 1983), 107–9. On New Deal accommodation, see Ronald Radosh, "A Radical Critique: The Myth of the New Deal," in Hamby, *The New Deal,* 44–46.

45. William Stott, *Documentary Expression and Thirties America* (New York: Oxford University Press, 1973), 92, 128, 240–41.

46. Louis Galambos, *The Public Image of Big Business in America, 1880–1940* (Baltimore: Johns Hopkins University Press, 1975), 262–63.

47. Pells, *Radical Visions,* 300, 362–64.

48. Stuart Davis, "Why an Artists' Congress?" in *Artists against War and Fascism: Papers of the First American Artists' Congress,* with an introduction by Matthew Baigell and Julia Williams (New Brunswick: Rutgers University Press, 1986, originally published 1936), 68; Davis, "A Medium of Two Dimensions," *Art Front* 1, no. 5 (May 1935): 6; Davis, August 27, 1937, as noted in Cecile Whiting, *Antifascism in American Art* (New Haven: Yale University Press, 1989), 76.

49. Helen A. Harrison, *Dawn of a New Day: The New York World's Fair, 1939/40,* catalog for an exhibit at the Queens Museum (New York: New York University Press, 1980). Benton showed the small oil *Conversation* at the fair; see *American Art Today: New York World's Fair* (New York: National Art Society, 1939), 46. Whiting (*Antifascism in American Art*) discusses Davis's mural on pp. 78–82.

50. Baigell and Williams, *Artists against War and Fascism,* 29–32; Navasky, *Naming Names,* 293–95.

51. Davis, June 1, 1940, quoted in Whiting, *Antifascism in American Art,* 91; Davis, "The American Artist Now," *Now* 1, no. 1 (August 1941), reprinted in Diane Kelder, ed., *Stuart Davis* (New York: Praeger Publishers, 1971), 165–69.

52. McElvaine, *The Great Depression,* 320.

53. John Kenneth Galbraith, *American Capitalism: The Concept of Countervailing Power* (Boston: Houghton Mifflin, 1952).

54. Benton, quoted in "Business and Art." See also Benton's essay "Business and Art," in Elisabeth McCausland, ed., *Work for Artists: What? Where? How?* (New York: American Artists Groups, 1947), 21–26.

55. Benton, "Blast by Benton," *Art Digest* 15, no. 14 (April 15, 1941): 6, 19.

56. Benton, "Art vs. the Mellon Gallery," *Common Sense* 10 (June 1941): 172–73.

57. Thomas Hart Benton, "And Still After," a 1968 essay appended to *An Artist in America*, 326, 327, 368.

58. Benton, "After," 298.

59. Ibid., pp. 297–99. Information on Lewenthal can be found in the Associated American Artists files, Microfilm Roll N–122, AAA. Benton discussed *The Year of Peril* series with Paul Cummings in July 1973; see the transcript of this interview in the Archives of American Art Oral History Collection, p. 61. See also Barbara J. Carr, "Thomas Hart Benton's Year of Peril" (master's thesis, University of Missouri-Columbia, 1981), and *The Year of Peril: A Series of War Paintings by Thomas Benton* (Chicago: Abbott Laboratories, 1942), which includes a Foreword by Archibald MacLeish and an essay by Benton.

60. John Morton Blum analyzes U.S. attitudes toward the enemy in *V Was for Victory: Politics and American Culture during World War II* (New York: Harcourt Brace Jovanovich, 1976), 45–52. I am also indebted to the observations made by Karen Huck in her paper "Seeing Japanese: The Constitution of the Enemy Other in *Life* Magazine, 1937–1942," presented at the American Studies Association Annual Conference, November 24, 1987, New York.

61. MacLeish, Foreword, *The Year of Peril*. Lewis is mentioned in "For All Americans Who Will Look," *Time* 39, no. 14 (April 6, 1942): 63. Negative reactions to the series are noted in Carr, "Thomas Hart Benton's *Year of Peril*," 12–13.

62. Blum, *V Was for Victory*, 31–39.

63. Breton, quoted in William Gaunt, *The Surrealists* (New York: G. P. Putnam's Sons, 1972), 7, 40; the Dream of Venus exhibit is described on p. 40. Dali appeared on the December 14, 1936, cover of *Time*.

64. Dali, quoted in Dawn Ades, *Dali and Surrealism* (New York: Harper & Row, 1982), 112–13.

65. Benton describes his work with Disney in "After," 312. See also Karal Ann Marling, "Thomas Hart Benton's *Boomtown*: Regionalism Redefined," *Prospects* 6 (1981): 126–27.

66. Benton's essay in Abbott's catalog also appeared in the University of Kansas City's *University Review* 13, no. 3 (Spring 1942): 178–80. The quotes here are from a manuscript called "The Year of Peril" (in the Benton Papers, AAA), which is considerably different from that published by Abbott or the *University Review*.

67. Benton, "The Year of Peril," Benton Papers.

68. Benton, "The Year of Peril," in *The Year of Peril.*

69. John Dewey, "No Matter What Happens—Stay Out," *Common Sense* 9 (March 1939): 11; see also Lawson, *The Failure of Independent Liberalism,* 241–49. For Dewey's statement in Pan Am's advertisement, see *Life* 13, no. 10 (September 7, 1942): 18–19.

70. Manny Farber, "Thomas Benton's War," *New Republic* 106 (April 20, 1942): 542–43; Alfred Frankfurter, "Benton," *Art News* 41 (May 1, 1942): 34; Anon., "The War and Thomas Hart Benton," *Art Digest* 15 (April 15, 1942): 13.

71. Benton painted *Negro Soldier* and *Embarkation* (*Prelude to Death*) shortly after he finished *The Year of Peril* series; see Baigell, *Thomas Hart Benton,* pl. 148 for an illustration of *Negro Soldier.* Hired through the AAA and Abbott Laboratories, Benton painted several other works that were published in Abbott's in-house magazine *What's New* throughout the war years. See the Associated American Artists files, Microfilm Roll D–255, AAA.

Curry was also hired through Lewenthal and the AAA and worked on projects for Abbott and for the U.S. army and the Treasury Department. See the Curry Papers, Microfilm Roll 165, AAA.

72. On Dali and advertising, see "Surrealism Pays," *Newsweek* 23 (January 3, 1944): 56–57. On criticism of surrealism, see Sheila Skidelsky, "The Sham of It," *Art Digest* 11 (February 1, 1937): 13, quoted in Jeffrey Wechsler, *Surrealism and American Art, 1931–1947* (New Brunswick: Rutgers University Art Gallery, 1977), 28, and James Thrall Soby, "Some Younger American Painters," *Contemporary Painters* (New York: Museum of Modern Art, 1948), 79.

73. Benton, "American Regionalism," 192.

74. Benton, "After," 320–21, 319.

From Regionalism to Abstract

Expressionism: Modern Art and

Consensus Politics in Postwar

America

I n the late 1960s, Thomas Hart Benton made the following re-
marks about his former student, abstract expressionist painter
Jackson Pollock:

> It is interesting to speculate about what might have happened had
> Jack Pollock adhered to the Regionalist philosophy long enough
> to have developed a representational imagery to implement it.
> Drawing *can* be learned if the need for it be strong enough. I have
> no doubt that his contributions to Regionalism, had he continued
> to make them, would have been quite as original as were the
> purely formalistic exercises to which he finally devoted himself.

Although it has not been fashionable to link them, much as it was until
recently unorthodox to link avant-garde painter Edouard Manet with
his teacher, the academic artist Thomas Couture, the fact is that Pollock
was Benton's foremost follower during the early 1930s.[1] His "contribu-
tions" to regionalism, including *Going West* (1934–35, fig. 5.1), show
his keen interest in the style's subject and design. Often, they are difficult
to distinguish from Benton's own work, such as *Cattle Loading, West
Texas* (1930, fig. 5.2). Pollock's pictures are darker and denser and his
draftsmanship was fairly mediocre, but their American scene flavor sug-
gests his youthful intention to assimilate the "philosophy" of region-
alism.

5.1. Jackson Pollock, *Going West*, 1934–35; oil on fiberboard, 15 ⅛″ × 20 ¾″. Courtesy of the National Museum of American Art, Smithsonian Institution. Gift of Thomas Hart Benton. Copyright 1990 Pollock-Krasner Foundation/ARS N.Y.

Yet, Pollock came to abandon his mentor's aesthetic in the 1940s, creating his own brand of modern art in postwar pictures like *Alchemy* (1947, fig. 5.3). Turning to what Benton disparagingly called "purely formalistic exercises," Pollock and a coterie of other artists largely avoided narrative painting for abstraction. The story of the relationship between these two artists, each a major painter in his particular era, is that of the shift from regionalism to abstract expressionism. As that aesthetic conversion is intimately linked with a similar transition in American political culture, the story of the shift from regionalism to abstraction is also that of the shift from the New Deal to the Cold War. Ultimately, it is also the story of the failure of modernism in twentieth-century American art.

Although the circumstances of Pollock's upbringing were vastly different from those of his mentor's, there were enough similarities for the

two to find common ground, or at least to recognize their dissimilarity with other artists. Pollock, like Benton, was a Westerner, born in 1912 in Cody, Wyoming, and raised in Arizona and California. LeRoy and Stella Pollock had five sons—Charles, Jay, Frank, Sanford, and Jackson, the youngest. Pollock's Scotch-Irish father, born in Iowa in 1877, was a man of all trades: stonemason, manual laborer, farmer, innkeeper, surveyor; his mother, also of Scotch origin and born in Iowa in 1875, was a skilled seamstress. They married in 1903; their first son, Charles, had been born out of wedlock a year earlier. While the Pollocks were by no means poor, Charles recalled that neither of his parents "had a sense for business or commercial profit." [2] Stella, a large, domineering figure, struggled to raise her sons in the best middle-class circumstances she could manage, demanding that each receive a good education and encouraging any sign of talent with music and art lessons. Like Benton's mother, Stella Pollock dreamed of a life of culture for her sons; eventually, three of the five boys followed careers in the arts.

The family drifted from town to town as both LeRoy and Stella pursued better or simply different jobs and locales. Leaving Cody shortly after Jackson's birth, they settled on a truck farm outside Phoenix in 1913, where LeRoy raised dairy cows and grew seasonal vegetables and fruit. The family thrived in this rural setting; in a letter to his sons years later LeRoy recalled, "the happiest time was when you boys were all home on the ranch. We did lots of hard work, but we were healthy and happy." But Stella "became obsessed" with the schools in Chico, California. [3] In 1917 the Pollocks moved there, growing fruit on an 18-acre citrus ranch. Unhappy in Chico, the elder Pollock demanded yet another move, to which Stella objected. Over the next few years family tensions escalated and finally, when Jackson was nine, his parents separated. LeRoy took a variety of surveying and construction jobs in the Southwest, occasionally visiting his sons and sending checks to his wife. Stella raised the boys, moving from Orland, California, back to Phoenix and then to Riverside, where she eventually settled in 1924. As he grew up, Pollock's contact with his father was, much like Benton's contact with his father, increasingly infrequent. But Pollock and his father (unlike Benton and his father), remained on fairly good terms. In long and emotional letters, LeRoy encouraged his youngest son's interest in the arts and his struggle for personal autonomy.

By the time Jackson Pollock reached adolescence, then, his family had split apart and been uprooted innumerable times. Still, his parents urged him and his brothers to "rise above" their lot through hard work and self-improvement. In a 1927 letter to Jackson, who had just en-

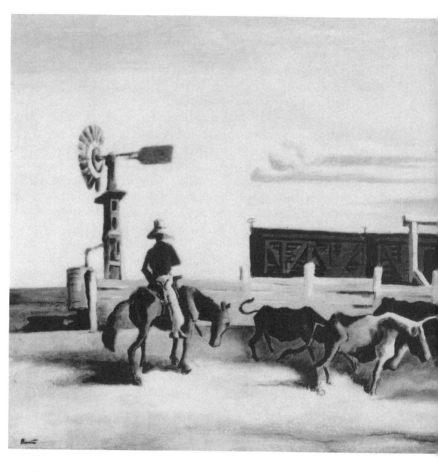

5.2. Thomas Hart Benton, *Cattle Loading, West Texas,* 1930; oil and tempera on canvas mounted on panel, 18″ × 38″. Courtesy of the Addison Gallery of American Art, Phillips

rolled at Riverside High School and was not doing especially well, LeRoy wrote:

> I would so much like to see you go on through high school as I know you would be in a better position to start into something. Education should really be a mind training—a training to make you think logically. The problems you solve today give you strength to solve a little harder ones tomorrow and so it goes. It

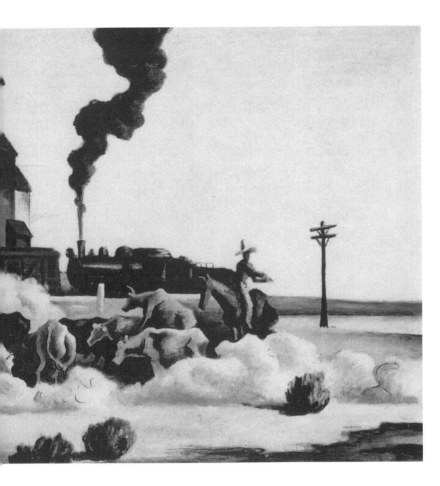

Academy, Andover, Massachusetts.

takes a lot of application and concentration and interest in your work in fact a hunger for knowledge and power of mind.

Adding that he "would be a poor Dad indeed" if he "did not wish for you the best future possible," it is evident that LeRoy Pollock felt deeply for his youngest son. Notwithstanding his absence from the family and the era's bias regarding male displays of affection, LeRoy Pollock struggled to maintain a certain degree of emotional commitment with

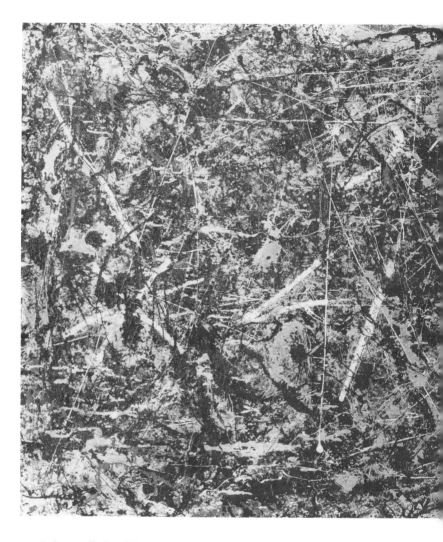

5.3. Jackson Pollock, *Alchemy*, 1947; oil and enamel on canvas, 45″ × 87″. Peggy Guggenheim Collection, Venice, The Solomon R. Guggenheim Foundation, New York. Copy-

all of his children. But as Pollock biographer Deborah Solomon observes, he was "incapable of providing Jackson with a lasting sense of direction or purpose."[4] In this same letter he admitted that he sometimes felt his life "has been a failure—but in this life we can't undo the things that are past we can only endeavor to do the best possible now and in the future." The dualistic nature of LeRoy Pollock's sentimental

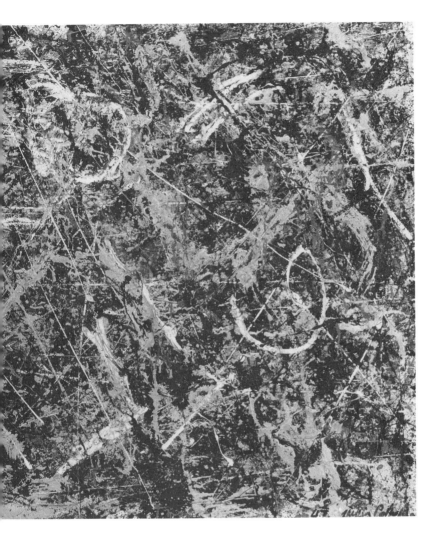

expression, preaching the necessity for self-improvement to his sons but also encoding his failure, would have considerable impact on his youngest son in later years.

Despite his fatalism and perhaps out of his own sense of self-identification, LeRoy Pollock encouraged his sons to champion the underdog. Described as the "lone Socialist in Ringgold [Iowa] County,"

LeRoy had embraced the radical reform gestures of Populism in the 1890s and supported the IWW and the organizational efforts of the labor movement in the early twentieth century. He became infuriated one day when a teacher cynically told one of the Pollock boys that the IWW stood for "I Won't Work." In 1917, LeRoy "celebrated at the news that the workers of Russia had taken control of their government." "My father," Charles Pollock observed, "was a very sensitive man, sensitive to human relations. In a country which could hardly tolerate the sight of blacks, Orientals, or Latins, my parents had warm relations with all of them." The elder Pollock dared his sons to buck authority; in a 1928 letter to Jackson he remarked: "I think every person should think, act & believe according to the dictates of his own conscience without to [sic] much pressure from the outside." [5] Leroy Pollock's humanitarian and questioning nature had no little influence on his children. Charles, for instance, eventually worked for various union newspapers in Detroit in the 1930s; Sanford (Sande) and Jackson worked for a short time in 1936 in the New York workshop of communist artist David Siqueiros.

Jackson Pollock first demonstrated antipathy to social, political, and aesthetic authority during his high school years. Like many adolescents, he struggled with institutional representatives of control and restraint and searched for ways to vent his anger and frustration. Acquaintances later recalled that Pollock was an intense figure who vacillated between moods of extreme happiness and severe depression. He found that the physical act of drawing helped alleviate his adolescent angst and emotional unevenness and decided to become an artist like Charles, who had begun studying in New York with Benton at the Art Students League in 1928. In a 1930 letter to his eldest brother, Pollock announced, "I feel I will make an artist of some kind," although he added that he had yet to prove this. [6]

But Pollock also found that alcohol tempered his adolescent mood swings, and in the summer of 1927 he started to drink. Throughout his life he struggled with alcoholism, apparently having both a physical intolerance and psychological need for alcohol. One biographer has written that while Pollock's "desire for alcohol was great, his tolerance was low, as if his system were allergic to it. Many of his friends remember how wildly drunk he became on comparatively small amounts of wine and beer and, of course, even smaller amounts of whiskey." Further, Pollock's dependence on alcohol only intensified his emotional instability: rather than leveling his moods it often heightened them and occa-

sionally led to violent confrontations. Only from about 1948 to 1950 would Pollock successfully control his alcoholism by essentially substituting tranquilizers for liquor.[7] These years, in turn, would be the most productive of his career.

An argument about the slovenly look of his ROTC uniform with his instructor during drill practice led to his dropping out of Riverside High during his freshman year. In 1928 he enrolled as a sophomore at Manual Arts High School, an industrial arts school in Los Angeles. There he studied art under Frederick John de St. Vrain Schwankovsky, who introduced him to eastern religions, vegetarianism, and the teachings of Hindu philosopher Jeddu Krishnamurti. Schwankovsky's "complete openness to all kinds of experience," coupled with the elder Pollock's independent pragmatism, undoubtedly further encouraged Jackson's adolescent rebellion. In 1929, Jackson and several of his friends (including future artists Philip Guston, Reuben Kadish, and Manuel Tolegian) published a subversive newsletter, *The Journal of Liberty*. Their broadsheet protested faculty authority ("why is it that inefficient or unjust teachers and heads of departments are placed over us?") and the school's emphasis on athletics ("we deplore mightily the unreasonable elevation of athletic ability and the consequent degradation of scholarship"). Although published only twice, the newsletter evoked faculty and administrative wrath with its appeal for the "reform" of Manual Arts High School (which included giving varsity letters to "our scholars, our artists, and our musicians instead of animated examples of physical prowess") and its overtone of collective revolt: "The power and might of a school lies in its student body. You are a sleeping gaint [sic]. AWAKE AND USE YOUR STRENGTH." Caught distributing the newsletter on school grounds, Pollock was expelled. Although readmitted the following year, he was kicked out again after coming to blows with the head of the Physical Education Department. In a letter to his brothers Charles and Frank, Pollock wrote that everyone at school thought he was a "rotten rebel from Russia."[8]

After his expulsion Pollock spent his time attending meetings at the Brooklyn Avenue Jewish Community Center in East Los Angeles, where "aging Bolsheviks" lectured about communism and the social realist art of Mexican muralists David Alfaro Siqueiros, Diego Rivera, and José Clemente Orozco. Intrigued by revolutionary aesthetics, Jackson visited Pomona College in June 1930 and viewed Orozco's recently completed mural *Prometheus* in the school dining room (fig. 5.4). The exuberant dynamism of Orozco's art, as well as its radical politics, so excited Pol-

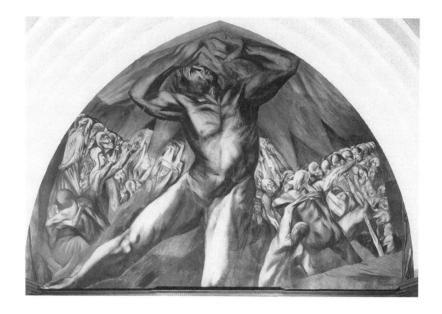

5.4. José Clemente Orozco, *Prometheus,* 1930; fresco mural, Frary Hall, Pomona College, Claremont, California. Courtesy of the Galleries of the Claremont Colleges, Claremont.

lock he visited Pomona several times that summer. When he learned that Orozco and Benton were beginning their murals at the New School for Social Research, Pollock decided to join his brothers in New York. He enrolled in Benton's Life Drawing, Painting, and Composition class at the Art Students League in the Fall of 1930.

Pollock studied with Benton for the next three years, and they developed a closer relationship than that between most teachers and their students. In fact, Jackson Pollock came close to becoming a member of Benton's own family—eating frequently at his home, babysitting his son, even vacationing with him. Benton later recalled that Pollock's "appealing nature made him a sort of family intimate. Rita, my wife, took to him immediately as did our son T.P., then just coming out of babyhood. Jack became the boy's idol [and] our most frequent dinner guest." He was also invited to play the jew's harp in Benton's folk music band, the Harmonica Rascals.[9] Although not especially talented, Pollock "looked" so much like a folkie Benton had him model as one in his 1934 picture *The Ballad of the Jealous Lover of Lone Green Valley* (fig. 5.5).

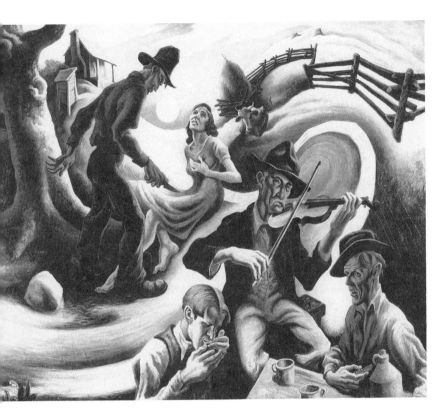

5.5. Thomas Hart Benton, *The Ballad of the Jealous Lover of Lone Green Valley*, 1934; oil and tempera on canvas, transferred to aluminum panel, 52 ½″ × 41 ¼″. Collection of the Spencer Museum of Art, The University of Kansas, Lawrence.

Amidst the dizzying vortex of Benton's regionalist form and the anecdotal details of the Appalachian folk tale a scraggly and intense young Pollock can be seen in the central foreground, blowing into a harmonica.

At the musical get-togethers in Benton's New York apartment and while vacationing with the Bentons at their retreat on Martha's Vineyard, Pollock came to know a variety of his teacher's friends and acquaintances, among them composer Charles Seeger (father of Pete Seeger) and artist Boardman Robinson. Benton recalled that Pollock was:

> treated as one of the family and encouraged to participate in all gatherings of people at our house. These were always highly talk-

ative and were mostly directed, as the major interests of the time dictated, to the social and political problems of America or, because of a number of teachers in our set, to the question of American education, which was then much affected by the struggles between John Deweyites, Marxist radicals, and extreme conservatives.

He added that Pollock "never spoke" and rarely drank at these gatherings: "Though plainly intelligent, he seemed to have no intellectual curiosity. . . . He was mostly a silent, inwardly turned boy and even in gay company carried something of an aura of unhappiness about him." Still, despite his lack of overt participation, Pollock absorbed quite a lot from Benton and his family. Invited to share in Benton's social life ("as if he had earned it" a Pollock sister-in-law later commented), he learned firsthand the nature of his teacher's personality and aesthetic philosophy.[10] Jackson Pollock soon came to think and paint like a regionalist.

In the early to middle 1930s Pollock presumably found in Benton a source of paternal support—and authority—which, at least at this point in his life, he found enormously appealing and even necessary. It is not surprising that he adopted Benton's mannerisms and mode of making art while under his tutelage, and came to reject them in the 1940s. While Benton was short and scrappy and Pollock was more "like a heavy, lumbering bear," when they were together they complemented one another. George McNeil, a fellow classmate at the Art Students League observed that there was "a rhythm, a flow, between them from the beginning to the end of their lives. It was a physical, gestural rhythm; teacher and student were *bonded* you might say." Other students noted how Pollock appropriated Benton's behavior. Sculptor Philip Pavia recalled:

Jackson had a high opinion of himself, but he got that from Benton. *There* was a macho bastard! Benton called curators homosexuals, you know; they were all scared of him. And Jackson used to act like him. . . . Here's Benton's babysitter become the same guy! We used to laugh.

Pavia added that Pollock "always walked around wearing his cowboy hat, and had complete contempt for all of us 'foreigners' as he called us. He loved the West and the Midwest, and he was a regional painter at that time." Cartoonist Whitney Darrow concurred: "there was that pride in being a Westerner. Like Benton, Pollock looked down then on

the East and Europe." Pollock's Western roots and boot-tromping, hard-drinking "frontier behavior" led at least one critic of the period to comment that he carried "regionalism with him." Both Benton and Pollock were heavy drinkers who delighted in assuming the persona of the "savage and the frontiersman" in art world company. Some have even linked Pollock's problems with chronic alcoholism to his desperate attempts to completely assimilate Benton's behavior. Pollock clearly idolized Benton and went out of his way to become like him, defending him and regionalist art when fellow students hurled accusations of fascism and provincialism. In letters home to his parents he championed his mentor and his socially constructive art: "Benton is beginning to be recognized as the foremost American painter today. He has lifted art from the stuffy studio into the world and happenings about him, which has a common meaning to the masses." [11]

Beyond Pollock's youthful imitation of his teacher's personality traits, the small oils, watercolors, and lithographs he produced in the early 1930s reveal Benton's strong aesthetic guidance. Pollock took painting, composition, and figure drawing classes with Benton five nights a week at the league. He became class monitor in Benton's mural painting class in the winter of 1931/32, and assisted with one of his drawing classes in the fall of 1933. Schooled in Benton's style and preferred subject matter, Pollock's work in the mid-thirties (and even later) is obviously Bentonesque, as the comparison of his 1934–38 watercolor *Cody, Wyoming* and Benton's drawing *Saturday Afternoon* (c. 1930–35) makes clear (figs. 5.6 and 5.7). Both were sketched quickly in a loose, freewheeling manner; both lead the viewer into the center of the composition; both denote the everyday activity of ordinary small-town America.

The dynamic composition and textural paint handling in the small oil *Going West* (fig. 5.1) more dramatically shows Pollock's assimilation of Benton's regionalist form. As Stephen Polcari observes, *Going West* especially follows Benton's "stylistic principles" in its synthesis of "modern and traditional elements." Moreover, its western landscape and pioneer history parallel Benton's own American scene themes (see *Cattle Loading, West Texas*, fig. 5.2), although Pollock never returned to the town of his birth and much of this picture was probably derived from a postcard his mother owned of Cody, Wyoming. Benton encouraged his students to travel, as he did, across the country in search of American scene flavor and anecdotes. Pollock made a number of cross-country trips in the early 1930s, hitchhiking from New York to Los

5.6. Jackson Pollock, *Cody, Wyoming*, 1934–38; ink and watercolor on paper, 14 ½″ × 20″. Copyright 1990 Pollock-Krasner Foundation/ARS N.Y.

Angeles and back again. In a letter to his brothers he recited his adventures on the road:

> My trip was a peach. I got a number of kicks in the but and put in jail twice with days of hunger—but what a worthwhile experience. . . . The country began getting interesting in Kansas—the wheat was just beginning to turn and the farmers were making preparation for harvest. I saw the negroes playing poker, shooting craps and dancing along the Mississippi in St. Louis. The miners and prostitutes in Terre Haute Indiana gave swell color— their [sic] both starving—working for a quarter—digging their graves.[12]

Such experiences, so similar to those Benton described in his 1937 autobiography, provided the fodder for Pollock's own regionalist output.

Departure (1934–38, fig. 5.8), which indicates Benton's influence in its swirling structural design, organic palette, and similarly exaggerated, rubbery figures, shows Pollock's rather more pessimistic assessment of

5.7. Thomas Hart Benton, *Saturday Afternoon*, c. 1930–35; ink wash on paper, 12″ × 9″. Courtesy of the Trustees of the Benton Testamentary Trusts, Kansas City.

those Americans he saw starving and "digging their graves." Its theme, suggesting the degradation of the American worker and the impact of such conditions on the American family, echoes several of the small pen and ink drawings Benton did for Leo Huberman's marxist history *We, the People* in 1932 (see fig. 2.26). But the despondency with which Pollock depicted the family group on the far right is far more morose than Benton's painted versions of similar subjects, such as his *Threshing Wheat* of 1938–39 (fig. 5.9). Perhaps Pollock's upbringing amidst the actual circumstances of rural poverty, which Benton observed but never actually lived, influenced his darker outlook, or perhaps his father's fatalism struck deeper than Benton's intonations of producerism. Still, while the youthful Pollock may not have been entirely convinced of the regionalist strategy of picturing the American scene in an uplifting, optimistic manner, his output in the early thirties does indicate the degree to which he readily accepted Benton's aesthetic principle: the art of social contract, of painting in a narrative mode for a public audience.

Other Pollock pictures from this period, ranging in title from *Camp with Oil Rig* and *Cotton Pickers* to *Landscape with White Horse* and

5.8. Jackson Pollock, *Departure*, 1934–38; oil on canvas, 15 ½" × 19 ¾'". Reprinted from *Jackson Pollock: The Early Years* (Santa Fe: Gerald Peters Gallery, 1988). Copyright 1990 Pollock-Krasner Foundation/ARS N.Y.

Abandoned Factory, also catered to regionalist stylistics and popular accessibility. Benton so admired the work of his young protégé that he encouraged him to exhibit at every opportunity. Pollock first showed his work in 1935 at the Brooklyn Museum. Two years later, Benton arranged for his inclusion in a group show at the Associated American Artists gallery in New York. Mistakenly described as one of Benton's Missouri students (Benton left New York for Kansas City in 1935, to teach at the Art Institute), Pollock showed *Departure* (called *Threshing* in a 1937 *Art Digest* article on the exhibit, where his name was misspelled "Pollack"). A critic who reviewed the show described it as "an altogether pro-Benton group" and observed that "Missouri is blossoming new talent under his teaching." [13] Indeed, while Benton found Pollock's draftsmanship crude, he considered the historical subject matter and "rhythmical continuities" of his pictures well within the regionalist camp:

5.9. Thomas Hart Benton, *Threshing Wheat*, 1938–39; oil and tempera on canvas mounted on panel, 26″ × 42″. Collection of the Sheldon Swope Art Museum, Terre Haute, Indiana.

The outlook he cultivated at this time and the experiences he sought on the American scene were completely Regionalist. However, his reportorial drawing was too deficient to produce the convincing descriptions that are basic to Regionalist imagery. Details especially were beyond his capacities. But he made pictures of his experiences and, formulistically speaking, some very interesting ones. In these he exploited quite successfully the knowledge he was obtaining in his historical studies.[14]

Going West and Departure also suggest the influence of American painter Albert Pinkham Ryder ("the only American master who interests me is Ryder," Pollock would say in 1944) and the turbulent dynamism of the Mexican muralists. In 1936, a year after Benton left New York, Pollock and his brother Sande volunteered to work in Siqueiros's workshop in Union Square. It seems fitting that Pollock turned to the radical aesthetics touted by the Mexican muralist. With Benton gone, Pollock struggled to retain some semblance of the regionalist commitment to public engagement. As his political sensibility was less optimis-

tic than Benton's and as he had been intrigued with Mexican political art since the late twenties, it follows that he found the atmosphere within Siqueiros's workshop stimulating. His biographers have maintained that the "politically revolutionary content of work by the Mexican muralists ultimately influenced Pollock no more than the politically reactionary content of Benton's work," but Pollock's own pieces from this period—and later—suggest otherwise.[15]

Jackson and Sande helped the communist artist mainly with May Day floats and posters, but Siqueiros also encouraged their experimentation with art techniques and materials. Pollock worked with commercial paints (such as Duco and enamel) and an airbrush and began to alter and refine his original regionalist style, splattering lithographs like *Landscape with Steer* (1936–37, fig. 5.10) with blotches of rich color. These early efforts at liberating narrative content in favor of dramatic form and color would eventually culminate in the drip paintings he produced in the late 1940s.

Benton had provided him with both aesthetic and financial tutelage; with his disappearance Pollock looked for other means to support himself. He found work in the Federal Arts Project of the WPA, where he was sporadically employed from 1935 to 1943. He began in the FAP's mural division and apparently assisted Job Goodman, a former Benton student, with a project at a New York high school. Solomon writes that Pollock soon realized "he had no patience for the teamwork required of mural painters" and in 1936 he joined the FAP's easel division, where he was required to submit one painting every month or so to maintain his $23.86 weekly salary.[16] Few of Pollock's canvases have survived but those that have, particularly from 1936 to 1938, show his continued reliance on regionalist subject matter and composition. He certainly did not have to; the FAP allowed its employees to create their easel-a-month in any style they preferred and many American artists, including Willem de Kooning and Lee Krasner, began experimenting with abstract art during their tenure with the WPA. But, in his FAP output and even in his private paintings, especially a handful he painted while visiting Benton in Kansas City in late 1937, Pollock retained an interest in the American scene, in further exploring an art of social contract.

From 1938 onward, however, Pollock's works reveal his burgeoning enthusiasm for formal experimentation and for personal exploration. He and Benton had planned to spend the summer together on a six-week sketching trip, but Pollock was unable to get a leave from the FAP. His drinking became worse and eventually he was fired for "con-

5.10. Jackson Pollock, *Landscape with Steer*, 1936–37; lithograph with airbrush, 13 5/8" × 18 9/16". Collection of The Museum of Modern Art. Gift of Lee Krasner Pollock. Copyright 1990 Pollock-Krasner Foundation/ARS N.Y.

tinued absence." In June he voluntarily entered a New York hospital and underwent four months of treatment for acute alcoholism. A year later, still drinking heavily, he began Jungian analysis under a New York psychotherapist.[17] Although rehired by the FAP, the works Pollock produced, including *Man, Bull, Bird* (1938–41, fig. 5.11), were radically different from his earlier Bentonesque landscapes: brighter, angrier, more symbolically indicative of his emotional turmoil and his attempt to reckon with it via Jungian psychotherapy. The personal and aesthetic relationship he and Benton had maintained throughout most of the decade seemingly eroded, as Benton veered in the direction of corporate patronage and Pollock turned his art into a vehicle for personal expression and healing.

In 1944, Pollock made the following oft-quoted remark about his relationship with his former mentor:

5.11. Jackson Pollock, *Man, Bull, Bird*, 1938–41; oil on canvas, 24″ × 36″. Private Collection. Copyright 1990 Pollock-Krasner Foundation/ARS N.Y.

> My work with Benton was very important as something against which to react very strongly, later on; in this, it was better to have worked with him than with a less resistant personality.

While obviously indicative of the breakdown of their relationship, Pollock's comments also reveal the significant impact Benton had on him. He expanded on the nature of Benton's influence in a 1950 interview:

> I spent two years at the Art Students League. . . . Tom Benton was teaching there then, and he did a lot for me. He gave me the only formal instruction I ever had, he introduced me to Renaissance art, and he got me a job in the League cafeteria. I'm damn grateful to Tom. He drove his kind of realism at me so hard I bounced right into non-objective painting.[18]

Armed with these quotes, postwar critics and historians who analyzed Pollock's shift from representational to abstract art fostered a number of assumptions. First, they suggested that Pollock's "break"

with Benton was a clean one, that his shift from regionalism to abstract expressionism was a complete "breakthrough" to nonobjective and apolitical art. Second, backed by the kind of sentiment Pollock himself expressed in 1944, they theorized that his years as a regionalist were merely a youthful aberration. Pollock's rejection of Benton's style was viewed as youthful rebellion against parental authority. In fact, this is how Benton explained it. He remarked in 1973 that Pollock's shift to abstract expressionism was "a natural reaction to me. You talk about sons rejecting their fathers. Well, he was practically a son." This notion of a generationally conditioned rift between Pollock and Benton has been consistently reinforced. Artist Nene Schardt has remarked, for instance, that Pollock was so "devoted to art and so honest with himself, he had to make the break with Benton. That father/son relationship, though, made it traumatic for Benton. He never quite understood or accepted it." [19]

The more astute analysis of Pollock's shift from regionalism to abstract expressionism, however, begins by recognizing that his "break" with Benton was far from complete. Simply in terms of style, Pollock's abstract pictures largely expanded and revised regionalist aesthetics. Moreover, Pollock's poured pictures of the later 1940s were as intertwined with the political culture of postwar America as Benton's 1930s pictures were with the New Deal. The real difference between them was not merely a stylistic or generational rift, but a political one.

In a 1950 interview Pollock commented: "Modern art to me is nothing more than the expression of contemporary aims of the age that we're living in." It is the kind of statement Benton might have made some twenty years earlier, but for Pollock these aims were expressed in quite a different way:

My opinion is that new needs need new techniques. And the modern artists have found new ways and new means of making their statements. It seems to me that the modern painter cannot express this age, the airplane, the atom bomb, the radio, in the old forms of the Renaissance or of any other past culture. Each age finds its own technique.

In his age, that of the 1940s and the postwar era, Pollock made no effort to project the kind of social progress onto his canvases that Benton had, which his former mentor noted: "I don't think Jack ever adopted my ideas about the functions of art in society. I don't think they even interested him." Benton was only partially right. Pollock did not completely

renounce an art of social contract; he simply offered a "utopian vision" different from the one Benton offered.[20]

Pollock remained, despite claims to the contrary, "interested" in expressing the ideology of his "age." But he did so in a nonobjective style which he felt more honestly embodied the political and social culture of his time. Pollock recognized that his age, an age he described in terms of the atomic bomb, was a changed culture. The hopeful, producerist society posited by Benton's regionalist art and the New Deal had dissolved, replaced by a tense consensus culture and its Cold War anxieties. Interest in national reform had dissipated, supplanted by an obsession with the international scene. Understanding that regionalist art did not "express this age," Pollock helped to create the style of abstract expressionism, which with its "new ways and new means" embodied the changed spirit of postwar America. That is not to say that Pollock strove for an overt social meaning in his abstract paintings, because he did not. Rather, Pollock's pictures embody his own sense of postwar disaffection and his attempts to dispel that disaffection. On the other hand, Pollock's abstract pictures were frequently viewed by contemporary observers as referents to postwar cultural and political conditions. Pollock's abstract work serves as a text by which we can ascertain the nature of life in postwar America and its significant difference from life in the Depression.

If "reform," "regeneration," and even "revolution" were the key words of the 1930s, "consensus," "containment," and "Cold War" were those of the postwar era. As the country underwent domestic reconversion, it became obvious that there would be neither a return to the ideology of the New Deal nor to the Depression conditions in which it had been fostered. Roosevelt's death on 12 April 1945 created a certain emptiness for Americans who had lived under his presidency for almost a generation. The bombing of Hiroshima and Nagasaki in August 1945 gripped them in "fear psychosis" and "atomic anxiety." Emptiness and anxiety had not characterized life in the 1930s—despite the Depression. President Harry Truman tried his best, but he was no Roosevelt and offered few upbeat maxims. He did attempt to maintain some semblance of New Deal liberalism, announcing his own Fair Deal in 1949 with the declaration "every segment of our population and every individual has a right to expect from our Government a fair deal." And his administration made some progress in civil rights legislation, in expanding social security and public housing, increasing aid to schools and power plants, maintaining farm price supports, and raising the min-

imum wage to 75 cents an hour.[21] But Fair Dealers also buttressed the corporate liberalism that had emerged under the later years of the New Deal. This kind of liberalism became the dominant mode underlying American economic, social, and cultural thought in postwar America.

Rejecting Roosevelt's paeans to recovery and reform, Fair Dealers focused on expansion and abundance. Capitalism was no longer a nemesis for them; how could it be when per capita income in America was fifteen times that of any other country, when mass unemployment had finally come to a standstill (fewer than 5 percent of the workforce was unemployed in 1949), when the GNP, which had risen more than 200% from 1940 to 1945, hit $284 billion in 1950—as compared with only $55 billion in 1933. Capitalism worked, and they took on the task of ensuring its continuation. First, to make certain America was never again infected by Depression, the public was urged into "one of history's great shopping sprees." Economic abundance had to be maintained and American consumers had to do their bit. Second, postwar liberals engineered a new social contract, one that tied the expansion of free-enterprise capitalism with the American democratic ideal of social justice. If capitalism were properly managed by a skilled coterie of government and corporate technocrats, its "apparently unlimited ability to generate economic growth" would guarantee an end to all economic (and hence, social) inequities.[22] That is, an ever-expanding capitalist economy perpetuated prosperity for everyone: the widespread distribution of consumer goods and services would satisfy the economic needs of all Americans.

Once these needs were met, inequity would be eliminated. As economist John Kenneth Galbraith explained in his appropriately titled book *The Affluent Society* (1957), postwar production "eliminated the more acute tensions associated with inequality. Increasing aggregate output is an alternative to redistribution."[23] Abundance alone, not legal reforms or revitalized republicanism, and certainly not the kind of capitalist revamping 1930s liberals and radicals had proposed, would generate genuine social justice in the United States.

But, coupled with their fierce faith in the promise of capitalism, postwar liberals were also beset by a sense of anxiety, of peril. The pursuit of affluence and abundance had its price, not the least of which was vigilant anticommunism. The anxiety that gripped many Americans after World War II cannot be entirely attributed to the Cold War. Rather, such apprehensions stemmed in large part from growing doubts that affluence and abundance were really what defined the American

experience, the American character. As Warren Susman explained, for many postwar Americans the world of leisure became a source of fear.[24] A culture seemingly fulfilled was, ironically, often unhappy. The manifestations of its despair were evidenced in a variety of postwar media, from intellectual tomes and noir movies to abstract expressionist paintings.

In 1949 historian Arthur Schlesinger, Jr., defined and defended the ideology of postwar liberalism in the profoundly ambiguous tract *The Vital Center*, ultimately one of the most influential books of the period. Schlesinger's "report" found that postwar liberalism was shaped by the "unconditional rejection of totalitarianism and a reassertion of the ultimate integrity of the individual." He also found that postwar America was "adrift" in an "age of anxiety" because "free society," defined as "a society committed to the protection of the liberties of conscience, expression and political opposition," had failed. First, the conservative right and its partners in the business community had succumbed to the "tyranny of the profit motive" and had not taken the proper risks of capitalist expansion. Second, "doughfaced" leftists had succumbed to "unwarranted optimism" about progress, human nature, and class ideology, all "naive" beliefs linked inextricably with mass politics and hence, the dangers of totalitarianism. Totalitarianism, said Schlesinger, "sets out to liquidate the tragic insights which gave man a sense of his limitations." Totalitarian man was a threat because he incarnated "mass purpose and historical destiny," in contrast to the individualism embodied in the freedom (albeit limited) of the American way of life. Thus, "to defend and strengthen free society," postwar liberals must concentrate on "the maintenance of individual liberties" and "the democratic control of economic life—and to brook no compromise, at home or abroad, on either of these two central tenets."

Schlesinger expanded on the economic ideology of postwar liberalism by stating that "free society cannot survive unless it defeats the problems of economic stagnation and collapse." In other words, freedom was fixed with capitalist expansion, affluence, and abundance. Finally, Schlesinger announced that this postwar liberalism was, above all, an international agenda. Although Americans might be "reluctant" to accept this position of world leadership, nevertheless they must stoically shoulder their "responsibility." Soviet expansion and the threat of totalitarianism must be checked—politically, socially, culturally. As Schlesinger observed, "with the death of Professor Beard [who died in 1948] isolationism lost its last trace of intellectual respectability." [25]

As Alonzo Hamby, David W. Noble, Richard Pells, and other histor-

ians have noted, Schlesinger completely reassessed the nature of twentieth-century American liberalism in *The Vital Center*. He broke sharply with prior accounts of its history and meaning, such as those written by Beard. Abandoned completely, for instance, were notions of American collectivity, class structure, and political ideology. The Americanist focus that had preoccupied a previous generation was now denounced as too narrow and too dangerously linked with perilous nationalist and hence potentially fascist politics. Liberalism itself was redefined as centrism—"the vital center"—not the radical fringe. Progress was viewed as an outmoded "sentimental" concept; the "innocence" with which Beard had envisioned the merger of large-scale industrialization and participatory democracy was debunked by both Schlesinger and Richard Hofstadter. Faith in human perfectibility was abandoned. Mankind was now viewed as essentially immoral and evil, especially in mass terms; the best that could be done in postwar America was to try to maintain some semblance of individual freedom. In contrast with Beard's histories, and their visualization in Benton's 1930s murals, Schlesinger's book colored America as a place of limitations and apprehensions—both of which were, ironically, central to the postwar concept of freedom. Challenging long-standing notions about American reform, uniqueness, and isolationism, *The Vital Center* embodied a significant shift in postwar intellectual thought, from a formerly optimistic and progressive sense of purpose, such as that held by both New Deal liberals and Popular Front communists, to conservative pessimism.[26]

In further contrast to the intellectual sensibility of Beard and Benton, Schlesinger painted postwar America as a classless society in which conflict (such as that between classes) was simply nonexistent. As Daniel Bell echoed in *The End of Ideology* (1960), in the stable postwar era ideologically based conflict was simply a non-issue, because ideology—meaning the politics of the left, had dissolved. That such a statement in and of itself implied a certain ideological bias was ignored. Schlesinger, Bell, Hofstadter, and others found in postwar America essential agreement on fundamental issues. This concordance was described by Bell as a "rough consensus":

> In the West, therefore, there is today a rough consensus among intellectuals on political issues: the acceptance of a Welfare State, the desirability of decentralized power; a system of mixed economy and of political pluralism. In that sense, too, the ideological age has ended.[27]

Bell believed that most postwar Americans were in agreement on a variety of pressing issues. The most important of these were the containment of communism and the primacy of individual rights and freedoms.

Postwar Americans were apparently able to sustain the contradiction implied by the assertion of individuality in a consensus culture. While mass consumption was generally heralded as a primary means of maintaining postwar abundance, resistance to the pressures of mass conformity and an emphasis on individualism were also touted. Such inconsistency suggests the constraints implied in postwar individualism, which Schlesinger expanded on in *The Vital Center*:

> The essential strength of democracy as against totalitarianism lies in its startling insight into the value of the individual. Yet arrogant forms of individualism sometimes discredit the basic faith in the value of the individual. It is only so far as that insight can achieve a full social dimension, so far as individualism derived freely from community, that democracy will be immune from the virus of totalitarianism. For all the magnificent triumphs of individualism, we survive only as we remain members of one another.[28]

In addition to this expression of faith in limited individualism, postwar Americans also reached a consensus on the issue of communism. If corporate capitalism was the true defender of freedom and individualism, communism was its most serious threat. Anticommunism, enforced by a policy of containment, became the rallying cry of all postwar "cold warriors." Capitalism and individualism were linked, quite ironically, and celebrated as the most virtuous tenets of the "American way of life." However, the tense dichotomy between these "vital center" issues of ostensible consensus did not go unnoticed.

Despite the overwhelming evidence of a comfortable consensus, accompanied by the economic security of "full" employment, higher wages, and a skyrocketing GNP, and the well-being implied by the baby boom, mass consumption, and life in the suburbs, cultural reactions in the atomic age overwhelmingly betray a mood of malaise. Optimism abounded, if somewhat ironically, in postwar movies from *It's a Wonderful Life* (1946) to *Father of the Bride* (1950), in the The Family of Man photography exhibit (1955), and in the *Saturday Evening Post* world that Norman Rockwell painted. But anxiety was abundant in film noir movies and abstract pictures. Abundance and affluence, it seems, did not necessarily create a culture of contentment. The issue at hand is not whether anxiety was more prevalent than contentment in

postwar America, but why malaise in the midst of all this abundance should exist at all.

One explanation can be found in recognizing, as many postwar Americans did, that domestic abundance was only maintained through an aggressive policy of communist containment, at home and abroad. Postwar economic and psychological security were wholly dependent on a threat and, as Schlesinger cautioned, would quickly slip away without constant vigilance. In other words, American well-being after the Second World War was conditioned by a chilly and apparently eternal wartime ambience.

Another explanation for postwar discontent can be found in the paradoxical concept of consensus. While the front of unity and conformity, or consensus, was touted, Americans were also encouraged to act as individuals. As the one implied the negation of the other, as the cost of mass conformity was that of individuality, and vice versa, both became perceived as false constructs; it was impossible to be both an authentic individual and a team player in postwar America. Finally, manifestations of anxiety after the Second World War can also be traced to the feelings of loss many Americans experienced in terms of the disintegration of the reform tradition that had preoccupied preceding generations. The tensions implicit in the dependence on communism to maintain domestic security, in the conflicted front of consensus, and in the failure of progressive ideology became readily apparent in a variety of American cultural expressions.

Film noir, that shadowy style that actually emerged before the war ended, cut across all movie genres and infected detective stories, melodramas, and musicals alike with its dense ambience of doom and disaffection. Scenic nuggets and entire plots described the late 1940s and 1950s as a changed world, about which postwar Americans were significantly apprehensive. In *Crossfire* (1947), a faded poster of FDR is almost entirely obscured by shadows, and an artist who "did a mural once in a post-office for the WPA," is cast as a nervous postwar psychotic. The conversation he and an army buddy (whom he is eventually accused of murdering) engage in is ripe with postwar apprehension: "Now we start looking at each other again. We don't know what we're supposed to do. We don't know what's supposed to happen." The hopeful reformist culture of the 1930s, represented by Roosevelt's shadowy visage and referents to New Deal art, had been relegated to the past and no new positivist worldview had emerged. The United States may have won the war and conquered the Depression but postwar Americans were unsure about their future. It was posited as one of success and

abundance but consensus expectations about "making it" in the corporate workplace and in the suburbs were haunted in film noir by feelings of guilt and images of entrapment.

In *Sorry Wrong Number* (1948), Burt Lancaster buys into sex and nine-to-five success by marrying his boss' domineering daughter (Barbara Stanwyck), but the menace of her sexual power and a blackmailer's threats lead him to plot his wife's death. King Vidor's 1949 melodrama *Beyond the Forest* features Betty Davis as an unhappy doctor's wife in small-town Wisconsin ("What a dump!" she says about her comfortable middle-class home) who struggles to break free through adultery and murder. Vidor's dark film is a far cry from the reformist optimism of *Our Daily Bread* fifteen years earlier. In postwar film noir neither work nor marriage was shown in the celebratory terms one expects in consensus culture. Rather, both were depicted as destructive institutions in which American individuals, male and female, were losers and victims. They were also alienated, as the lyrics to a nightclub tune sung in *Destination Murder* (1950) voiced: "I'm all alone / In a palace of stone / Down in a city of fear."

Disturbing insights into the human condition in postwar America were not confined to the pessimistic plots and shadowy style of film noir. David Riesman's 1950 sociological survey *The Lonely Crowd* described the burgeoning numbers of "other-directed" Americans who had lost "their social freedom and their individual autonomy in seeking to become like each other."[29] Grace Metalious's *Peyton Place* (1956) portrayed the dark underbelly of life in a New England village. And J. D. Salinger's 1951 novel *The Catcher in the Rye* depicted the alienation of an entire generation.

Postwar disaffection was similarly captured in the 1946 novel *The Hucksters*, which was made into a film in 1947 starring Clark Gable, Sydney Greenstreet, and Deborah Kerr. Both novel and movie focused on advertising agent Vic Norman, a "sincere" guy recently returned from the Office of War Information with "dark and gloomy" feelings about "the future":

> The peoples of the world seemed to him to be writhing and moiling, as the earth itself had once shuddered and heaved up and reformed itself. There was yearning after security and struggling against that yearning, there was a new primeval urge to destroy all security. We all wanted to go places, but there was no place to go, and always the mob beckoned, the reckless, turbulent, subhuman mob.

Vic (Gable) climbs the corporate ladder by managing the Beautee Soap account. In the movie, he observes that in the four years he had been in the army, radio ads had gotten worse, treating people as "dolts" with hysterical jingles like "Buy more, buy more, buy more, BUY MORE BEAU-TEE SOAP!" Vic vows to create more tasteful advertising, promoting Beautee Soap in color ads with *Vogue*-like layouts that appeal to the high-culture overtones of mass consumerism. His ad campaign is a great success, but in both book and movie he is cynical and angry about corporate authority, resenting expectations that he become an "organization man." Hollywood's version of *The Hucksters* ends with Gable's girlfriend urging him just to "sell things you believe in," as if his unhappiness were related to misplaced values rather than corporate authority and its denial of personal autonomy. Wakeman closed *The Hucksters* on a far more somber note, with Vic unemployed (he quits his job because advertising lacks "sincerity") and alone (ending his love affair with a married woman because if they continued "I don't think I'd like myself"). Although Wakeman describes Vic's actions as "honorable," he leaves Vic a disillusioned postwar American for whom honor implies estrangement—from the "subhuman mob," from the business world, from love. For Vic Norman, there really was "no place to go." [30]

His alienation was echoed in the eerie pictures of realist George Tooker, whose 1950 painting *Subway* conveys the anguish of an entire society with "no place to go" (fig. 5.12). *Subway* shows the middle-class men and women who formed postwar consensus culture oppressed by their uniformity. Its tight, tense form and crisscrossed composition of ensnaring horizontal and vertical elements perfectly express the sense of entrapment and loss of individuality Tooker found in contemporary society: "I was thinking of a large modern city as a kind of limbo. The subway seemed a good place to represent a denial of the senses and a negation of life itself." [31] Like those of film noir, Tooker's Kafkaesque images and Wakeman's descriptions of edgy disaffection with corporate expectations and interpersonal relationships demonstrate the tensions inherent in postwar America.

The spidery webs of Jackson Pollock's abstract expressionist paintings also reflect postwar disaffection and anxiety. Pollock's response to the dissolution of regionalism's reformist culture—a culture in which he had been a direct participant in the early 1930s—and his reaction to the uneasy consensus culture in which he found himself in the late 1940s, were made via such abstract pictures as *Alchemy* (fig. 5.3) and *Autumn Rhythm* (1950, fig. 5.13). Abandoned were recognizable references to American scene imagery, to the political aesthetics of the Mexican mu-

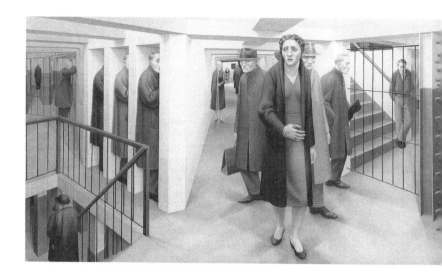

5.12. George Tooker, *Subway,* 1950; egg tempera on composition board, 18 ⅛″ × 36 ⅛″. Collection of the Whitney Museum of American Art, New York. Purchase, with funds from the Juliana Force Purchase Award. 50.23.

ralists, to Jungian myth and symbol. Instead, Pollock opted to create dense, abstract canvases and experiment with a variety of paints and surfaces.

Beginning in 1947, Pollock took his pictures off the easel and placed them on the floor of his East Hampton studio. After a considerable period of contemplation and preparation, Pollock would suddenly begin to paint. Walking around and occasionally onto his pictures, sometimes literally dancing amidst them, he poured paint directly from cans or dripped it onto the canvas, masonite, metal, or parchment surface with sticks and hardened brushes. Often sand, broken glass, and miscellaneous items including keys, combs, cigarette butts, and caps from paint tubes found their way into his paintings, adding to their dense and private character.

Hans Namuth's photographs of Pollock painting, and the ten-minute color film Namuth made in the fall of 1950 with Paul Falkenberg, provide invaluable clues to Pollock's intense personality, mode of working, and innovative techniques (fig. 5.14). Initially published in *Art News* in 1951 (accompanying the article "Pollock Paints a Picture"), and then spreading like wildfire throughout both the art press and mass

media, Namuth's photographs provided postwar Americans with a firsthand look at the making and mind set of abstract expressionism.[32] They also aided in the construction of the Jackson Pollock myth, a myth that (like his abstract paintings) ambiguously corresponded to the needs of those both disaffected by postwar conditions and content with consensus.

Response to Pollock's art, or more correctly to Namuth's photographic interpretations of his production, consistently found in Pollock's abstract pictures evidence of his personality. In his 1952 essay "The American Action Painters," critic Harold Rosenberg claimed "a painting that is an act is inseparable from the biography of the artist. The painting itself is a 'moment' in the adulterated mixture of his life." It follows that Pollock's paintings—that is, his life—were repeatedly described by postwar viewers in terms of chaos, confusion, violence, anger, drama, intensity, energy, immediacy. Namuth's own initial response—"My first reaction was hostile. The paintings seemed disorderly and violent"—was by no means atypical. Many, including sculptor George Segal, saw Pollock as the art world's version of a 1950s rebel:

> I had an image of Marlon Brando's brooding pouting profile looking down while Stella ripped his tee-shirt from his sloping shoulders with gouging fingernails. But Pollock's creased forehead in his photographs intrigued me. He had the agonized look of a man wrestling with himself in a game of unnameable but very high stakes.[33]

By extension, many saw in Pollock's pictures evidence not only of the artist's personal turmoil, but that of the entire postwar era. In 1947, abstract painter Adolph Gottlieb made the following comment:

> Today when our aspirations have been reduced to a desperate attempt to escape from evil, and times are out of joint, our obsessive, subterranean and pictographic images are the expression of the neurosis which is our reality. To my mind certain so-called abstraction is not abstraction at all. On the contrary, it is the realism of our time.[34]

For Gottlieb, postwar abstract painting (including his own) was linked with the anxiety of the age, with the "neurosis" of an era "out of joint."

Painter and critic Robert Motherwell echoed Gottlieb's sentiments, positing that the abstract expressionist art of Pollock and his peers was:

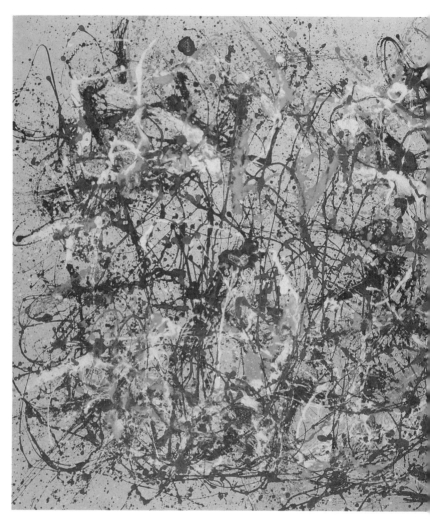

5.13. Jackson Pollock, *Autumn Rhythm*, 1950; oil on canvas, 105″ × 207″. Collection of The Metropolitan Museum of Art, George A. Hearn Fund. 1957 57.92. Copyright

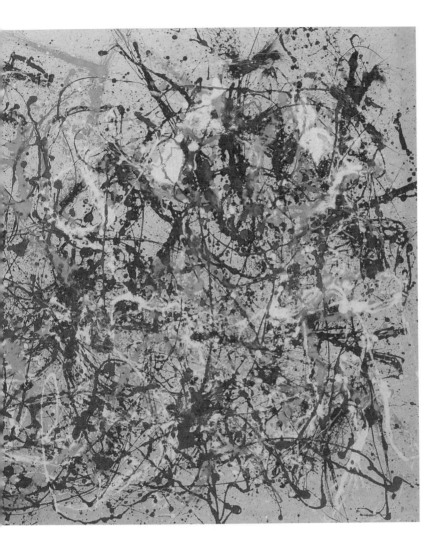

1990 Pollock-Krasner Foundation/ARS N.Y.

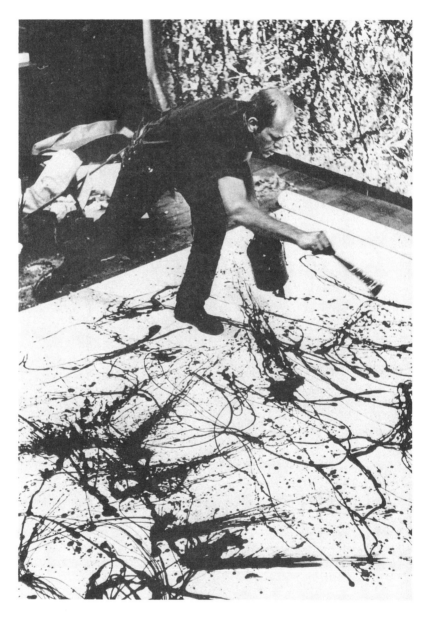

5.14. Hans Namuth, photograph of Jackson Pollock, 1950. Courtesy of Hans Namuth.

rebellious, individualistic, unconventional, sensitive, irritable. . . . this attitude arose from a feeling of being ill at ease in the universe. . . . Nothing as drastic an innovation as abstract art could have come into existence, save as the consequence of a most profound, relentless, unquenchable need. The need is for felt experience—intense, immediate, direct, subtle, unified, warm, vivid, rhythmic.

Motherwell's comments, made in 1951, highlight the disaffection many American artists felt after the Second World War. Pollock—his paintings and his Namuth-made image—was mythologized by them as "a tormented, agonized man, torn by self-doubt, the victim of an inner *Sturm-und-Drang* nakedly revealed in his contorted face." He seemingly personified the alienated, freedom-seeking individual addressed in the existential philosophy of Kierkegaard, Camus, and Sartre. A Cold War version of the savage and the frontiersman, of the artist-outcast and artist-hero, Pollock was idolized and imitated by an entire generation of younger American and European artists. Speaking for them, and insinuating that life in postwar America was stale and constricting, Allan Kaprow remarked that Pollock was "the embodiment of our ambition for absolute liberation and a secretly cherished wish to overturn old tables of crockery and flat champagne." [35] But, of course, Pollock was only mythologized in this manner because there existed in postwar America, as Motherwell indicated, a "most profound, relentless, unquenchable need." Despite the overwhelming comfort of abundance, there was also the chilly presence of angst and alienation.

While most critics, foremost among them Clement Greenberg, responded to Pollock's abstract paintings purely in formalistic terms, some found in them the semblance of this postwar unease. It is telling that so many Pollock reviews were peppered with phrases torn from a Cold War consciousness: just a week after the bombing of Hiroshima and Nagasaki, *San Francisco Chronicle* writer Alfred Frankenstein described Pollock's work in terms of "a fury of movement," "heated color," "tangled complexity," and "a grand swirling heave." Postwar critics described Pollock's pictures as "unorganized explosions of random energy," as "disintegration with a possibly liberating and cathartic effect," as "nightmarish expressionist visions . . . of doomsday." In a 1950 *New York Sun* review, Henry McBride made the overtly literal observation that Pollock's drip paintings resembled the look of a "flat, war-shattered city, possibly Hiroshima." [36] Despite his pragmatism,

McBride's interpretation meshed neatly with Pollock's own remark that the experimental nature of his art expressed "this age, the airplane, the atom bomb, the radio."

Admittedly, some viewed Pollock's pictures as an art-world hoax; *Time*, for instance, sarcastically remarked that they resembled "a child's contour map of the Battle of Gettysburg" and labeled him "Jack the Dripper." But more astute observers took abstract expressionist art seriously and saw in Pollock's pictures either portents of doom or the expression of existential freedom. Marxist critic John Berger, writing in the *New Statesman* in 1958, saw the "disintegration of our culture" in Pollock's art:

> I believe that Pollock imaginatively, subjectively, isolated himself. . . . he tried to preserve only his consciousness of what happened at the moment of the act of painting. If he had not been talented this would not be clear; instead one would simply dismiss his work as incompetent, bogus, irrelevant. As it is, Jackson Pollock's talent did make his work relevant. Through it one can see the disintegration of our culture, . . . the consequence of his living by and subscribing to all our profound illusions about such things as the role of the individual, the nature of history, the function of morality.[37]

While the nature and technique of his aesthetic experimentation was foremost in their reviews, a variety of postwar critics saw personal and social alienation in Pollock's pictures.

In the 1940s, as it became obvious that the reformist culture posited by Benton, Beard, and Roosevelt would not come to pass and was, in fact, being debunked as dangerous naivete by postwar intellectuals like Schlesinger, a sense of emptiness and uneasiness spread among those artists once intrigued with the notion of social progress. Pollock was one of these, as his youthful interest in radical politics during the 1920s and his work with Benton and Siqueiros in the 1930s attests. While he did not return to the terms of the social contract set up by Benton, he did not completely renege on them either. He may have disengaged from the kind of political activism that Benton took with regionalist art, but Pollock's postwar pictures were inherently political in their particular social significance.

Perhaps feeling himself caught in a trap where the American majority supposedly shared such contradictory assumptions as a sense of domestic complacency and a paranoid fear of communism, Pollock re-

sponded, as did other avant-garde artists, with the style of abstract expressionism. With their tangled, tormented lines and lack of central focus, Pollock's all-over drip paintings were revolutionary attempts to liberate himself from both traditional modes of artmaking and ties to consensus culture. Pollock shared with Benton the aims of the radical modernist: to seize an aesthetic strategy which challenged established models of art and aimed at the merger of art and life. The strategy was action-painting, putting his pictures on the floor—where he felt "more at ease"—and allowing himself, as he noted in 1947, to "literally be *in* the painting." With such a strategy Pollock blatantly linked his art with his life, to such a degree that the Happenings artists, like Kaprow, embraced his model in the late 1950s:

> Pollock, as I see him, left us at the point where we must become preoccupied with and even dazzled by the space and objects of our everyday life. . . . Not satisfied with the *suggestion* through paint of our other senses, we shall utilize the specific substances of sight, sound, movements, people, odors, touch. The young artist of today . . . is simply an artist. All of life will be open to him.[38]

This is not to imply that Pollock (or the Happenings artists) were obsessed simply with the banality of ordinary life. Rather, with his abstract pictures Pollock attempted to redefine and redirect postwar culture: away from the constricting banality of consensus and toward a new world, as Motherwell described it, of "felt experience—intense, immediate, direct, subtle, unified, warm, vivid, rhythmic." And if he did so for intensely personal reasons, Pollock also provided a model of rebellion and possibility for others.

But, as Berger and other critical observers noted, Pollock's work also seemed to embody the "disintegration" of postwar America, not the integrative world that Benton tried to construct. Indeed, the tightly webbed style of Pollock's drip pictures may be seen as his irretrievable entrapment *in* his atomic age. Quite unlike Benton's regionalist art, Pollock's modern abstract pictures revealed social alienation. Still, our understanding of what Pollock's abstract pictures are all about should not end with the self-evident observation that his art discloses the social and political conditions of consensus culture. As will be seen, Pollock painted *both* the tense, estranged world of postwar America and a way out of that world. Despite our ongoing bias that only narrative or representational art—like Benton's—is capable of garnering an audience and mediating social change, Pollock's abstract pictures proposed per-

sonal and political reform, as an analysis of their formal character and subject demonstrates.

Although Pollock rejected the narrative character of Benton's art, he retained much of the regionalist form he learned under his tutelage. He did so because he recognized the dynamic energy and strength inherent in Bentonesque form, and he understood the visual appeal of such an aesthetic to the public. In color, size, and energy the drip paintings *Alchemy* and *Autumn Rhythm* reflect Benton's guiding hand and Pollock's abiding interest in creating public art. Benton described Pollock as an "extraordinary natural colorist" and while color is by no means the primary characteristic of his poured paintings, Pollock did continue with the intense chromatic spectrum he developed under Benton.[39] (Although he rejected color in his "black painting" period, from 1950 to about 1953, Pollock's last works show a return to color.) Like Benton, Pollock chose to work in the brightest hues; rarely did he employ a pastel palette.

Moreover, he chose to work in a large format. Pollock studied under Benton during the years he painted the murals for the New School for Social Research and the Whitney Museum. In addition to "action posing" for certain scenes in these murals, Pollock "managed to make himself useful in other ways," basically serving as an apprentice by mixing paints and washing brushes. Pollock probably also watched José Orozco work on his New School mural and became reacquainted with the large-scale social realist art he had first viewed in California. In Benton's mural classes at the Art Students League he was introduced to grand-scale public art and the "problems inherent in keeping all of a large surface . . . alive and interesting." [40]

Benton relied on the enormous size and bright colors of his murals to convince his public audience of his regionalist message. Pollock also came to rely on an oversized, dramatic format to garner public attention, but for a different need. In his 1946 application for a Guggenheim Fellowship, Pollock explained his interest in mural art: "I intend to paint large movable pictures which will function between the easel and the mural. . . . I believe the easel picture to be a dying form, and the tendency of modern feeling is towards the wall picture or mural." [41] Pollock, in other words, depended on monumental art to describe modern "feeling," directing his large-scale art to the world of "felt experience" rather than to the literal improvements proposed in Benton's regionalist pictures. *Autumn Rhythm*'s monumental size (8 feet 10½ inches x 17 feet 8 inches) indicates Pollock's mastery of Benton's mural style, but it also reveals his avoidance of Benton's pragmatism.

Particularly reflective of Benton's stylistic influence is the sense of energy and turbulence in Pollock's postwar pictures. At the Art Students League, Benton instructed his students according to the model of "representational dynamism," on which he had published a series of five articles in *The Arts* from 1926 to 1927. Students were encouraged to "search for anatomical sequences of form rather than the usual study of the model's appearance in terms of light and shade" and were advised to keep sketchbooks of geometric drawings which followed his theoretical directions.[42] Stressing the use of overlapping and rhythmic forms, the integration of line, color, shadowing, and texture, and the overall spatial unity of the picture plane, Benton developed a forceful modernist aesthetic. With it, he linked modernism with republicanism, relying on the dynamism of his regionalist anecdotes to engage Depression America in social reform.

In mid-1930s pictures such as *Going West*, Pollock's assimilation of regionalist dynamism is obvious; Benton later recalled that Pollock demonstrated "an intuitive sense of rhythmical relations." While he eventually came to reject the pragmatism of Benton's political agenda, Pollock's allegiance to the dynamic, formal constructs of Bentonesque regionalism continued in his postwar pictures, especially in their pictorial unity and intensity. Several authors have noted the formal similarities between the diagrams Benton developed to explain regionalist form and Pollock's use of rhythmic counterpoint in his drip paintings.[43] Certainly, *Autumn Rhythm* shows Pollock's continued commitment to an art of dynamic rhythm; like Benton's 1930s murals, this frenetic work conveys an aesthetic obsession with movement. In this sense, both artists seemingly treated their canvases as vehicles, literally as "moving" pictures. In their attentiveness to motion, hence physical change, both embraced the picture surface as an arena indicative also of social and political change. These paintings are not about complacency or satisfaction—but of the struggle for a new and better world.

Purely in terms of formal structure, then, Pollock's postwar pictures demonstrate a surprising degree of continuity with regionalism. Connections can also be seen in Benton and Pollock's dependence on myth, interest in public interaction, and desire for social and political reform. Pollock's art, like regionalism, was an art of myth. Indeed, Mark Rothko referred to his fellow abstract expressionists as a "small band of myth-makers" in 1946. But the mythical quest in Pollock's postwar art was complicated by his interest in creating a public art with universal, rather than strictly nationalist overtones, and his search for personal healing. The mythical orientation, the worldview that Pollock pre-

sented, was further complicated by the dualistic conditions of postwar America, an ironic environment marked, as Pollock himself described it, by its potential for communication—hence commonality—and its potential for destruction: "The modern painter cannot express this age, the airplane, the atom bomb, the radio, in the old forms of the Renaissance or of any other past culture." [44]

Serge Guilbaut suggests that the inherently mythical scope of 1930s culture continued into the 1940s because artists remained committed to an aesthetic of public communication:

> While using automatism, myth, and surrealistic biomorphism, the modern American painter kept intact one aspect of his political experience from the thirties and held on to one cherished notion: the idea that the artist can communicate with the masses, though now through a universal rather than a class-based style.

Postwar artists like Pollock "retained traces of political consciousness" from the reformist thirties and developed a universal aesthetic language with which they could convey their particular personal and political insights to a broad audience. *What* they communicated was, of course, quite different from what the American scene artists of the 1930s conveyed, as was their mode of communication. Guilbaut suggests that their politics were "devoid of direction" but his assessment is too harsh.[45] True, none of the abstract expressionists adhered to a pragmatic political platform, but this does not negate the potent exhortations of alternative consciousness they offered in their art. Pollock's drip paintings embodied the tensions of postwar America. But, in their mythical capacity—derived from his assimilation of Jungian theory and American Indian culture, Pollock's pictures also proposed a kind of empowerment which could free him, and his audience, from the alienating conformity of postwar consensus.

Pollock's search for self-expression and by extension, self-healing, began with elements and attitudes derived especially from the theories of C. G. Jung. In 1939, after spending four months out of the previous year voluntarily hospitalized for alcoholism, Pollock was diagnosed by one doctor as a schizophrenic who experienced episodes of "violent agitation" and demonstrated "a pathological form of introversion." That year he entered Jungian analysis, which he continued until 1942. His understanding of Jung, the Swiss-born psychiatrist who theorized on the concept of the collective unconscious and dealt with myth and symbol in the exploration of human development, dated to the early 1930s,

when he befriended teacher Helen Marot, a friend of Benton's, founding editor of *The Dial*, and devotee of Jungian theory. Put simply, Jungian psychotherapy centers on bringing "an individual's troubled unconscious into harmony with his conscious mind," a process which relies on archetypes, "the basic structural elements of man's unconscious." Jung theorized that these archetypes existed as much in modern dreams as in ancient myth, and thus developed the idea of a collective or universal unconsciousness. In Jungian therapy Pollock was encouraged to draw these archetypes, using symbols to express the conflicted psychic forces at work in his troubled mind. Elizabeth Langhorne suggests that works like *The Moon Woman Cuts the Circle* (1943, fig. 5.15), where a female figure (representing the unconscious) cuts herself free from a circle (the third eye in her forehead) and releases Pollock's "individuated self" from psychic imbalance, were deliberately self-therapeutic.[46]

Jackson Rushing explains that Pollock, like his abstract expressionist peers, also believed that the "vitality and spirituality of Indian culture" could significantly influence the direction of American art and that such "primitive" art reflected "a universal stage of primordial consciousness that still existed in the unconscious mind." In this Pollock was greatly influenced by critic and painter John Graham, who in the late 1930s "was perhaps the single most credible purveyor of the idea that atavistic myth and primitivism are an avenue to the unconscious mind and primordial past."[47]

Pollock combined Jungian theory with the formal and ritualistic scope of American Indian art in further attempts at personal holism. His knowledge of Southwest Indian culture was quite extensive due to his upbringing in Arizona and California, where he and his brothers explored Indian ruins and witnessed Navajo and Wadatkut religious rituals. Such interests continued as an adult: Pollock's New York home library featured the *Annual Report of the Bureau of American Ethnology,* whose field reports were illustrated with artifacts and ritualistic objects; he attended the Museum of Modern Art exhibit "Indian Art of the United States" in 1941; in 1944 he observed: "I have always been very impressed with the plastic qualities of American Indian art. The Indians have the true painter's approach in their capacity to get hold of appropriate images . . . their vision has the basic universality of all art."[48] Pollock familiarized himself with the symbols of American Indian culture to reach the universal archetypes essential to Jungian theory. *The Moon Woman Cuts the Circle, The Guardians of the Secret* (1943), *Night Sounds* (1944), *Totem Lesson 1* (1945), and other pictures of the

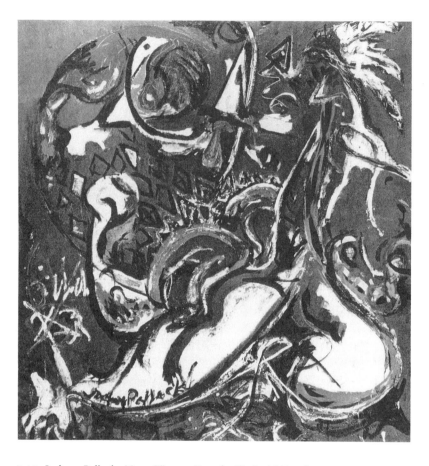

5.15. Jackson Pollock, *Moon Woman Cuts the Circle*, 1943; oil on canvas; 42″ × 40″. Collection of the Tate Gallery, London. Copyright 1990 Pollock-Krasner Foundation/ ARS N.Y.

period "quote" from Indian pictographs, petroglyphs, and masks.

But aside from symbol appropriation, Pollock's immersion in American Indian culture was directed by an interest in shamanism and in the power of art and artmaking to heal. Comparisons have been made, for instance, between Pollock's drip pictures and Navajo sand painting, the transient art of ritualistic ceremonies in which the sick are cured through physical contact with art, usually by sitting or lying upon pictorial images made on the ground. This act puts the sick in touch

with the healing power of the art and restores them to psychic and natural harmony, after which the art is destroyed. Pollock would have known of sand paintings through his childhood experiences and through MOMA's 1941 show. In 1947 he made the connections between drip pictures like *Alchemy* with Southwestern shamanistic art when he described how he painted on the floor, rather than on an easel:

> On the floor I am more at ease. I feel nearer, more a part of the painting, since this way I can walk around it, work from the four sides and literally be *in* the painting. This is akin to the method of the Indian sand painters of the West. When I am *in* my painting, I'm not aware of what I'm doing. . . . It is only when I lose contact with the painting that the result is a mess. Otherwise there is pure harmony.[49]

Like the sand painting shamans, he worked with impermanent materials: combining oils, house paints, industrial enamels, and aluminum paints, Pollock purposely created art that was not meant to stand the test of time. He was not interested in creating objects entirely for future investment; artmaking for Pollock was largely an act, a ritualistic process by which he hoped to become whole.

Namuth's photographs and films showing Pollock making the drip pictures detail his direct bodily involvement; he did literally enter *in* to his art (fig. 5.14). With this painting method Pollock the chronic alcoholic acted as Pollock the shaman, attempting to cure himself and return to the "harmony" of psychic integration. Working in a frenetic but controlled manner by pouring and dripping paints onto his large unprimed canvases, Pollock tried both to define his sickness and to cure it. His attempts at self-healing were remarkably successful: from 1948 to 1950 Pollock completely stopped drinking and was especially productive, painting some 55 works in 1950 alone. It is interesting that the very day Namuth finished filming, a chilly afternoon in October 1950, Pollock took up drinking again. It was as if the banality of Namuth's material documentation violated the sacred act of Pollock's painting (which, of course, Pollock had himself allowed). Or perhaps, by late 1950, Pollock felt that his aesthetic proposal for personal and public empowerment was too inconsequential in the face of growing art world and popular misconceptions of his work. In any case, shortly before he died in 1956 Pollock observed: "Painting is a state of being. . . . painting is self-discovery. Every good artist paints what he is."[50] Combining the symbolic archetypes and rituals of American Indian culture, Pollock em-

braced the act of making an integrative modern art which merged art and life. His manner of making art also offered a model for self-healing and universal transformation.

As much as Pollock's poured pictures were used for personal therapeutic purposes they were also oriented, as Benton's regionalist pictures were, to an audience. Simply because the drip paintings are abstract and intensely personalized does not negate Pollock's commitment to public art: the mural scale, bright coloration, and dynamism of *Alchemy* and *Autumn Rhythm* convey Pollock's obvious desire for social interaction. Like the De Stijl artists, Pollock used nonobjective art to voice personal and political insights and to propose the urgent need for social change. While his view of social change was colored by a postwar emphasis on individualism and the mood of tragic alienation that obsessed critics, filmmakers, novelists, and philosophers, it was also influenced by Pollock's own faith in the liberal concept of progress and the necessity—despite the claims made by consensus politicians and historians—for social reconstruction.

Pollock turned to abstraction and reneged on Benton's literal, anecdotal, and narrative visualization of a better future because he, and many of his peers, desperately wanted to avoid any potential commercial and/or political manipulation of their own modern art. Pollock had seen how Benton's powerful visual images of reform had been appropriated (with Benton's help, of course) by mass media and, during the war, by government propaganda agencies. Like Frederic Wakeman, Pollock had observed Benton's institutionalization by the American Tobacco Company. Images that proposed the revamping of capitalism and the regeneration of republicanism now served to validate corporate culture. Furthermore, in Germany and the Soviet Union a similar mode of representational art was being used to fortify fascist politics.

That a younger generation of artists was disgusted with this exploitation of the narrative style, a style with which most had been previously associated, is evident in the satirical cartoons abstract painter Ad Reinhardt drew for *P.M.*, a liberal daily newspaper in New York. "How to Look at Modern Art in America," published in June 1946 (fig. 5.16), placed Benton, Norman Rockwell, Reginald Marsh, and other narrative painters in a graveyard-like cornfield ("where no demand is made on you") filled with headstones labeled "Lucky Strike," "Associated American Artists," and "Life," and depicted Pollock (misspelled "Pollack") and the abstract painters as the vital leaves on the "tree of modern art." Possibly inspired by Nathaniel Pousette-Dart's 1938 art tree (fig. 4.19), but rejecting Pousette-Dart's plea that "no one individual or group"

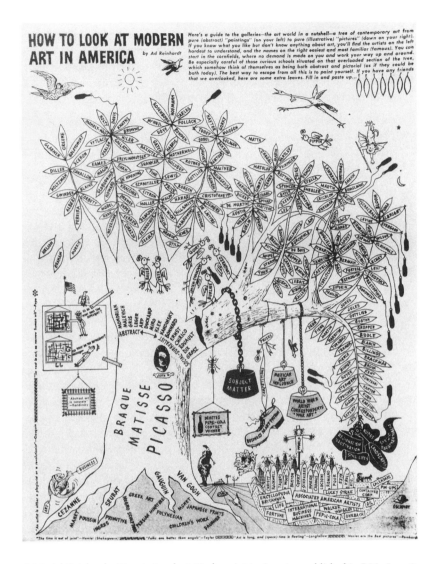

5.16. Ad Reinhardt, *How to Look at Modern Art in America*, published in *P.M.*, June 2, 1946. Copyright 1990 Anna Reinhardt.

dominate American art, Reinhardt's implication was clear: representational art, infected by its innumerable distasteful associations, was dead.[51] Abstract art now embodied the life force of modernism.

For Reinhardt and Pollock modernism was, as it had been for Benton, a revolutionary aesthetic impulse, the embodiment of radical change. As representational art had apparently ceased to be an effective instrument for social reform, Pollock and his peers turned to a modern art of abstraction, an artistic "unconvention" which could:

> imply depth of meaning with a rawness and directness that no representational art, whatever its methods, could begin to fathom, without cultural assumptions and ideological safeguards that would guarantee depth of meaning.[52]

By denying reference to an external world, abstract art seemingly avoided any possibility of political or social manipulation. The abstract nature of Pollock's drips showed the tense instability of life in postwar America; the dense webbed content of his pictures embodied the entrapment of consensus culture. But the visual dynamism inherent in Pollock's abstract works also conveyed a desperate sense of the need for revolution, for the overthrow of authority. The shallow, banal world of everyday material culture was to be exposed and purged. In the way he painted Pollock defied the conventions of traditional art making and proposed a method for self-healing and individual empowerment. He visualized especially the need to loosen—if not completely dissolve—the restraint of consensus conformity.

Pollock's thick, intertwined layers of paint challenged the shallowness of this inauthentic postwar conformity. The all-over abstraction of his drip pictures challenged the corporeal obsessions of postwar consumerism; for a culture that insisted on self-definition through materialism Pollock created an art, which, while admittedly tangible, demanded spiritual and intellectual consideration. In abandoning the narrative style of his mentor, perhaps Pollock aspired to the advice of John Graham, who declared that "academico-impressionist art methods . . . only lull the masses gently to sleep, precisely the aim of the capitalist state. Abstract art with its revolutionary methods stirs the imagination to thinking and consequently to action."[53]

Extending his high school and art world interests in radicalism, Pollock developed an abstract art with profoundly revolutionary intentions. Although it was abstract and focused on himself, it provided a model for social reform via individual autonomy. Rather than retreating from sociopolitical concerns, Pollock's abstract art demonstrated a way in which anyone could achieve self-determination. No martyr to the alienating anxieties of his age Pollock was, like Benton, a seer who of-

fered solutions. The very act of challenging the aesthetic and social traditions of his age indicates Pollock's desire for a different future.

The future Pollock proposed was not like the one that Benton anticipated; it was universal and personalized, devoid of referents to nationalism and collectivity. In 1944 Pollock made this interesting remark:

> The idea of an isolated American painting, so popular in this country during the thirties, seems absurd to me, just as the idea of creating a purely American mathematics or physics would seem absurd. . . . An American is an American and his painting would naturally be qualified by that fact, whether he wills it or not. But the basic problems of contemporary painting are independent of any one country.

Obviously, his comments reveal a declension from the regionalist focus on the American scene, although he somewhat confusedly admitted that "Americanism" was almost an intrinsic quality. But, Pollock did not reject nationalism for the consensus concept of internationalism. Rather, he substituted a kind of "universalist humanism," a utopian schema by which all individuals could work toward personal holism.[54] Like other artists of the period, Pollock rejected the unifying stance of collectivity in favor of individualism. Pollock had consistently been intrigued with defying authority and social reconstruction, as his high school exploits and work in the 1930s with Benton and Siqueiros suggest. By conveying and also challenging the alienating conformity of consensus, Pollock's postwar abstract paintings revealed his continued commitment to social reform and reconstruction, albeit on an individualistic level.

The character of this postwar remaking, or more specifically, what consensus culture was to be replaced with, was left purposely ambiguous. That is, there is an unresolved quality to Pollock's pictures, an unpragmatic avoidance of commitment to any *particular* social or political construct. The way he painted and the frenzied activity within his canvases bespoke change, but Pollock remained unfocused about the outcome of that activity. Such indecision may be the result of the fatalistic sensibility he inherited from his father. Or it may be taken as the sort of ambivalence, the "abiding lack of resolution and certainty," the "refusal to achieve closure," that characterizes much of modernist culture.[55] But the irresolute temperament of Pollock's abstract pictures also reveals that Pollock, in the spirit of the true modernist, placed considerable emphasis on individual autonomy. He proposed a method for personal and

social revolution and restoration; he did not prescribe any single ideology. Rather naively, Pollock and other abstract artists of his generation believed that the open-ended nature of their modern art would certainly prevent its appropriation by those cultural or political factions with which they did not wish to be associated—how could such an ambiguous art be used to substantiate a particular culture or ideology? Unfortunately, as Pollock and other abstract painters increasingly discovered in the postwar years, even their art could be misconstrued and misused. A modern art of social renaissance based on authentic individualism had profoundly threatening implications for the future of consensus culture.

N O T E S

1. Benton, "And Still After," a 1968 essay appended to his 1937 autobiography, *An Artist in America* (Columbia: University of Missouri Press, 1983), 338. Albert Boime discusses the links between Manet and Couture in *Thomas Couture and the Eclectic Vision* (New Haven: Yale University Press, 1980). See esp. chap. 13, "Couture's Influence on the Younger Generation," pp. 457–80.

2. For information on Pollock's upbringing and background, see Elizabeth Frank, *Jackson Pollock* (New York: Abbeville Press, 1983), 11–15; Jeffrey Potter, *To a Violent Grave: An Oral Biography of Jackson Pollock* (New York: G. P. Putnam's Sons, 1985), 17–31; Deborah Solomon, *Jackson Pollock: A Biography* (New York: Simon & Schuster, 1987), 15–48, 83–84; B. H. Friedman, *Jackson Pollock: Energy Made Visible* (New York: McGraw-Hill, 1972), 3–14; Ellen Landau, *Jackson Pollock* (New York: Harry N. Abrams, 1989), 12–21, 109–12; and Steven Naifeh and Gregory White Smith, *Jackson Pollock: An American Saga* (New York: Clarkson N. Potter, 1989) 10–155. Charles Pollock, quoted in Friedman, p. 5.

3. LeRoy Pollock, quoted in Solomon, *Jackson Pollock*, 23.

4. LeRoy Pollock, quoted in Francis V. O'Connor and Eugene V. Thaw, eds., *Jackson Pollock: A Catalogue Raisonné of Paintings, Drawings, and Other Works* (4 vols.; New Haven: Yale University Press, 1978), 4:205–6. Solomon, *Jackson Pollock*, discusses this letter on p. 35.

5. See Naifeh and Smith, *Jackson Pollock*, 28–31; Potter, *To a Violent Grave*, 22; Solomon, *Jackson Pollock*, 24; and *Catalogue Raisonné*, 4:206.

6. *Catalogue Raisonné*, 4:208–9; Friedman, *Jackson Pollock*, 9.

7. Friedman, *Jackson Pollock*, 8; Naifeh and Smith, *Jackson Pollock*, 577–79.

8. *Catalogue Raisonné*, 4:206–7, and Friedman, *Jackson Pollock*, 9–10.

9. Benton, "And Still After," 332; Solomon, *Jackson Pollock,* 68.

10. Benton, "And Still After," 334. Elizabeth Pollock, wife of Charles, discusses Pollock in Potter, *To a Violent Grave,* 34.

11. On Pollock's physical characteristics, see Solomon, *Jackson Pollock,* 109. McNeil's comments are noted in Potter, *To a Violent Grave,* 36; Pavia, in John Gruen, *The Party's Over Now: Reminiscences of the Fifties* (New York: Viking Press, 1967), 262, and Potter, *To a Violent Grave,* 36; Darrow, in Friedman, *Jackson Pollock,* 25; critic Harold Rosenberg, in Brian O'Doherty's essay on Pollock in *American Masters: The Voice and the Myth* (New York: E. P. Dutton, 1974), 107. O'Doherty discusses Pollock's frontiersman persona, pp. 105–6, and Elizabeth Pollock intimates the "harmful" links between Benton and Pollock in Potter, p. 34. Pollock, quoted in Solomon, p. 51.

12. Polcari discusses *Going West* in "Jackson Pollock and Thomas Hart Benton," *Arts* 53, no. 7 (March 1979): 123; Pollock, quoted in *Catalogue Raisonné,* 4:210.

13. *Catalogue Raisonné,* 4:219. For the review of the 1937 AAA show, see "Benton, Historian of 'Backwoods America,'" *Art Digest* 12, no. 3 (November 1, 1937): 7.

14. Benton, "And Still After," 337.

15. Pollock discussed Ryder in a 1944 interview, "Jackson Pollock," in *Arts and Architecture* 61 (February): 14, reprinted in *Catalogue Raisonné,* 4:232. Friedman discounts the political influence of both the Mexican muralists and Benton on Pollock's work on p. 29.

16. Solomon, *Jackson Pollock,* 80. See also *Catalogue Raisonné,* 4:219.

17. *Catalogue Raisonné,* 4:223–24.

18. *Arts and Architecture* 61:14; "Talk of the Town: Unframed Space," *New Yorker* 26 (5 August 1950): 16.

19. See, for example, Rudi Blesh, *Modern Art USA* (New York: Alfred A. Knopf, 1956), 253–55; Barbara Rose, *American Art since 1900* (New York: Holt, Rinehart & Winston, 1967), 129, 146–51; Sandler, *The Triumph of American Painting: A History of Abstract Expressionism,* (New York: Harper & Row, 1970), 102–3. Sandler refers to the "breakthroughs" of the abstract expressionists in his *New York School: The Painters and Sculptors of the Fifties* (New York: Harper & Row, 1978), ix. For Benton's remarks, see Robert S. Gallagher, "An Artist in America," *American Heritage* 24 (June 1973): 90. Schardt, noted in Potter, *To a Violent Grave,* 61.

20. Pollock, "An Interview with Jackson Pollock" (1950), reprinted in Francis V. O'Connor, *Jackson Pollock* (New York: Museum of Modern Art, 1967), 79–81. Benton, quoted from letter to Francis V. O'Connor, n.d., Benton Papers, Archives of American Art (AAA), Smithsonian Institution, Washington, D.C. Donald Kuspit discusses Pollock's "utopian vision" in "Abstract Expressionism: The Social Contract," *Arts* 54, no. 7 (March 1980): 119.

21. On "atomic anxiety," see Paul Boyer, *By the Bomb's Early Light: Amer-*

ican Thought and Culture at the Dawn of the Atomic Age (New York: Pantheon Books, 1985), 14–26. On the Fair Deal, see Alonzo L. Hamby, *Beyond the New Deal: Harry S. Truman and American Liberalism* (New York: Columbia University Press, 1973), 293.

22. For information on the postwar economy, see Godfrey Hodgson, *America in Our Time* (New York: Doubleday, 1976), 20, 50, 78–85; Norman L. Rosenberg and Emily S. Rosenberg, *In Our Times: America since World War II* (New York: Prentice Hall, 1987), 24–25, 36–38. Thomas Hine discusses postwar consumerism in *Populuxe* (New York: Alfred Knopf, 1986), 3.

23. Galbraith, quoted in Hodgson, *America in Our Time,* 81.

24. Warren Susman, "Did Success Spoil the United States? Dual Representations in Postwar America," *Recasting America,* ed. Lary May (Chicago: University of Chicago Press, 1989), 19–37.

25. Arthur Schlesinger, Jr., *The Vital Center: The Politics of Freedom* (Boston: Houghton Mifflin Co., 1949), 1, 29, 38, 56, 169, 189, 219. Hamby discusses the book in *Beyond the New Deal,* 272–82. See also Richard Pells, *The Liberal Mind in a Conservative Age* (New York: Harper & Row, 1985), 136, 141.

26. Hofstadter is discussed in David W. Noble, *The End of American History* (Minneapolis: University of Minnesota Press, 1985), 144 and passim; Schlesinger, *The Vital Center,* 38. On the shift in postwar intellectual thought, see Pells, *The Liberal Mind,* Alan Wald, *The Rise and Decline of the Anti-Stalinist Left from the 1930s to the 1980s* (Chapel Hill: University of North Carolina Press, 1987), and Terry Cooney, *The Rise of the New York Intellectuals* (Madison: University of Wisconsin Press, 1986).

27. Bell, quoted in Hodgson, *America in Our Time,* 75.

28. Schlesinger, *The Vital Center,* 248.

29. David Riesman, *The Lonely Crowd: A Study of the Changing American Character* (New York: Doubleday, 1950), 349.

30. Frederick Wakeman, *The Hucksters* (New York: Rinehart & Co., 1946), 104, 306.

31. Tooker is quoted in Greta Berman and Jeffrey Wechsler, *Realism and Realities: The Other Side of American Painting, 1940–1960* (Rutgers: Rutgers University, 1981), 85.

32. On Namuth's photos, see *Pollock Painting,* ed. Barbara Rose (New York: Agrinde Publications, 1980), n.p., and Robert Goodnough, "Pollock Paints a Picture," *Art News* 51 (May 1951): 38–41, 60–61.

33. Namuth, quoted in the essay "Photographing Pollock," Segal, quoted in the essay "Namuth's Photographs and the Pollock Myth," in Rose, *Pollock Painting,* n.p.

34. Adolph Gottlieb, "The Ides of Art," *Tiger's Eye,* no. 2 (December 1947): 43, quoted in Stephen C. Foster, *The Critics of Abstract Expressionism* (Ann Arbor: UMI Research Press, 1980), 42.

35. Motherwell, "What Abstract Art Means to Me," *Museum of Modern Art Bulletin* 18, no. 3 (Spring 1951): 12. On the Pollock myth, see Rose, "Namuth's Photographs and the Pollock Myth," n.p., O'Doherty, *American Masters*, 96–137, Landau, *Jackson Pollock*, 11–21, and Mary Lee Corlett, "Jackson Pollock: American Culture, the Media, and the Myth," *Rutgers Art Review* 8 (1987): 71–106. Kaprow, quoted in "The Legacy of Jackson Pollock," *Art News* 57, no. 6 (October 1958): 24.

36. A portion of Frankenstein's August 12, 1945, review is reproduced in O'Connor's *Jackson Pollock*, 38. For other reviews quoted, see pp. 43, 46, and 62; McBride's review is reproduced on p. 49.

37. "Words," *Time* 53 (February 7, 1949): 51; "The Wild Ones," *Time* 67 (February 20, 1956): 70–75; Berger, "The White Cell," *New Statesman* 56 (November 22, 1958): 722–23.

38. Pollock, "My Painting," *Possibilities*, Winter 1947–48, pp. 78ff., a one-time New York art magazine edited by Motherwell and Rosenberg, reproduced in O'Connor, *Jackson Pollock*, 40. Kaprow, quoted in "The Legacy," 56–57.

39. Benton, "And Still After," 333.

40. Solomon notes Pollock's work on Benton's New York murals, *Jackson Pollock*, 51. Friedman notes the influence of Benton's mural classes, *Jackson Pollock*, 25.

41. Pollock, *Catalogue Raisonné*, 4:238.

42. For Benton's essays in *The Arts*, see "Mechanics of Form Organization in Painting," 10, no. 5 (November 1926): 285–89, no. 6 (December 1926): 340–42; 11, no. 1 (January 1927): 43–44, no. 2 (February 1927): 95–96, and no. 3 (March 1927): 145–58. Benton described his teaching method in "And Still After," 332.

43. Benton, "And Still After," 333. For a discussion of Benton's impact on Pollock's later works, see Polcari, "Jackson Pollock and Thomas Hart Benton," *Catalogue Raisonné*, 2:196, and Matthew L. Rohn, *Visual Dynamics in Jackson Pollock's Abstractions* (Ann Arbor: UMI Press, 1987), 47.

44. Rothko, "Introduction," *Clyfford Still* (New York: Art of This Century Gallery, 1946), n.p.; Pollock, "An Interview," in O'Connor, *Jackson Pollock*, 79.

45. Guilbaut, *How New York Stole the Idea of Modern Art: Abstract Expressionism, Freedom, and the Cold War* (Chicago: University of Chicago Press, 1983), 113.

46. For Pollock and Jung, see C. L. Wysuph, *Jackson Pollock: Psychoanalytic Drawings* (New York: Horizon Press, 1970), 13–14. On *Moon Woman*, see Elizabeth L. Langhorne, "Jackson Pollock's 'The Moon Woman Cuts the Circle,'" *Arts* 53, no. 7 (March 1979): 128–37.

47. W. Jackson Rushing, "Ritual and Myth: Native American Culture and Abstract Expressionism," *The Spiritual in Art: Abstract Painting, 1890–1985* (New York: Abbeville Press, 1986), 273–74. In *System and Dialectics of Art*

(Baltimore: Johns Hopkins Press, 1937, 1971), Graham stated that the "purpose" of art was to "reestablish a lost contact with the unconscious." Rushing, 282, notes that Pollock owned a copy of this book.

48. Rushing, "Ritual and Myth," 281–92, discusses Pollock's knowledge of Indian art and culture; see also Naifeh and Smith, *Jackson Pollock*, 83–85; Pollock, quoted from "Jackson Pollock" (1944), 14.

49. Pollock, "My Painting," in O'Connor, *Jackson Pollock*, 40. Rushing, "Ritual and Myth," 284, 291–92, discusses Pollock and sand painting.

50. Solomon, *Jackson Pollock*, 211–13, discusses Namuth's film and Pollock's drinking; see also Naifeh and Smith, *Jackson Pollock*, 647–53; Pollock, quoted from an interview with Selden Rodman in *Conversations with Artists* (New York: Devin-Adair, 1957), 76–87.

51. Michael Leja discussed this cartoon in "The Formation of an Avant-Garde in New York," *Abstract Expressionism: The Critical Developments* (New York: Abrams, 1987), 26. For Pousette-Dart's comments, see "Freedom of Expression," *Art and Artists of Today* 1, no. 6 (June–July 1938): 3.

52. Kuspit, "Abstract Expressionism," 118.

53. See Graham, *System and Dialectics of Art* (Baltimore: John Hopkins Press, 1937, 1971), 136–37, as noted in Annette Cox, *Art as Politics: The Abstract Expressionist Avant-Garde and Society* (Ann Arbor: UMI Research Press, 1977, 1982), 33.

54. Pollock, "Jackson Pollock," 14, see note 15. Guilbaut, *How New York Stole the Idea of Modern Art*, 175, uses the term "universalist humanism."

55. Daniel Joseph Singal, "Towards a Definition of American Modernism," *American Quarterly* 39, no. 1 (Spring 1987): 22.

The Misconstruction of

Abstract Expressionism:

Institutional Orthodoxy and

Commodification

I n 1946 art historian H. W. Janson wrote an extraordinary article for the *Magazine of Art* which equated regionalism with Nazi art. "To be sure," he said, the "hey-day of regionalism was in the years before Pearl Harbor." But it was still "sufficiently dangerous to invite the closest scrutiny" because of its nurturing "by some of the fundamental ills of our society—the same ills that in more virulent form, produced National Socialism in Germany." Janson, who went on to fame and fortune as the author of the most widely used art history textbook in the twentieth century, described these "ills" as antimodernism and mob politics. He linked regionalism with both. Its "traditional" oil painting techniques and representational style were nonprogressive and hence, antimodern; its American scene content was thinly disguised chauvinism; its audience was an unthinking mob with "insecure esthetic instincts." Regionalism was not a "positive artistic creed" but a perverted maneuver to "substitute 'Americanism,' i.e., nationalism, for esthetic values." And nationalism, Janson explained, "is a state of mind justified only in the imperfect world of events, not in the realm of ideas; its proper sphere of action is not art but politics." [1]

For the scholar that he was, Janson wrote an extraordinarily ahistorical and ill-informed essay. He conveniently dismissed, for instance, Benton's theories of modernism published in *The Arts* in 1926–27 and he neglected to assess the aim of many modernists to merge art and life.

His omission of such information implies not so much an honest oversight as a hidden agenda. Indeed, Janson's admitted intention with his regionalist vendetta was to "recognize its implications and reduce its influence." As its "implications" were the deviant mass politics Janson associated with recently vanquished Nazi Germany, regionalism too had to be destroyed. In subsequent essays he declared: "modern art must not be made dependent on mass appeal." He also warned American artists not to "sacrifice the inner satisfaction of bringing one's talent to full maturity for the sake of social and financial rewards." [2]

Janson's attack on regionalism was by no means atypical in postwar America nor was his message to contemporary artists unclear. As regionalism was condemned for its parochialism and its politics, an abstract style seemingly unique to the postwar American art world was lauded. Abstract expressionism was celebrated as a nonobjective, intensely personalized, and especially apolitical form of aesthetic expression. The artists who worked in this style were hailed by many as the era's heroic avant-garde, figureheads of the postwar emphasis on freedom and individuality, alienated though they might be. Jackson Pollock, for instance, was praised by Clement Greenberg in 1945 as "the strongest painter of his generation and perhaps the greatest one to appear since Miro." [3]

Closely following such critical adulation, American cultural and political institutions began to patronize contemporary abstract art; both the Museum of Modern Art and the State Department exhibited various shows of recent American nonobjective art throughout the postwar world. Likewise, corporate America came to embrace the style of abstract modernism; after initial hesitancy, Time-Life, Inc., and even the Associated American Artists agency eventually gave it their full support. Home design tastemakers got into the act too, turning the drip style of Pollock's canvases into tasteful wallpaper, floor tile, and fabric design. The reasons underlying this significant shift in preference and patronage from regionalism to abstract expressionism are embodied in a larger cultural and political transformation at work in America from the New Deal to the Cold War. As American ideology shifted from reform to consensus, so did American art. Janson's critical renunciation of regionalism helped define the terms by which postwar culture was largely determined.

In 1947, Thomas Hart Benton, the last living member of the regionalist triumvirate that Janson was intent on seeing dead and buried, responded to Janson's attack in the Kansas City department store mural

Achelous and Hercules (fig. 6.1). Depicting the contest between Hercules and the river-god Achelous (in the guise of a bull) over the maiden Deianeira, Benton's mural ostensibly domesticated the Greek myth and told the story of Missouri settlement. Hercules' conquest of the river-god was meant to evoke the taming of Missouri waterways by Kansas City pioneers; the horn that Hercules snaps from Achelous' head symbolized the cornucopia of midwestern agriculture.[4] But Benton's mural also provided the framework for his unceasing argument with the critics of regionalism, with Hercules (Benton himself) and the bull (Janson) fighting over the future of American art. From Benton's point of view the future looked pretty good for the American scene style he had promoted for almost three decades: the world he painted in *Achelous and Hercules* was abundant and fertile and full of promise.

But if we look at the pictures produced that same year by Benton's former student Jackson Pollock, such as the poured piece *Alchemy* (fig. 6.2), we see the direction modern art took in postwar America. It was Pollock's abstract expressionist style that proved to be the breeding ground for a future generation of artists, not Benton's regionalism. Pollock's mythical persona as the James Dean or Marlon Brando of the art world appealed to many, but so too did the manner in which he painted and the world view he presented. In the frenzied, labyrinthine layers of his pictures Pollock elicited both the anxious instability of postwar life and the constricted nature of consensus culture. But beyond the self-evident fact that his artwork illustrated and embodied the crisis of his personal life and contemporary history, Pollock proposed a utopian aesthetic by which individuals could strive for autonomy. In paintings that were largely based on his own therapeutic efforts at self-discovery and self-healing, Pollock offered a revolutionary model for social transformation and reconstruction.

Aspects of Pollock's utopian aesthetic were, not surprisingly, enormously appealing to postwar critics. Pollock focused on the tragedy of contemporary social alienation and the primacy of individual expression, reneging on a previous generation's specific attention to nationalism and collective reform. For postwar intellectuals who had abandoned the "search for community" in favor of "the virtues of privacy and personal fulfillment" and the search for individual identity, Pollock's aesthetic model was perfectly appropriate.[5] But, his appeal to individual empowerment was also an enormous threat to the ideology of postwar consensus, which albeit conflicted, centered on conformity and consumption rather than individual rebellion and personalized spiritual

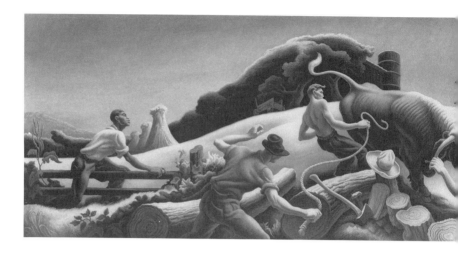

6.1. Thomas Hart Benton, *Achelous and Hercules*, 1947; egg tempera and oil on canvas, affixed to panel, 62 ⅞" × 264 ½". Originally painted for Harzfeld's Department Store, Kansas City, the painting is now in the collection of the National Museum of American

introspection. Although individuality was touted in the consensus era, its authentic character was limited, restricted. Pollock challenged the sociopolitical conditions of postwar America by proposing the alternative of self-healing and therapeutic holism, a proposal simply too powerful in view of the limited notion of freedom embodied in consensus ideology.

Subsequently, while Pollock's abstract art actually challenged the constraints of Cold War culture, it was misconstrued to buttress consensus ideology. In some cases, the misunderstanding of abstract expressionism resulted from the flawed mechanisms that many theorists relied on to explain the perplexing context of consensus. In other cases, the gloss on Pollock's paintings—and those of the other abstract expressionists—was quite conscious. Although Pollock painted to express social anxieties and to propose personal, individualist modes of healing, his abstract pictures were lauded by consensus critics, politicians, and corporate leaders as portraits of America's postwar strength, freedom, and lack of conflict. Through the auspices of the State Department, abstract art was exhibited throughout postwar Europe to promote America's creative freedom, in direct contrast to the Soviet Union's style of socialist realism. Abstract expressionism became, as several authors

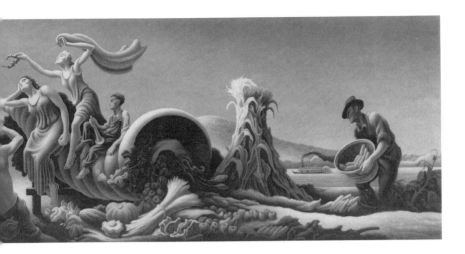

Art. Courtesy of the National Museum of American Art, Smithsonian Institution. Gift of Allied Stores Corporation & Museum Purchase through Smithsonian Institutions Collections Acquisition Program.

have noted, a weapon in the Cold War as its abstracted anxieties and resolution thereof were translated, ironically, into symbols of the superiority of American laissez-fairism.[6]

The misconstruction of abstract expressionism began with its critical appropriation as a style. Postwar writers cast the abstract painters as a group and molded their output into a particular art historical style. The term "abstract expressionism" was chosen to describe them, ostensibly because it suggested that their art combined the nonobjective formal character of the early twentieth-century modernists (the European cubists, in particular) and the emotional intensity of the German expressionists, all in a unique American format. Of course, this stylistic label also helped to distance the postwar modernists from the nativist, localized, and storytelling overtones of regionalism. Despite the objections of the abstract artists themselves—wary of the ideology implied in any labeling of their art—critics insisted on their codification. But the fact is that "aesthetic and conceptual differences, resolute individualism, [and] difficult interpersonal dynamics" prohibited Jackson Pollock, Mark Rothko, Adolph Gottlieb, Robert Motherwell, Ad Reinhardt, Lee Krasner, Clyfford Still, Helen Frankenthaler, Barnett Newman, Franz Kline, and many other postwar abstractionists from developing an authentic

6.2. Jackson Pollock, *Alchemy*, 1947; oil and enamel on canvas, 45″ × 87″. Peggy Guggenheim Collections, Venice, The Solomon R. Guggenheim Foundation, New York.

artistic collective.[7] Efforts to unite them provide evidence of the essentially false construct of postwar consensus. Indeed, it may be that many observers intentionally misread the separatist thrust of the abstract expressionist painters and the essence of their art: the utopian social

implications of their painting, particularly in postwar America, were dangerously appealing.

One of the most powerful critics to shape postwar response to abstract expressionism—and modern art in general—was Clement Green-

berg. Born in the Bronx in 1909, the eldest son of Lithuanian immigrants, Greenberg's Jewish cosmopolitan upbringing was radically different from that, for example, of Benton or Beard or Pollock; his world view simply did not encompass the same notions regarding American republicanism and pragmatism. Both of Greenberg's parents were socialist and apparently raised their three sons with this political framework in mind. Switching from retail clothing to manufacturing metal goods, his father provided the family with a comfortable middle-class existence. Following his graduation from Syracuse University in 1930, Greenberg worked in St. Louis, Cleveland, San Francisco, and Los Angeles in the wholesale dry goods business but discovered that his "appetite for business did not amount to the same thing as an inclination." From 1937 until 1942, he worked as an appraiser with the U.S. Customs Service in the Port of New York. During the thirties Greenberg had also been attending lectures by artist Hans Hoffman, sketching at a WPA studio (Greenberg began painting in 1945), and writing. In 1939 he published his first article, a review of a Bertolt Brecht novel, for *Partisan Review*.[8]

Also in 1939, Greenberg published an essay in the same magazine which gave his account of the course of avant-garde culture since the nineteenth century. In prose that is lucid and forceful and, as T. J. Clark has noted, "blessedly free from Marxist conundrums," the thirty-year-old author set forth a cultural model which would have enormous ramifications in postwar criticism.[9] In an essay which was essentially a revisionist marxist critique of capitalist culture, Greenberg found in avant-garde art the source for revolutionary consciousness and hence social change. Staking his claim within the intellectual left at *Partisan Review*, the young writer retained the radical political framework in which he had been raised, redefined it according to the changed context of leftist politics in the late thirties, and applied it to what he viewed as an elite form of modern art.

In the essay, called "Avant-Garde and Kitsch," Greenberg prescribed the rigid separation of an avant-garde aristocracy from "that thing the Germans give the wonderful name of Kitsch": the popular culture dreck addressed to and favored by the masses. Kitsch, Greenberg declared, was bad because it represented the perilous conformity and inauthenticity of mass culture and because it reinforced dangerous political ideologies. Kitsch, "the debased and academicized simulacra of genuine culture," the "mass product of Western industrialism," had destroyed "folk culture" and "native art." As a mass or "universal" cul-

ture which was "an integral part of our productive system" and was "compelled to extend as well as to keep its markets," kitsch threatened the autonomy of all art, especially that of the avant-garde. Kitsch was the culture of consumerism, and Greenberg did not find therapeutic benefits in mass consumption. He explained its "irresistible attractiveness" to the masses on the grounds that kitsch embodied "vicarious experience and faked sensations." [10] Kitsch, in other words, was escapist: it masked the authentic aspects of individual consciousness and the realities of modern living.

The real danger of this was that it could be used to fortify a political culture which aimed to do exactly the same thing. Kitsch, explained Greenberg, was "the official tendency of culture in Germany, Italy, and Russia. . . . kitsch is the culture of the masses in these countries. . . . kitsch is merely another of the inexpensive ways in which totalitarian regimes seek to ingratiate themselves with their subjects." Although neither regionalist nor American scene art was specifically mentioned in his essay (although Norman Rockwell's *Saturday Evening Post* covers were elicited as "the products of American capitalism"), it was obvious that Greenberg found these art styles and the mass politics they represented just as debased and just as dangerous as the fascist propaganda of Nazi Germany and the socialist realism of the Soviet Union. [11] Impugning the masses and their easy and apparently willing manipulation at the hands of both corporate capitalist and totalitarian regimes, Greenberg shunned the kinship between mass culture and mass politics. It goes without saying that the collectivity inherent in republicanism was adamantly rejected.

While damning kitsch, Greenberg found solace in the world of avant-garde art. Because it had detached itself from mass culture, the avant-garde was free of the taint of capitalist, fascist, or Stalinist political repression. Avoiding subject matter or content "like a plague," the avant-garde artist developed abstract and nonobjective art:

> The avant-garde poet or artist tries in effect to imitate God by creating something valid solely on its own terms, in the way nature itself is valid; something *given*, increate, independent of meanings, similars, or originals. Content is to be dissolved so completely into form that the work of art or literature cannot be reduced in whole or in part to anything not itself.

Moreover, Greenberg charged avant-garde culture—and it alone—with providing the impetus for social change:

It developed that the true and most important function of the avant-garde was not to "experiment," but to find a path along which it would be possible to keep culture *moving* in the midst of ideological confusion and violence. Retiring from public altogether, the avant-garde poet or artist sought to maintain the high level of his art.[12]

In this 1939 essay, Greenberg developed a cultural critique that elevated modern abstract art, which he defined as art for art's sake, as a revolutionary force. It was revolutionary because it resisted appropriation by mass culture or repressive politics; it was revolutionary because it implied the supremacy of individual action over that of the manipulatable mass.

Greenberg's antagonism about the masses was typical at *Partisan Review*, where intellectual disillusionment and apprehension about collectivism abounded by the later years of the Depression. Although initiated in 1934 as a cultural journal for New York's John Reed Club, the impact of the Moscow Show trials and the decline of radical political thought under the "benign aegis" of the Popular Front led Philip Rahv and Dwight Macdonald to reorganize *Partisan Review*. What emerged in the late thirties was a journal that condemned mass politics in favor of individual alienation and denounced popular culture in favor of the avant-garde. Greenberg's essay on the latter was influenced by several pieces Leon Trotsky wrote for *Partisan Review* in 1938 which declared the intrinsic independence of art and politics: "Art can become a strong ally of the revolution only in so far as it remains faithful to itself." Trotsky's argument was shaped, of course, by personal anti-Stalinism. Thus, any art that linked itself with politics and was determined by its function, such as the Soviet style of socialist realism, was condemnable. Greenberg further developed Trotsky's argument by proposing the autonomy of avant-garde art. His elevation of nonobjective art, which eventually included that of Pollock and the abstract expressionists, was conditioned, then, by a deliberate political argument. Indeed, in 1961 Greenberg recalled: "some day it will have to be told how 'anti-Stalinism', which started out more or less as 'Trotskyism', turned into art for art's sake, and thereby cleared the way, heroically, for what was to come."[13]

Because of its heroic authority, avant-garde art was constantly in danger of appropriation by the rear guard: "Kitsch's enormous profits are a source of temptation to the avant-garde. . . . The net result is always to the detriment of true culture." To prevent this, Greenberg de-

manded that the "ruling class" patronize the avant-garde. They had always done so, he maintained, and their contemporary ambivalence about continuing to do so was a threat to "the survival in the near future of culture in general":

> The avant-garde's specialization of itself . . . had estranged a great many of those who were capable formerly of enjoying and appreciating ambitious art. . . . The masses have always remained more or less indifferent to culture in the process of development. But today such culture is being abandoned by those to whom it actually belongs—our ruling class. . . . No culture can develop without a social basis, without a source of stable income. And in the case of the avant-garde, this was provided by an elite among the ruling class.[14]

Greenberg did see a paradox in the failure of elite support for contemporary avant-garde culture. Ironically, he did not reflect on the inherent fallacy that elites could be expected to support a revolutionary culture whose function, as he had made explicit, was to generate social change and pave the way for marxism. By stressing that elites alone were responsible for keeping the avant-garde alive, Greenberg further isolated a potentially revolutionary art form. First defining it as art for art's sake, he now restricted radical art to the realm of elite taste and self-interest.

"Avant-Garde and Kitsch" was primarily a theoretical exercise in which Greenberg linked mass culture with totalitarian politics and the avant-garde with revolution. In 1940, in the *Partisan Review* piece "Towards a Newer Laocoön," Greenberg elaborated on his earlier essay and provided a specific model for the avant-garde artist: nonobjective painting. He loosely followed the 1766 treatise on the classical sculpture *Laocoön* (c. 150 B.C.), in which German aesthetician Gotthold Lessing, appealing to the principle of *Materialgerechtigkeit,* urged the separation and autonomy of the plastic arts and championed the doctrine of "truth to materials." Constructing an historical apology for abstract art, Greenberg asserted that the rejection of three-dimensional space and the tendency to "flatness" was the inevitable course for modern painting: "The history of avant-garde painting is that of a progressive surrender to the resistance of its medium." Interestingly enough, this alone was the criterion by which Greenberg heralded the "present superiority of abstract art." [15] While he charted the progress of avant-garde abstraction, from Courbet and Manet to the cubists, he ignored its revolutionary function. Readers familiar with his earlier essay would

have understood that nonobjective art, by appearing to deny the repressive tendencies of mass culture, embodied the potential for revolutionary change. But those who did not connect these two *Partisan Review* essays would come to assume that the authentic avant-garde artist worked in a nonobjective format because of, well, "history." In the postwar era, when Americans became obsessed with realizing their place in history and the art world became centered in New York rather than in Paris, Greenberg's easy analysis that flat and apparently apolitical paintings typified the historical progress of the avant-garde became widely accepted as aesthetic gospel.

In "Towards a Newer Laocoön," Greenberg especially praised early twentieth-century cubist painting for its progressive nonobjectivity. The cubists had "brought painting to the point of pure abstraction" by denying realistic three-dimensional space, eliminating color, and breaking the canvas into a "multiplicity of subtle recessive planes." But because the cubists had always retained content in their pictures, they had not progressed far enough. It remained, Greenberg asserted, for contemporary artists to do so and consolidate abstract art "into a school, dogma, and credo." In the postwar era, Greenberg found the dogma of progressive nonobjectivity especially evident among the American abstract expressionists. Their art, he claimed in 1949, was "uninflated by illegitimate content—no religion or mysticism or political certainties. And in its radical inadaptability to the uses of any interest, ideological or institutional, lies the most certain guarantee of the truth with which it expresses us." Greenberg thus named abstract expressionism the inheritor of "the mantle of revolutionary progress" he had described in "Avant-Garde and Kitsch." In many of his subsequent essays on the abstract expressionists, Greenberg pleaded for their patronage by the elite. Indeed, even after Pollock et al. *had* achieved substantial critical acclaim and some degree of financial success, Greenberg continued to prod collectors to support the American modernists, presumably out of adherence to his earlier generated theories on the avant-garde and revolution.[16]

Greenberg interpreted Pollock's pictures as perfect examples of avant-garde progress and Pollock himself as one of a handful of contemporary artists who were successful in the struggle against the "pedagogic vulgarization that infects everything," that is, mass culture. "The most powerful painter in contemporary America," Greenberg announced in 1947, was Pollock. His art was derivative of cubism, but superior to it: "Pollock's strength lies in the emphatic surfaces of his

pictures, which it is his concern to maintain and intensify in all that thick, fuliginous flatness which began—but only began—to be the strong point of late cubism."

Claiming Pollock as a "disciple of Picasso's Cubism and Miro's post-Cubism," as well as of Kandinsky and the surrealists, Greenberg ignored Pollock's debt to Orozco, Benton, Siqueiros, Ryder, Graham, Jungian symbolism, and native American art.[17] More important, Greenberg forced Pollock (and other abstract painters) within the narrow confines of the theoretical framework he had outlined for the avant-garde in his *Partisan Review* essays. While he certainly looked at the art, and befriended many of the artists, theory took precedence over painting in Greenberg's writing on abstract expressionism.

Greenberg's rejection of anecdotal and popular art forms and subsequent support for nonobjective modernism coincided with the postwar ascendancy of both consensus ideology and abstract expressionism. Abstract art like Pollock's, Greenberg maintained after the war, freed the artist from dangerous links to mass culture. And this, by extension, was indicative of American cultural and hence, political, superiority. In 1948, Greenberg made this announcement:

> the level of American art has risen in the last five years, with the emergence of new talents so full of energy and content as Arshile Gorky, Jackson Pollock. . . . the main premises of western art have at last migrated to the United States, along with the center of gravity of industrial production and political power.

The therapeutic art of Pollock's abstract expressionism was thus redefined by Greenberg as the "reflection of the prosperity, pragmatism, and positivism" of postwar consensus culture.[18] A modern art of immense power and revolutionary potential was reduced to the superficial level of "flatness" and art for art's sake. Isolated from the masses and urged instead on wealthy collectors, an art with the potential for revolution was tied to the purse strings of an elite that could hardly be expected to crave radical social change. An art form that embodied reform was neutralized and objectified, eventually to assume "a position of institutional orthodoxy in international culture." [19]

In many ways, Greenberg was as much a cultural chauvinist in the postwar era as regionalist apologist Thomas Craven had been in the 1930s. Both looked to art as a vehicle for political and social reform. Their differences lay in their politics and their attitudes about mass culture. Craven anticipated a native art of mass popularity, but Greenberg

feared the dilution and manipulation of political intentionality at the hands of mass culture. Thus, while Craven lauded an art that blatantly bespoke its popular culture, republican, and folk ideology, Greenberg championed an abstract art that he found devoid of mass political and cultural referents, and—because it wasn't tainted by these referents—considered it the only art form capable of generating political revolution. Greenberg chose to articulate the revolutionary art of abstract expressionism as "art for art's sake" and developed his theory of the supremacy of avant-garde culture largely out of political considerations. In the 1950s, he became a leading anticommunist and abandoned faith in marxist revolution. Still, in many of his essays, he continued to stress the dire necessity for the separation of high and low art, for avant-garde resistance to all-consuming kitsch.

Greenberg's renunciation of popular culture was the product of a general intellectual backlash against "the masses" in the late thirties and especially in the forties. Evidence that the "toiling masses" could easily turn into an irrational mob abounded, from Father Coughlin's devotees to those who nourished totalitarianism in Germany, Italy, and the Soviet Union. Intellectuals who had once trusted in the efficacy of collective reform, either liberal or leftist, now feared the growing political power of uprooted mass movements, the social base for worldwide totalitarianism. Ortega's earlier prophesied threat of "mass man" had become a horrible reality, and in the postwar era Hannah Arendt, Arthur Schlesinger, Daniel Bell, Janson, Greenberg, and Rosenberg came to denounce mass political and cultural movements openly. The origins of totalitarianism, cautioned the German-born Arendt, lay in the dismantling of law and tradition, and the attractiveness therein to the lonely and displaced modern masses.[20]

The degree to which this kind of thinking had resonance in the art world is typified in an exchange between critic James Thrall Soby and Benton in a 1951 issue of *Saturday Review*. Benton's essay, "What's Holding Back American Art?" conceded that regionalist art was now dead. He placed the blame on the collapse of the political culture to which regionalism had been attached, and on the "coteries of highbrows, of critics, college art professors, and museum boys" who preferred European modernism to the homegrown variety. His angry, emotional essay (eventually added to a revamped version of Benton's autobiography, *An Artist in America*) ended with a gossipy account of the deaths of Wood and Curry (in 1942 and 1946, respectively), focusing on their "despondency" about the demise of regionalism. Clearly,

Benton's account of their "profound self-doubts" and disillusion paralleled his own.[21]

Soby responded to Benton's essay by acknowledging the death of regionalism ("one hears the same story . . . all over the country: there is no longer anywhere a vigorous, identifiable painting of region") and observed that younger artists across America now followed an abstract style. While assailing Benton's "Philistine abuse" of art world professionals and his prewar isolationism, Soby reserved the major thrust of his essay to explain that the real reason for regionalism's demise was its dependence on mass popularity. "The arbiter of taste in art, as Mr. Benton makes clear in his article," Soby wrote, "has been for him the American public at large."[22]

Soby found this abhorrent: "one can only be appalled by the surrender of conscience as an artist to which Mr. Benton's faith in mass opinion eventually led him," and noted the following:

> In the spring of 1946, for the catalogue of his exhibition at the Associated American Artists Gallery in Chicago, [Benton] wrote what must surely be the most ignominious words of artistic abdication of recent times: "I ask then, Chicagoans, that you let the question of how 'good' these paintings are pass in favor of another question: 'How like are they to the things you know, to the experiences you have had in the America in which you live?'"

In Soby's view, Benton's focus on the doings of the American public, and by extension, allowing that public to determine his aesthetic, was simply unconscionable. Soby misread Benton's aim of public service as a surrender to "popularity."[23] But no matter; any art or artist geared toward the masses was viewed with suspicion in the postwar period.

Reneging on a previous generation's trust that humanity was rational and reformable, consensus-oriented intellectuals held that they were intrinsically irrational, even evil. Ortega, in his appropriately titled 1956 book, *The Dehumanization of Art*, discussed how the retention of the human form in some contemporary art was "romantic" and hence inappropriate for postwar modern culture. Expanding on Greenberg's arguments, Ortega explained that "truth to materials" now took precedence over "truth to nature":

> Preoccupation with the human content of the work is in principle incompatible with aesthetic enjoyment proper. . . . Even though pure art may be impossible, there doubtless can prevail a tendency

toward a purification of art. Such a tendency would effect a progressive elimination of the human, all too human elements predominant in romantic and naturalistic production. . . . The new art is an artistic art.[24]

Condemning the links between romanticism—or the display of "human elements" and their suggestion of sentimentality—and modern art, in much the same way Schlesinger damned "doughfaced" leftist optimism about human nature, Ortega made it clear that the best art for postwar America was an abstract art devoid of naturalistic elements that referred to the human condition. Reference to the masses (either on positive or negative terms) was simply too sticky an issue for postwar intellectuals; their advice was to avoid it entirely. Indeed, "aesthetic enjoyment" was not possible unless modern art was free of figuration. Joining Greenberg, Ortega aided in codifying abstract art as art for art's sake.

Ortega, Greenberg, Arendt, and other postwar writers also repudiated the notion that progress—human, historical—was possible and indeed probable. Progress was now viewed as a dangerous class-based concept, and the conservative and pessimistic concept of a "vital center" had to be stoically maintained, especially in the tense age of the Cold War. This view was held by all sorts of postwar intellectuals, including those in the art world. Summarizing the emergence of abstract art in an essay on Arshile Gorky in 1962, Harold Rosenberg remarked: "The bankruptcy of a rationale of progress in regard both to art and social history had to be acknowledged and an appeal addressed to other powers of the mind."[25]

But Rosenberg had not always been so disillusioned with human progress, social integration, and cultural collectivity. Born in Brooklyn in 1906 to Eastern European Jewish immigrants, Rosenberg's cultural interests were quite diverse. After attending City College in New York, he earned his law degree and also wrote for various avant-garde magazines in the thirties. He was an editor at *Art Front* in 1935—the year it featured the volatile debates between Benton and Stuart Davis. Also during the mid-thirties, Rosenberg assisted on various FAP mural projects. From 1938 to 1942, he worked for the WPA's Writer's Project as the national art editor for the American Guide Series, a collection of illustrated regional guides that detailed America's collective history and material culture. Throughout the 1930s (and into the 1940s) Rosenberg was affiliated with *Partisan Review,* writing poems, critical reviews, and

essays. (It was Rosenberg, in fact, who introduced Greenberg to *Partisan Review* editor Dwight Macdonald in 1938, thus setting in motion the publication of "Avant-Garde and Kitsch" in 1939.) The following poem, published in 1935, reveals the extent to which Rosenberg subscribed to a collective political sensibility:

> who thrust his fist into cities
> arriving by many ways
> watching the pavements, the factory yards,
> walked out on the platform
> raised his right arm, showing the fist clenched
> 'comrades, I bring news'[26]

In essays and reviews of the period Rosenberg determined that the goal of the modern artist was to provide a framework for social integrity and revolutionary change.

In the 1940s, Rosenberg maintained an abiding faith in marxism. He was no Communist party loyalist, however, and dramatically changed his views on how social revolution was to occur. Of the number of events that led to his crisis of confidence, from the Moscow Show trials to the Comintern's ratification of the aesthetic of social realism, the coming of world war particularly affected him. In his 1940 *Partisan Review* essay "On the Fall of Paris," he postulated that the new goal for the modern artist was to combat fascism and to do so on *individual* rather than collective terms. Modern art, Rosenberg explained, "has been a series of individual explosions tearing at strata accumulated by centuries of communal inertia." The cultural partnership of individuality and modernism was entrusted with the political responsibility of "advancing beyond the perils of Fascism and the complete host of other contemporary regressive political institutions."[27]

After the war, Rosenberg continued to revise his views on the role of the modern artist and marxism, filling his essays in *Partisan Review, Commentary,* and *Kenyon Review* with references to the proletariat and the struggle for revolutionary consciousness. As a number of his postwar essays reveal, Rosenberg's theoretical and intellectual interest in marxism was now tempered by an attentiveness to Sartre's existential writings and a focus on individual action. Rosenberg believed that revolutionary consciousness was prohibited in postwar America by the alarming strength of the culture that capitalism validated: mass culture, what Greenberg had called "kitsch." The problems with mass culture, Rosenberg explained in the 1948 *Commentary* essay "The Herd of In-

dependent Minds," were twofold: it led individuals away from "historical reality by creating illusory selves" and, once individuals had succumbed to these illusions and joined the mass "herd," it empowered regressive political authority—fascist, Stalinist, or capitalist. "We may take it for granted," Rosenberg wrote:

> that the collective experience of the Russians resembles at any given moment the version of it presented by Soviet novels and movies to roughly the same degree that the common experience of Americans corresponds to the Hollywood, TV, or Sunday Supplement presentation of it. Each American knows that these slick and *understandable* portraits are not faithful to *him*. But he does not know that they do not truly picture other Americans. In sum, mass-culture-making operates according to certain laws that cause it to be potentially "true" of the mass but inevitably false to each individual.[28]

To "break through mass culture" and reach "the actual situation from which all suffer," required, Rosenberg said, a "creative act—that is to say, an act that directly grasps the life of people during, say, a war." This act, which Rosenberg described as a "work of art," challenged the hegemony of mass culture by taking away from its audience:

> its sense of knowing where it stands in relation to what has happened to it and suggests to the audience that its situation might be quite different than it has suspected, that the situation is jammed with elements not yet perceived and lies open to the unknown, even though the event has already taken place.[29]

Thus, Rosenberg advised the modern artist with an interest in creating revolutionary consciousness in the proletariat to *act*: by developing an aesthetic which avoided the appeal of mass illusion and led its viewers to question and eventually reject the tenets of mass culture.

This aesthetic action was first and foremost individualist. After rejecting mass culture's packaging of personal experience, the artist must, Rosenberg asserted, enter into "a kind of Socratic ignorance" and accept the fact that he "cannot know, except through the lengthy unfolding of his work itself, what will prove to be central to his experiencing; it is his way of revealing his existence to his consciousness." The art that was then produced "communicates itself as an experience to others" when those observers recognize its similarity to, and also the essential individuality of, their own experiences. Their observation might even

lead to their understanding of "the presence of some common situation and the operation of some hidden human principle." Rosenberg stressed that the "authentic artist" only arrived at this common situation *at the end* of his effort." In other words, to break through mass cultural illusion and yet to create an experience—or ideology—which might be shared by the mass and perhaps incite revolutionary consciousness, the modern artist must abandon theory and intention and simply act, create. As early as 1948, then, Rosenberg had developed a framework—solidified in his 1952 essay "The American Action Painters"—which gave primacy to that art which seemingly evaded mass culture appropriation by abandoning tradition and providing an individualism which, shared, might generate social revolution.[30]

In "The Herd of Independent Minds" Rosenberg adopted the language and ideology of the existentialists, emphasizing the alienated isolation—and political responsibility—of the individual artist. He stressed in this 1948 essay that the artists' individualist focus was not at a remove from everyday social and political reality: "the isolation of an artist's work, or his personal loneliness, if that happens to be his fate, does not deprive his accomplishment of social meaning. Nor in rejecting the 'responsibility' of the representative of mass-thought for the sake of his concrete experience does he make himself an 'irresponsible.'"[31] Formulating and then sharing his personal experiences via the work he produced, the modern artist was avoiding the clichés of a suffocating mass culture and providing the fodder for revolution.

A year later, in the 1949 *Kenyon Review* essay "The Pathos of the Proletariat," Rosenberg provided a theoretical model for revolution, based essentially on the abandonment of history, of tradition. This essay, largely a critique of dialectical materialism, analyzed the precise manner in which revolutionary consciousness could be created among the "pathetic" proletariat, pathetic because of his "no" place in history. "History," Rosenberg maintained, was the history of class. Once the proletariat had discovered his or her authentic place in that history, and then *abandoned* its restrictive class bias, revolutionary consciousness could be achieved. "The proletarian revolution," Rosenberg asserted, "is to be characterized by its total abandonment of the past." Proletarians are "new men, an invention of modern time." And they are "barbarian in exactly the same manner that the American has long been Europe's barbarian."[32]

Rosenberg thus ascertained that the proletarian should model himself on the prototypical American: an individual without a sense of the

past, of tradition, of history; a modern individual who had created a new world far different—and better—than that of Europe. "The American," Rosenberg claimed, "does not mediate, he acts":

Free of traditional auras, the American stakes everything on the value of his deed. Nothing "in" objects or men checks him from changing or replacing them. Transforming landscapes, materials, memories, he "takes things in his stride," "finds the right man for the right job." He converts the past itself to his needs; to a significant degree he realizes Marx's vision of communism as a society in which "the present dominates the past."

Although his prose sounds a bit cynical, Rosenberg essentially championed this American man of "action" and urged the proletariat to become like him by denying the past, setting pragmatic goals, and acting them out. In one romantic passage he characterized the theoretical American as a "free man and master of the individual epoch." While such a statement seems to suggest an earlier generation's notion of producerist autonomy, Rosenberg's sentiment actually provides strong evidence for the hegemony of the postwar belief—among both liberals and leftists—in the unique character of American freedom. Merging consensus era concepts of individualism with the historical myth of the rugged Westerner, Rosenberg cast the active, independent American as a revolutionary figure: "Before Marx's internal pioneer opens a frontier without end." [33]

Despite his emphasis on the supremacy of this individual Americanesque action, Rosenberg recognized that socialism would only come about through community. In an interesting passage in "The Pathos of the Proletariat" he asserted that "individual existence corresponds exactly to that of the collectivity." Rosenberg now made individual and mass reform one and the same. He clarified the position he had taken a year earlier in *Commentary*: by pursuing his or her individuality, the modern artist destroyed mass culture and helped to create revolutionary circumstances for all. In his revised critique, Rosenberg argued that radical social reform "did not consist of the subjugation and elimination of individuality by a mass movement," but "the molding of individuality and community into one." As a result, the proletarian revolution "became a resolution of the antithesis between individuality and mass"and "the need for 'illusory selves' disappeared." Proletarian revolution called for "the inner alteration of men on a mass scale . . . it is a drama of self-creation." In other words, the action of individuality was as-

serted as the goal of revolution, rather than revolution (political or social) being the goal of the individual.[34]

In one sense, Rosenberg was revising Charles Beard's old world/new world dichotomy, although his celebration of the American as an individual man of action differed considerably from Beard's notion of democratic collectivity. Indeed, Rosenberg's suggestion that action, pragmatism, and independence are uniquely American qualities seems to echo the chauvinistic Depression era writings of Thomas Craven and Benton. On the other hand, in a strange and yet seemingly typical kind of postwar parallel, Rosenberg's theoretical marxism and his celebration of native virtues coincided with the ideas advanced in such tracts as Schlesinger's *Vital Center* (also published in 1949). Rosenberg implied that the disappearance of mass culture would result in the destruction of class structuring, and hence the end of class conflict: exactly what consensus-oriented liberals such as Schlesinger anticipated. Similarly, Rosenberg's emphasis on the merits of the particularly American man of action corresponded to the ideal championed by consensus era figures like Henry Luce. In postwar America, both leftist and mainstream figures abandoned the notion of class consciousness, and replaced it with an emphasis on individualism.

In his 1952 *Art News* essay "The American Action Painters" Rosenberg discussed the makers of an aesthetic model—seemingly *the* model posited in his earlier writings on marxism and modern art. Now he linked American pragmatism and alienated individualism with the abstract expressionists (he always called them action painters). Interestingly, his attention to social revolution was absent. In an essay which neither described the art nor mentioned the names of any of its practitioners, Rosenberg heroized the typical abstract expressionist painter as an individual who resisted conformity: "this new painting does not constitute a School." He was also, especially, a man of action:

> At a certain moment the canvas began to appear to one American painter after another as an arena in which to act—rather than as a space in which to reproduce, re-design, analyze or "express" an object, actual or imagined.

Abandoning history and tradition ("the painter no longer approached his easel with an image in mind"), postwar American abstract artists decided "just TO PAINT":

> Many of the painters were "Marxists" (W.P.A. unions, artists'

congresses)—they had been trying to paint Society. Others had been trying to paint Art (Cubism, Post-Impressionism)—it amounts to the same thing.

The big moment came when it was decided to paint. . . . Just TO PAINT. The gesture on the canvas was a gesture of liberation, from Value—political, aesthetic, moral.[35]

Here was an art which in its "liberation" from "Value" apparently avoided mass culture, art world, and political appropriation. It was an especially male art; like most other postwar critics, Rosenberg saw action painting almost exclusively as an all-male club, although a significant number of women—Elaine de Kooning, Helen Frankenthaler, Grace Hartigan, Lee Krasner, Joan Mitchell—pioneered postwar America with abstract art.

It was an art made by particularly *American* men of action, for whom the creation of abstract art was very much a spiritual need:

With the American, heir of the pioneer and the immigrant, the foundering of Art and Society was not experienced as a loss. On the contrary, the end of Art marked the beginning of an optimism regarding himself as an artist.

The American vanguard painter took to the white expanse of the canvas as Melville's Ishmael took to the sea. . . .

Based on the phenomenon of conversion the new movement is, with the majority of the painters, essentially a religious movement.

Emphasizing its native frontier roots and its spiritual specialness—characteristics cited throughout American history to differentiate the new world from that of Europe—Rosenberg claimed abstract expressionism as a uniquely American product. In other postwar essays, most notably "A Parable of American Painting," he elaborated on the unique cultural contributions of the action painters and other American artists (including Thomas Eakins and Albert Pinkham Ryder), calling them Coonskinners (as opposed to the art world Redcoats who followed European taste), and celebrating their nativist unconventionality and "unStyle" or "antiStyle" individualism.[36] Rosenberg's previous concentration on a universal radical culture was now replaced with a zeal for Americana.

Hand in hand with its mythical American heritage, abstract expressionism was defined as an art liberated as much from social and aesthetic values as from restrictive historical traditions, much as Rosen-

berg's theoretical American was also history-free. As he explained, "Liberation from the object meant liberation from the 'nature,' society and art already there. It [abstract art] was a movement to leave behind the self that wished to choose his future and to nullify its promissory notes to the past." Finally, Rosenberg described abstract expressionism as an art which concerned itself only with the situation of the individual: "A painting that is an act is inseparable from the biography of the artist. The painting itself is a 'moment' in the adulterated mixture of his life."[37] True to the criteria of the theoretical marxism he had laid out in the late 1940s, abstract expressionism seemingly contained all the essential ingredients to spark revolutionary consciousness.

Missing from Rosenberg's 1952 essay, however, are the specific political references that had peppered his earlier writings on modern art and marxism. Indeed, "The American Action Painters" has a peculiarly fatalistic tone, suggesting that by 1952 Rosenberg's faith in social revolution, in the proletariat, and perhaps in the ability of abstract art to maintain its autonomy, was ambivalent. Most of the essay focuses on the struggle of the abstract expressionists to distance themselves from the sociopolitical stranglehold of mass culture and to establish their art on individualist terms. But, by providing little in terms of artistic intentionality—except that these artists had decided "just TO PAINT"—Rosenberg left readers understanding abstract expressionism merely as art for art's sake. Its denial of tradition made it seem ahistorical; its value-free nature made it seem to some value-less. Rosenberg celebrated the integrity and independence of the abstract expressionist painters, explaining that the individualist thrust of their art was essential in the battle against mass culture and repressive politics. But, by failing to actually describe the art he "failed to explain how the interlaced webs of line, broad brushstrokes, and fragmented shapes of gesture painting represented opposition to Stalinism and McCarthyism."[38] As a result, the activity of the action painters became translated as simply action for action's sake; lost was its potential to spark revolutionary consciousness.

As much as Rosenberg lost faith in abstract expressionism doing much more than defending itself against the authority of postwar politics and mass culture, he also lost faith in the proletariat. Whereas in earlier writings he posited the mass impact of an individualist modern aesthetic, now he limited the audience for abstract expressionism to the educated elite. First, he blasted public disinterest in action painting, and their miscomprehension of abstract art as the "phenomena of The Age

of Queer Things." Next, he described the real audience for abstract art:

> American vanguard art needs a genuine audience—not just a market. It needs understanding—not just publicity.
>
> In our form of society, audience and understanding for advanced painting have been produced, both here and abroad, first of all by the tiny circle of poets, musicians, theoreticians, men of letters, who have sensed in their own work the presence of the new creative principle.[39]

In other words, the audience for abstract expressionism was restricted to a tiny handful of privileged intellectuals and connoisseurs. Like Greenberg, Rosenberg did not seem to find it ironic that this elite audience would find it desirable to patronize an art that both critics had initially championed as the culture of radical social change. With such an assessment, Rosenberg thus further removed abstract expressionism from its revolutionary potential.

Rosenberg certainly understood the therapeutic aim of an abstract expressionist like Pollock, who produced paintings to heal himself. He did not, however, pursue Pollock's aesthetic intentionality to its logical conclusion: that the abstract art form he offered could also serve as a therapeutic model for all alienated postwar individuals. On the evidence of his prose from the late 1940s, one assumes that Rosenberg managed to retain a certain degree of faith in marxism; one writer suggests that he "worked to find a safe haven for radical progress within the realm of individualistic culture" and, in his 1952 essay, placed abstract expressionist art "at the center of this venture."[40] But the tenuous and laborious manner in which he constructed his aesthetic-political theories eventually rendered abstract expressionism as an apolitical art form.

In their essays from the late thirties and into the forties, it is obvious that Rosenberg and Greenberg viewed avant-garde art, specifically abstract expressionism, as a vehicle for social change. It also becomes clear that both recognized and feared the enormous power of mass culture to trivialize and adulterate radical aesthetic and political intentionality. Rather than urging avant-garde artists with an interest in social reform to appropriate the tools of mass culture and manipulate and redefine that culture, their solution was to protect avant-garde art by freezing it in a no-man's-land of formalist experimentation ("flatness") and elite patronage. Protecting modern art from mass culture, they isolated it, turning it into art for art's sake. Critics who had anticipated revolution restricted themselves in the 1950s to the defense of a seemingly apoliti-

cal style of art. Like other former leftist intellectuals, in postwar America Rosenberg and Greenberg abandoned allegiance to marxist revolution in favor of the virtues of a secluded, ahistorical, and uniquely American avant-garde. It was a shift that placed them both—and abstract expressionism—securely in the camp of consensus culture.

The cultural critiques that Rosenberg and Greenberg produced after World War II parallel those of many other writers, historians, political scientists, and corporate leaders; so many that the notion of intellectual consensus is obvious. James Burnham, a founding member of the American Workers party in the 1930s, provides another excellent example of a former leftist who reneged on socialism and came to champion neoconservatism. Like other intellectuals of the period, Burnham was profoundly disillusioned by the nature of the political culture he directly experienced: the betrayal of revolutionary politics evidenced in Soviet totalitarianism, the easy persuasion of the masses suggested in the growth of modern consumerism, the irrationality of mass politics and nationalism revealed in the "total war" ideology, death camps, and atom bombs of World War II.

Burnham reacted by completely repudiating, rather than redefining, collectivist politics in the 1940s. Joining the pilgrimage to consensus, he and postwar intellectuals in a number of different fields came to dismiss their earlier defense of radical politics as adolescent aberration. Burnham's *Managerial Revolution* (1941) equated, vilified, and yet found inevitable the authority of a "power elite" (and hence, mass subjugation) in the New Deal, the Third Reich, and the Soviet Union. His postwar treatise, *The Struggle for the World*, "endorsed the Truman doctrine and the theory of containment as the only way to check Soviet expansion" and hence, totalitarianism. It was condensed in *Life* in 1947, and hundreds of readers responded. One of those—although his letter was never published—was Thomas Hart Benton, who used Burnham's book to vent his own fury and frustration at the direction postwar consensus culture had taken.[41]

In 1951 Burnham helped organize the American Committee for Cultural Freedom, a loose group of intellectuals (including Greenberg, Rosenberg, Schlesinger, and Bell) dedicated to "the survival of free speech and free thought in a world threatened by totalitarianism." Receiving a large portion of its substantial budget from the CIA, this organization of former dissidents helped to uphold "the interests of American world power." Exchanging "revolution for respectability," Burnham and other postwar figures redefined cultural freedom in terms

of corporate capitalism and consensus ideology.[42] And if an essentially apolitical individualism generated this freedom, it was consistent that social collectivity degenerated into totalitarianism. Thus, "the masses" and, by extension, any art form linked with them, threatened the freedom inherent in postwar consensus.

Placed in this context, the vicious postwar assault on regionalism by H. W. Janson and other critics becomes understandable. Regionalism, and other art styles that claimed to speak for the masses, had to be denounced and swept away to make room for an art more appropriate to consensus America: abstract expressionism. Greenberg's *Partisan Review* essays helped, by placing representational art in the kitsch category and promoting abstraction as the avant-garde answer to the aesthetic crisis of modernism.

Greenberg's revival of the distinctions between high and low culture, which Benton and other modernists had tried to merge in the thirties, was echoed throughout the American art press of the 1940s, as were the dangerous links between narrative art and nationalism. In 1940 critic Elizabeth McCausland saw an "ominous trend" in the sentimental nationalism of a show of American scene painting at the Whitney Museum. A painting by Grant Wood ("about the worst painting ever seen") was described as "a kind of cheap illustration the *Saturday Evening Post* would not stoop to." That same year the editor of *Art Digest* proposed "shelving" American scene art because "its true meaning has since been twisted and bent." In 1943 art dealer and author Samuel Kootz openly attacked the "fatuous" contentions of "America's Nationalist school," claiming both that "chauvinism of this type has always depended for its existence upon an uncultivated audience," and that the regionalists had "never really captured America." [43]

Art historian Robert Goldwater went a step further in 1945 and declared that American scene art was an historical fraud: "There is, a priori, no more a single American style than there is a preconceived American subject-matter." Other essays on contemporary art relegated the "bully-boy, xenophobic and almost secessionist" art of regionalism to the distant past. Holger Cahill, former director of the WPA, stated in 1946 that the "minus" of American scene art was its "chauvinism" and "warmed-over academic technique." He also observed that "the younger artists today" had nothing to do with such art, tending rather "toward an internationalist position more in harmony with postwar ideas." The stage was thus set for the irrevocable shift from the "perverse and inflated" propaganda of regionalism to an art more represent-

ative of consensus America.[44] Janson's equation of regionalism with Nazi art helped dramatize the exigency of the shift.

Preceding Janson's 1946 *Magazine of Art* article by six months was a lengthy analysis of "Art in the Third Reich" by Alfred Barr and critics Lincoln Kirstein and Jacques Barzun. Their *Magazine of Art* essays, accompanied by several illustrations of recent German painting and architecture, described Nazi art as that "of the lowest common denominator," "anti-imaginative, anti-psychological," and anti-modern. In addition, a number of correlations were made between Nazi and American art: Paul Mathias Padua's battle scene *10 Mai 1940* was called "the *Washington Crossing the Delaware* for the Germans," and a family portrait by Adolf Wissel was described as "a kind of Bavarian Grant Wood, but more careful, smug, and laudatory" (fig. 6.3).[45]

Intentionally or not, such comparisons helped enhance the dangerous political sentiments seemingly inherent in any representational art geared toward popular appeal. Reacting to the visual evidence of one crushed totalitarian regime and the perceived Cold War threat being made by another, these authors extended the arguments made in Greenberg's 1939 essay on avant-garde and kitsch and rewrote the history of America's socially directed prewar art. Regionalism, an aesthetic aimed at social reform and the development of a uniquely American cultural expression, was now associated with deviant mass politics. In particular, its well-publicized (and exaggerated) denunciation of European modernism, evidenced especially in Thomas Craven's biting criticism, was singled out as the American equivalent of fascist German and Stalinist Russian efforts to outlaw "degenerate" modernism.

While "leafing through" these illustrations of Nazi art in preparation for his own *Magazine of Art* essay, Janson observed that it was "difficult to suppress the feeling that a vast majority of the American public, given a choice in the matter, would agree with the policies of the Reichskulturkammer. Here, as in Germany, the man in the street regards the modern artist as a crazy, morbid charlatan." Janson's distaste for the cultural preferences he perceived of the American public (and perhaps for that public itself), and subsequently the correlations he made between regionalist and Nazi art, stem from his personal background. Born in St. Petersburg in 1913, Janson was educated in Hamburg and Munich from 1932 to 1935, and completed his Ph.D. at Harvard University in 1942. He was thus an uprooted European intellectual, much like Hannah Arendt, who had experienced firsthand the stirrings of fascism.

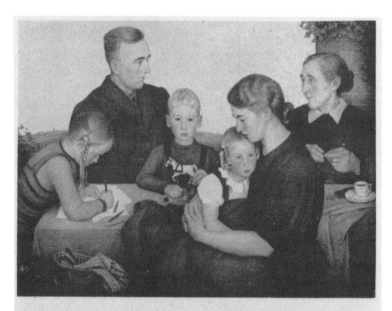

Adolf Wissel: WORKER'S FAMILY. *"A kind of Bavarian Grant Wood, but more careful, smug, and laudatory."* *Included in the Great German Art Exhibition, Munich, 1939.* BELOW: *Paul Padua:* 10TH OF MAY, 1940. *"It became the* WASHINGTON CROSSING THE DELAWARE *for the Germans of this war."*

6.3. Illustrations of Nazi art: Adolf Wissel's *Worker's Family,* c. 1933–45, and Paul Padua's *10th of May, 1940,* c. 1940–45. Reprinted from *Magazine of Art,* October 1945.

From 1939 to 1942, Janson taught at the State University of Iowa, where Grant Wood was an artist-in-residence. Not surprisingly, they did not get along. Wood apparently despised Janson's "historical or fact-memorizing approach," which he believed was "stifling the creative spirit" of the art department. And he was incensed when Janson appeared to challenge the authority of American scene art by taking a group of students to the Art Institute of Chicago to see a Picasso exhibit. In fact, Wood "helped convince the dean that Picasso was pernicious material" and Janson was fired. Although intercession by the art department chairman, Lester Longman (Wood did not get along with him, either), led to Janson's reinstatement, the entire affair must have understandably conditioned Janson's lifelong loathing of regionalist art. Throughout his career (Janson was a specialist in Italian Renaissance art history and taught at New York University from 1949 to 1979) he attacked regionalism as antiartistic antimodernism.[46] Needless to say, it was not mentioned in his *History of Art* textbook.

Janson's connection of fascism and regionalist aesthetics sounded the death knell for socially oriented representational art in postwar America, and made way for the "triumph" of abstract art. His way of thinking had an enormous impact in the art world. In a letter to painter Louis Bunce, written a month after the publication of Janson's 1946 article, Jackson Pollock wrote:

> There is an intelligent attack on Benton in this month's Magazine of Art—it's something I have felt for years. He began coming around before I moved out here. Said he liked my stuff but you know how much meaning that has.[47]

It is questionable whether or not Pollock had really "felt for years" that Benton's work was representative of dangerous political ideology. What is clear upon reading this letter is the extent to which Pollock's relation with his former teacher had broken down. In a sense, Janson's article gave Pollock permission to minimize the importance of that relationship, at a pivotal time in his career when his previous links with regionalism might diminish his esteem in the eyes of postwar critics and collectors.

That American abstraction like Pollock's was ready and waiting to take reign of the postwar art world was made clear in a collection of sixteen essays on the "State of American Art" published in 1949 by the *Magazine of Art*. Although he admitted that other trends existed, Alfred Barr declared that "a strong, broad and diversified movement toward

abstraction" characterized contemporary American art. Most of the other authors, including Cahill, Janson, and Greenberg, concurred, the latter punctuating his antirealist bias with the declaration "the naturalistic art of our time is unredeemable, as it requires only taste to discover; and the sheer multitude of those who still practice it does not make it any more valid." [48]

Janson's championship of abstract art was accompanied by a fear that it might be "crushed by public pressure." Modern art, said Janson, "must not be made dependent on mass appeal":

> It is one of the tragedies of twentieth-century civilization that the painter who has something significant to say can hope only for a very limited audience. In our age of standardized mass responses, his existence as the champion of individual experience and self-realization is increasingly precarious. This problem of survival is . . . acute. . . . whether it can be solved depends on the future course of Western civilization as a whole. [49]

Setting up a series of dependent relationships—modern abstract art and the "future" of the West, for instance, were dependent on the "survival" of individualism—Janson substantiated the ideology of consensus and equated the freedom inherent in Western, or American, culture with the individualist thrust of abstraction.

By the mid-fifties, these links between abstract art and freedom had been definitively formed. In a 1956 edition of *What Is Modern Painting?* a MOMA booklet "for people who have had little experience in looking at . . . modern paintings which are sometimes considered puzzling, difficult, incompetent or crazy," Barr made the following statement:

> looking around one, it is clear that abstract painting is the dominant, characteristic art of the mid-century. (That is, in the free world. Painters controlled by the Communists, however, are enjoined to use a realistic style.)

Although he hastened to add that "realistic" painters in postwar America were not "ordinarily Communist in sympathy," Barr's characterization of the freedom intrinsic to abstract art could not have been lost on a Cold War culture obsessed with the distinctions between itself and the Soviet Union. [50] Critical evaluations such as these translated the revolutionary art of abstract expressionism into a symbol of the freedom unique to the American way of life.

Nowhere was this symbol exploited more consistently than in the pages of *Life* magazine, which promoted, albeit often in its typically pejorative manner, postwar American abstraction throughout the late 1940s and 1950s. While shows of postwar abstract art sponsored by MOMA, the State Department, and the United States Information Agency were paraded throughout Europe to demonstrate American artistic freedom and the lack thereof for Soviet propaganda hacks, it was the mass media coverage of abstract art that truly codified its associations with consensus culture.[51] Reversing its prewar patronage of regionalist art, Time-Life, Inc., coupled abstract expressionism with internationalism and corporate liberalism, the terms by which publisher Henry Luce defined the "American Century."

In its premiere issue of 23 November 1936, *Life* had featured New Deal workers, snapshot photos of FDR's entourage, and the regionalist paintings of John Steuart Curry (fig. 3.9). A bit more than a decade later, in one typical 1949 issue, *Life* showed pictures of suburban living in Fairfield County, a photo-spread on the Marshall Plan, and the abstract expressionist paintings of Jackson Pollock, who, *Life*'s editors noted, "at the age of 37, has burst forth as the shining new phenomenon of American art" (fig. 6.4). But at *Life*, Pollock's art was more than just "new" and newsworthy, for it seemed to express the very ideals Luce associated with the American way of life: individuality and freedom.[52]

In a speech to advertisers in 1937, Luce explained that America could only be saved from the "barbarous dominion of the mass mind" when a business elite took on the "burden of ethical and cultural responsibility."[53] It was a pitch to get ad agencies to appropriate some $100 million over a ten-year period for *Life*, but it also suggests Luce's personal fear of the political stronghold of the displaced masses, the underpinning of totalitarianism. In the postwar era, Luce sided with Arendt and Greenberg and condemned collectivist politics and mass culture. The battle against mass man could only be won through the ascendancy of noble man: independent, moralistic, and cultured. In 1949, Jackson Pollock was viewed—more or less—as just such a man. *Life*'s postwar pictorial mission, then, became one of aligning its readership with an art that seemingly avoided direct reference to the much-feared mass mind and stressed instead individual creativity.

A "Round Table" discussion on modern art organized by *Life* in October 1948, featuring Greenberg, Janson, Meyer Schapiro, Aldous Huxley, and "other distinguished critics and connoisseurs," set the tone

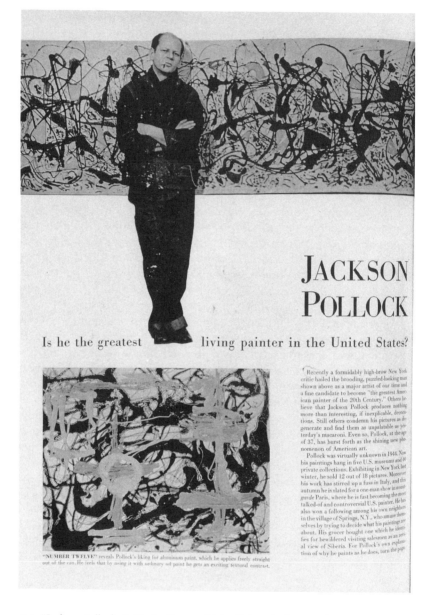

6.4. "Jackson Pollock, Is He the Greatest Living Painter in the United States?" *Life,* August 8, 1949. Reprinted with permission of Life Magazine. Copyright Time Warner, Inc.

for Time-Life's postwar cultural interests. *Fortune* had initiated these panels in the late 1930s with their discussions on international economics and the future of corporate capitalism. After the war, *Life* took the reins of heady intellectual discussion in their lengthy coverage (often over fifteen pages of dense text and few pictures) of the Round Table meetings. Like the Great Books discussions organized at Columbia and the University of Chicago, and the seminars initiated by Walter Paepcke at the Aspen Institute in the 1950s, Time-Life, Inc., was keenly involved in the creation of cultural consensus.[54]

Life's first symposium, in July 1948, focused on "The Pursuit of Happiness." Eighteen "prominent Americans," including Sidney Hook, Stuart Chase, Erich Fromm, and Betsey Barton (daughter of the advertising executive), were asked to "reinterpret in modern terms a great Jeffersonian Right." Not surprisingly, the panel came to a resounding consensus that it was "in the inner lives of men and women," rather than in an "outer" world of politics, that "the final solutions to happiness" were to be found for postwar Americans. As Betsey Barton stated:

Mystics have shown us that when they set out to achieve spiritual understanding, they cleared the way by depriving themselves of *things,* by their own will. But we are so suffocated with things and with distractions that the real pursuit of happiness is almost impossible.

I feel that we should learn how not be to afraid of being alone. Then we would not seek to run from alone-ness into distractions. If self-understanding is a component of happiness (as we agreed) this is best achieved in silence, in stillness and in solitude.[55]

Barton's comments were the complete reverse of the ideas preached by her father only a decade earlier. Notwithstanding her own personal tragedy (she lost her legs in a car crash in 1934), Betsey Barton's analysis of the third "unalienable" right of the Declaration of Independence was, typically in postwar America, equated with the search for personal, not social, wholeness. Her father's paeans to mass consumption and corporate republicanism were studiously, if somewhat ironically, avoided. The only alternative postwar liberals could offer to the "distractions" a previous age revered was to act as a "mystic," a sort of Jackson Pollock type who worked alone, "in solitude."

The *Life* Round Table panelists who discussed modern art a few months later came to similar conclusions (fig. 6.5). As "a democratic device for the exploration of important questions by many minds,"

A Life Round Table on

MODERN ART

FIFTEEN DISTINGUISHED CRITICS AND CONNOISSEURS
UNDERTAKE TO CLARIFY THE STRANGE ART OF TODAY

LIFE's first Round Table was on the Pursuit of Happiness (LIFE, July 12). Here the technique is applied to the question of modern painting. Held in the penthouse of the Museum of Modern Art in New York, attended by experts from both Europe and America, the meeting produced a lively debate. This report was written by Moderator Russell W. Davenport, who conducted the Round Table, with the collaboration of Winthrop Sargeant.

FOR about 40 years the art of painting has exhibited a variety of manifestations loosely identified in the public mind with the phrase "modern art." Originating in the works by such acknowledged masters as Cézanne, Van Gogh, Seurat and Gauguin, these manifestations made their appearance in the studios of Paris in the first decade of this century, multiplied into a kaleidoscope of new artistic styles, found a kinship with a wide variety of intellectual currents and spread throughout the world wherever artists paint. Today they confront the visitor to almost any gallery as strange distortions of reality, private nightmares, depictions of "ugly" things, human figures and objects that "look wrong," cubes and geometrical patterns that accord with nothing recognizable in nature. These "modern" works do not, of course, constitute the whole of 20th Century art. Many artists have remained quite unaffected by them, others have been influenced only during certain periods of their careers. Nevertheless it is fair to say that the "modern" movement has constituted the dominant trend in the art of our time. It has been encouraged by important institutions. It has been promoted by art dealers. And it has left behind it so much controversy and confusion that a great part of the public has become antagonistic to contemporary painting.

It is not easy to sum up the nature of modern art in a few words. Of course there are a number of official categories—cubism, surrealism, expressionism, futurism, abstractionism, nonobjectivism and so on. But when the layman uses the phrase he has in mind two particular characteristics which, for him, set this art off from more conventional painting. First of all, he finds it *difficult to understand*; secondly, he often finds that it does not concern itself with the "beautiful" but with the *"ugly" or the strange*. The layman is reassured to find that this kind of painting has drawn the fire of distinguished thinkers. Arnold Toynbee, for example, has declared that modern art is symptomatic of a decay in the moral values of our age; and in a well-known essay, *Art and the Obvious*, Aldous Huxley deplored the failure of much modern art to come to grips with what he called the "great obvious truths" of human life.

Now from the point of view of our civilization as a whole, this situation certainly has its dangers. It may well be true that there has always been a gap between the most vital art of a given period and the general public. For example, the great masters of the Renaissance may not have been immediately comprehensible to the public of their day—and for that matter they are not fully comprehensible even today to one whose education or sensitivity is deficient. Yet the gap today appears to be wider—some would even argue that it is a different kind of gap. And it leaves us with this question: How can a great civilization like ours continue to flourish without the humanizing influence of a living art that is understood and enjoyed by a large public?

In order to shed some light on this, the editors of LIFE determined to hold a Round Table on the subject in accordance with the technique already developed for the exploration of the Pursuit of Happiness (LIFE, July 12). To this end they brought together a group of distinguished critics and connoisseurs and posed to them the following question: *Is modern art, considered as a whole, a good or a bad development? That is to say, is it something that responsible people can support, or may they neglect it as a minor and impermanent phase of culture?*

It was an exciting debate documented throughout by pictures from the collection of New York's Museum of Modern Art and from other collections, many of which are reproduced herewith. The panel of 15 had traveled many miles to get there: Aldous Huxley from California; Sir Leigh Ashton and Raymond Mortimer from London; Georges Duthuit, editor of *Transition Forty-Eight*, from Paris. The "local" representatives from St. Louis, New Haven and New York were equally distinguished and are listed below. The Table was carefully balanced between those who were known to be enthusiasts for "modern art" and those who had registered serious criticisms of it. Yet even more important than the balance was the *caliber* of the participants. The object was to obtain a discussion between persons whose knowledge of art could not be questioned, irrespective of whether one might or might not agree with their evaluations.

There is no more complicated subject in the world than that of esthetics. To ask these gentlemen to be honest was, in effect, to ask them to disagree; indeed, as a number of them pointed out, if complete agreement could be reached concerning the important issues of art,

TEXT CONTINUED ON PAGE 65

WHO'S WHO AT THE ROUND TABLE (OPPOSITE)

The gentleman whose head shows in the lower left-hand corner is Clement Greenberg, *avant-garde* critic. Next, going around the table clockwise, is James W. Fosburgh, LIFE adviser; Moderator Russell W. Davenport (in light suit); Meyer Schapiro, professor of fine arts, Columbia University; Georges Duthuit, editor of *Transition Forty-Eight*, Paris, France; Aldous Huxley (leaning forward), noted author; Francis Henry Taylor (behind Mr. Huxley), director of New York's Metropolitan Museum of Art; Sir Leigh Ashton (shirtsleeves), director of Victoria & Albert Museum, London, England; R. Kirk Askew Jr., New York art dealer; Raymond Mortimer, British critic and author; Alfred Frankfurter, editor and publisher, *Art News*; Theodore Greene (head in hand), professor of philosophy, Yale; James J. Sweeney, author and lecturer; Charles Sawyer, dean of School of Fine Arts, Yale; H. W. Janson, professor of art and archaeology, Washington University, St. Louis. Not shown in this picture are A. Hyatt Mayor, curator of prints, Metropolitan Museum, New York and James Thrall Soby, chairman, Department of Painting and Sculpture, Museum of Modern Art, New York.

6.5. "A *Life* Round Table on Modern Art," *Life*, October 11, 1948. Reprinted with

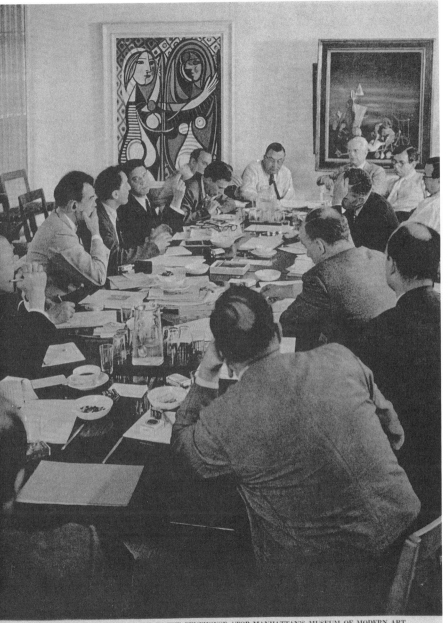

LIFE'S ROUND TABLE DELIBERATES IN THE PENTHOUSE ATOP MANHATTAN'S MUSEUM OF MODERN ART

CONTINUED ON NEXT PAGE

Life's Round Table on modern art asked: "Is modern art, considered as a whole, a good or a bad development? That is to say, is it something that responsible people can support or may they neglect it as a minor and impermanent phase of culture?" While responses were varied (Greenberg praised Pollock's 1947 picture *Cathedral* as "one of the best paintings recently produced in this country," while Huxley described it as "wallpaper"), the links between abstract art and consensus ideology were clearly made. Janson's assertion that "the modern artist . . . is preserving something that is in great danger—namely, our ability to remain individuals," was echoed by *Life*'s own observation that "the artist of today is engaged in a tremendous individualistic struggle—a struggle to discover and to assert and to express him*self*." [56]

And, *Life*'s editors declared, this struggle ("so difficult for the layman") was "one of the great assets of our civilization":

> For it is at bottom the struggle for freedom. As several at the Table pointed out, the temptation in authoritarian societies is to settle the problem of modern art by fiat. Both Hitler and Stalin have actually done so—and in both cases the artists were ordered to return to representational painting. . . . in light of it the layman, who might otherwise be disposed to throw all modern art in the ashcan, may think twice—and may on second thought reconsider.

At Time-Life, Inc., modern abstract art proved the supremacy of American postwar politics. It is worth noting that Benton sent a letter of protest to *Life*'s editors, saying their latest Round Table "certainly bolsters the Russian view that our contemporary Western art is illusory, decadent and given to an empty formalism utterly incapable of coming to grips with solid cultural meanings." [57] Benton, of course, missed the point. Abstract expressionism did not deny "solid cultural meanings," it presented them in a manner which, for consensus liberals, was seemingly indicative of postwar American political attitudes.

Despite their obvious promotion of abstraction—at least as it echoed the politics of consensus—it is also true that Time-Life, Inc., often lampooned modern art and treated it with considerable reservation. Henry Luce's own aesthetic preferences were always conservative and veered toward the anecdotal: "as a spasmodic collector of Western painting, he felt secure only as far as the postimpressionists" and "looked for the 'meaning' in every work of art." While his personal response to abstract art like Pollock's was to make light of it, he was also persuaded of its sociopolitical significance. [58] Correspondingly, Time-

Life's earliest treatment of abstract expressionism was ambivalent, bouncing between sponsorship and sarcasm.

In the pages of the Lucepress from the late forties through the mid–1950s, abstract expressionism was often described—as was almost everything—in very sardonic terms: *Life* referred to Pollock's painting style as "dribbling" in 1949; *Time* labeled him "Jack the Dripper" in 1956. But the caustic nature of their coverage does not necessarily negate Time-Life's interest and support (offhanded though it was) for American forms of abstract modernism. The fact of the matter is that rhetorical exchange at Time-Life was always ironical, with ridicule and mockery veritable magazine trademarks. Nor did Pollock seem to care about the barbs Time-Life threw at him; one biographer observes that he kept a "stack of copies of the August 8, 1949 *Life* on a kitchen shelf" and made sure "that everyone saw it."[59]

A review was a review, sarcastic or supportive. It is worth noting as well that by the later years of the 1950s, Time-Life revised its account of abstract expressionism: putting it into a particular political context, the Lucepress hailed postwar abstraction as a serious and uniquely American style of freedom, independence, and individuality.

Still, *Life's* treatment of Pollock in their 1949 article, titled "Jackson Pollock, Is He the Greatest Living Painter in the United States?" was typically dualistic, celebratory and cynical. As it did with anything that threatened the stability of consensus culture and corporate liberalism, *Life* acted to displace Pollock from the revolutionary context of his art. The article, interestingly enough, was the brainchild of former regionalist enthusiast Daniel Longwell. By 1949, Longwell was so enamoured with American abstract art that he had purchased one of Pollock's paintings and suggested that *Life's* art department "do a piece on this fella." *Life's* article described Pollock's method in typically sarcastic rhetoric: "sometimes he dribbles the paint on with a brush," and "after days of brooding and doodling, Pollock decides the painting is finished." The condescending tone of this article is obviously patriarchal and served to objectify and hence domesticate Pollock's potentially threatening art. And it worked: of the 532 letters that poured in to *Life's* editorial offices, only a handful were supportive. Most poked fun, joining in *Life's* spoof of Pollock's artistic talent, and perhaps his sanity.[60] Objectified by the corporate gaze of *Life* magazine, Pollock's art was thus conveniently construed as simply another cultural commodity, fit neatly into the consumerist orientation of postwar America. Pollock's efforts to depict postwar alienation, and offer a model for social transforma-

tion, were thus misconstrued. His true significance as a modernist seer was ignored.

Pollock's art was not the only potential threat to postwar consensus society that *Life*'s editors aimed to reduce. In September 1948, *Life* published its now famous "Country Doctor" photo-essay, which centered on the life of a small-town Colorado family doctor. Featuring pictures by W. Eugene Smith, the essay was published the same month that the Truman administration announced plans for national health insurance. Along with the American Medical Association, *Life* viewed federal interest in the health of its citizens with suspicion, particularly as compulsory health insurance threatened organized medicine's stranglehold on American health care. *Life* used the photo-essay "Country Doctor" as an "ideological tool" to help brand such proposed Fair Deal social benefits as "socialized medicine" and hence, "a threat to American freedom." [61] Their journalistic lobbying helped kill the Fair Deal plan for national health insurance.

The major menace to consensus, of course, was communism, and it was against this threat that *Life*'s editors especially directed their attention. "America," Luce had declared in his 1941 "American Century" essay, "must now undertake to be the Good Samaritan of the entire world." Celebrating America's "powerhouse" ideals of freedom and justice—and keeping in mind their contrast with Stalinist or Red Chinese totalitarianism—was the civic and moral duty of all citizens, and that included artists. Subsequently, the abstract expressionists were shown in *Life* as an "irascible" lot, individuals who had advanced beyond the need to create art for the masses and who concentrated instead on "inner" expression. Because their abstract art seemed to avoid explicit reference to domestic or international conflict and concentrated instead on personal creativity, *Life* strategically shaped it into the dominant visual expression of consensus America, where conflict was nonexistent because of certain widespread freedoms, such as that of individual expression. [62]

In one *Life* article, art historian Meyer Schapiro defended the diverse styles of the abstract expressionists as a "counter-attack on the standardization of the 20th Century," and said their paintings were among "the last hand-made, personal objects within our culture." The sense that they had been commodified in that culture was ignored. *Life*'s writers did explain, however, that while the personal art of the abstract artists may be "a source of bafflement and irritation" for the "layman," it was really a "no-holds-barred art of originality, energy, and freedom." [63]

And freedom, *Life*'s readers were told again and again, was what distinguished America from the Soviet Union. One 1955 article described how Soviet artists were forced to paint what *Life* writers called the "woeful" life of communism under the dictatorship of the socialist realist style. Another piece described the "assembly-line culture" of the U.S.S.R.: "On any given day Soviet workers all over Russia are singing the same songs, sculpturing the same skulls, seeing the same movies, reading the same books." [64]

But, *Life*'s readers were shown in the 1960 article "The Art of Russia That Nobody Sees" (fig. 6.6), so strong was the pull of creative freedom that some Russian artists were rejecting their roles as propagandists for the Soviet state and were venturing into the forbidden field of abstract art. A portrait of Lenin in "the rigidly realistic style that the Soviet government has imposed" was juxtaposed with a "Pollock-like" abstract picture by one of Moscow's "most experimental artists." [65]

The powerful style of abstract expressionism, inextricably linked with the freedom and individualism that Luce and other postwar proponents of consensus considered the bastion of the American way of life, was pictured as a triumph over Soviet oppression. *Life*'s postwar focus on abstract art thus linked modernism with the ideology of postwar consensus. But, even more, *Life*'s promotion of abstract art which heralded the freedom of individual creativity, and its rejection of the social reform orientation of regionalist art, helped steer American culture after World War II from attention to real issues of domestic conflict, such as civil rights, to those of consensus compromise. In the pages of *Life* magazine Jackson Pollock's modern art, developed to articulate and argue against the constraints of consensus, was placed in an institutional context which did not threaten but defended the political and social modes of the postwar status quo.

Life's shift from regionalism to abstract expressionism was by no means atypical. While representational art hardly disappeared after World War II, postwar criticism and art exhibitions focused on abstraction. Benton did not exhibit in New York from 1942 until 1954, when the Metropolitan Museum organized a show of regionalist pictures as "nostalgic reminders of a vanished era in recent U.S. history." [66]

Even the Associated American Artists agency, Reeves Lewenthal's once overtly chauvinist regionalist clearinghouse, began to disassociate itself from American scene art. In 1947 Lewenthal opened the Beverly Hills branch of the AAA and stocked it with contemporary abstract and surrealist pictures. An early exhibit at the new gallery featured 73 artists from eleven different countries. Although regionalist prints continued

THE ART OF RUSSIA.

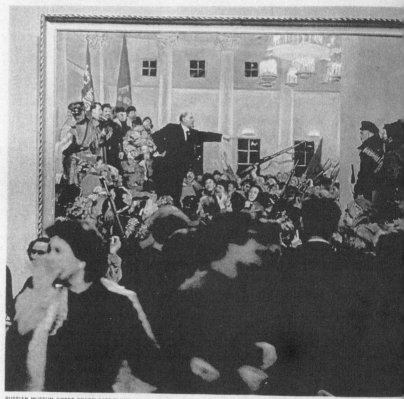

RUSSIAN MUSEUM-GOERS SWARM PAST PAINTING BY V. A. SEROV SHOWING LENIN PROCLAIMING SOVIET POWER BEFORE TUMULTUOUS REVOLUTIONA

IN AN AMAZING HIDDEN MOVEMENT, YOUNG PAINTERS
ARE GOING MODERN. HERE IS AN EXCLUSIVE REPORT

The painting above hangs for all Russians to see in a museum in Moscow. It is a standard example of the rigidly realistic style that the Soviet government has imposed upon its art for more than 30 years.

The painting opposite lies in a closet in a private home in Moscow. It is a unique example of an astounding development in Russia—a hidden rebellion of young painters and sculptors who are turning against the academic official art and experimenting in the most personal and extreme modern styles. LIFE here presents an exclusive report, the first published anywhere in color, on this secret art of Russia.

Ever since the death of Stalin, which brought a more relaxed atmosphere, a growing number of young Russians have been cautiously exploring modern art. Working quietly at home, they have tried to catch

up with the innovations they have heard about and have see ductions or in rare exhibitions of foreign art that have been p Russia. Because they have largely concealed their work and sue of their activities, Soviet officials have not clamped down

The experiments of these creative young artists are not the ern works hidden in Russia today. In museum storerooms masterpieces by Russia's famous pioneers—Kandinsky, Cha vich—as well as a remarkable unknown master named Filono the others, was denounced by Communists for "bourgeois d On the following pages LIFE reproduces some of these hidde which were photographed by U.S. Writer Alexander Marsha the few Westerners allowed to penetrate the hidden world of R

6.6. "The Art of Russia That Nobody Sees," *Life*, March 28, 1960. Reprinted with

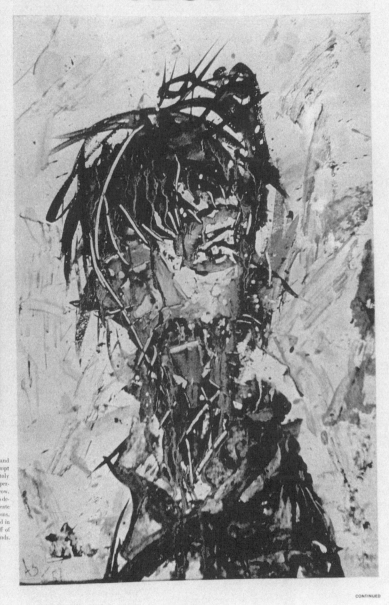

and
:mpt
ltoly
sper-
cow,
o de-
reate
ions,
ed in
off of
:nds.

CONTINUED

to be (quietly) marketed, the AAA announced it was now exploring "New Frontiers in American Art" in its magazine advertisements. Certainly, Lewenthal knew that this was also the title of Samuel Kootz's 1943 book linking regionalism with fascism. Lewenthal later said the gallery's shift was simply the result of art world "fashion," but it was obviously planned to mesh with postwar cultural attitudes. He opened a "Division for Latin American Art" after the war and described it as "another step in the general direction of international cultural exchange." [67] Lifting the taint of nationalism from his gallery, Lewenthal led the AAA into the global mode of the "American Century."

And, while the AAA had always linked culture with consumerism, it did so blatantly after the postwar. All manner of art, from regionalist to abstract, was appropriated as household goods: furniture, lampshades, vases, curtains, wallpaper. Grant Wood's 1931 painting *Midnight Ride of Paul Revere* and several nonobjective paintings by other artists were translated into "art by the yard" and manufactured as ready-made draperies, dust ruffles, and couch covers. Other artworks became the design fodder for Stonelain, an artsy ceramic ware that Lewenthal touted with this appeal:

> We have entered the field of home accessories in the belief that an important contribution can be made by uniting the efforts of American artists and craftsmen to make the vessels man uses daily a more beautiful part of his life, to add to them that touch of creativity which raises them above the level of pure utilitarianism into the realm of art. [68]

Despite the separatist efforts of Greenberg and Rosenberg, abstract expressionist paintings were also treated as "home accessories." In an April 1950 *Vogue* layout, titled "Make Up Your Mind: One-Picture Wall or Many-Picture Wall," the spirituality of Mark Rothko's luminous abstractions was reduced to "wall space" decoration. Juxtaposed with the cluttered look of a multipictured wall, a spare room featuring only Rothko's *Number Eight* (1950) and a low-level coffee table was touted as the more "strikingly beautiful" example of interior design (fig. 6.7). Rothko's canvas, the copy read:

> not only dominates the wall (it is eight feet high by five feet wide), but animates the whole room with a glowing sense of space and light and liberated shapes. The boldly sparse wall suggests a single guest of honour, serenity, undefined vistas, and an intangible excitement—it has its own diversity. [69]

In the pages of *Vogue,* postwar abstraction served exclusively as domestic merchandise. Still, its "liberated" look was a bold reminder of the tenets of postwar liberalism.

Nor did Pollock's postwar pictures escape commodification. Although he clearly understood the dangers in creating art for advertising—the fate of his former teacher should have been memorable—in 1948 Pollock allowed one of his drawings to promote County Homes, Inc., a Tarrytown, New York, real estate outfit (fig. 6.8). The firm was doing its part in fighting the postwar housing crunch and accelerating suburban flight. "Avoiding, like a plague, the too-familiar horrors suggested by the word 'development'" it offered, instead, exclusive estate-like country houses in Tappan Hill. Pollock's small drawing, as Guilbaut notes, was used to market luxury living to an upscale clientele.[70] The ad-copy appealed to them in particular, capitalizing on their discomfort with urban blight—and yet their dependence on New York City jobs—by emphasizing that "windows stay clean for months" in the suburbs and "commuting time" from Tappan Hill to Manhattan was only 35 minutes.

While Pollock's abstract art challenged the sociopolitical conditions of postwar America—conditions which fostered these suburban developments—he nevertheless accepted this art-for-business assignment. Unlike Benton's dualistic interest in linking regionalist art with advertising, by which he hoped to make money and create social reform, Pollock's interest was probably only financial: the abundance of coverage in *Time, Life,* and the art press gained the abstract expressionists critical fame, but little monetary success. Indeed, art market sluggishness persisted until the mid-1950s; only then would Pollock and others reach some degree of financial autonomy.[71]

The drawing used in the County Homes advertisement was sufficiently ambiguous to mask Pollock's genuine feelings about the real estate company; theoretically, their abstract style helped postwar artists avoid ideological contamination. But, County Homes, Inc., made the most of Pollock's art, noting that he and other artists in its campaign (including Gottlieb) found it "unusual" to be asked to participate. This, of course, was the ad's hook: both abstract art and the houses it endorsed were represented as being clearly distinct from the undistinguished aesthetic preferences of the middle-class American public. In this context, even supposedly ideology-free abstraction could be used to vest corporate capitalist authority.

The drip style of Pollock's paintings came to be appropriated for a variety of postwar uses. In March 1951, *Vogue* photographer Cecil Bea-

Make up your mind:

ONE-PICTURE WALL *or*
MANY-PICTURE WALL

Although they may seem dissimilar at first glance, the designs of the wall spaces in these two photographs come from the same impulse—the use of a variety of shapes and colours to make a single design. It is strikingly beautiful to use one enormous non-objective painting which contains, in one composition, the colour and shape variations of three or four smaller paintings. Instead of a group of paintings, separated by frames, there is only one—and that one is unframed.

Below: The wall space used for a composite still-life of small prints, paintings, and objects ... a dark-painted wall arranged in an abstract pattern of Piranesi prints, Michelangelo drawings, a bust of Hermes, a *collage* of stones, old English prints and prints of sea captains, Greek medallions, and random paintings. The artfully cluttered wall gives the effect of intimacy, of a group of compatible guests, of gaiety and spontaneity—it has its own unity.

Opposite: The wall space used for a single still-life composed of abstract gradations of line and colour ... Rothko's luminous canvas, that not only dominates the wall (it is eight feet high by five feet wide), but animates the whole room with a glowing sense of space and light and liberated shapes. The boldly sparse wall suggests a single guest of honour, serenity, undefined vistas, and an intangible excitement—it has its own diversity.

SCOTT HYDE

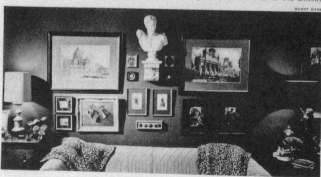

Above: THE MANY-PICTURED WALL IN THE
NEW YORK APARTMENT OF EMMETT DAVIS.
Opposite: THE ONE-PICTURE WALL. A PAINTING
BY MARK ROTHKO, "NUMBER EIGHT."

RAWLINGS

ROTHKO FROM THE BETTY PARSONS GALLERY

6.7. "Make Up Your Mind: One-Picture Wall or Many-Picture Wall," *Vogue,* April 15, 1950, featuring Mark Rothko's *Number Eight,* 1950. Courtesy of Vogue. Copyright

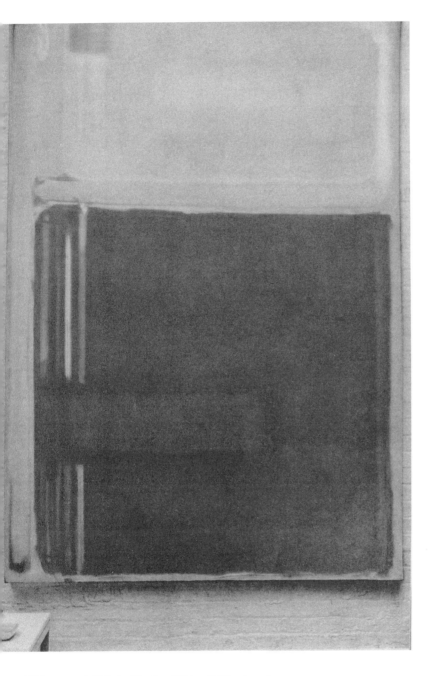

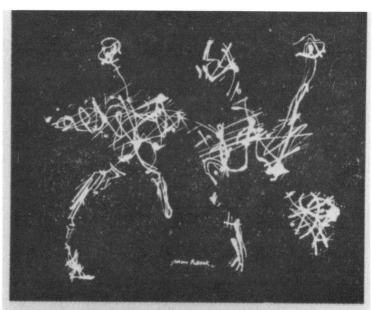

Drawing (1948), by Jackson Pollock Courtesy of County Homes, Inc.

WE ASKED Jackson Pollock to draw this picture to help tell PR readers what County Homes is doing about housing. This is the second of a series by contemporary artists, all of whom find it unusual to illustrate a real estate advertisement.

THE UNUSUAL, however, is our business. We sell land and build houses; the results are extraordinary in that they fit both their surroundings and the ideas of their owners to such a satisfactory degree. You may buy our land and use your own architect and builders, or County Homes will handle all the elements involved in building or reconverting, from the first plan to the intricacies of home financing. Anyone who can afford $150 rent for a New York apartment can buy or build on the banks of the Hudson, where windows stay clean for months. Land is available from ¼-acre up. Commuting time: 35 minutes.

RIGHT NOW we are putting nine large estates, ghosts of a past era, back into use—dividing them into sites of more reasonable size but avoiding, like a plague, the too-familiar horrors suggested by the word "development." We are preserving the individuality, the magnificent, natural landscaping, and the privacy the original owners enjoyed. We want you to see this work. We should like to show you some of the remarkable houses already complete, and suggest the possibilities in property still available. Our Tappan Hill office is a pleasant 40 minute drive up the Sawmill River Parkway, or we shall be glad to meet you at the Tarrytown Station.

COUNTY HOMES, Inc. DAVID SWOPE, President
Tappan Hill
Tarrytown, N. Y. Tarrytown 4-3034

6.8. Advertisement for County Homes, *Partisan Review,* September 1948, featuring a drawing by Jackson Pollock. Copyright 1990 Pollock-Krasner Foundation/ARS N.Y.

ton posed models in ball gowns against backdrops of Pollock's pictures, on view at the Betty Parsons Gallery (fig. 6.9). The effect was to make the taffeta and silk dresses all the more visually appealing; elegant but restrained outfits were elevated to the category of extraordinary. Within a short period of time the background appeal of Pollock's pictures became foremost: *Vogue* layouts from 1952–53 show the use of Pollock-like splatters and drips in fashion design (fig. 6.10).[72] It was Greenberg's worst dream come true: abstract art commodified as kitsch. But, by defining the modern art of abstract expressionism on purely formalist terms and by linking it with the consumerist and political culture of postwar America, Greenberg more or less aided in its appropriation.

Jackson Pollock and Thomas Hart Benton reacted to this neutralizing institutionalization of their modern art (which, to no small degree, both had assisted) in different ways. While Clyfford Still instructed gallery dealer Parsons to show his paintings "only to those who may have some insight into the values involved" and said Greenberg and Barr were to be "categorically rejected" from viewing them, Pollock was not so forthright. Parsons (Pollock's dealer from 1947 to 1951) allowed *Vogue* to commodify abstract expressionism because she hoped their articles would sell the art. Prices for abstract paintings had increased dramatically (asking prices for Pollock's pictures went from a few hundred dollars to $3,000 by 1950), but sales were slow.[73] Perhaps a few fashion layouts and home-design features in *Vogue* could sell abstract art. Some of the artists in her stable objected to this utilitarian treatment of their work, but Pollock apparently did not; he wanted to live off the sale of his work.

In fact, when Reeves Lewenthal approached him in 1951 about doing something with the AAA gallery (possibly a mural), Pollock seriously considered it. In a letter to friends he wrote that the AAA was "a Department store of painting (most of it junk) but they do a terrific business."[74] Although nothing came of Lewenthal's offer, it is clear that Pollock did not find the marketing of his art in *Vogue* or at the AAA abhorrent. Despite the fact that Ad Reinhardt found such art-for-business activities tantamount to aesthetic suicide (see his satirical 1946 cartoon, fig. 5.16), it seems that Pollock seemed unaware of the damage it might do to his—or his art's—reputation. Presumably, the abstract style of his paintings would prevent their political or social manipulation.

Pollock's reaction to *Life*'s interest in his work was a bit more speculative, and ambivalent; perhaps because he was confronted firsthand with the power of the Lucepress to create fame and popularity, and also

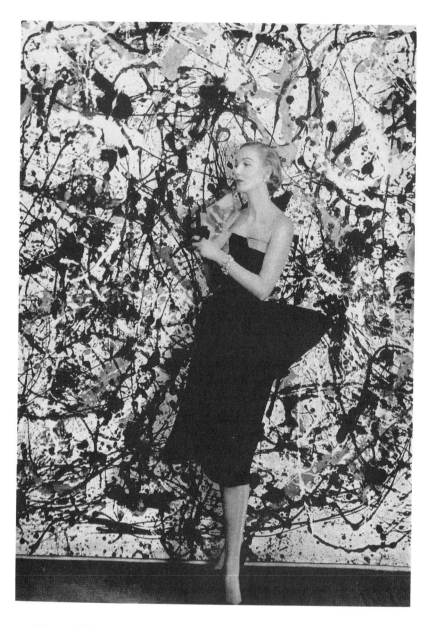

6.9. "Spring Ball Gowns," *Vogue*, March 1, 1951, featuring photographs by Cecil Beaton of models posed in front of paintings by Jackson Pollock. Courtesy of Vogue. Copyright 1951, renewed 1979, by The Condé Nast Publications, Inc.

to distort aesthetic meaning. Friends noted that he was "proud" that *Life* had—offhandedly—declared him the greatest painter in America in 1949. But, artist James Brooks reveals that *Life*'s coverage made Pollock feel uneasily "self-conscious" at a time when "the only way he could work was unselfconsciously." Betty Parsons recalled that Pollock "thought fame was a huge responsibility. The more successful he got, the more nervous he got . . . and the more he drank." Another friend reminisced: "Jackson said to me about the *Life* double-page spread, 'They only want me on top of the heap so they can push me off.'" Pollock himself complained to Jeffrey Potter that patronage by *Life* was "like death. . . . you're not your own you any more." Still, he did not reject it. It helped sell pictures, and after 1949 Pollock lived (although not extremely well) off the sale of his work.[75]

But, consistent with his antiauthoritarian nature and perhaps feeling a certain loss of autonomy in his acceptance by the very sociopolitical institutions that he and his abstract expressionist art opposed, Pollock dramatically changed his style in 1951. The drip pictures were abandoned in favor of such works as *Number 27, 1951* (fig. 6.11), which showed mutilated human figures and faces. Not surprisingly, Pollock's reintroduction of subject matter in these "black paintings" astounded postwar critics, some of whom condemned his "return to the figure." Greenberg initially treated them favorably but later wrote that after 1951 Pollock was "profoundly unsure of himself," suggesting that his black paintings were eminently forgettable. The works did not sell, either; collectors wanted only the much-vaunted drip paintings.[76] Pollock persisted with his new style, but he also resumed drinking. From 1952 to 1956 he produced few works, completing only two paintings in the last three years of his life.

Pollock died on 11 August 1956 of massive head injuries sustained in a "drunken, probably suicidal" car crash. His obituary in *Life*, entitled "Rebel Artist's Tragic Ending," summarized his consensus commodification:

> Pollock's method made him famous. His style, with its restless activity of color and dramatic textures, stirred a whole generation of young American painters. His designs have found their way into everyday things like fabrics and his paintings, which sell today for as much as $10,000, are in nearly every major U.S. gallery.[77]

Reducing Pollock's revolutionary art to the "restless activity" of painterly form and the "designs" of consumer goods, *Life* completed its "ap-

6.10. Two examples of drip-style fashion design in *Vogue*, March 1952 and April 1953. Courtesy of Vogue. Copyright 1952, renewed 1980, and 1953, renewed 1981, by The Condé Nast Publications, Inc.

propriation of oppositional practices" and contributed to the misconstruction of modernism. Hinting of Pollock's influence on "young American painters," *Life*'s editors articulated the cultural legitimacy of future abstract art, and in so doing gave a veritable road map to art world success for the next avant-garde generational outburst—the Pop art movement.[78]

The Valentina idea

Valentina works from the figure first—and the fashion just comes naturally. Practically no one can relate those two factions better than she— one reason why this serious and accomplished designer has a unique place in American design. People who judge her solely by her exotic first-night appearances, or the "meenk is for football" gag, would be bowled over if they saw her in the fitting room. And she *is* in the fitting room for every fitting. Her scrutiny is intense, her directions practically surgical. She has never designed anything that deforms the body (constricted waists or distended hips), for her idea is to perfect the natural figure, and to make clothes that work. This is not surprising: her first designing successes were for the theatre, beginning with *Come of Age*, in 1934, and continuing brilliantly with the costumes for (among others) *Amphitryon 38, Idiot's Delight*, and, this year, for the modern-dress *As You Like It* that will be part of London's Coronation excitement. Valentina has her own ideas about materials, uses a superb quality of timeless ones: antelope, poult-de-soie, crêpe, embroidered organdie, classic wools . . . and she uses them as a non-conformist. (She was the first to design an embroidered organdie winter ball dress.) She has a genius for planning clothes that work together: a coat, suit, dress, blouse, shorts, and separate skirts, that relate in colour and material, so that, as Valentina says, "the woman is all of one piece" for a season or a journey.

On this page: A suit in black summer-weight duvetine (as black as black comes).
Below: Pale-blue organdie, all shape—and embroidered in black velvet.
Facing page: Black cotton piqué dress shaped with two petticoats; white batiste under a strong yellow taffeta one. A natural straw hat.

LIFE, APRIL 6, 1953

73

Pollock's former teacher did not react quite so passively to the institutional seizure of ideals he still held in great esteem immediately after the Second World War. In March 1947 *Life* published a condensed version of *The Struggle for the World,* James Burnham's summons for an

6.11. Jackson Pollock, *Number 27, 1951*, 1951; enamel on canvas, 55 ¾″ × 73″. Private Collection. Copyright 1990 Pollock-Krasner Foundation/ARS N.Y.

American crusade against communism. Letters to *Life*'s editors poured in over the next few months (running, interestingly enough, about two-to-one against Burnham), including a five-page, single-spaced dispatch from Benton—never published.[79]

Siding with Burnham that the United States was ill-prepared to fight communism, Benton found that "the lack of realism which Mr. Burnham deplores in our foreign policy" had its "stronghold" in American mass media:

> the American radio, the movies, the advertising business, and a hell of a lot of the press are now engaged in a highly organized murdering, raping and burning of all the values of American political and economic freedom. They are making outright and conscious sham [of] our chief national characteristics.

Seconding Burnham's conviction that "if we believe in democracy we must suppress the Communist party," Benton added that the "business

parties" who controlled American mass media must also be suppressed, for they, "as surely as the Communist party itself," were "engaged in the business of wrecking democracy." The "syrupy and disgusting broth" of the movies, the "idiotic gags" on radio shows, and the "fraud" of advertising were "so stupefying" Americans that in a decade, Benton predicted, "all power of judging and acting intelligently will have been drugged out of existence." Democracy, he warned, "cannot survive" without a "reasonable and intelligent populace"; to ensure its continuation the media had to be controlled and directed "to social purposes." Benton's vitriolic outburst echoes that of Vic Norman in the 1947 film *The Hucksters*: just out of the army, Vic angrily remarks that in his four-year absence radio ads have "gotten worse" because they treat the public as "dolts."

Benton's letter might be read as simply an hysterical Cold War call to arms against international communism and homebound moral degeneration. It is certainly that. But, his scathing denunciation of mass culture suggests a personal agenda as well. Benton, who had once aligned himself and his reformist art with Hollywood and the "advertising game," was now horrified at what he saw as their destruction of his dream of a reinvigorated form of republicanism. Diverting the public from issues of social reform "in the chase for immediate profits," the media was "breaking down the moral fiber of America and opening the country up to easy capture by the very people they most hate and fear." Benton recognized that the progressive ideology he had espoused for over three decades was now in steady decline, trampled by the profit-motive of corporate capitalism and ignored by an American public pacified through dreams of abundance and consumerism.

While Benton found this abhorrent, his only solution was censorship. Gone were dreams of collective social action: the "business parties" of the motion picture industry, of radio, and of advertising had destroyed the minds of the masses he once championed. He was still fighting for them, but regionalist art alone was not going to generate the better future he hoped for. Realizing that censorship was not exactly the "democratic" method of solving social ills, Benton did end his unpublished letter to *Life* by begging the moguls of mass media to "wake up and stop the foolishness while you can and help channel American society into something sane and hopeful and worth fighting for."

True to the republican idealism he inherited from his father and his great-uncle, Benton thus demonstrated his desire to continue the quest for social change. Like their's, Benton's downfall was the result of a per-

sonal allegiance to partisan politics, in his case the reform aesthetic of regionalism. Years later his daughter, Jessie Benton, would recall that her father's absorption in political culture, in fact, took precedence over—and certainly colored—his aesthetic attention: "He was like an old time Missouri politician. He was so interested in politics that I think I knew more about politics by the time I was a teenager than I knew about art." [80]

Benton's 1947 letter to *Life* obviously reflected his own loss of autonomy and feeling of alienation in postwar America. In the 1930s, Benton had tried to unify American culture through the regeneration and redefinition of the producer tradition. It is ironic that a similar rhetoric of unity was touted in the 1940s and 1950s by the proponents of consensus culture, although in considerably distorted terms. His regionalist art had dominated American culture throughout the Depression with its public, popular culture appeal and its links to the liberal politics of the New Deal. It failed to retain its dominance after the war because of those political links.

Still, Benton persisted with the regionalist style, painting literally until the day he died, on 19 January 1975. Exhibits of his work were mounted occasionally, although always as nostalgic retrospectives of a "vanished era" in American art history.[81] By choosing to remain a regionalist in a culture clearly committed to consensus politics, consumerism, and the Cold War, Benton became an outsider in postwar America. Ironically, the student who succeeded him, who, postwar critics and corporate leaders felt, embodied the political sensibility of this consensus culture, was also an outsider. Both Benton and Pollock had subscribed to a modern art of social reform, and both saw it commodified and rendered meaningless by corporate and political forces neither believed they could control.

Not until a future generation of artists—ironically called postmodernists—reckoned with the institutional manipulation of public engagement, would American culture be returned to the realm of social reform. Articulating the dispiriting effects of cultural hegemony and misappropriation, challenging the authority with which art has been institutionalized and commodified, and offering cultural critiques (most notably feminist) which insist on social and political transformation, postmodern artists in the late twentieth-century struggle to relegitimize art as an agent of radical change.[82] For them, the experience of Benton and Pollock in the shift from regionalism to abstract expressionism, may prove to be highly informative.

1. H[orst] W[oldemar] Janson, "Benton and Wood, Champions of Region-alism," *Magazine of Art* 39, no. 5 (May 1946): 184–86, 198–200. Janson's *History of Art* (New York: Abrams) was first published in 1962.

2. Janson, "Benton and Wood," 184; also "The State of Modern Art," *Magazine of Art* 42, no. 3 (March 1949): 96; and "Philip Guston," *Magazine of Art* 40, no. 2 (February 1947): 56.

3. Clement Greenberg, "Review of Exhibitions of Mondrian, Kandinsky, and Pollock," *The Nation*, April 7, 1945, reprinted in John O'Brian, ed., *Arrogant Purpose*, vol. 2 of *Clement Greenberg: The Collected Essays and Criticism* (Chicago: University of Chicago Press, 1986), 16.

Irving Sandler provides one account of the emergence of abstract expressionism in postwar America in *The Triumph of American Painting: A History of Abstract Expressionism* (New York: Harper & Row, 1970). For a revisionist account, see Serge Guilbaut, *How New York Stole the Idea of Modern Art: Abstract Expressionism, Freedom, and the Cold War* (Chicago: University of Chicago Press, 1983).

4. Matthew Baigell notes the allegorical theme of Benton's mural in *Thomas Hart Benton* (New York: Abrams, 1975), 122–23.

5. Richard Pells, *The Liberal Mind in a Conservative Age* (New York: Harper & Row, 1985), 186–87.

6. See Guilbaut, *How New York Stole the Idea of Modern Art*, and Max Kozloff, "American Painting during the Cold War," *Artforum* 11 (May 1973): 43–54; Eva Cockcroft, "Abstract Expressionism: Weapon of the Cold War," *Artforum* 12 (June 1974): 39–41; Jane de Hart Mathews, "Art and Politics in Cold War America," *American Historical Review* 81 (October 1976): 762–87; Cecile Shapiro and David Shapiro, "Abstract Expressionism: The Politics of Apolitical Painting," *Prospects* 3 (1977): 175–214.

7. On the labeling of the abstract expressionists, see Annette Cox, *Art as Politics: The Abstract Expressionist Avant-Garde and Society* (Ann Arbor: UMI Research Press, 1982, 1977), 3–5; on the obstacles to their collective identity, see Michael Leja, "The Formation of an Avant-Garde in New York," *Abstract Expressionism: The Critical Developments* (New York: Harry N. Abrams, 1987), 22–23.

8. For biographical information, see John O'Brian's introduction to *Perceptions and Judgments, 1939–1944*, vol. 1 of *Clement Greenberg: The Collected Essays* (Chicago: University of Chicago Press, 1986), pp. xix–xx, and "Chronology to 1949," pp. 253–55. Greenberg described his lack of business acumen in his entry in *Twentieth Century Authors: A Biographical Dictionary of Modern Literature*, First Supplement, ed. Stanley Kunitz (New York: H. W. Wilson, 1955), p. 386. See also Cox, *Art as Politics*, p. 144. Greenberg's 1939 review of Brecht is reproduced in *Perceptions and Judgments*, pp. 3–5.

9. Clark, "Clement Greenberg's Theory of Art," *Critical Inquiry* 9, no. 1 (September 1982): 139–56, reproduced in *Pollock and After: The Critical Debate*, ed. Francis Frascina (New York: Harper & Row, 1985), 48.

10. Greenberg, "Avant-Garde and Kitsch," *Partisan Review* 6, no. 5 (Fall 1939): 34–39, reproduced in *Perceptions and Judgments*, 5–22. Quotes here are from pp. 11–14. For critical analysis of this essay, see Clark, "Clement Greenberg's Theory of Art"; Paul Hart, "The Essential Legacy of Clement Greenberg from the Era of Stalin and Hitler," *Oxford Art Journal* 11, no. 1 (1988): 76–87; and James D. Herbert, *The Political Origins of Abstract-Expressionist Art Criticism: The Early Theoretical and Critical Writings of Clement Greenberg and Harold Rosenberg*, Stanford Honors Essay in Humanities, no. 28 (Stanford: Stanford University Humanities Honors Program, 1985), 3–8.

11. Greenberg, "Avant-Garde and Kitsch," in *Perceptions and Judgments*, 20.

12. Greenberg, "Avant-Garde and Kitsch," 8.

13. On Greenberg and *Partisan Review* in the late thirties, see Richard Pells, *Radical Visions and American Dreams* (New York: Harper & Row, 1973), 334–39; Terry Cooney, *The Rise of the New York Intellectuals* (Madison: University of Wisconsin Press, 1986), 211–12; and Fred Orton and Griselda Pollock, "Avant-Gardes and Partisans Reviewed," *Art History* 4, no. 3 (September 1981): 304–27, where Trotsky is quoted on p. 311. Revising a 1957 essay, Greenberg commented about anti-Stalinism in "The Late Thirties in New York," *Art and Culture* (Boston: Beacon Press, 1961), 230.

14. Greenberg, "Avant-Garde and Kitsch," 10.

15. Greenberg, "Towards a Newer Laocoön," *Partisan Review* 7, no. 4 (July–August 1940): 296–310, reproduced in *Perceptions and Judgments*, pp. 23–38. Quotes are from pp. 34, 37.

16. Greenberg, "Towards a Newer Laocoön," pp. 35–36, and "Our Period Style," *Partisan Review* 16, no. 11 (November 1949): 1138, reproduced in *Arrogant Purpose*, 322–26, esp. 326. On Greenberg's writings on postwar patronage of the avant-garde, see Herbert, *The Political Origins of Abstract-Expressionist Art Criticism*, 9–11; for facts on that patronage, see Deirdre Robson, "The Market for Abstract Expressionism: The Time Lag between Critical and Commercial Acceptance," *Archives of American Art Journal* 25, no. 3 (1985): 19–23.

17. Greenberg, "The Present Prospects of American Painting and Sculpture," *Horizon* 16, nos. 93–94 (October 1947): 29, reproduced in *Arrogant Purpose*, 160–70, esp. 163, 166.

18. Greenberg, "The Decline of Cubism," *Partisan Review* 10, no. 3 (March 1948): 369, reproduced in *Arrogant Purpose*, 211–15, esp. 215. See also Cox, *Art as Politics*, 157.

19. Hart, "The Essential Legacy of Clement Greenberg," 86.

20. Hannah Arendt, *Totalitarianism,* Part 3 of *The Origins of Totalitarianism* (New York: Harcourt Brace Jovanovich, 1951).

21. Benton, "What's Holding Back American Art," *Saturday Review of Literature,* December 15, 1951, pp. 9–11, 38; James Thrall Soby, "A Reply to Mr. Benton," *Saturday Review of Literature,* December 15, 1951, pp. 11–12.

22. Soby, "A Reply," 11–12.

23. Ibid., 12.

24. Ortega, *The Dehumanization of Art* (New York: Doubleday, 1956), 9, 11–12, quoted in Lucy Lippard, *Ad Reinhardt* (New York: Abrams, 1981), 47.

25. Rosenberg, *Arshile Gorky* (New York: Horizon Press, 1962), 94, quoted in Stephen C. Foster, *The Critics of Abstract Expressionism* (Ann Arbor: UMI Research Press, 1980), 58.

26. For biographical information, see Cox, *Art as Politics,* 130, and Dore Ashton, *The New York School: A Cultural Reckoning* (New York: Penguin Books, 1972), 163. On Rosenberg and Greenberg at *Partisan Review,* see Hart, "The Essential Legacy of Clement Greenberg," 77–78. Rosenberg's 1935 poem (reprinted in Foster, *The Critics of Abstract Expressionism,* 23) was published in the essay "The Front," *Partisan Review* 2, no. 6 (January-February 1935): 75.

27. Rosenberg, "On the Fall of Paris," *Partisan Review* 7, no. 6 (November-December 1940): 443. Herbert discusses Rosenberg's synthesis of modern art and individualism in *The Political Origins of Abstract-Expressionist Art Criticism,* 16.

28. Rosenberg, "The Herd of Independent Minds," *Discovering the Present: Three Decades in Art, Culture, and Politics* (Chicago: University of Chicago Press, 1973), 18.

29. Rosenberg, "The Herd," 19, 27.

30. Ibid., 27; "The American Action Painters," *Art News* 51, no. 8 (December 1952): 22–23, 48–50.

31. Rosenberg, "The Herd," 27–28.

32. Rosenberg, "The Pathos of the Proletariat," *Kenyon Review* 11, no. 4 (Autumn 1949): 602–3, 605.

33. Rosenberg, "The Pathos," 606–10.

34. Rosenberg, "The Pathos," 611–12; Herbert, *The Political Origins of Abstract-Expressionist Art Criticism,* 19.

35. Rosenberg, "The American," 22–23.

36. Rosenberg, "The American," 48, and "Parable of American Painting," *The Tradition of the New* (New York: Horizon Press, 1959), 21.

37. Rosenberg, "The American," 23, 48.

38. Cox, *Art as Politics,* 137.

39. Rosenberg, "The American," 50.

40. Herbert, *The Political Origins of Abstract-Expressionist Art Criticism,* 2.

41. On Burnham, see John P. Diggins, *Up from Communism: Conservative*

Odysseys in American Intellectual History (New York: Harper & Row, 1975), 160–98, 303–37; Pells, *The Liberal Mind*, 77–80; and Alan Wald, *The Rise and Decline of the Anti-Stalinist Left from the 1930s to the 1980s* (Chapel Hill: University of North Carolina Press, 1987), 176–82, 280–81. A condensed version of *The Struggle for the World* (New York: John Day, 1947) appeared in *Life* 22, no. 13 (March 31, 1947): 59–60, 62–80.

42. Christopher Lasch notes the connections between the CIA and the ACCF in "The Cultural Cold War: A Short History of the Congress for Cultural Freedom," in Barton J. Bernstein, ed., *Towards a New Past: Dissenting Essays in American History* (New York: Pantheon Books, 1968), 348–51.

43. Elizabeth McCausland, quoted in "Ominous," *Art Digest* 14, no. 9 (February 1, 1940): 31; idem, "Shelving 'American Scene,'" *Art Digest* 14, no. 16 (May 15, 1940): 3; Samuel Kootz, *New Frontiers in American Painting* (New York: Hastings House, 1943), 10–14.

44. Robert Goldwater, "Abraham Rattner: An American Internationalist at Home," *Art in America* 33, no. 2 (April 1945): 84; James Thrall Soby, *Romantic Painting in America* (New York: Museum of Modern Art, 1943), 45; Holger Cahill, "In Our Time," *Magazine of Art* 39, no. 7 (November 1946): 309, 319.

45. See "Art in the Third Reich," *Magazine of Art* 38, no. 6 (October 1945): 211–41. Barr's essay was written in 1933.

46. Janson, "Benton and Wood," 184. Grant Wood, letter to Earl Harper, director, School of Fine Arts, State University of Iowa, January 26, 1940; courtesy of James Dennis and the Grant Wood Archives, University of Iowa. Janson died in 1982, and his biography is briefly noted in *Burlington Magazine* 125, no. 961 (April 1983): 226. Janson noted his dismissal in "Artists and Art Historians," *Art Journal* 33, no. 4 (Summer 1974): 334. Wanda Corn also cites this episode in *Grant Wood: The Regionalist Vision* (New Haven: Yale University Press, 1983), 59. For Janson's other essays on regionalism, see "The International Aspects of Regionalism," *College Art Journal* 2 (May 1943): 110–15; "The Case of the Naked Chicken," *College Art Journal* 15 (Winter 1955): 124–27.

47. Pollock, letter to Louis Bunce, June 2, 1946. See "Regionalist Report: West Coast," *Archives of American Art Journal* 24, no. 1 (1984): 37, and Paul J. Karlstrom, "Jackson Pollock and Louis Bunce," *Archives of American Art Journal* 24, no. 2 (1984): 26.

48. "A Symposium: The State of American Art," *Magazine of Art* 42, no. 3 (March 1949): 82–102, with Barr quoted on p. 85, Greenberg on p. 92.

49. Janson, "A Symposium: The State of American Art," 96.

50. Alfred Barr, *What Is Modern Painting?* (6th ed.; New York: Museum of Modern Art, 1956), 42. This booklet was first published in 1943.

51. On overseas exhibits sponsored by MOMA, the State Department, and the United States Information Agency, see Cockcroft, "Abstract Expressionism," de Hart Matthews, "Art and Politics," and Guilbaut, *How New York*

Stole the Idea of Modern Art. See also Frances Pohl, "An American in Venice: Ben Shahn and United States Foreign Policy at the 1954 Venice Biennale, or Portrait of the Artist as an American Liberal," *Art History* 4, no. 1 (March 1981): 80–113.

52. "10,000 Montana Relief Workers Make Whoopee on Saturday Night," "The President's Album," and "Curry of Kansas," *Life* 1, no. 1 (November 23, 1936): 9–17, 26–27, 28–31; "Fairfield County," "Arms for Europe," and "Jackson Pollock," *Life* 27 (August 8, 1949): 74–84, 26–27, 42–45.

53. Luce, quoted in John K. Jessup, ed., *The Ideas of Henry Luce* (New York: Atheneum, 1969), 41.

54. "A *Life* Round Table on Modern Art," *Life* 25 (October 11, 1948): 56–59, 75–79. On the *Fortune* round tables, see James L. Baughman, *Henry R. Luce and the Rise of the American News Media* (Boston: Twayne Publishers, 1987), 114. On the Great Books seminars and the Aspen Institute, see James Sloan Allen, *The Romance of Commerce and Culture: Capitalism, Modernism, and the Chicago-Aspen Crusade for Cultural Reform* (Chicago: University of Chicago Press, 1983), 81–85, chaps. 7–8.

55. "A *Life* Round Table on the Pursuit of Happiness," *Life* 25 (July 12, 1948): 95–113; Barton quoted p. 113.

56. "A *Life* Round Table on Modern Art," 56, 62, 79.

57. "A *Life* Round Table on Modern Art," 79. For Benton's comments, see "Letters to the Editors," *Life* 25 (November 1, 1948): 11.

58. On Luce's aesthetic sense, see Jessup, *The Ideas of Henry Luce*, 260–61.

59. Deborah Solomon, *Jackson Pollock: A Biography* (New York: Simon & Schuster, 1987), 195.

60. On Longwell, see Steven Naifeh and Gregory White Smith, *Jackson Pollock: An American Saga* (New York: Clarkson N. Potter, 1989), 593. Frank C. Lewis made the compelling assessment of Pollock's objectification in "Defined by the Gaze: Jackson Pollock and the Media," a paper presented at the 51st Annual Conference of the Mid-America College Art Association, Minneapolis, October 22, 1987. *Life*'s article on Pollock (cited in note 52) appeared on 8 August 1949. Piri Halasz discusses Longwell and the anti-Pollock letters in "The Magazines," the second part of "Art Criticism (and Art History) in New York: The 1940s vs. the 1980s," *Arts* 57 (March 1983): 67–68.

61. Glenn Willumson noted these connections in his paper "*Life* Magazine's 'Country Doctor': The Photo-Essay as Ideological Tool," presented at the American Studies Association Annual Conference, November 24, 1987, New York. See also Sally Stein's essay on FSA medical photography, "Seeking the Photographic Cure," *Exposure* 25, no. 2 (Summer 1987): 28–54.

62. Luce, "The American Century," *Life* 10 (February 12, 1941): 65; "Irascible Group of Advanced Artists Led Fight against Show," *Life* 47 (January 15, 1951): 34.

63. "Baffling U.S. Art: What It Is About," *Life* 47 (November 9, 1959): 69.

Schapiro quoted in "The Varied Art of Four Pioneers," *Life* 47 (November 16, 1959): 86.

64. "Painters Show Woeful Side of Soviet Life," *Life* 38 (May 16, 1955): 147; "Palaces for a Worker's Culture," *Life* 40 (May 28, 1956): 130.

65. "The Art of Russia That Nobody Sees," *Life* 48 (March 28, 1960): 60–71.

66. The Metropolitan exhibit is noted in "As They Saw It: Three from the '30s," *Time* 63, no. 9 (March 1, 1954): 72. On postwar realism, see Greta Berman and Jeffrey Wechsler, *Realism and Realities: The Other Side of American Painting, 1940–1960* (Rutgers: Rutgers University Art Gallery, 1981).

67. Arthur Millier, "Associated Artists Open California Gallery," *Art Digest* 22, no. 6 (December 15, 1947): 16. For an AAA "New Frontiers" ad, see *Art News* 51 (Summer 1952): 112. Lewenthal, quoted in Donna Stein, "A Dealers' Round Table, 27 June 1985," catalog essay in *Americans at Work: Realism between the Wars* (Houston: Transco Energy Co., 1985), n.p.

68. For information on AAA fabric design and Stonelain, see the Associated American Artists papers, Archives of American Art (AAA), Smithsonian Institution, Microfilm Roll D–255, D–256.

69. "Make Up Your Mind: One-Picture Wall or Many-Picture Wall," *Vogue*, April 15, 1950, pp. 66–67.

70. Guilbaut, *How New York Stole the Idea of Modern Art*, 184–85.

71. Robson, "The Market for Abstract Expressionism," 20.

72. For Beaton's photos, see "Spring Ball Gowns," *Vogue*, March 1, 1951, pp. 156–59; for drip-style fashion design, see *Vogue*, March 1952, p. 104, and *Vogue*, April 1953, p. 73.

73. Still, quoted in Guilbaut, *How New York Stole the Idea of Modern Art*, 201. On Parsons and Pollock, see Robson, "The Market for Abstract Expressionism," 20.

74. Pollock, quoted in a letter, June 7, 1951, to Alfonso Ossorio and Ted Dragon, in Francis V. O'Connor and Eugene Victor Thaw, eds., *Jackson Pollock: A Catalogue Raisonné*, vol. 4: *Other Works, 1930–1956* (New Haven: Yale University Press, 1978), 258. Pollock mentioned the possibility of doing a mural for the AAA in a letter to them dated August 6, 1951; see *Other Works*, 262.

75. Brooks, Parsons, Denise Hare, Potter, and Pollock, quoted in Jeffrey Potter, *To a Violent Grave: An Oral Biography of Jackson Pollock* (New York: G. P. Putnam's Sons, 1985), 115.

76. On criticism of the black paintings, see Sandler, *The Triumph of American Painting*, 117, and Barbara Rose, "Namuth's Photographs and the Pollock Myth," in *Pollock Painting*, ed. Rose (New York: Agrinde Publications, 1978), n.p. Solomon, *Jackson Pollock*, discusses their disappointing sales on p. 225.

77. Andrew Kagan notes Pollock's "drunken" death in "Heroic Individual-

ism, Moral Purpose, and the Absolute Affirmation in Contemporary Art," *Arts* 61, no. 9 (May 1987): 59. On Pollock's death, see "Rebel Artist's Tragic Ending," *Life* 34 (August 27, 1956): 58.

78. On appropriation, see Thomas Crow, "Modernism and Mass Culture in the Visual Arts," in Frascina, ed., *Pollock and After*, 258. On Pop art, see Sidra Stitch, *Made in U.S.A.: An Americanization in Modern Art—The '50s and '60s* (Berkeley: University of California Press, 1987).

79. Burnham, "The Struggle for the World," *Life* 22, no. 13 (March 31, 1947). Benton's unpublished letter, dating to April 4, 1947, is in the Benton Papers, AAA.

80. Jessie Benton, quoted in the film *Thomas Hart Benton*, directed by Ken Burns (1988).

81. See, for instance, *Thomas Hart Benton: A Retrospective Exhibition of the World of the Noted Missouri Artist* (Lawrence: University of Kansas Museum of Art, 1958).

82. See, for instance, Craig Owens, "The Discourse of Others: Feminists and Postmodernism," in Hal Foster, ed., *The Anti-Aesthetic: Essays on Postmodern Culture* (Port Townsend, Wash.: Bay Press, 1983), 57–82.

Page numbers in italic indicate the location of illustrations.

Abandoned Factory (Pollock), 326
Abbott Laboratories, 155, 166, 220, 229, 282
Abraham Lincoln Brigade, 246
Abstract art, 35, 275, 355, 392
 women artists, 384
Abstract expressionism, 1, 3, 4, 7, 98, 253, 301, 365–67, 384–86
 advertising, use in, 405, 408–10
 commodification, 404, 405
 critical reaction, 341, 345, 346
 government use, 364, 366, 367, 393
 Life patronage, 393, 399–401, 409–12
 misconstruction of, 367–70, 372–76
 Pollock, Jackson, 331, 339–41, 345–47, 356–58, 367
 regionalism, influence of, 348, 349
 surrealism and, 300
Académie Julian, 34, 35
Academy of Motion Picture Arts and Sciences (AMPAS), 214
Achelous and Hercules (Benton), 364–65, 366, 367
Addams, Jane, 48
Advertising, 151–55
 American Tobacco Company, 5, 155, 166, 220, 229, 232, 233, 235, 236, 239, 253, 270, 288, 289
 art, 156
 Coca-Cola, 272, 273
 Depression, 272
 Pan American Airlines, 296–97, 298, 299

Pepsi-Cola, 272, 274
 regionalism in, 166, 178
 surrealism in, 300
Affluent Society, The (Galbraith), 333
After Many Springs (Benton), 253, 255, 258
Again (Benton), 282, 283, 285, 288
Agar, Herbert, 262
Agricultural Adjustment Act, 266, 269
Agricultural Adjustment Administration, 108, 164, 165, 243
Albright, Ivan
 Wherefore Now Ariseth the Illusion of a Third Dimension, 258, 259
Alchemy (Pollock), 312, 316, 317, 348, 353, 354, 365, 368, 369
Ali Baba Goes to Town, 194, 208, 210, 210–12
Ameche, Don, 204
American Artists Congress (AAC), 275, 278
American Committee for Cultural Freedom, 387
American Gothic (Wood), 2, 162, 163
American Historical Epic (Benton), 5, 9, 13–16, 34, 37, 43–46, 49, 50, 53, 54–57, 67
 Discovery, 10, 11
 1927—New York Today, 54, 55
 Over the Mountains, 10, 12, 54
 Slaves, 10, 13, 54
American Leviathan, The (Beard), 67

American Madness, An (Capra), 150
American Medical Association, 400
American Mercury, The (periodical), 97
American Tobacco Company, 5, 155, 166, 220, 229, 232, 233, 235, 236, 239, 253, 270, 288, 289
American Tragedy (Evergood), 181, 186, *187*
American Workers party, 115, 387
America Today (Benton), 68, 69, 88, 110, 122, 348
 Changing West, 70, 76, 80
 City Activities with Dance Hall, 71, 72, 77, 79
 City Activities with Subway, 71, 72, 78, 83
 City Building, 1, 2, 70, *71,* 83, 85, 86, 162, 267
 critical reaction, 87
 Deep South, 70, 74, 80
 Instruments of Power, 69, 70, *70*
 Midwest, 70, 74, *75*
 movies, influence of, 83
 Outreaching Hands, 73, 74, 79, 80, 96
 producerism and, 83
 Steel, 70, 72, 74, 83, 85, 86
Andy Hardy Gets Spring Fever, 242
Anna Christie, 242
Anthiel, George, 112
Architectural League, 54
Arendt, Hannah, 376, 378, 393
Arise My Love, 252
Armory Show (1913), 46, 88
Arnold, Edward, 268
Arnold, Thurman, 232
Art Digest, The (periodical), 120, 158, 326, 388
Art Front, The (periodical), 113, 118, 120, 134, 186, 278, 378
Art Institute of Chicago, 33, 391
Artist in America, An (Benton), 125, 126

Artists Union, 113, 118
Art News (periodical), 297, 340, 383
Arts, The (periodical), 13, 87, 97, 349,
 Benton modernist theory, 13, 14, 363
Arts of Life in America (Benton), 68, 88, 110, 348
 Arts of the City, 91
 Arts of the South, 89, 91, 92, 121, 123
 Arts of the West, 91, 121
 critical reaction, 121
 Indian Arts, 91
 Political Business and Intellectual Ballyhoo, 89, 91, 95, 96, 109, 121, 150, 181, 271
 Unemployment, Radical Protest, Speed, 91, 95
Art Students League, 6, 45, 68, 112, 181, 318, 320, 322, 323, 348, 349
Ash Can school, 45, 46, 88
Associated American Artists (AAA), 5, 156–58, 164–66, 189, 194, 229
 abstract expressionism and, 364, 401, 404, 409
 advertisements, 158–61, *159, 160,* 166
 Benton, Thomas Hart, 158, 161, 162, 164–66
 Curry, John Steuart, 162, 165, 166
 Lewenthal, Reeves, 5, 156–62, 164–66, 175, 176, 188, 189, 194, 220, 229, 233, 241, 243, 401, 404
 movies, 241
 regionalism and, 162–65
 Wood, Grant, 162, 165, 166
Autumn Rhythm (Pollock), 1, 339, *342, 343,* 348, 354
Avant-garde art, 4, 90, 370–74
Ayer, N. W., 155

Bacon, Peggy, 165
Baigell, Matthew, 126, 258
Bald Knobber Gang, 25
Ballad of the Jealous Lover of Lone Green Valley (Benton), 320, 321, 321
Ballyhoo (periodical), 94, 150
Bancroft, George, 54
Baptism in Kansas (Curry), 2, 162, 164
Barr, Alfred, 90, 258, 389, 391, 409
Barton, Betsy, 395
Barton, Bruce, 151–54, 166, 196, 235
Barzun, Jacques, 389
Battle of the Lapiths and the Centaurs, The (Michelangelo), 40, 41
Baum, Frank
 Wonderful Wizard of Oz, The, 27
Bayer, Herbert, 155
Beard, Charles, 2, 50, 54–56, 67, 74, 120, 138, 186, 262, 263
 American Leviathan, The, 67
 Economic Origins of Jeffersonian Democracy, The, 54
 Future Comes, The, 109
 movies, 196
 New Deal, 109, 110, 264–67, 271
 Old Deal and the New, The, 264, 265, 271
 Rise of American Civilization, The, 54
Beard, Mary, 138
Beaton, Cecil, 405, 409
Beaux Arts Institute, 156
Bell, Daniel, 376, 387
 End of Ideology, The, 335
Bellows, George, 48
Benedict, Ruth, 94
Benjamin, Walter, 7, 239
Benton, Jessie (daughter), 416
Benton, Maecenas Eason (father), 15, 22–32, 57, 131
 photograph, 23
Benton, Nat (brother), 131

Benton, Thomas Hart, see also
 American Historical Epic, America Today, Arts of Life in America, A Social History of the State of Indiana, A Social History of the State of Missouri, Year of Peril
 Achelous and Hercules, 364–67, 366, 367
 advertising work, 166, 167, 229, 232–37, 239, 240, 272, 280
 After Many Springs, 253, 255, 258
 ambivalence, 35–37, 50, 95, 136, 137, 181, 186, 258, 264, 272, 281, 293, 295–97
 art training, 2, 33–35
 Artist in America, An, 125, 126
 Associated American Artists, 158, 161, 162, 164–66
 Ballad of the Jealous Lover of Lone Green Valley, 320, 321, 321
 Burning of Chicago, 204, 206
 Cattle Loading, West Texas, 311, 314, 315, 323
 Cézanne and, 38–40, 42
 childhood, 5, 14, 15, 24, 30, 31
 Common Sense essays, 131–35
 communism and, 113–15, 413–15
 corporate sponsorship, 5, 6, 138
 Craven, Tom, 98
 critical reaction, 1, 11, 87, 98, 112–15, 121–25, 162, 252, 281, 297, 300, 308, 389
 Dali, 292, 293
 death, 9, 416
 Directors Conference, 216, 216
 Dubbing in Sound, 149, 204
 Factory Workers, 114
 Fantasy, 253, 256, 257, 258
 fascism, 126
 father, relationship with, 30–32, 57

Benton, Thomas Hart (*continued*)
Figure Organization No. 3, 40, *40*, 41
Flint, Michigan, work, 179–81, 186–88, 220
Harmonica Rascals, 320
Hollywood, 147, 194, 195, 197, 215, 217, 248
Hollywood, 147, *150*, 194, 198–208, 217–20, 233, 293
homophobia, 35–37, 280, 281, 376
integration, 5, 25
Landscape, 38, *39*
lecture tour, 282
Life work, 178–81, 186–88, 194, 217–19
marxism and, 35, 36, 52, 53, 132
Mine Strike, 51, 52, *52*
misogyny, 35, 36, 122, 123, 212
modernism and, 10–14, 37, 38, 41–46, 56, 97, 229, 232
modernist theory (as published in *The Arts*, 1926–27), 13, 14, 363
motion pictures, influence on Benton, 2, 42–44, 83, 201–4
movie work, 42, 43, 49, 194
New Deal, 4, 68, 87, 112, 126, 134, 165, 264–67, 271
Outside the Curing Barn, 230, 233
Persephone, 253, *254*, 258, 281
Plowing It Under, 164, 165, *165*
politics, 29, 30, 68, 111, 112, 114, 123–26, 247, 414–16
Pollock, Jackson and, 1, 3, 37, 70, 304, 311, 312, 320–23, 326, 328, 330, 331, 348, 349, 375, 391
popular culture, 83
postwar experiences, 49, 50
Prodigal Son, 253, *256*
producerism, 74, 79–81, 83, 85,

91, 93, 101, 120, 124, 132, 186, 211, 213, 258, 272
racism, 5, 25, 93, 97, 121, 122
Reds and Red-Hots, 181, *184*
regionalism, 256, 258, 272, 282, 301, 376, 377
republicanism, 30, 34, 44, 52, 53, 56, 70, 71, 91, 94, 107, 108, 110, 131, 186, 258, 267, 293, 295, 296, 300, 415
sarcasm, 95, 97
Saturday Afternoon, 323, *325*
Set Designing, *148*
Shore Leave, 240
Sorting Tobacco at Firing House, 234
stereotyping, 54, 93, 123, 204, 283
Strike, 114
style, 13, 14, 16, 37, 38, 42, 43, 68, 87, 116, 201–3, 256, 258, 272, 289, 349
synchromism and, 39–42
Tactical Discussion in Flint's Smolny Institute, 181
teacher, as, 112, 320
Threshing Wheat, 325, *327*
Time, 201, 235
Time cover, 98, 99, 118, 138
Tobacco, 231, 233, 235
Tobacco Sorters, 235, *236*
unions, 80, 81
urbanism, 93
Workers! You've Got Nothing to Lose But Your Change, 181, *183*
World War II and, 29, 262–89, 295–97
Benton, Senator Thomas Hart, 2, 14–22, 111
portrait (Bingham), *19*
sculpture (Hosmer), *18*
Benton, Senator William, 212
Berger, John, 346, 347

Bergman, Andrew, 196, 211
Berthoff, Rowland, 21
Bethlehem Steel, Sparrows Point Plant, 70
Betty Parsons Gallery, 409
Beyond the Forest (Vidor), 338
Biddle, Thomas, 17
Bingham, Alfred, 131, 132, 262, 263, 277, 296
Bingham, George Caleb, 17, 19, 37
 Stump Speaking, 20
Black Fury, 197
Blanch, Arnold, 165
Bland, Richard "Silver Dick," 27
Blockade, 244, 246, 247, 278
Blume, Peter, 90, 258
 Landscape with Poppies, 259
Bolshevik Revolution, 50
Bohrod, Aaron, 165
Bourke-White, Margaret, 219
Brady, Alice, 204
Brando, Marlon, 365
Brecht, Bertold, 239, 370
Breton, André, 289, 291, 300
Brody, David, 180, 265
Brooklyn Museum, 326
Brooks, James, 411
Brooks, Van Wyck, 56, 94
Brown, Milton, 252, 253
Bryan, William Jennings, 27
Bumboat Girls (Quintanilla), 248, 249
Burchfield, Charles, 98, 118
Burnham, James, 115, 118, 123
 Managerial Revolution, 387
 Struggle for the World, The, 387, 413, 414
Burning of Chicago (Benton), 204, 206

Cadmus, Paul
 Herrin Massacre, The, 192, 193
Cahill, Holger, 388, 392

Calhoun, John C., 22
Calverton, V. F., 115
Camp with Oil Rig (Pollock), 325
Canary Murder Case, The, 72
Cantor, Eddie, 147, 210, 211, 213
Capra, Frank, 250, 268
 American Madness, An, 150
Carnegie Institute Art Exhibit, 219
Carroll Gallery, 39
Carroll, Madeline, 246
Cassandre, A.M., 155
Casualty (Benton), 282, 283
Catcher in the Rye (Salinger), 338
Cather, Willa, 56
Cattle Loading, West Texas (Benton), 311, *314*, *315*, 323
Central Intelligence Agency (CIA), 387
Cézanne, Paul, 37–39, 43, 44, 90
Chandor, Douglas, 156, 162
Changing West (Benton), 70, 76, 80
Chase, Stuart, 395
Chicago, 33, 34
Chicago Tribune (newspaper), 156
Chicago Worlds Fair (1933), 100
City Activities with Dance Hall (Benton), 71, 72, 77, 79
City Activities with Subway (Benton), 71, 72, 78, 83
City Building (Benton), 1, 2, 70, *71*, 83, 85, 86, 162, 267
Civilian Conservation Corps (CCC), 108, 151, 265
Citizen Kane, 248
Civil War, 22, 102, 105
Clark, Champ, 24, 131
Clark, T. J., 370
Cleveland, Grover, 24
Click (periodical), 172
Coiner, Charles, 155
Coca-Cola, 280
 advertisement, 272, 273
Cody, Wyoming (Pollock), 323, *324*
Colbert, Claudette, 197

Cold War, 4, 332, 333, 364–67, 389, 392, 415
Color-field painting, 39
Columbia Broadcasting System, 288
Commentary (periodical), 379, 382
Common Sense (periodical), 112, 120, 262–64, 271, 277, 296
Benton essays, 131–35
Commonweal (periodical), 252
Communism, 113–15, 272, 275, 278, 379
containment, 337
Cone, Fairfax, 235
Congress of Industrial Organizations (CIO), 180
Consensus culture, 4, 6, 336, 337, 350, 356, 357, 366, 368, 375, 382, 387, 388, 401
Constructivism, 12, 37, 56
Consumerism, 149, 196, 387
modernism and, 156
New Deal, 212
producerism, 272
Container Corporation of America, 154, 155
Cooley, Charles Horton, 49
Cooper, Gary, 195, 268
Copeland, Aaron, 77
Corcoran Gallery of Art, 30, 135
Cornstalks and Power Lines (Benton), 127
Coronet (periodical), 166
Cotton Pickers (Pollock), 325
Coughlin, Father, 124, 376
Country Gentlemen (periodical), 166
Country Homes, Inc.
advertisement with Pollock drawing, 405, 408
Courbet, Gustave, 373
Couture, Thomas, 311
Crane, Hart, 56
Craven, Thomas, 56, 97, 98, 112, 118, 124, 138, 375, 376

Men of Art, 97, 122
Modern Art: The Men, the Movements, the Meaning, 97, 122
Paint, 97
racism, 98, 122
Croly, Herbert, 74
Crossfire, 337
Cubism, 16, 155, 373, 374
Cultural Panel 11: Indiana Puts Her Trust in Thought (Benton), 105, 107
Cultural Panel 11: Indiana Puts Her Trust in Work (Benton), 105, 106, 122, 267
Cultural Panel 4: Early Schools, Communities, Reformers, Squatters (Benton), 104
Currier and Ives, 155
Curry, John Steuart, 2, 88, 118, 136, 157, 301, 376, 393
advertising, 235
Associated American Artists, 162, 165, 166
Baptism in Kansas, 2, 162, 164
Grading a Pile of Tobacco after Curing, 237
Hoover and the Flood, 189–92, 190, 191
Life feature, 167, 168, 174, 175
Parade to War, 264
World War II, 264
Curtiz, Michael, 195

Daily Worker, 278
Dali, Salvador, 291
advertising, 300, 302, 303
Benton, influence on, 292, 293
Family of Marsupial Centaurs, 293, 295
Persistence of Memory, 293
Soft Construction with Boiled Beans, Premonition of Civil War, 291, 292

Spectre of Sex Appeal, The, 293, 294
Dark Horse, The, 94
Darrow, Whitney, 322
Davidson, Donald, 92
Davis, Betty, 338
Davis, Stuart, 90, 97, 116–24, 186, 275, 277–79, 378
 History of Communications, 276, 276, 277, 291
 New York Mural, 116, 117, 276
Day of the Locust, The (West), 197
Dean, James, 365
Death of Dillinger, The (Marsh), 189
De Beers Diamonds, 155
Debs, Eugene, 5, 53, 110
de Chirico, Giorgio, 291
Deep South (Benton), 70, 74, 80
Dehn, Adolph, 157
Dehumanization of Art, The (Ortega), 377, 378
de Kooning, Elaine, 384
de Kooning, Willem, 328
Democratic Party, 24, 27, 28, 32
Democracity exhibit, 276
Demuth, Charles, 56
Departure (Pollock), 324–27, 326
Depression (1930s), 1–4, 57, 68, 69, 86, 87, 148–50
 advertising, 272
 imperialism, effect, 261
 movies, 195–97, 268
 New Deal, 108, 109
Derain, André, 155
De Stijl, 12, 56, 118, 354
Destination Murder, 338
Detroit Industry (Rivera), 83
Dewey, John, 31, 48, 50, 56, 76, 115, 132
 Pan Am advertisement, 296–99, 299
Dial, The (periodical), 97, 351
Diamond Horseshoe Saloon, 281

Dingley Tariff, 28
Directors Conference (Benton), 216, 216
Discovery (Benton), 10, 11
Documentary style, 270, 278
Dodge, Mabel, 49
Dole Pineapple Company, 155
Dove, Arthur, 97
Duchamp, Marcel
 Nude Descending a Staircase II, 47
Dubbing in Sound (Benton), 149, 204
Dufy, Raoul, 155
Du Pont, 152

Eakins, Thomas, 384
Eastman, Max, 72, 132
Economic Origins of Jeffersonian Democracy, The (Beard), 54
Edward G. Robinson (Lee), 219
Emperor Jones, The, 242
Encyclopedia Britannica, 155
End of Ideology, The (Bell), 335
Erenberg, Lewis, 73
Erie Railroad, 155
Ernst, Max, 291, 300
Esquire (periodical), 166, 252
Evergood, Philip
 American Tragedy, 181, 186, 187
Existentialism, 381
Expressionism, German, 367
Exterminate! (Benton), 282, 283, 287, 293

Face the Music, 94
Factory Workers (Benton), 114
Fair Deal, 332, 333, 400
Fair Labor Standards Act, 265
Family of Man photography exhibit, 336

Family of Marsupial Centaurs (Dali), 293, *295*
Fantasy (Benton), 253, 256–58, *257*
Farber, Manny, 297
Farm Credit Administration, 266
Farmer, The (periodical), 166
Farm Security Administration, 269
Fascism, 123, 227, 242, 246, 261–63, 268, 272, 275, 227, 278
 modern art, 277
Father of the Bride, 336
Fauvism, 37
Faye, Alice, 204, 211, 213
Federal Arts Project (FAP), 151, 157, 328
Federal Emergency Relief Administration (FERA), 108
Federal Writer's Project, 270, 378
Fields, W. C., 147
Fiene, Ernest, 248
 photograph, *250*
Figure Organization No. 3 (Benton), 40–41, *40*
Film noir, 198, 242, 248, 250, 251, 283, 285, 336–38
Fitzgerald, F. Scott, 56
 Last Tycoon, The, 197
Flagg, James Montgomery, 243
Flint, Michigan, 179–81, 186–88, 220
Focus (periodical), 172
Fonda, Henry, 246
Forbes, B. C., 154
Forbes Magazine (periodical), 154
Force, Juliana, 88
Ford, John, 242, 248
Fortune (periodical), 166, 167, 170, 171
Forum Exhibition, 41, 42
Franco, 246
Frank, Waldo, 77, 262
Frankenstein, Alfred, 345
Frankenthaler, Helen, 367, 384
Frankfurter, Alfred, 297

Freud, Sigmund, 48
Friends of Young Artists, 88
Fromm, Erich, 395
Futurama exhibit, 269, 276, 277
Future Comes, The (Beard), 109

Gable, Clark, 338
Gabriel over the White House, 244–46
Galbraith, John Kenneth, 280
 Affluent Society, The, 333
Gallup poll, 194
 New Deal, 268
Gauguin, Paul, 90
Gellert, Hugo, 115, 118
General Electric, 152, 269
General Motors, 155, 265
 Labor conflict, 180
Georgia, 233, 234
Germany, 123, 261, 267, 354, 364, 376
 World War II, 297
"Gestaltian Chart of Contemporary American Art" (Pousette-Dart), 258, *260*
Gibson, Charles Dana, 34
Going West (Pollock), 311, *312*, 323, 327, 349
Goldwater, Robert, 388
Goodman, Job, 328
Goodrich, Lloyd, 87, 88
Gorky, Arshile, 378
Gottlieb, Adolph, 341, 367
Grading a Pile of Tobacco after Curing (Curry), 237
Graham, John, 351, 356, 375
Grapes of Wrath, 242
Graumann's Chinese Theater, 220
Greenberg, Clement, 6, 98, 253, 271, 345, 364, 369–79, 386–88, 392, 393, 398, 404, 409, 411
Greenstreet, Sydney, 338

Griffith, D. W., 44, 46, 56
Griffith, Raymond, 194
Guardians of the Secret (Pollock), 351
Guernica (Picasso), 291
Guilbaut, Serge, 4, 350, 405
Guston, Philip, 319

Hamby, Alonzo, 334
Harlow, Jean, 195, 213
Harmonica Rascals, 320
Harris, Neil, 172
Hart, Moss, 94
Hartigan, Grace, 384
Harvest (Jones), 135, *135*
Harvest, The (Benton), 282
Hawley, Ellis, 232, 269
Hays, Will, 211
Hearst, William Randolph, 118
Hebrew Technical Institute, 48
Hemingway, Ernest, 56
Henri, Robert, 45, 48, 57, 90, 97, 116
Herrin Massacre, The (Cadmus), 192, *193*
Hicks, Wilson, 171
Hill, George Washington, 229, 232, 233, 235, 240
History of Art (Janson), 363, 391
History of Communications (Davis), 276, 276–79, 291
Hitchcock, Alfred, 292
Hofstadter, Richard, 335
Hogue, Alexandre
 Spindletop, 189
Holiday (periodical), 166
Hollywood, California, 195–97, 220, 292
 Benton, Thomas Hart, 147, 194, 195, 197, 217, 248
 movie industry, 240
 New Deal, 211

producerism, 147–49, 209–12, 216
unions, 213, 214, 220
Hollywood (Benton), 147, *150,* 194, 198–208, 212–15, 217–20, 233, 293
Hollywood, 10, 278
Hollywood: The Movie Colony, the Movie Makers (Rosten), 214, 215
Hokusai prints, 34
Hook, Sidney, 115, 118, 395
Hoover, Herbert, 150, 188, 192
Hoover and the Flood (Curry), 189–92, *190, 191*
Hopper, Edward, 56, 90
 New York Movie, 198
 Nighthawks, 198
 Office at Night, 198
Hopper, Hedda
 photograph, *218*
Horne, Lena, 220
Hosmer, Harriet, 17
How to Look at Modern Art in America (Reinhardt), 354, 355, *355*
Huberman, Leo, 53
 We, the People, 113, 325
Hucksters, The (movie), 338, 339, 415
Hucksters, The (Wakeman), 232, 338, 339
Humphrey, Doris, 77
Hull-House, 48
Hurd, Peter, 165
Huxley, Aldous, 393, 398

I'll Take My Stand, 92, 93
Imperialism, 261
Impressionism, 37, 38
Index of American Design, 270
Indian Arts (Benton), 91
Indifference (Benton), 282, 283, 285, 293

Industrial Panel 4: Home Industry, Internal Improvements (Benton), 104

Industrial Panel 6: Civil War, Expansion (Benton), 103

Industrial Panel 6: Old Time Doctor, the Grange, Woman's Place (Benton), 103

Industrial Workers of the World (I.W.W.), 49, 50, 318

Ingram, Rex, 42–44, 46, 47, 93, 197

In Old Chicago, 194, 199, 202, 204, 206–8, *207,* 242, 285

Instruments of Power (Benton), 69, 70, *70*

International Alliance of Theatrical Stage Employees and Motion Picture Operators (IATSE), 213, 214

International Business Machines (IBM), 155

Interventionism, 271

Invasion (Benton), 282, 283, 285, *286*

Iowa, University of, 112, 391

Isolationism, 335

Italy, 123, 261, 267, 376

Its a Wonderful Life, 336

James Gang, 129

James, Jesse, 128

Jackson, Andrew, 16, 17, 22

James, Henry, 48

Janson, H. W., 364, 376, 388–90, 392, 393

History of Art, 363, 391

Japan, 261

John Reed Club, 113, 118, 372

Johnson, Alvin, 68, 77, 79, 80

Jones, Alfred Haworth, 208

Jones, Joe, 165

Harvest, 135, *135*

Joplin, Missouri, 34

Journal of Liberty, The (newsletter), 319

Jules, Mervin, 121, 123

Julien Levy Gallery, 291

Jung, C. G., 350

Jungian theory, 3, 6, 350, 351, 375

Kadish, Reuben, 319

Kansas City Art Institute, 37, 126, 281

Kaprow, Allan, 345, 347

Kaufman, George S.

Of Thee I Sing, 94

Kent, Rockwell, 155

Kenyon Review (periodical), 379, 381

Kepes, Gyorgy, 155

Kerr, Deborah, 338

Kid Millions, 202

King, Henry, 204

Kirkendall, Richard, 266, 267

Kirstein, Lincoln, 389

Kitsch, 370–73, 376, 379

Kitty Foyle, 194

Klee, Paul, 291

Klimt, Gustav, 30, 33

Kline, Franz, 367

Kootz, Samuel, 388

Koppers Paints

Advertisement, 300, 302

Kramer, Hilton, 10

Krasner, Lee, 328, 367, 384

Krishnamurti, Jeddu, 319

Ku Klux Klan, 105, 111, 122

Kuniyoshi, Yasuo, 155

Kwait, John, 113

La Follette, Philip, 189

Lambert Pharmaceutical Company, 96

Lancaster, Burt, 338

Landscape (Benton), 38, *39*
Landscape with Poppies (Blume), 259
Landscape with Steer (Pollock), 328, *329*
Landscape with White Horse (Pollock), 325
Lange, Dorothea, 270
Langhorne, Elizabeth, 351
Laning, Edward
 T.R. in Panama, 189
Laocoön, 373
Lasky, Jesse, 244
Last Tycoon, The (Fitzgerald), 197
Laurencin, Marie, 155
Lawson, John Howard, 246–48
League for Independent Political Action, 271
Lears, Jackson, 35, 154
Lee, Doris, 165, 220
 Edward G. Robinson, 219
Lee, Gypsy Rose, 210, 212, 213
Leger, Fernand, 155
Lessing, Gotthold, 373
Leuchtenburg, William, 151
Leutze, Emanuel, 54
Lewenthal, Reeves, 5, 156–62, 164–66, 175, 176, 188, 189, 194, 220, 229, 233, 241, 243, 401, 404
 World War II, 282
 Pollock, Jackson, 409
Lewis, Sinclair, 56
Liberalism, 335
Library of Congress, 30
Life (periodical), 5, 7, 147, 166, 171, 172, 174, 175, 188, 189, 204, 228
 abstract expressionism, 393, 399–401, 409–12
 anticommunism, 172
 "Artist Thomas Hart Benton Hunts Communists and Fascists in Michigan," 182

Benton, Thomas Hart, 178–81, 186–88, 194, 217–19
 Curry feature, 167, *168,* 174, *175*
 history series, 188, 189, 192
 labor conflict, reaction to, 178–81, 186–88, 218
 "'Menaces' to Michigan Democracy as Sketched & Captioned by Tom Benton," *184, 185*
 movies, 194, 195
 Pan American Airlines advertisement in, 296–99, *298, 299*
 postwar era, 400, 401
 regionalism, support, 167, 174, 175, 178, 179, 188, 189, 233
 Round Tables, 393, 395, *396, 397,* 398
Social History of the State of Missouri, 176, 177
Lieber, Colonel Richard, 100, 111
Life Begins at College, 194, 208, 209, *209,* 211
Liggett & Myers, 229, 232
Lincoln, Abraham, 105
Listerine, 96
Lombard, Carole, 195
Lonely Crowd, The (Riesman), 338
Long, Huey, 97, 124
Longman, Lester, 391
Long Voyage Home, The, 241–43, 247, 248, 250–52
 opening, *243*
 stills from, *244, 245*
Longwell, Daniel, 188, 194, 199, 212, 213, 399
Look (periodical), 166, 172
Lord & Thomas, 234, 235
Lorentz, Pare, 252
Los Angeles County Museum of Art, 135
Lozowick, Louis, 115, 118
Luce, Henry Robinson, 167, 170–72, 174, 186, 189, 192, 193,

Luce, Henry Robinson (*continued*)
196, 214, 215, 217, 233, 240,
247, 393, 398, 400
fascism, 170, 246
Lucioni, Luigi, 157
Lucky Strike cigarettes
advertisements, 155, 229, *230,
231, 232–36, 237, 238*
Lunn, Eugene, 10
Lynd, Robert, 153
Lynes, Russell, 155, 156

Macdonald, Dwight, 372, 379
MacDonald-Wright, Stanton, 39
Motion Picture Studio (detail),
198, *200*
Moving Picture Industry (mural),
198, *200*
MacLeish, Archibald, 262, 282,
285, 288, 289
Maclure, William, 102, 105
Magazine of Art (periodical), 157,
363, 389, 391
Magic realism, 258, 289
Magritte, René, 291
Maillol, Aristide, 155
Maltese Falcon, The, 250, 285
Managerial Revolution (Burnham),
387
Man, Bull, Bird (Pollock), 329, *330*
Manet, Edouard, 311, 373
Manifest destiny, 17
Marchand, Roland, 154
Marling, Karal Ann, 68, 123, 137,
138, 203
Marot, Helen, 351
Marshall Plan, 393
Marsh, Reginald, 90, 98, 118, 212
Death of Dillinger, The, 189
Paramount Picture, 197, 198
Striptease in New Jersey, 213
Twenty Cent Movie, 198, *199*
Martha's Vineyard, 321

Martin, David Stone
OWI Poster No. 8, 289, 290
Marxism, 37, 52, 53, 379
"Americanizing," 113
Masses, The (periodical), 51, 72,
118
Masson, André, 300
Matta, Roberto, 300
May, Lary, 15, 153
McBride, Henry, 345, 346
McCall's (periodical), 166
McCausland, Elizabeth, 388
McCrady, John
Shooting of Huey Long, The, 189
McNeil, George, 322
McNutt, Paul, 105, 110
Meet John Doe, 250, 268, 269
Men of Art (Craven), 97, 122
Metalious, Grace
Peyton Place, 338
Metro-Goldwyn-Mayer, 195
Michelangelo
*Battle of the Lapiths and the Cen-
taurs, The,* 40, *41*
Midnight Ride of Paul Revere,
(Wood), 404
Midwest (Benton), 70, 74, *75*
Milestone, Lewis, 246
Mine Strike (Benton), 51, 52, *52*
Minor, Robert
Pittsburgh, 51, *51*
Missouri Capitol building, 69
Mitchell, Joan, 384
*Modern Art: The Men, the Move-
ments, the Meaning* (Craven), 97,
122
Modernism, 2, 3, 5, 78, 101, 275,
355, 356, 392
Benton, Thomas Hart and, 10–14,
37, 38, 41–46, 56, 229, 232,
363
consumerism, 156
Craven, Thomas, 97, 98
definition, 10

Depression, effect of, 90, 91
failure of, 312
fascism, 277
Museum of Modern Art, 90
New School for Social Research
 and, 77–79
Pollock, Jackson and, 347
social role, 48
Modern Monthly (periodical), 112,
 115, 120
Monaco, James, 201
Moon Woman Cuts the Circle, The
 (Pollock), 351, *352*
Motherwell, Robert, 341, 345, 347,
 367
Motion Picture Journal, The (peri-
 odical), 246
Motion Picture Studio (MacDonald-
 Wright), 198, *200*
Movies, 2, 37, 42–44
 Depression, 195–97, 268
 Life coverage, 194, 195
 New Deal, 211, 212
Movies, Five Cents (Sloan), 46, *47*,
 197
Moving Picture Industry (Mac-
 Donald-Wright), 198, *200*
Mumford, Lewis, 10, 33, 50, 57, 77,
 91, 120, 132, 186
 regionalism, 93, 94
 Sticks and Stones, 33
 Technics and Civilization, 93, 94
 World War II, 261, 262
Munchner Illustrierte Presse (period-
 ical), 172
Museum of Modern Art (MOMA),
 88, 90, 91, 98, 258, 292, 351,
 364, 392
 postwar era, 364
Murals, Commission Chambers
 (Shinn), 45, 46, *46*
Mussolini, 170, 246
Muste, A. J., 132
Myers, Jerome, 157

Namuth, Hans, 340, 341
 Pollock photograph, *344, 353*
National Academy of Design, 88,
 156
National Association of Manufac-
 turers, 151, 154
National Gallery of Art, 137
National Labor Relations Act, 213
National Recovery Administration
 (NRA), 108, 151
Native American culture, 3, 375
 Pollock and, 350–53
Navajo, 351, 352
Nelson-Atkins Museum of Art, 37,
 147
Nelson Gallery of Art, 129
Neosho, Missouri, 24, 31, 33
Neosho Plan, 31
New Deal, 2, 5–7, 57, 123, 124,
 151, 152, 197, 243, 251, 264–
 72, 279
 arts patronage, 135–37, 269
 Benton, Thomas Hart, 4, 68, 87,
 112, 126, 134, 165, 264, 267,
 271
 consumer culture, 212
 Roosevelt, Franklin Delano, 108–
 10, 267, 268, 272
New Harmony, Indiana, 102, 104
New Hope (periodical), 112
Newman, Barnett, 367
New Masses (periodical), 113
New Republic (periodical), 74, 75,
 77, 96, 252, 297
 World War II, 261
New School for Social Research, 68,
 69, 74–79, 81
New Statesman (periodical), 346
New York American (newspaper),
 118
New York Movie (Hopper), 198
New York Mural (Davis), 116, *117*,
 276
New York Times (newspaper), 158

New York World's Fair (1939–40), 155, 174, 269, 276, 291
Nighthawks (Hopper), 198
Night Sounds (Pollock), 351
1913 Armory Show, 46, 88
1927—New York Today (Benton), 54, 55
Noble, David W., 334
Noguchi, Isamu, 155
Nude Descending a Staircase II (Duchamp), 47
Number Eight (Rothko), 404, *407*
Number 27, 1951 (Pollock), 411, *414*
N. W. Ayer and Son, advertising agency, 155

Office at Night (Hopper), 198
Office of Facts and Figures (OFF), 282, 283, 285, 289
Office of War Information (OWI), 282, 283, 289, 300
Of Thee I Sing (Kaufman), 94
O'Keeffe, Georgia, 90, 97, 155
Old Deal and the New, The (Beard), 264, 265, 271
O'Neill, Eugene, 241
Orozco, José Clemente, 68, 78, 79, 81, 348, 375
 Prometheus, 319, *320*
 Struggle in the Occident, The, 79, 84
Ortega y Gasset, José, 376
 Dehumanization of Art, The, 377, 378
 Revolt of the Masses, 170
Our Daily Bread (Vidor), 94, 250, 268, 285
Outreaching Hands (Benton), 73, 74, 79, *80*, 96
Outside the Curing Barn (Benton), 230, 233
Over the Mountains (Benton), 10, *12*, 54

Owen, Robert, 102
OWI Poster No. 8 (Martin), 289, *290*

Padua, Paul Mathias
 10 Mai 1940, 389, *390*
Paepcke, Walter, 155
Paint (Craven), 97
Pan American Airlines advertisement, 296, 297, *298*, *299*
Panic of 1819, 21
Parade to War (Curry), 264
Paramount Picture (Marsh), 197, 198
Paramount Pictures, 244, 283
Pareto, Vilfredo, 170
Parnassus (periodical), 252
Parrington, Vernon L., 56
Parsons, Betty, 411
Partisan Review (periodical), 113, 125, 126, 370, 372–74, 378, 379, 388
Paterson Strike Pageant, 49
Pavia, Phillip, 322
Pearl Harbor, 242, 275, 297
Pell, Yacob, 175
Pells, Richard, 50, 91, 334
Pendleton, Nat, 208, 209, 211
People's Art Guild, 48–50, 77
Pepsi-Cola, 155, 280
 advertisement, 272, *274*
Persephone (Benton), 253, *254*, 258, 281
Persistence of Memory (Dali), 293
Peyton Place (Metalious), 338
Phantom President, The, 94
Photo (periodical), 172
Photo-History (periodical), 172
Photoplay (periodical), 204
Piacenza, Rita, 36
Pic (periodical), 172
Picasso, Pablo, 90, 155
 Guernica, 291
Picture (periodical), 172

Picture Post (periodical), 172
Picture Show (periodical), 204
Pittsburgh (Minor), 51, *51*
Pittsburgh Steel, 300
Plowing It Under (Benton), 164, 165, *165*
P.M. (newspaper), 354
Pocock, J. G. A., 14
Pointillism, 37
Political Business and Intellectual Ballyhoo (Benton), *89,* 91, 95, 96, 109, 121, 150, 181, 271
Politics, Farming, and Law in Missouri (Benton), 24, *26,* 127–29, 131
Pollock, Charles (brother), 181, 313, 318
Pollock, Frank (brother), 313
Pollock, Jackson, 1, 3, 6, 7
 Abandoned Factory, 326
 abstract expressionism, 331, 339–41, 345–47, 356–58, 367
 Alchemy, 312, *316, 317,* 348, 353, 354, 365, *368, 369*
 alcoholism, 318, 319, 323, 328, 329, 350
 alienation, 347, 348
 Autumn Rhythm, 1, 339, *342, 343,* 348, 354
 Benton, Thomas Hart, and, 1, 3, 37, 70, 304, 311, 312, 320–23, 326–28, 330, 331, 348, 349, 375, 391
 Camp with Oil Rig, 325
 Cody, Wyoming, 323, *324*
 commodification, 405, 409
 communism, 319
 Cotton Pickers, 325
 critical reaction, 341, 345, 346, 364–66, 374, 375, 393, 398, 411
 death, 411
 Departure, 324–27, *325, 326*
 existentialism, 345

Going West, 311, *312,* 323, 327, 349
Guardians of the Secret, 351
hitchhiking, 323, 324
ideology, 332
Jungian theory, 3, 6, 350, 351, 375
Landscape with Steer, 328, *329*
Landscape with White Horse, 325
Life, 393, 394, 399, 409, 411, 412
Man, Bull, Bird, 329, *330*
modeling for Benton, 70
modern art, 331
modernism, 347
Moon Woman Cuts the Circle, The, 351, *352*
Native American culture, 350–53
Night Sounds, 351
Number 27, 1951, 411, *414*
politics, 319, 346
regionalism, 300, 311, 312, 322–31
Siqueiros, David, and, 327, 328
technique, 340, 353
Threshing, 326
Time, 399
Totem Lesson 1, 351
World War II, 345
youth, 312–19, 325
Pollock, Jay (brother), 313
Pollock, LeRoy (father), 313–18, 325
Pollock, Sanford (brother), 313, 318, 327, 328
Pollock, Stella (mother), 313
Pop art, 412
Popular Front, 113, 132, 258, 272, 275–79
Populism, 25, 35
Postmodernists, 416
Post office murals, 135, 136, 151, 270
Postwar era, 3, 6, 251, 253, 258, 301, 332–35, 338, 339, 345, 350, 356, 364, 365, 368, 376–78, 382, 383, 399, 400

Pousette-Dart, Nathaniel, 253
 "Gestaltian Chart of Contemporary American Art," 258, *260*
Power, Tyrone, 204
Prendergast, Tom, 129
President's Research Committee on Social Trends, 153
Printer's Ink (periodical), 300
Prints (periodical), 158
Prodigal Son (Benton), 253, *256*
Producerism, 15, 35, 45, 71, 74, 79, 80, 149
 Benton, Thomas Hart, and, 74, 79, 80, 81, 83, 85, 91, 93, 101, 120, 124, 132, 186, 211, 213, 258, 272
 consumerism, 272
 Depression, 87
 Hollywood, 147, 149, 209–11, 216
Production code, 211
Progressivism, 29, 93, 94
Prometheus (Orozco), 319, *320*
Public Works Administration (PWA), 108
Public Works of Art Project (PWAP), 135
Putnam, Samuel, 112

Quigley, Martin, 246
Quintanilla, Luis
 Bumboat Girls, 248, *249*

Racism, 80, 97, 234–36
 Benton, Thomas Hart, 93, 97, 121, 122
 Craven, Thomas, 98, 122
Rahv, Philip, 372
Rapp, Father, 102
Reds and Red-Hots (Benton), 181, *184*
Red Scare of 1919, 50
Reed, John, 49

Regionalism, 1, 2, 4, 6, 9, 45, 155, 282, 303, 304, 331
 abstract expressionism and, 348, 349
 advertising, 233–36, 239, 240
 antimodernism, 125
 Benton, Thomas Hart, 256, 258, 272, 282, 301, 376, 377
 critical reaction, 252, 253, 281, 301, 363, 364, 388, 389
 development of, 34, 38, 42, 44, 47, 49, 50
 film noir, 248
 Mumford, Lewis, 93, 94
 Nazi art, 363, 364
 politics, 68
 Pollock, Jackson, 300, 311, 312, 322–31
 popular appeal, 162–64
 reform, social, 81
 Time-Life Inc. support, 167, 174, 175, 178, 179, 188, 189, 233
 republicanism and, 56
Reinhardt, Ad, 367, 409
 How to Look at Modern Art in America, 354, 355, *355*
Republicanism, 14, 15, 17, 21, 25, 29, 32, 37, 53, 70, 120, 124, 267, 300, 415
 Benton, Thomas Hart, and, 30, 34, 44, 52, 53, 56, 70, 71, 91, 94, 107, 108, 110, 131, 186, 258, 267, 293, 295, 296, 300, 415
 regionalism and, 56
 Social History of the State of Indiana (Benton), 107, 108
Republican Party, 26, 27
Revolt of the Masses (Ortega), 170
Reynolds, Peggy, 72
Riesman, David
 Lonely Crowd, The, 338
Riley, James Whitcomb, 105
Rise of American Civilization, The (Beard), 54

Ritz Brothers, 208
Rivera, Diego, 5, 119, 319
 Detroit Industry, 83
R. J. Reynolds, 229, 232
Robinson, Boardman, 53
Robinson, Edward G., 88, 220
 portrait (Lee), *219*
Robinson, James Harvey, 74
Rockwell, Norman, 336
 critical reaction, 371
Rodman, Selden, 131, 132
Rogers, Will, 94, 95, 211
Roman Catholic Church, 247, 261
Rooney, Mickey, 211
Roosevelt, Franklin Delano, 2, 5,
 68, 91, 124, 135, 151, 197, 242,
 252, 264, 271, 279, 337,
 393
 on art, 137
 New Deal, 108–10, 267, 268,
 272
 World War II, 261
Rorty, James, 132
Rose, Billy, 281
Rosenberg, Harold, 6, 341, 376,
 378–87
Rosenfeld, Paul, 96, 97, 253
Ross, Murray, 214
Ross, Steven, 14
Rosten, Leo
 Hollywood: The Movie Colony,
 the Movie Makers, 214, 215
Rothko, Mark, 349, 367
 Number Eight, 404, 407
R. R. Donnelley and Sons, printers,
 174
Rural Electrification Administration,
 266
Rushing, Jackson, 351
Russell, Morgan, 39
Russian Revolution, 50
Rutkoff, Peter, 78
Ryder, Albert Pinkham, 327, 375,
 384
Ryerson, Margery, 157

Salinger, J. D.
 Catcher in the Rye, 338
Sample, Paul, 165
Santa Monica Public Library, 198
Saturday Afternoon (Benton), 323,
 325
Saturday Evening Post (periodical),
 166, 204, 235, 336
 Rockwell covers, 371
Saturday Review (periodical), 376
Schapiro, Meyer, 9, 10, 77, 125,
 126, 393, 400
Schardt, Nene, 331
Schiaparelli Cosmetics, 300
Schlesinger, Jr., Arthur, 346, 376,
 378, 387
 Vital Center, The, 334–36, 383
School of the Art Institute of Chi-
 cago, 33
Schultz, Elizabeth, 36
Schwab's Pharmacy, 220
Schwankovsky, Frederick John de St.
 Vrain, 319
Scott, William, 78
Screen Actors Guild, 213
Scribner's (periodical), 97
Securities and Exchange Commis-
 sion (SEC), 108, 151
See (periodical), 172
Seeger, Charles, 321
Segal, George, 341
Sentimental Ballad (Wood), *241,*
 248
Set Designing (Benton), *148*
Settlement houses, 48
Seurat, Georges, 90
Sheeler, Charles, 56
Sheets, Millard
 Tenement Flats, 86
Sherman Antitrust Act, 232
Shinn, Everett, 83
 Murals, Commission Chambers,
 45, 46, *46*
Shooting of Huey Long, The (Mc-
 Crady), 189

Shore Leave (Benton), *240*
Singal, Daniel, 56
Sino-Japanese War, 261
Siqueiros, David, 318, 319, 375
Slaves (Benton), 10, *13*, 54
Slim, 204
Sloan, John, 48, 57
 Movies Five Cents, 46, *47,* 197
Smith, W. Eugene, 400
Soby, James Thrall, 376, 377
Social History of the State of Indiana, A (Benton), 68, *101,* 100–112, 120, 121
 critical reaction, 1, 11, 162
 Cultural Panel 11: Indiana Puts Her Trust in Thought, 105, *107*
 Cultural Panel 11: Indiana Puts Her Trust in Work, 105, *106,* 122, 267
 Cultural Panel 4: Early Schools, Communities, Reformers, Squatters, 104
 Industrial Panel 4: Home Industry, Internal Improvements, 104
 Industrial Panel 6: Civil War, Expansion, 103
 Industrial Panel 6: Old Time Doctor, the Grange, Woman's Place, 103
 scale, 108
Social History of the State of Missouri, A (Benton), 24, 26, 68, 126–31, 174, 253
 Cornstalks and Power Lines, 127
 Life coverage, *176, 177*
 Pioneer Days and Early Settlement, 127, *127,* 129
 Politics, Farming, and Law in Missouri, 24, 26, 127–29, 131
 St. Louis and Kansas City, 127, 129–31, *130,* 131
Socialism, 5, 110
 postwar era, 382

Social realism, 51, 85, 115, 118, 278, 401
Social Security Act, 269
Social Viewpoint in Art exhibition, 113
Society of American Etchers, 156, 157
Soft Construction with Boiled Beans, Premonition of Civil War (Dali), 291, 292
Solomon, Deborah, 316
Sorry Wrong Number, 338
Sorting Tobacco at Firing House (Benton), *234*
Sowers, The (Benton), 282, 283, 286, 293
Soyer, Raphael, 165
Spanish Civil War, 246, 261, 291
Spectre of Sex Appeal, The (Dali), 293, 294
Spellbound, 285, 292
Spencer, Jesse Ames, 54
Spindletop (Hogue), 189
Spring Turning (Wood), 175, *178*
Stagecoach, 242
Stalin, 7, 275, 279
Standard Oil, 166
Standard Oil of New Jersey, 155
Stand Up and Cheer, 197
Starry Night (Benton), 282, 283, *284*
State Fair, 204
Steel (Benton), 70, *72, 74,* 83, 85, 86
Steele, Tom, *23*
Stein, Leo, 77
Stella, Joseph, 56
Stewart, Jimmy, 211
Stickley, Gustav, 33
Sticks and Stones (Mumford), 33
Stieglitz, Alfred, 48, 122
 Stieglitz Circle, 96
 291 Gallery, 48
Still, Clyfford, 367

St. Louis and Kansas City (Benton), 127, 129–31, *130*
Stonelain, 404
Stott, William, 270
Strike (Benton), *114*
Striptease in New Jersey (Marsh), 213
Structuralism, 2, 39, 43, 116
Struggle in the Occident, The (Orozco), 79, 84
Struggle for the World (Burnham), 387, 413, 414
Stuart, Gloria, 198
Stump Speaking (Bingham), *20*
Subway (Tooker), 339, *340*
Suckow, Ruth, 195
Surrealism, 289, 291–93, 300
Susman, Warren, 7, 153, 334
Swope, Gerard, 269
Sylvania, 300
Symbolism, 37
Synchromism, 2, 37, 41–44, 116

Tactical Discussion in Flint's Smolny Institute (Benton), 181
Taine, Hippolyte, 47
Taylor, Robert, 194
Teagle, Walter, 269
Technics and Civilization (Mumford), 93, 94
Temple, Shirley, 211
Tenement Flats (Sheets), *86*
10 Mai 1940 (Padua), 389, *380*
Tennessee Valley Authority (TVA), 151
Thomas, Norman, 53
Threshing (Pollock), 326
Threshing Wheat (Benton), 325, 327
Tierney, Gene, *218*
Time (periodical), 158, 166, 170, 174, 188
Benton cover, 98, 99

Benton, Thomas Hart, 201, 235
Dali cover, 291
Mao tse Tung cover, *173*
Pollock, Jackson, 399
"U.S. Scene," 118, *119*
Time-Life Incorporated, 155, 167, 280, 364, 393, 395, 398
Tobacco (Benton), *231*, 233, 235
Tobacco Sorters (Benton), 235, *236*
Toland, Gregg, 248
Tolegian, Manuel, 319
Tooker, George
Subway, 339, *340*
Totalitarianism, 334, 387, 400
Totem Lesson 1 (Pollock), 351
Touch of Evil, 250
Treasury Relief Art Project (TRAP), 135, 151
Treasury Section on Painting and Sculpture, 135, 151
T. R. in Panama (Laning), 189
Trotsky, Leon, 372
Truman, Harry, 332
Tugboat Annie Sails Again, 241
Tugwell, Rexford Guy, 164, 165
Tuttle, Frank, 198
Twentieth Century–Fox, 194, 202, 204, 215, 216
Twenty Cent Movie (Marsh), 198, *199*
291 Gallery, 48

Unemployment, Radical Protest, Speed (Benton), 91, 95
Union of Soviet Socialist Republics, 79, 278, 334, 354, 376, 392
art, *Life* article, 401, *402*, 403
Russian Revolution, 50
Unions, 48–51, 179, 180, 186, 265, 266
Congress of Industrial Organizations (CIO), 180

Unions (*continued*)
Hollywood, 213, 214
International Alliance of Theatrical
Stage Employees and Motion
Picture Operators (IATSE), 213,
214
United Auto Workers (UAW), 180,
181, 186
United Artists (UA), 5, 166, 220,
229, 242, 246, 253, 280
United Automobile Work (periodi-
cal), 181
United Auto Workers (UAW), 180,
181, 186
United States Information Agency,
393
University of Iowa, 112, 391
Urban, Joseph, 78, 79, 108
U.S. Steel, 152, 265

Vanderlyn, John, *54*
Van Dine, S. S., 72
Van Gogh, Vincent, 90
Vanity Fair (periodical)
"Hollywood Beauties," 204, *205*
Veblen, Thorstein, 76
Vest, Senator George, 28, 30
Victoria the Great, 202
Vidor, King, 56, 94, *250*
Beyond the Forest, 338
Our Daily Bread, 94, 250, 268,
285
Vital Center, The (Schlesinger), 334–
36, 383
Vogue (periodical), 404, 405, *406,
407,* 409
advertisements, 409, *410, 413*
Vu (periodical), 172

Wadatkut, 351
Wagner Act, 180, 265
Wainwright, Loudon, 174
Wakeman, Frederick, 232, 233, 354

Hucksters, The, 232, 338, 339,
415
Walkowitz, Abraham, 48
Wallace, Henry, 164
Walt Disney Studios, 292
Wanger, Walter, *241,* 241–44, 246,
247, 252, 262
Wayne, John, 242, 248, *250*
Weekly Illustrated (periodical), 172
Weischel, John, 42, 48–50, 77, 97
West, Nathanael
Day of the Locust, The, 197
We, the People (Huberman), 113,
325
Wheeler, Burton, 243
*Wherefore Now Ariseth the Illusion
of a Third Dimension* (Albright),
258, *259*
Whistler, James Abbott McNeill, 34
Whitney, Gertrude Vanderbilt, 88
Whitney Museum of American Art,
69, 87, 88, 90, 388
Whitney Studio Club, 87, 88
Wilson, Edmund, 56
Wise, Elizabeth, 24, 30
Wissel, Adolf
Worker's Family, 390
Wizard of Oz, The, 202
Wonderful Wizard of Oz, The
(Baum), 27
Wood, Grant, 2, 90, 112, 118, 136,
301, 376
American Gothic, 2, 162, *163*
Associated American Artists, 162,
165, 166
critical reaction, 388
Janson, H. W. 391
Midnight Ride of Paul Revere,
404
Sentimental Ballad, 241, 248
Spring Turning, 175, 178
Women in War, 252
Worker's Family (Wissel), *390*
Workers! You've Got Nothing to

Lose But Your Change (Benton), 181, *183*
Works Progress Administration, 108, 136, 151, 265, 270, 328, 378
World War I, 2
World War II, 3, 4, 6, 229, 251, 261, 272, 279, 282, 283, 287–89, 295, 296, 297, 301, 387
 Benton, Thomas Hart, 29, 262–89, 295–97
 Pollock, Jackson, 345
Wright, Fanny, 36
Wright, Frank Lloyd, 33
Wright, Willard Huntington, 72
Wyeth, N. C., 155

Year of Peril (Benton), 6, 282, 283, *284*, 288–93, 295, 297
 Again, 282, 283, 285, *288*
 Casualty, 282, 283
 critical reaction, 297, 300
 Exterminate!, 282, 283, 287, 293
 Harvest, The, 282
 Indifference, 282, 283, 285, 293
 Invasion, 282, 283, 285, 286
 Sowers, The, 282, 283, 286, 293
 Starry Night, 282, 283, *284*
Young, Roland, 210

Zanuck, Darryl F., 204, 215–17, *217, 218*
Zepf, Toni, 155